W9-BCC-670

MATISSE: HIS ART AND HIS PUBLIC

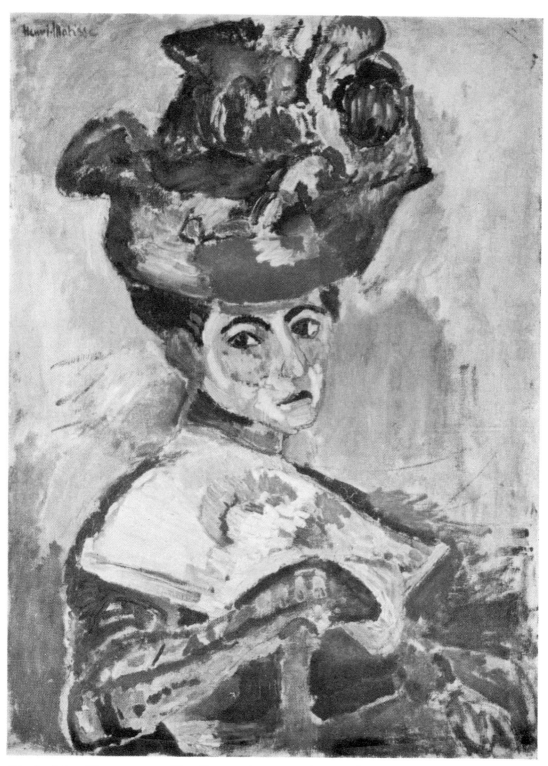

Color frontispiece: WOMAN WITH THE HAT (*Femme au chapeau; Madame Matisse*). Paris (1905, autumn)
Oil, 32 x 23½″. San Francisco, Mr. and Mrs. Walter A. Haas (formerly collections: Leo and
Gertrude Stein; Michael and Sarah Stein)

MATISSE

HIS ART AND HIS PUBLIC

BY ALFRED H. BARR, JR.

THE MUSEUM OF MODERN ART, NEW YORK

REPRINT EDITION, 1966 PUBLISHED FOR
THE MUSEUM OF MODERN ART BY ARNO PRESS

This edition of *Matisse: His Art and His Public* reproduces exactly the text of the original clothbound edition. Textual references to color plates should be ignored, since the color plates of the original edition are here reproduced in black and white. However, the reader will find eight notable examples of Matisse's art reproduced in color following page 278.

Copyright © 1951 by The Museum of Modern Art
All rights reserved

Arno Press Reprint Edition 1966
Second Printing 1974
Library of Congress Catalog Card #66-26118
ISBN #0-405-01525-9

The Museum of Modern Art
11 West 53 Street
New York, N.Y. 10019
Printed in the United States of America

MATISSE: HIS ART AND HIS PUBLIC:
ADDITIONS AND CORRECTIONS

A = left-hand column. B = right-hand column. par = paragraph.

Corrections received from Matisse's secretary, Mme Lydia Delectorskaya, letter of February 7, 1952, are initialed L.D.; those from Pierre Matisse, P.M.

Attention is called to additions and corrections already listed on page 529; especially important are those referring to pages 30, 313, 340-341, 360, 375, 426, 430, 457, 493.

Additions, changes of ownership, etc., occurring since publication, November 1951, are not listed.

Besides Mme Delectorskaya and Pierre Matisse I have to thank the following for their corrections and additions: Barnes Foundation, T. L. Berger, Miss Betty Chamberlain, Georges Duthuit, A. E. Gallatin, Frau Marg Moll, John Rewald, Daniel Catton Rich, M. J. Sandler.

<div style="text-align:right">A. H. B., JR.</div>

page

6 *for* O'Keefe *read* O'Keeffe.

15A, par 1. It was especially Goya's *Jeune et Vieille* at the Lille Museum which encouraged Matisse to go on with painting, saying to himself: "Çà, je pourrais le faire." (L.D.)

23. Photograph of Matisse on horseback was taken at Robinson near Clamart, 1912/13. (P.M.)

33A, par 2. *Trompe l'oeuil* lettering on copy of the *Dead Christ* (p. 293) was probably done by another painter. (P.M.)

37A, par 3. *For* Payrayre *read* Parayre. (P.M.)

37B, par 4. The Fenouillet here mentioned is near Toulouse not in the Pyrenees. (P.M.)

46A, par 3. The general tone of *Breton Serving Girl* (p. 298) is sandy rather than silvery.

48A, par 4. *Still Life against the Light* (p. 302): background, bright orange with deep reds and green blues at left; tablecloth, violet and turquoise; still life includes crimson and blue.

48B, par 2. *Male Model* (p. 304): background, dull blue, blue green, violet; figure, dull pink and orange down to dark green and violet; outlines, dark blue, black.

52B, par 4. Sculpture of human foot was done not in 1900 but about 1909 as study for the *Dance* (pp. 360, 362). (L.D.)

60A, end of par 3. *omit* both

95A, par 2. *for* three-score *read* two-score.

117A, par 2. Halvorsen was Norwegian, not Swedish. Dardel was a painter, not a sculptor. Sigrid Hjerten also studied with Matisse. (M. J. Sandler). Dubreuil has achieved considerable fame in France as a book illustrator. (P. M.)

130B, par 6. *Olga Merson* (p. 353): background, turquoise above, Prussian blue below; brown hair; gown, bright greens shot with brown.

132A, par 4. *Bathers with a Turtle* (p. 357): background: bright green ground, dark cobalt sea, darkish blue sky.

136B, par 1. *Dance — Study* (p. 361): hair of figures dark brown, black, green black.

142B. *The Back, I*: *cf*. reference below to page 218A.

154B, par 3. *Flowers and Ceramic Plate* (p. 377): background bright blue shot with violet; plate, strong blue green.

184A, par 1. *Woman on a High Stool* (p. 393): grey background; table top, orange red; yellow and reddish tones in stool and forearm; dress grey with blue and green in skirt.

184B. *Mlle Yvonne Landsberg* (p. 395): figure, steel grey with black against grey background; scratched lines show white; green streaks on chair legs; reddish patch above mouth.

186B, par 1. Matisse never made a copper-plate portrait of Francis Carco. (G. Duthuit)

189B, par 5. *Apples* (p. 406): background, black with pale brown and yellow at lower right; basket, pale brown; apples, green, red, ochre.

190A, par 3. *Bathers by a River* (p. 408): figures, grey and pink; background at right pale blue.

198B, par 3. The first public museum in the United States to acquire a Matisse painting was not the Detroit Institute of Arts but the Art Institute of Chicago which in 1921 purchased the *Woman at the Window* through the Joseph Winterbotham Fund.

201A, par 2. *Cf*. above correction to page 198B.

201B, par 2. The Musée du Luxembourg, Paris, acquired *The Sideboard* (p. 450) in 1929. It was presented by the Association des Amis des Artistes Vivants which paid Matisse one franc, about four cents, according to A. E. Gallatin, at that time Vice-President of the Association.

206B, par 3. *Tea* (p. 426). The dress of Marguerite, at right, is violet on pale violet; her cat is white.

209B, par 3. *Interior at Nice* (p. 435). Color is not "almost entirely grey and blue." Wallpaper is tannish; curtains, grey white; shutter, blue green; sea, dull blue; floor, dull pink; table top, grey white; chair, tan.

218A, par 5 and 218, note 1. *The Back, I, II* and *III* (pp. 313, 458, 459). In a letter to the author, dated Nice, April 1, 1952, Matisse writes: "With regard to the dates of the three reliefs I really cannot give you exact information. The first one was done at the Boulevard des Invalides; the second, it seems to me, before the war of 1914; and the last one in 1929 just before my trip to Tahiti. . . . The last state . . . was . . . cast in bronze only last summer."

Matisse lived at the Invalides address from the spring of 1908 through the spring of 1909. Madame Matisse, however, is sure that *The Back, I* was done at Issy after the summer of 1909, p. 142B.

220B, par 2. The mistake in measurements for the first version of the Barnes Foundation decoration was the artist's not the Foundation's. On February 22, 1932, Matisse cabled from Nice to Dr. Barnes in Merion: "MILLE EXCUSES COMME NOUVELLE COMPOSITION EST NECESSAIRE JE TERMINE PANNEAUX ACTUELS PRESQUE FINIS ET RECOMMENCE SUR NOUVELLES TOILES ENVOYEZ GABARIT INUTILE VENIR MERCI LETTRE SUIT." (*Gabarit* means full-scale pattern.) A letter dated Nice, February 23, confirms Matisse's error and apologies. Neither letter nor cablegram was available to the author before publication.

243A, par 4. *Omit* moved in part by Dr. Barnes' apologies and eager exhortations.

247B, line 1. *For* dark green *read* yellow green.

252B, par 4. *Music* (p. 481): general effect brilliant; upper background, bright bluish green leaves against black; right-hand figure, dark blue against scarlet cloth. Left-hand figure, ochre dress; table top, bright blue green with scarlet apple and white sheet music.

255A, par 4. Matisse planned a one-month visit to Brazil during the "cold war," but after the Germans attacked he gave up the project although he might have sailed from Genoa June 8. At no time did he think of fleeing France. (L.D.) *Cf.* also page 256A, last paragraph.

265A. Clement Greenberg explains that he intended the word cubism as a designation for the general period rather than for a particular movement.

267A, par 1. *Sleeping Woman* (p. 486): the painting reproduced was an early state, soon over-painted, of the *Sleeping Girl*. (L.D.)

275B, par 2. *The Nightmare of the White Elephant* (p. 501): misinterpretation of subject led to inversion of plate. Right side up, elephant is seen, standing on a starred ball, with flapping ears, raised trunk and tail. (L.D.)

COLOR PLATES: *Color Corrections*

66 *Sideboard and Table:* somewhat too red over-all.

68 *Pont St. Michel:* blues should be more violet.

79 *Music (Sketch):* sky should be paler and greyer.

163 *Red Studio:* most colors a little too pale.

165 *Goldfish and Sculpture:* blue is too violet, other colors somewhat too dull.

166 *The Blue Window:* blues and greens too pale.

173 *The Moroccans:* violet color poorly registered and too strong over-all; buildings at left should be grey with less pink; greens are too dark, yellows much too dark and orange.

228 *Shrimps:* over-all tone too red; blues and pinks too bright.

233 *Odalisque with a Tambourine:* reds too bright; greens too weak.

236 *Pineapple and Anemones:* all colors somewhat too dull except the yellow.

239 *The Egyptian Curtain:* colors too dull; blue sky too violet.

NOTES TO BLACK-AND-WHITE REPRODUCTIONS

316 *By the Sea.* Collection: Chicago, Col. Robert R. McCormick

331 *Blue Still Life.* Color: *House and Garden,* Dec. 1942, p. 42

342 *Still Life with a Greek Torso.* (Ex Moll)

377 *Flowers and Ceramic Plate.* Color: A. Crane, *A Gallery of Great Paintings,* New York, 1944, p. 62

458 *The Back, II.* Date: c. 1914?

486 *Sleeping Woman.* An early state of the *Sleeping Girl,* reproduced in Philadelphia, bibl. 152, pl. 82. (L.D.)

501 *The Nightmare of the White Elephant.* Plate inverted. (L.D.)

510 *Mimosa.* Color: *Art News Annual,* 1951, p. 7.

560 *Magazine, Book and Catalog Covers.* Add: *Verve,* vol. 6, no. 23, 1949.

CONTENTS

ACKNOWLEDGMENTS 5

PREFACE 9

PART I: 1869-1896 EARLY REBELLION AND
 ACADEMIC SUCCESS 13

 1. Youth in Picardy: First Paintings; Revolt against the Law, 1869-1891.
 2. Paris: Bouguereau, 1891-1892. *3.* Gustave Moreau's Studio, 1892-1897.
 4. Moreau as a Teacher. *5.* Matisse's Fellow Students, 1891-1897. *6.* Paint-
 ings, 1892-1896: The Louvre Copies. *7.* Original Paintings, 1892-1896.
 8. The Salon de la Nationale, Spring, 1896.

PART II: 1896-1904 MATISSE DISCOVERS MODERN
 PAINTING 35

 SECTION I MATISSE'S LIFE, PERSONAL AND PROFESSIONAL, 1896-1904 35

 1. Brittany; the *Dinner Table* and the Revolt against the Nationale, 1896-
 1897. *2.* Matisse's Elders and Contemporaries in the 1890s. *3.* Marriage,
 1898, and a Year in the South. *4.* Paris, 1899-1901; More Future Fauves.
 5. Cézanne's *Three Bathers*. *6.* Matisse's Position about 1900. *7.* Matisse's
 Family, 1900-1904. The Dark Years. *8.* Mme Matisse and Her Husband.
 9. Matisse and His Children. *10.* Matisse's Life as a Painter, 1899-1904.
 11. Vlaminck and Derain. *12.* Roger Marx and Berthe Weill. *13.* The
 Salon d'Automne, 1903. *14.* First One-man Show, 1904.

 SECTION II MATISSE'S ART, 1896 TO EARLY 1904 45

 1. Brittany and Impressionism, 1896. *2.* The *Dinner Table*, 1897. *3.* Paint-
 ing: Corsica, 1898. *4.* Toulouse and "Pointillism," 1898-1899. *5.* Painting:
 Paris, 1899-1901. *6.* "Proto-Fauve" Painting: Summary. *7.* Painting: The
 "Dark" Period, 1901-1904. *8.* First Sculptures, 1899-1904.

PART III: 1904-1907 MATISSE IN PARIS: "THE KING
 OF THE FAUVES" 53

 SECTION I MATISSE'S LIFE, MID-1904-1907 53

 1. St. Tropez, Signac and Cross: Summer, 1904. *2. Luxe, calme et volupté* and
 the Indépendants of 1905. *3.* Collioure, 1905. *4.* The Salon d'Automne of
 1905. *5.* The Four Steins. *6.* Sale of the *Woman with the Hat*. *7.* Rue de
 Fleurus and rue Madame. *8.* Hans Purrmann.

SECTION II PAINTING, 1904 TO FALL, 1905 59

1. St. Tropez and Neo-Impressionism, Summer, 1904. *2. Luxe, calme et volupté,* 1904-1905. *3.* Painting, Collioure, 1905. *4.* The *Woman with the Hat* and "*The Green Line,*" Autumn, 1905.

SECTION III CRITICISMS, SALON D'AUTOMNE, 1905 62

1. André Gide. *2.* Geffroy and Vauxcelles. *3.* Maurice Denis. *4.* Denis in Retrospect.

SECTION IV MATISSE'S LIFE, 1906-1907 81

1. The *Joy of Life* at the Indépendants, 1906. *2.* The Druet Exhibition. *3.* Biskra and Collioure, 1906. *4.* The First Matisse in America. *5.* Salon d'Automne, 1906: The Indépendants, 1907. *6.* Italian Journey, 1907. *7.* Salon d'Automne, 1907. *8.* The Steins, 1907. *9.* Picasso and Matisse, 1907. *10.* The *Joy of Life* and *Les Demoiselles d'Avignon.* *11.* Cézanne and the Crisis of 1907-1908.

SECTION V MATISSE'S ART: LATE 1905 THROUGH 1907 88

1. The *Joy of Life* (*Bonheur de vivre*). *2.* The Poetic Subject. *3. Joy of Life:* The Composition. *4. Joy of Life:* The Style. *5.* Painting, 1906-1907: Variety of Style. *6.* Landscape, 1906-1907. *7.* Still Life, 1906-1907. *8.* The *Young Sailor, I* and *II;* the *Self Portrait; Marguerite.* 1906. *9.* The *Blue Nude* and Other Figures, 1907. *10. Le luxe, I* and *II.* *11. Three Bathers* and *Music* (*sketch*), 1907.

SECTION VI GRAPHIC ART AND SCULPTURE THROUGH 1907 97

1. Matisse's Drawings through the Fauve Period. *2.* The Early Etchings and Drypoints. *3.* Matisse's First Lithographs, 1906. *4.* The Three Early "Woodcuts," 1906. *5.* Sculpture, 1905-1907. *6.* Matisse's Ceramics.

SECTION VII APOLLINAIRE'S INTERVIEW, 1907 101

PART IV: 1908-1910 MATISSE, THE INTERNATIONAL ARTIST 103

SECTION I MATISSE'S LIFE, 1908-1910 103

1. The School, 1908; Exhibitions Abroad; Issy-les-Moulineaux, 1909. *2.* Painting and Sculpture, 1908-1910. *3.* Friends and Collectors: American, German, French, 1908-1910. *4.* Shchukin and Morosov. *5.* Matisse in Germany, 1908-1910. *6.* Bavaria, Summer, 1908. *7.* Berlin and the Cassirer Show, Winter, 1908-1909. *8.* Munich and the Islamic Exhibition, Autumn, 1910. *9.* Scandinavia. *10.* Moscow, 1908-1909. *11.* England, 1908-1910. *12.* New York, 1908-1910. *13.* The First Matisse Show at "291," 1908. *14.* Berenson's Letter to *The Nation,* 1908. *15.* The Second Matisse Show at "291," 1910.

SECTION II MATISSE'S SCHOOL, 1908-1911 116

1. The Original Class, 1908. *2.* Growth and Decline of the School. *3.* Matisse as a Teacher.

SECTION III "NOTES OF A PAINTER," 1908 119

SECTION IV STILL LIFES AND INTERIORS, 1908-1910 123

1. Summary. *2.* Still Lifes, 1908. *3.* The *Harmony in Blue*, 1908. *4.* The *Harmony in Red*, 1909. *5.* The *Conversation*, 1909. *6.* The Extreme Arabesque. *7.* Matisse's Still Life as Drama. *8.* Still Lifes, 1909-1910.

SECTION V PORTRAITS, 1907-1911 128

1. Characterization and Style. *2.* The *Red Madras Headdress*, 1907. *3.* The *Greta Moll* and Other Portraits, 1908-1909. *4.* Three Portraits of 1910. *5.* The *Manila Shawl*, 1911.

SECTION VI FIGURE COMPOSITIONS, 1908-1910 132

1. Retrospect. *2.* Compositions, 1908-1909. *3.* Shchukin Commissions the *Dance* and *Music*, 1909. *4.* Shchukin Rejects *Dance* and *Music*, 1910. *5.* The Origins of the *Dance*. *6.* The *Dance:* Composition and Color. *7.* The *Music*, 1910.

SECTION VII SCULPTURE, 1908-1911 138

1. Sculpture, 1908-1909. *2.* *La Serpentine*, 1909. *3.* The Five Heads of Jeannette. *4.* *Jeannette, I, II, III.* *5.* *Jeannette, IV, V.* *6.* The *Back, I*, about 1910.

PART V: 1911-1913 SPAIN AND MOROCCO 143

SECTION I—LIFE, 1911-1913 143

1. Spain, 1910-1911. *2.* Issy and Collioure, 1911. *3.* Moscow, Autumn, 1911. *4.* Morocco, Winter, 1911-1912. *5.* Issy, Summer-Fall, 1912. *6.* Exhibitions in Paris and Abroad, 1912-1913. *7.* Second Moroccan Sojourn, Winter, 1912-1913. *8.* The Bernheim-Jeune Exhibition, 1913. *9.* Matisse, "A Fabulous Personage." *10.* Matisse and the Cubists. *11.* Shchukin's Letter of October, 1913.

SECTION II EXHIBITION AND CRITICISM, 1911 TO SPRING 1913 148

1. Paris. *2.* Foreign Exhibitions, 1911-1913. *3.* Sculpture at "291," New York, 1912. *4.* Cologne and London, 1912. *5.* The New York "Armory Show," 1913; Chicago; Boston.

SECTION III PAINTINGS, 1911 151

1. The Two Spanish Still Lifes, 1911. *2.* The Four "Symphonic Interiors," 1911. *3.* *The Painter's Studio*, Early 1911. *4.* *The Painter's Family*, Spring, 1911. *5.* The *Interior with Eggplants*, 1911. *6.* The *Red Studio*, Autumn, 1911. *7.* The Still Lifes of 1911.

SECTION IV PAINTINGS: THE FIRST MOROCCAN VISIT, 1911-1912 154

1. Matisse in Morocco. *2.* *Zorah Standing; Fatma; Amido*, 1912. *3.* The Three Garden Paintings, 1912. *4.* The *Window at Tangier*.

SECTION V PAINTINGS: ISSY, SUMMER AND FALL, 1912 156

1. *Nasturtiums and the "Dance,"* I and II. *2.* A Path in the Woods of Clamart, 1912? *3.* The Barnes *Goldfish* and *Still Life with a Bust*, Issy, 1912. *4.* Structure and Sobriety.

SECTION VI PAINTINGS: THE SECOND MOROCCAN VISIT, 1912-1913 159

1. *Zorah on the Terrace.* *2.* Flower Pieces and Still Lifes. *3.* *The Riffian.* *4.* The *Moorish Café* and Marcel Sembat.

PART VI: 1913-1917 AUSTERITY AND ARCHITEC-
TONICS; THE FIRST WORLD WAR 177

SECTION I MATISSE'S LIFE, MID-1913 THROUGH 1917 177

1. Summer at Issy, 1913. *2.* Quai St Michel, 1913-1914. *3.* The Second Berlin Exhibition, 1914. *4.* War; Collioure; Juan Gris: Summer, 1914. *5.* Paris, Autumn, 1914. *6.* The Montross Gallery Exhibition, 1914-1915. *7.* American Collectors, about 1915. *8.* Paris, Issy-les-Moulineaux, 1915-1916. *9.* Paris, Issy, 1916-1917. *10.* Nice, Paris: 1916-1917.

SECTION II PAINTINGS AND PRINTS, MID-1913 THROUGH 1915 183

1. The *Mme Matisse,* 1913, and the *Woman on a High Stool.* *2.* The Portraits of Yvonne Landsberg, 1914. *3.* The *Goldfish* and Other Paintings of 1914. *4.* Prints, 1914. *5.* Lithographs, 1914. *6.* Etchings and Drypoints, 1914-1915. *7.* Monotypes, 1914. *8.* Paintings, Late 1914-1915. *9.* Four *Goldfish:* 1911, 1912, 1914, 1915.

SECTION III PAINTINGS: PARIS, ISSY-LES-MOULINEAUX, 1916-1917 189

1. Portraits, 1916. *2.* Still Lifes, 1916. *3.* *The Window,* 1916. *4.* The *Bathers by a River.* *5.* The *Gourds* and *The Moroccans,* 1916. *6.* Studio Interiors, 1916. *7.* Paintings of Lorette, 1916-1917. *8.* The *Three Sisters* Triptych, 1916-1917. *9.* The *Music Lesson,* 1917, and the *Piano Lesson,* 1916. *10.* Landscapes, 1916, 1917. *11.* Still Lifes, 1916-1917.

PART VII: 1917-1929 RELAXATION IN NICE AND
RENEWED EXPERIMENT 195

SECTION I MATISSE'S LIFE 1916 (NICE) THROUGH 1929 195

1. Nice, late 1916 to 1918. *2.* The Visits with Renoir, 1917-1918. *3.* Nice, Issy, London, Etretat: 1918-1920. *4.* Publications on Matisse, 1920. *5.* Nice and Paris, 1921-1925. *6.* Honors, Exhibitions, Museum Accessions, 1921-1925. *7.* Collectors, 1917-1925. *8.* A Turning Point, 1925. *9.* Exhibitions, 1925-1930. *10.* Matisse Collectors, 1925-1930. *11.* Criticism, 1923-1930.

SECTION II NICE—THE FIRST THREE SEASONS, 1917, 1918, 1919 203

1. The General Reaction, 1912-1925. *2.* Nice, 1917-1918: Hôtel Beau-Rivage. *3.* Nice, 1918-1919: Hôtel de la Méditerranée. *4.* The Plumed Hat. *5.* Issy, Summer and Fall, 1919; *Tea.* *6.* The *Bouquet for the 14th of July,* 1919.

SECTION III *LE CHANT DU ROSSIGNOL,* 1920 207

1. Matisse Commissioned, 1919. *2.* Reception of *Le chant du rossignol,* 1920.

SECTION IV NICE, ETRETAT, 1920-1925 208

1. Evaluation of the Period. *2.* Etretat, Summers, 1920 and 1921. *3.* Nice,

1921. *4.* Landscapes. *5. Checker Game and Piano Music,* 1923. *6.* Odalisques, 1923-1924. *7.* Still Lifes and Interiors, 1924-1925. *8.* Lithographs, 1922-1925.

SECTION V RENEWED EXPERIMENT: SCULPTURE AND PAINTING, 1925-1929 213

1. The Sculptured *Seated Nude,* 1925. *2.* Painting, 1926-1927. *3.* The *Decorative Figure on an Ornamental Background,* 1927. *4.* Reaction and Retrospection, 1927-1928. *5.* Rococo, again, 1928. *6.* The détente, 1929.

SECTION VI GRAPHIC ART AND SCULPTURE, 1926-1930 216

1. Lithographs, 1926-1930. *2.* Etchings and Drypoints, 1929. *3.* Drawings, 1926-1930. *4.* Sculpture, 1927-1930. *5. Reclining Nude, II* and *III,* 1929? *6. The Back, II* and *III,* 1928-1929? *7.* Sculpture, 1930.

PART VIII: 1930-1939 FROM THE BARNES MURALS TO THE *ROUGE ET NOIR* 219

SECTION I MATISSE'S LIFE, 1930-1939 219

1. Tahiti, Spring, 1930. *2.* The Carnegie Jury, Autumn, 1930. *3.* The Barnes Murals; the *Mallarmé* Etchings; the Rockefeller Center Invitation, 1930-1933. *4.* The Four Retrospectives, 1930-1931. *5.* Praise and Slander, 1930-1935. *6.* Paintings and Commissions, 1935-1938. *7.* Collectors and Museums in the 1930s. *8.* Paris, 1939; War.

SECTION II THE BARNES MURAL 241

1. The Barnes Mural: Preliminary Problems. *2.* The Barnes Mural, First Version, 1931-1932. *3.* The Barnes Mural, Second Version, 1932-1933. *4.* The Barnes Mural—Analogies and Reactions.

SECTION III THE MALLARMÉ ETCHINGS, 1931-1932 244

1. Matisse's First Illustrated Book. *2.* Technical and Esthetic Problems. *3.* The *Mallarmé* in Progress. *4.* A New Iconography. *5.* The *Mallarmé* Published, 1932.

E CTION IV PAINTINGS AND DRAWINGS, 1931-1935 246

1. Paintings, 1931-1933. *2.* Portrait Drawings. *3. The Magnolia Branch,* 1934. *4.* Nudes, 1933-1935. *5.* The *Pink Nude,* 1935: Trial and Error. *6.* A Complex of Balances.

SECTION V COMMISSIONS, 1935-1937: ILLUSTRATIONS, TAPESTRY, GLASS 249

1. The *Ulysses* Etchings, 1935. *2.* The Tapestry for Mme Cuttoli, 1935. *3.* The Design for Steuben Glass.

SECTION VI PAINTINGS AND DRAWINGS, 1935-1939 251

1. Drawings, 1935-1936. *2.* Paintings, 1936-1938. *3. The Conservatory,* 1938. *4.* The Overmantel for Nelson Rockefeller, 1939. *5.* The Buffalo *Music,* 1939. *6.* A Prophetic Scissors-and-Paste Composition, 1938. *7.* Interiors with a Black Background, Four Self Portrait Drawings, Late 1939. *8. Rouge et Noir;* Massine's Symphonic Ballets, 1933-1939. *9.* Matisse's Designs for *Rouge et Noir,* 1938. *10. Rouge et Noir* performed, 1939.

PART IX: 1939-1951 SECOND WORLD WAR; BOOKS; THE CHAPEL AT VENCE

PART IX: 1939-1951 SECOND WORLD WAR; BOOKS; THE CHAPEL AT VENCE 255

SECTION I BIOGRAPHY, 1939-1951 255

1. War—Cold and Hot, 1939-1940. *2.* Nice during the War, 1940-1942. *3.* Matisse and "Vichy" France. *4.* Radio Broadcasts, 1942. *5.* Vence, 1943. *6.* Mme Matisse and Marguerite Duthuit in the Resistance. *7.* Painting and Graphic Art during the War Period: A Summary. *8.* Books on Matisse during the War. *9.* Post-War Exhibitions: Paris, London, Brussels, Nice, 1945-1946. *10.* Matisse in Films, 1946. *11.* Matisse in the New Musée National d'Art Moderne. *12.* Paintings; Illustrated Books; Decorative Designs: 1946-1950. *13.* The Vence Chapel and other works, 1948-1951. *14.* The Return to Nice: Matisse's 80th Birthday, 1949. *15.* Matisse Exhibitions, 1948-1949: Philadelphia, Paris, Lucerne, Nice. *16.* Matisse at the Maison de la Pensée Française, 1950; Japan and Germany, 1951. *17.* Museums and Collectors.

SECTION II MATISSE'S CRITICAL POSITION SINCE THE WAR 263

SECTION III PAINTING AND DRAWING, 1940-1945 266

1. Paintings, 1940. *2.* Compositions with a "Dialogue," 1941-1942. *3.* Still Lifes, 1941-1942. *4.* A "Floraison" of Drawing, 1941-1942. *5.* Still Lifes, 1943. *6.* Interiors with a Seated Girl, 1942-1943. *7.* Vence.

SECTION IV ILLUSTRATED BOOKS, 1941-1950 270

1. The Canon. *2.* The Eight Books of the 1940s. *3.* De Montherlant's *Pasiphaé*, 1937?-1944. *4.* The *Florilège des Amours de Ronsard*, 1941-1948. *5.* The *Poèmes de Charles d'Orléans*, 1943-1950. *6.* Baudelaire's *Les fleurs du mal*, 1944-1947. *7.* The *Lettres portugaises*, 1946; Books by Reverdy, 1946, and Rouveyre, 1947. *8. Jazz*, about 1943-1947. *9.* Matisse and the Collages of Cubists, Dadaists, Silhouettists. *10. Jazz:* the Text and Subject Matter. *11.* Four Plates from *Jazz*.

SECTION V PAINTING, DRAWING, CUT-AND-PASTED PAPER, 1946-1950 275

1. Figures and the First Large Interior, 1946. *2.* Small Interiors with Two Girls, 1947. *3.* Secular Drawings, 1947-1950. Chinese Analogies. *4.* The Large Interiors of Early 1948. *5.* The *Large Interior in Red*, 1948. *6.* Cut-and-Pasted Papers, 1947-1950.

SECTION VI DESIGNS FOR DECORATIVE ARTS, 1940-1950 278

SECTION VII THE CHAPEL AT VENCE 279

1. Sister Jacques and Brother Rayssiguier. *2.* The Church at Assy: Its Significance. *3.* Matisse's *St. Dominic* at Assy, 1948. *4.* "Une église gaie!" *5.* The Communists and the Chapel, 1950. *6.* The Architecture of the Chapel. *7.* The Decoration of the Chapel. *8.* The Windows. *9.* Murals. *10.* The Stations of the Cross. *11.* The Virgin and Child. *12.* St. Dominic. *13.* Minor Tile Compositions. *14.* The Altar and Its Furniture. *15.* The Crucifix. *16.* The Chasubles. *17.* The Door to the Confessional. *18.* The Spire. *19.* The Chapel Completed, 1950-1951. *20.* Consecration of the

Chapel, June 25, 1951. *21.* Matisse's Message to the Bishop. *22.* The Bishop's Response. *23.* Matisse's Position. *24.* "For religious art . . . a revolution." *25.* " . . . the course that I am still pursuing."

PLATES

COLOR PLATES frontispiece; 66-79; 161-175; 226-239

COMPARATIVE AND DOCUMENTARY ILLUSTRATIONS 17-32

PLATE SECTION 289-528

NOTES

NOTES TO PLATES 529

NOTES TO TEXT 529

APPENDICES

APPENDIX A: MATISSE SPEAKS TO HIS STUDENTS, 1908: NOTES BY SARAH STEIN 550

APPENDIX B: APOLLINAIRE'S *"Medaillon: Un Fauve"* 553

APPENDIX C: CONTRACTS BETWEEN MATISSE AND BERNHEIM-JEUNE 553

APPENDIX D: TWO LETTERS FROM SHCHUKIN TO MATISSE, 1909, 1912 555

APPENDIX E: MATHER ON MATISSE'S DRAWING, 1910 556

APPENDIX F: WORKS BY MATISSE IN THE PUBLIC MUSEUMS OF ENGLISH-SPEAKING COUNTRIES 556

APPENDIX G: ILLUSTRATIONS BY MATISSE 559

APPENDIX H: HENRI MATISSE, "EXACTITUDE IS NOT TRUTH" 561

APPENDIX I: MATISSE'S RADIO INTERVIEWS, WINTER, 1942 562

APPENDIX J: HENRI MATISSE, "HOW I MADE MY BOOKS," 1946 563

BIBLIOGRAPHY

564

INDEX

575

For

FRANK JEWETT MATHER, JR.
CHARLES RUFUS MOREY
PAUL JOSEPH SACHS

This "work in progress"

ACKNOWLEDGMENTS

Far more than is usual this book has been a collaboration. The publisher and author have been the beneficiaries of the generous courtesy of hundreds of individuals and institutions throughout Europe and America. Many of their names are given in the text, the captions of the plates, the notes and bibliography. Others are mentioned in the following paragraphs though there may be some whose names through unhappy oversight have been omitted. The Museum of Modern Art and the author wish to thank them all.

First, Henri Matisse and his family. Some of the trouble this book has caused him has been indicated in the preface. He has borne the bombardment of questions with patience and so has Mme Matisse to whom the author feels a special indebtedness. Far more than anyone, Pierre Matisse has given time and thought, conveying questions to his parents or answering them himself, supplying photographs and documents, reading the typescript and, with the cooperation of his wife, Patricia, assisting in every possible way. Indeed his name might well have appeared as co-author. Matisse's daughter, Mme Georges Duthuit, and her husband, Georges Duthuit, have also answered many questions.

Second only to Pierre Matisse, we are obliged to John Rewald for his help in securing photographs, going over questionnaires with Matisse and in many other ways. Mrs. Bertha Slattery Lieberman and Monroe Wheeler have also helped in the friendly inquisition of the artist.

Among the friends of Matisse during his early controversial period we are especially indebted to Mrs. Michael Stein whose valuable notes taken down in Matisse's class are here published for the first time, and to Hans Purrmann who in half a dozen letters has given a wealth of information. Among others of Matisse's older friends and acquaintances who have searched their memories and generously answered questions are Clive Bell, Bernard Berenson, Georges Besson, Mme Juan Gris, Daniel Henry Kahnweiler, A. Clinton Landsberg, Frau Margarete Moll, Walter Pach, Carl Palme, Edward Steichen, Maurice Sterne and Max Weber.

Three scholars have given special assistance in research: Gertrude Rosenthal, of the Baltimore Museum of Art, who has ransacked the archives of the Cone Collection; Donald C. Gallup, Curator of the Collection of American Literature, Yale University Library, who has helped in the study of the Gertrude Stein and Alfred Stieglitz collections; and John W. Dodds of Stanford University, a friend of Mrs. Michael Stein. James Thrall Soby has kindly read the typescript.

Others who have taken exceptional trouble in giving assistance are Lily van Ameringen; Morris Carter of The Isabella Stewart Gardner Museum, Boston; Jean and Henri Dauberville of the Bernheim-Jeune gallery; Mme Lydia Delectorskaya, Matisse's secretary; the staff of the Frick Art Reference Library; José Gómez Sicre of the Visual Arts Section, Organization of American States; Iván Grünewald, the

5

son of Isaac Grünewald; Mrs. Sheldon Keck; **M. Gordon Knox** of the United States Embassy, Moscow; Corliss Lamont; Maurice Lavanoux of *Liturgical Arts;* Mrs. Denver Lindley; Mrs. Aline Louchheim of *The New York Times;* George Macy; Mrs. Alexina Matisse; Agnes Mongan of the Fogg Art Museum; Grace L. McCann Morley and Robert Church of the San Francisco Museum of Art; Eric P. Mosse, M. D.; Mrs. Dorothy Norman; Georgia O'Keefe; Alexandre P. Rosenberg; W. J. H. B. Sandberg of the Stedelijk Museum, Amsterdam; Leo Swane of the Statens Museum for Kunst, Copenhagen; Mabel Foote Weeks.

Two of the color plates have been generously subscribed by Mr. and Mrs. Samuel A. Marx and one each by Mr. and Mrs. William A. M. Burden, Mr. and Mrs. Richard Deutsch, General and Mrs. A. Conger Goodyear, Mr. and Mrs. Walter A. Haas, Mr. and Mrs. Albert D. Lasker, Dr. and Mrs. David M. Levy, Mrs. Sam A. Lewisohn and the late Mr. Lewisohn, Mr. and Mrs. William S. Paley, Mr. and Mrss John Hay Whitney, Mr. and Mrs. John S. Wintersteen, and an anonymous donor. The publishers Albert Skira, Geneva, and François Lachenal of the Editions de. Trois Collines, Geneva, have courteously lent several color plates for republication.

The Philadelphia Museum of Art has let us reprint a score of the halftone plates and much of the text of its 1948 Matisse catalog, edited by Henry Clifford. Its staff, especially Fiske Kimball, Henry McIlhenny and Carl Zigrosser, have been helpful in many ways. The Baltimore Museum of Art, Adelyn D. Breeskin, Director, and the Yale University Library, James T. Babb, Librarian, have been exceptionally cooperative. Carl O. Schniewind of the Art Institute of Chicago has generously made available his unpublished catalog of Matisse's prints; and Lester B. Bridaham took great pains in checking the photographs for the color plates of works in Chicago collections. *Harper's Bazaar*, Carmel Snow, editor, and *Art News*, Dr. Alfred M. Frankfurter, editor, have lent invaluable photographs and furnished information at considerable inconvenience.

Among the many others who have assisted by providing photographs and information are Otto Karl Bach of the Denver Art Museum; Martin Baldwin of the Art Gallery of Toronto; Pierre Berès; Gaston Bernheim de Villers; Ernest Brummer; William P. Campbell of the Worcester Art Museum; Jean Claparède of the Musée Fabre, Montpellier; Mr. and Mrs. Ralph F. Colin; Gerald Corcoran of Alex. Reid & Lefevre, Ltd.; Eleanor F. Derby of the Columbus Gallery of Fine Arts; Howard Devree of *The New York Times;* Dr. Alfred Gold; Dr. Ludwig Grote of the Haus der Kunst, Munich; George Heard Hamilton; Leonard C. Hanna, Jr.; Thomas B. Hess; Mrs. Dorothy Hope; Sidney Janis; Prof. Michael Karpovich; Antoinette Kraushaar; Katherine Kuh and Lester B. Bridaham of the Art Institute of Chicago; Georgia O'Keeffe; Robert M. MacGregor; Isabel Mackintosh of the Glasgow Art Gallery; Mrs. Louise Burroughs, Florence E. Day, Maurice S. Dimand, Aschwin Lippe, Elizabeth Naramore and Alan Priest of The Metropolitan Museum of Art; Agnes Mongan of the Fogg Art Museum; Lamont Moore of the Yale University Art Gallery; J. B. Neumann; Benedict Nicolson of *The Burlington Magazine;* Dr. Hugo Perls; Veljko Petrovic of the Belgrade Museum; Dr. Grete Ring of Paul Cassirer, Ltd.; Spencer Roberts; Derik Rogers of the Art Gallery and Museum, Brighton; Paul Rosenberg; Siegfried Rosengart; Dr. H. K. Röthel of the Bayerische Staatsgemäldesammlungen; John Rothenstein of the Tate Gallery; Sam Salz; Dr. Heinrich Schwarz of the Museum of Art, Rhode Island School of Design; Margaret Sharkey of the Carstairs

6

Gallery; Matthew Smith; Lionel S. Steinberg; Earl L. Stendahl; Dr. Georg Swarzenski; Allene Talmey of *Vogue;* Lelia B. Tomes of Steuben Glass; Charles Terrasse; Mr. and Mrs. Justin K. Thannhauser; Curt Valentin; Alexander O. Vietor; Florence Walters of A. P. Rosenberg & Co., Inc.; Jane Wilson of *Life;* Lelia Wittler and Elizabeth King of M. Knoedler and Company; Christian Zervos.

We are indebted to many publishers, besides those already mentioned, for quotations or reproductions, including Architectural Record; Braun et Cie.; Crown Publishers, Inc.; Librairie Floury; Gallimard; Alfred A. Knopf; Albert Messier; E. Weyhe; Wittenborn, Schultz, Inc.; and the periodicals *L'Age Nouveau, Cahiers d'Art, Les Cahiers d'Aujourd'hui, Hound and Horn, Liturgical Arts, Look, Magazine of Art, The Nation, Partisan Review, Transition, Verve,* and *Vogue.*

Among photographers, Robert Capa, Henri Cartier-Bresson, José Gómez Sicre and Pierre Matisse have been especially generous in giving prints for reproduction. Sources of other photographs and names of photographers are here listed unless they occur in the captions: Bérard, Bing, Clifford Coffin, Colten, Devinoy, Peter Juley, Carl Klein, Lemare, Sam Little, S. W. Newbery, André Ostier, John Borrows Peaty, Ch. Piccardy, William Reagh, George Sanderson, Seiders, Sunami, Vizzavona.

Bernheim-Jeune, Galerie Charpentier, French Art Galleries, Inc., Sidney Janis Gallery, M. Knoedler & Co., Liturgical Arts Society, Inc., Galerie Maeght, Magazine of Art, Pierre Matisse Gallery, Alex. Reid & Lefevre Ltd., A. P. Rosenberg & Co., Inc., Sovfoto, Thannhauser Gallery, Underwood & Underwood, Vanity Fair.

Albright Art Gallery, Buffalo Fine Arts Academy; The Art Institute of Chicago; The Baltimore Museum of Art; Fogg Art Museum; Museum Folkwang, Essen; Frick Art Reference Library; The Isabella Stewart Gardner Museum; The Metropolitan Museum of Art; Philadelphia Museum of Art; Museum of Art, Rhode Island School of Design; Statens Museum for Kunst, Copenhagen; Worcester Art Museum; Yale University Art Gallery.

Among the staff of the Museum of Modern Art, Betty Chamberlain, Charles T. Keppel, Dorothy L. Lytle, Margaret Miller, Pearl L. Moeller, Hannah B. Muller, C. Frances Radway, Andrew C. Ritchie, Paula D. Sampson, Jean Stepanian, and Monroe Wheeler have been very helpful in various ways.

A book of this size, completed and produced against time, has placed several others of the Museum staff under heavy pressure of work quite beyond their maximum obligations. Frances Pernas, assisted by Olive Bragazzi, has seen the book through the press; Edward L. Mills has supervised the typography; Dorothy C. Miller and William S. Lieberman have read copy and proof and made many valuable suggestions; Bernard Karpel has prepared the extended bibliography, Mr. Lieberman the list of Matisse's illustrations; Letitia Howe and Marianne Hartog have done research and prepared the typescript.

Richard F. Nett of the Plantin Press, and printer of many Museum books since 1930, has shown remarkable devotion in the production of this volume.

The index is the expert work of Helen M. Franc of the *Magazine of Art* who most generously volunteered her services.

The author's wife, whose research and translations appear in the following pages under the name Margaret Scolari, has been indispensably helpful. In fact, without her the author might not have survived his book.

A. H. B., JR.

PREFACE

This book was undertaken with the modest intention of revising and bringing up to date the catalog of the Matisse exhibition held at the Museum of Modern Art in 1931. In spite of determined efforts on the author's part the book has grown. For this Matisse himself is partly responsible. At the time of that exhibition he remarked: "I have been working from morning to night every day for forty years." Later on the term grew to "fifty years," and now it's "sixty years." Time and extraordinary energy at the service of one of the great creative talents of our century have produced a body of work so vast and so varied that it cannot properly be reviewed on a scale ordinarily devoted to the achievement of a living artist.

Even if one brought together the thirty books already published on Matisse one could not get a complete or well-proportioned view of his work as a whole. His drawings and, to a less extent, his prints one would find fairly well surveyed, his paintings too, with a few important exceptions. But his sculpture has been seriously neglected. Probably half of it has never been reproduced even in catalogs and periodicals, and this half, surprisingly, includes several of his most original and significant pieces. Another division of his work, his illustrated books, is almost unrepresented in previous monographs on Matisse; and so is his considerable quantity of design for the decorative arts, which has been greatly augmented by the stained glass and liturgical furnishings of the just completed chapel at Vence. To bring together and set in order an adequate number of reproductions of works in all these categories has been one of the principal purposes of this book.

Neither bringing together nor setting in order has been easy. Though Matisse's entire work has been produced during our age of profuse documentation and easy communication, certain curious circumstances have surrounded its study with difficulties. The three greatest collections of his paintings are in Moscow, Copenhagen and Merion, Pennsylvania. Of these Copenhagen is by far the most accessible to the student and accommodating in the matter of photographs. The other two could not be less so. Fortunately most of the needed photographs have been obtainable elsewhere—but not all. Such important paintings as the *Conversation*, 1909, and the *Girl with Tulips*, 1910, have had to be reproduced from halftones in rare publications. *Luxe, calme et volupté*, a legendary canvas of 1904-1905, and several other major paintings are probably reproduced here for the first time and so are such sculptures as the climactic *Jeannette, V* and the imposing *Back, II*.

Setting Matisse's works in a sound chronological sequence has proven equally difficult. Only at the last minute before publication has it been possible to

correct the previous dating of *The Back, I,* page 313, from 1904 to 1910. *The Back, II* may date from about 1929 or it may have been done a dozen years earlier—neither Matisse nor Mme Matisse can remember, though the *Back* series comprises by far his largest sculptures. The virtual disappearance of *Luxe, calme et volupté* for forty years had produced a comedy of confusion involving the two very large canvases, *Le luxe, I* and *II.* Even today Matisse and his family differ as to whether *Le luxe, II* was painted in 1907 or 1911. And for over twenty years now, most writers about Matisse, including this one, have chronically misdated one of his two most famous works, the *Joy of Life.*

No one of course should blame Matisse because he has been largely responsible for many of these errors. Problems of exact dating are for him irrelevant if not pedantic. Even when questions of priority arise he is, unlike some famous artists, as completely lacking in vanity as he is in precision. He is simply not interested in the history of his own art so that the ennui he has suffered during the cross-questioning necessitated by this book can be imagined. Of course he is right in assuming that chronology contributes nothing to the esthetic enjoyment of his art. Yet a clear historic sequence is essential for an understanding and appreciation both of his development and his importance as an artist.

Fortunately Mme Matisse has more sympathy for the historian, perhaps because she and the artist's daughter, Marguerite Duthuit, are at work on a great *catalogue raisonné.* Pierre Matisse, the artist's son, has also shown remarkable patience in helping to reconstruct the past, not only by racking his own memory but by his persistence in getting his parents to answer the author's questionnaires.

These questionnaires, submitted directly or through mutual friends, have been one the writer's chief instruments of research. The answers they have evoked depend for the most part on the memory of M. and Mme Matisse and whatever records they may have at hand—not, unfortunately, very numerous or accessible. Mme Matisse's memory has proven the more trustworthy and efficacious; yet her memories and those of her family need to be supported by the recollections which friends have provided in written memoirs and letters or in conversation. These are often fallible of course but they are firsthand and, taken cumulatively, weave a background of valuable reminiscence and anecdote. Sometimes they can be brought to a sharp factual focus by the historian's usual documents, such as letters, contracts, cablegrams, exhibition catalogs, newspaper accounts and so forth.

(Occasionally a more modern instrument has supplemented traditional research. In the Yale University Library is preserved a postcard of September, 1913, sent to Gertrude Stein by Matisse who writes: "*Picasso est cavalier et nous cavalons ensemble ce qui étonne beaucoup de monde.*" Pierre Matisse, under the stimulus of a recent radio interview, recalled that the ride lasted a full two hours so that afterwards Picasso, who was in fact not at all a *cavalier,* was agonizingly sore for several days. His fury was equaled only by Matisse's amusement. Thus, out of the air, a last minute footnote which throws a small but revealing beam upon the thorny forty-five year friendship between the two greatest painters of our period.)

Yet, though it includes a good deal about Matisse's life, this book is only incidentally a biography or a study of character. Not that Matisse's life is uninteresting. On the contrary it has been full not only of tangible hardships and triumphs but of quiet inner drama. Outwardly disciplined and measured, his personality is actually a complex of powerful tensions and dissatisfactions. For the creator of the happiest canvases of our day is exceptionally afflicted by anxieties which appear variously in his Cézanne-like agonies while working, his valetudinarianism, his relentless severity with himself and his intimates and his magnificent devotion to his art. These are grist for a biographer's mill but the primary subjects of this volume are, as its title indicates, Matisse's art and his public.

Matisse has endured more contumely than most important artists of the past hundred years. And, even more than most recent French painters, he suffered the neglect or hostility of his fellow-countrymen. As late as 1910 a French critic could write of Matisse: "We are happy to note that his disciples and active admirers include no one but Russians, Poles and Americans." Russians, Germans, Scandinavians and Americans were indeed the chief among Matisse's loyal friends and supporters in those early years, above all the four Steins from San Francisco, Hans Purrmann from Munich, Edward Steichen from New York and Sergei Shchukin of Moscow. To them a single Frenchman must be added, Marcel Sembat of Grenoble.

These enthusiasts were for years the most essential members of Matisse's *public*. They formed the nucleus, but his public, by which we mean to include all those who responded to his art, was of course manifold. It involved at the beginning his teachers and fellow students, then his colleagues and the first purchasers of his academic still lifes, then little by little the critics who began to see his paintings at the big annual Salons organized by artists, and then in a modest way the dealers—though Matisse had been painting for twenty years before a dealer began to play an important rôle and by then (contrary to legends about dealers' promotional conspiracies) the crucial campaign was over. By the end of 1908 the public had begun to see Matisse's paintings in London, New York, Moscow and Berlin, in all cases thanks to the activities of artists or amateurs who also brought about the first museum acquisition of a drawing (New York, 1910) and a post-academic painting (Munich, 1912). Meanwhile the reading public was confronted by a good many articles for or against Matisse though it was not until 1920 that the first book on him appeared. The general public outside the art world first saw his work abroad at the huge international exhibitions of modern art held in Cologne, London, New York, Chicago and Boston during 1912-1913.

During the early 1920s Matisse's relationship to the public changed. The growing traditionalism and charm of his painting greatly increased his popularity and the commercial value of his art. In 1921, at the age of 51, Matisse, as a modern painter, received his first modest recognition in French official quarters: the Luxembourg Museum acquired an *Odalisque*. Foreign museums, which already owned many of his works, began to organize Matisse exhibitions, first in Scandinavia (1924), later in Switzerland and the United

States (1931). During the 1930s he received increasing patronage in the form of commissions: mural paintings, book illustrations, designs for tapestries and glass and for the ballet.

In the same decade, to continue this preface to the *public* Matisse, the artist willy-nilly became a political figure. As a *Kunstbolschewist* his paintings were thrown out of German museums and sold abroad by the Nazis. About the same time Marxian criticism was closing in on his art in the U.S.S.R. though the fabulous collections of his paintings confiscated by the Soviet State in 1918 remained accessible to the Moscow public until fairly recently.

Finally, in his own country, the notable post-war renascence of French official art and museum administration has opened the way to many public honors. In 1947 Matisse was made a Commander of the Legion of Honor and in 1949 he was given an exhibition at the Musée National d'Art Moderne. His prestige as a public figure was by then so great that in the political hurly-burly of post-Liberation France his allegiance was, and is still, being persistently and unsuccessfully wooed both by the Communist party and the Catholic Church. Today his art is recognized as a national asset and its dissemination to the public at home and abroad, through cinema and exhibition, is encouraged by official subsidy and sanction.

What is much more important, however, is the fact that Matisse has recently recaptured the esteem of young artists of the *avant-garde*, esteem which he had largely lost during the three previous decades. For any good artist, the admiration and acclaim of his younger colleagues is more significant and more valuable than any amount of worldly or official success.

This story of Matisse's public is spread through the following pages in some detail as significant counterpoint to the history and analysis of Matisse's art.

"History" is perhaps the wrong word, semantically at least, for it connotes a certain finality. It should be made clear of course that in spite of its length (and weight!) and the apparatus of notes, appendices, lists and indices, this book is far from definitive. Its scholarship is only partially controlled and is therefore tentative; unquestionably much new material will eventually come to light in the form of letters and other documents; and the *catalogue raisonné* will also surely solve a number of problems besides greatly enriching our knowledge of the full scope of Matisse's art. Happily, Matisse himself has provided a still more cogent barrier to finality. Now that his chapel at Vence is finished, he burgeons with plans for the future. Already, it is reported, he has new drawings, sculpture, paintings, designs for windows under way.

Matisse will be eighty-two on the last day of this year, 1951: it is a pleasure to agree with the critic and collector, distinguished for his interest in the *avant-garde*, who recently returned from Vence exclaiming, "Never has Matisse seemed to me so young!"

PART I: 1869-1896

EARLY REBELLION AND ACADEMIC SUCCESS

1 Youth in Picardy: First Paintings; Revolt against the Law, 1869-1891

When Matisse's contemporary and oldest friend Georges Rouault was born, his mother was lying in the cellar of the house where she had sought refuge from exploding shells during the Paris *Commune*. Yet this did not discourage his grandfather's enthusiasm when the news came that the infant was a boy. "Good!" exclaimed the old gentleman, "let's hope he'll grow up to be an artist!"

Matisse's birth occurred under circumstances neither so hazardous nor so auspicious. Toward the end of 1869, a year and a half before Rouault was born, and while France was still at peace, Matisse's mother traveled for her lying-in from her home at Bohain-en-Vermandois to her own mother's house at nearby Le Cateau-Cambrésis.[1] There, at his grandmother Gérard's, Matisse was born on December 31, 1869. He was christened Henri Emile Benoît Matisse.[2]

Matisse's father, Emile Hippolyte Henri Matisse, was a reasonably successful grain merchant at Bohain-en-Vermandois, a town in Picardy a dozen miles northeast of St. Quentin. Matisse's mother, Anna Héloïse Gérard, was artistically inclined and painted china; his father was a practical man.

At about the age of ten Henri was sent from Bohain to the much larger St. Quentin to attend the *lycée* where he took the classics course. Then in 1887 his father sent him to Paris to study law at the University, in the curriculum which led to the diploma of attorney or *avoué*. Matisse was not much interested in his subject and remembers spending a good deal of time at the Louvre. Yet he passed his first set of examinations before leaving Paris in 1889.

Back in St. Quentin Matisse took a position as a clerk in a law office but found the practice of law even more boring than its study. Many years later he recalled how he used to fill page after page of legal foolscap by copying out the fables of La Fontaine—"no one read these '*conclusions grossoyées*' anyway, not even the judge, and they served no purpose other than to use up stamped paper in a quantity proportionate to the importance of the lawsuit."[3]

Meanwhile his interest in art increased. In 1889, not long after his return from Paris to St. Quentin, he entered the elementary drawing course of Professor Croisé at the Ecole Quentin de La Tour which was primarily a school for tapestry and textile designers. Croisé's pupils, however, drew from plaster casts—and met every weekday morning from 6:30 to 7:30 so that during the winter months Matisse went to art school in the cold dark and then after an hour's discipline in line and chiaroscuro passed on to his drudgery with torts and breaches of contract. It is possible that the highly competent charcoal study of a cast of the Capitoline "Niobid," illustrated on page 293, was done in Croisé's class.[4]

Early in the summer of 1890 at the age of twenty he began to paint as an amateur. He had been quite ill with appendicitis and during his slow convalescence in Bohain-en-Vermandois his mother gave him a box of colors to help him pass the time. He read an elementary handbook by Goupil and began by copying one of the "chromo" landscapes on the cover of the paint-box intended as models for beginners. In June he painted his first original canvas, a still life with a pile of old books. This he signed, modestly reversing his signature, *essitam, H.* and dated it *Juin 90*.[5] His second painting, the *Books and Candle*, page 293, is firmer in drawing and quite competent in rendering of surfaces. Tight and literal in technique, it falls within the rather provincial tradition of semi-*trompe-l'oeil* pictures of old books, newspapers and candlesticks which were popular in the late 19th century. Indeed it seems not far removed from the work of such American practitioners as Harnett and Peto. Thirty years

later Matisse exhibited both these still lifes of 1890 in an exhibition at Bernheim-Jeune, Paris, October 1920. He listed them as 1. *Mon premier tableau* and 2. *Mon deuxième tableau.*

2 Paris: Bouguereau, 1891-1892

Another year went by and Matisse grew more and more restive. His father was stubbornly opposed to Matisse's giving up a respectable career in law for a life as problematical and insecure as painting. Matisse was recalcitrant in his belief that painting was, as he put it, more interesting than the quarrels of others. He insisted that he must leave for Paris to study art and finally he won out.

The elder Matisse was somewhat reconciled to his son's folly when he was assured that the young man would go to school under the great Bouguereau. A painter of St. Quentin, Paul Louis Couturier, had been a pupil of Picot who in turn had studied with Bouguereau in Paris. Couturier recommended Bouguereau to the Matisses as a great teacher and, even more reassuring, as a successful man who might serve as a model for the aspiring student.

So, in the winter of 1891-1892,[6] Matisse set out for Paris to become an artist.

When he went to call on Bouguereau to present his credentials Matisse found the master in the presence of admirers busily making a copy of a copy[7] of what was to be one of his most famous works, *Le guêpier*, page 17—*The Wasp's Nest*, as it was called when shown in 1893 at the Chicago World's Fair, or *Invading Cupid's Realm*, as it was also known. Quite aside from the style of the painting Matisse was dismayed by this spectacle of a famous painter mechanically copying his own rather mechanical handiwork. Nevertheless Matisse entered Bouguereau's class at the Académie Julian.

Bouguereau is worth a moment's attention for, had Matisse been of different timber, the master might have inspired the pupil to imitation rather than with contempt. In any case, Bouguereau soon became to Matisse—just as for years he had been to a painter Matisse had not yet heard of, Paul Cézanne—the embodiment of the hated—and still formidable—academic spirit.

In 1892 Adolphe William Bouguereau was one of the three or four most famous living French painters. In 1850, when he was twenty-five, he had won the most sought-after students' award, the Prix de Rome. In Italy he spent many months copying the Giottos and 13th-century "primitives" at Assisi and the 6th-century Byzantine mosaics at Ravenna. From then on his art declined into ineffable saccharinity. But his fortunes rose. His porcelain nudes and mawkish altarpieces gained him fame, wealth and every honor official France could bestow. In 1855 he won a second medal at the Salon, in 1857 the first medal. In 1859 he was made a Chevalier of the Legion of Honor; in 1876 an Officer, in 1885 a Commander. When Matisse entered his class Bouguereau at sixty-seven was a Member of the Institute of France, President of the ancient Society of Painters, Sculptors and Engravers and the winner of dozens of medals and prizes at international exhibitions throughout the world. Even Cézanne, who despised Bouguereau's art, identified him with official success and complained bitterly over his own exclusion from the "*salon de Bouguereau.*" The immaculate, banal beauty of Bouguereau's painting coincided perfectly with the taste of philistine France—and no one would ever have questioned his industry, his integrity or his sincere desire to please.

Bouguereau taught at the Académie Julian, a private school taught by professors from the Ecole des Beaux-Arts. Matisse recalls that his course consisted of twenty lessons in drawing from the plaster cast:—"Don't rub out the charcoal with your fingers—that denotes a careless man; take a bit of rag or, better, some lint. Draw the casts hanging there on the studio walls. You can show your work to one of the older students; he'll give you some advice . . . you'll have to understand perspective . . . but first you must learn how to hold a crayon. . . ." Finally, after some days, when Matisse had not achieved the dead perfection required, Bouguereau exclaimed, "You'll never learn how to draw!"[8]

Gabriel Ferrier, who alternated with Bouguereau at Julian's, approved one of Matisse's charcoal studies after an 18th-century plaster mask and permitted him to work from the living model. Ferrier came every Thursday to give his corrections and criticisms. The first Thursday Matisse, hearing Ferrier approach, hastily erased the head from his drawing, feeling that it was too poor to show. He left the hand, though with some misgivings. "Ferrier coming up behind me exclaimed, suffocating with indignation, 'What, you've done the hand when you haven't done the head! Now that is so bad I—I just can't tell you how bad that is! How are you going to finish your drawing before the

end of the week when so far you've just done the hand?' "[9]

3 Gustave Moreau's Studio, 1892-1897

Matisse left the Académie Julian in disgust at the incoherence and triviality of the instruction. But a visit to the museum at Lille early in 1892 restored his enthusiasm. Lille is not far north of Bohain, and doubtless he had been there before. But on this visit he studied with great excitement the canvases of Chardin and Goya. His purpose confirmed by their vitality, he returned to Paris, but no longer to submit himself as a student to the academic injunction: *"Copiez bêtement la nature"*— "Copy nature stupidly."[1] He began to work independently from casts of Greek and Roman sculpture in the "Cours Yvon,"[2] the big glass-enclosed court of the Ecole des Beaux-Arts through which such famous professors as Bonnat, Gérôme and the newly appointed Gustave Moreau passed, sometimes stopping to look over the work of students who aspired to enter their studios. Someone had praised Moreau's teaching to Matisse who caught the master's attention as he walked by. Moreau thereupon invited Matisse to work with him informally, not as an officially enrolled student, since he had entered no competitions and passed no academic examinations.

Moreau, as an artist, represented the last decadence of the romantic tradition of Delacroix. One year younger than Bouguereau, he had learned much from Chassériau, a brilliant eclectic who combined the linear mastery of Ingres with the exotic color and often literary subject matter of Delacroix. Moreau reduced Chassériau's grand style to exquisite miniature, not unrelated to the work of the English Pre-Raphaelites but more sophisticated. Even his larger paintings are jewel-like in color and detail. The exquisite, hot-house refinement of such paintings as the *Apparition* or *Dance of Salome* inspired J. K. Huysmans to an ecstatic critical essay published in *Certains*, 1889. A small version of the *Apparition* is reproduced on page 17.

4 Moreau as a Teacher

Matisse, however, was not greatly interested in Moreau as an artist, though it is possible that the older painter's orientalism and love of what he called a "necessary richness" may have slightly influenced Matisse's later work. Yet there is a world of difference between Moreau's effete houris and Matisse's healthy *niçoises* posing as odalisques. Matisse's art owes little more to Moreau's overrefined romanticism than it does to Bouguereau's vulgarized classicism, that is to say, practically nothing. But to Moreau, the teacher, Matisse feels greatly indebted.

The visual atmosphere of Moreau's studio has been recorded by Matisse in several small paintings of the interior, the model on the stand, the students busy at their easels, a cast of Polycleitus' *Doryphoros* in the corner, page 295. But there was much more to Moreau's instruction than criticizing students' rendering of statuary or the living model.

Moreau seems indeed to have directly criticized Matisse's work rather little and never, in any case, attempted to impose his own style upon his pupil. Rather, as Matisse put it, Moreau gave him "intelligent encouragement." Moreau's methods as a teacher were very liberal, incredibly liberal considering his official position as a professor at the Beaux-Arts. Unlike Bonnat, Gérôme and Bouguereau, he did not make a fetish of academic drawing. True to the romantic tradition of Delacroix he accepted the fact that from the beginning the student who aspired to be a painter might, even should, be interested in color. He did not damn a figure painting because the drawing was imperfect. He encouraged individualism in his students and was not alarmed by early expression of personal attitudes toward the complex problem of learning.

Moreau was equally liberal in his taste. Continually he urged his students to study the masters at the Louvre, sometimes taking them there, more often encouraging them to make their own discoveries. Besides extraordinary first-hand knowledge and breadth of taste among the masters, Moreau possessed another virtue equally important to his students—enthusiasm. "On one day," Matisse recalls, "he affirmed his admiration for Raphael, on another, for Veronese. One morning he proclaimed that there was none greater than Chardin. Moreau knew how to pick out and show us who were the greatest painters, while Bouguereau, *he* invited us to admire Giulio Romano."[3]

Moreau however was not entirely bound by the walls of the Louvre. Matisse recalls that he warned his pupils not to confine themselves to the museum or the studio but to sketch in the streets, too. Yet Moreau's wonderfully open mind seems to have been comparatively closed in one very important

respect: he was generally unaware of the "modern" art being produced around him. He never sent his students to see the Gauguin show at Durand-Ruel's in 1893, the Cézanne show at Vollard's in 1895. In those years Matisse seems to have known little or nothing of van Gogh, or Seurat, Signac and the Neo-Impressionists, or of the younger "Nabis" such as Bonnard and Vuillard who were only a year or so older than he and already well along in their careers.

It has been said and denied that Matisse did not even come to know first-hand the work of the great impressionists until the opening of the Caillebotte Bequest in the Luxembourg—during the spring of 1897, five years after he had entered Moreau's studio.[4] Moreau's isolation from all the principal currents of contemporary art may be forgiven when one remembers the attitude of his fellow professor, Gérôme, who threatened to resign from the faculty of the Ecole des Beaux-Arts if the Luxembourg Museum accepted the Caillebotte Bequest. "Does it not contain paintings by M. Monet, by M. Pissarro and others? For the Government to accept such filth there would have to be real moral decadence...."[5]

Moreau seems to have had no share in this official bigotry though recent painting did not interest him. Yet occasionally he would step out of his ivory tower. Matisse recalls how one Saturday morning Moreau came into the studio for the weekly criticism exclaiming, "I've just seen a Lautrec poster of an acrobat on a newspaper kiosk. It has a certain rude vigor." And when Matisse exhibited his first important impressionist picture in 1897, Moreau defended it against conservative attacks. For a Beaux-Arts professor this took courage, even though impressionism as a movement was already some twenty-five years old. It is little wonder that when Moreau began to teach at the Beaux-Arts in 1891 he attracted the most vigorous and original students of the new generation.

5 Matisse's Fellow Students, 1891-1897

When Matisse entered Moreau's studio in 1892 he found Rouault there before him. Rouault, though two years younger than Matisse, was much further along in his career. His enthusiastic grandfather, Alexandre Champdavoine, mentioned in the first paragraph of this book, was seeing his hopes for Rouault's future realized. Indeed while Matisse was unwillingly poring over law books,

Champdavoine had been introducing Rouault to his beloved Rembrandt, Daumier, Courbet and Manet.[6]

Before he met Matisse in Moreau's studio Rouault had spent years as an apprentice to a stained-glass maker and had already won a first prize for painting at the Ecole des Beaux-Arts. Rouault, who was much more influenced by Moreau, painted religious subjects and competed vigorously but vainly for the Prix de Rome. Though he left Moreau's studio in 1895 he remained the master's favorite and in 1898, after Moreau's death, was appointed Curator of the Gustave Moreau Museum, the house and collection which Moreau had bequeathed to the State. More deeply committed to an academic tradition, Rouault broke with it somewhat later than Matisse, but within a dozen years of their first meeting he had become an ally of the rebel fauve group. Profoundly religious and essentially a recluse, Rouault never became an intimate of Matisse but he has remained a loyal friend and admirer to this day.

Though Rouault was to be the greatest artist among Matisse's fellow students in Moreau's studio, Albert Marquet was his closest friend. Born in Bordeaux in 1875, Marquet had come up to Paris at the age of fifteen to study art. In 1894 he entered Moreau's studio and, though he was six years younger than Matisse, they soon formed a friendship which was to last through their student period and their years of rebellion and privation. Even after both men had won success they remained friends, sometimes traveling and working together. Matisse, of course, proved to be by far the greater painter but during their formative period there were times when Marquet may briefly have taken the initiative.

In 1894, besides Marquet, Henri Manguin entered Moreau's studio and in the following years came Jules Flandrin, René Piot, Charles Guérin and, in 1897, Charles Camoin, youngest of the group whom Matisse was to lead in the fauve campaign ten years later. Moreau died in 1898 but a group of his former students including Matisse, Marquet, Manguin, Flandrin and Camoin exhibited together at Berthe Weill's gallery from 1902 to 1904 and again on a much more formal and retrospective occasion at the Georges Petit Gallery in 1926.

Looking back over French art it is hard to find Moreau's equivalent. David and Ingres were great

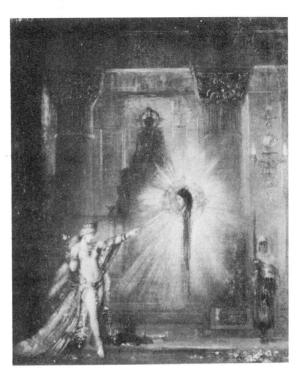

ADOLPHE WILLIAM BOUGUEREAU (1825-1905): *The Wasp's
Nest* (*Le guépier*) or *Invading Cupid's Realm*. Paris, 1892. Oil,
84 x 60". Lent by Charles P. Yerkes to the Chicago
World's Fair, 1893. Courtesy M. Knoedler & Co.

GUSTAVE MOREAU (1826-1898): *The Apparition* or *Dance of
Salome* (small version). c.1876? Oil, 21¾ x 17½". Cam-
bridge, Massachusetts, The Fogg Museum of Art, Grenville
L. Winthrop Bequest

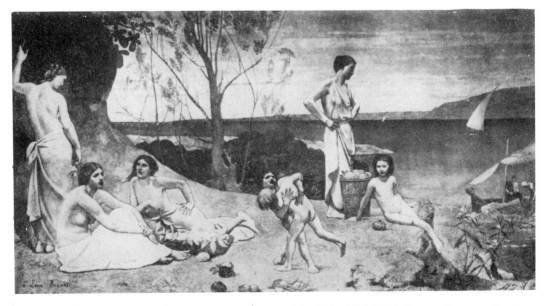

PUVIS DE CHAVANNES (1824-1898): *The Happy Land*. 1882. Oil, 90½ x 118". Musée Bonnat, Bayonne. Courtesy
Fogg Museum of Art

PAUL CÉZANNE (1839-1906): *Three Bathers (Trois baigneuses)*. Oil, c.19¾ x 19¾″. Bought by Matisse from Vollard in 1899 for about 1300 francs; given by him to the Musée de la Ville de Paris in 1936

PAUL CÉZANNE (1839-1906): *The Overture to Tann-häuser (Jeune fille au piano)*. Aix-en-Provence, c.1867. Oil, 22½ x 36¼″. Bought by Ivan Morosov from Vol-lard in 1908. Now in Museum of Modern Western Art, Moscow

PAUL SIGNAC (1863-1935): *The Bay of St. Tropez*. 1906. Oil, 28 x 32″

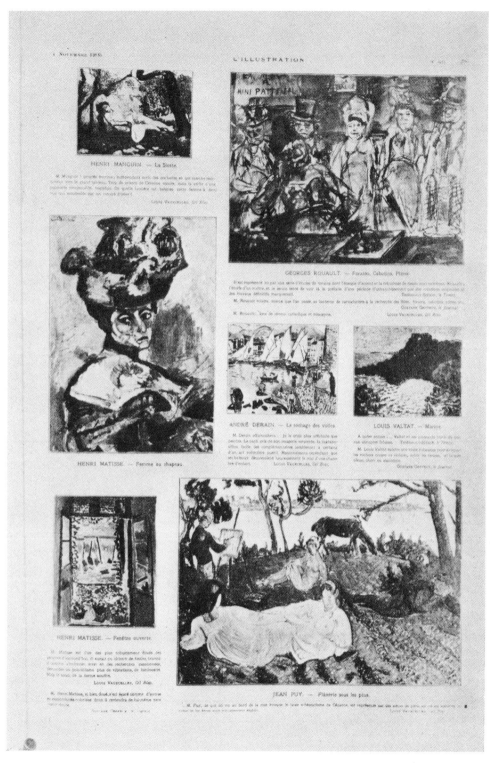

Fauve paintings in the Salon d'Automne of 1905, from *L'Illustration*, Nov. 4, 1905. The remarks beneath the reproductions were quoted from newspaper criticisms of the show. The page opposite this one reproduced paintings by Guérin, Cézanne, Vuillard, Henri Rousseau and Alcide le Beau. The two paintings by Matisse are reproduced on frontispiece and page 73

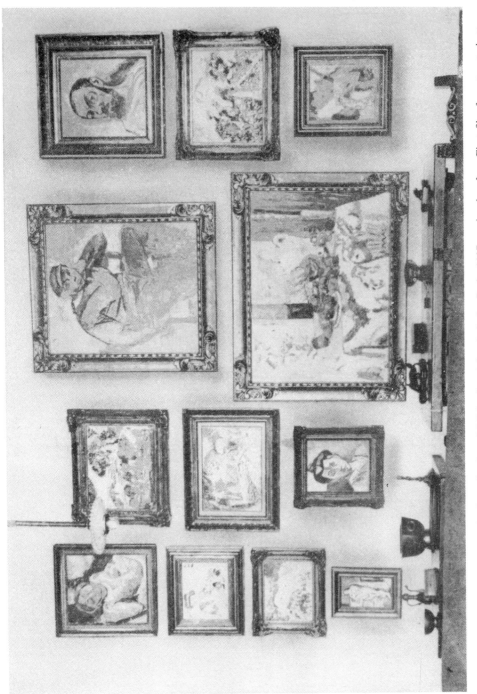

Some of the paintings by Matisse in the collection of Michael and Sarah Stein, Paris, 1907 or shortly after. First file, from top to bottom: "*The Gypsy*," 1906; figure; landscape; nude. Second file: landscape; composition study for the *Joy of Life*, 1905, p. 321; *Mme Matisse* ("*The Green Line*"), 1905, p. 75. Third file: *The Young Sailor, I*, 1906, p. 334; *Blue Still Life*, 1907, p. 331. Fourth file: *Self Portrait*, 1906, p. 333, landscape; *Woman with a Branch of Ivy* (*L'italienne*), 1905? All the paintings are of the fauve period, 1905-07

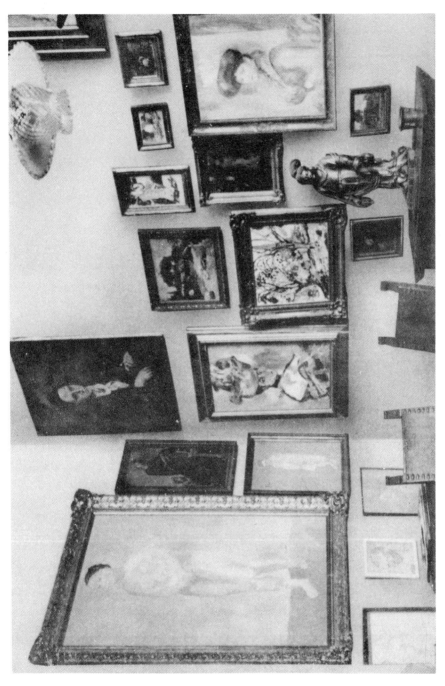

A room in the apartment of Leo and Gertrude Stein, 27 rue de Fleurus, about 1907. Top row, left to right: Picasso, 1906; Florentine Madonna; Picasso, *Gertrude Stein*, 1906; four small Matisses. Middle: Picasso, 1905; Matisse, *Woman with the Hat*, 1905; Matisse, *Landscape*; Manet; Renoir. Bottom: Three Picassos; Daumier; Renoir. Both photographs from Leo Stein, *Journey into the Self*, courtesy Miss Mabel Weeks and Crown Publishers, New York

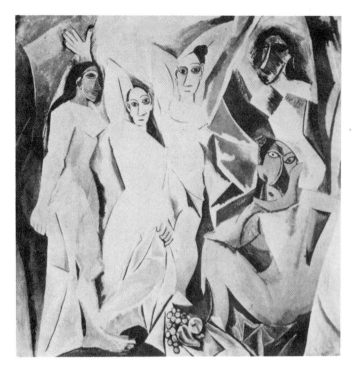

PICASSO: *Les demoiselles d'Avignon*. Paris, 1907. Oil, 96 x 92″. New York, Museum of Modern Art, acquired through the Lillie P. Bliss Bequest

MAX WEBER: figure study made in Matisse's class in the Couvent des Oiseaux, rue de Sèvres, early 1908. Oil, 22⅛ x 12″. Owned by the artist, Great Neck, New York

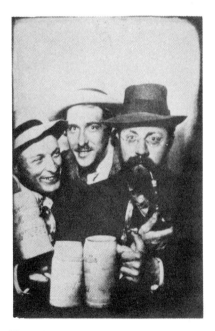

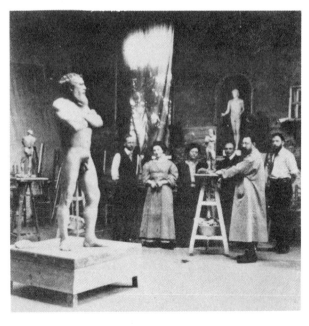

Hans Purrmann, Albert Weisgerber and Matisse in the Löwenbräukeller, Munich, summer 1910. Courtesy Hans Purrmann

Matisse's sculpture class in the old Couvent du Sacré Coeur, Boulevard des Invalides, about 1909. Left to right: Heiberg, unknown woman, Sarah Stein, Purrmann, Matisse and Bruce. Courtesy Hans Purrmann

Right: Matisse modeling *La Serpentine*, p. 367, Issy-les-Moulineaux, autumn 1909. Photograph by Edward Steichen, first published in *Camera Work*, New York, no. 42-43, 1913, pl. 6

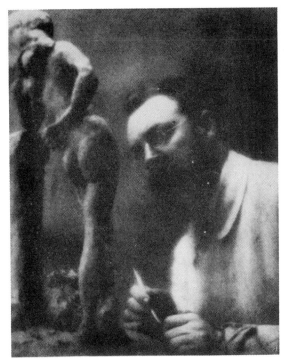

Below: Matisse on horseback, Issy-les-Moulineaux, about 1910-12. Courtesy Alexina Matisse

Below right: Matisse in his new studio at Issy-les-Moulineaux, autumn 1909, painting the *Still Life with the "Dance,"* p. 346, now in the Museum of Modern Western Art, Moscow. In the background is the full-size study for the *Dance*, p. 360, painted early in 1909 and now in the Walter P. Chrysler, Jr., collection. Courtesy Pierre Matisse

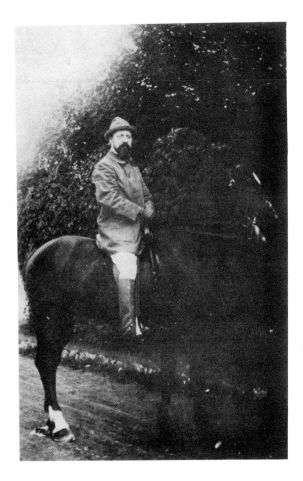

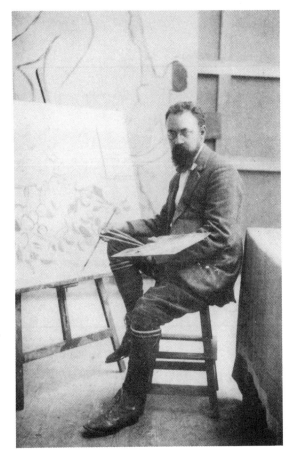

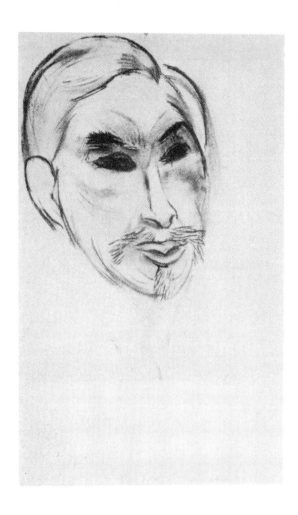

Left: MATISSE: *Sergei I. Shchukin.* (1912.) Charcoal, 19½ x 12″. Owned by the artist

Dining-room of S. I. Shchukin, Moscow, 1912. End wall, center: *Harmony in Red* (1908-09); right: *Corner of the Studio,* 1912. On the long wall to the right hung 15 or more Gauguins. Courtesy Pierre Matisse

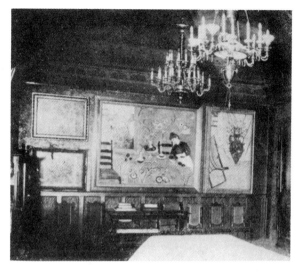

Below: Paintings in the "Matisse" room in the house of S. I. Shchukin, Moscow, 1912. Top row, left to right: *Venice, Lady on a Terrace* (1907); *Still Life; Girl with Tulips,* 1910; *Spanish Dancer,* 1909. Bottom row: *Flowers* (1909); *Still Life with a Red Commode,* 1910; *Interior with Spanish Shawls,* 1911; *Still Life in Venetian Red,* 1908. Courtesy Pierre Matisse

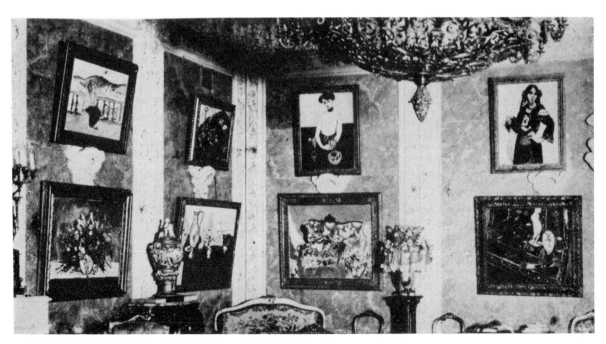

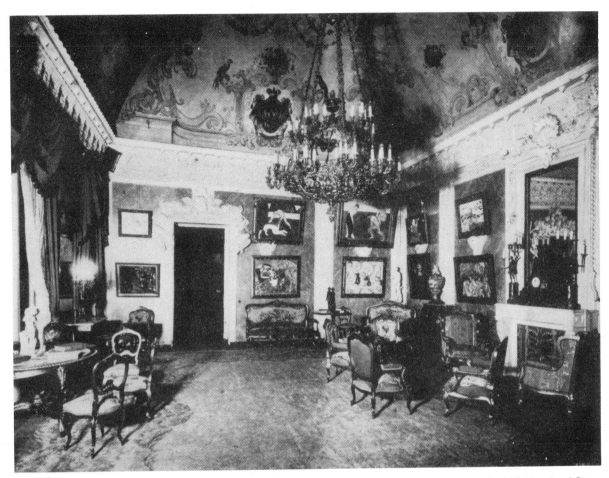

The "Matisse" room in the house of S. I. Shchukin, Moscow, 1912. Top row, left to right: *Still Life* (1901?) *Nymph and Satyr*, 1909; *Game of Bowls*, 1908; *The Luxembourg Gardens* (c.1902); *View of Collioure*, 1906. Bottom row: *Bois de Boulogne*, 1902; *Still Life—Seville* (1911); *Coffee Pot, Carafe and Fruit Dish*, 1909; *Still Life*, 1900; *Still Life* (c.1907?). Courtesy Pierre Matisse

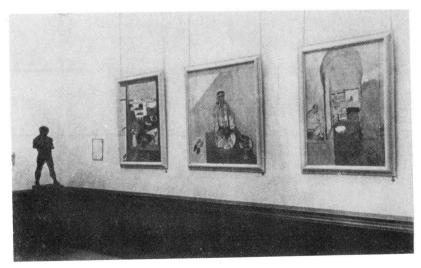

A wall in the exhibition of Matisse's sculpture and Moroccan paintings, Paris, Bernheim-Jeune, April 1913. Left to right: *The Slave*, p. 305, and the three canvases, pp. 386-387, bought by Ivan Morosov before the exhibition opened and hung as a triptych, as in the photograph, in his house in Moscow. Photo Bernheim-Jeune

Matisse painting the portrait of Michael Stein, Paris, Quai St. Michel, early 1916. Courtesy Prof. John W. Dodds

Right: Matisse with a *Self Portrait*, p. 422, in his room in the Hotel Beau-Rivage, Promenade des Anglais (now des Etats-Unis), Nice. Photograph by Georges Besson, January 1918

Below: Matisse in a single scull of the Club Nautique, Nice, 1920-1925

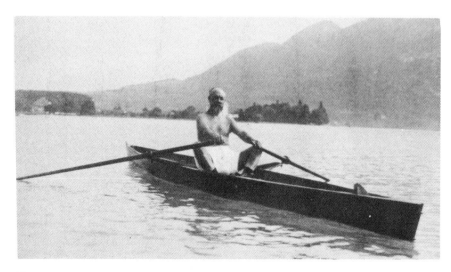

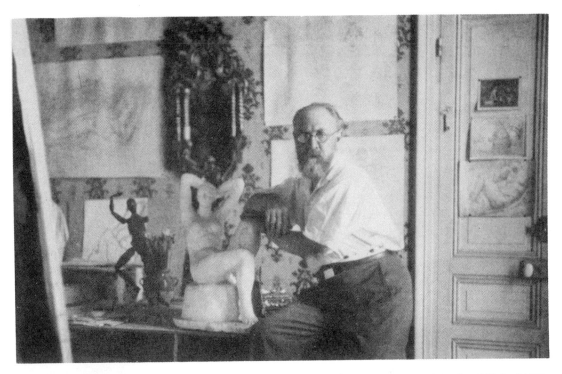

Matisse in Nice, Place Charles-Félix, about 1928. Beside him, an early state in plaster of the *Seated Nude* of 1925, p. 444. Behind him, some of his lithographs, and, on the door, reproductions of Delacroix's *Bark of Dante* and a Michelangelo drawing. Photograph from *Vanity Fair*. ©The Condé Nast Publications, Inc.

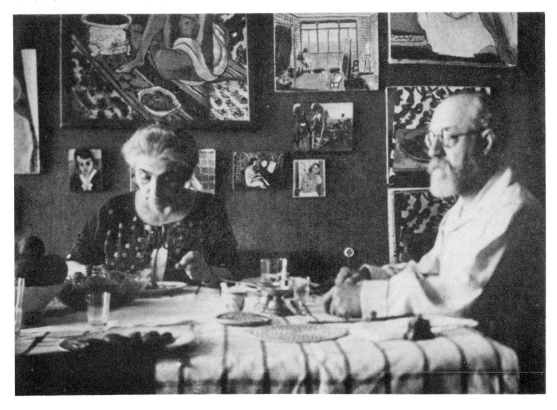

Mme Matisse and her husband at table, Nice, about 1929. Courtesy Alexina Matisse

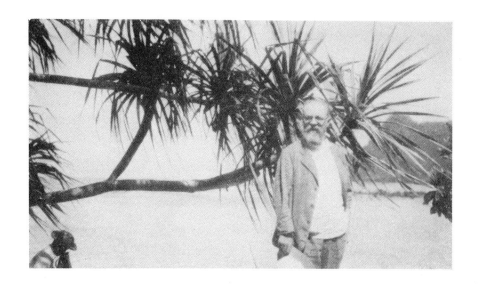

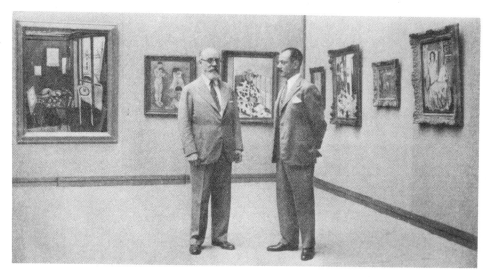

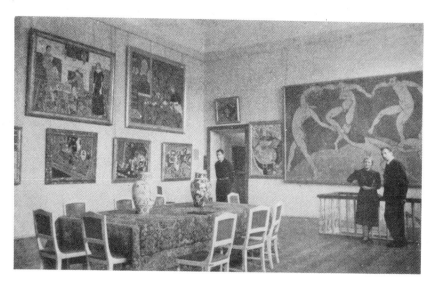

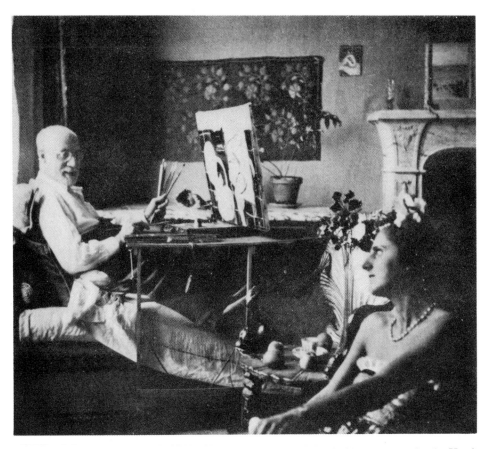

Matisse painting the *Dancer and Armchair, Black Background*, p. 488, in his apartment in the Hotel Régina, Cimiez, Nice, September 1942. Photograph André Ostier

Opposite

Above: Matisse in Tahiti, spring 1930. Photograph by F. W. Murnau, courtesy Pierre Matisse

Center: Matisse with Etienne Bignou in the Galeries Georges Petit, Paris, June-July 1931, during the second and largest of his four retrospective one-man shows held in 1930-31

Below: Part of the Matisse collection in the Museum of Modern Western Art, Moscow, 1933. Left-hand wall, above: *The Painter's Family* (1911); *Harmony in Red* (1908-09); below: *Still Life in Venetian Red*, 1908; *Fruit and Bronze*, 1910; *Still Life—Seville* (1911). Right-hand wall: *Still Life; Goldfish* (1911); *Dance*, 1910. The *Fruit and Bronze* was formerly in Morosov's collection; all the others, in Shchukin's. Photograph Tass

Matisse painting the tapestry cartoon *Nymph and Faun* in his studio at the Hotel Régina, Cimiez, Nice, about August 1941. Photograph by Varian Fry

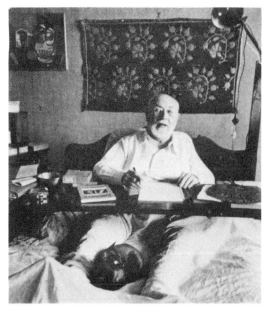

Matisse, Hotel Régina, 1947. Upper left, a still life by Picasso. Photograph courtesy Robert Capa-Magnum

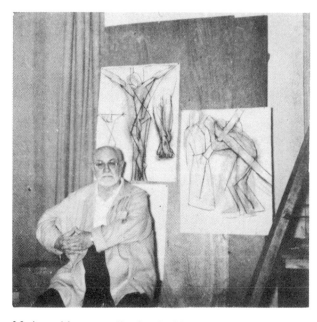

Matisse with two studies for the Vence chapel *Stations of the Cross*. Nice, Hotel Régina, 1949. Photograph José Gómez-Sicre

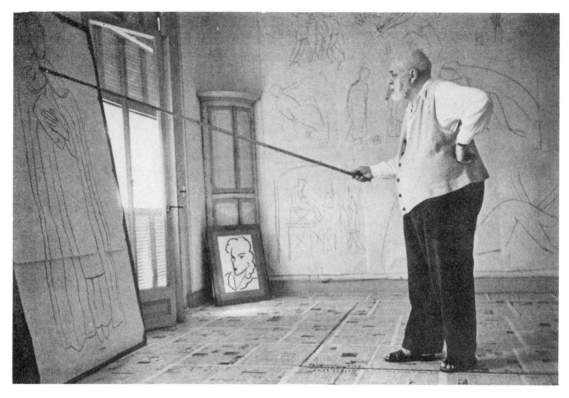

Matisse drawing a study for the Vence chapel *St. Dominic*. Nice, Hotel Régina, 1949. Photograph Robert Capa-Magnum

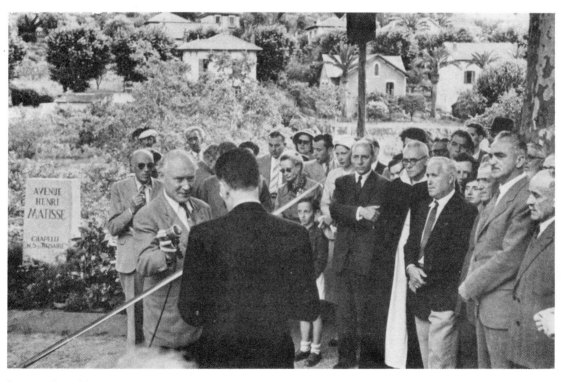

Inauguration of Avenue Henri Matisse, Vence, June 25, 1951. Front row, center, right to left, Father Couturier, Pierre Matisse and his daughter Jacqueline. Photograph Henri Cartier-Bresson, courtesy Magnum

Matisse in Tériade's garden, Nice, June 1951. Photograph Henri Cartier-Bresson, courtesy Magnum

academic teachers; Pissarro, in the impressionist movement, was just as great though he taught informally by personal example. Gleyre's studio in the early '6os afforded hospitality simultaneously to four young students, Monet, Renoir, Bazille and Sisley, but Gleyre himself was neutral and conventional in his teaching.

6 Paintings, 1892-1896: The Louvre Copies

However liberal and stimulating Moreau's teaching may have been, its immediate effects on Matisse were certainly far from radical. He spent much time copying in the Louvre, partly by way of study, partly to increase his income for he found the small allowance his father sent him inadequate. Although Moreau himself was deeply interested in earlier painters, especially Mantegna and Leonardo, Matisse seems to have copied nothing earlier than the 16th century. All his replicas were of pictures of the Baroque or Rococo periods with the exception of a Raphael portrait. He reproduced three Poussins, the *Bacchante*, *The Bunch of Grapes* and the *Narcissus*, the last of which was bought by the State. A replica of Philippe de Champagne's *Christ*, complete with *trompe l'oeil* lettering along the bier, was also done to sell, but without success, page 293.

From the Dutch 17th century Matisse copied a *Village Church* by van der Heyden and David de Heem's grandiose *Dessert*, curious selections, for both painters were masters of tight, minute detail which can scarcely have interested Matisse, even as a student. At the same time he neglected Rembrandt whom Moreau admired and who was at that time the chief inspiration of Matisse's fellow student, Rouault. About 1916 Matisse bought back the de Heem copy[7] from the Louvre and used it as the basis for a large and brilliant fantasia, the *Variation on a Still Life by de Heem*, page 170. Actually the early copy of the de Heem is not only much smaller than the original (both are reproduced on page 171) but appears to be quite free in brushing as if Matisse had set out to reduce the Dutch master's Baroque scale and meticulously simulated surfaces to a pleasant dining room still life with the richer, scumbled surfaces of a Chardin.

Almost half Matisse's copies were of 18th-century French pictures: Watteau's *Concert champêtre*, Fragonard's *Leçon de musique* and two *Pastorales* by Boucher sold to the Gérards, members of his mother's family in Le Cateau. The Bouchers and

the Fragonard certainly seem related to Matisse's subsequent painting, as do the copies after Chardin of which he made no less than five: *The Pipe*, *Pyramid of Fruit*, *Still Life (Fruit and Vegetables)*, *Still Life with a Red Lacquer Table* and, lastly, *The Ray* which together with a *Storm at Sea* after Ruysdael he painted as studies, finishing them after he had left Moreau's studio. Besides the Poussin *Narcissus*, the State bought the Chardin *Pyramid of Fruit* and a copy after Annibale Caracci's *Hunt*. These copies were distributed as decorations for official buildings in the provinces: the Caracci, for instance, hung for years in the town hall of Grenoble.

If Matisse had been more interested in literal detail the State might have bought more. Matisse has credited Roger Marx the critic (and discoverer of Seurat ten years before) with having acted as a determined salesman. In a note written for Raymond Escholier[8] he recalls that "the students of the masters of the Louvre, almost all of them pupils of Moreau, were defended by Roger Marx before the Purchase Committee of which he was a member. Without him not a single copy would have been bought, for the Committee wanted to take only facsimile copies which were always executed by ignoramuses."

Aided by Moreau's discerning connoisseurship of the masters and even more by his own extraordinarily receptive sensibility, Matisse profited greatly from working in the Louvre. Copying three Poussins provided not only the discipline but, to a student of Matisse's intelligence, an understanding of the intricacies of composition as demonstrated by the greatest French master of the art. Of Poussin's lofty, poetic grandeur he may have been aware, though he made no use of it. But when he was studying the medium of oil paint by copying Chardin he found himself more in sympathy with the spirit and subject matter of the master. For the first years of his career—until 1898 at least—Matisse was to be primarily a painter of still life and of intimate interiors.

7 Original Paintings, 1892-1896

As we have seen, Matisse's first two original canvases were still lifes of books painted in 1890, page 293; and one of his earliest studies made in the Louvre is the copy after the big de Heem still life, *Un dessert*, which Matisse dates as in 1893. The year before that we know he had been deeply impressed by the Chardins at Lille and followed this, with

Moreau's blessing, by copy after copy of the 18th-century master's work in the Louvre. Still life, and particularly Chardin's still life, was now his chief concern. One of Matisse's earliest dated paintings in the manner of Chardin is the *Still Life with Peaches* of 1895, page 294. Somber in tone, the objects are monumentally disposed as in a Chardin but the canvas is more freely brushed, without the subtle scumbling and stippling of Chardin and without his emphasis on texture.

Other still lifes of the period are more complex but less secure in composition with the exception of the excellent *Still Life with a Black Knife*, page 296, painted early in 1896. In it the old-master gloom gives way to a lighter, more luminous tone, perhaps reflecting the secondhand, academic impressionism which was already appearing in the annual official Salons visited by Matisse.

The interiors painted by Matisse in his student period were at first equally conventional in technique and form. The little *Woman Reading*, page 294, of about 1894, now in the Château at Rambouillet, suggests a Metsu or Janssen in its studied composition but has none of their luminous clarity. *Gustave Moreau's Studio* of about the same time is a less old-masterish and quite subtle study of grey interior light values, page 295. Far more vigorously painted and more in the dark, naturalistic tradition of Courbet and early Manet is the comparatively large *Interior with a Top Hat*, page 296, which Matisse dates 1896. In spite of its bold brushing and informal almost disheveled composition, its gloomy chiaroscuro and local color seem the work of a painter who was still ignorant of impressionism.

As early as 1895, Matisse began to paint Paris out-of-doors, particularly views of the Seine. *The Bridge*, page 297, is a modest, indeed rather timid sketch in soft greys and tans with a suggestion of Corot about it. The *Dam at Pont Neuf* of 1896 in the Baltimore Museum is even greyer but marks an advance in its mastery of outdoor light values within a very restricted range.

8 The Salon de la Nationale, Spring, 1896

In the spring of 1896 Matisse was a few months over twenty-six years of age. He had been painting as a student for over four years. At least once his father had come anxiously to Paris to ask Gustave Moreau if his son really had talent. Moreau had reassured the merchant of Bohain that Matisse was one of his most gifted students, but Matisse must have felt

obliged to prove this more concretely. Following a conventional path to recognition he sent several of his paintings to the new, liberal salon of the Société Nationale des Beaux-Arts, sometimes called the Salon du Champ-de-Mars or, simply, the "Nationale."

The Nationale had been founded in 1890 under the leadership of the aged but redoubtable battle painter Meissonier as the result of a quarrel with the old Salon des Artistes Français. The old Salon, headed by Bouguereau, Gérôme, Bonnat and Cabanel, had not changed fundamentally in spirit in spite of occasional reforms in procedure such as those initiated by the Salon des Refusés scandal of 1863. Among the stars of the new Salon were the fashionable portrait painters Carolus-Duran and Jacques-Emile Blanche, augmented by the even more brilliant foreigners Sargent, Boldini and Zuloaga; Albert Besnard, who applied a kind of decorative impressionism to mural painting; René Menard, painter of prettified classic landscapes; Simon and Cottet, makers of Breton peasant pictures; and, of more moment, Eugène Carrière whose dim but intense figures seemed half lost in an emotional mist; the sculptor Rodin who was much too big for the Society; and Puvis de Chavannes who, when Meissonier died in 1891, succeeded to the Presidency. *The Happy Land*, a characteristic figure composition by Puvis de Chavannes painted some ten years before, is reproduced on page 17.

Puvis was still in office five years later when Matisse submitted his works to the jury. Four of them were accepted: a *Studio Interior*, very possibly the painting with the female model reproduced on page 295, the *Woman Reading*, and two still lifes, one of which is reproduced on page 296. The show opened April 25th and before it closed Matisse had sold two paintings. The State bought the *Woman Reading*, and the *Still Life with a Black Knife* was sold to a M. Thénard for 120 francs—although there was argument about the doubtful verticality of the wine glass at the left.

At the end of the exhibition Matisse's election as an Associate Member of the Société Nationale was announced; the President, Puvis de Chavannes himself, had nominated him. At Matisse's age such an honor was considerable. Moreover it gave him the privilege of showing several paintings every year without having to submit them to the Salon jury, and greatly increased his chances of selling both to collectors and the State.

PART II: 1896-1904

MATISSE DISCOVERS MODERN PAINTING

SECTION 1 MATISSE'S LIFE, PERSONAL AND PROFESSIONAL, 1896-1904

1 Brittany; the Dinner Table and the Revolt against the Nationale, 1896-1897

Matisse did not rest on his laurels won at the Salon de la Nationale. In fact they began to make him uneasy. Moreau, who warned his pupils against an early success, now encouraged him to leave the atmosphere of the Louvre for a while. Not long after the Nationale show closed, Matisse set out for Brittany in the company of the young landscape painter Emile Wéry to whom he had dedicated his little grey river view *The Bridge*, page 297, painted the year before. Wéry, who had also shown at the Nationale, had some knowledge of impressionist technique which now affected some of Matisse's own landscapes done on Belle-Ile in Brittany, though Matisse may not yet have seen a painting by Monet or Pissarro.

A year later, in the summer of 1897, Matisse painted in Brittany again and further developed his impressionist technique. He met there by chance the American friend of van Gogh, J. P. Russell, and bought from him a drawing by van Gogh, his first acquisition of a work by a martyr of modern painting.[9] Between the two summers in Brittany Matisse himself, to his astonishment, underwent his baptism of fire as a young "radical."

When Matisse returned to Paris and to Moreau's studio at the end of the summer of 1896 Moreau reminded him that he had been painting professionally for nearly five years and advised him to summon his resources for a major effort. During the following winter Matisse worked intensively on a masterpiece—to use an exhausted word in its original sense: a work which would prove his graduation from apprenticeship to mastership. In the spring he sent the painting now called *La desserte* or

the *Dinner Table*, page 299, to the Salon de la Nationale along with four smaller paintings.

That same spring of 1897 the Luxembourg Museum finally put on view the paintings of the Caillebotte Bequest. This exhibition marked a great victory for the impressionists over official defenses against anything so modern as a movement only twenty-five years old. As it was, the State, under heavy reactionary pressure, had refused to accept two of the Caillebotte Renoirs, eight of the Monets, eleven of the Pissarros, two of the Cézannes and a Manet.

Matisse's *Dinner Table*, though shown in the supposedly liberal Salon de la Nationale, stirred up a small storm itself, possibly because it reminded the conservatives of the hated impressionists. Had he not been an Associate Member his canvas might well have been rejected by his outraged elders—as it was they hung it badly. Moreau however defended *La desserte* enthusiastically and said he preferred it to all Matisse's previous work, remarking to Georges Desvallières that the carafes were painted with such conviction "that you can hang your hat on their glass stoppers." Matisse, looking back on the controversy, remembers the popular reaction with a smile: "It was the period when a terror of microbes was raging among the public. One never saw so much typhoid fever. The public discovered that I had microbes at the bottom of my carafes!"[1]

2 Matisse's Elders and Contemporaries in the 1890s

In the face of such professional and popular hostility Matisse might still have turned back to a safer course. Instead he went forward, slowly in his art, more rapidly in his knowledge of what his older

35

contemporaries had achieved. Moreau, most elaborate of living French painters, had told him, "You are going to simplify painting." But so isolated had Matisse been in Moreau's studio that ten years of tentative trial and error were to elapse before Moreau's prophecy was to come true—before it could truly be said that he had carried simplification further, say, than had Gauguin as early as 1890.

The pictures of the Caillebotte Bequest made a deep impression on Matisse. Perhaps he had already learned that other paintings by the impressionists could be seen at Durand-Ruel's gallery. There he did see Manet's *Musicians*, now in the Chester Dale Collection in the National Gallery, Washington, several portraits by Goya, and El Greco's amazing *View of Toledo* which Mrs. H. O. Havemeyer later bequeathed to the Metropolitan Museum. The big Cézanne show at Vollard's, the van Gogh show at the Théâtre de l'Oeuvre, both of 1895, had come and gone apparently without his knowledge but now, two years later, he often visited Vollard's where he could see the Cézannes and van Goghs which Vollard had in stock. He could also study the work of younger men such as Bonnard and Vuillard whose work Vollard was beginning to show now that they had won some reputation.

Pierre Bonnard was just two years older than Matisse, Edouard Vuillard, only one, yet both were already important masters of the *avant-garde* of the mid-'90s. Curiously enough both had, like Matisse, been students of Bouguereau at the Académie Julian. That was in 1888 while Matisse was studying law at the University. Unlike Matisse, Bonnard and Vuillard, though personally retiring, quickly came in contact with the various movements which had developed during the 1880s as reactions against, or efforts to reform, impressionism. They knew, and were at first deeply influenced by, the work of Gauguin and his followers who called themselves Symbolists or Synthetists or both; they were familiar with the quasi-scientific Neo-Impressionism of Seurat, Signac and Cross; in fact Bonnard had himself shown a painting at the Salon des Indépendants of 1891 where Seurat exhibited his *Cirque* just before his death, and where the van Gogh memorial exhibition was held. In the early '90s they came to know well both Toulouse-Lautrec and his opposite Odilon Redon; and they watched without much sympathy the antics of the pale, mystic esthetes of the Rose-Croix group. By 1892, not long after Matisse entered the Académie Julian, Bonnard and Vuillard, along with their friends K. X. Roussel, Paul Sérusier and Maurice Denis, were exhibiting under the name "The Nabis," a group which held together for several years in spite of divergent personal styles and ideas.

Besides painting, Bonnard and Vuillard were extraordinarily active in many other ways: they designed for the *avant-garde* theatres, illustrated books and sheet music, were pioneer poster designers, and contributed to the decorative arts movement which in the mid-'90s became known as *art nouveau*. They formed friendships and alliances with poets, playwrights, musicians, actors, publishers and critics. They exhibited at the anarchic Salon des Indépendants, then at the more advanced dealers, at Le Barc de Boutteville's and Vollard's and at Durand-Ruel's where early in 1896 Bonnard had his first one-man show.

What Bonnard and Vuillard had passed through we have indicated here, however briefly, because it suggests what their contemporary, Matisse, seems to have missed almost entirely. Even in 1896 or 1897 when Matisse began to notice their work at Vollard's and Durand-Ruel's he seems not to have been much impressed, or even to have struck up any special friendship with them. Yet, in spite of Matisse's retarded and sequestered experience, the three had a good deal in common. All were realists, in the broadest sense of the word. They made paintings of what they saw in the world about them, in the studio, in rooms where people lived. In his paintings of interiors Matisse had come quite close to Vuillard's intimate scenes with a woman sewing or dusting or clearing a table.[2]

Matisse had studied for five years with Moreau but never once had been tempted by a mythological or fantastic subject. For a longer period, too, Bonnard and Vuillard had known and loved the ethereal fantasies of Redon; they had associated with the Symbolists, the Rosicrucians, the *Idéistes*, the Neo-Traditionists, a host of over-refined, over-elaborate or over-simple *fin-de-siècle* poets and theorists who practiced painting; yet they had developed their own personal, witty, elegant, intimate art of the commonplace. Now, having learned much from Gauguin and Japanese prints, they were already turning away from flat surfaces, sinuous lines and shallow patterns to a more realistic, even impressionist style with greater sense of depth and atmosphere and a bow to Degas here, to Renoir there.

Matisse, after years of the old masters, was just beginning to flatten his space and merge his forms by means of the unifying light and soft edges of impressionism. In a sense their artistic paths were converging when Matisse first became aware of them.

It is strange that in 1897 the liberated Matisse did not see more of the Symbolist-Nabi generation of Bonnard and Vuillard, of Denis, Sérusier, Vallotton, Maillol, and of the Neo-Impressionists Signac and Cross. Perhaps he was too reserved or did not sufficiently feel that he had got his bearings among artists who already years before had repudiated impressionism in which he had just recently grown deeply interested. It is significant however that he did come to know Pissarro, the dean of the impressionists. Kind and approachable as he was, Pissarro, who had taught both Cézanne and Gauguin twenty years before, now encouraged Matisse in his impressionist direction, even advising the younger artist to go to London to study Turner as he himself and Monet had done in 1870. In spite of his generous attitude toward younger artists Pissarro at this period detested the Symbolists and Nabis. The year before he had written his son: "Another Symbolist has failed miserably! . . . All the painters worth anything, Puvis, Degas, Renoir, Monet and your humble servant, unanimously term hideous the exhibition held at Durand-Ruel's of the Symbolist named Bonnard . . ."[3] Pissarro was sixty-eight years old. For the previous decade he and his colleagues had been attacked by a younger *avant-garde* who found impressionism too subservient to nature, too vague and spineless in form, too concerned with effects of light to achieve a maximum clarity of design. Matisse, for the time being however, was inclined to follow Pissarro, but he was also studying the work of his own generation as well as that of Manet, the impressionists, Cézanne, Renoir, van Gogh, Gauguin and Signac.

3 Marriage, 1898, and a Year in the South

Taking Pissarro's advice, Matisse went to London for a week in January 1898. And he looked at the Turners in the National Gallery and the Tate but was not much impressed. Perhaps he was distracted by more urgent matters, for the journey to London, though characteristically it also involved art, was his wedding trip. He had just married Amélie Payrayre of Toulouse.[4]

Years later, incensed by Gertrude Stein's description of his wife in the *Autobiography of Alice B. Toklas*,[5] Matisse proceeded to describe her himself:[6]

Madame Matisse was a very lovely Toulousaine, erect, with a good carriage and the possessor of beautiful dark hair that grew charmingly, especially at the nape of the neck. She had a pretty throat and very handsome shoulders. She gave the impression, despite the fact that she was timid and reserved, of a person of great kindness, force and gentleness.

Madame Matisse was much more than that. Among the many admirable wives of great artists very few have been more generously self-sacrificing and at the same time effectively practical than Amélie Matisse. During the four decades of their marriage she gave herself to Matisse with the same consuming devotion that he gave himself to his art.

When the Matisses returned to Paris they stayed only a few weeks and then left for Corsica for a long visit. Matisse felt the need of getting away from Paris, not so much from Moreau and the Louvre as from the bewildering cross-currents of recent painting which he had scarcely begun to assimilate. They spent half a year in Ajaccio, on the west coast of Corsica. It was Matisse's first experience of the Mediterranean, which was to be the background of so much of his life and art in the years to come. In August 1898 the Matisses left Corsica for a six months' visit in Toulouse where Mme Matisse had grown up, and at Fenouillet, a small town in the foothills of the eastern Pyrenees some thirty miles west of Perpignan.

4 Paris, 1899–1901; More Future Fauves

In February 1899 Matisse and his wife returned to Paris and settled in the apartment at 19 Quai St. Michel where they were to live until 1907. Though Marquet, Matisse's closest friend, lived in the same building and they still sketched together, Matisse found Paris changed and his own habits of work disrupted. Moreau had died the year before, a few weeks after Matisse had left for Corsica, and had been succeeded at the Ecole des Beaux-Arts by the painter of historic melodramas, Fernand Cormon. Matisse who regularly worked from the model for an hour or so every day began to draw in the old studio now used by Cormon. But he was not comfortable there.

Rouault had left Moreau's studio two years before Matisse's journey south and had just been appointed Curator of the Gustave Moreau Museum.

Moreau's other pupils had found Cormon's teaching comparatively uninspiring: "Let's get out of here," Marquet had remarked to Camoin. "It's more fun painting an omnibus."

Cormon on his part found Matisse's work upsetting, particularly a view of the Seine at sunset with the Louvre in the distance which Matisse had brought in as an example of work done outside the studio. When he saw the painting Cormon said nothing, but Matisse soon received word that he must leave on the grounds that he was over thirty.

I had then to look elsewhere [Matisse writes]. *I imagined that I could return to the Académie Julian* [where he had worked under Bouguereau in 1892] *with the intention of not having my work corrected; but I had to take flight quickly: the students took my studies for jokes. By chance I heard that there was on the rue de Rennes, in the court of the Vieux Colombier, a studio organized by an Italian where Carrière came to correct every week. I worked there, and there I met Jean Puy, Laprade, Biette, Derain, Chabaud. There wasn't a single pupil of Moreau's there.*

At last one could work in quiet, for the professor corrected only his rather submissive pupils . . . and merely looked guardedly at the more personal work of the others. That suited us.

Unfortunately this studio closed, for want of students. Then we clubbed together to hire a model and all worked in Biette's own studio on the rue Dutot.

All this happened during the single year since I had left Cormon's.[1]

Thus, at the "Académie Carrière" Matisse came to know the second group of students from whom a few years later the fauves were to emerge. At the same time he kept in touch with his friends of Moreau's studio, Manguin, Camoin, Marquet, of course, and, less closely, Rouault.

While they were still students in Moreau's studio Matisse and Marquet had obeyed their liberal teacher's injunction: "Don't rest content with going to the museum but go down into the streets!" Now, after Moreau's death, they continued to do so, sketching as rapidly as possible to catch the essentials of a movement or gesture. While a cyclist or a cab went by they used to intone Delacroix's maxim: "You should be able to draw a man falling from a fifth floor window and finish it before he hits the ground," to which Marquet once added a postscript: "Yes, and make it a recognizable likeness too!"[2]

Besides street sketching they also worked at the *cafés concerts* or night clubs, especially the Petit Casino near the Opéra where Matisse recalls that he saw the debuts of Gabrielle Lange, Mistinguette and other famous *diseuses*. About 1936, during a housecleaning, he reports having torn up over two hundred of these rapid sketches![3]

During his absence in the South, Matisse had not exhibited at the Salon de la Nationale in 1898, which that year, incidentally, had been rocked to its foundations by the scandal over Rodin's *Balzac*. But now that he was back in Paris, Matisse submitted four still lifes and a drawing made near Ajaccio. Thanks to his rank as an Associate they were hung, but this was his last appearance at the Nationale. Its liberal second President, Puvis de Chavannes, had died the year before and the Société was no longer hospitable even to Matisse's rather mild contributions.

5 *Cézanne's* Three Bathers

Pissarro in the mid-'70s had confirmed Gauguin's interest in Cézanne and in 1885 had persuaded Signac to buy a Cézanne landscape. And it was Pissarro again, almost fifteen years later, who encouraged Matisse to study the master of Aix. Matisse remembers almost word for word an early and enlightening conversation with Pissarro which he dictated[4] recently to Pierre Matisse.

PISSARRO: *Cézanne is not an impressionist because all his life he has been painting the same picture.* [Matisse here explained that Pissarro was referring to the "bathers" picture which Cézanne repeated so obsessively, pursuing and developing the same qualities of composition, light, etc.] *He has never painted sunlight, he always paints grey weather.*

MATISSE: *What is an impressionist?*

PISSARRO: *An impressionist is a painter who never paints the same picture, who always paints a new picture.*

MATISSE: *Who is a typical impressionist?*

PISSARRO: *Sisley.*

Then, thinking of Pissarro's words, Matisse added: "A Cézanne is a moment of the artist while a Sisley is a moment of nature."

Doubtless it was with Pissarro's blessing that Matisse now bought the little Cézanne which was to prove so important to him over the years to come. Matisse had seen and been impressed by a van Gogh *Arlésienne* at Vollard's; the dealer was asking 500 francs for it. Matisse had a little money at the time but after a few days when he returned to buy the van Gogh Vollard had raised the price to

Henri - Matisse

SELF PORTRAIT (*Portrait de l'artiste*). (c.1900.) Brush and ink. Courtesy John Rewald

900 francs. While looking at it longingly Matisse noticed nearby a small Cézanne canvas of *Three Bathers*, page 18, which seemed to him completely to eclipse the van Gogh. He had also been much attracted by the original plaster bust of Henri Rochefort by Rodin which Vollard had bought from Manet's widow. Vollard asked 1,300 francs for the Cézanne, 200 for the Rodin. Matisse had to leave Paris for Bohain for a week but he could not get the Cézanne out of his mind. Finally he wrote Marquet to offer Vollard 300 francs down payment for the two with a year to meet the balance. Vollard

accepted. About the same time, perhaps as part of the same deal, he got from Vollard a *Head of a Boy* by Gauguin in exchange for one of his own canvases.[5] The prices were reasonable enough but for Matisse and his wife the purchase represented a great financial sacrifice. And during the difficult years that followed, keeping the Cézanne came to represent an even greater sacrifice, for again and again he was urged by his friends to sell it to meet some crisis in his family economy.

Matisse's deep and indebted love for his Cézanne was movingly expressed years later when he pre-

39

sented the picture to the Petit Palais, the Museum of the City of Paris. In a letter to Raymond Escholier, the Director of the Museum, he wrote:[6]

Nice, November 10, 1936
Yesterday I consigned to your shipper Cézanne's Baigneuses. I saw the picture carefully packed and it was supposed to leave that very evening for the Petit Palais.

Allow me to tell you that this picture is of the first importance in the work of Cézanne because it is a very solid, very complete realization of a composition that he carefully studied in various canvases, which, though now in important collections, are not the studies that culminated in the present work.

I have owned this canvas for thirty-seven years and I know it fairly well, I hope, though not entirely; it has sustained me spiritually in the critical moments of my career as an artist; I have drawn from it my faith and my perseverance: for this reason allow me to request that it be placed so that it may be seen to the best advantage. For this it needs both light and perspective. It is rich in color and surface and only when it is seen at a distance is it possible to appreciate the sweep of its lines and the exceptional sobriety of its relationships.

I know I do not need to tell you this but nevertheless I think it is my duty to do so; please interpret my remarks as a pardonable testimony of my admiration for this work which has grown ever greater since I first acquired it.

Let me thank you for the care you will give it for I hand it over to you with the deepest confidence. . . .

Henri Matisse

The Rodin bust and the Gauguin canvas were less beloved by Matisse but they were also of great significance, for in this same year of 1899 Matisse undertook his first work in sculpture, a study after Barye's *Jaguar Devouring a Hare*, page 303, and at times during the next dozen years the influence of Gauguin was to be at least more obvious if not stronger than Cézanne's.

Two other artists were conspicuously influential among younger painters in the Paris of 1899, Odilon Redon and Paul Signac. Redon, then sixty years of age, was given a place of honor in a large exhibition at Durand-Ruel's organized by the Nabis and their allies. Maurice Denis, Emile Bernard, Paul Sérusier, Bonnard, Vuillard and many others took part. Matisse doubtless knew Redon's work before this but Redon's pastels, then shown for the first time, impressed him deeply, not of course for their dreamlike fantasy but for their brilliant color harmonies which, suspended in misty space, seemed

completely liberated from all naturalistic or descriptive function. Matisse came to know Redon personally and often acknowledged the influence of his color.

6 Matisse's Position about 1900

Matisse's position around the year 1900 in the Paris art world and indeed in his own eyes was still that of a student. He had turned his back on his promising achievements as a conservative painter but he had not yet begun to exhibit among the *avant-garde*. Only in the spring of 1901 did he send paintings to the Salon des Indépendants. But in spite of his reserve and modesty he was already beginning to establish himself as a leader. Because of his late start as a painter, Matisse was considerably older than most of his fellow students. His sobriety and his intense determination to master his art combined with the bold quality of his work, set him apart. Even at the Ecole des Beaux-Arts two years after Matisse had left the studio of Cormon, Raoul Dufy, who entered the school in 1901, heard echoes of Matisse and his theories. At the Atelier Carrière he rapidly assumed an influential role. Jean Puy recalls how he clarified Cézanne's importance to his fellow students, thereby helping them to gain a new sense of structure in their work.[7]

7 Matisse's Family, 1900-1904. The Dark Years

The six years after the Matisses set up their ménage at 19 Quai St. Michel were to be very difficult. Official favor had been withdrawn from him at the Salon de la Nationale and after 1899 he never showed at a conservative Salon again. At the same time his new work was experimental and, outside a small circle of artists, had at first little reputation and even less selling value. The birth of Jean in 1899, Pierre in 1900 further taxed their resources.

In 1900, to make ends meet, Matisse and Marquet, who was so poor that at times he could not buy paints, took jobs with a certain Jambon who ran a workshop for theatrical scenery near the Buttes-Chaumont. Jambon needed more workmen for he had secured a contract to help decorate the Grand Palais which was being built for the great Exposition Universelle of 1900. Matisse, called the Professor by his fellow artisans, and Marquet painted the miles of laurel leaves which decorated the cornice of the huge exhibition hall. They also labored on the great panorama of the *Transsibérien*.

The work was as hard as it was tedious but all during this period Matisse spent his evenings studying sculpture as a free municipal student in the rue Etienne Marcel.

While working on the decorations for the Grand Palais he caught bronchitis which recurred during the winter of 1900-1901. In the spring his father took him to Vallors-sur-Ollon in Switzerland west of Lake Geneva for a few weeks' convalescence. That same spring of 1901, he exhibited at the Salon des Indépendants for the first time but with little result beyond shocking his father, who had been impressed by Matisse's early official success but was now gloomy and impatient about his future. The blue mountains which he observed in Matisse's Swiss sketches did not encourage him. Then, or a little later, he cut off Matisse's allowance.

Back in Paris the affairs of the Matisse family grew worse. Friends urged Matisse to sell back his Cézanne *Bathers* and his Rodin *Rochefort* to Vollard. He refused and Madame Matisse sustained him in his decision. In desperation he tried to paint a pot-boiler, something that would sell, but he could not finish it. Finally, driven by necessity, Matisse took his family back to his parents' home in Bohain-en-Vermandois for the winters of 1902, 1903. There, he recalls, "since I couldn't sell a picture or a drawing I got the idea of asking a dozen amateurs to guarantee the purchase of a dozen pictures a year, pricing the pictures at 200 francs each."[1] One of his cousins agreed on condition that the artist would paint two decorative views of his house. But no one else was interested and the whole scheme fell through.

In the spring of 1902 Matisse sent some of his Bohain paintings to the Salon des Indépendants. A collector bought one of them, the *Bouquet on a Bamboo Table*, page 307, for 400 francs. About this same month, April 1902, the courageous Berthe Weill sold a second painting for 130 francs, apparently the first Matisse to be sold by a dealer.[2] But such streaks of luck came rarely. Many years later the artist remarked to Jacques Guenne: "The collectors used to tell me 'We're keeping an eye on you,' which meant that after several years they might risk paying a hundred francs for one of my canvases."[3]

Under these circumstances Matisse found it impossible to keep his family together all year 'round. His daughter Marguerite stayed in Paris but Jean, the older boy, went to stay with his Matisse grand-parents in Bohain; Pierre, the younger, with his mother's family in the South, where he lived much of the time with his aunt, a schoolteacher at Perpignan and later in Corsica.

8 *Mme Matisse and Her Husband*

Fortunately Mme Matisse was not only a devoted wife with deep faith in her husband's talent but a courageous and able woman. Without the two little boys to take care of, she was able to open a small milliner's shop on the rue de Chateaudun which provided the family's principal source of income during these lean years and left the apartment on the Quai St. Michel comparatively free for Matisse to paint in.

Mme Matisse found time too to pose for many of her husband's paintings, including the *Guitarist* of 1903, page 310, and as years passed, the very important *Woman with the Hat* of 1905, frontispiece, the portrait nicknamed "*The Green Line*" of late 1905, page 75, the *Red Madras Headdress* of 1907-1908, page 350, *The Manila Shawl* of 1911, page 355, and the superb portrait of 1913 now in Moscow, page 392.

In connection with the *Guitarist* of 1903 Matisse describes an incident which reveals something of the strain under which he and Mme Matisse worked, a strain increased by their economic worries at this time:[4]

My wife was posing for me in a dark blue toreador costume embroidered in silver. Her toe was resting on a little stool in order to support the knee on which the guitar was resting. This position, which is not very comfortable for anyone who is not a guitar player, gave her cramps in her leg which, added to the long periods of absolute immobility required for posing, caused her to grow impatient. I, on the other hand, was absorbed in my work, quite silent and often intense as a result of the effort I was making. Suddenly my wife gave a quick pluck at the strings: ding, ding. I let this pass without comment. After it had happened several times, I realized that it was getting on my nerves. I told her so with all the gentleness of a person who is holding on to himself. Finally, when my wife repeated the same sign of exasperation as a sort of unconscious form of relaxation, I gave a vigorous kick against the bar of my easel which was oblique and very light-weight. The bar broke in two with a loud noise, the easel fell down as did also the canvas and the oil cup which splattered everything. At this moment my wife threw the guitar on top of the other things with a gesture that was as

quick as what had gone before. *The guitar did not break,
but we burst out laughing. This relaxed our nerves and
united us in our gaiety as we had been united in our
tension.*

Matisse's friend, Jean Puy, tells another story
equally revealing. Matisse had come in to Paris
from the country on business and wanted to take
back a small present for his wife:

*His available fortune at the moment amounted to 40
francs. What should he buy—some trinket or piece of cos-
tume jewelry? Musing over the problem along the streets of
Paris, he came to a sudden stop before the window of an
entomologist's shop where there were displayed, framed in
white plaster mountings, some magnificent exotic butterflies.
One of them, above all, was of a metallic iridescent blue so
intense and so rich that it offered to the dazzled retina all
the shades of the most bewitching azure. Confronted by
such sensuous delight nothing could have kept Matisse from
acquiring it—and that was his* cadeau de retour *for
his wife.*[5]

9 Matisse and His Children

His daughter Marguerite also devoted herself to
Matisse, caring for him and posing for innumer-
able drawings and paintings, among them those re-
produced on pages 332, 354, 401, 418. 426. The
two boys, who were not so close to their father,
posed more rarely. Pierre at the age of nine sat for
the little portrait on page 354.

All three children together with Mme Matisse
appear in *The Painter's Family* of 1911, page 373,
and again in the huge *Music Lesson*, page 419. In its
pendant, the *Piano Lesson*, page 175, Pierre is seated
alone behind the Pleyel. Marguerite and Pierre
with their father's encouragement were in fact quite
musical, playing both the violin and piano. Ma-
tisse himself had studied the violin as a youth and
took it up again intensively during World War I.

All three children also wanted to be artists. Mar-
guerite eventually showed considerable talent as a
painter and Jean became a professional sculptor.[6]
A drawing by Pierre, aged thirteen, appears on the
wall in his father's *Woman on a High Stool*, page 393,
and he remembers as a small boy "selling" a water-
color to Ambroise Vollard when the dealer had
come to buy a painting from his father. Pierre
Matisse is now a distinguished art dealer in New
York. In 1923 Marguerite married Georges Duthuit,
Byzantine scholar, authority on the fauve painters
and, later, editor of *Transition* (bibl. 13, 177-179).

10 Matisse's Life as a Painter, 1899-1904

Meanwhile despite poverty and worry Matisse
worked at his painting from morning to sunset, then
often drew from the figure for an hour or more and,
finally, spent the evening on his sculpture. In
Paris he painted in the apartment on the Quai St.
Michel and worked from the model at the various
student ateliers such as Colarossi's and the Grande
Chaumière. In 1901 he painted at Melun, page
308, in 1902 in the Luxembourg gardens and the
Bois de Boulogne, and in 1903 at Arcueil, again
often sketching side by side with Marquet. At
Bohain in 1902 and again in 1903 he worked in a
bleak attic room with a single window opening
under the mansard so that the canvas had to be
tilted strongly forward to avoid reflections, page
307. Around Bohain, particularly at Bohéries, he
painted the landscape of Picardy.

At the Salon des Indépendants in the spring of
1901 Matisse began to exhibit publicly for the first
time since the Nationale of 1899. There he showed
three still lifes and a number of sketches including
several "*croquis de café concert.*" These were doubt-
less some of the sketches of Mistinguette and other
vaudeville troupers which he made in the company
of Marquet at the Petit Casino and later destroyed.

11 Vlaminck and Derain

In the same year, 1901, Matisse met Vlaminck.
Later Matisse described the encounter: "I knew
Derain from having met him in the studio of
Eugène Carrière, and I took an interest in the seri-
ous, scrupulous work of this highly gifted artist. One
day I went to the van Gogh exhibition at Bern-
heim's in the rue Lafitte. I saw Derain in the
company of an enormous young fellow who pro-
claimed his enthusiasm in a voice of authority. He
said: 'You see, you've got to paint with pure
cobalts, pure vermilions, pure veronese.' I still
think Derain was a bit afraid of him. But he ad-
mired him for his enthusiasm and his passion. He
came up to me and introduced Vlaminck."[1] This
historic meeting brought together for the first time
the three painters who were to be the chief pillars
of the fauve movement. Shortly afterwards Matisse
went out to Chatou where Derain and Vlaminck
had a studio in common. Matisse remembers that
"the painting of Derain and Vlaminck did not sur-
prise me, for it was close to the studies I myself was
doing. But I was moved to see that these very young
men had certain convictions similar to my own."[2]

Though Vlaminck was over six years younger than Matisse he had in fact got to know the work of the *avant-garde* as early as 1895 while Matisse was still comparatively cloistered in Moreau's studio. Vlaminck's work of 1901 was indeed far more radical in color than that of Matisse during his period of somber reaction which had already set in. Consequently Vlaminck, who did not know Matisse's own radical experiments of the year before, felt retrospectively that the paintings which Matisse saw in the studio at Chatou had been a revelation to the older painter. Derain however who had been close to both artists during the years 1899 to 1901 gives, as we shall see, the priority to Matisse, page 49.

During much of Matisse's dark period of 1901-1903 his young and talented friend Derain was away on military service. Vlaminck kept on painting under the influence of van Gogh, using brilliant color which far more closely anticipated the fauve explosion of 1905 than did Matisse's sober palette of these years. But Vlaminck worked in isolation around Chatou. He saw little or nothing of the other future fauves and did not exhibit either at the two liberal Salons or at Berthe Weill's. Thus Matisse, even though his direction was pictorially speaking reactionary, continued to act as leader, partly because of his age, superior initiative and strength of character, partly because of his art. For his painting of this period was, with all its retrospection, vigorous, honest and occasionally powerful. Biette and Puy followed him in his austere course and Marquet may even at times have led the way. They followed him again when in 1904 he rediscovered color with the help of Signac and Cross.

12 Roger Marx and Berthe Weill

All through 1901 no dealer had taken the slightest interest in Matisse's painting. But during the winter of 1901-1902 Roger Marx introduced Matisse to the tiny shop of the dealer Berthe Weill. Roger Marx, it will be remembered, was the critic who had championed the copies of older masters made by Moreau's students when they were bought by the official Purchasing Committee. He had kept in touch with the group of young artists and during the first years of the new century often asked them to his house. Berthe Weill was more courageous than discriminating but among the many scores of artists whose work she exhibited were most of the best young painters of Paris. It was she who first

showed Picasso in Paris in 1900 a few days after he had arrived from Barcelona and now, two years later, it was she who first exhibited Matisse. In February 1902 she put on a small exhibition of the work of six little-known artists including Matisse, Marquet and Flandrin, all of them Moreau's pupils.[3] Marquet sold one sketch for 50 francs, Matisse nothing, but the show was the first of several public manifestations of the group which first came together in Moreau's studio. Matisse, as we have seen, had better luck a month later at the Salon des Indépendants of 1902 where he exhibited six canvases including four flower pieces, at least one of which he sold, page 307.

Thanks to Roger Marx' encouragement, Berthe Weill's hospitality and Matisse's leadership, the group grew in size and solidarity, Manguin, Camoin, and Jean Puy joining the ranks. Other future fauves, Raoul Dufy, Kees van Dongen, Othon Friesz, also showed at Berthe Weill's before the "fauve" Salon of 1905, but not as a group.

During these years Matisse and his friends exhibited in greater strength every spring at the Salon des Indépendants. In 1903, for instance, Matisse, Marquet, Puy, Manguin, Camoin were all represented, as well as the two future fauves from Le Havre, Friesz and Dufy, whom Matisse did not yet know but who already knew him by reputation.

Matisse sent seven paintings and a drawing to the Indépendants of 1903 including a *Guitarist*, probably the one reproduced on page 310, two heads and three landscapes. At this, his first Indépendants, Camoin, youngest of the Moreau group, sold six paintings, his entire entry, a success which must have inspired mixed feelings in the mind of Matisse whose sales were still very few, although in 1902 and 1903 he was sufficiently well known among his fellow artists to have been appointed to the hanging committee.

13 The Salon d'Automne, 1903

In the fall of 1903 a public event of great importance to Matisse and the other future fauves took place. This was the opening of the first Salon d'Automne. The Salon de la Nationale had been completely captured by the academic forces which controlled its jury and had thus taken its place beside the even more conservative Salon des Artistes Français. The Salon des Indépendants on the other hand was liberal, even anarchic, since it was juryless and imposed no professional standards.

Henri-Matisse

MALE MODEL. Paris (c.1900). Pen and ink. Courtesy Justin K. Thannhauser Gallery

The first Salon d'Automne was held in the unpretentious galleries of the basement of the Petit Palais —thanks to the assistant curator Yvanhoé Rambosson. Its success was considerable both as an artistic and worldly occasion. Matisse showed only two paintings, an interior and a flower piece. Yet the event was of great significance to him for only two years later, in 1905, his paintings were to be at the very core of the dramatic display for which the Autumn Salon is now chiefly remembered, the launching of the fauve movement with Matisse as its foremost champion.

In 1904, however, Matisse and his group still felt more at home at the Salon des Indépendants where, under the dogmatically democratic leadership of Paul Signac, almost all the friends of the Galérie Berthe Weill contributed work to swell a grand total of around twenty-five-hundred entries. Matisse sent an interior, a flower piece, a *Monk in Meditation* which he had done in Jean Puy's studio, two landscapes painted near Bohain and *Une allée du Bois de Boulogne* which is very likely the canvas reproduced on page 308 and now in Moscow. Early in April, a week after the Indépendants closed, Berthe Weill exhibited Matisse's group again, Camoin, Manguin, Marquet and Jean Puy all taking part. A Matisse still life which Mlle Weill called "*superbe*" was sold for 180 francs.

14 First One-Man Show, 1904

In June Matisse had his first one-man show. Ambroise Vollard rarely ventured to open his galleries to little-known painters but he kept an alert though rather uncritical eye on Berthe Weill's gallery in the early 1900s, just as he had on Père Tanguy's and Le Barc de Boutteville's in the 1890s. Vollard had of course known Matisse since 1899 when he sold the young painter the treasured Cézanne *Bathers*. He had not been much impressed by Matisse's paintings though he had bought a few and was aware of his growing reputation among artists. So, encouraged by Roger Marx, he decided to give Matisse an exhibition. Roger Marx wrote the preface in the catalog which lists forty-six works and records that the dates of the show were June 1 to June 18, 1904. Roger Marx' preface—the first formal article published on Matisse's work—is worth quoting here at some length since it not only gives the opinion of the most alert among the older professional art critics of the time but also because it serves as a brief review of Matisse's career up to

The new Salon d'Automne—so called to distinguish it from the other three Salons, which opened in the spring—solved the problem by choosing its jury by lot from among its members. The initiator and first President of the new Salon was the liberal architect, Frantz Jourdain (who had bought the Marquet sketch at Berthe Weill's the year before). Among the influential charter members were Carrière, Redon, Vallotton; the Moreau pupils Desvallières, Rouault, Marquet, Guérin; and the critics Roger Marx and J. K. Huysmans, balanced by the already reactionary Camille Mauclair and the fashionable painter-critic Jacques-Emile Blanche. The former Nabis, Bonnard, Denis, Vuillard, as well as Vallotton and Sérusier, were conspicuous among the exhibitors and their first leader Gauguin, who had died the previous May in the Marquesas, was given a large memorial show. Thus at its very beginning the Salon d'Automne, though mixed, was dominated by the generation which had grown to maturity in the '90s.

the summer of 1904 when his art was to take a new direction:

The art of Henri Matisse harmoniously reveals the synthesis of the combined teachings of Gustave Moreau and Cézanne; it captures the curiosity of the historian as well as that of the enlightened amateur. Furthermore the artist's discipline is such as to justify anyone's confidence and esteem. At the age of twenty-seven—in 1896—Henri Matisse exhibited at the Salon du Champ-de-Mars with exceptional brilliance; his promotion to Associate went unchallenged and his paintings swept into private and public galleries with no interference. Now, if a painter prudently follows in the path that first brings him success, he has little to fear for the future—but in this case the promise of an easy life seemed to hold little appeal. To a fashionable success Matisse preferred the challenge of struggle and the bitter honor of satisfying himself. The more one ponders the more it becomes evident in this case that the constant growth of his talent was caused by endlessly renewed efforts which stimulated the artist to make the most ruthless demands upon himself.

Always on the alert, Matisse took pleasure in setting down all that gave joy to his perceptive eyes. He expressed the miracle of a sunbeam which falls on shadowed chrysanthemums and tulips, or lights with gay reflections the sparkling surface of ceramics and jewelry. His sense of intimacy—like that of Francis Jammes or Edouard Vuillard—is most precisely revealed in his representation of his home, at times deserted, always quiet, even when the yarn is being unwound. Outdoors, Matisse falls in love with snowcapped mountains interlaced with clouds or, more simply, paints the coast of Belle-Ile beaten by the waves, or the quais of the Seine under the snow, or Corsica while the almond trees are in bloom and the grey-green olives edge the blue sea. Tomorrow other festivals of color and light will tempt him and he will spend himself to set them down with an effort of his whole being, and with the same purpose of equaling in his expression the sensitiveness of his vision, and of rendering the harmonies of the external world according to his passionate and tender nature.

Roger Marx

The show at Vollard's was not much of a success. There was one favorable review, in the *Chronique des Arts*—but it was by the loyal Roger Marx and repeats what he had already written in the catalog.

Vollard did not offer to buy Matisse's "whole studio"—all his available paintings—as he sometimes did with other indigent and even younger artists, Picasso and Derain among them. The following autumn, however, he did buy the famous *Dinner Table* of 1897, page 299, for 200 francs and, according to Matisse,[4] sold it very soon afterwards to a Berlin collector for 1500 francs.

During the winter of 1903-1904 Matisse continued to paint in his somber realistic style, producing such excellent though retrospective canvases as the *Guitarist* and *Carmelina*, pages 310, 311. His earliest etchings such as the *Self Portrait* and *Two Women in Street Costumes*, page 312, may also date from this period.

After his one-man show at Vollard's closed in June, Matisse and his family moved for the summer to St. Tropez at the suggestion of Paul Signac who had a villa there. The summer was crucial in Matisse's career. Not only did his palette become more brilliant under Signac's influence but the economic horizon, so gloomy during the previous few years, began to lighten. There were still difficulties and crises ahead but the dark period in both his art and his life was drawing to a close.

SECTION II MATISSE'S ART, 1896 TO EARLY 1904

1 Brittany and Impressionism, 1896

After his success at the Salon de la Nationale early in 1896 Matisse decided, as we have seen, to leave Paris and the Louvre for a summer's painting in Brittany with his friend and neighbor Emile Wéry.

Brittany had been the center of Gauguin's school seven or eight years before, but Matisse was practically unaware of the Synthetists though he of course knew the work of Dagnan-Bouveret, Lucien Simon and Charles Cottet who were winning increasing popularity and fame at the Salon de la Nationale by their realistic tableaux of wrinkled Breton peasants in black and white costumes.

Emile Wéry however had been influenced, perhaps indirectly, by the impressionists, and from him Matisse learned for the first time something of the excitement of paint brushed on in small strokes of comparatively pure color and of the use of complementary violet shadows to enhance the predom-

inantly warm tones of sunlight. On the coast of Belle-Ile-en-Mer, the large island south of Brittany, he painted studies such as the *Cliffs at Belle-Ile*, page 297, which were far bolder in color than anything he had attempted before.

In Brittany Matisse also painted several interiors of which the *Breton Serving Girl*, page 298, is the most ambitious. Except for the Breton costume the picture bears no resemblance to the work either of Gauguin or of Cottet. Chardin still presides in the composition, but the scale of the figure within the room, the silvery light and the cool, limpid objectivity suggest Corot. This scene with the dining-table still life, the maid at the right, the chair at the left, the door—or window—in the background, Matisse was to paint again more ambitiously within a few months, and yet again a dozen years later in one of his most famous works, the *Harmony in Red* of 1908-1909, page 345.

Related to the *Breton Serving Girl*, in fact almost its epitome, is the little study in pale greys and blues of the open door of a Breton cottage, page 298. An extremely simplified design of rectangles, it seems to anticipate on a small scale the austere, highly abstract compositions of twenty years later. Yet Matisse probably thought of the *Open Door* rather as an elementary study of light falling on planes set at different angles to its source and complicated by shadows and reflections. Nevertheless the *Open Door* is the most striking and personal picture he had so far produced.

2 *The* Dinner Table, *1897*

When Matisse got back to Paris in the fall of 1896 after the summer in Brittany, Moreau, as we have seen, incited him to prove himself by attempting a large composition. Matisse thereupon concentrated his energies upon the remarkable canvas now known as *La desserte*[1] or the *Dinner Table* which, in the spring, he sent to the Salon de la Nationale of 1897, with the consequences already related on page 35.

The *Dinner Table*, page 299, is a large picture over four feet wide. The general effect of the table with its furnishings and white cloth is silvery, accented with the dark red of the wine decanters. The maid's apron is white, her dress maroon, the walls in the background greenish blue. Obviously developed from the *Breton Serving Girl* of the previous summer, the *Dinner Table* differs significantly from the earlier picture not only in size and complexity:

the *Breton Serving Girl* is luminous but the light resembles Corot's; the *Dinner Table*, though darker in tone, is clearly impressionist in its luminosity which pervades and absorbs the forms in a manner suggesting the occasional interiors or still lifes by Pissarro and Monet.

Prophetic of Matisse's later development is the increasing compression of space observable in the *Dinner Table*. The upper half of the *Breton Serving Girl* is surrendered to a light, blank wall but the top edge of the *Dinner Table* is brought down until it almost touches the cap of the servant. Moreover the table perspective is tilted further forward, seen from above. All three factors tend to destroy the apparent depth of the canvas so that the elements seem to be brought more and more up against the plane of the canvas.

The still life *Apples* of 1897, page 299, when compared with the *Still Life with a Black Knife*, page 296, of a year before, clearly demonstrates the same tendency to bring the objects up close to the picture plane while at the same time suppressing the sense of depth behind them. This change in his handling of space is the first concrete evidence we have that Matisse was gradually feeling his way toward the post-impressionist approach to painting as seen for instance in the still lifes of Cézanne.

In the summer of 1897 Matisse again went to Brittany where he painted *Rocks and the Sea*, page 297, among many similar studies. Both his color and brushing grew freer and more impressionist than in his work of the previous summer.

3 *Painting: Corsica, 1898*

When he returned to Paris in the fall of 1897 Matisse studied with renewed eagerness the works of the great impressionists and won the friendship of Pissarro, page 37. During the year February 1898 to February 1899, spent in Corsica and the South of France, page 37, he became like a true impressionist primarily a landscape painter, working directly from nature out of doors.

In Corsica he produced dozens of small sketches and only a few larger canvases. One of them, painted in the court of an old mill at Ajaccio, is characteristic in technique and more interesting in design than most of the Corsican landscapes. The composition of the *The Old Mill, Ajaccio*, page 300, depends on a fairly conventional diagonal division of the canvas into a dark and a light triangle. Almost the whole canvas is covered by flat, freely

touched-in spots of color, the shadows all in blue and violet. The total effect is luminous but not brilliant. The *Tree*, page 300, a sketch painted nearby, is brighter in effect, the pigment thicker, the surface more broken, the local color heightened. A more important Corsican landscape, *Petits oliviers*, reproduced in color in Escholier, bibl. 83, page 9, suggests Renoir.

As in Brittany, Matisse painted occasional interiors such as the view of his own chamber, the *Room in Ajaccio*, page 300. This painting, perhaps his most important Corsican canvas, is exceptional in its large scale and careful detail. The local color is modulated by reflections from other surfaces of the room. The white sheet, for instance, like the tablecloth in his big *Dinner Table* of the year before, is suffused with green, violet and pink tints.

4 Toulouse and "Pointillism," 1898-1899

Matisse's painting done in the fall and winter of 1898-1899 in Toulouse and Fenouillet is definitely more advanced. In the outdoor sketches such as the *Toulouse Landscape*, reproduced in color by Skira,[2] passages of pure violet, orange and blue supplant or heighten natural color in a way which recalls van Gogh or even Matisse's own fauve sketches of eight or nine years later.

The Invalid, page 301, an interior with Mme Matisse sick in bed, differs significantly from the *Room in Ajaccio*. The surface is rich and varied, much of it laid on with a palette knife. The original colors of the objects and surfaces are preserved only in a general way: the face of the invalid, for instance, is touched with red, green and orange strokes. The volume of the room had been clearly rendered in the *Room in Ajaccio;* in *The Invalid* the space is comparatively flattened and vague. The *Still Life*, page 301, is apparently painted about the same time and shows a similar almost iridescent richness of pigment and, again, a tendentious halfway suppression of depth.

Matisse may well have remembered Signac's Neo-Impressionist paintings at the Salon des Indépendants of 1898 before he left for Corsica but his paintings give no evidence of it until almost a year later, toward the end of his visit in Toulouse. Meanwhile he had been reading Signac's *De Delacroix au Néo-Impressionisme* which was coming out serially in *La Revue Blanche*.[3] Based on the theories of Seurat and of Signac's friend Charles Henry, this persuasive study did much to strengthen the ranks

NUDE STUDY. (Before 1905.) Pen and ink

of the Neo-Impressionists who were commonly called "divisionists" because they divided their tones into primary hues, or "pointillists" because they painted in little points or spots.

Since its invention by Seurat about 1884, Neo-Impressionism had attracted a number of important painters who used its systematic technique for brief periods but did not adhere to the doctrine with the devotion of Signac and Cross. Pissarro, for instance, called the new movement "scientific impressionism" and for several years after 1885 practiced its discipline, then turned against it; van Gogh used divisionism in many pictures about 1887, Gauguin in only two or three. But the quasi-scientific appeal of Seurat's doctrine and the vigorous proselytizing of Signac maintained Neo-Impressionism as an active influence throughout the '90s and well into the 20th century. About 1899 even Vuillard and some of the Nabis were affected by it, as well as Matisse.

During 1897 in Brittany and Paris, and 1898 in Corsica, Matisse had been employing a kind of

vigorous impressionism. But in such pictures as *The Invalid* painted at Toulouse early in 1899 his willingness to sacrifice a sense of light and atmosphere for structural design is apparent. Matisse, stimulated by Signac's argument, now attempted to preserve both luminosity and construction by experimenting briefly with a Neo-Impressionist technique in the *Sideboard and Table* reproduced in color on page 66 and analyzed there.

On page 67, opposite the color plate, are reproduced two other closely related still lifes, *Fruit Dish and Glass Pitcher, I* and *II*, which are probably studies for the left-hand side of the *Sideboard and Table* but may possibly be postscripts to it. Whether it is a study for the large still life or a variation after it, *Fruit Dish and Glass Pitcher, I*[4] is far less consistent technically, the thin, flat, transparent color of pitcher and fruit contrasting both with the dense, loaded white of the china and the broken color of the background, spotted at the left, streaked like a van Gogh at the right. The effect of the whole is brighter than in Matisse's previous still-life paintings; and there is something of Cézanne, though not yet fully understood, in the composition and in the color modeling of the fruit. *Fruit Dish and Glass Pitcher, II*[5] is important because it seems to anticipate the broader, more synthetic style which Matisse developed during 1899 after his return to Paris.

5 Painting: Paris, 1899-1901

When Matisse returned to Paris from Toulouse he had not yet recovered from his first attack of pointillism. A study with a female model probably made in Moreau's old atelier (which had been taken over by Moreau's successor Cormon) shows much the same mixed technique as that of the Baltimore *Fruit Dish and Glass Pitcher*, page 67, done in Toulouse. A study by Marquet[6] of the same model in the same pose and doubtless done while sitting beside Matisse shows that he, too, was mixing his methods: Marquet's figure is modeled more solidly than Matisse's but, like his, is seen against a completely pointillist background. Matisse now abandoned the pointillist technique for several years but the Neo-Impressionist method, if not the doctrine, was to attract him again and much more strongly in 1904, when he actually worked near Signac at St. Tropez.

Perhaps the most remarkable painting of 1899 is known variously as the *Still Life Against the Light* or *Orange Still Life*, page 302. The effect of the whole is

of an almost monochromatic red-orange entirely free of Neo-Impressionist dotting. In spite of the curious lighting and strong cast shadows, the light effects are subordinated to an over-all richness of color and pigment which looks back to Chardin—Matisse was working on a copy of Chardin's *Ray*[7] about this time—and a freedom from both local color and impressionist color which, though still in a somber key, looks forward to fauvism.

Much bolder however is a series of studies of the nude model painted at the "Académie Carrière," then, later, in Jean Biette's studio during the period 1899-1901. Though dark in effect, *The Model*, page 303, is boldly constructed in complementary cold and warm tones which, combined with the vigorous drawing, suggest the figures Rouault was to paint some years later. Some of these figure studies are modeled in green and violet[8]; others, such as that of the formidable *Male Model*, page 304, predominantly in blue with a few contrasting warm tones. The planes of this figure are boldly simplified, the drawing more decisive than in any previous work of Matisse. For the first time Cézanne's influence is paramount. The blue tones and the bold drawing are in fact rather coarse, if effective, exaggerations of structural elements in Cézanne's later figure style.

Working with an intensity and pertinacity beyond that of his fellows, Matisse made many studies of this thick-set, bearded model, an Italian named Bevilaqua (Jean Puy calls him *une espèce d'anthropoïde*). Manguin later told Leo Stein how the group was "not satisfied with the week's pose, because it did not give them time enough for thorough study. So they got a pose for a month, but Matisse was the only one who stuck it out. Not only that, but still dissatisfied, he got the same model to pose in the same position for a statuette and worked on it for three years with more than a hundred sittings."[1] Manguin was undoubtedly speaking specifically of Bevilaqua who was also the model for *The Slave*, page 305, the most important of Matisse's early sculptures. Another of several studies of Bevilaqua in the same pose as the big blue *Male Model* and the bronze *Slave* is reproduced on page 304. Though small and unfinished its savage power is impressive.

Another *académie*, a female figure also in blue tones,[2] Matisse used as a study for his first completed figure sculpture, the *Madeleine* of 1901, page 305. That was the year in which Picasso painted the first pictures of his "blue period." Matisse, though

he anticipates Picasso by over a year, thinks their use of a blue tonality a coincidence. In any case, as he points out, Picasso's blue conveys a romantic mood whereas his own, used in conjunction with complementary warm tones, is structural.[3]

The emphatic drawing of the *Male Model* is seen again in the *Interior with Harmonium*, page 302, of about the same time. In it Matisse has "tilted" the perspective—as if drawing from a stepladder—more even than in the *Sideboard and Table* and *The Invalid* of the year before. The resulting design is easily the most radical so far achieved by Matisse, though no more so than Vuillard and before him Degas, guided by Japanese prints, had often produced in the course of the previous two decades. Gauguin in the late '80s had painted several pictures in which the perspective is still more abrupt and the effect even more abstract.[4] Yet, if Matisse's design is not so striking as some of theirs, it reveals a more obvious concern for structure. Cézanne, not Gauguin or the Nabis, was his principal guide. And whatever its relation to the past, the *Interior with Harmonium* looks forward to the great still lifes and interiors which Matisse was to paint a dozen years later. In the little *Street in Arcueil*, page 302, of about 1899, Matisse again shows his interest in filling his picture space with an active angular design reminiscent of Cézanne's landscapes of the mid-'80s, particularly the Gardanne series.

6 "Proto-Fauve" Painting: Summary

In several ways Matisse's work of 1899-1901 anticipates the fauve period. In fact his work of this time might well be called proto-fauve. The two best painters who worked with him at that time, Marquet and Derain, both bear witness to Matisse's position as pioneer. Marquet writes: "We worked, Matisse and I, before the exposition from about 1898 in what was called much later the fauve manner. The first Indépendants, where I believe we were the only two painters to express ourselves in pure tones, was in 1901."[5] Derain, as has been noted, first worked with Matisse in Carrière's studio in 1899. Years later Derain recalls that "in fact, from around 1900, a kind of fauvism held sway. One has only to look at the studies from the model which Matisse made at that time."[6]

Intensifying local color in landscape, or painting the figure in complementary tones of blue and orange or violet and ochre were devices which five years later became common practice with the fauves. Matisse's trenchant drawing, sometimes with abrupt, heavy bounding lines, his exaggerations and distortions of contour also anticipate the fauves. So does his tendency to fill the whole canvas with esthetically active form, as in the *Street in Arcueil* and the *Interior with Harmonium*. Yet there are important differences between Matisse's painting of 1900 and that of his fauve period. Color in the early work rarely seems arbitrary or decorative; its intention is always structural. Similarly the design does not move in curves and arabesques but in straight lines, blocks and angles. Matisse clearly has his eye and mind on Cézanne and not on the sinuous, flowing line and flat color which characterize the decorative tradition of the moment stemming from Gauguin and Japanese prints. Matisse's proto-fauve period is neither gay nor charming but on the contrary serious and studious, at times brutally honest, especially in the figure studies. Yet the overemphatic power of such studies as the *Male Model* also anticipates the latent anti-decorative strain in Matisse's fauvism that appears in *The Blue Nude* and *Standing Model* of 1907, pages 336, 338, and that was to win for him the epithet "apostle of the ugly."

7 Painting: The "Dark" Period, 1901-1904

Except for innumerable *académies* or classroom drawings or studies such as the *Male Model*, his copies in the Louvre, and the rather incidental characters in his interiors such as the *Dinner Table*, page 299, Matisse had done no figure painting during the first ten years of his career. His finished compositions had been predominantly still lifes. Of the thirteen oils exhibited at the Salons de la Nationale of 1896, 1897 and 1899, all were either still lifes or interiors. From 1895 on he had also painted landscapes, but almost all of them had been little more than sketches. Now, during his dark period, he gained sufficient confidence to send several landscapes, heads and figure paintings to the Indépendants. Indeed his most important canvases of the period are figures.

The first and one of the largest of these is *La coiffure* of 1901, page 306. Though essentially a study of a handsome nude back, the atmosphere is intimate, with little suggestion of the studio. The figure is symmetrically posed and placed forthrightly in the center of the canvas. The drawing is achieved through irregular Cézannesque contours, sometimes a little broken or jagged but with very

little dependence on line. The modeling is simpli-
fied into planes, and contrasts of light and shade are
restrained so that the back seems flat in the rather
neutral light of the room. Except for a few arbi-
trarily cold tones in the shadows of the flesh, local
color is followed throughout. The generally somber
tonality of blacks, browns, and dull whites is re-
lieved by the red in the bouquet on the table. The
painting would verge on dullness were it not for
the Cézannesque intelligence of the drawing and
the density and sensual richness of the pigment.
La coiffure calls to mind Manet's paintings of about
1860 though it lacks Manet's refinement of surface
quality and tonal values.

At Bohain in the dark years of 1902 and 1903,
Matisse painted a number of small pictures in an
attic room which he used as a studio. One of his
most interesting canvases of the period is *Studio
under the Eaves*, page 307. The large gloomy room
with its plain surfaces and awkward perspective
comes to focus on the bright rectangle of the win-
dow before which play the sparse, angular shapes
of the easel, a cheap folding table and a packing
case on which the painter has left his palette. There
is possibly some debt to Vuillard in this picture:
yet, at a period when Matisse in his discouragement
felt driven to attempt agreeable or at least con-
ventional subjects, the *Studio under the Eaves* is as
original in conception as it is disconsolate in
atmosphere.

The canvas on the easel in the *Studio under the
Eaves* is, as it happens, the *Bouquet on a Bamboo
Table*, page 307, which under the name *Flowers in
a Silver Vase* Matisse sold at the Salon des Indé-
pendants in the spring of 1902, page 41. Many
years later when Matisse was asked to authenticate
this modest grey flower piece he replied enthusiasti-
cally: "This painting of the attic is one of my best
pictures as is the one of the flowers. . . . It is the
period of transition between values and color. Here
values have been the dominant factor. . . . What
depth, suppleness in the shadows."[7] He added
later[8] that he also valued this flower piece for its
sense of "atmosphere and intimacy."

50

Most of the many landscapes which Matisse painted in 1901-1903 in or near Paris and in Picardy have been dispersed and are not easy to identify. He sent a *Paysage* to the Indépendants of the spring of 1902, three to that of 1903 and three more to the Indépendants of 1904 including a *Blasted Oak* (Bohain) and a *Path in the Bois de Boulogne* which was probably the painting of 1902 bought by Shchukin and now in the Museum of Modern Western Art, Moscow.

We reproduce *The Chézières Road*, page 309, one of the bold sketches of snow and misty blue mountains which he did in Switzerland in 1901. The *Trees near Melun*, page 308, another small landscape of the same year, reveals Matisse's concern with simplifying the complex accidents of nature into a few broad forms. One of the most ambitious landscapes of the period is *The Path in the Bois de Boulogne*, page 308. Though painted on a sunny day, the canvas is subdued in color, quiet in surface. Structural color planes prevail, with no trace of impressionist sparkle or agitation.

A couple of years earlier, Matisse had painted the view looking west from his apartment on the Quai St. Michel, page 68. Now, in 1902, he painted several canvases looking east over the Petit Pont which crosses the Seine to the Préfecture de Police, and beyond to the great west front of Notre Dame. One of them, painted in a dull morning light, passed into the collection of Jean Biette; another and more important view, *Notre Dame in the Late Afternoon*, page 309, is now in the Buffalo Museum. There are still impressionist elements in the painting such as the suggestion of Japanese perspective and the sketchily painted passers-by casting thin reflections on the wet pavement. The crepuscular violet-grey light, the generalized misty forms, even the title suggest some Whistlerian precursor of impressionism. Perhaps Matisse's own state of mind and fortune explains the minor mood of this *Notre Dame*. The style of the painting, if not its sentiment, is certainly close to that of Marquet who ordinarily followed Matisse but in these city views may well have influenced him.

During 1903 the gloom which shrouded Matisse's palette—and spirit—began to lift. The *Carmelina*, page 311, now in the Boston Museum, is an uncomprising study of a graceless, naked model. Ochres and browns are relieved by accents of modest red and blue, local colors all, with almost no complementary shades or shadows. The modeling and lighting however are incisive, the background ingeniously organized in asymmetric rectangles. One of them reflects the image of the painter, a device which he was often to use in later pictures and drawings.

Matisse's acceptance of a rather prosaic sensual reality in such paintings as *Carmelina* and *La coiffure*, page 306, of two years earlier seems 19th century. In fact early Manet, even Courbet or at the latest Félix Vallotton, come to mind. Matisse however was not alone in his retrospection: Marquet, Puy and others were painting similar studies though theirs were less distinguished in quality of color and surface.

Matisse has not much lightened his palette in the *Guitarist*, page 310, a small canvas of his wife costumed as a Spanish guitar player, but the painting is altogether livelier than the severe *Carmelina* or the dour *La coiffure*. The staccato contrasts of light and shade, the glitter of the costume so deftly distinguished from the flowered hanging, contribute to an effect quite unlike anything Matisse had achieved before, an effect which looks forward prophetically to the vivacious Rococo of his paintings of the early 1920s. But there are other values in the *Guitarist* which the pleasant pictures of twenty years later do not have, a beauty of surface for instance and a certain intensity of feeling conveyed partly by the dramatic lighting, partly by the active tension of the figure's unstable swastika pose.

This *Guitarist* is one of three canvases entitled *Guitariste* which appear among Matisse's entries in the Salons of 1903 and 1904. *La japonaise*, a much larger but unfinished canvas of 1903, is also a portrait of Mme Matisse.

8 First Sculptures, 1899-1904

During the years when Matisse was producing those canvases which we have called proto-fauve, he also undertook his first sculptures. Doubtless his general preoccupation with problems of form and structure, as a reaction against the impressionism of his work of the previous couple of years, led him to try his hand at the most concrete and tactile of plastic mediums.

As a student of painting Matisse had gone to school in the Louvre with the masters of the 17th and 18th centuries, but now when he began to work at sculpture he chose as his models the two great 19th-century sculptors of France, Barye and Rodin.

Rodin was then on the threshold of that position of prophetic or demi-god-like eminence which was to raise him above all other artists of the early 20th century in popular esteem. Yet only the year before Matisse first began to model clay, conservative opinion had fought its strongest rear-guard action against Rodin's art. Rodin had sent to the Nationale of 1898 the large study for the statue of Balzac which had been commissioned by the Société des Gens de Lettres ten years before. Instead of a conventional portrait, Rodin had designed the first monumental expressionist sculpture of our time. Argument approached the stage of rioting at the Nationale, news of which must have reached Matisse in Corsica. The Société was so shocked by the figure that, urged on by official art opinion, it withdrew its commission and awarded it instead to the academic sculptor Falguière.

Not long after Matisse returned to Paris, he bought from Vollard the plaster for Rodin's portrait of Rochefort, page 39, and before the end of 1899 began his own first sculpture, a free copy of Barye's *Jaguar Devouring a Hare*, page 303. For many months during 1900 he worked at night at the Ecole de la Ville de Paris on the rue Etienne Marcel, a free municipal school with a studio for sculpture. Even during the period of his exhausting labor on decorations for the Grand Palais he would work from eight to ten in the evening on his Barye copy. With characteristic thoroughness he even got the body of a cat from a medical school and dissected it to study the muscles of the back and claws. The planes of muscular structure he simplified somewhat but without loss of power and tension. The *Jaguar* in its final state is a powerful interpretation of—and a magnificent homage to—Barye's masterpiece.

During the winter of 1900 he began his first original piece, the figure of the model Bevilaqua which he called *The Slave*, page 305. Matisse went to see Rodin, bringing with him some drawings, in the hope that he might be permitted to work in the great man's studio. Rodin seems to have rebuffed him.[1] In any case Matisse turned to Rodin's leading pupil Bourdelle and worked with him for several months at the studio of La Grande Chaumière.[2]

Matisse did not finish *The Slave* until 1903. The original pose, perhaps influenced by Rodin's *Walking Man*, was fixed in the oil studies of the model in early 1900 but for several years thereafter Matisse had Bevilaqua pose off and on so that he might master in clay the complexities of muscular detail, bony structure and balance. The figure was originally designed with arms which were lost before the plaster was cast in bronze and shown at the Salon d'Automne of 1908, no. 910, *le Serf*.

The Slave might be criticized as somewhat overworked, a little excessive in muscular detail. In fact *The Slave* barely avoids the decorative elaboration of Bourdelle such as Matisse must have known in the warrior's torso designed by the older artist in 1900 for the Franco-Prussian war monument at Montauban. Yet, though *The Slave* is an act of studious discipline, it is a notable achievement as a sculptor's first original work. Outside of Rodin's own *oeuvre* it would be hard to find a contemporary figure to equal Matisse's in energy and tense vitality. *The Slave* was imitated by his students, page 22, and greatly admired by early amateurs of his work, partly because it was more traditional in character than was much of his sculpture of the next few years.

In 1901, long before he finished *The Slave*, Matisse modeled his first female figure, the *Madeleine*, page 305, in which the exaggerated S-curve formed by head and body seems a kind of foil to the masculine rigidity of *The Slave*. The *Madeleine* is modeled with a featureless face and without arms so that nothing detracts from the rhythmic swing of the figure.

Besides these works Matisse made several minor pieces during his first three years as a sculptor. In 1900 he modeled a study of a human foot, in 1901 a small study of a horse. In 1903, the year he completed *The Slave*, he made a second version of the *Madeleine* and also a tiny bas-relief of the head of his son Pierre.[3] *The Back*, a large relief, was formerly dated[4] 1904 and is illustrated, as if done in that year, on page 313; but as this book goes to press it seems fairly certain that it was made between 1910 and 1912.

PART III: 1904-1907

MATISSE IN PARIS: "THE KING OF THE FAUVES"

SECTION I MATISSE'S LIFE, MID-1904-1907

1 St. Tropez, Signac and Cross: Summer, 1904

Matisse had given little thought to Signac's Neo-Impressionist doctrine or technique since the early months of 1899. Nevertheless during the spring of 1904, perhaps through Signac's influential position in the Salon des Indépendants where Matisse was becoming an important annual exhibitor, the two artists came to know each other better. Consequently the Matisses decided to spend the summer at St. Tropez not far from Signac's villa, La Hune. There the two families saw a good deal of each other—*The Terrace, St. Tropez*, page 315, for instance, is actually a view of the side of Signac's boathouse[5] with Mme Matisse posing in a Japanese kimono. And at Le Lavandou, not far from St. Tropez, lived Henri-Edmond Cross, Signac's chief Neo-Impressionist colleague.

Cross was a gentler personality than Signac and a better colorist. Matisse has often spoken of him with respect and it seems probable that Cross, at least as much as Signac, now helped change the course of Matisse's art. Matisse perhaps found Signac's manner somewhat assertive. Furthermore, Signac's canvases of the period, page 18, tended to be over-systematic in brush stroke and doctrinaire in color. His watercolors, though, were wonderfully bold and free[6] and some of them done as early as the 1890s remain among the closest anticipations of fauve painting.

At first, as we shall see, Matisse kept his mind on Cézanne but before the summer was over he had become virtually a Neo-Impressionist, though not without much troubled experiment. Cross observed Matisse's struggle with some amusement. "We've been to St. Tropez," he wrote Théo van Rysselberghe on September 7th.[7] "Matisse the anxious, the madly anxious! You will easily realize that I was as pleased to chat with him as I was delighted, though for opposite reasons, to sense the fine self-

assurance of our friend Signac. And after all, why put too much trust in exterior evidence?" Signac, the proselyting leader of the "pointillists," was less observant and, in any case, was greatly pleased at having won a new and obviously talented recruit.

Matisse returned to Paris in time for the second Salon d'Automne which opened October 15, 1904, this time in glory at the Grand Palais. It was a great success in spite of the furious attacks of the President of the Salon de la Nationale, Carolus-Duran, who threatened to excommunicate those members who showed at the new Salon but was countered by Carrière who threatened to resign if the order was put into effect.

Matisse sent thirteen canvases to the Salon d'Automne, two landscapes, two pictures called *Guitariste* and several interiors and still lifes. One of the interiors was the *Dinner Table* of 1897 which was reproduced in *L'Illustration*, actually a fairly safe choice for that respectable "family weekly" since the picture had been painted seven years before in a style initiated in the 1870s. It was in any case an excellent impressionist painting and not long afterwards Vollard bought it for 200 francs and quickly sold it to a Berlin collector for 1500 francs.[8]

The Paris season of 1904-1905 was marked by great Neo-Impressionist activity. The Galerie Druet gave Signac a one-man show in December and Cross one in March. At the Indépendants Signac organized a Seurat retrospective and welcomed with enthusiasm an important Neo-Impressionist painting by Matisse.

2 Luxe, calme et volupté *and the Indépendants of 1905*

Matisse's principal concern during the fall of 1904 had been his big new figure composition *Luxe, calme et volupté*, page 317, finished well before the Salon des Indépendants of 1905 to which he sent it

53

along with other canvases of the previous summer including *The Terrace, St. Tropez.* The *Luxe, calme et volupté* caused a good deal of comment. As we shall see, Maurice Denis thought it dangerously abstract while Raoul Dufy found it a revelation; but, because of its Neo-Impressionist character, Signac was so delighted that he bought it immediately and as soon as the Salon closed bore it off triumphantly to St. Tropez. There it hung in the dining room of Villa La Hune undisturbed for almost forty years—so long in fact that only those who had seen it at the Indépendants of 1905 remembered it: apparently Signac had been so importunate that the big canvas was never photographed before it left Paris. Then, within six years, Signac was separated from his wife who retained La Hune and the Matisse. Not until 1950 was *Luxe, calme et volupté* exhibited again and, so far as the writer knows, it is reproduced for the first time here in the present volume.[9] Meanwhile, since the painting had disappeared, its name *Luxe, calme et volupté* was confused with *Le luxe,* the title of two equally crucial paintings of 1907, pages 340, 341.

Signac's triumph was short-lived. Within a year he found that Matisse had repudiated Neo-Impressionism in his *Joy of Life,* page 320, exhibited at the Salon des Indépendants of 1906. Yet Matisse owed Signac much and Henri-Edmond Cross even more.[1] These two Neo-Impressionists had shown him the way toward pure, high-keyed color which he was to use in such a revolutionary manner during his fauve period, now under way.

Thanks perhaps to Signac's influence, Matisse had been chairman of the hanging committee of the Salon des Indépendants of 1905. To help him as members of his committee he had Camoin, Manguin and Marquet, who had been his fellow pupils under Gustave Moreau, and Jean Puy whom he had met at the Académie Carrière, all four of them to be counted among the fauves within the ensuing year. Other fauves-to-be also showed at the Indépendants, including Vlaminck, Friesz, Dufy, Rouault and Derain. The critics already began to note the violent color and freedom of line and form which united these younger artists, though they were not yet given a name or spoken of as a cohesive group.

The 1905 Indépendants was also memorable for its van Gogh exhibition to which Matisse lent a drawing. It was Vlaminck however who was closest of all the younger painters to the vehement Dutch-

man. In the boldness and violence of his art Vlaminck was at this moment more fauve than Matisse.

Matisse saw something of Vlaminck at this time and a little later took Vollard to his studio. Both played the violin, Vlaminck semi-professionally, and once they tried duets together. It was not a happy occasion. As Matisse remarked afterwards, Vlaminck insisted on playing *fortissimo* all the time. The same might have been said of his painting at this period.

Before the Indépendants, Derain had returned to Paris from military service and had sought out Matisse. Derain wanted to resume his life as a painter, but his parents, choosing this critical moment, tried to oppose his career as an artist. Derain, feeling that Matisse would carry weight with his father, asked the older painter to intercede. Matisse, who in any case was never bohemian in appearance and whose beard and spectacles added to his dignity, put on his best clothes and, taking with him Mme Matisse to make the visit more impressive, went out to Chatou to call on Derain's father and mother. The visit was successful. Derain's parents were persuaded and that spring he joined the Matisses when they went south to Collioure. A few weeks earlier, in the catalog of the Salon des Indépendants, the following entry appeared under the name MATISSE (Mme Henri): 2770. *Ecran tapisserie sur un carton d'André Derain.*

3 Collioure, 1905

Half a year before, in the fall of 1904, Mme Matisse had explored Collioure as a possible summer place for her family.[2] Collioure is on the French coast just ten miles north of Portbou and the Spanish border, five miles north of Banyuls where Maillol lived, and fifteen miles east of Céret, a hill town which a few years later was to become the "summer capital" of cubism. The Matisses liked Collioure and spent many months a year there during the succeeding decade. In scores of paintings and drawings Matisse made famous the little fishing port with its two towers and curving beach. (One of the best-known of the Collioure drawings, *The Fisherman,* is sometimes called a portrait of Derain on the theory that it is he who is fishing when, as a matter of fact, Derain is the tiny swimmer in the distance. Matisse later gave this amusing souvenir to his great Russian patron Sergei Shchukin.)

That first summer at Collioure proved to be

THE FISHERMAN (*Le pêcheur*). Collioure (1905, summer). Pen and ink, 11¾ x 19¼″. Moscow, Museum of Modern Western Art (*ex* Shchukin, gift of the artist)

of the greatest importance to both Matisse and Derain, for during it they painted their first pure and characteristic fauve canvases. Matisse's were mostly small in size—*Landscape at Collioure*, page 70, and the *Open Window*, page 73—but as soon as he got back to Paris at the end of the summer he began work on a large and striking portrait of Mme Matisse, the *Woman with the Hat*, frontispiece, finishing it by mid-October. This formidable work he sent to the Salon d'Automne together with the *Open Window*, a still life, a couple of small outdoor studies and several watercolors and drawings, among them *The Fisherman*.

4 *The Salon d'Automne of 1905*

The celebrated Salon d'Automne of 1905 has been described so often that only a brief account is given here. The paintings of Matisse, Derain (who sent several of his Collioure landscapes), Manguin, Marquet, Jean Puy, Valtat, Vlaminck, Friesz and Rouault, the last more somber but equally violent, were hung together. They created a furor.

The newspapers, with important exceptions, outdid themselves. Marcel Nicolle sent a dispatch to the *Journal de Rouen*[3]: "We now come to the most stupefying gallery in this Salon so rich in astonishment. Here all description, all reporting as well as all criticism become equally impossible since what is presented to us here—apart from the materials employed—has nothing whatever to do with painting: some formless confusion of colors; blue, red, yellow, green; some splotches of pigment crudely juxtaposed; the barbaric and naïve sport of a child who plays with the box of colors he just got as a Christmas present." And Jean-Baptiste Hall characterized the ensemble as " . . . this choice gallery of pictorial aberration, of color madness, of unspeakable fantasies produced by people who, if they are not up to some game, ought to be sent back to school."[4]

L'Illustration published a famous spread, page 19, reproducing seven of the most striking paintings in the fauve gallery. These included Manguin's *Siesta*, a marine by Valtat, Derain's view of boats in the

harbor at Collioure called *Drying the Sails*, Jean Puy's ambitious figure piece *Resting under the Pines* and two Matisses, the *Open Window* painted at Collioure and the *Woman with the Hat*. Beneath these halftones the editors ironically printed sentences from those critics who had been comparatively sympathetic to the new painters. Camille Mauclair, himself a founding member of the Salon d'Automne, commented with bitter satisfaction on the *L'Illustration* article: "One of our illustrious colleagues has invented an amusing pleasantry by reproducing a score of the most ridiculous 'works' and under them has run captions of some favorable remarks about them by 'the masters of criticism.' The contrast is enough to make you die laughing."[5]

Among the "masters of criticism" disparaged by Mauclair was Louis Vauxcelles of *Gil Blas*, an able and witty critic whose writings may some day be forgotten but who will always be remembered as having been largely responsible for naming the two most important movements in Paris painting of the early 20th century, fauvism and cubism, though accounts vary as to exactly how and when the epithets were born. According to an often repeated version, in the middle of the large center gallery where the paintings of the radicals were hung, there had been installed a small quattrocento-like bronze of a baby by the sculptor Albert Marque. As he spied the little figure surrounded by such ferocious canvases Vauxcelles remarked: "*Ah—Donatello au milieu des fauves!*" His *mot* caught on, the gallery was soon known as the *cage centrale* and within a year, at least, the painters were called *les fauves*, the wild beasts.

Georges Duthuit repeats the story but places the incident at the Salon des Indépendants of 1906.[6] Vauxcelles[7] himself includes Matisse as co-author of the term: writing apparently of the spring of 1906, he tells how he and the painter were walking together through the galleries of the Indépendants when one of them "characterized as a 'cage des fauves' the gallery where the canvases of our friends were flaming; the phrase stuck."[8] Jean Puy[9] recalls that the fauves at the Salon d'Automne of 1905 were labeled "Incoherents" and "Invertebrates" but that the term "fauve" was not generally used until a year later at the Salon d'Automne of 1906.

Puy's recollection is confirmed by Gelett Burgess in his remarkable article "The Wild Men of Paris" published in the *Architectural Record* of May 1910.[10]

There were of course serious and intelligent criticisms of the 1905 Salon d'Automne and these will be reviewed later, but first we must follow Matisse's own fortunes in the fray. They were centered chiefly around the *Woman with the Hat*, though the *Open Window* shared some of the contumely—and glory.

Even before the exhibition opened, when the *Woman with the Hat* arrived at the Salon it excited controversy. President Frantz Jourdain, not a timid man but discreet, was so alarmed by Matisse's painting that, according to Vollard,[11] he urged the jury to exclude the picture, not so much, he explained, for the sake of the Salon as for the welfare of the artist whose friends ought to protect him against the consequences of his own folly. The jury however accepted the picture and the *Woman with the Hat* was hung.

Jourdain had good reason to be concerned over the reception of the *Woman with the Hat*. Leo Stein who thought the painting "the ugliest smear he had ever seen" recalls that "the visitors howled and jeered. Even the most faithful supporter of Matisse, the socialist Sembat, would have none of it. Matisse came to the Salon once only, and his wife never dared to come at all."[1] Hans Purrmann remembers that "some of his colleagues asked him what kind of hat and what kind of gown had this woman worn that were so incredibly loud in color. Matisse, exasperated, answered 'obviously black.' Other artists, more malicious, sent him a hideous woman painted with chrome oxide green stripes from forehead to chin: here was a model whom he would certainly want to paint."[2]

5 *The Four Steins*

Fortunately Matisse's disappointment and sense of defeat were broken by an event of great importance: he sold the *Woman with the Hat*. The circumstances of the sale have become a subject of some controversy. Leo Stein, Gertrude Stein, Michael Stein and his wife Sarah Stein were all more or less directly involved. Leo, Gertrude, Sarah as well as Matisse himself have all given their versions of how the picture was bought. Whoever is right, the purchase was not only an act of considerable courage and extraordinary discernment but it marked the beginning of a relationship between Matisse and the four Steins who immediately became his most important patrons.

At the time, Leo Stein was an amateur painter, philosopher and, in the best sense of the word,

esthete. For the two brief years between 1905 and 1907 he was possibly the most discerning connoisseur and collector of 20th-century painting in the world. As he himself rather wearily pointed out some fifteen years after the publication of the *Autobiography of Alice B. Toklas:* "I was the only person anywhere, so far as I know, who in those early days recognized Picasso *and* Matisse."[3]

Born in San Francisco, Leo Stein spent his spare time as a Harvard undergraduate among the paintings in the museums of Boston, New York and Baltimore. Later in the '90s he lived in Europe tudying painting, especially Italian Renaissance painting, in and about Florence under the general guidance of Bernard Berenson. In 1902, in London, he bought his first modern painting, a Wilson Steer. Early in 1903 he settled in Paris at 27 rue de Fleurus, where he was joined shortly by his younger sister Gertrude. With his mind and eye trained by the greatest paintings of the European past, Stein found Simon, Blanche, Henri Martin, Ménard, Cottet—the leading lights of the Salon de la Nationale—sadly lacking. Looking back on these Salon painters years later he decided that their shortcomings lay in their inability to fuse construction and composition, that is, engineering structure and architectural design.[4]

Berenson, on a visit to Paris, advised him to go to Vollard's and take a look at the Cézannes. Stein had never heard of Cézanne, but before the spring of 1904 was over he had bought a landscape —only to discover Charles Loeser's Cézannes when he returned to Florence. At Vollard's Stein also saw Matisse's first one-man show but was not greatly impressed. When he returned to Paris in the fall he discovered van Gogh, Gauguin and, at the Salon d'Automne of that year, the Nabi generation and the younger men who a year later were to take part in the fauve outburst. Not long afterwards Leo Stein wrote Mabel Weeks that they—Gertrude and himself—had already bought Renoir, Cézanne, Gauguin and Maurice Denis (who reminded Leo of Fra Angelico) and that they wanted to buy Manet, Degas, Vuillard, Bonnard and van Gogh.[5]

At the Salon des Indépendants of 1905 Leo did not much like Matisse's pointillist pictures but he bought a Vallotton and a Manguin nude which he later discovered was merely "Matisse at second hand." Matisse, at first hand, was to bowl him over in the fall with the *Woman with the Hat.*

Gertrude Stein, when she joined her brother in Paris, had just finished her schooling, first at Radcliffe, where she studied with William James, and then at the Johns Hopkins medical school. At first she could not keep pace with her brother in his exploration of modern painting but within five years, that is by 1908, she was to out-distance him as an amateur of the *avant-garde*. For Leo, although he first discovered Picasso and bought one of his pictures against Gertrude's wishes, later could not follow Picasso—or Gertrude—into cubism. On the other hand, Gertrude's interest in Matisse was never so strong nor so analytical as was Leo's.

Michael Stein, the oldest of the three, was a San Francisco businessman who with his wife Sarah had settled in Paris before Leo and Gertrude. Though it was Leo who first called Matisse to the attention of Michael and Sarah, the Michael Steins were to surpass Leo and in fact everyone else but Sergei Shchukin as Matisse collectors during the period before World War I. Sarah especially became a devoted friend and student of the artist. Through the Michael Steins such American Matisse collectors as Claribel and Etta Cone of Baltimore and Harriet Levy of San Francisco first came to know of the artist.

6 *Sale of the* Woman with the Hat

To return to the *Woman with the Hat*, the painting which was roaring the loudest in the *cage centrale* of the Autumn Salon of 1905, Gertrude Stein in her *Autobiography of Alice B. Toklas*[6] writes that it was she who wanted to buy it at once but Leo was less attracted and preferred a picture by another artist. After much debate they decided to buy both pictures.

Leo Stein states[7] that it was he who bought the picture: "It was . . . a thing brilliant and powerful, but the nastiest smear of paint I had ever seen . . . I would have snatched it at once if I had not needed a few days to get over the unpleasantness of the putting on of the paint.

"After the couple of days needed to get used to the smearing, I made an offer for the picture. . . ." At this point Leo and Gertrude agree: Matisse rejected the sum which had been suggested to the Steins by the sales office of the Salon and held to his asking price of 500 francs. The original price was gladly agreed to and the Steins had bought their first Matisse—or, as Leo puts it, "I had bought my first Matisse."

Sarah Stein's account, given early in 1948

through Jeffery Smith, differs significantly: "Visiting the Salon d'Automne the Stein group—Mr. and Mrs. Michael Stein, Gertrude and Leo—were carried away by the *Femme au chapeau*. Before it Mrs. Stein was not only deeply moved by the unprecedented magnificence of its color, but also was deeply touched by the striking resemblance of the portrait to her mother. It was decided by Leo and Sarah that the picture should be acquired by the family. For a while it was in Gertrude's and Leo's collection. Then it gravitated to the collection of Michael and Sarah."[8]

Matisse himself in a statement published by *Transition*[1] in 1935 questions Gertrude Stein's accounts:

Madame Michel Stein, whom Gertrude Stein neglects to mention, was the really intelligently sensitive member of the family. Leo Stein thought very highly of her because she possessed a sensibility which awakened the same thing in himself.

It was Madame Michel Stein and her brother [-in-law] who discussed the advisability of purchasing La femme au chapeau. *When the purchase had been made, Leo said to Madame Michel Stein: "I am going to ask you to leave it with me for I must know in detail the reasons for my preferences."*

In the end, it was Madame Michel Stein who came into possession of the picture at the time when Leo, who had broken with Gertrude Stein, sold his collection. . . .

7 Rue de Fleurus and rue Madame

In any case the sale of the *Woman with the Hat* marked a turning point in Matisse's fortunes. Not long afterwards Leo Stein got Manguin to take him to see Matisse. Leo bought a drawing and then took Michael and Sarah who also bought a drawing, the beginning of their great Matisse collection. The Matisses returned the calls and soon became frequent visitors to the Leo-Gertrude Stein ménage on the rue de Fleurus and to the rue Madame where the Michael Steins lived.

The friendship with the four Steins was of the greatest value to Matisse. At the rue de Fleurus he broadened his horizon which had previously been limited to his artist friends and enemies and a few French collectors and critics none of whom seem to have stood by him effectively in the crucial fauve battles of the winter of 1905-1906. For years Matisse had suffered the neglect or active hostility with which the French have ordinarily rewarded their greatest painters of the past hundred years only to complain, long after the artists have won their uphill battles, that wealthy and rapacious Americans have deprived the Louvre of French masterpieces. As late as 1910 a French critic[2] was to take complacent comfort in the fact that Matisse had so few French supporters—the people who had the bad taste to buy his pictures were mostly Americans and Russians.

At the rue de Fleurus, on Saturday evenings, Matisse met Germans, Englishmen, Poles, Russians, Scandinavians, Spaniards and, of course, Americans. They were critics, painters, sculptors, writers, collectors, society people, businessmen, musicians, museum people, art historians—and most of them had come to see the paintings, the Cézannes and Renoirs at first, then after 1905 the Matisses too and, a little later, the Picassos, page 21.

It was of course most advantageous to Matisse that the Steins had his paintings and showed them enthusiastically to so many visitors from all over the world. Even more important was the kind of Matisse that they showed. For each year Leo bought Matisse's most crucial, powerful and difficult works: in 1905 the *Woman with the Hat*, in 1906 the great *Joy of Life*, page 320, in 1907 the formidable *Blue Nude*, page 336, his last purchase.

The Steins of the rue Madame could not offer Matisse the high bohemia of the rue de Fleurus. Their purchases, page 20, were numerous though at first comparatively modest. They bought the small portrait, *Mme Matisse*, page 75, the dark version of *The Young Sailor*, page 334, the famous *Self Portrait*, page 333. In 1907, the year that Leo and Gertrude began to lose interest in Matisse, the Michael Steins bought the great *Blue Still Life*, page 331, and thereafter a number of excellent pictures, the bulk of which they were to sell to Scandinavians after World War I. The Michael Steins were more than patrons and hosts to Matisse, they were intimate and loyal friends. Years later, in 1923, when Matisse's daughter was married, they were the only guests besides the witnesses to be invited to the wedding luncheon. Sarah Stein, "Sally," was also a pupil of Matisse and with Hans Purrmann organized his class in 1907.

8 Hans Purrmann

Hans Purrmann[3] came from Munich to Paris to see the Manet retrospective at the Salon d'Automne of 1905. There he was overwhelmed by the Matisses, especially the *Open Window* and the *Woman*

with the Hat. The American painter, Maurice Sterne, took him to the rue de Fleurus, where he was deeply impressed by the Cézannes, the El Greco and, once more, by the *Woman with the Hat.* Leo Stein introduced him to Matisse who already seemed a heroic figure to the young German. With Sarah Stein and Patrick Henry Bruce, Purrmann organized Matisse's school and became its "student manager." Later he made no less than three trips with Matisse to Germany, arranged his first one-man show in Berlin, sold his pictures to German collectors, wrote three valuable memoirs about him, and in many ways has proved his devotion down to the present year, 1951, when at the age of seventy he made the trip to Vence to be present at the opening of the Matisse chapel.

SECTION II PAINTING, 1904 TO FALL, 1905

1 St. Tropez and Neo-Impressionism, Summer, 1904

The summer of 1904 brought about remarkable changes in Matisse's painting. For three years in Paris and Picardy he had been working in a subdued style, much less radical both in color and in drawing than his work in 1899 and 1900. Especially in his figures his style had increased in assurance but had remained extraordinarily conservative both in terms of his own development and against the background of the exhibitions of van Gogh, Gauguin, Redon, and other older masters which were taking place, as well as the work of such younger men as Vlaminck, which had grown bolder and more brilliant in color. During these years of excitement in Paris Matisse continued to work in a style closer to that of Manet in his pre-impressionist 1860s than to that of anyone more recent, though he may have glanced with some sympathy at the realism of Félix Vallotton. Even after the progressive changes in his work at St. Tropez during the summer of 1904, his painting was to be no further advanced than that of the previous generation by the end of the 1880s. In fact it was upon two of the revolutionary masters of the '80s that he was now to base his own growth, namely Cézanne and Signac.

Matisse's paintings done during the early summer of 1904 at St. Tropez are perhaps closer to Cézanne than are any others in his long career. The composition of the *Place des Lices,* page 314, with its view of architecture through an arch of trees recalls Cézanne's views of the *allée* at the Jas-de-Buffon. The drawing of the trees and especially the painting of the foliage in series of short parallel hatchings is Cézanne's too. Even closer to Cézanne is the first version of the *Still Life with a Purro,* page 314. *The Terrace, St. Tropez,* page 315, is flatter and freer, more fauve, though the palette is still restrained and

local color is followed quite consistently.

All three of these canvases were painted as if Matisse were in another Riviera town instead of next door to Signac and a short distance from Henri-Edmond Cross. It is curious that Matisse with his humility, willingness to learn, and evident need to change his course, should at first have resisted Signac's influence; but before the summer was over he had succumbed. Early in 1899, as we have seen, Matisse, having read Signac's series of articles in *La Revue Blanche* "From Delacroix to Neo-Impressionism," had experimented with a personal and rather informal Neo-Impressionism in such pictures as the *Sideboard and Table,* page 66, now at Dumbarton Oaks. Now, before the end of 1904, he was to become for a moment almost an orthodox Neo-Impressionist. The sparkling small second version of the *Still Life with a Purro,* page 315, dramatically demonstrates Matisse's second conversion to a pointillist technique. Yet his Neo-Impressionist period culminated not in a still life nor a Signac-like landscape, page 18, but in a figure composition *Luxe, calme et volupté,* page 317, which mingles suggestions of Cézanne, certain pictures of Cross, and perhaps even Puvis de Chavannes. Unlike Signac, Cross often peopled his landscapes with figures posed as nymphs climbing trees or bathing by the shore. Undoubtedly Matisse knew these compositions as well as the more modest and more successful landscapes of Cross.

Matisse painted *By the Sea,* page 316, out of doors at the end of the pine-bordered Bay of St. Tropez. Though it is a sketch made on the spot in a free style much of the color is laid on in the spot technique of Cross and Signac; the subject is close to Signac and even the contour of the shore is drawn in a manner resembling the calligraphic lines of Signac's watercolors.

Somewhat later Matisse painted the composition

study for *Luxe, calme et volupté*, page 316, using *By the Sea* as a point of departure. He kept the clothed woman and child at the left and the tree at the right, but between them he introduced four nude figures of women reclining, sitting and standing. At the left, beyond the clothed woman, is a dancing figure and in the center background a boat with furled sail. Both the color and the brush strokes are far closer to Signac than they were in *By the Sea*, yet, unlike Signac, they are unsystematic.

Since in color this study, page 316, is bolder or at least more brilliant than any Matisse had hitherto used, it is worth describing. The sky is pink and yellow, the tree trunk indigo and scarlet, the ground vermilion, orange and crimson. The figures are equally arbitrary in hue: the standing woman for instance is drawn in heavy blue and lavender lines and modeled with complementaries of rose and pale green. The modeling of the reclining figure is done with turquoise in the light, mauve in the shading, bounded by heavy blue outlines. She casts a deep green shadow and has scarlet hair.

Such color would not have seemed radical to Signac and Cross but it is certainly very far removed from Matisse's own sober, tonal palette of the previous three years. What is significant about the color, however, is not so much its brightness or its radical departure from "nature" as the freedom with which Matisse uses it. Though still tentative and on a small scale, this study, taken in detail, is thoroughly fauve and at the same time possesses that extraordinary beauty of color which distinguished Matisse's painting from that of both his Neo-Impressionist seniors and his fauve colleagues who were to assemble in full strength within the coming year.

2 Luxe, calme et volupté, *1904-1905*

Back in Paris during the following winter Matisse expanded and developed this study into the big composition which he called *Luxe, calme et volupté*, page 317, using Baudelaire's famous phrase from the couplet thrice repeated in *L'Invitation au voyage*:

Là, tout n'est qu'ordre et beauté,
Luxe, calme et volupté.

The canvas is painted throughout in Signac's mosaic of bright, pure color, but there are significant departures from Signac's style. The color bricks are not nearly so systematically placed as in Signac; the hues are not confined to the six primaries more or less heightened by white, but defy Signac's system by being mixed. The forms are drawn in a variety of ways, sometimes with a sharp line, sometimes with a heavy line of mosaic and sometimes, notably in the standing figure at the right, by darkening the background to create a contour outside and behind the form. The composition is carefully calculated: the curving figures are disposed with very little overlapping against a geometrical structure established by the major and minor verticals of the tree trunk and mast cut by the imposing diagonals of the ship's spar and the receding shore.

Such a composition with its half dozen figures set in a landscape is entirely new in Matisse's art. Not since he had copied Poussin and Annibale Caracci in the Louvre had he turned his attention to such a problem except in his contemplation of Cézanne's *Bathers*. He knew of course the work of Puvis de Chavannes and there are certain striking resemblances in setting and iconography between Puvis' *The Happy Land*, page 17, and Matisse's *Luxe, calme et volupté*—the bay, the tree, the lateen-rigged boat, the figures, the food. But although Matisse's scene is doubtless imaginary it is strictly contemporary, not arcadian. The seated mother with her gown and plumed hat of 1904 and her standing child have been joined around a picnic spread by a company of sun-bathing nudes, combing their hair or drinking coffee from a cup. Perhaps Matisse had in the back of his mind Manet's *Déjeuner sur l'herbe* with its modern figures clothed and naked, the nudist-like bathers of Cross or the various bather groups of Maurice Denis.[4] Though the poetic suggestions of the title are also radical innovations in Matisse's art, it is worth remembering that the wonderful phrase *"Luxe, calme et volupté"* was drawn not from the classics but from the great poet of modern sensibility.

Along with seven other canvases, including *The Terrace, St. Tropez*, Matisse sent *Luxe, calme et volupté* to the Salon des Indépendants in the spring of 1905. The composition made a considerable impression. In the course of a long essay in which he attacked Camille Mauclair's ultra-nationalistic esthetics, Maurice Denis, reviewing the show, gives a whole paragraph to Matisse's big picture.[5] Though a year younger than Matisse, Denis was the chief spokesman of the previous artistic generation of Nabis and one of the most liberal and astute art critics writing in France. After dismissing a number of shallow innovators, he writes: "Matisse,

HARBOR AT COLLIOURE (*Port de Collioure*). Collioure (1906?) Lithograph, 4¼ x 7⅝″. Inscribed: *hommage à Mademoiselle Stein/ Henri-Matisse.* New York, Museum of Modern Art, gift of Mr. and Mrs. Sheldon Keck in memory of Leo and Nina Stein

on the contrary, because he wants to compose, ought by rights to interest the blasé public of 1905 which no longer laughs at Rousseau. He will not be discouraged by this first experiment; it should, indeed, help him avoid the dangers of abstraction. *Luxe, calme et volupté* is the diagram of a theory. But it is in reality that he will develop to the best advantage his very rare gifts as a painter. He will rediscover, within the French tradition, the sense of the actual."

For the youthful Raoul Dufy, *Luxe, calme et volupté* was a turning point. Since his arrival in Paris in 1901, he had known of Matisse and had exhibited with him at the Indépendants the previous year without having been much interested in

Matisse's rather sober work. But now, as he told his biographer: "I understood all the new principles of painting, and impressionist realism lost its charm for me as I contemplated this miracle of the imagination introduced into design and color. I immediately understood the new pictorial mechanics."[6]

Matisse continued to use a Neo-Impressionist technique during much of the winter of 1904-1905. The *Tulips* or *Vase de fleurs*[7] in the Dale collection is very Signac-like in brush stroke (a second, fauve, version of the same subject was in Félix Fénéon's collection[8]). The often reproduced pointillist *Notre Dame*[1] was painted in late 1904 in a freer style. Matisse continued to use Neo-Impressionist technique off and on during 1905 and even in 1906,

61

especially in his landscape studies, although he sometimes mixed it with the synthetic flat areas of paint more characteristic of the fauve period.

3 Painting, Collioure, 1905

Most of the sketches made during the summer of 1905 and even that of 1906 still show the influence of Signac and Cross. The sensitive spotting and the delicate muted color, even the greyish paper border around the little watercolor *Harbor of Collioure*, page 318, suggest Cross' watercolors. In the *Olive Trees*, page 318, there is still much of Signac in the brilliant square touches of color bounded by wiry, curved lines, but the swirling motion of the spots was very likely suggested by van Gogh's own vehement transformation of Neo-Impressionism—forty-five van Goghs had been exhibited at the Salon des Indépendants of 1905.

Just as the summer of 1904 at St. Tropez had seen the change in Matisse's style from the emulation of Cézanne to that of Signac, the summer of 1905 at Collioure witnessed the transformation of Matisse's Neo-Impressionism into a new style, this time his own. The change was gradual, and in certain pictures rather tentative, for instance in the Copenhagen *Landscape at Collioure*, page 70, with its mixed technique. On the other hand some canvases painted at Collioure in 1905, notably the *Open Window*, page 73, are among the purest of all fauve works. Both these paintings are analyzed briefly in the notes opposite their reproductions.

4 The Woman with the Hat and "The Green Line," Autumn, 1905

Most of Matisse's canvases of the summer at Collioure were small in size. They included landscape sketches, a few still lifes, and several out-of-door studies of his wife dressed in a Japanese kimono. When he got back to Paris that fall he painted Mme Matisse again, seated, her gloved arm on a chair and wearing a magnificent 1905 hat. The face of the *Woman with the Hat*, frontispiece, is modeled in bright green with touches of yellow and pink. It rises from the yellow and vermilion neck and is framed by hair which is brick red and violet on the right side and dark green on the left. The gown beneath is a riot of color but is far surpassed by the hat above. The violent color of the millinery, gown and face are echoed in the paler greens and oranges and violets of the background.

The *Woman with the Hat* was completed in time to send to the Autumn Salon along with the *Open Window* and a number of lesser works. The subject of course was fairly commonplace at the moment: Besnard, Sargent, Boldini, Desvallières, Alfred Maurer, even the youthful Picasso, and countless magazine cover artists had celebrated similar masterpieces of millinery. But this very fact, added to the circumstance that the canvas was obviously a characterization of an individual, made its innovations in color seem all the more radical. Its riotous reception by artists, critics and the public has been told, but even today the reckless-seeming but controlled boldness of the color keeps the painting within the front rank of Matisse's achievements.

Matisse may have paid some attention to criticisms such as Vauxcelles' remark, page 63, that his daring explorations of color were leading him to neglect form; or, more likely, he himself felt some reaction against the sketchy character of such paintings as the *Landscape at Collioure* and the *Open Window*, and the informality of the *Woman with the Hat*. In any case he painted, late in 1905, a second, smaller portrait of his wife, the *Mme Matisse* which was soon nicknamed "*The Green Line*." It is reproduced in color on page 75 and analyzed on the page opposite. Its broad, synthetic color planes and thoughtful simplicity differ strikingly from the intuitive, rather undisciplined freshness of the first climax of Matisse's fauve painting which had so astonished and dismayed the public at the Salon d'Automne in October.

SECTION III CRITICISMS, SALON D'AUTOMNE, 1905

Aside from the philistine clamor of journalists appealing to the timid prejudices of an uninformed and resentful public—and this does not include the reactionary malice of Camille Mauclair—there were a number of respectable reviews of the Salon d'Automne of 1905, some of them worth quoting. The writers differ in their criticisms but are united in focusing their attention on Matisse as the painter of the *Woman with the Hat* and the chief figure of the *avant-garde*.

1 André Gide

André Gide, born a month earlier than Matisse and already the author of a masterpiece, *L'Immoraliste* (1902), wrote a rather glib account in the *Gazette des Beaux-Arts*[2] under the heading "*Promenade au Salon d'Automne.*" Of Matisse he remarked:

For the sake of convenience, I am willing to admit that M. Henri Matisse is endowed with the finest natural gifts. As a matter of fact he has in the past given us works that were both rich and pleasantly robust. . . . The canvases which he paints today seem to be the demonstrations of theorems. I stayed quite a while in this gallery. I listened to the visitors and when I heard them exclaim in front of a Matisse: 'This is madness!' I felt like retorting: 'No, Sir, quite the contrary. It is the result of theories.' Everything can be deduced, explained; the intention has nothing to do with the matter. Without a doubt, when M. Matisse paints the forehead of this woman apple-color and the trunk of this tree an outright red he can say to us 'It is because—.' Yes, this painting is reasonable, or rather it is itself reasoning. How far removed from the lyrical excesses of a van Gogh. And behind the scenes I overhear: 'All the tones must be exaggerated.' 'Grey is the enemy of painting.' 'The artist should never hesitate to exceed the norm!' * M. Matisse, you've let them tell you. . . .*

* *Delacroix* [Gide's footnote]

Perhaps Gide, whose taste in painting was uncertain, had read Maurice Denis' warning to Matisse after the Salon des Indépendants half a year before: "*Luxe, calme et volupté est le schéma d'une théorie*" (page 61).

2 Geffroy and Vauxcelles

From Gustave Geffroy's review in *Le Journal*, *L'Illustration* quoted the remark that "Matisse, so greatly gifted, has been misled like the others into eccentricities of color from which doubtless he will recover himself." For fifteen years Geffroy had been one of the most discerning of French critics; he had defended Rodin, Lautrec, the Nabis, and had sat for one of Cézanne's greatest portraits. But Matisse's *Femme au chapeau* was too much for him.

Though more understanding, Louis Vauxcelles of *Gil Blas* had reservations: "M. Matisse," he wrote, "is one of the most richly endowed of today's painters. He might have won a facile success; instead he prefers to drive himself, to undertake passionate researches, to force pointillism to greater vibration. . . . But his concern for form suffers."

3 Maurice Denis

Much the most thoughtful and valuable review of the Salon d'Automne of 1905 was that of Maurice Denis in *L'Ermitage* (November 15th).[3] Denis begins by remarking how disconcerting the show is with its exclusion of the impressionist epigones and its inclusion of such variety as Matisse, *Le bain turc* of Ingres, and *le douanier* Rousseau. Yet the Salon d'Automne reflects "the mind of youth" as revealed in a series of interviews with younger artists recently published by Charles Morice: impressionism is dead; Cézanne is the chief subject of argument in the studios; Ingres is no longer considered a dangerous reactionary. Of the one-man shows at the Salon, Denis praises Renoir's astonishing last manner in which there is no trace of impressionism; Cézanne, "that Poussin of the still life"; Manet so substantial and honest, who now seems traditional, his art "richer in health than in charm" and a g od tonic "for a number of frail talents." Then, after tributes to the showings of Carrière, Redon, Rodin (whose sculpture however he finds too sketchy) and Ingres, "our most recently discovered master," he comes to the contemporaries.

He notes that the organizers of the Salon have given the place of honor to Bonnard, Vuillard and Vallotton, the old Nabis who had moved back toward impressionism or realism rather than toward classicism as had Sérusier, Maillol and Denis himself. He mentions the work of Gustave Moreau's more conservative pupils, Desvallières, Piot and Guérin who maintain the "idealistic" tradition of their teacher. Their disciplined finished work pleases Denis who attacks the current fashion for the sketch, the cult of the personality, the idea that originality is the supreme virtue.

Yet at the same time Denis notes how little genuine originality appears in the Salon. He sees "a school of Cézanne, a school of Guérin, a school of Matisse . . . etc." And it is the school of Matisse that is "the most alive, the newest, the most debated." Denis goes on:

When one enters the gallery devoted to their work, at the sight of these landscapes, these figure studies, these simple designs, all of them violent in color, one prepares to examine their intentions, to learn their theories; and one feels completely in the realm of abstraction. Of course, as in the most extreme departures of van Gogh, something still remains of the original feeling of nature. But here one finds, above all in the work of Matisse, the sense of

the artificial; not literary artificiality . . . not the decorative artificiality of the Turkish and Persian weavers; no, it is something still more abstract; it is painting outside every contingency, painting in itself, the act of pure painting. All the qualities of the picture other than the contrasts of line and color, everything which the rational mind of the painter has not controlled, everything which comes from our instinct and from nature, finally all the factors of representation and of feeling are excluded from the work of art. Here is in fact a search for the absolute. Yet, strange contradiction, this absolute is limited by the one thing in the world that is most relative: individual emotion. . . .

Now, what you are up to, Matisse, is a kind of dialectic: by definition, as the Neoplatonists would put it, that is, by abstraction and generalization, you arrive at the idea, the noumenon of the painting. You are not satisfied when all the elements in your work are intelligible. You have to be sure that nothing of the conditional or accidental remains in your work; you eliminate everything that does not coincide with the possibilities of expression with which your reason provides you. Yet, as Taine says, we know a million facts . . . but understand nothing. You have to resign yourself: everything is not intelligible. You must give up reconstructing an entirely new art out of your reason alone. You have to take advantage of sensibility, of instinct, and accept without too many scruples much of the expression of the past. Recourse to tradition is our best safeguard against infatuation with reason, against an excess of theory.

Denis by way of warning Matisse points out how Puvis de Chavannes before him had also made this mistake of applying a system, of deliberately idealizing and stylizing nature whereas in Poussin and Delacroix nature and style were fused. Even in his drawings and rare sketches, Poussin achieved a style equal to that in his completed paintings. Then excusing Matisse, he places the blame: "Ah, Matisse! let us curse the pedants . . . the academic jobholders . . . who insist upon servility before nature, before their kind of photographic nature. It is the materialism of our professors who have led us, by reaction, to search for Beauty outside of Nature, for Nature through Science, and for art in theories. All the same, Matisse, let us be objective!"

Then further to point his homily to Matisse, Denis praises Maillol's *Seated Woman*, the great figure later called *La Méditerranée*, which was then shown for the first time. With unbounded enthusiasm Denis takes refuge in "this noble work . . . created without a system, by genius alone. . . . This classic figure is the most novel work of art in the whole Salon d'Automne. . . ."

4 Denis in Retrospect

There is a good deal of neo-humanistic cant about Denis' remonstrances. Increasingly anemic and eclectic in his own art he doubtless felt some personal alarm at the creative energy of Matisse and the fauve group. Furthermore, Denis was the chief spokesman and theorist of the Synthetist-Nabi movement which, however various and shifting, had constituted the principal *avant-garde* during the years between the Café Volpini show of 1889 and the Salon d'Automne of 1905. Gauguin, who had been their chief inspiration at first, had stated even before 1889 that "painting is an abstraction."[4] And Denis had followed suit in 1890 with the famous injunction: "Remember that a picture—before being a battle horse or a nude woman, or some anecdote—is essentially a flat surface covered over with colors in a certain order."[5]

Denis might have quoted his own cogent words fifteen years later in his review of the Salon d'Automne of 1905 as evidence that Matisse, who seemed so radical, was actually painting according to the Gauguin-Denis doctrine. But Denis' 1890 pronouncement, it may be noted, constituted the opening paragraph of a manifesto entitled *Definition of Neo-Traditionism*. As time went on Denis' revolutionary boldness dwindled, his "traditionism" grew. Matisse on the contrary had just completed fifteen years' patient discipline in the imitation of the old masters and the study of the new. Now, in the fall of 1905, he had taken a fresh step forward.

In the spring of 1905 in his review of the Salon des Indépendants, Denis had praised Matisse's *Luxe, calme et volupté* as an attempt at composition and warned the painter, in a kindly way, against the dangers of abstraction—all in a six-line paragraph. Six months later in reviewing the Salon d'Automne, Denis, thoroughly alarmed, devoted two long pages to Matisse. The prestige of Denis and his artistic generation was threatened, their ambivalent prestige both as veterans of the *avant-garde* of 1890 and as prophets of the eclectic reaction which set in a little later. Matisse and the fauves now obviously held the field.

Quite aside from questions of personal prestige or group rivalry, Maurice Denis' analysis of Matisse's art at the Salon d'Automne of 1905 is important. He was one of the few who discerned that Matisse's

Early in 1896, three years before he painted the *Sideboard and Table*, Matisse had won honors at the academic Salon de la Nationale; but the following year he offended the conservatives by exhibiting a large impressionist interior, the *Dinner Table*, page 299. Then, turning his back on a safe conservative career, he began to explore the modern movements of the '70s and '80s. At the beginning of 1899 he was working in Toulouse, the home of his wife. Though absent from Paris for a year, he had been reading Paul Signac's "From Delacroix to Neo-Impressionism," which was coming out in the avant-garde magazine, *La Revue Blanche*. This may have encouraged him to try his hand at the "pointillist" or dot technique invented by Seurat and, after his early death, expounded by Signac (page 18).

The *Sideboard and Table*, Matisse's most important work of this first pointillist period, is much more advanced in design than the *Dinner Table*. The small round or oval forms of fruit and china are arranged on two levels across the middle of the composition against rectangular surfaces seen in steep diagonal perspective. Though there are no sharp edges the main volumes are clearly defined, the whole giving the effect of a well-ordered composition within a definitely controlled space no deeper than the canvas is wide. On the plane surfaces—walls and tables—the color is applied in confetti-like dots with the canvas showing through in places. But the doctrinaire Signac would not have approved the informal variations either in the size and density of the dots or in their color which is ordered freely and intuitively rather than by a system of pure tones neutralized by complementaries. Furthermore in painting the fruit Matisse has often merged the dots into broad strokes. As "divisionism" the picture is half-hearted; but as painting it is handsomer in color than the work of the orthodox Neo-Impressionists.

To the left are two studies of the objects on the left-hand side of the *Sideboard and Table*. The upper one reveals a mixed technique prophetic of Matisse's fauve paintings of 1905, pages 70, 73; the lower one with its flat tones leads into the style of the *Pont St. Michel* of 1900 reproduced on the next page. They are further discussed in the text, page 48.

PONT ST. MICHEL. Paris (1900?). Oil, 25½ x 31¾". New York, Mr. and Mrs. William A. M. Burden (*ex* Oskar and Greta Moll)

From the window of his apartment on the Quai St. Michel Matisse could look east along the Seine to the cathedral of Notre Dame on the opposite bank, page 309; and to the west, he could see the busy Pont St. Michel and beyond it the Palais de Justice on the Ile de la Cité with the pavilions of the Louvre in the distance. He painted these two vistas many times in the five years between 1899 and 1904.

Most of these views of the Seine are tentative and thinly painted but the *Pont St. Michel* of 1900 is confident in design and completely covered over with pigment laid on in broad flat areas of local color recalling Gauguin's Brittany landscapes of the late '80s. There is no trace of impressionism except in the general informality of the scene, no breaking of surfaces or of tones, no complementary shadows. In color the *Pont St. Michel* is as handsome as anything Matisse had painted up to that time but the picture as a whole marks the end of proto-fauve boldness, pages 302-304, and the beginning of a period of somber but constructive reaction, pages 306-311.

Photograph taken from the window of Matisse's former studio at 19 Quai St. Michel, looking west. Hélène Adant, courtesy *Art News*

LANDSCAPE AT COLLIOURE—Study for the Joy of Life (Paysage de Collioure—étude pour le Bonheur de vivre). Collioure (1905, summer). Oil, 18⅝ x 21⅝". Copenhagen, Statens Museum for Kunst, J. Rump Collection (*ex* Michael and Sarah Stein). Color plate courtesy Albert Skira, Geneva

When Matisse left Paris for Collioure in the spring of 1905 he was emerging from his Neo-Impressionist period developed at St. Tropez the previous summer under the influence of Signac and Cross, pages 315-317. (He had previously painted a few "pointillist" canvases early in 1899 such as the *Sideboard and Table*, page 66.)

The *Landscape at Collioure* is characteristic of Matisse's revolutionary style of the summer of 1905. Henri-Edmond Cross had painted similar arabesques of tree trunks in brilliant, pure color before Matisse. But Cross' color, though instinctively good in quality, was laid on in regular spots according to the logic of Neo-Impressionist analysis of light. Matisse's joyous color on the contrary seems completely free of any responsibility for description of natural appearances. The tree trunks, for instance, as one reads the picture from left to right, are blue-green, maroon, bright blue, yellow-green, scarlet and purple, dark green and violet, and at the right, ultramarine. They spring from a ground that is spotted blue, orange, ochre and sea-green, and they carry foliage of vermilion, green and lavender. Only the sea in the distance and the sky retain their natural color.

Matisse's brush technique is equally bold and carefree, ranging from small bricks of pigment like Signac's, page 18, through van Gogh-like streaks to a few, rather tentative, flat tones.

Back in Paris in the fall of 1905, after the turbulent Salon d'Automne, Matisse began his ambitious *Joy of Life*, page 320, for which as a starting point he used this *Landscape at Collioure*. At the Salon des Indépendants of 1906 where the *Joy of Life* was exhibited, the word fauve—wild beast—was first used to describe the paintings of Matisse and his companions, though the term now includes paintings of 1905 and even 1904. The *Landscape at Collioure* is a typical early fauve canvas.

Now among the famous Matisses of the Copenhagen Museum, the *Landscape at Collioure* was originally in the collection of Mr. and Mrs. Michael Stein.

Open Window (*Fenêtre ouverte*). Collioure (1905, summer). Oil, 21¾ x 18⅛ ". Paris, private collection. Color plate courtesy Editions des Trois Collines, S.A., Geneva

The *Open Window* is painted as thinly and freely as a watercolor, the white sizing of the canvas shining through the thin glazes of paint or between the strokes. Through the window, framed in brilliant green ivy, one sees the Collioure fishing boats with vermilion masts floating on pink and pale blue water. The scarlet flowerpots on the balcony serve as a reflexive complementary to the ivy. The view is reflected in the open glass shutters. The wall which surrounds the window is bright green-blue at the left, dark green above and, at the right, brilliant red-violet, a sequence of colors completely artificial but brilliantly effective as a frame to the brighter and more agitated central part of the picture.

The *Open Window*, like so many fauve paintings, is not consistent in style throughout. Passages of impressionist and Neo-Impressionist broken color alternate with areas of broad, flat, even tone. Similarly certain areas follow somewhat intensified local color—that is, the natural color of the objects—while other surfaces are quite arbitrary in tone. Fifteen years before this, Gauguin and his Synthetist and Nabi followers had used flat tones of strong color. Van Gogh and, later, Vlaminck had used more brilliant color with greater dramatic intensity, but in Matisse's *Open Window* there is a lyrical freshness and purity of color, a kind of gay informal spontaneity which is new. Even the sketchiness and inconsistencies seem virtues at this stage of Matisse's development.

When Matisse returned to Paris in the fall he sent the *Open Window* to the Salon d'Automne where in spite of its small size it ran second only to the *Woman with the Hat*, frontispiece, in arousing the doubts of the critics and the ire of the public. It was reproduced with other conspicuous fauve pictures on a famous page in *L'Illustration*, page 19.

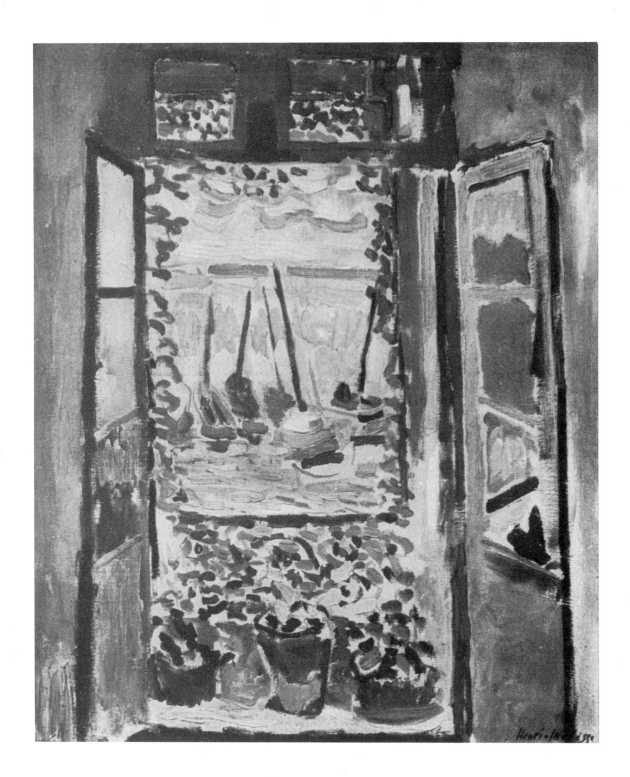

MADAME MATISSE ("*The Green Line*"; *Portrait à la raie verte*). Paris (1905, autumn). Oil, 16 x 12¾". Copenhagen, Statens Museum for Kunst, J. Rump Collection (*ex* Michael and Sarah Stein; Tetzen Lund). Color plate courtesy Editions des Trois Collines, S.A., Geneva

After the controversial Salon d'Automne of 1905 Matisse may have felt some reaction against the comparative spontaneity and informality of such works as the *Open Window*, page 73, and the *Woman with the Hat*, frontispiece. In any case the *Madame Matisse*, nicknamed "The Green Line" by the Steins, is far more compact and consistent in style than the *Woman with the Hat*, which is also a portrait of Mme Matisse. In the larger and earlier picture the face is modeled rather splotchily in ochres and rose with pale pink or yellow high lights and green shadows. By contrast the face in this smaller picture is frontally and schematically divided into halves by a pea-green stripe. The light half is pink with red contour lines, the half in shadow is ochre with a green contour. The hair is dark blue throughout with black contours.

The background, unlike that of the *Woman with the Hat*, is completely covered with well-defined areas of strong color: at the left, violet and vermilion behind the ochre-to-green cheek, and, at the right, green to set off the pink-to-red cheek. By means of these approximate complementaries Matisse intensifies the colors of both face and background. The "green line" which once made the painting so controversial not only serves to divide the face and give it relief but, more importantly, saves the face from being overwhelmed by the assertive background. The *Woman with the Hat* with all its bright and arbitrary color is essentially in the impressionist tradition of Manet and Cézanne. The *Madame Matisse*, however, is post-impressionist. Such bold contours and flat tones were first used by Gauguin and van Gogh. But Matisse's color is here more daring than that of Gauguin or van Gogh. At the same time it is less decorative in intention if not in effect. With all its brilliance it seems more functional than theirs as a means of establishing form.

How this portrait affected an American journalist five years after it was painted is eloquently expressed by Gelett Burgess in *The Wild Men of Paris*, published in the *Architectural Record* of May 1910, page 403. Himself the composer of the famous line "I never saw a purple cow," Burgess writes of Matisse:

. . . Oh yes, his paintings do have life! One cannot deny that. They are not merely models posing, they are human beings with souls. You turn from his pictures which have so shocked and defied you, and you demand of other artists at least as much vitality and originality—and you don't find it . . . But alas! when he paints his wife with a broad stripe of green down her nose, though it startlingly suggests her, it is punishment to have made her appear so to you always. He teaches you to see in her a strange and terrible aspect.

74

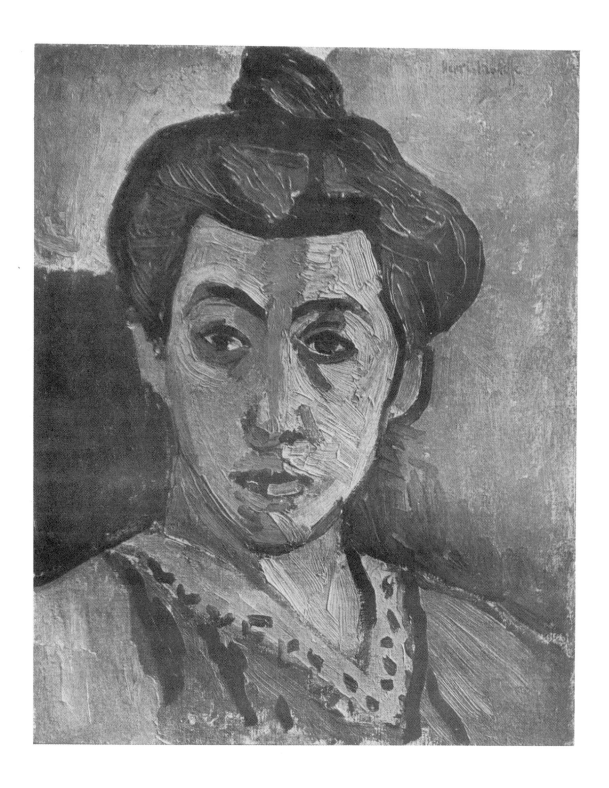

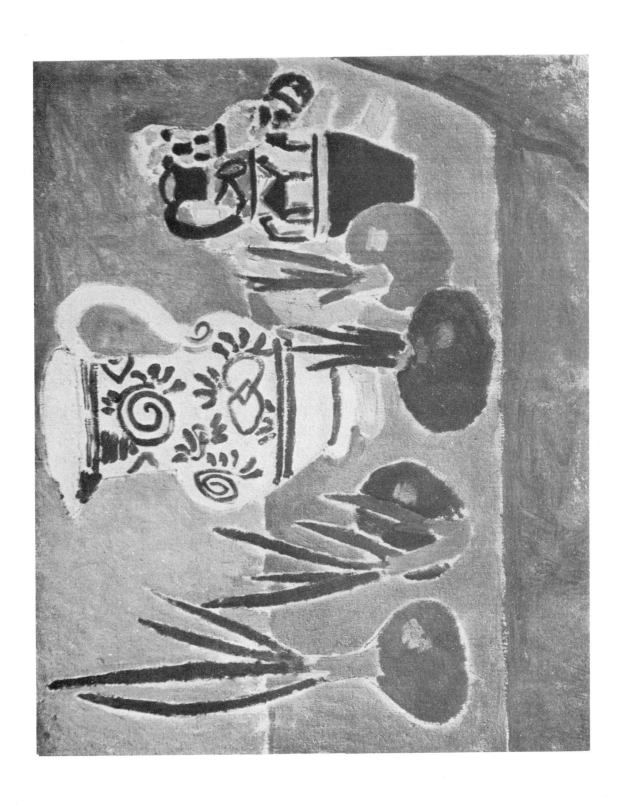

PINK ONIONS (*Les oignons roses*). Collioure (1906). Oil, 18⅛ x 21⅝". Copenhagen, Statens Museum for Kunst, J. Rump Collection (*ex* Michael and Sarah Stein; E. R. Weiss; Tetzen Lund). Color plate courtesy Albert Skira, Geneva

Hans Purrmann* remembers that after Matisse had painted the *Pink Onions* he felt so uncertain about it that he casually asked his old friend Jean Puy to look at a picture "just painted by the Collioure postman" who had been taking an interest in Matisse's paintings. When Puy saw the picture he exclaimed instantly: "You're lying, Matisse, you painted it yourself!"

Matisse, who worked in a continual state of anxiety, was often diffident about his art. In this picture the technique, simple to the point of apparent naïveté, doubtless caused him special misgivings. His pretending to Puy that the mailman had painted it suggests that Matisse may have had at the back of his mind the work of another petty official, Henri Rousseau, for there are some resemblances between the *Pink Onions* and certain still lifes of the *douanier*.

In the *Pink Onions* there is no modeling except for the reticent high lights on the onions. The whole canvas is painted in flat bright tones. Yet, except for the background, which is divided arbitrarily into blue and green, the local color of the objects is respected and there are no heavy dark outlines as there are in so many of Matisse's fauve paintings. Instead, an unassertive margin of light-toned canvas is left between the objects and their backgrounds. The effect is clean, fresh and gay, and so ingenuous technically as to suggest the watercolors of children—perhaps Matisse's own small sons who at this period were busy painters. The piquant juxtaposition of sprouting onions and cheap Algerian pottery is also new in Matisse's still life which had hitherto been fairly conventional in the choice of objects and their arrangement.

The *Pink Onions* has had an eventful history. Bought from Matisse by Michael and Sarah Stein not long after it was painted, it hung in their apartment on the rue Madame for many years. In June 1914 the Steins were persuaded to lend to a Matisse exhibition at the Gurlitt Gallery in Berlin. After the war started in midsummer they were unable to get their paintings back to France, and when the United States entered the war they were confiscated by the German Government as the property of enemy aliens. A sale was held at which the *Pink Onions* was bought by the painter E. R. Weiss. Later however Purrmann, a friend of the Steins, persuaded Weiss to give up the picture but in the end most of the Stein Matisses passed into the hands of the greatest Matisse collector of the period, Christian Tetzen Lund of Denmark. Later, another Dane, Johannes Rump, acquired the *Pink Onions* and added it to the great Matisse collection now in the State Museum of Art in Copenhagen.

*Letter to the author, March 3, 1951.

MUSIC (SKETCH) (*La musique* [*esquisse*]). Collioure (1907, summer?). Oil, 28¾ x 23⅝ ". New York, General A. Conger Goodyear (*ex* Leo and Gertrude Stein; John Quinn)

Few paintings by Matisse have greater germinal significance than this canvas which he painted in Collioure not later than the summer of 1907 and sent to the Salon d'Automne of that year under the modest title *La musique* (*esquisse*). For this small composition not only anticipates the subject matter of two of Matisse's greatest works, the *Dance* and *Music* of 1910, pages 362, 364, but also their style. *Music* (*sketch*) is no longer in the fauve style with its motley color and inconsistent drawing so clearly illustrated in a much larger and somewhat earlier canvas, *Le luxe, I*, page 340, which Matisse also sent to the Salon d'Automne of 1907. The *Music* of mid-1907 is in fact post-fauve. Its palette is practically limited to a few flat tones of ochre and white for the figures, green for the grass, pale blue for the sky. The strong dark outlines of the figures are equally forthright. The style of *Music* (*sketch*) is further developed and strengthened in such paintings as the *Bathers with a Turtle* of 1908, page 357, and the *Bather* of 1909, reproduced in the next color plate, page 161.

When the great Russian collector Sergei Shchukin wanted Matisse to paint two large decorations for his staircase they agreed, early in 1909, on *Dance* and *Music* as the subjects. Shchukin had already seen *Music* (*sketch*) of 1907 at Leo and Gertrude Stein's so that it doubtless served as a point of departure in their discussion as well as in the actual conception of the big canvases.

The two dancers in the background of the *Music* of 1907 do not reappear in the Shchukin murals, but the standing fiddle player and the seated figure at the right survive, somewhat modified, in the *Music* of 1910, pages 364, 365.

Music (*sketch*) remained in the collection of Leo and Gertrude Stein on the rue de Fleurus until about 1914. It was later acquired by John Quinn, in his period the greatest American collector of 20th-century painting, and after his death in 1925 passed into the collection of A. Conger Goodyear who was to be the first President of the Museum of Modern Art in New York.

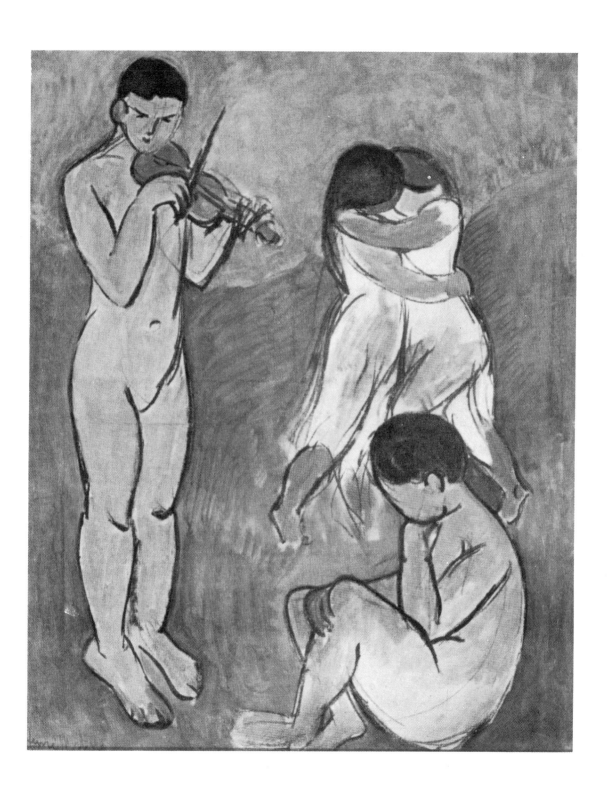

shocking color and unconventional drawing which so disturbed other critics were only the phenomena of a deep and powerful impulse toward abstraction.

Yet Denis was wrong in supposing that Matisse's "abstraction" was born of "dialectic" or some "excess of theory." Doubtless the *Luxe, calme et volupté*, the first Matisse which engaged Denis' critical attention, had misled him. For this important picture was obviously (though not essentially) a Neo-Impressionist school piece. Even Signac thought so. To Denis as a Synthetist-Nabi follower of Gauguin, Signac's Neo-Impressionist analysis of color with its consequent disintegration of form had always been anathema. And to Denis, champion of humanistic "traditionism" and the old masters, Signac's Cartesian disregard of instinct and his enthusiasm for scientific formula seemed equally deplorable. Since Matisse had first won general attention by adapting the rational system of Neo-Impressionism, Denis mistakenly assumed, half a year later, that his fauvism also sprang from a theory. Denis had failed to see what the youthful Dufy felt so strongly, that the *Luxe, calme et volupté* was important not for its resemblances to Signac but for its imaginative departures from Neo-Impressionist routine.

Matisse, it is true, owed much of the liberation of his color to Signac and Cross but his "abstraction" sprang not from a rational dialectic but from what might be called an empirical dialectic or, simply, trial and error guided by sensibility and great experience. Indeed Matisse's fauve abstraction, far from being the result of rational method, was unpremeditated and, in a sense, largely unconscious. To directly contradict Denis, Matisse's painting did "come from instinct and from nature." In fact Matisse at the fauve Salon had gone only a little step in abstraction beyond Denis' heroes Gauguin and Cézanne.

A little later, perhaps in front of the *Joy of Life*, page 320, Matisse had it out with Maurice Denis. Leo Stein[6] recounts how once Matisse told him "that Maurice Denis had in a book said that it was all calculated, whereupon he had led Denis up to one of his pictures and asked him to examine it minutely and tell him whether the feat of calculating all those relations would not be a far more extraordinary thing than composing them intuitively. On this confrontation, Denis admitted that it would be."

Yet if Denis, for all his superior intelligence and sense of history, could not understand what moved Matisse, he did very clearly see that Matisse was moving toward an art which was "free of all contingency . . . an act of pure painting." Freedom and purity are perhaps the two important spiritual values of Matisse's fauve painting at its best. To Denis, as champion of eclectic moderation, of "neo-traditionism," these values were heresy. For freedom and purity are dynamic concepts: they tend toward the absolute and thereby frighten the reactionaries who masquerade as moderates or "humanists."

Matisse was deeply wounded by the public hubbub and critical fury. He was also astonished and puzzled. But he was not belligerent as was Vlaminck. Though determined and persistent he was not revolutionary in temperament. Working patiently during the summer at Collioure and briefly in Paris during the fall, he had freed himself from Signac's influence and by courageous but gradual experimentation had found his way. His new style, in spite of its apparent purity and simplicity, was in a sense eclectic too. From Manet, Cézanne, van Gogh, Gauguin, Redon, Signac and Cross, Matisse had borrowed more or less unconsciously whatever elements he needed and fused them into a style which had seemed to him a clarification rather than a revolution.

SECTION IV MATISSE'S LIFE, 1906-1907

1 The Joy of Life *at the Indépendants, 1906*

The major undertaking of the year 1905 was the big composition *Joy of Life*, page 320, which Matisse began in October, while the clamor over the *Woman with the Hat* was still raging, and finished very early in 1906. In order to paint so large a canvas he rented some inexpensive space in the expropriated

Couvent des Oiseaux on the rue de Sèvres and used it as a studio until the fall of 1908.

The *Joy of Life* was completed well before the Salon des Indépendants which opened the 20th of March, 1906. Always before, Matisse had sent half a dozen works to the annual Salons, but this time he put all his eggs in one basket and sent the *Joy of Life* alone. Most of Matisse's contributions to the

Salon d'Automne of the previous fall had been small and all of them had had a comparatively tentative, sketchy appearance. But the *Joy of Life* was obviously a grand composition, a definitive statement. Because of this and because of its size, originality and brilliance of color, it created a furor.

Angrier than any of the critics or academic painters was Paul Signac, the domineering vice-president of the Indépendants. At the Indépendants of the year before, Matisse, with Signac's blessing, had been chairman of the hanging committee; he had been welcomed by Signac as a distinguished convert to Neo-Impressionism; and Signac had bought his *Luxe, calme et volupté*. Now, two months before the opening of the Indépendants the Neo-Impressionist hive was buzzing. Signac wrote to Angrand January 14th:[7] "Our young painters, a little ravenous, manage to exhibit all the time and everywhere and to bowl over the collector. Matisse whose attempts I have liked up to now seems to me to have gone to the dogs. Upon a canvas of two and a half meters he has surrounded some strange characters with a line as thick as your thumb. Then he has covered the whole thing with flat well-defined tints, which—however pure—seem disgusting . . . ah! those rosy flesh tones. It evokes the worst Ranson (of the 'Nabi' period), the most detestable 'cloisonnismes' de feu Augustin—and the multicolored shop fronts of the merchants of 'paints, varnishes and household goods.'

"Let us work in peace, we old fellows!"

But Signac was anything but peaceful. Duthuit reports that he was so angry at Matisse "that he went so far as to pick a fight with the painter at the café where the exhibitors and the members of the hanging committee met after the opening."[8]

Even Matisse's new champion was shaken. The first time Leo Stein went to the Indépendants he was with Maurice Sterne. They looked at the *Joy of Life* together. Sterne recalls[9] that they both disliked it at first, Stein only a little less intensely than Sterne. Stein returned again and again to study it. After several weeks he announced to Sterne that the big painting was the most important done in our time and proceeded to buy it though his funds, as always, were limited.

2 The Druet Exhibition

On March 19, 1906, the day before the vernissage of the Salon des Indépendants, Matisse opened his second one-man show, this time at the Galerie Druet. By then an enterprising dealer, Druet had begun as an artists' photographer, instituting the "Druet Process" which involved handsome large photographs completely recording an artist's paintings. Much of the documentation of Matisse's work of this period we owe to the *Procédé Druet*.[1]

The Matisse show at Druet's was larger than the one at Vollard's two years before. There were fifty-five paintings, three sculptures, watercolors and, as innovations, lithographs and one or more woodcuts.[2] The woodcuts were without much question the linoleum cuts one of which is reproduced on page 325, an ink drawing for another on page 322. The lithographs were doubtless the first of the series of 1906, two of which are illustrated on page 324. The Druet exhibition, though important, was somewhat eclipsed by the Salon des Indépendants with its large contingent of fauve paintings, chief of which was Matisse's own *Joy of Life*.

3 Biskra and Collioure, 1906

Just after the two shows opened[3] Matisse made his first trip to North Africa and spent a couple of weeks at Biskra in Algeria "to see the desert." He made a few sketches such as the *Street in Algiers*, page 328, and returned directly to Collioure bringing with him contemporary pottery and textiles which he used repeatedly in still lifes of 1906-07.

At Collioure during the spring and summer he painted with unflagging energy, producing the two versions of *The Young Sailor*, pages 334, 335, the first of which the Michael Steins bought; the *Oriental Rugs*, page 329, which was sold to Marcel Sembat; the *Pink Onions*, page 76; and, probably late in the season, the famous *Self Portrait*, page 333. These last two were purchased by Michael and Sarah Stein in the fall.

4 The First Matisse in America

During the same summer the Michael Steins had been in San Francisco to look after their affairs following the earthquake and fire of April 1906. Sarah Stein took with her a drawing by Matisse of a reclining nude leaning on one arm and an oil of a model standing before a screen, the first Matisses to be seen in America. She showed these pictures to friends in San Francisco, among them Alice B. Toklas, and, in New York, to George F. Of, the painter and master picture-framer. George Of was so impressed that he asked Mrs. Stein to buy a Matisse for him, sight unseen. When she returned to

Paris she bought for Of the *Nude in a Wood*, page 319, the first Matisse to be acquired by a collector in America. In Paris, the Steins' house-guest, Miss Etta Cone, bought the *Yellow Jug*, the first of the sixty-six Matisse paintings in the Cone Collection now in the Baltimore Museum.[4]

5 Salon d'Automne, 1906: The Indépendants, 1907

Back in Paris after the second summer in Collioure, Matisse sent five paintings to the Salon d'Automne of 1906, including the Grenoble *Marguerite Reading*, page 332, the *Oriental Rugs*, page 329, *Flowers*, a *Landscape*, and probably the *Still Life with a Plaster Figure*, page 329. Matisse's pictures did not attract special attention—they were, in a sense, anticlimactic to the *Joy of Life* of the previous spring—but the fauve group as a whole was represented in full and splendid array: Matisse's old circle by Marquet, Manguin, Puy, Biette; the "school of Chatou" by Vlaminck and Derain, the latter showing one of his brilliant views of London; the "school of Le Havre" by Friesz and Dufy; van Dongen, influenced by Matisse; and, on the margin of the movement, Rouault. Matisse, Derain, Marquet, Friesz, Dufy all worked more or less in an informal, decorative spirit which was at the same time not far removed from the impressionist tradition. Vlaminck, a strong personality, infused his brilliant color with emotional vehemence sanctioned by his admiration for van Gogh. Rouault, a fauve seen through dark glasses, was set apart from the group by his somber color, his mordant subject matter and his moral and religious passion.

During 1907 Matisse continued to be looked on as chief of the fauves. At the Salon des Indépendants of that year he exhibited two drawings, three "woodcuts," the largest of which is one of his most striking fauve designs, page 325, and an entry titled simply *Tableau No. III* which was apparently *The Blue Nude (Souvenir of Biskra)*,[5] page 336.

6 Italian Journey, 1907

In the early summer of 1907 Matisse and his wife made a long-desired journey to Italy.[6] They visited Venice and Padua, where Matisse studied the Giottos. At Florence they stayed with the Steins in their villa at Fiesole. Walter Pach met Matisse for the first time there and tells[7] how the painter "ran down to Arezzo for a day and returned with enough admiration for the perfect art of Piero della Francesca to last a lifetime." He also visited Siena where, Hans Purrmann recalls,[8] his "interest in the Sienese primitives,[9] especially Duccio, was so strong that he scarcely wanted to stop over in the other cities, even including Venice." Matisse apparently painted nothing in Italy—the *Venice: Lady on the Terrace*, now in Moscow, was done later at Collioure where Matisse spent the balance of the summer, working with renewed energy after his journey abroad.

7 Salon d'Automne, 1907

To the Salon d'Automne of 1907 Matisse sent five paintings including two works of great importance, *Music*, page 79, and the first version of *Le luxe*, page 340. Matisse modestly designated these and two other paintings *esquisses*, a term which Jean Puy[1] protests in his critique of the Salon, since they appeared to him to be more than sketches. To the old guard of the fauves Puy adds the new recruits Czobel, virtually a pupil of Matisse, Le Fauconnier, Metzinger and Braque; the last had already been welcomed at the Indépendants of 1907 where he sold all six of his rather mild entries. Puy might have added the name of the American follower of Matisse, Alfred Maurer, who like Matisse had abandoned a safe and in his case even more brilliant career as a conservative painter.

The group's lack of inner cohesion was not yet clearly apparent and Matisse still reigned not only as the *roi des fauves* but as the most influential younger master in Paris. Painter-critics of the slightly older generation, such as the classicist Denis and the realist Vallotton, could not like Matisse's art; but they respected him and accepted the fact of his leadership among the young. Yet before the end of the year Guillaume Apollinaire, who was emerging as the new champion of the *avant-garde*, in a famous article, page 101, described Matisse not as a wild beast, nor a leader of the "cult of the ugly," nor a renegade seduced by the exotic delights of the Orient, but as a student of the great masters of European painting and a solid pillar of their tradition.

Within the next few years Matisse's reputation was to grow enormously until he became one of the most famous living painters. But early in this period it gradually became clear that his position as the generating power at the very heart of the school of Paris was threatened. The rival star—or, better, dynamo—was Pablo Picasso.

8 The Steins, 1907

During 1907 the Steins had continued to be Matisse's foremost supporters, far outdistancing their nearest French rival Marcel Sembat or the enthusiastic Hans Purrmann. Among them the Steins bought almost all Matisse's important paintings of that year. Michael and Sarah acquired the great *Blue Still Life*, page 331, the monumental *La coiffure*, page 339, and the *Red Madras Headdress*, page 350. To the collection of Leo and Gertrude on the rue de Fleurus went *Music (sketch)*, page 79, and the formidable *Blue Nude*, page 336, though these were their last Matisse purchases.

Leo Stein's enthusiasm for Matisse was waning. He had begun to feel that Matisse's art was "rhythmically insufficient." At the same time he was becoming even more skeptical about his other principal protégé, Picasso. Picasso was painting his big *Demoiselles d'Avignon* which initiated cubism—and cubism Leo was later to condemn as "godalmighty rubbish."[2] Gertrude Stein, on her part, now grew more and more deeply interested in Picasso though both she and Leo continued to welcome the Matisses to their Saturday evenings on the rue de Fleurus. Leo Stein however, within two years from the time that he had first come to know Matisse and Picasso, began to turn his back on them—not socially but esthetically. Nevertheless, as he himself has pointed out, he was the critic who first felt that Matisse *and* Picasso were the two important artists of his time.

9 Picasso and Matisse, 1907

Picasso was twelve years younger than Matisse. As a child he had had, it is said, his first one-man show in the doorway of an umbrella-maker in Corunna. That was about 1890—the very year Matisse, as an amateur, painted his first still life. After an academic success as a youthful prodigy and a few brilliant years in Barcelona's bohemia, Picasso had come to Paris toward the end of 1900 to see the same World's Fair that a few months before had provided Matisse with a badly needed decorator's job. Within a few weeks Berthe Weill had sold some of his pictures and in June 1901 Vollard gave him a show, almost three years before Matisse was to receive the same attention.

It is a curious coincidence that Picasso in 1901 was just entering his "blue period," a year or more after Matisse had begun his famous series of "blue" studies from the model. And just as Matisse had

retired in discouragement to his home town of Bohain in 1902, Picasso in the same year, and in spite of Berthe Weill's efforts, starved and went back defeated to Barcelona, to return to Paris permanently only in 1904. Late in 1905 the minor dealer Clovis Sagot recommended Picasso to Leo Stein, who bought one of his circus pictures. A little later, guided by Pierre Roché, Stein went to Picasso's studio on the rue Ravignan and soon the painter and his mistress, Fernande Olivier, began to come to the rue de Fleurus. This happened shortly after the Steins had met Matisse as a result of buying his *Woman with the Hat* at the Salon d'Automne of 1905.

In his book *Appreciation* Leo Stein, after describing Picasso's shabby and disorderly room, and the artist himself as "more real than most people without doing anything about it," compares him with Matisse:

The homes, persons and minds of Picasso and Matisse were extreme contrasts. Matisse—bearded, but with propriety; spectacled neatly; intelligent; freely spoken, but a little shy—in an immaculate room, a place for everything and everything in its place, both within his head and without. Picasso—with nothing to say except an occasional sparkle, his work developing with no plan, but with the immediate outpourings of an intuition which kept on to exhaustion. . . .

Matisse was a social person rather than a convivial one. Picasso was more convivial than social. Matisse felt himself to be one of many, and Picasso stood apart, alone. . . . Matisse exhibited everywhere. He always wanted to learn, and believed there was no better way than to see his work alongside the work of everybody else. Picasso never showed with others. . . [3]

During the early months of 1906 Picasso worked on the portrait of Gertrude Stein now in the Metropolitan Museum of Art and in the summer went to Gosol in the Pyrenees where he developed his rose or "pink" style. Matisse, who at the beginning of the year had completed his *Joy of Life*, then visited North Africa and spent the summer as usual at Collioure, not far, as it happened, from Gosol across the border. Back in Paris in the fall, at the rue de Fleurus, Matisse and Picasso met for the first time.

Fernande Olivier, closer of course to Picasso, yet fairly objective in her memoirs *Picasso et ses amis*,[4] describes this historic moment:

The type of the great master with his regular features and vigorous red beard, Matisse was a sympathetic

character. At the same time, behind his big spectacles, he seemed to mask the exact meaning of his expression. Whenever he began to talk about painting, he chose his words deliberately.

He argued, affirmed, wanted to convince. Clear, of an astonishing lucidity of spirit, precise, concise, intelligent. Perhaps much less simple than he wished to appear.

He was already forty-five years old.

Very much the master of himself at his meeting with Picasso who was always a bit sullen and restrained at such encounters, Matisse shone imposingly.

They were the two artists one paid the most attention to.

Actually Matisse was thirty-seven at the time but Picasso was only twenty-five. They seem to have respected each other uncomfortably from the first and, as time went on, to have learned considerably from each other. Gertrude Stein states—and Matisse himself confirms her story—that, not long after they met, Matisse showed Picasso the first piece of African sculpture he had seen, and later Picasso learned a good deal about color and something perhaps about sculpture from Matisse, just as Matisse was at times influenced by Picasso's cubism.

Picasso had Matisse to thank for one extremely important and generous gesture: the older painter brought Sergei Shchukin, the foremost collector of modern painting then active, to Picasso's studio for the first time and Shchukin became by far Picasso's greatest patron, buying in all some fifty paintings from him during the succeeding six years. That was in 1908. Not long before that Matisse and Picasso had even exchanged pictures, Picasso choosing the quasi-childlike portrait of Matisse's daughter, Marguerite (a selection which the gossips, no doubt mistakenly, suppose was made to reveal the donor's weakness as a painter). Yet they were too different in age and temperament to become intimate. Fernande Olivier concludes, "Matisse . . . did not have the same ideas as Picasso. 'North Pole' and 'South Pole,' Picasso would say, speaking of the two of them."

10 The Joy of Life *and* Les Demoiselles d'Avignon

The same metaphor might have been used to contrast the remarkable pictures by which the masters most completely expressed themselves at this period. If by some chance Picasso did not see Matisse's *Joy of Life*, page 320, at the Salon des Indé-

pendants in the spring of 1906, he surely saw it often at the rue de Fleurus during the following autumn and winter. Very possibly it inspired him to emulation or at least to the concentration of his resources in a single great effort. Leo Stein tells with amusement how Picasso had a huge canvas relined as if it were already a classic work, even before he began to work on it.[5] In any case, early in 1907 after months of preparation, he began to paint a figure composition, page 22, larger and more elaborate than any he had attempted before, at least since his student days. Many years after it was finished someone gave it the troubadour title *Les Demoiselles d'Avignon*, an ironic reference to the gay inmates of a house on the Carrer d'Avinyó— Avignon Street—in Barcelona.

Although *joie de vivre* may be said to have inspired both pictures the connection is tenuous, for Matisse's nymphs lolling in a bosky meadow or dancing a Dionysian round in the distance could scarcely be further removed from Picasso's *filles de joie* in their curtained interior. Matisse's figures are scattered sparsely over a perspective as wide and deep as a vast ballet stage; Picasso's loom like giantesses on a shallow, crowded, cabaret-like platform. Matisse's style is spacious, easy, curvilinear, flowing; Picasso's rectilinear, cramped, angular, rigid. Lastly, the effect of Matisse's *Bonheur de vivre*—enjoyment of the good life—fulfills its title but the effect of *Les Demoiselles d'Avignon* is forbidding, formidable, even frightening.

Yet there are certain significant resemblances, minor and major. As preliminary sketches prove,[6] the format of Picasso's original composition was much closer to that of the *Joy of Life* than the final compressed proportions of the *Demoiselles* reveal. The general lines of the setting are similar: for instance the enclosing curtain at the left of the *Demoiselles* not only follows the contour of the trees at the left of the *Joy of Life* but, like them, is warm in color by contrast with the cold tones of the right-hand "scenery" in both pictures. More important is the experimental and synthetic character of both canvases. Matisse's inconsistencies of style in the *Joy of Life* are numerous, his borrowings from such disparate sources as Ingres and Islamic art evident. Picasso in the *Demoiselles* suggests that, without completely assimilating them, he has learned from sources as various as the archaic bronzes of prehistoric Spain, the masks of West African Negroes and the mannerist altarpieces of El Greco. But it

is Cézanne's bather compositions which, above all, lie back of both pictures; and in relation to Cézanne Picasso had, as will be seen, the curious advantage of a Johnny-come-lately.

Whatever the similarities and differences between the two paintings, they represent moments of climactic achievement in the careers of the two artists and they are both landmarks in the history of modern painting. Both are signposts pointing in the same general direction, toward abstraction, but by very different routes: Matisse, with the brilliant, singing color and organic, curving, fluid forms of the *Joy of Life*, opens the way to Kandinsky and, after him, to Miro and the more recent masters of color-cloud-and-flowing-line abstraction; Picasso's austere, stiff, angular structure leads on to cubism —in fact the *Demoiselles* has justly been called the first cubist picture—and beyond cubism to Malevich, Mondrian and "geometric" abstraction.

The histories of the two pictures during their period of greatest influence differ as dramatically as the paintings themselves and the personalities of their makers. The *Joy of Life* was scarcely dry before it was publicly and conspicuously exhibited at the Salon des Indépendants. It was bought very soon after and hung in the most influential collection of the moment—that of the Steins on the rue de Fleurus. By contrast—and contrary to the fond philistine illusion that Picasso always paints with his eye on sensational publicity—*Les Demoiselles d'Avignon* was never publicly exhibited until 1937; apparently it was never even reproduced in a European publication until the early '20s. Instead, during its first dozen years, it remained in the artist's studio, part of the time rolled up or turned to the wall. Yet artists saw it, studied it, were perturbed and then influenced by it and by its author. Among them were Derain, Matisse's most important follower, and Braque, the youngest recruit to fauvism. These conversions, catalyzed by Picasso, occurred during 1907. But even before that year Matisse himself was painting certain pictures, notably his own *Self Portrait*, page 333, which anticipate a return to a more structural style.

II Cézanne and the Crisis of 1907-1908

There were two principal factors at work in this new concern for structure: first, a reaction against the excessive color and spontaneous but often flimsy design of fauvism; second, the rapidly rising influence of Cézanne. Cézanne, thanks largely to

Pissarro, had of course been known and admired by Gauguin and van Gogh in the 1880s and by the Nabis in the 1890s. Vollard had shown him at full length in 1895 and 1899, and at the Salon des Indépendants of 1901 Denis had exhibited his own *Hommage à Cézanne*, a portrait group of the Nabis and Symbolists gathered reverently around a Cézanne still life.

Jean Puy,[7] while confirming Matisse's role as an innovator among the fauves, recalls especially how he helped his fellow students at Carrière's to gain a new sense of structure in their work by clarifying for them the importance of Cézanne. Matisse continued to look to Cézanne as his chief guide through his years of somber discipline following the turn of the century. As late as the summer of 1904 the *Place des Lices, St. Tropez* and *Still Life with a Purro*, both page 314, are obviously Cézanne school-pieces in composition and brush stroke if not in color. Cézanne's drawing and composition continued to inspire Matisse subtly or patently during his entire fauve period from 1905 through 1907. Matisse looked to Cézanne—especially to his watercolors— for guidance in construction through color planes, as the *Woman with the Hat* demonstrates. In fact even in the midst of his fauve period Matisse was painting the *Self Portrait* of 1906 and the *Blue Still Life* of 1907, page 331—pictures more Cézannesque than anything by his fauve colleagues or Picasso. And such powerful studies as the *Standing Model* of 1907, page 338, anticipate much of the dark, rather heavy-handed Cézannism which both the ex-fauves and the budding cubists were soon to adopt.

It is worth recalling that in 1899 Matisse had at first been tempted by a van Gogh *Arlésienne* which he had seen at Vollard's but on second look had found the small Cézanne *Bathers* more to his liking. This is significant, for in the ensuing years it was van Gogh and Gauguin who chiefly influenced the future fauves such as Vlaminck, Derain, Friesz and Dufy. The big van Gogh shows at Bernheim-Jeune's in 1901 and at the Indépendants of 1905, the Gauguin memorial show of 1903 at the first Salon d'Automne and the even larger exhibition at the 1906 Indépendants served to strengthen the influence of these two important but, by comparison with Cézanne, somewhat more superficial and therefore easily understood masters.

Cézanne, who had been obscured first by his fellow impressionists and then by van Gogh and Gauguin, began to rise in the esteem of the whole

new generation of artists only in 1904. At the Salon d'Automne of that year forty-two paintings by Cézanne were included—his first public one-man show—and ten more were in each of the Salons of 1905 and 1906. His death in 1906 was followed in 1907 by a show of seventy-nine watercolors at Bernheim-Jeune's, a memorial exhibition of forty-eight paintings at the Salon d'Automne and the publication of a number of articles and letters. Among them was the famous sentence Cézanne had written three years before to Emile Bernard, a former Symbolist and Gauguin pupil: "You should see in nature the cylinder, the sphere, the cone. . . ."

By 1905 Charles Morice, page 63, had found that Cézanne was the chief subject of argument in the studios of the younger artists. And in his review of the Salon d'Automne of the same year Maurice Denis had noted among various other groups a "school of Cézanne." Within two or three years most of the fauves themselves, Vlaminck, Derain, Friesz and the youthful Braque, had become enthusiastic Cézannists or, more or less under the influence of Picasso, had pushed a single aspect of Cézanne into various forms of early cubism.

As was true of the fauves, Picasso himself had paid little serious attention to Cézanne until late 1906. But in 1907, as we have seen, he painted the *Demoiselles d'Avignon*, which, with all its admixture of primitivism and El Greco, was a far more creative *hommage à Cézanne* than had been Maurice Denis' pious portrait group of 1901. The early cubism of Picasso and Braque through 1909, the early post-fauve pictures of Vlaminck, Friesz, Derain and others, all owe more to Cézanne than to any other artist.

Matisse in 1907 thus found himself in the curious position of having been a "premature Cézannist"—to paraphrase a recent political epithet. For eight years or more he had been studying Cézanne and undoubtedly understood his work more profoundly than did Picasso, Derain or Braque. But Matisse's relationship to Cézanne was not apparent to his critics nor clearly understood by his colleagues, who in fact did not comprehend Cézanne as a whole.

Most of Matisse's Cézannesque pictures of 1906-1907 however, though excellent in themselves, were comparatively personal reactions against fauve license; they were recurrent exercises in formal discipline. The main course of his art lay in a post-Cézannesque direction of ever bolder use of brilliant decorative color in comparatively flat design, such

as is indicated by the second version of *Le luxe,* page 341, painted late in 1907. Thus by 1908 he found himself no longer the captain of the vanguard in Paris but a figure against whom a new vanguard—many of them formerly his own followers—had already begun to react. Maurice Denis, reviewing the Salon des Indépendants of early 1908 in an essay tendentiously titled *Liberté, épuisante et stérile,*[8] noted with satisfaction that "it is apparent that there is much less influence of Matisse here than of Cézanne." (In 1910, Guy Pène du Bois, far from the scene of action, page 116, was to write an angry article in the *New York American*[9] proclaiming that "a great injustice is being enacted today. It is the widespread publicity given to the name of Henri Matisse, who, in reality, far from being the head of a new movement in art is simply a disciple of Cézanne. . . ." Ironically, Max Weber remembers how in 1908 Matisse would speak of Cézanne to his pupils as "*le père de nous tous.*")

Matisse was not unaffected by the turn of the tide. Fernande Olivier says, implausibly, that he threatened to "get" Picasso, and, though a man of extraordinary fair-mindedness and objectivity, he was in fact an official of the Salon d'Automne of 1908 which rejected Braque's early cubist landscapes of Cézanne's own L'Estaque country. Matisse denies the story that while the jury was reviewing Braque's new paintings he had exclaimed impatiently, "*Toujours les cubes!*"[10] thereby helping to initiate the word which soon developed into cubism, the name of the movement about to eclipse fauvism. Yet he could scarcely have viewed those angular, pale green and tan compositions without reflecting that, only a year before, Braque had been the bright new star of fauvism.

On the other hand Matisse had won his position of leadership not through ambitious schemes for grasping power but through the combined strength of his art, his mind and his character. The inconsistent and sometimes unsubstantial methods of fauvism were exhausted for him as well as for more overt deserters of the movement. But Matisse would not join the other ex-fauves and Picasso in their youthful, somewhat belated and at times naïve discovery of Cézanne. Nor could he follow, except casually and at a distance, the radical, epoch-making development of cubism.

Yet, though during 1908 Matisse was losing his dominant position in the Paris *avant-garde*, he was to have many and great compensations on different

levels of achievement and satisfaction. Before the year was over students from the United States, Germany, eastern Europe and Scandinavia were flocking to the class which Sarah Stein and Hans Purrmann had persuaded him to open; Shchukin was surpassing the Steins in buying quantities of his most daring paintings; he exhibited for the first time abroad, in New York, Moscow, Berlin and London; he wrote and published *Notes of a Painter*, one of the most influential statements ever made by an artist; and, most important of all, he was developing his art with greater courage, confidence and originality than ever before. His greatest decade lay ahead of him. Before it was over he was to be generally recognized throughout the world as the foremost painter of his generation.

SECTION V MATISSE'S ART: LATE 1905 THROUGH 1907

1 *The* Joy of Life (Bonheur de vivre)

In the winter of 1904-1905 Matisse had concentrated and summarized his Neo-Impressionist discoveries of the St. Tropez summer in a single large composition, the *Luxe, calme et volupté*, which he showed at the Salon des Indépendants in the spring of 1905. Now, a year later, he gathered his resources, so augmented by the summer's work at Collioure, and focused his chief efforts on one great work, the *Joy of Life*, page 320. Matisse began to paint the huge canvas of the *Bonheur de vivre*—happiness of living, *joie de vivre*—in October[1] 1905, doubtless after he had sent off the *Woman with the Hat* and his other entries to the Salon d'Automne. He worked on it all that fall with many difficulties and completed it some weeks before the Salon des Indépendants of March 1906.

2 *The Poetic Subject*

Specifically, the subject of the *Joy of Life* belongs to that great series of arcadian pastorals or bacchanals[2] of which the archetype is perhaps Giovanni Bellini's *Feast of the Gods* in the Washington National Gallery. Giorgione,[3] Titian, Rubens, Poussin maintained and varied the tradition, which dwindled to Rococo sentiment and charm in the 18th century but was revived with crepuscular poetry by Corot, awkward vehemence by Cézanne, anemic serenity by Puvis de Chavannes and academic banality by Third Empire decorators.

More generally, the *Joy of Life* belongs among the vast number of compositions in which naked figures disport themselves in idyllic landscape with Dionysiac enthusiasm or relax in blissful ease—in the *Joy of Life* they do both. Arcadia is variously revived, free of both inhibitions and any labor more arduous than pastoral piping.

In such compositions there is usually some reference to classical myth or poetry. Even within the impressionist generation, so conscientiously faithful to everyday reality, Renoir, remembering Rubens, could paint a *Judgment of Paris* and Cézanne, in the name of Poussin, a *Bacchanale*. But ordinarily Cézanne and Renoir painted simply "bathers."

Inspired partially by his own Cézanne, Matisse in his first ambitious figure composition painted bathers, too, the figures of modern women picnicking by the shore. The atmosphere however is idyllic and the title poetic—*Luxe, calme et volupté*. In the second composition, *Joy of Life*, the poetic content is explicit, the modern world is forgotten and the figures live in a classical arcadia complete with a pair of lovers, a nymph twining a garland of flowers in her hair, a goatherd piping to his goats and a round of dancing bacchantes. In fact one might at first glance plausibly suppose that the picture presented a fantasia on the theme of Daphnis and Chloë.

In any case in the *Joy of Life* Matisse for the first time turned his back on the realist tradition in which he had been painting since leaving Moreau's studio. The figures in the *Joy of Life* are cousins to those in Ker-Xavier Roussel's fauny pastorals, Maurice Denis' *Bucoliques d'Automne*, Bonnard's lithographs for *Daphnis and Chloë* published by Vollard three years before, and some of Maillol's designs of the 1890s. In other words, the *Joy of Life* relates Matisse for the first time to the Nabis' interest in the pictorial equivalent of such Symbolist poetry as Mallarmé's *L'après-midi d'un faune* and at the same time to Gauguin, the poetic painter of Breton pastorals and Polynesian arcadias. Some of Matisse's closest associates were also affected by a new interest in poetic subject: Jean Puy painted his *L'après-midi d'un faune* in 1905, Derain a large pointillist *L'age d'or* in the same year and many watercolor bacchanals in 1906.

Not for years to come was Matisse to be so deeply involved with nostalgic or poetic sentiment

as were Puvis de Chavannes, Gauguin, Denis, Roussel or even Bonnard. With occasional exceptions such as the *Nymph and Satyr* of 1909, page 358, the ballet designs for *The Song of the Nightingale* of 1920, and the big *Europa* drawing of 1928, he was not again to concern himself with myth or poetry or literature for around twenty-five years. Yet when he did, he produced one of his greatest masterpieces, the design and illustration of Mallarmé's *Poésies*, pages 466-467. This he followed with illustrations for the poetry of Ronsard, Baudelaire, Montherlant, Charles d'Orléans, pages 494-498, besides a series of etchings of scenes from Homer's *Odyssey* as illustrations for Joyce's *Ulysses*, page 474. For these reasons the subject matter and iconography of the *Joy of Life* have a considerably greater significance than is usually accorded them. And quite aside from these specific mythological or literary elements, the content, the very title of *Joy of Life* involve the intention of expressing and inducing hedonistic relaxation which preoccupied Matisse throughout his life. Indeed, three years later, page 119, he was to state that this was his chief aim as an artist. At the same time he made clear that he proposed to achieve this pleasure-giving effect primarily and directly through the medium of painting. For the *Joy of Life* is essentially a "pure painting," a brilliant and original achievement in line and color.

3 Joy of Life: *The Composition*

Matisse worked on the *Joy of Life* for many months in the course of which he made numerous preparatory studies and drawings. The year before, when he came to paint the *Luxe, calme et volupté*, he developed his composition by placing the figures in a landscape done at St. Tropez in the previous summer. Now, in beginning the *Joy of Life*, he took as his starting point the brilliant study of a vista of trees, *Landscape at Collioure*, page 70, painted in the summer of 1905. The *Pastoral*, a sketch of an arcadian family listening to the piping of a faun, may be an early study as may also be the *Nude in a Wood*, both page 319, made perhaps before the artist decided to use the *Landscape*. In any case it is the *Landscape at Collioure*, reproduced almost line for line and tone for tone, which appears as the setting for the composition study for the *Joy of Life*, page 321, originally in the collection of the Michael Steins. In this brilliant sketch all the figures in the final composition are already incorporated. There must have been dozens of intervening essays between the

landscape and the composition study but Matisse has made public, so far as we know, only a tiny color study in the museum of the Barnes Foundation[4] and several drawings for single figures.

Two of these drawings we reproduce, page 321. The ink study for the standing girl wearing a garland in her hair, at the left of the composition, is followed almost line for line in the completed painting though the contours and details, as on a 5th-century Attic amphora, are greatly simplified, the essential rhythms revealed.

By contrast the drawing of the reclining model, *Nude with Pipes*, is very considerably altered in the figure which reappears in the foreground of the painting. The alterations are significant. Obviously the artist wanted to eliminate the cushion under the elbow of the original model. At the same time, for compositional purposes, he wanted to keep the upper contour of the figure sloping at the original angle. Had she not had to use both hands to play her pipes he might have solved his problem by making her support herself on her extended arm. Instead he simply and arbitrarily stretches her bent arm to half again its normal length so that the prolonged elbow makes up for the missing pillow and at the same time clearly establishes the corner of the triangle. The advantage gained may be seen if the final figure is compared with the unstable, sloping triangle of the corresponding figure in the composition study. The lengthening of the arm and the concomitant widening of the torso are distortions more radical than any Matisse had used before.

The compositional value of this "distorted" figure may be seen if one examines how Matisse fills the foreground wedge of grass, *ABC*, page 91, that slopes upward toward the right like half the gable of a Greek temple. In the corner of the gable lies the girl with the pipes; then, to the right, Matisse places the pair of lovers who together form a shape which approximately repeats that of the piping girl. This repetition, emphasized by the fact that the lovers appear to have only one head, is a remarkably ingenious pictorial simile, comparable indeed to a poetic simile which might liken the lovers to the double pipes animated by a single breath.

The composition as a whole suggests a stage with painted multicolored flats arching over a vista of yellow ground to a backdrop of horizontal blue sea and violet pink sky. This light-toned central triangle, *ABD*, rests on the dark sloping wedge of foreground grass, and is flanked by the darker, though still

brilliant, triangles of trees at left and right. "Triangle" is however much too rigid a term for the wonderfully rhythmic play of lines presented by the tree trunks and the curves which define and simplify the flat masses of foliage.

If we compare the final composition with the original landscape sketch, page 70, we can see how Matisse has emphasized and clarified the latent linear rhythms of the natural scene. The two great embracing lines of the composition spring from a point in the left foreground which in the *Joy of Life* the artist has happily marked by a cluster of flowers. One line, *AB*, rises abruptly at first, then slopes gradually up to the right in an almost uninterrupted straight line to form the foreground wedge or half-pediment of grass. The other rises toward the left, slowly at first, then more rapidly as it swoops up like a rocket past the standing girl, up and over until it bursts at the top, *D*, and falls in a cascade which meets the counter-rhythms rising from the other side of the canvas. The minor rhythms are clarified with equal care: for instance the casual echelon of half a dozen tree trunks at the left in the original landscape are, in the big canvas, reduced to four lines which count alternately as thin, thick, thin, thick, and curved, straight, curved, straight.

The composition of the figures in relation to each other and to the setting is more subtle. Seen in the flat, the major form is the three-stepped triangle *XYZ*, formed by the foreground figures as the base, the two reclining women as the middle level, the ring of dancers as the apex. This major triangle is flanked by the smaller triangular group at the left and the much smaller one of the herdsman and two goats at the right. *Seen in depth* the large central foreshortened triangle of figures overlaps and at the same time topples *over and into* the large central triangle of empty space. The intricate counterpoint, the multiple echoing of curves which Matisse sets in motion between figures and trees may be explored by the eye but is too complex to be described in words without overtaxing the reader's already exhausted attention.

Matisse's handling of depth in the *Joy of Life* is less obvious. Depth is suggested in several ways: most simply, of course, by the overlapping of forms—figures in front of trees, trees in front of sea and sky; by the dark foreground which throws the eye back into the lighter distance (a standard device of Baroque landscape painting); and lastly by the diminution of forms in perspective. Yet Matisse

handles perspective as freely as he does human anatomy and local color. The girl playing the pipes in the foreground is only half the size of the embracing figures, though all three are at the same distance from the eye—a kind of discrepancy ancient artists often used to distinguish between gods and mortals. Simultaneously the piping girl is exactly the same actual size as the two women reclining in the middle distance. Here Matisse seems to be using a kind of perspective by superimposed planes without diminution, a common practice in much primitive and some oriental art.

Yet in the scale of the comparatively tiny round of dancers and the goatherd, western perspective reasserts itself and, thanks to our conditioned eyes, does indeed give some sense of depth. But again the suggestion of solid forms existing in deep space is contradicted by the fact that both figures and trees are unmodeled by light and shade and therefore seem flat—with the exception of the goatherd who is modeled! The arms and legs of the figures are sometimes foreshortened in depth and sometimes the figures cast shadows—the girl plucking flowers, for instance, and the goatherd. But more often they do not.

The drawing of the figures is also freely varied. The lovers—light bodies against a dark background—are drawn with a simple, even wiry line; the contours of the reclining women beyond—light bodies against a light field—are defined by broad, contrasting ribbons of color which flow in back of, or outside the forms, giving them a kind of token background and reinforcing their rhythms. The goatherd, an important though distant figure, is drawn with a heavy, shaded line kept entirely within the contours of the form. Thus each kind of drawing fits the exigencies of the particular figure in relation to the composition as a whole.

4 Joy of Life: *The Style*

The oriental influences in the *Joy of Life* have been somewhat exaggerated. Previous to 1906 Matisse's work reveals very little interest in oriental art except for occasional and probably secondhand suggestions of Japanese prints, particularly in perspective. He did not, as has been stated, see the Exposition d'Art Musulman at the Palais de l'Industrie in 1893, nor does his work of the period give any evidence that he visited the big Moslem art show at the Pavillon Marsan of the Louvre in 1903.[5] There is doubtless some general influence

from Byzantine and Persian sources in the drawing and color of the *Joy of Life* but it is fairly well assimilated and diffused.

More explicit perhaps is the influence of Ingres' drawing and figure style. Just before Matisse began work on the *Joy of Life*, the Salon d'Automne of 1905 had included a special one-man show of Ingres which Matisse must have seen. That he greatly admired Ingres is suggested by an anecdote of Jean Puy[6] who tells how in 1907 he and Matisse went eagerly to the Louvre to see Manet's *Olympia* which Clemenceau had just had elevated from the Luxembourg to glory in the Louvre. To the anger of academicians the *Olympia* was hung as a pendant to the great *Odalisque* of Ingres. The *avant-garde* was split by a more serious argument as to which was the better. Puy preferred the Manet. Matisse had no doubts: he chose the Ingres "because the sensual and willfully determined line of Ingres seemed to him to conform more to the needs of painting." There is surely much of the Ingres *Odalisque* and *Le bain turc* (which had just been shown at the Salon d'Automne) in the sinuous line and cogent distortions of Matisse's figures in the *Joy of Life*.

The ballet-like character of the scene has been

mentioned. The analogy is historically misleading for Matisse had little interest in the theatre at the time. But there is nevertheless something about the varied, fluid composition of each group of figures, and the relationship between the groups, which suggest the recent choreography of George Balanchine and his school. Each figure, too, is studied so carefully that its stance and gesture remain vividly in the memory like the attitudes of dancers who well understand how to use the body as an expressive instrument.

Yet, to paraphrase Maurice Denis, the *Joy of Life*, before being an arcadian pantomime with references to ancient myth or a congeries of nudes in a woodland glade, is essentially a flat surface covered with colors assembled in a certain order. Never before had Matisse made this point so clear. In spite of the elaborate complex of form and association, the big canvas is more abstract in style, more arbitrary in its departures from conventional representations of nature than anything he or his contemporaries had painted, except of course such fantasists in form and color as Redon and Ensor. That these departures from "nature" in anatomy, perspective, scale and color should be so various and

inconsistent, should derive from so many sources, is a sign of Matisse's courage, eagerness for new ideas, inventiveness and insistence upon the artist's right to take liberties—liberties with nature, with the conventions of his predecessors and even with the classic ideal of stylistic consistency itself.

Of course there are weaknesses in the *Joy of Life*. The picture does suffer somewhat from its mixture of styles. It is a little flimsy in structure—Cézanne is too much eclipsed by a new interest in oriental decoration. The surface is thin and poor, perhaps a reaction against the sensuality of *matière* so much admired at the time, perhaps a device to repel the eye back and away from the surface so that only the total effect should be seen. The rhythms are perhaps too obvious and superficial: though today one can once more look at the best *art nouveau* decoration with interest and pleasure, the arabesque of tree forms in the *Joy of Life* is perhaps too reminiscent of the monotonous sinuosity of the *style 1900*.

Leo Stein recalls how long and arduous was Matisse's travail with the *Joy of Life*. The finished work does not conceal evidence that there was much trial and some error. Yet this big canvas is a magnificent act of courage, a prime monument in the history of modern painting and, what is equally important, still a delight to the eye.

5 *Painting, 1906-1907: Variety of Style*

If "fauvism" may be used to denote a period of experiment in which color is used with greater variety and freedom in relation to nature than ever before in European painting, then Matisse's art of 1906-1907 is fauve. It would be hard however to define it more precisely, so great is the range of style and esthetic intention in Matisse's art of these years which lie between the early fauve paintings of the 1905 Autumn Salon and the monumental figure compositions and boldly decorative still lifes of 1908. Several pictures of this transitional period, in apparent reaction to the structural weakness of so much fauvism, carry forward the severe architectonics of powerful figure studies such as *The Model*, page 303, and the *Male Model*, page 304, made at the turn of the century. In other canvases Matisse abandons all modeling and emphasis on construction for a flat, decorative style, with or without linear support. In the most characteristic fauve paintings the style is mixed, with elements which suggest impressionism, Neo-Impressionism, Cézanne's structural planes, and flat areas all in one picture.

6 *Landscape, 1906-1907*

Many landscapes of the fauve period are small sketches painted from nature. They seem curiously retarded in technique for in them Matisse still mixes Signac's color-bricks with irregular areas of flat tone. Yet in such studies as the *Street in Algiers*, page 328, done in February 1906, and the numerous sketches of the seacoast at Collioure from the summer of the same year, the charm and sparkle of Matisse's color make up for a certain vacillation of style. The Collioure *Landscape*[7] in the Barnes Foundation and the larger *View of Collioure*[8] in Moscow are more studied in composition but still mixed in style.

Perhaps the most significant landscape of the fauve period is the *Brook with Aloes*, page 328, of 1907. Only slight traces of Neo-Impressionist mosaic remain: the color, applied mostly in flat areas with bare canvas between, is based on natural color in a comparatively subdued harmony of reddish earth and green foliage. Partly through his choice of subject, a steeply rising river bank, partly through his suppression of perspective and cast shadow, Matisse has filled almost the entire canvas with a decorative but informal and natural design. The flat, all-over style of this composition anticipates the similar but more abstract landscapes painted in Morocco five years later, page 380.

7 *Still Life, 1906-1907*

Three still lifes of 1906 reveal both Matisse's skill and apparent uncertainty of direction. The large *Oriental Rugs*, page 329, in the Grenoble Museum is typically fauve in its mixture of pointillist spots with patches of flat color and bare canvas. Equally fauve are the heavy dark lines used to reinforce the drawing of the book or, even more emphatically, the upper part of the wrinkled rug at the right which then fades off to bare canvas toward the bottom of the picture. The composition as a whole is out of Cézanne, but the presence of oriental rugs (doubtless brought back from Biskra) is important, for Matisse was to exploit their decorative qualities to excess in the great still lifes of 1908-1910. However in the Grenoble picture the design of the rugs is suppressed, in fact the patterns are barely intelligible. Even their color, though boldly emphasized in the central field of the rug or the wall, is generally disintegrated. Equally characteristic is the large, handsome and loosely painted *Still Life with a Potted Plant* in the Art Institute of Chicago.[1]

One of the same oriental rugs appears as a table cover in the smaller *Still Life with a Plaster Figure*, page 329, at Yale University. Though modestly fauve in color this canvas is essentially a study in the tonal values of forms in light and depth. The objects seem to float in the soft atmosphere of an impressionist interior, their contours subtly established without the use of linear definition or reinforcement. Possibly this picture was painted before the more advanced Grenoble still life, but its conservative character seems astonishing when compared with the two portraits of Mme Matisse or the *Joy of Life*, probably painted as much as six months earlier. Doubtless such a study served Matisse both as relaxation from experiment and as discipline in painting from nature in a fairly traditional manner.

The Copenhagen *Pink Onions*, reproduced in color on page 76 and discussed on page 77, seems at first glance as advanced as the Yale picture is retrospective.

The North African pottery of the *Pink Onions* appears again in the striking big *Still Life with Asphodels*, page 330, of 1907, still in the Folkwang Museum at Essen. Over the sprawling crockery the red and pale blue flowers rise from the dark green vase and sing against a background of blue and purple. The forms are sharply outlined, the composition lively and informal.

Matisse painted *The Rose*, page 330, in the same year; and the same little Biskra pitcher with camels on it that is almost lost in the *Still Life with Asphodels* and the *Pink Onions* appears here in solitary dignity. There is nothing fauve about *The Rose*. It is carefully, even richly painted, naturalistically modeled and effectively separated from its background by a cast shadow. Its concentrated focus seems almost a penance for the experimental diffuseness of the other still lifes.

Matisse's most elaborate painting of 1907 is the magnificent *Blue Still Life*, page 331, now in the museum of the Barnes Foundation. The composition, though derived largely from Cézanne, is almost as formal as the classic still lifes of the 17th century Dutch and Italians. The richness and excitement in a still life of Heda, de Heem or Bettera depend largely upon their marvelous skill in rendering literally, though with style, a great variety of textures. In Matisse's *Blue Still Life* there is very little sense of superficial texture. Instead the surface of the textiles and objects is translated into an equivalent richness of color and painted surface. The dense array of fruit and pottery on the glazed table top is realized with much of Cézanne's sensual solidity. These solid objects play in counterpoint to the arabesque design of the table cloth (a cotton print in the style of *toile de Jouy* which Matisse still owns and which is reproduced on page 344).

Though the *Blue Still Life* is one of Matisse's most beautiful[2] paintings it seems essentially retrospective in character if compared with the *Pink Onions* or the *Asphodels*. The fluid handling of the decorated surfaces, certain color passages, even the technical variety are more or less fauve in spirit but the rather conventional dignity in the composition and the density of the objects seem far closer to Cézanne than to most of Matisse's paintings of the year before or the year following.

8 The Young Sailor, I *and* II; *the* Self Portrait; Marguerite. *1906*

Matisse's figure paintings of 1906-1907 display even greater extremes of style. The two versions, pages 334 and 335, of *The Young Sailor* done at Collioure in 1906, it is said within the same month, reveal how Matisse transformed fauve color and a rather heavy-handed study of structure into a composition of great decorative elegance. Both pictures, as noted in the captions under our halftones, are easily available in color reproductions. The first version is rather somber in effect; the drawing is bold and rather angular; the hands and face are modeled in reddish lights and green shadows, the blouse is irregularly hatched in dull blue, the trousers in greens; the background is mottled and sketchy as in the *Woman with the Hat*.

In the second version of *The Young Sailor* the drawing of both outer silhouette and interior lines has become graceful and flowing. The luminous blue and green areas of the costume curve against a vermilion chair and solid pink background. The strong, sullen face of the first version is redrawn in bright green and pink lines to give an expression of almond-eyed charm verging on prettiness. The whole effect is supremely decorative. In fact *The Young Sailor, II* is perhaps the only other picture of 1906 that obviously appears to be by the painter of the *Joy of Life*, page 320, finished at the beginning of the year. But whereas the larger canvas seems labored and inconsistent in style, *The Young Sailor, II* is brought off with consummate ease and con-

fidence. The oriental influence in the *Joy of Life* seems comparatively unassimilated and artificial, as if assembled from a museum. *The Young Sailor, II* is of course a far simpler problem than the *Joy of Life* but its orientalism, though artful, is integrated. Its technique is as deft, its color as fresh and translucent as that of the folk craftsmen who decorated the pottery and tiles and plastered walls of Biskra, which Matisse had admired on his visit there a very short time before.

Two portraits mark the extreme range of Matisse's style in 1906, the famous *Self Portrait*, done at Collioure probably in the fall[3] and now in the Copenhagen Museum, and the *Marguerite*, probably painted in Paris toward the end of the year.[4]

In the *Self Portrait*, page 333, the artist has presented himself in a striped sailor's jersey and without spectacles. Curiously, the effect is both informal and monumental. The features are hewn in great planes and slashing black lines as if with a hatchet. The color is restrained and largely structural except for a casual stripe or two of scarlet in the jersey. The modeling of the face moves from flesh-toned lights to olive green shadows with accents of pink and blue green. Both the drawing and to some extent the color-modeling suggest Cézanne on one hand and, on the other, Roman mosaics of the 4th and 5th centuries. The latter resemblance is heightened, of course, by the penetrating eyes and apostolic dignity of the countenance. This is one of the most powerful heads ever painted by Matisse.

In the *Marguerite*, page 332, the pendulum swings to the other extreme. The artist's daughter wears a black band around her neck to conceal a scar left by a throat operation. Matisse has painted her with the utmost technical simplicity. The forms are unmodeled, the features drawn in with a very few broad lines. Even more than the *Pink Onions*, this portrait suggests a child's watercolor, a similarity amusingly confirmed by the clumsy lettering MARGUERITE which runs slightly askew across the top of the canvas. Yet in spite of the deliberately ingenuous effect, the prim, shy pride of the schoolgirl who only recently has put her hair up for the first time, is subtly disclosed. Matisse had admired the simplicity of the artisan-painters in Biskra. Returning to Collioure he had learned something too from the drawings and watercolors of his own children, all of whom painted. The *Self Portrait* is a more important work of art but the *Marguerite* is a greater act of courage.

Other notable portraits and figure studies of 1906, all of them more characteristically fauve in style than the two just mentioned, are *The Idol*[5] in the Ellisen collection, Paris; the *Margot* or *Marguerite in a Veiled Hat*,[6] formerly Leo Stein's and now in the Kunsthaus, Zurich; and the sumptuously painted half-length figure of an ugly model called *The Gypsy*,[7] which brings Matisse superficially close to Rouault and remarkably anticipates the style of Matisse's English pupil, Matthew Smith. The *Boy with a Butterfly Net*,[8] a life-size portrait of Allen Stein, was done in the following year, 1907.

9 The Blue Nude *and Other Figures, 1907*

During 1907 Matisse began to paint life-size nudes for the first time perhaps. As it happened, the first of them was inspired by a piece of sculpture, one of Matisse's own. The artist was working in Collioure on the sculpture *Reclining Nude*, the salvaged version of which is reproduced on page 337.[1] While modeling he wet the clay too freely so that when he turned the stand the figure fell off on its head and was ruined. Exasperated, he began to paint the figure instead, putting in some palm leaves which he remembered from his fortnight at Biskra the year before.[2] The result is *The Blue Nude*,[3] page 336.

The Blue Nude—Souvenir of Biskra (to use its full title) is a life-size figure of uncompromising power, drawn with heavy blue lines and modeled with fauve gradations from blue up to pale pink and ochre.[4] The background is fauve, too, with its sketchily painted grass and its rose, ochre, green and violet-pink palm leaves.

The pose of the figure is one which often interested Matisse. It appears first in the rather svelte figure drinking coffee in *Luxe, calme et volupté*, page 317, and again, a year later, in the more active silhouette of the reclining woman in the right center of the *Joy of Life*, page 320. In *The Blue Nude* the elbow of the raised arm, the dome of the hip, are heavily accented but less so than in the sculpture of the same subject, *Reclining Nude*, page 337, which Matisse finished soon afterwards. In these four figures Matisse clarifies the gesture and silhouette step by step to the point of expressive exaggeration. It is noteworthy that in both *The Blue Nude* and *The Young Sailor, II* there is little foreshortening. The figures are distorted and flattened so that every part is seen in its most characteristic aspect.

The Blue Nude was shown publicly, apparently[5] at

the Salon des Indépendants of 1907, where it served to increase Matisse's popular reputation for gratuitous ugliness and iconoclasm—the broken image in this case being the conventional prejudice as to what a Salon nude should be. But Leo Stein bought *The Blue Nude* and hung it at the rue de Fleurus—his last Matisse purchase. There for years it shocked unprepared visitors. "What's that supposed to be?" they would exclaim, to which Gertrude Stein would reply[6] by quoting the equally exclamatory remark of their concierge's five-year-old son who, when he saw the picture for the first time, "cried out in rapture, oh là là, what a beautiful body of a woman."

When Leo Stein sold his Matisses *The Blue Nude* passed into the great collection of John Quinn of New York and, upon his death, to Dr. Claribel Cone of Baltimore. Now it hangs in the Baltimore Museum, the capital piece among the three-score Matisses in the Cone Collection.

The *Standing Model*, page 338, is one of a series of vigorous studies of the nude in which Matisse produces a maximum sense of mass and relief by means of weighty lines and strong chiaroscuro modeling either in sober complementaries or, as here, entirely in gradations of grey. The effect of somber power is scarcely relieved by the dull orange of the floor, the neutralized pink and green of the background. In these studies the heavy lines remain *inside* the contours of the form. In *The Blue Nude*, on the contrary, the contour of the hip and lower side of the torso are established by broad bands of dark color running *outside* the form; the rest of the figure is defined by mixed inner and outer contours.

Along with these canvases and innumerable drawings of single figures Matisse painted the large *Hairdresser* or *La coiffure*, page 339, in which two figures, one seated, one standing, are compressed within a triangle recalling the deliberate (and ultimately academic) ingenuity of a Raphael *Holy Family*. Picasso had painted *La coiffure*,[7] a somewhat similar but less perfected composition, the year before.

10 Le luxe, I and II

In 1907 Matisse painted two versions of an important composition of women by the shore called *Le luxe*. The fact that there were two of them and that Matisse gave them a title unhappily like that of his *Luxe, calme et volupté*, page 317, of 1904-1905 has given rise to extraordinary confusion.

Le luxe, I, page 340, was painted in oil at Col-lioure early in 1907[8] and was exhibited at the Salon d'Automne of that same year under the title *Le luxe (esquisse)*. It remained in the artist's possession until it was sold in 1945 to the Musée National d'Art Moderne, Paris.

Le luxe, II, page 341, was painted in the casein medium during the fall of 1907 or, just possibly, early in 1908 at Matisse's Paris studio in the Couvent des Oiseaux.[1] It was not shown at any of the Paris Salons but was exhibited in 1912 at Cologne and London and, in 1913, at the New York "Armory Show," and then in Boston and Chicago. In 1917 it was bought by the Danish engineer J. Rump, who presented it as part of his magnificent collection to the State Museum, Copenhagen, in 1928.

As we have seen, *Luxe, calme et volupté*, the big Neo-Impressionist composition begun late in 1904, won considerable fame at the Salon des Indépendants of 1905. But then Signac bought it and took it back with him to St. Tropez. Though it was apparently never photographed or published or exhibited again until 1950, its name was preserved by word of mouth and in a few critical writings, notably Maurice Denis' account of the Indépendants quoted on page 60. As a result of the virtual disappearance of the picture for forty-five years its title and history have often been transferred to one or the other version of *Le luxe*, or to both. The excellent 1948 catalog of the Rump Collection[2] lists what we now know to be *Le luxe, II*, 1907, as "*Komposition (Luxe, Calme et Volupté.) (c.1905)*." And in 1950 the popular Skira *History of Modern Painting*, volume II, conveniently reproduces both versions in color on opposite pages with the identical captions: "*Luxe, calme et volupté. Collioure. 1905.*"

The confusion would have been a minor comedy of scholarly errors were it not for the fact that all three pictures are of great importance in Matisse's development during a crucial period which has been seriously obscured by the disappearance of one and the consequent misnaming and misdating of the other two. Even as late as 1950 Matisse himself proposed 1911 as the date of *Le luxe, II*, until cross-questioning led him to settle on late 1907 or at the latest early 1908.[3]

Le luxe I and *II* are identical in size, each measuring almost seven feet high. The composition is the first in which Matisse uses over-life-size figures. Obviously the subject—"bathers," or women by the shore— is related to the *Luxe, calme et volupté* of

1904-1905, probably by way of the small *Three Bathers*, page 338. Indeed it may be that the reduction of the number of figures from seven to three and the general simplification is half-humorously reflected in the corresponding reduction of the title to *Le luxe*. As in the earlier picture the largest figure in *Le luxe* rises above her discarded drapery. The whole symbolism of the picture is concentrated upon her as the personification of *luxe*—ease and luxury—as she stands naked and carefree while one attendant stoops to free her feet from her clothing and another rushes toward her with a bouquet of flowers[4]. At the same time the arrangement of the two foreground figures in *Le luxe* is similar to the two women at the far left of the *Joy of Life*, page 320, the stooping attendant in *Le luxe* deriving, in reverse, from the figure picking flowers in the earlier picture.

The style of *Le luxe, I* is puzzling. It might be called "dark fauve" for it displays the ambiguities and vacillations of Matisse's fauve pictures without their compensating brilliance. At the same time it lacks the vigorous drawing which so enhances other dark fauve pictures such as the *Self Portrait*, page 333, and the first version of *The Young Sailor*, page 334, both of 1906, or the less somber *Blue Nude*, page 336, done about the same time as *Le luxe, I*, itself. The rather tentatively modulated line defining the standing woman almost disappears in the crouching and running figures which are silhouetted rather than outlined. The color of the figures is equally indecisive, ranging from light tan through turquoise to pink. The alternating bands of warm and cold behind the figures are also muffled, even muddy in tone.

In his review of the Salon d'Automne of 1907, Félix Vallotton awarded *Le luxe, I* probably the longest notice so far given by a critic to any of Matisse's exhibits. Vallotton was the realist among the Nabi group; indeed he could look back several years to such paintings as the *Carmelina* of 1903 in which Matisse drew surprisingly close to Vallotton's art. In the face of *Le luxe, I*, Vallotton was both defensive and supercilious but he was far more tolerant than was the Nabi idealist, Maurice Denis, confronted by *Luxe, calme et volupté* in 1905, or the Neo-Impressionist, Signac, raging before the *Joy of Life* in 1906. Vallotton writes in *La Grande Revue*[4]:

M. Matisse exhibits a large panel, Le luxe, *which seems to arouse some controversy—I say* some *because really it seems to me that the* time *for invectives is over, either because I am used to them or because I am no longer interested in them. Some people say "There is the Matisse"; they look and pass on; others meditate and their wrinkled brows prove that it is hard going. Evidently the meaning of this work—cryptic according to some, clear as crystal according to others—is in no sense absolute and can be made to furnish arguments in favor of the most divergent opinions.*

The canvas represents three women against a seascape background of greens, browns and blues; the tall one is dominant and stands in a frontal pose, the second one in profile crouches at her feet and in the distance the third seems as though she were split by the movement of a suspended gallop; all this with no strong connections of forms or volumes. The contours are marked by the hypnotic and broken draftsmanship adopted by M. Matisse as the only line that can record without betrayal the meanderings of his sensibility. The color is agreeable though flat and the chromatic relations are felicitous though somewhat elementary. This produces a bizarre impression: the painting is attractive at a distance because these waves of color without definite representation make a pretty play on the wall [font sur le mur un joli jeu] but on closer approach this charm is dispelled by disappointment, depending on one's mood, the weather or the friend who. . . .

. . . I have gone into this at some length because he is representative and will most probably create a school. No one takes his art more seriously than does M. Matisse; no one sets more exalted ideals for his art; and above all he is a craftsman of real probity; therefore one should give him due credit.

When Matisse listed *Le luxe, I* in the catalog of the Autumn Salon of 1907 he added in parentheses the word "*esquisse*." Doubtless he intended to indicate a lack of finality about the picture, though he used the same word after the titles of four other canvases—to the puzzlement of his friend Jean Puy who felt that "sketch" was a misleading term when applied to works which by fauve standards were finished pictures. One of these, probably painted between *Le luxe, I* and *Le luxe, II*, was the important *La musique (esquisse)*, page 79, to be discussed later. Whatever Matisse meant by the word, he now painted a second and revised version of *Le luxe, I* which he did not call an *esquisse*, beginning it perhaps while the first version was still at the Salon.

Even in the halftone reproduction, *Le luxe, II* seems to be greatly clarified in style. No inconsistencies remain. The drawing throughout is executed in a thin, carefully modulated neutral line

quite like that used in the foreground figures of the *Joy of Life*, page 320. The flesh tones of all the figures are reduced to a flat, ochre monochrome. Almost equally flat are the hues of the light green sea which divides the chestnut-colored foreground from the distant hills, one chestnut, one violet, and the blue sky. A white cloud in the upper right-hand corner responds to the white drapery at the lower left. The black or yellow hair of the women and the multicolored bouquet serve as valuable accents. The whole effect is as direct, simple and elegant as Greek red figure vase painting or an Utamaro nude.

At first glance *Le luxe, II* is a welcome relief after the vacillation of *Le luxe, I*. As an act of clarification it appeals to the mind as well as to the eye. Yet after study the earlier picture grows on one in spite of its faults or perhaps because of them. The sense of experiment and struggle sets up a tension which holds the interest by comparison with the decorative grace of the second version. And there is more for the eye to feed on in the muffled iridescence of the Paris picture than in the blank tones of the Copenhagen decoration.

Whether or not one prefers a sense of trial and error in a work of art or a sense of final perfection, there can be no question as to the significance of the two pictures as indications of Matisse's direction. Even the year before, the first and second versions of *The Young Sailor*, pages 334, 335, had suggested what *Le luxe, I* and *II* confirm, that Matisse's revisions of his first intuitions were leading him toward a flat, decorative style. This style at its purest is devoid of modeling either through color or chiaroscuro. Entirely liberated from impressionism, it lacks all sense of diffused or directional light. But it is faithful in a simplified way to local color which had been largely discarded by the fauves and, before them, by the pointillists and impressionists. *Le luxe, II* stands halfway in time and much more than halfway in style between Matisse's first big figure composition, the *Luxe, calme et volupté* of 1904-1905, and the culmination of his decorative figure style in the *Dance* and *Music* completed in 1910.

11 Three Bathers *and* Music (sketch), *1907*

Two smaller three-figure compositions, the *Three Bathers* and the *Music (sketch)*, are related both to *Le luxe, I* and *II* and to the new and very important series of figure pieces which was to begin in 1908 with the *Bathers with a Turtle*, page 357, and culminate in the *Dance* and *Music* of 1910, pages 362, 364.

The *Three Bathers*, page 338, was done at Collioure during the summer of 1907, probably before *Le luxe, I*, page 340. The three figures are similar to those in *Le luxe, I* but they are spread out in a frieze-like composition before horizontal bands of sand, sea and sky. Like Cross and Signac before him, Matisse enlivens the background of the composition by the repeated sharp white triangles of sailing craft. In fact the *Three Bathers* recalls Matisse's first painting of nudes by the sea, the *Luxe, calme et volupté* of 1904-1905 which had been largely inspired by the two Neo-Impressionists. Though it is the direct source in composition of Matisse's big *Bathers with a Turtle* of the following year, the *Three Bathers*, with its heavy outlines and brilliant color, is still thoroughly fauve in style by comparison with the *Music (sketch)*, color plate page 79, the painting which served as a starting point in color as well as iconography for the huge *Music* of 1910. *Music (sketch)* is discussed on page 78.

SECTION VI GRAPHIC ART AND SCULPTURE THROUGH 1907

1 *Matisse's Drawings through the Fauve Period*

Matisse rarely dated his early drawings and now often cannot remember accurately just when they were done. The elementary classroom studies of casts made in the early '90s, page 293, have practically no personal quality. The drawings from the figure in Moreau's studio are at first very tight and realistically modeled,[5] then rather soft without definite contours, and later, as Matisse gained confidence, freer and more vigorous in the interplay between modeling and contour as in the figure illustrated on page 295.

During the succeeding decade Matisse developed a mastery of drawing unequaled by any artist of his generation. The *Self Portrait*, page 39, of about 1900 is an able but fairly conventional brush-and-ink study. Perhaps from the same period, the *Nude Seated on the Floor*, page 50, is characteristic of a

number of ink drawings which seem affected by pointillist destruction of continuous line.

Three of Matisse's most famous drawings are reproduced on pages 322 and 323. The big *Nude in a Chair* is thoroughly fauve in its technical variety and informality. The form is indicated in a spirited mixture of line, silhouetted contour, hatching and wash. The handsome *Seated Nude Leaning on Her Arm* was given a full-page reproduction as early as 1909 in the Moscow art magazine *Zolotoye Runo*[6] and again in the New York *Camera Work*,[7] 1912. Though conventional in technique the penciled multiple contours of this drawing both reveal and caress the rich formal rhythms of the figure. By contrast the thin, angular, adolescent forms in the *Seated Model, Hands Clasping Knee*[8] are rendered by a line both sensitive and dry.

The brush-and-ink *Seated Woman*, page 322, is a study for one[1] of Matisse's three linoleum cuts of 1906 and clearly demonstrates by its counterpoint of ornamental patterns Matisse's new interest in all-over decorative effects. Never before had Matisse permitted himself such freedom as he does here in the two legs of the model. The mixture of decorative design and expressionist distortion in this drawing may be compared with the expressive naturalism of the *Nude in a Chair* of about the same date and reproduced on the same page. Both were probably done not long after[2] the completion of the *Joy of Life*, Matisse's first radical break with the essentially realist-impressionist tradition in which he had been working for a decade.

The *Nude with Pipes* and *Girl with Ivy in Her Hair*, both page 321, are working studies for the *Joy of Life*. Though the line cut reproduction of the latter is not exact, a comparison with the finished figure in the painting throws light on Matisse's mastery of linear simplification, for the painted figure is virtually a drawing, too.

Apparently extremely few, perhaps none, of Matisse's street and cabaret sketches done in Marquet's company about 1900 have survived that most unfortunate housecleaning of 1936, page 38. Some of Marquet's[3] sketches of the period may indicate something of the character of this lost chapter in Matisse's graphic art though it seems doubtful that Matisse's drawing could have been so stylishly "Japanese." The early etching *Two Women in Street Costumes* is obviously germane in subject matter but is so tentative technically that it probably gives no idea of the freedom and verve of the destroyed

sketches. The lithographs of 1906-1907 however are really valuable in extending the range of this too brief review of Matisse's early drawings. The lithograph *Harbor of Collioure*, page 61, reduces to a few brush lines the general subject matter of Matisse's best-known landscape drawing *The Fisherman*, page 55, a large rather impressionist pen-and-ink sketch done during the first summer at Collioure. Matisse esteemed this drawing so highly that he sent it to the Salon d Automne of 1905 and later presented it to his greatest patron, Sergei Shchukin.

In striking contrast to his paintings, Matisse's drawings of this period were early appreciated in conservative, if not academic circles. Bernard Berenson was enthusiastic about them, page 114, and the long critique by Frank Jewett Mather, Jr., written in 1910, Appendix E, remains one of the best studies of Matisse's draftsmanship.

The most complete insight into Matisse's own ideas at this time about drawing are given in the first pages of Mrs. Michael Stein's notes taken down in Matisse's class in 1908, Appendix A. These may well be studied in connection with the illustrations of his early drawings, which sometimes fail to conform to the master's own precepts. To whet the reader's interest, here is a single paragraph from these eloquent notes:

All things have their decided physical character—for instance a square, and a rectangle. But an undecided, indefinite form can express neither one. Therefore exaggerate according to the definite character for expression. You may consider this Negro model as a cathedral, built up of parts which form a solid, noble, towering construction—and as a lobster, because of the shell-like, tense muscular parts which fit so accurately and evidently into one another, with joints only large enough to hold their bones. But from time to time it is very necessary for you to remember that he is a Negro and not lose him and yourself in your construction.

2 *The Early Etchings and Drypoints*

Matisse began to work on copper[4] sometime between 1900 and 1904. Perhaps his first etching is the *Self Portrait*,[5] page 312, a patient, honest, literal study of what he saw in the mirror and quite in the spirit of the objective realism of his paintings of the period. As has been noted, the tentative drypoint *Two Women in Street Costumes*, page 312, may be one of our few vestiges of many sketches made by Matisse in the streets of Paris during a period beginning

about 1896. This drypoint seems even more timid technically than the *Self Portrait*. The plate *Two Nudes, Two Heads of Children* is more assured and may well be as late as 1905 or 1906.[6] It is one of half a dozen studies of the nude model which was Matisse's principal subject in these early and on the whole rather tentative plates. He was, apparently, not to take up etching again until 1914.

3 Matisse's First Lithographs, 1906

Early in 1906 Matisse began his first series of lithographs, a dozen or more rapid studies in crayon of the model, standing, seated or reclining. They superbly demonstrate one aspect of Matisse's draftsmanship, its spontaneity. The unaccustomed problem of making large drawings for formal publication might have led him to work slowly and deliberately. But the contrary is true. Few sketches made for his own private study surpass these lithographs in freedom and informality. Yet, for all their immediacy, they suggest no carelessness.

The *Half-length Nude*, page 324, is characteristic of the series, the arms and torso indicated in a few fluent, easy lines. Exceptionally interesting is the head of a reclining model, same page, seen upside down. Such a pose, by eliminating any habitual rendering of a familar object, both liberates and challenges the eye and hand of the draftsman—as may be understood by turning the print itself upside down and, consequently, the head right side up. Matisse returned again and again to such problems, solving them with extraordinary virtuosity, particularly in his drawings and prints of the years around 1930-1935.

Some, if not all, of this early series of lithographs[7] were apparently shown in Matisse's big retrospective at the Druet Gallery in March 1906. The very rare lithograph, perhaps a unique proof, *Harbor at Collioure*, may have been drawn shortly afterwards during the second summer at Collioure.[8] It is Matisse's only landscape lithograph and like some of the figure lithographs suggests the extreme brevity and condensation of Far Eastern brush-and-ink drawing.

4 The Three Early "Woodcuts," 1906

Matisse, like every artist of the Paris vanguard, knew the revolutionary woodcuts of Gauguin, the pioneer in bringing to life a medium which for decades had been expertly debased and refined for the purpose of reproducing paintings and illustrations. Gauguin, using a deliberately crude technique, gouged and scraped his compositions directly into the plank so that when the block was printed it appeared as a bold white design against black. The effect is not only expressive and highly decorative but looks as if it had really been cut in wood.

Matisse also knew the woodcuts of his friend Félix Vallotton, one of the original Nabi group. These are technically far less "primitive" than Gauguin's and though they make a striking black-and-white effect, they suggest that the artist had really conceived them as ink designs.

The same is true of Matisse's three early linoleum cuts: they are essentially translations of brush-and-ink drawing, but drawing of such a vigor and power that, at the time they were made, they were rivaled in boldness of design only by those of the great Norwegian, Edvard Munch.[1]

Unlike the lithographs with their thin, swift, flexible line, Matisse's linoleum cuts are more nearly the equivalent in a black-and-white medium of his strongest fauve paintings. In fact the largest of the three linoleum cuts, page 325, presents a figure more uncompromising in its distortions and angularities than even *The Blue Nude*, page 336, of the following year. Fauve, too, is the inconsistently patterned background, the mixture of dots, straight lines, curved lines and plain areas throughout the design as a whole.

Matisse's "woodcuts," like his early lithographs, were first shown in March 1906 in his large one-man show at the Galerie Druet and all three were included in the Salon des Indépendants which opened in March 1907.[2] In his review of the Salon, Georges Desvallières, though an old friend of Matisse, was especially taken aback by the largest of the three "*gravures sur bois.*" In it he saw "willful deformations, a bit too premeditated, above all in the large figure" and complained of the "great effort to look at it seriously, attentively, respectfully."[3]

The two[4] smaller "woodcuts" are milder and were accepted by some critics as decorative designs "for tapestries." A study for one of them is reproduced on page 322, right.

5 Sculpture, 1905-1907

During 1905-1907, the period when he was painting his fauve pictures, Matisse made between fifteen and twenty sculptures. Half a dozen of them are small heads; the rest, except for a *Thorn Extractor*,

are female figures ranging in size from the little nine-inch sketches to a carefully studied *Decorative Figure* nearly thirty inches high.

The *Woman Leaning on Her Hands*, page 326, is simply modeled, smooth in surface but complex in pose with radiating limbs and rhythmic counterpoise of head and torso, especially when seen, as it should be, from above. The informality of the pose comes from Rodin but the perfection of the composition is Matisse's.

The heavy coiffure, long torso and short heavy thighs of the *Standing Nude*, page 327, are simply exaggerations of the idiosyncrasies of the model, curiously (and unforgettably) emphasized by the rigid frontality of the pose. Frontal, too, is the pinched little *Torso with a Head*, so sharp-breasted and sharp-buttocked that it may be one of Matisse's few sculptures influenced by West African figures.

Quite different in purpose is the *Decorative Figure* in which the limbs are composed with great care for the three-dimensional organizations of directions: parallels and right angles formed by arms and legs being studiously related to and about the main diagonal of the torso. The *Decorative Figure* is Matisse's largest sculpture before *The Back*, an over-life-size relief of 1910-1912, page 313, (wrongly dated there "1904?").

The diminutive heads and busts of 1905-1906 are mostly informal portraits of members of Matisse's family, but the smallest of them, the *Little Head* of 1906, is a study of a model. Less than four inches high it is as broadly modeled and big in conception as a life-sized head by Maillol. As Matisse said,[5] "the smaller the bit of sculpture, the more the essentials of form must exist."

How Matisse himself saw his own sculpture may be studied in several of his paintings in which his figures of about 1906 are reproduced: the *Standing Nude* is to be seen in plaster in the Yale *Still Life with a Plaster Figure*, page 329; the *Thorn Extractor*, inspired by a Greek prototype and one of Matisse's rare male figures, is placed on the right-hand side of the table in the big Grenoble Museum *Interior with Eggplants* of 1911, page 374; and on the mantelpiece at the left of the same painting is the *Dancer;* the big *Decorative Figure* is the bronze sculpture at the left in the Moscow *Painter's Studio*, page 375, again at the right in the *Red Studio*, page 162, and, finally, in the lower left-hand corner of the *Piano Lesson*, page 175.

The accident which destroyed the unfinished first version of the *Reclining Nude*, page 337, and gave birth to the painting *The Blue Nude*, page 336, has been recounted on page 94. The theme of the woman resting on elbow and thigh with knees drawn up and the other elbow pointing skyward was developed slowly by Matisse over a period of years. The bronze is less imposing in size than *The Blue Nude* yet, in a sense, the big painting actually served as a study for the sculpture. The sculpture is more powerfully composed, the distortions bolder, particularly in the bent but towering left arm. No sculpture by Matisse is more admirably designed to interest the eye and satisfy the sense of rhythmic *contrapposto* when seen from different points of view. The *Reclining Nude* of 1907 is one of Matisse's masterpieces.

That Matisse himself found the *Reclining Nude* exceptionally interesting is proven by the fact that for years after it was done, and far more often than any other piece of sculpture, he incorporated it as an important compositional element in his paintings. It appears, seen from different angles, in the Oslo *Sculpture and Persian Vase* of 1908, page 342; the Copenhagen *Goldfish* of 1909, page 348; the Whitney *Goldfish* of 1911, page 165; the Barnes *Goldfish* of 1912, page 385; and the *Still Life with Ivy* of about 1915, not reproduced. The motif itself he took up again in drawings and sculptures of the late '20s, pages 456 and 457.

6 Matisse's Ceramics

Probably the first time Matisse reproduced the motif after completing the sculptured *Reclining Nude* was when he brushed the figure on a ceramic tile, page 337, now in the collection of Max Weber, who acquired it from his teacher in 1908. This tile was only one of several ceramic plaques and plates done by Matisse. Vollard the dealer tells how he got the ceramist André Metthey to "open his kilns" at Asnières to a number of the best younger painters. With Metthey's technical guidance, Denis, Vallotton, Roussel, Bonnard, Valtat, Rouault, Matisse, Vlaminck, Friesz, van Dongen, Puy—in other words most of the distinguished Nabis and fauves—collaborated in this ceramic enterprise which extended from about 1907-1909.[6] A plate by Matisse is reproduced in the left foreground of the *Red Studio*, page 162, and another, with mysterious ambiguity, in the *Flowers and Ceramic Plate*, page 377.

In *La Phalange* of December 15, 1907, the new critic of the Paris vanguard, Guillaume Apollinaire, published his first study of Matisse.[7] Though questionable in certain details the *Phalange* article is worth quoting as a whole, especially as it includes some candid and disarming remarks by Matisse himself about his debts to other artists, remarks which Apollinaire illustrates and analyzes.

HENRI MATISSE

This is a tentative article about an artist in whom, I believe, are combined the most tender qualities of France: the force of her simplicity, her serenity and clarity.

There is no connection between painting and literature, and I am eager not to create any confusion in this respect. The aim of Matisse is plastic expression just as lyric expression is the aim of the poet.

When I came to you, Matisse, the crowd had looked at you and as it laughed at you, you smiled.

They saw a monster there where a wonder was taking shape.

I questioned you and your replies explained what causes the equilibrium of your reasonable art.

"I have worked," you told me, "to enrich my knowledge by satisfying the diverse curiosities of my mind, striving to ascertain the different thoughts of ancient and modern masters of plastic art. And this study was also material because I tried at the same time to understand their technique."

Then, pouring me some of the liqueur you had brought back from Collioure, you tried to retrace for me the adventures of this perilous voyage to discover your own personality. It proceeds from science to conscience, and leads to complete forgetfulness of everything that is not in your own self. What a difficult thing! Tact and taste are the only policemen who can sweep aside forever what should no longer be encountered on the way. Instinct is no guide; it got lost and we are trying to find it.

"Then," you said, "I found myself or my artistic personality by looking over my earliest works. They rarely deceive. There I found something that was always the same and which at first glance I thought to be monotonous repetition. It was the mark of my personality which appeared the same no matter what different states of mind I happened to have passed through."

Instinct was found again. You at last subordinated your human consciousness to the natural unconscious. But this took place at its own good time.

What an image for an artist: the gods, omniscient and almighty, but subjected to destiny!

You told me: "I made an effort to develop this personality by counting above all on my intuition and by returning again and again to fundamentals. When difficulties stopped me in my work I said to myself: 'I have colors, a canvas, and I must express myself with purity, even though I do it in the briefest manner by putting down, for instance, four or five spots of color or by drawing four or five lines which have a plastic expression.' "

You have often been reproached, my dear Matisse, for this summary expression but you have thereby accomplished one of the most difficult tasks: to give a plastic sense to your pictures without the aid of the object except as it arouses sensations.

The eloquence of your works comes first of all from the combination of colors and lines. That is what constitutes the artistry of a painter and not—as some superficial spirits still believe—the mere reproduction of the object.

Henri Matisse makes a scaffolding of his conceptions, he constructs his pictures by means of colors and lines until he gives life to his combinations so that they will be logical and form a closed composition from which one cannot remove a single color or line without reducing the whole to a haphazard meeting of lines and colors.

To make order out of chaos—that is creation. And if the goal is to create, there must be an order of which instinct is the measure.

To one who works this way the influence of other personalities can do no harm. He has his inner conviction, which comes from his sincerity; and the doubts which harass him only stimulate his curiosity.

"I have never avoided the influence of others," Matisse told me, "I would have considered this a cowardice and a lack of sincerity toward myself. I believe that the personality of the artist develops and asserts itself through the struggles it has to go through when pitted against other personalities. If the fight is fatal and the personality succumbs, it means that this was bound to be its fate."

Therefore, all plastic handiwork: the hieratic Egyptians, the refined Greeks, the voluptuous Cambodians, the creations of the ancient Peruvians, the statues of African Negroes proportioned according to the passions which inspired them, all may interest an artist and help him to develop his

personality. It is by incessantly comparing his art with other artistic conceptions and by keeping his mind open to other related arts that Henri Matisse—whose personality, already so rich that it might have developed in isolation— has attained the greatness and confident conviction which distinguish him.

But, although curious to know the artistic capacities of all human races, Henri Matisse remains above all devoted to the European sense of beauty.

Europeans, our inheritance reaches from Mediterranean gardens to the solid seas of the far north. We find here the nourishment which we love, and the spices from other parts of the world can at most serve us as seasoning. Furthermore, Henri Matisse has above all pondered Giotto, Piero della Francesca, the Sienese primitives, and Duccio, less powerful in volume but more so in spirit. Then he meditated upon Rembrandt. And standing at this crossroad of painting, he looked at himself to find the path which his triumphant intuition should follow with confidence.

We are not in the presence of some extremist venture; the essence of Matisse's art is to be reasonable. Whether this reasonableness is by turn passionate or tender, it is expressed purely enough to be understood. The conscience of this painter is the result of his knowing other artistic consciences. He owes his plastic innovations to his own instinct or self-knowledge.

When we speak about nature we must not forget that we are part of it and that we must look at ourselves with as much curiosity and sincerity as if we were looking at a tree, a sky, or an idea. Because there is a relationship between ourselves and the rest of the universe, we can discover it and then no longer try to go beyond it.

Guillaume Apollinaire

Apollinaire's insistence upon the importance of the European tradition in the art of Matisse is both discerning and salutary. In their excitement over the esthetic revaluation of primitive and exotic arts, 20th-century critics have often exaggerated their usefulness to modern artists. Japanese prints greatly influenced such artists as Degas, Whistler, van Gogh and Bonnard but their art remained essentially European. At the very moment Apollinaire was writing, Negro sculpture was affecting the development of cubism but in the end Picasso and Braque studied the European art of Cézanne far longer and harder than they did the masks and fetishes of West Africa.

By 1907 Matisse himself was however no laggard in the exploration of non-European traditions. In fact it may have been he that first introduced Picasso to African sculpture.[8]

Before 1906 Matisse's art had also shown some influence of Japanese prints; from 1906 on it reveals an interest in Near Eastern art, textiles, pottery, miniatures, and possibly the popular frescoes which he had seen in Biskra. But the Algerian trip of 1906 has tended to eclipse the Italian trip of 1907 in the minds of historians and critics. What is sometimes assumed to be North African, Persian or Mughal influence upon Matisse's drawing is likely to stem from Ingres or 14th-century Siena or 5th-century Athens. However, in his increasing use of flat, clearly defined areas of color in unprecedented harmonies and dissonances, and in his daring jugglery of several different decorative patterns within the flattened space of a single canvas, Matisse certainly drew inspiration from the East.

PART IV: 1908-1910

MATISSE, THE INTERNATIONAL ARTIST

SECTION I MATISSE'S LIFE, 1908-1910

The years 1908-1910 were marked by great improvement in Matisse's economic position and domestic circumstances; by a further decline in his position of leadership among young French painters compensated to some extent by an extraordinary ascendency as a teacher of young foreigners; by the spread of his fame in Europe and America; by travel and the exhibition and publication of his work abroad; by the publication of an article which remains the most famous statement of theory by a 20th-century artist; by the achievement, followed by frustrating disappointments, of his first great mural commission; and by the production of other paintings more confident and much more imposing than the work even of his fauve period.

1 The School, 1908; Exhibitions Abroad; Issy-les-Moulineaux, 1909

During the early part of 1908 the Matisse family continued to live in the apartment at 19 Quai St. Michel overlooking the Seine. The apartment had been far less crowded since the fall of 1905 when Matisse, looking for space in which he could paint the big *Joy of Life*, had found room for a studio in the building of the former Couvent des Oiseaux on the rue de Sèvres.

It was in this same building, during the winter of 1907-1908, that Mrs. Michael Stein, Hans Purrmann, and others among his young admirers organized Matisse's famous school, page 116. Small at first, the "Académie Matisse" grew during 1908, attracting scores of students from the United States, Central Europe and, above all, Scandinavia.

In the spring of 1908 the Couvent des Oiseaux was sold by the government. Matisse thereupon moved not only his studio and school but also his family to new quarters in the Hôtel Biron, an 18th-century mansion at the corner of the Boulevard des Invalides—Matisse's address was No. 33—and the rue de Varenne. This large property built on two sides of a park-like court had since 1820 been used by the Couvent du Sacré Coeur. In 1904 the convent had been expropriated and offered to the public at low rentals. Rodin as well as Matisse moved there in 1908 and after Rodin's death in 1917 a part of the Hôtel Biron became the Musée Rodin.

Matisse's family thus came to give up their apartment on the Quai St. Michel where they had lived since 1899 and Matisse, himself, at the same address for seven years before that. Later, in 1913, some years after the family had moved to a suburb, Matisse again leased rooms at 19 Quai St. Michel as a *pied à terre* in town until after World War I.

Early in 1908 the young American photographer and painter, Edward Steichen, arranged with Alfred Stieglitz to hold an exhibition of Matisse's graphic art and watercolors at the "291" gallery in New York, Matisse's first one-man show abroad, page 113. In 1908 Matisse also exhibited in London and Moscow for the first time and at the end of the year Hans Purrmann arranged his second foreign one-man show, in Berlin, page 108. He persuaded Matisse to go to the German capital but the show was not a success and the trip was far less agreeable than the gay jaunt he and Purrmann had had in Bavaria the previous summer, page 107.

In December 1908 *La Grande Revue* published Matisse's influential *Notes of a Painter*, pages 119-123, which were soon translated into German and Russian, bibl. 40.

The new apartment and studio on the Boulevard des Invalides were commodious; and it was convenient to be able to step across the court to the school. But his teaching proved too arduous and time-consuming for an artist of Matisse's conscien-

tious temperament and he found some of his many new pupils too superficial or irresponsible. Moreover, the pressure of his own work was increasing so that in 1909 he partially, and in 1911 entirely, withdrew from the school. At the end of the summer of 1909 he and his family moved from the Boulevard des Invalides to a country house near Issy-les-Moulineaux, a suburban town a few miles southwest of Paris. The Matisses' new address was 42 (later changed to 92) route de Clamart, a road which led to the next town farther out from Paris. Consequently the Matisses often refer to their suburban house as at Clamart rather than Issy-les-Moulineaux.

The move to Issy-les-Moulineaux was made feasible, perhaps even necessary, by the increasingly generous patronage of Sergei Shchukin, who not only bought most of Matisse's best paintings of 1908 and 1909, but in March of the latter year commissioned him to paint the two big decorations, *Dance* and *Music*, pages 362, 364, completed in 1910.

Much of the summer of 1909 the Matisses spent at the little village of Cavalière on the Mediterranean coast, about halfway between Hyères and St. Tropez, where Matisse had painted with Signac five years before. There he made a number of figure paintings in preparation for the Shchukin decorations, working from the model outdoors when the weather permitted. The Matisses exchanged visits with the Michael Steins, who were staying at Le Trayas further east. Matisse also again saw something of Henri-Edmond Cross who was then an invalid at near-by Le Lavandou.

When the Matisses returned to Paris early in the fall they moved out to Issy-les-Moulineaux. There Matisse spent a good part of the amount Shchukin had promised for *Dance* and *Music* to pay for a prefabricated, demountable wooden studio large enough so he could work conveniently on the big canvases. This studio had been suggested to him by Edward Steichen who was using one himself. Not long after Matisse moved to Issy, Steichen photographed him modeling his most controversial sculpture, *La Serpentine*, pages 23 and 367. Another photograph on page 23, taken during the fall of 1909, shows him at work in his new studio upon the *Still Life with the "Dance,"* page 346. In the background is the first version of the *Dance* and at the right is a second big canvas, stretcher-side out, ready for the final version of the *Dance* or, perhaps,

the *Music*. Matisse rode horseback a good deal near Clamart. In the third photograph on page 23 he is seen alone but another snapshot in the possession of Alexina Matisse shows the painter out riding with his three children. Later in 1913 Matisse and Picasso sometimes rode together near Clamart.

2 Painting and Sculpture, 1908-1910

Besides the Shchukin decorations Matisse painted three remarkable series of canvases during the years 1908 through 1910, one of still lifes, pages 342-349, another of portraits, pages 350-354, a third of figure compositions, pages 356-359. In addition he completed in 1909 one of his most extraordinary and least-known canvases, the big interior called *Conversation*, page 347, and his most famous sculpture *La Serpentine*, page 367, and began the *Jeannette* series, pages 368-371.

All these works were dwarfed by the *Dance* and *Music*, which were completed after long study and re-study in time for the Salon d'Automne of 1910. Any satisfaction Matisse may have had from their success at the Salon, however, was soon destroyed by Shchukin's announcement that for reasons of propriety he could not accept them. Eventually Shchukin changed his mind, but for the time being Matisse was so chagrined that shortly after he got back from a third trip to Germany in October he left Paris for Spain where he spent the last six weeks of the year, returning to Issy-les-Moulineaux only in January 1911.

3 Friends and Collectors: American, German, French, 1908-1910

Though Shchukin, thanks to his superior resources, supplanted the Michael Steins as Matisse's foremost patron during 1908, the Steins continued to increase their collection. They had already acquired most of the best Matisses of 1907 and had added the striking portrait of Mme Matisse, the *Red Madras Headdress*, page 350, which was probably painted before the end of the year. But after these masterpieces their purchases began to diminish, though their devotion to Matisse continued. They bought a *Still Life with a Bronze* in 1908 and an *Autumn Landscape* in 1909. Leo Stein no longer added Matisses to the collection on the rue de Fleurus but the friendly hospitality of himself and his sister continued to serve Matisse by introducing him and his pictures to foreign critics and collectors.

Among the American friends of the Stein family,

Miss Harriet Levy of San Francisco bought the *Girl with Green Eyes*, page 352, in 1909 and Dr. Claribel Cone of Baltimore and her sister Etta acquired several pictures of earlier periods. And about this time Thomas Whittemore, the American who later uncovered the mosaics of Hagia Sofia in Constantinople, bought *The Terrace, St. Tropez*, page 315, which soon after he gave to the great Boston collector Mrs. Isabella Stewart Gardner, in whose house, now a public museum, the painting still hangs, doubtless the first Matisse to come to New England. It was Whittemore who sent Matisse the laurel wreath from Berlin at the time of his 1908-09 exhibition there, page 108.[9] Another and more famous American art historian, Bernard Berenson, also bought a Matisse, a small early landscape of *Trees near Melun*, page 308, which twenty years later he gave to the Royal Museum of Yugoslavia.

The Englishman closest to Matisse during this and later years was the esthetician and ex-museologist Matthew Stewart Prichard. He had been a specialist in Greek archaeology in Boston. There, about 1900, he joined the staff of the Museum of Fine Arts where his revolutionary reforms in museum methods, later to be generally adopted throughout the United States, led to his dismissal about 1907.[10] Not long afterwards he came to Paris, studied the philosophy of Bergson, and came to know and greatly admire Matisse with whom he often discussed art and esthetics. In 1910 he introduced to Matisse the young writer Georges Duthuit, later to become the historian of fauvism and Matisse's son-in-law. Prichard had not the means to collect on any scale but like Whittemore, whom he knew, he gave a Matisse to Mrs. Gardner, perhaps the drawing reproduced on page 379. Another Englishman, also a refugee from an American museum, was a more important though less intimate friend of Matisse. This was Roger Fry who did more than anyone to spread Matisse's fame in Britain.

Hans Purrmann persuaded German friends to buy, among them Curt Glaser, the Berlin art historian, Heinz Braun of the Neue Staatsgalerie in Munich, and the artists Emil Orlik and E. R. Weiss. Three of the early pupils of Matisse, Oskar and Greta Moll and Rudolf Levy, continued to acquire his paintings and drawings.

The Molls had come to Paris in the fall of 1907, trimmed a Christmas tree for the Matisse children and soon owned the big fauve portrait of Allen Stein called the *Boy with a Butterfly Net*, the fauve *Three Bathers*, page 338, the little *Rose*, page 330, a still life and two sculptures.[1] Early in 1908 Greta Moll sat for her portrait by Matisse. The largest, if not the most important canvas of 1908, the *Bathers with a Turtle*, page 357, passed into Karl Osthaus' private Folkwang Museum in Hagen. The young Scandinavian artists who crowded Matisse's class in 1908-1910 also prepared the way for several purchases and one of them, Walther Halvorsen, became a Paris dealer.

As has so often happened to the best French painters of the last hundred years, Matisse was generally neglected by French *amateurs*. Marcel Sembat, Matisse's chief French supporter, bought rather little after the two fauve paintings of 1906, *Marguerite Reading* and *Oriental Rugs*, pages 332, 329, which he bequeathed to Grenoble. A powerful study of a model called *L'Algérienne* went to Guy de Cholet in 1909, and before 1910 Alphonse Kann had purchased a half dozen paintings, most of them minor except the *Brook with Aloes* of 1907, page 328.

In spite of the lack of French support the discerning Félix Fénéon, critic, collector and manager of Bernheim-Jeune, was able to induce that influential gallery to sign a contract with Matisse in September 1909. The contract, a translation of which is given in Appendix C, was to hold for three years: it required the dealer to buy all Matisse's canvases up to Format 50 (41¾ x 35 inches in size) at prices ranging from 1875 down to 450 francs, but gave Matisse permission to sell directly providing he gave Bernheim-Jeune a share. He was also free to accept portrait and mural commissions directly.

However, during the three years 1908 to 1910 (and indeed thereafter until 1914) the combined purchases of Matisse's paintings by Americans, Germans, Scandinavians and French scarcely equaled those of a pair of Russians, Shchukin and, to a less extent, his friend Morosov.

4 Shchukin and Morosov

Sergei I. Shchukin was a successful Moscow importer who lived in the palace built for the Troubetzkoi princes in the 18th century. Its sumptuous Rococo interior Shchukin filled with the greatest collection in the world, public or private, of French paintings of the early 20th-century school of Paris, many of them purchased almost before their paint was dry. During the decade before 1914 he bought generously of the fauve generation: a few each of

Vlaminck, Friesz, Rouault, van Dongen, Manguin and Puy; nine Marquets, sixteen of the best Derains and no less than thirty-seven Matisses. Not quite so early as Leo Stein, he too recognized both Matisse and Picasso as the two great masters of the period. But unlike Leo Stein, he maintained his faith[2] in both, acquiring fifty paintings by Picasso, many of them major works of the "Negro" and cubist periods.

Shchukin had begun to collect in the 1890s and had pictures by the Nabi generation too, Denis, Vuillard, Roussel, and older men who worked outside of the "movements" such as Puvis de Chavannes, Carrière, Redon and especially *le douanier* Rousseau. He also had fourteen large Gauguins which he hung on the long wall of his dining room, six Renoirs, eight superb Cézannes, and a score or more impressionist paintings. Shchukin was further distinguished by the fact that he bought very few poor pictures.

Matisse's vivid portrait drawing of Shchukin made in 1912, page 24, shows us half-Mongol features of intense vitality though at the time he was past middle age. Fernande Olivier remembers him as "a little man with a big head and a rather porcine face. Afflicted with a horrible stuttering, he had the greatest difficulty expressing himself and this embarrassed him and shrank his physical appearance still further."[3] His letters to Matisse, pages 133, 134, 147, and Appendix D, reveal him to have been generous, impulsive, but not entirely dependable. Nor was he always boldly discerning: Gertrude Stein tells how after he first saw Picasso's *Demoiselles d'Avignon*, page 22, in 1908 he exclaimed in horror "What a loss to French art!"—yet within a year he was buying big Picassos only slightly less overpowering. Again, after he had enthusiastically commissioned Matisse to paint the huge decorations *Dance* and *Music*, he vacillated for a long period before he dared hang them in Moscow, page 133. Yet his courage surely surpassed that of any other collector of his time, for it should be kept in mind that Shchukin was not a liberated expatriate living in Paris like the Steins, a wealthy museum director like von Tschudi of Munich, an aristocratic dilettante like Count Kessler, a radical politician like Marcel Sembat or the devoted founder of a private museum like Karl Osthaus of Hagen. On the contrary he was a very successful businessman who bought pictures out of the studios of Matisse and Picasso at the height of their controversial fame in

order to hang them in his otherwise conventional bourgeois mansion in one of the most conservative cities in Europe.

Shchukin seems to have paid his first visit to Matisse on his own initiative after having seen his paintings in exhibitions. That was about 1906; but he had already bought a Matisse a couple of years earlier, apparently out of one of the Salons, and shortly after he had acquired the magnificent Fayet collection of Gauguins.[4] This first purchase may have been one of two still lifes of about 1900 or maybe the *Bois de Boulogne*, page 308, painted in 1902. From Matisse's fauve period Shchukin bought four representative canvases including the important figure study *Nude: Black and Gold*[5] of 1905 and the unique Venetian subject, *Woman on a Terrace*[5] of 1907. But it was not until 1908 that Shchukin began to surpass all rivals by acquiring four paintings, among them the *Still Life in Venetian Red*, page 343, the *Game of Bowls*, page 356, and the magnificent *Harmony in Blue*, page 344, which, however, was transformed into the *Harmony in Red* before it reached Moscow in 1909 to be hung on the end wall of Shchukin's dining room, page 24. From Matisse's work of 1909 he took the *Nymph and Satyr*, page 358, the *Coffee Pot, Carafe and Fruit Dish*, page 346, the *Girl in Green* and the *Spanish Dancer*, page 352. (The monumental *Conversation*, page 347, was apparently not actually purchased until 1912.) It was also in 1909 that Shchukin commissioned Matisse's most renowned work the *Dance* and its pendant *Music*, both finished in 1910. From 1910 also date one of Matisse's most distinguished portraits, the *Girl with Tulips*, page 353, and the *Still Life with the Red Commode*, both sold to Shchukin. Most of these paintings along with later Matisse purchases were hung in one of the great salons in Shchukin's palace where they were photographed in 1912, pages 24, 25.

From 1911 through 1913 Shchukin continued to buy the best Matisses with unabated enthusiasm, including no less than six paintings of the Moroccan periods, but in 1912 he was to meet with serious competition from his friend Morosov.

Ivan A. Morosov belonged to a great Moscow family of collectors. Although he was twenty years younger his taste was more conservative, "softer" than Shchukin's.[6] He assembled eighteen excellent Cézannes (including the Matisse-like *The Overture to Tannhäuser*, page 18), but among 20th-century painters he was chiefly interested in the Nabi gen-

eration. He had thirteen Bonnards, of which several were large commissioned decorations. Shchukin had none. And he had a dozen paintings by Maurice Denis including the famous *Cupid and Psyche* scenes. Morosov's taste in the fauve generation ran to Valtat and Guérin, and his three Picassos were mild early paintings. When Shchukin took Morosov to Matisse's studio about 1908 Morosov may already have acquired several of five early still lifes. He was, in any case, not immediately won over to Matisse's more challenging mature work. Yet he bought the powerful figure study *Seated Woman* of that year and the *Still Life with the "Dance"* of 1909, page 346, and another big still life in 1910. In 1912, to Shchukin's generous delight, Morosov was to buy from Matisse a famous trio of Moroccan paintings, which he hung as a triptych, page 25.

Thus, contrary to malicious propaganda about the part played by dealers in promoting modern art, it is clear that in the case of Matisse at least, his survival in his earlier years, and his later success, depended to a large extent upon friends who were not commercially concerned; and even after his contract with Bernheim-Jeune in 1909 Matisse continued to sell directly from his studio.

The catalog of Matisse's big retrospective show at Bernheim-Jeune's early in 1910 reveals two interesting facts: almost all the paintings were already in the hands of collectors who had bought them out of the Salons or directly from the artist, and most of these were owned by foreigners (not including the Russians whose pictures were in Moscow and could not be lent).

There is no sign that the French were at that time uneasy about this state of affairs, though some of them have since blamed foreigners, especially Americans, for having used their wealth to deprive France of its artistic heritage. But in 1910, years after foreigners had begun to buy the best Matisses, French critics seem to have been complacent when not actively hostile. Of Matisse's show at Bernheim-Jeune's in 1910, J. F. Schnerb wrote in *La Chronique des Arts*[7] that "we are happy to note that his disciples and active admirers include no one but Russians, Poles and Americans."

5 *Matisse in Germany, 1908-1910*

Schnerb should of course have added the Scandinavians, who outnumbered the French twenty to one in Matisse's school, and the Germans who, as a nation generally, provided his most numerous and widespread support. No German critic displayed Leo Stein's early discernment of Matisse's greatness and no Germans approached Sarah and Michael Stein or the prodigious Shchukin as individual collectors, yet there were more collectors in Germany and they were widespread throughout the whole country from the Rhineland to Silesia. It was in Germany, too, that Matisse, as a modern painter, first received official recognition through the purchase in 1912 of the big *Still Life with Geraniums*, page 349, for the Munich Neue Staatsgalerie. This was nine years before the Luxembourg was persuaded to acquire a modest *Odalisque* of 1921. And it was to Germany that Matisse made no less than three expeditions during the years 1908-1910.

Matisse's growing fame in Germany and his first sales to German collectors and museums was very largely the work of Hans Purrmann, though such important artist-collectors as the Molls bought independently. How Purrmann first came to Paris and met Matisse in the winter of 1905-1906 has been recounted on page 58 and his important role in the organization of Matisse's School is told on page 116. His activities on Matisse's behalf were not confined to Paris: he was largely responsible for organizing exhibitions of Matisse's paintings in Berlin, the one at Cassirer's gallery in the winter of 1908-1909, the showing of the first version of the *Dance* at the Berlin Autumn Salon of 1913, and the ill-fated Gurlitt Gallery exhibition of 1914, page 177. And such was his devotion that three times he served as Matisse's guide in Germany, not always an easy task.

Matisse's German voyages are rarely mentioned in French and English writing about the artist, and Purrmann's accounts, though circumstantial and often entertaining, are not always certain as to date, but the chronology of the German voyages can be confirmed thanks partly to the archives of the Gertrude Stein Collection at the Yale University Library[8] which preserve a number of tourist postcards sent by Matisse to Gertrude and Leo Stein from 1908-1913.

6 *Bavaria, Summer, 1908*

The first trip to Germany was apparently a carefree tour during the summer of 1908. On June 12, from Speyer, Purrmann's native city, he and Matisse sent a picture postcard of the cathedral to Leo and Gertrude Stein in Fiesole. "*La vie est bonne, Amitiés— H. Matisse*" Matisse wrote on the back. Three days

later the tourists sent comic postcards to the Steins. Leo's card, signed by both travelers, shows a fat German drinking beer from a barrel: "*Avez-vous soif? Nous n'avons pas pu trouver notre mesure,*" was Matisse's message. On a card picturing an equally fat German eating a string of sausages, Matisse asked Gertrude "*en voulez-vous?*" to which Purrmann added "*Prosit!*"

In Munich they visited Purrmann's haunts as a student and even drew from a German model in the studio where Purrmann had received instruction from Franz Stuck before coming to Paris. Matisse liked Munich but was enthusiastic over Nuremberg, that is the old Nuremberg and the Germanic Museum. The excessive bad taste of modern Germany he scorned outspokenly—as if his own country were free of error. They also visited Heidelberg before returning to France.

7 Berlin and the Cassirer Show, Winter, 1908-1909

The second German trip, to Berlin, was as serious in purpose and generally gloomy in atmosphere as the Bavarian trip had been carefree. Purrmann was an associate of the *Berliner Sezession* which had been founded under the leadership of Max Liebermann and other followers of Manet and the French impressionist tradition. The organizers of the *Sezession* exhibition of 1908 had asked Purrmann to invite a number of Frenchmen to participate, expecting him to propose such painters as Cottet, Simon and Jacques-Emile Blanche who still seemed, from the distance of Berlin, to be the significant new figures in French painting. Purrmann countered with a Matisse show. The *Sezession* refused; but Paul Cassirer, the great Berlin dealer, who sometimes visited Purrmann in Paris, seemed willing to show Matisse in his galleries. The pictures were selected and sent off to Berlin toward the end of the year. Soon after, Purrmann began to receive discouraging reports. He consulted with Matisse and they decided to go to Berlin personally to see the show through. They arrived shortly before Christmas 1908 to find Cassirer very uneasy about the coming show and alarmed by the hostility of the German artists and critics who had had a preview of the paintings. During the long intervals between arguments, they wandered disconsolately through the wintry Berlin streets and museums, Matisse scandalizing the Germans and embarrassing Purrmann by wearing a sheepskin coat with the fleece out. Purrmann was quite short so Max Liebermann, the influential German impressionist, dubbed the pair "Don Quixote and Sancho Panza." Finally, Purrmann recounts:[9]

. . . we got Cassirer to let us hang the pictures but in his worst gallery, a sort of vestibule. No sooner had we begun than in came an important critic named Plietsch. He started to fume and sputter, announcing that he could not get by these monstrosities in order to review the show of Count Kalkreuth's pictures in the main gallery. Cassirer was beside himself. . . .

Wisely sensing that Max Liebermann would be a sharp corner to navigate, we called on him. . . . Liebermann accepted our invitation, came to see the exhibition, shook his head, expressed fear that youth would be corrupted and seemed far more interested in his dachshund than in Matisse's paintings. 'Gingercookie' painting, 'wallpaper' were some of the epithets used at the time. The only one to make an effort to create some understanding was Curt Hermann who had a long talk with his friend Meier-Graefe [the great German critic and champion of van Gogh] but without being able to persuade him. Lovis Corinth however urged me to explain this alien art to him. . . . Only one artist showed artistic sensibility and a friendly spirit of professional solidarity—August Gaul.

Matisse went to Gaul's studio and gave him some helpful suggestions about solving the composition of a monumental group which was causing the sculptor great difficulty. Matisse, however, grew more and more depressed and Purrmann was at his wit's end to keep him in a good humor. They left Berlin as soon as they could after the show opened.

Frau Moll's memories of Matisse's Berlin visit are happier. Before the show opened, she and her husband were hosts to Matisse at a *gemütlich* Christmas party attended by the English 'cellist Williams and the German editor Ilgenstein who at the moment was threatened with a prison term for having insulted the Kaiser. Greta Moll translated Matisse's *Notes of a Painter* which was eagerly circulated among Berlin studios, but some of those who saw Matisse's paintings thought they were some kind of holiday joke.

There seems to have been little response in the Berlin press to the Matisse exhibition, perhaps because the paintings were taken down as soon as Matisse and Purrmann left town. However, a critic in the Leipzig *Kunstchronik*[1] signing himself M. O., gives a reasonably serious though conservative review of the show. He warns that while Matisse is "honored by the French youth as the bringer

of a new Promethean spark" his work cannot be introduced to "the young Berlin artists' community without danger." He warmly commends a large impressionist dinner-table composition—this was the *Dinner Table* of 1897, page 299, already bought from Vollard by Dr. Curt Friedmann of Berlin—and praises some flower pieces, doubtless of about 1903-1904, influenced by Cézanne, and some figure drawings. These he notes resignedly "belong to a bygone epoch." He then goes on to deplore the new figure pieces "rubbed raw . . . with colored contours . . . so-called decorative compositions . . . pseudo-naïve bronzes, numbered 1 to 10! How ridiculous and childish! I stand speechless in front of these extravaganzas and, I confess it openly, have only one feeling in response to them: a huge, irrepressible impulse to laugh!"

On the train on their way back from Berlin, Purrmann recalls, he and Matisse met and had a long talk about art in Germany with the Belgian architect and designer Henry van de Velde who was at that time head of the Weimar Academy of Arts and Crafts, later to become the Bauhaus. They also stopped off at Hagen to see Karl Osthaus and his collection called the Folkwang Museum, later transferred to Essen. Osthaus, who lived ascetically in order to buy pictures, already owned two large Matisses, the *Asphodels*, page 330, and the *Bathers with a Turtle*, page 357, so that the visit must have brought the painter some comfort after his ordeal in Berlin.

8 Munich and the Islamic Exhibition, Autumn, 1910

Late in the summer of 1910 Matisse again traveled to Germany, this time to see the great exhibition of Islamic art in Munich. He and Marquet were met by Purrmann at Strasbourg and the three of them reached Munich during the last days of the show. Matisse was by then deeply interested in Near Eastern art so that he studied the exhibition intensively, especially the rugs and aquamaniles, and bought many postcards and photographs of miniatures and metalwork.[2] What he saw there has been magnificently published in the big two-volume catalog of the exhibition.[3]

Fortunately, on the last day of the show, they met the great museum director Hugo von Tschudi in the galleries. Von Tschudi, because of his interest in Cézanne and other modern painters, had aroused the disfavor of the Kaiser and had had to leave his position in the Kaiser Friedrich Museum in Berlin. In Munich he was less trammeled and there formed the handsome group of impressionist and post-impressionist paintings in the Neue Staatsgalerie, some of which survived the Nazi purge.

Earlier in 1910 von Tschudi, thanks it seems to Purrmann's persuasion, had asked Matisse to paint a still life for his own collection. Matisse set to work; all went well and quickly so that he finished the canvas with unusual speed. When von Tschudi received the *Still Life with Geraniums*, page 349, so soon after he had commissioned it, he felt that Matisse could not have done his best and that, somehow, he had been imposed upon. But he soon changed his mind and received Matisse, Marquet and Purrmann in his home where they debated the relative merits of van Gogh, Gauguin and the other masters so well represented in von Tschudi's collection. Matisse upset the Germans when he showed preference for Gauguin, and even Redon, over van Gogh and pointed out the Dutchman's weakness in composition by comparison with a newly discovered Grünewald which was hanging in the next room.

That not all the time in Munich was spent in the serious examination and discussion of works of art is suggested by the *Automat* snapshot[4] of Matisse, Purrmann and the German painter, Albert Weisgerber, page 22. A card[5] postmarked Garmisch, "*11 Oktober 1910*" to "M. et Mlle Stein" announced "I will be back Friday and will tell you all about my trip—H.M."

9 Scandinavia

Matisse did not himself journey to Scandinavia but his fame was spread there by his enthusiastic pupils who returned to Sweden and Norway from the atelier in the Couvent du Sacré Coeur. In 1909 the *Matissare*—the Matissites—held an epoch-making show at the Hallins Gallery on the Drottningsgat in Stockholm. For a dozen years thereafter Matisse was the chief influence affecting the course of painting in Norway and Sweden. Scandinavian collectors took their cue from the painters and, later, museums followed suit, Jens Thiis, Director of the Christiania Museum, taking the lead.

Few if any Danes attended Matisse's school, and it was not until about 1914 that Christian Tetzen Lund and Johannes Rump began to form their great collections of Matisses many of which, thanks to the latter's generosity, are now in the State Museum in Copenhagen. Curiously, there does not

seem to have been an important exhibition of Matisse's own art in Scandinavia until 1924, though by then many of his paintings were to be seen in public and private collections.

10 Moscow, 1908-1909

It is not surprising, considering the activities of Shchukin and Morosov, that the earliest important showing and publication of Matisse's oil paintings outside of France should have occurred in Moscow. In the spring of 1908 the Salon of *La Toison d'Or* presented the most discriminating general exhibition of French post-impressionist painting held anywhere—including France—up to that time and, with the exception of the London Grafton Gallery show of 1912, up through World War I. Among the fifty-one artists, Cézanne, Degas, Lautrec, Redon, the Neo-Impressionists (excepting Seurat), the Nabis, the older Moreau pupils, and above all, the fauves, were there in quantity. Matisse was represented by *La coiffure* of 1901, page 339, *The Terrace, St. Tropez*, page 315, and the *Still Life with a Potted Plant*,[6] all now in American museums. A special number of the periodical *La Toison d'Or* (*Zolotoye Runo*, no. 7-9) reproduced scores of the exhibits including all three of the Matisses and a color plate of van Gogh's *Night Café*, now in the Stephen C. Clark collection, New York, but in 1908 already owned by I. A. Morosov.

Matisse was again represented by three paintings in the *Toison d'Or* Salon of 1909, but a much more significant Russian recognition was the issue of *La Toison d'Or*, 1909, no. 6, which devoted its entire art section to Matisse, reproducing thirteen paintings and three drawings, most of them radical, recent works, right up through the big study for the *Dance*, page 360, which must have been finished only a few weeks before. Along with the plates were an essay by Henri Mercereau on Matisse's position in French painting and a complete translation of Matisse's own *Notes d'un peintre*. This was the most complete single publication on Matisse in any language before 1920. The founder and editor of the extraordinary *Toison d'Or* was Nicolas Riabuchinsky, in whose private collection were several excellent Rouaults.

Matisse's influence in Moscow at this time was very great, particularly among the artists of the "Jack of Diamonds"—Bubnovy Valet—though not so great as that of Cézanne; yet, curiously, in Paris he seems to have had no Russian pupils.

11 England, 1908-1910

Though far less important than these Russian demonstrations, the first public exhibition of a Matisse canvas outside of France seems to have taken place in Britain.[7] At the very beginning of 1908, the International Society of Painters, Sculptors and Engravers held an exhibition at the New Gallery in London. By way of review, the February issue of *The Burlington Magazine*[8] published an unsigned article entitled "The Last Phase of Impressionism." In Matisse's picture, the article announced, "Impressionism reaches its second childhood . . . with M. Matisse motive and treatment alike are infantile."

Matisse, however, was shortly to have admirers in England. Roger Fry, the foremost British art writer, had met Matisse at the Steins on the rue de Fleurus about 1908, Clive Bell came a little later, and in 1910 Matthew Smith was to become one of Matisse's latest pupils at the studio on the Boulevard des Invalides. Matthew Prichard's friendship with Matisse has already been mentioned, page 105.

During the summer of 1910 the large show, *Modern French Artists*, organized by Robert Dell for the Public Art Galleries, Brighton,[9] included two still lifes by Matisse, one lent by Walther Epstein of Berlin, the other by Alphonse Kann. His ex-fauve comrades were also there with one or two paintings each—Marquet, Vlaminck, Puy, Rouault, Derain —but they were lost among eighty painters most of whom are now forgotten. The catalog[1] preface by Robert Dell cautions the public against hasty laughter or anger, reminding the reader that the once-ridiculed works of the impressionists are now "competed for by American millionaires." Matisse is mentioned along with Gauguin and Redon as a pioneer of the Symbolist school and there are many references to articles by Maurice Denis and Roger Fry recently published in *The Burlington Magazine*, of which Dell was the Paris correspondent.

The Brighton show was widely publicized but it was not until the winter of 1910-1911 that London itself first saw modern French paintings in quantity at the epoch-making show called *Manet and the Post-Impressionists* at the Grafton Galleries.[2] An executive committee headed by Roger Fry comprised Lionel Cust and Charles Holmes, both museum officials, Lady Ottoline Morrell, Lord Henry Bentinck, Dr. Rudolf Meyer Riefstahl of Munich (and later of New York University), Robert Dell (Paris),

and Desmond MacCarthy. The honorary committee included the directors of the chief British public galleries, the widow of van Gogh's brother Theo, Clive Bell, a number of French and German collectors such as Count Kessler, Auguste Pellerin, Octave Mirbeau and assorted noble lords. The exhibition itself was superior even to its auspices. Cézanne, van Gogh, Gauguin, were represented by twenty or thirty works each. No insignificant artists were included, even among the living. By Matisse there were three oils: landscapes lent by Leo Stein and Bernard Berenson, page 308, and the *Girl with Green Eyes*, page 352, lent by another friend of the Steins, Miss Harriet Levy. Matisse was surpassed in number of canvases by Denis, Vlaminck, and Derain, but, curiously, was better represented in two other media than was any other artist, with no less than seven bronzes and twelve drawings.

The unsigned preface written by Desmond Mac-Carthy from notes provided by Roger Fry[3] is discerning, except for the dismissal of Seurat. Of Matisse "MacCarthy-Fry" writes:

In the work of Matisse, especially, this search for an abstract harmony of line, for rhythm, has been carried to lengths which often deprive the figure of all appearance of nature. The general effect of his pictures is that of a return to primitive, even perhaps of a return to barbaric, art. This is inevitably disconcerting; but before dismissing such pictures as violently absurd, it is fair to consider the nature of the problem which the artist who would use abstract design as his principle of expression, has to face. His relation to a modern public is peculiar. In the earliest ages of art the artist's public were able to share in each successive triumph of his skill, for every advance he made was also an advance towards a more obvious representation of things as they appeared to everybody. Primitive art, like the art of children, consists not so much in an attempt to represent what the eye perceives, as to put a line round a mental conception of the object. Like the work of the primitive artist, the pictures children draw are often extraordinarily expressive. But what delights them is to find they are acquiring more and more skill in producing a deceptive likeness of the object itself. Give them a year of drawing lessons and they will probably produce results which will give the greatest satisfaction to them and their relations; but to the critical eye the original expressiveness will have vanished completely from their work.

The development of primitive art (for here we are dealing with men and not children) is the gradual absorption of each newly observed detail into an already es-tablished system of design. Each new detail is hailed with delight by their public. But there comes a point when the accumulations of an increasing skill in mere representation begin to destroy the expressiveness of the design, and then, though a large section of the public continues to applaud, the artist grows uneasy. He begins to try to unload, to simplify the drawing and painting, by which natural objects are evoked, in order to recover the lost expressiveness and life. He aims at synthesis in design; that is to say, he is prepared to subordinate consciously his power of representing the parts of his picture as plausibly as possible, to the expressiveness of his whole design. But in this retrogressive movement he has the public, who have become accustomed to extremely plausible imitations of nature, against him at every step; and what is more, his own self-consciousness hampers him as well.

On the other hand so well-known and open-minded a critic as C. Lewis Hind had never heard of Henri-Matisse[4] until just before the exhibition opened when he was taken to see Michael Stein's collection in Paris. He was shocked, but within a year was looking back upon the *Girl with Green Eyes*[5] with enthusiasm. The public, however, was of course generally against the new artists in an unprepared London of 1910, but Matisse's paintings, and Picasso's too, were a rather mild selection by comparison with those which Roger Fry and his friends were to include in the second post-impressionist show two years later.

12 *New York, 1908-1910*

Matisse's work was first introduced to the American public under far happier circumstances than in Germany or England. Excepting a few friends of the Steins, New York in 1908 was almost totally uninformed about recent developments in French painting. Some collectors and a few museums in America had bought the impressionists with enthusiasm, in fact two Manets had entered the Metropolitan Museum in 1889, eighteen years before the Louvre would tolerate this subversive artist,[6] but Gauguin, van Gogh and even Cézanne were almost unknown. As for Matisse and the fauves they had had no more than casual mention in "letters from Paris" in magazines. For instance *The Nation* of October 29, 1908 published a brief account of the Salon d'Automne which had just opened: "Some of the younger artists," its correspondent reported, "have surprisingly good and new work, along with direct insults to eyes and understanding. Such is

Letter from Edward Steichen, Paris, January? 1908, to Alfred Stieglitz, New York. Courtesy Yale University Library, Alfred Stieglitz Collection. A complete transcript of the letter is printed on the opposite page

Henri Matisse, who forgets that beholders are not all fools. . . ." This unnamed journalist was apparently unaware that Matisse had already had an exhibition in New York early in the year.

Just before the Matisse show New York had been scandalized by a group of painters called "The Eight," who had held an exhibition at the Macbeth Gallery early in February. Artists such as Henri, Glackens, Sloan and Luks painted more or less in the style of Manet's more informal canvases of the 1860s. It was their shabby street scene and saloon subject matter more than their style that shocked the art-loving public and outraged powerful academic artists. They all felt that beauty had been betrayed. The Eight were called the "ash can school" and a "revolutionary black gang." Not only their taste but also, as so often happens, their morals and their politics were suspected by those who preferred the prettily painted still lifes, pleasant landscapes, fashionable portraits and idealized nudes which won prizes in the National Academy annuals.

Of course, as has been recounted, the Steins' enthusiasm for Matisse had been infecting a number of American students and visitors in Paris ever since Leo had brought home the *Woman with the Hat* from the Salon d'Automne of 1905. Even before that, in the winter of 1904-1905, Mabel Weeks had received a long letter from Leo about the modern movement in Paris, followed by others referring to Matisse.[7] Another friend of Leo's, Bernard Berenson, was to write before the end of the year a cogent answer, page 114, to *The Nation*'s Paris correspondent's just-quoted attack on Matisse; and George Of, a New York friend of the Michael Steins, had, as we have seen, actually bought a Matisse canvas in 1907, probably the only one in America for several years thereafter.

13 The First Matisse Show at "291," 1908

At the beginning of 1908 a third friend of the Steins, Edward Steichen, initiated a far more important event, the first Matisse exhibition in the United States, in fact the first Matisse one-man show outside of Paris. Steichen, then as now one of the best American photographers, was deeply involved in the Little Galleries of the Photo-Secession, more familiarly known as Alfred Stieglitz' gallery at 291 Fifth Avenue or, simply, "291." There the vanguard of photographers had for years been exhibiting under the devoted and courageous leadership of Stieglitz, who now wished to include other artists.

In January[8] Steichen, who was also a painter at that time, wrote Stieglitz:

Paris [no date (Jan? 1908)]

My dear A. S.—

I have another cracker-jack exhibition for you that is going to be as fine in its way as the Rodins are.

Drawings by Henri Matisse the most modern of the moderns—his drawings are the same to him & his painting as Rodin's are to his sculpture. Ask young Of about him.

I don't know if you will remember any of his paintings at Bernheim's. Well they are to the figure what the Cézannes are to the landscape. Simply great. Some are more finished than Rodin's, more of a study of form than movement—abstract to the limit. I'll bring them with me, and we can show them right after mine, if you can so arrange it. They were just show[n] in Berlin at Cassirer's.

Unless I get a cable from you not to come, count on me the first week in March as I think I will sail the 29th on the Provence. Hastily

Steichen.

This was followed by a cablegram dated Paris, February 4, 1908:

STIEGLITZ, 291 FIFTH AVE., NYK.

COMING END FEBRUARY ALSO BRINGING EXHIBITION MATISSE DRAWINGS—STEICHEN

The January exhibition of Rodin drawings at "291" had also been selected and sent over by Steichen. Rodin was at the time the most famous living artist—he had to be treated with respect in spite of the racy freedom of his draftsmanship and the unconventional poses of his models. Matisse was less well armored. Nevertheless, three months later, on April 1, 1908, Stieglitz sent out the following announcement:

An Exhibition of Drawings, Lithographs, Water-Colors, and Etchings by M. Henri Matisse, of Paris, will be held at the Little Galleries of the Photo-Secession, 291 Fifth Avenue (between thirtieth and thirty-first streets), New York, opening on April sixth and closing April twenty-fifth. The Galleries are open from ten A.M. till six P.M. daily, Sundays excepted.

Matisse is the leading spirit of a modern group of French artists dubbed "Les Fauves." The work of this group has been the center of discussion in the art-world of Paris during the past two to three years. It is the good fortune of the Photo-Secession to have the honor of thus introducing Matisse to the American public and to the American art-critics.

The show made a considerable stir, for it included not only a few watercolors of Collioure, some of them quite charming like the one reproduced on page 318, but also the bold figure lithographs of the 1906 series, page 324, and a number of uncompromisingly forthright figure drawings. Again, as was true of the attacks on The Eight, the public and most of the critics[1] were disturbed as much by the subject matter as by the technique.

J. Edgar Chamberlain[2] of the *New York Evening Mail* explained that "the 'fauves' are the French equivalent for the out-eighters of our Eight, and Matisse is their limit. . . ." Matisse's "idea is that you should get as far away from nature as possible. The artist should paint only abstractions . . . ideas in broad lines, splotches of color . . . a few broadly simple sketches are strangely beautiful, perhaps. Yet they are not beyond the power of any other trained artist. . . .

"And there are some female figures that are of an ugliness that is most appalling and haunting, and that seems to condemn this man's brain to the limbo of artistic degeneration. On the strength of these things of subterhuman hideousness, I shall try to put Henri Matisse out of my mind for the present." Elizabeth Luther Cary[3] of *The New York Times* conceded that "one or two of his views of water and shore . . . have a charm like that of broken snatches of song. . . . The drawings in the inner room . . . show a trained insight into problems of form and movement with a Gothic fancy for the ugly and distorted, many of them amounting to caricatures without significance."

The nameless critic[4] on *The Scrip*, June issue, was deeply and honestly perturbed. He felt that Matisse was "a great master of technique" but "like nearly all the other very modern Frenchmen . . . he feels that sickening malevolent desire to present

the nude (especially women) so vulgarized, so hideously at odds with nature, as to suggest . . . the loathsome and abnormal, and both with a marvel of execution and a bewildering cleverness that somehow fills one with a distaste for art and life.''

James Gibbons Huneker of *The New York Sun* was the most "sophisticated" of the American art critics of the period. Though he wrote in the tradition of 1890 estheticism his judgment of Matisse's drawings and lithographs was strangely moralistic.[5] "With three furious scratches he can give you the female animal in all her shame and horror," Huneker announced, shuddering. He was so put off balance that it does not seem to have occurred to him that what he supposed to be "memoranda of the gutter and brothel" were in fact simply studies of the model made by Matisse at Colarossi's or in his own studio; and that when he charged Matisse with "a cruel temperament" and "the coldness of moral vivisection" he was revealing his own reaction to an art of fearless visual and emotional honesty.

Yet in spite of its Anglo-American moralism there is, looking back, a good deal to be proud of in these responses to Matisse's first New York show. The Paris press in 1905 had in general been blinder and more violently hostile. Even so intelligent an artist-critic as Georges Desvallières had found Matisse's distortions extravagant, page 99. In any case very few if any of the American critics had announced that Matisse "could not draw"—at least not yet.

14 Berenson's Letter to The Nation, 1908

The New York critics were to have a second chance at Matisse's drawing within two years. Meanwhile, *The Nation* of November 12, 1908, published Bernard Berenson's vehement counterattack on its own Paris correspondent's remarks of October 29, page 111. It is worth quoting[6] in full:

DE GUSTIBUS

To the Editor of The Nation:

Sir:

In a note which appeared in your issue of October 29, regarding the autumn Salon at Paris, there occur the two following sentences:

"Some of the younger artists have surprisingly good and new works, along with direct insults to eyes and understanding. Such is Henri Matisse, who forgets that be-

holders are not all fools, and that it is not necessary to do differently from all other artists."

Will you allow one of the fools whom Matisse has thoroughly taken in to protest against these phrases? They are more hackneyed than the oldest mumblings in the most archaic extant rituals. There is nothing so hoary in the sacrificial Vedas. They have been uttered with headshakings in Akkadian, in Egyptian, in Babylonian, in Mycenaean, in the language of the Double-Ax, in all the Pelasgic dialects, in proto-Doric, in Hebrew, and in every living and dead tongue of western Europe, wherever an artist has appeared whose work was not as obvious as the "best seller" and "fastest reader." Of what great painter or sculptor or musician of the last centuries has it not been said in the cant phrase of the Boulevards—"C'est un fumiste. Il cherche à épâter le monde"?

Henri Matisse seems to me to think of everything in the world rather than of the need of "doing differently from all other artists." On the contrary, I have the conviction that he has, after twenty years of very earnest searching, at last found the great highroad traveled by all the best masters of the visual arts for the last sixty centuries at least. Indeed, he is singularly like them in every essential respect. He is a magnificent draughtsman and a great designer. Of his color I do not venture to speak. Not that it displeases me—far from it. But I can better understand its failing to charm at first; for color is something we Europeans are still singularly uncertain of—we are easily frightened by the slightest divergence from the habitual.

Fifty years ago, Mr. Quincy Shaw and other countrymen of ours were the first to appreciate and patronize Corot, Rousseau, and the stupendous Millet. Quantum mutatus ab illo! It is now the Russians and, to a less extent, the Germans, who are buying the work of the worthiest successors of those first mighty ones.

Boston, November 3. *B. Berenson*

Berenson, writing at the end of 1908, is strictly accurate about the Russians, but he might have pointed out that it was the Paris-American Steins who had led the way.

This letter, extraordinarily interesting in the light of Berenson's more recent contemptuous hostility toward 20th-century art as a whole, may well have made some impression on American critics of 1908 for "B.B." was already one of the most authoritative connoisseurs and historians of painting writing in English. And, on the more popular level, his four small volumes on Italian Renaissance painting had for some years superseded Ruskin in the pockets of cultivated American tourists.

When the second show of Matisse drawings brought by Steichen from Paris opened at "291," at the end of February 1910, the New York critics were more discerning, or at least more respectful. Huneker[7] lowered his hands which had been raised in horror at Matisse's "memoranda of the gutter" two years before and was now able to "forget their pose and pessimism and the hollow pits that serve for their ferocious eyes in the truth and magic of their contours. . . . In a word, an amazing artist, original in observation and a scorner of the facile line, the line called graceful, sweet, genteel; worse yet, moral. Men like Matisse . . . do good in stirring the stale swamp of respectability. . . . This exhibition is more instructive and moving than a century of academy shows."

Frank Jewett Mather of the *Evening Post* wrote a long review of Matisse as a draftsman, which equals Berenson's *Nation* letter of 1908 in enthusiasm and may well surpass any previous critical article on Matisse in any language for its objective analysis and sense of history. Louis Aragon's much later and much longer essay,[8] prefacing a series of Matisse's drawings, seems by comparison poetic and diffuse. Paragraphs from Mather's review are reprinted in Appendix E.

The lesser critics were not so convinced except Chamberlain of the *Evening Mail* who had completely changed his tune since 1908. He concluded his review[1] with the remark: "It is not really necessary to hate Matisse because one loves someone else. He is a man to study." Miss Cary of the *New York Times*,[2] still uneasy, said the drawings were "out of place in a public gallery" but would be appreciated "by every pupil at the Art Students' League," and Arthur Hoeber of the *Globe* was actively hostile—far less so, however, than were the academic artists, though they still believed Matisse would pass like a bad dream.

Among the visitors to the show was Mrs. George Blumenthal, first wife of the prominent collector of the art of the past, and future President of the Metropolitan Museum of Art. Stieglitz, who as usual was in watchful attendance at "291," well remembered what happened when she came, and told it in detail to Dorothy Norman.[3] Briefly, Mrs. Blumenthal asked the price of a drawing. Stieglitz informed her they were a hundred francs—twenty dollars—apiece. She picked out three, but Stieglitz,

with his quixotic contrariness, refused to let her buy them, thinking she would take them home to hang in her great mansion full of Gothic and Renaissance art. When she explained that she intended to give them to the Metropolitan Museum, Stieglitz was dumfounded. "What, the Metropolitan Museum of Art! Why, they'll never accept them." Mrs. Blumenthal drew herself up proudly. "The Museum will take what I offer it," she said. In that case, at least, the Museum did accept and furthermore hung the acquisitions for a while, for Stieglitz saw them there during the following year. These three excellent drawings, one of them reproduced on page 323, right, were probably the first works by Matisse to enter a public museum anywhere, excepting of course the early academic still lifes and copies of old masters bought by the French State during the 1890s and dispersed to provincial galleries.

Stieglitz' *Camera Work*, no. 32, October, 1910, reproduced two of the drawings, including the one we illustrate on page 323, left, which had already been reproduced, full page, the year before in the Moscow *Zolotoye Runo*. Under the heading "Photo-Secession Notes," *Camera Work* also reprinted many of the criticisms of the exhibition,[4] preceding the quotations by the following evaluation of the show:

MATISSE DRAWINGS

Coming at a time when the name, Matisse, is being used indiscriminately to explain the influence to which any painter at present may have succumbed whose work is un-academic, the exhibition of Matisse drawings, and photographs of his drawings, held from February twenty-seventh to March twentieth was most opportune.

The recent exhibition exemplified positively the power and sanity of the man, his scientific and almost mathematical attitude toward form, his almost Oriental sense of decorative spotting, so irreconcilably opposed to some of the more emotional tendencies for which critics have tried to make him responsible. "Influenced by Matisse" has become the common explanation of anything that seems queer, any departure from the old standards of artistic representation. The New York public was given a good chance for comparison and study in the exhibition which followed of the work of some of his supposed American disciples.

The exhibition of Matisse's "American disciples" referred to by *Camera Work* was held at "291" in March 1910 and included work by Hartley, Stei-

chen, Carles, Dove, Marin, Maurer, and Weber. Only one of them, Max Weber, had actually studied with Matisse. Of the others perhaps only Steichen and Maurer knew him personally. Some of the rest may have been influenced by him though Marin was still working as an impressionist, Hartley as a Ryderesque romantic. Yet, such was Matisse's fame in New York early in 1910 that these young painters were lumped together, and for the most part damned, under the label of "Matissites."

Guy Pène du Bois of the *New York American* wrote an angry protest[5] in which he deplored the "wide publicity given the name Henri Matisse, who, in reality, far from being the originator, the head of a new movement in art, is simply a disciple of Cézanne . . . Matisse, greater in ability, in power of speech, in perhaps magnetism, has dissected and divulged the older man's theories . . . so successfully as to have been awarded the spurs that rightly belong to Cézanne." He regrets the fate of the young Americans: "What individuality they have is immediately merged, literally swamped by the overpowering suggestion in the big letters of the name of Matisse." He points out, quite justly—and how Matisse would have approved!—that some of the young have gone over his head to "grandfather" Cézanne.

Du Bois, in the course of his complaint, exclaims: "We need here a comprehensive exhibition of the works of Matisse, and, better still, Cézanne. What an opportunity for the Metropolitan!"[6] But, with all the initiative and courage of "291," New York had to wait until 1913[7] to see Matisse's paintings and 1931[8] before it saw a really comprehensive exhibition of his work.

It must be remembered that Matisse's New York reputation in 1910 was based primarily upon his drawings, a few watercolor sketches, very few casual reproductions in periodicals, travelers' tales, and the work of such pupils as Weber or followers like Maurer. Had his oils been shown, the reaction would have been much more violent as we can guess from the opprobrium heaped upon Weber's 1911 exhibition at 291, "a brutal, vulgar, and unnecessary display." Berenson, who knew his work in Paris in 1908, could hail his mastery of drawing but had to add that "of his color I do not venture to speak." Mather, another art historian, praised his drawing to the skies—but Matisse's painting though "almost unknown" to him, he nevertheless suspected of "arbitrary caprice." So the New York battle of Matisse was a critical triumph which had to be won all over again when his most important work, his painting in oil, was seen at the "Armory Show" in 1913 and at the Montross Gallery two years later.

SECTION II MATISSE'S SCHOOL, 1908-1911

1 *The Original Class, 1908*

The idea of forming a class[1] to be taught by Matisse seems first to have occurred to both Sarah Stein and Hans Purrmann, page 59, in the fall of 1907. Well before that Mrs. Stein had been receiving criticism from Matisse and had invited Purrmann to share in this privilege. When they approached Matisse with the suggestion that the informal instruction given them should be extended to a class he agreed, though with some misgivings. Michael Stein was persuaded to help finance the undertaking and a large studio space was secured at a low rental in an expropriated convent, the Couvent des Oiseaux at 56 rue de Sèvres where, in a smaller room, Matisse himself had been painting since the end of 1905. There, very early in 1908, the "Académie Matisse" opened its doors.[2]

In addition to Sarah Stein and Hans Purrmann,[3] two young Americans, Max Weber,[4] brought by Purrmann, and Patrick Henry Bruce[5] were among the original group[6]; Leo Stein, Maurice Sterne, and Walter Pach were occasional visitors. Gertrude Stein[7] remembers how a French paper, making fun of Matisse and his class, asked rhetorically where all the students came from and then gave its own answer "from Massachusetts."

Though Americans were chiefly responsible for initiating and financing the school, there were, during the early months, just as many Germans. Purrmann was appointed *massier*, or studio monitor, and he brought his compatriots Oskar and Greta Moll and Rudolf Levy. Carl Palme[8] of Sweden writes that he also was a member of the original class, the first of many Scandinavians. Another of the early students was Joseph Brummer who had come from Hungary to study sculpture and had cut marble for

Rodin. The students seem to have paid tuition according to their means, but Brummer, later to become the greatest of American art dealers, was almost penniless and earned his fee by tending the stove and occasionally serving as model. Brummer remembered how Weber sometimes used to play the harmonium to his fellows in the new Académie Matisse. There may have been one or two other students when the class opened, making a total of not over ten, and all of them seem to have come together directly or indirectly through the Steins, all, that is except Jean Biette,[1] a friend of Matisse's from the days of the Académie Carrière, who, Purrmann recalls, also worked in the studio.

2 Growth and Decline of the School

There are many accounts—German, American, Scandinavian—of Matisse's school, and they differ considerably. It is clear however that from the beginning the class was a "success." Before the end of 1908 students were flocking to study with "le prince des fauves." By far the largest contingents were Scandinavian.[2] Besides Carl Palme there were about fifteen Swedes including Walther Halvorsen, Nils Dardel the sculptor, and Isaac Grünewald, author of a book on Matisse, bibl. 86, and generally considered the leading 20th-century Swedish painter and designer for the theatre. Of the ten or so Norwegians, Per Krogh later achieved the greatest international reputation. Among the additional Americans was A. B. Frost, Jr., son of the famous illustrator; and besides Joseph Brummer there were Czobel, Perlrot and Bereny among the Hungarians.[3] The later German contingent included Ahlers-Hestermann, Langer, Franz Nölken, Walter Rosam and Fräulein Vollmoeller.[4] There were also an Icelander Jon Stefanson, an Englishman Matthew Smith, who is now recognized as the best British colorist of his generation, von Tscharner a Swiss, and two Frenchmen, Albert Guindet and Pierre Dubreuil, who have remained obscure. Late in the spring of 1908 the school moved, along with Matisse and his family, to larger quarters in the former Couvent du Sacré Cœur on the Boulevard des Invalides. Purrmann moved too taking an apartment over the school.

Most French and German chroniclers of the class bring it to an end after the spring of 1909 when Matisse went south for the summer to Cavalière. They assume apparently that he no longer taught after he moved out of Paris to Issy-les-Moulineaux in the fall. Actually the class continued up to the summer of 1911 though Matisse no longer came every Saturday to criticize the week's work as he had at first. For a time the model kept the same pose for two weeks and Matisse paid the class a fortnightly visit. In the spring of 1911, Carl Palme[5] remembers, Matisse sent word more and more often that he could not meet his class, though both he and Grünewald agree that the class was at its largest during the preceding few months.

Grünewald estimates that altogether some 120 students[6] passed through the Académie Matisse from its beginning to its closing in 1911. He publishes a photograph of Matisse in the big studio on the Boulevard des Invalides surrounded by thirty-five of his pupils—a most interesting document,[7] for it reveals that a third of the class were women and that far from a company of wild-eyed young bohemians many of the students were mature men, some of them appearing to be almost as old as their master who was nearly forty at the time. Only one faced the photographer in shirt sleeves, but near him stands another in a frock coat! Carl Palme, who owns the photograph, writes that it was taken by the German painter Howarth in October 1910.

The Académie Matisse had grown too big—and perhaps too fashionable. There were, it seems, too many students who supposed that Matisse, because his own art was so unacademic, would offer them some short cut to mastery. Nothing, of course, could have been further from Matisse's intentions. His own attitude toward teaching, as toward art, was profoundly serious. Yet he was reluctant to impose a collective academic discipline on his students—he had too much belief in the value of cultivating the talent of the individual. He was equally determined not to tolerate superficial imitation of his own style by his students. Consequently, after four seasons, he decided he could no longer stand the strain of teaching, especially as it was making serious inroads into the time and energy required by his own arduous painting.

3 Matisse as a Teacher

There are many accounts of Matisse's teaching methods, notably Purrmann's, Grünewald's, the brief memoirs by Scandinavian painters published by Swane[8] and, most important of all, an heretofore unpublished record of Matisse's criticisms and injunctions taken down in the studio itself by Sarah Stein, Appendix A.

During the first year at least, Matisse would come to the studio every Saturday morning and stay all day criticizing the work which the students had done during the preceding week. The class worked from casts and from the model, like any other in Paris. Drawing and painting the figure and still life and modeling in clay were included in the curriculum. The snapshot of the sculpture class, page 22, was taken during the second year of the school after it had moved to the old Couvent du Sacré Coeur, Boulevard des Invalides. Some of Matisse's students such as Greta Moll and Nils Dardel were primarily sculptors but in this photograph Sarah Stein, Purrmann, Bruce and the Norwegian Heiberg were all primarily painters working in clay as a discipline. The model (Purrmann, who owns the photograph, says Matisse had worked from him in Moreau's studio) has taken a pose not unlike Matisse's own sculpture *The Slave*, page 305. Matisse is seen correcting one of the student's figures while the others look on. The close adherence to the model in all the students' work is evident.

Matisse's attitude as a teacher was clear from the opening day. Maurice Sterne, though he was not a pupil, accompanied Matisse on his first visit to the new academy. Sterne[1] remembers the occasion vividly. The students had been painting busily all week in preparation for the master's Saturday criticisms. When Matisse entered the room he was aghast to find an array of large canvases splashed with garish colors and distorted shapes. Without a word he left the atelier, went to his own quarters in the same building, and returned with a cast of a Greek head. This he put on a stand in the center of the class and told his students to turn their half-baked efforts to the wall and start drawing "from the antique." "Don't think you are committing suicide," Purrmann[2] remembers his exclaiming, "by adhering to nature and trying to portray it with exactness. In the beginning you must subject yourself totally to her influence. . . . You must be able to walk firmly on the ground before you start walking a tightrope!" According to Max Weber,[3] his was the only effort that received the master's commendation on that opening day: it was a modest sketch in subdued colors.

Another uncompromising little *académie* painted by Weber in Matisse's class early in 1908 is reproduced on page 22. It is modeled in fauve complementaries of orange and yellows in the lights, violets and blues in the shadows. Weber remembers that Matisse praised the vigorous drawing, especially of the legs.

Joseph Brummer described Matisse's atelier as "the severest in Paris, as I know from my visits there,"[4] yet though his classroom criticisms were very just and fair Matisse seemed reluctant to interfere.[5] Weber remembers him as almost overconscientious and somewhat ill-at-ease as a pedagogue. He always insisted on the fundamentals of drawing. Although he taught his own practice of modeling in complementaries, as Weber's study proves, he discouraged any but the most controlled use of color, reminding his pupils that "local color was beautiful, too."[6] No student, Maurice Sterne recalls, was permitted to paint a clothed figure before first drawing it in the nude in the same position. Matisse of course imposed the same discipline upon himself: Sterne once came upon him in the Louvre sketching from the large and populous Fra Angelico *Coronation of the Virgin*—in Matisse's rendering all the figures were nude.[7]

Matisse's teaching methods were in fact unexpectedly conservative and disciplinary. Besides criticizing their work in the studio he took his students occasionally to the Louvre to analyze the Poussins and Chardins just as Moreau had taken him fifteen years earlier. To the study of the Louvre, Matisse added the study of Cézanne, who he told his class was "the father of us all."

Yet, like Moreau, Matisse was deeply concerned about developing the students' independence and individuality. Purrmann recalls that he completed his warning about "tightrope walking" by remarking: "Of course, I think I could tell you whether you are walking on the rope or lying under it, but I don't think my telling you would be of any intrinsic value. You must take the controls into your own hands."

The most direct and complete record we have of Matisse as a teacher is comprised of the notes, Appendix A, taken down by Mrs. Michael Stein during the first year of his class in the Couvent des Oiseaux. They seem almost stenographic in character and though somewhat repetitious at times they throw authentic light not only upon Matisse's teaching but upon his own art as well. They are published here in their entirety through the courtesy of Mrs. Stein and Professor John W. Dodds of Stanford University.

SECTION III "NOTES OF A PAINTER," 1908

"*Notes d'un peintre*" was originally published in *La Grande Revue*, Paris, December 25, 1908. The painter Georges Desvallières is said to have initiated the article, which immediately made an impression in Paris and within a year was translated into Russian[8] and German.[8] The first complete English translation, by Margaret Scolari, was published in *Henri-Matisse*, Museum of Modern Art, 1931. It is reprinted here, together with paragraph headings which have been added by the editor for the convenience of the reader.

Quite aside from its historic importance and the light it throws upon Matisse's painting both before and after the article was published, *Notes of a Painter* remains Matisse's most complete and important statement about art.

NOTES OF A PAINTER BY HENRI MATISSE

THE PAINTER AS WRITER

A painter who addresses the public not in order to present his works but to reveal some of his ideas on the art of painting exposes himself to several dangers. In the first place, I know that some people like to think of painting as dependent upon literature and therefore like to see in it not general ideas suited to pictorial art, but rather specifically literary ideas. I fear, therefore, that the painter who risks himself in the field of the literary man may be regarded with disapproval; in any case, I myself am fully convinced that the best explanation an artist can give of his aims and ability is afforded by his work.

However, such painters as Signac, Desvallières, Denis, Blanche, Guérin, Bernard, etc. have written on such matters in various periodicals. In my turn I shall endeavor to make clear my pictorial intentions and aspirations without worrying about the writing.

One of the dangers which appears to me immediately is that of contradicting myself. I feel very strongly the bond between my old works and my recent ones. But I do not think the way I thought yesterday. My fundamental thoughts have not changed but have evolved and my modes of expression have followed my thoughts. I do not repudiate any of my paintings but I would not paint one of them in the same way had I to do it again. My destination is always the same but I work out a different route to get there.

If I mention the name of this or that artist it will be to point out how our manners differ so that it may seem that I do not appreciate his work. Thus I may be accused of injustice towards painters whose efforts and aims I best understand, or whose accomplishments I most appreciate. I shall use them as examples not to establish my superiority over them but to show clearly through what they have done, what I am attempting to do.

"EXPRESSION" AND "COMPOSITION"

What I am after, above all, is expression. Sometimes it has been conceded that I have a certain technical ability but that, my ambition being limited, I am unable to proceed beyond a purely visual satisfaction such as can be procured from the mere sight of a picture. But the purpose of a painter must not be conceived as separate from his pictorial means, and these pictorial means must be the more complete (I do not mean complicated) the deeper is his thought. I am unable to distinguish between the feeling I have for life and my way of expressing it.

Expression to my way of thinking does not consist of the passion mirrored upon a human face or betrayed by a violent gesture. The whole arrangement of my picture is expressive. The place occupied by figures or objects, the empty spaces around them, the proportions, everything plays a part. Composition is the art of arranging in a decorative manner the various elements at the painter's disposal for the expression of his feelings. In a picture every part will be visible and will play the rôle conferred upon it, be it principal or secondary. All that is not useful in the picture is detrimental. A work of art must be harmonious in its entirety; for superfluous details would, in the mind of the beholder, encroach upon the essential elements.

Composition, the aim of which is expression, alters itself according to the surface to be covered. If I take a sheet of paper of given dimensions I will jot down a drawing which will have a necessary relation to its

format—I would not repeat this drawing on another sheet of different dimensions, for instance on a rectangular sheet if the first one happened to be square. And if I had to repeat it on a sheet of the same shape but ten times larger I would not limit myself to enlarging it: a drawing must have a power of expansion which can bring to life the space which surrounds it. An artist who wants to transpose a composition onto a larger canvas must conceive it over again in order to preserve its expression; he must alter its character and not just fill in the squares into which he has divided his canvas.

THE "CONDENSATION OF SENSATIONS"

Both harmonies and dissonances of color can produce very pleasurable effects. Often when I settle down to work I begin by noting my immediate and superficial color sensations. Some years ago this first result was often enough for me—but today if I were satisfied with this, my picture would remain incomplete. I would have put down the passing sensations of a moment; they would not completely define my feelings and the next day I might not recognize what they meant. I want to reach that state of condensation of sensations which constitutes a picture. Perhaps I might be satisfied momentarily with a work finished at one sitting but I would soon get bored looking at it; therefore, I prefer to continue working on it so that later I may recognize it as a work of my mind. There was a time when I never left my paintings hanging on the wall because they reminded me of moments of nervous excitement and I did not like to see them again when I was quiet. Nowadays I try to put serenity into my pictures and work at them until I feel that I have succeeded.

Supposing I want to paint the body of a woman: first of all I endow it with grace and charm but I know that something more than that is necessary. I try to condense the meaning of this body by drawing its essential lines. The charm will then become less apparent at first glance but in the long run it will begin to emanate from the new image. This image at the same time will be enriched by a wider meaning, a more comprehensively human one, while the charm, being less apparent, will not be its only characteristic. It will be merely one element in the general conception of the figure.

Charm, lightness, crispness—all these are passing sensations. I have a canvas on which the colors are still fresh and I begin work on it again. The colors will probably grow heavier—the freshness of the original tones will give way to greater solidity, an improvement to my mind, but less seductive to the eye.

IMPRESSIONISM

The impressionist painters, Monet, Sisley especially, had delicate, vibrating sensations; as a result their canvases are all alike. The word "impressionism" perfectly characterizes their intentions for they register fleeting impressions. This term, however, cannot be used with reference to more recent painters who avoid the first impression and consider it deceptive. A rapid rendering of a landscape represents only one moment of its appearance. I prefer, by insisting upon its essentials, to discover its more enduring character and content, even at the risk of sacrificing some of its pleasing qualities.

THE ESSENTIAL AND PERMANENT

Underneath this succession of moments which constitutes the superficial existence of things animate and inanimate and which is continually obscuring and transforming them, it is yet possible to search for a truer, more essential character which the artist will seize so that he may give to reality a more lasting interpretation. When we go into the 17th- and 18th-century sculpture rooms in the Louvre and look for instance at a Puget, we realize that the expression is forced and exaggerated in a very disquieting way. Then again if we go to the Luxembourg, the attitude in which the painters seize their models is always the one in which the muscular development will be shown to greatest advantage. But movement thus interpreted corresponds to nothing in nature and if we catch a motion of this kind by a snapshot, the image thus captured will remind us of nothing that we have seen. Indication of motion has meaning for us only if we do not isolate any one sensation of movement from the preceding and from the following one.

There are two ways of expressing things; one is to show them crudely, the other is to evoke them artistically. In abandoning the literal representation of movement it is possible to reach toward a higher ideal of beauty. Look at an Egyptian statue: it looks rigid

to us; however, we feel in it the image of a body capable of movement and which despite its stiffness is animated. The Greeks too are calm; a man hurling a discus will be shown in the moment in which he gathers his strength before the effort or else, if he is shown in the most violent and precarious position implied by his action, the sculptor will have abridged and condensed it so that balance is re-established, thereby suggesting a feeling of duration. Movement in itself is unstable and is not suited to something durable like a statue unless the artist has consciously realized the entire action of which he represents only a moment.

COMPOSITION: EMPHASIS AND ORDER

It is necessary for me to define the character of the object or of the body that I wish to paint. In order to do this I study certain salient points very carefully: if I put a black dot on a sheet of white paper the dot will be visible no matter how far I stand away from it—it is a clear notation; but beside this dot I place another one, and then a third. Already there is confusion. In order that the first dot may maintain its value I must enlarge it as I proceed putting other marks on the paper.

COMPOSITION: COLOR

If upon a white canvas I jot down some sensations of blue, of green, of red—every new brushstroke diminishes the importance of the preceding ones. Suppose I set out to paint an interior: I have before me a cupboard; it gives me a sensation of bright red—and I put down a red which satisfies me; immediately a relation is established between this red and the white of the canvas. If I put a green near the red, if I paint in a yellow floor, there must still be between this green, this yellow and the white of the canvas a relation that will be satisfactory to me. But these several tones mutually weaken one another. It is necessary, therefore, that the various elements that I use be so balanced that they do not destroy one another. To do this I must organize my ideas; the relation between tones must be so established that they will sustain one another. A new combination of colors will succeed the first one and will give more completely my interpretation. I am forced to transpose until finally my picture may seem completely changed when, after successive modifications, the red has succeeded the green as the dominant

color. I cannot copy nature in a servile way; I must interpret nature and submit it to the spirit of the picture. When I have found the relationship of all the tones the result must be a living harmony of tones, a harmony not unlike that of a musical composition.

COMPOSITION: FIGURES

For me all is in the conception—I must have a clear vision of the whole composition from the very beginning. I could mention the name of a great sculptor who produces some admirable pieces but for him a composition is nothing but the grouping of fragments and the result is a confusion of expression. Look instead at one of Cézanne's pictures: all is so well arranged in them that no matter how many figures are represented and no matter at what distance you stand, you will be able always to distinguish each figure clearly and you will always know which limb belongs to which body. If in the picture there is order and clarity it means that this same order and clarity existed in the mind of the painter and that the painter was conscious of their necessity. Limbs may cross, may mingle, but still in the eyes of the beholder they will remain attached to the right body. All confusion will have disappeared.

COLOR AS EXPRESSION

The chief aim of color should be to serve expression as well as possible. I put down my colors without a preconceived plan. If at the first step and perhaps without my being conscious of it one tone has particularly pleased me, more often than not when the picture is finished I will notice that I have respected this tone while I have progressively altered and transformed the others. I discover the quality of colors in a purely instinctive way. To paint an autumn landscape I will not try to remember what colors suit this season, I will be inspired only by the sensation that the season gives me; the icy clearness of the sour blue sky will express the season just as well as the tonalities of the leaves. My sensation itself may vary, the autumn may be soft and warm like a protracted summer or quite cool with a cold sky and lemon yellow trees that give a chilly impression and announce winter.

My choice of colors does not rest on any scientific theory; it is based on observation, on feeling, on the very nature of each experience Inspired by certain

pages of Delacroix, Signac is preoccupied by complementary colors and the theoretical knowledge of them will lead him to use a certain tone in a certain place. I, on the other hand, merely try to find a color that will fit my sensation. There is an impelling proportion of tones that can induce me to change the shape of a figure or to transform my composition. Until I have achieved this proportion in all the parts of the composition I strive towards it and keep on working. Then a moment comes when every part has found its definite relationship and from then on it would be impossible for me to add a stroke to my picture without having to paint it all over again. As a matter of fact, I think that the theory of complementary colors is not absolute. In studying the paintings of artists whose knowledge of colors depends only upon instinct and sensibility and on a consistency of their sensations, it would be possible to define certain laws of color and so repudiate the limitations of the accepted color theory.

SUBJECT MATTER

What interests me most is neither still life nor landscape but the human figure. It is through it that I best succeed in expressing the nearly religious feeling that I have towards life. I do not insist upon the details of the face. I do not care to repeat them with anatomical exactness. Though I happen to have an Italian model whose appearance at first suggests nothing but a purely animal existence, yet I succeed in picking out among the lines of his face those which suggest that deep gravity which persists in every human being. A work of art must carry in itself its complete significance and impose it upon the beholder even before he can identify the subject matter. When I see the Giotto frescoes at Padua I do not trouble to recognize which scene of the life of Christ I have before me but I perceive instantly the sentiment which radiates from it and which is instinct in the composition in every line and color. The title will only serve to confirm my impression.

". . . LIKE A GOOD ARMCHAIR . . ."

What I dream of is an art of balance, of purity and serenity devoid of troubling or depressing subject matter, an art which might be for every mental worker, be he businessman or writer, like an appeasing influence, like a mental soother, something like a good armchair in which to rest from physical fatigue.

NATURE AND ART

Often a discussion arises upon the value of different processes, and their relation to different temperaments. A distinction is made between artists who work directly from nature and those who work purely from their imagination. I think neither of these methods should be preferred to the exclusion of the other. Often both are used in turn by the same man; sometimes he needs contact with reality before he can organize them into a picture. However, I think that one can judge of the vitality and power of an artist when after having received impressions from nature he is able to organize his sensations to return in the same mood on different days, voluntarily to continue receiving these impressions (whether nature appears the same or not); this power proves he is sufficiently master of himself to subject himself to discipline.

The simplest means are those which enable an artist to express himself best. If he fears the obvious he cannot avoid it by strange representations, bizarre drawing, eccentric color. His expression must derive inevitably from his temperament. He must sincerely believe that he has painted only what he has seen. I like Chardin's way of expressing: "I put on color until it resembles (is a good likeness)," or Cézanne: "I want to secure a likeness," or Rodin: "Copy nature!" or Leonardo: "He who can copy can do (create)." Those who work in an affected style, deliberately turning their backs on nature, are in error—an artist must recognize that when he uses his reason, his picture is an artifice and that when he paints, he must feel that he is copying nature—and even when he consciously departs from nature, he must do it with the conviction that it is only the better to interpret her.

TRUTH AND PLATITUDE

Some will object perhaps that a painter should have some other outlook upon painting and that I have uttered only platitudes. To this I shall answer that there are no new truths. The rôle of the artist, like that of the scholar, consists in penetrating truths as well known to him as to others but which will take on for him a new aspect and so enable him to master them in their deepest significance. Thus if the aviators were to explain to us the researches which led to their leaving earth and rising in the air they would be merely con-

firming very elementary principles of physics neglected by less successful inventors.

"THE RULES"

An artist has always something to learn when he is given information about himself—and I am glad now to have learned which is my weak point. M. Peladan in the "Revue Hébdomadaire" reproaches a certain number of painters, amongst whom I think I should place myself, for calling themselves "fauves" and yet dressing like everyone else so that they are no more noticeable than the floorwalkers in a department store. Does genius count for so little? In the same article this excellent writer pretends that I do not paint honestly and I feel that I should perhaps be annoyed though I admit that he restricts his statement by adding, "I mean honestly with respect to the Ideal and the Rules." The trouble is that he does not mention where these rules are—I am willing to admit that they exist but were it possible to learn them what sublime artists we would have!

Rules have no existence outside of individuals: otherwise Racine would be no greater genius than a good professor. Any of us can repeat a fine sentence but few can also penetrate the meaning. I have no doubt that from a study of the works of Raphael or Titian a more complete set of rules can be drawn than from the works of Manet or Renoir but the rules followed by Manet and Renoir were suited to their artistic temperaments and I happen to prefer the smallest of their paintings to all the work of those who have merely imitated the "Venus of Urbino" or the "Madonna of the Goldfinch." Such painters are of no value to anyone because, whether we want to or not, we belong to our time and we share in its opinions, preferences and delusions. All artists bear the imprint of their time but the great artists are those in which this stamp is most deeply impressed. Our epoch for instance is better represented by Courbet than by Flandrin, by Rodin better than by Frémiet. Whether we want to or not between our period and ourselves an indissoluble bond is established and M. Peladan himself cannot escape it. The estheticians of the future may perhaps use his books as evidence if they get it in their heads to prove that no one of our time understood a thing about the art of Leonardo da Vinci.

SECTION IV STILL LIFES AND INTERIORS, 1908-1910

1 Summary

Matisse painted very little in the fauve style after 1907, as has been remarked. *Le luxe, II*, probably completed before the end of the year, virtually belongs to the big figure compositions which begin in 1908 with the *Bathers with a Turtle*, page 357, and come to a climax with the *Dance* and *Music* of two years later, pages 362-364. The *Red Madras Headdress*, page 350, the first of the great post-fauve portraits, was also very likely painted before the end of 1907. It initiates a long and notable series which concludes with *The Manila Shawl* of early 1911, page 355.

The equally remarkable sequence of still lifes begins with two compositions in which sculpture is the chief motif, page 342, and culminates with a group of noble canvases, the best known of which is the Munich *Still Life with Geraniums* of 1910, page 349. Towering above the dozen still lifes and epitomizing the contrast between florid decoration and austere monumentality which characterizes them as a group are the two very large interiors, the *Harmony in Red*, page 345, and *Conversation*, page 347, both completed in 1909 and both acquired by Sergei Shchukin.

2 Still Lifes, 1908

Perhaps the most fauve of the paintings of 1908 is the dated *Still Life with a Greek Torso*, page 342. The foreground composition with its North African vase rising above flat yellow lemons reminds one of the *Pink Onions* of 1906, page 76; even the pink torso of "Theseus" is quite fauve in color. But the other still lifes of 1908 do not resemble their fauve predecessors at all.

The greatest of Matisse's previous table-scape compositions, the *Blue Still Life* of 1907, page 331, was already post- or extra-fauve in its monumental Cézannesque composition in shallow depth, its sense of solid forms and its acceptance of local color, at least by comparison with the typically fauve *Oriental Rugs* of 1906, page 329. In the Oslo *Sculpture and Persian Vase* of 1908, page 342, Matisse carries his perspective deeper than in the *Blue Still Life*, in

which depth is limited by a screen and curtain close behind the table. The same screen appears in the Oslo still life but it is set well back and away from the table while the wall at the left recedes on an abrupt diagonal as in many Japanese prints. The whole composition is in fact based on active counterthrusting diagonals beginning with the forward edge of the table. The lack of decorative patterns, the deep perspective and the emphasis on the powerful forms of the terra cotta figure mark a brief moment of painting solid forms in deep space before the artist began to move in the opposite direction.

The general effect of the *Still Life in Venetian Red*, page 343, with its decorative patterns and flattening of space, contrasts strikingly with the *Sculpture and Persian Vase*. The eye is brought close to the objects on the rug; at the same time the rug appears to be pulled up from above by unseen hands, thereby further flattening the space and seeming almost to tip the objects forward against the picture plane. Yet, paradoxically, the objects are vigorously foreshortened and modeled so that their solidity seems to conflict with the apparent instability of their position in space. Thus Matisse, perhaps without conscious intention, maintains the apparent mass of the still-life objects even while moving further toward the all-over decorative patterning which characterizes most of his still lifes of this and the next two years.

3 *The* Harmony in Blue, *1908*

The culmination, though not the extreme point, of this development is the great *Harmony in Red*, page 345, one of Matisse's most magnificent paintings and one of the chief glories of the Museum of Modern Western Art in Moscow. The Moscow catalog lists it as *La chambre rouge, The Red Room*. It has also been called *Harmonie rouge*, the *Dinner Table*, *La desserte* and, in its first state, *Panneau décoratif pour salle à manger*.

The history of this big canvas is extraordinary, for it was apparently first painted as a green composition which Matisse later referred to as the *Harmony in Green*,[1] (*Harmonie verte*); then it was repainted, sold to Sergei Shchukin and publicly exhibited in a second version, the *Harmony in Blue*, page 344, (*Harmonie bleue*); ultimately it was largely repainted again and delivered to the owner in its final version which, for convenience, we have called *Harmony in Red*.

Apparently Matisse began, or at least conceived,

the painting in the spring[2] of 1908. As has been noted on page 46, the subject is of course almost the same as the large *Dinner Table* or *La desserte*, page 299, which marked the turning point in Matisse's career at the Salon de la Nationale of 1897. In the *Harmony in Blue*, page 344, the artist has moved his position so that the table is parallel to his picture plane and he can look out of the window at the left and see the trees in the ex-convent garden. The white-aproned servant is shifted farther to the right and one of the chairs is moved down front to the left of the table while the other remains behind it. The table is much less profusely furnished, a few scattered fruits, two carafes and two fruit dishes, one of them apparently the same curious *compotier* with the flower vase in the middle which the maid tends in the early picture. Unquestionably Matisse set out deliberately to paint again in his new style the old subject over which he had labored so long and which had caused him such critical difficulties a decade before.

The *Harmony in Blue* is also closely and significantly related to the *Blue Still Life*, page 331, which he had painted the year before and which could offer him a far more serious trial of strength than his *La desserte* of 1897. The table in the *Blue Still Life* is placed in the same perspective and is covered with the same pale blue[3] "*toile de Jouy*" cotton ornamented with blue arabesque branches winding between blue baskets of blue flowers. The backgrounds of the two pictures are similarly divided: the left-hand third of the earlier picture is a panel of a screen with floral ornament which corresponds roughly to the window with shrubs and flowering trees. Yet beyond these resemblances in subject matter and general arrangement there is little similarity between the two canvases but, on the contrary, a striking contrast.

The receding rectangular plane of the table top in the *Blue Still Life* is emphasized by perspective; depth is further indicated by cast shadows on the background; the fruit and vase are solidly modeled, for the most part with a definite sense of light direction. But the *Harmony in Blue* does away with all sense of light, all modeling and all shadows (except on the maid's neck). With one melodramatic exception local color is carefully preserved, but it is applied to surfaces which are deprived of all play of light and all texture. Linear perspective and foreshortening are retained but they are almost neutralized through one astonishing device: the color and

bold pattern of the tablecloth in the foreground is carried over the entire background wall with scarcely any diminution in value or scale. This fantastic wall of course did not exist: it was invented by the arbitrary continuation of the tablecloth. The result, optically, is to bring the background forward to the same plane as the foreground; at the same time the foreshortening of the table, chairs, and platters suggests space in depth. Consequently an optical anomaly or contradiction is set up, more complex and more subtle for instance than that of the *Still Life in Venetian Red*, page 343, in which the rug seems pulled up behind the solidly modeled objects. The esthetic value of this conflict or tension lies in the fact that it helps keep such paintings as the *Harmony in Blue* from becoming merely decorative. Matisse himself might not have accepted this justification for he was making clear at this very time in his *Grande Revue* statement, page 119, that he thought of himself as working toward harmony, that is toward the elimination of tension, discord and inconsistency.

In any case the extension of the tablecloth color and pattern to cover the entire background wall in the *Harmony in Blue*—and later *in Red*—is the most radical and far-reaching innovation Matisse had made up to that time. His fauve paintings had of course been extremely arbitrary in color; the wall in the *Open Window*, page 73, for instance passes from violet through greens and blues back to violet; and the face in the *Madame Matisse*, page 75, is divided between ochre and pink by a broad pea-green line. But these mutations, bizarre and bold as they may have seemed, occur in a style in which no local color was safe thanks to the previous disintegration of color by light as observed or conceived by the impressionists and Neo-Impressionists. For over a year before the *Harmony in Blue* Matisse had been gradually abandoning the licentious catch-as-catch-can of fauve color. The *Blue Still Life* and *Le luxe, II* of 1907, even the *Pink Onions* of 1906, page 76, are generally faithful to the "normal" local color of the objects represented, however simplified or flattened they may be. Similarly in the *Harmony in Blue* the face of the maid is flat over-all flesh colored, her hair light brown, her apron white; the grass through the window is green and the fruit tree blossoms white. Even the reflecting surfaces of the wine in the two carafes are carefully modified in color and value in relation to the local color of the wine, whether red or white. Yet with all this humili-

ty toward the "real color" of the objects, Matisse suddenly and arrogantly turns every surface in the room excepting those of the objects into an overwhelming pattern of dark blue arabesques and baskets on pale blue. Thus were conventional concepts of color—as well as of perspective and foreshortening—traduced and transcended in one dramatic gesture.

4 *The* Harmony in Red, *1909*

Harmony in Blue is no longer visible, so that we cannot compare it with the painting which largely covers it, the *Harmony in Red*, page 345. Fortunately the first version was carefully photographed by Druet at the time of the Salon d'Automne in October 1908 when it was exhibited as "No. 898. *Panneau décoratif pour salle à manger*, p. (app. à M. Sch.)" which translated and disabbreviated would read: *Decorative Panel for a Dining-Room*, painting (belonging to Mr. Shchukin). Sergei Shchukin had in fact bought the *Harmony in Blue* out of Matisse's studio before the opening of the Salon. But Matisse, doubtless studying the big painting on the walls of the Salon, began to be dissatisfied with it. When the Salon was over he asked Shchukin to let him keep it for a while and during the early months of 1909 he repainted large areas.

It has been supposed that the transformation of the *Harmony in Blue* into the *Harmony in Red* might have been carried out at the request of Shchukin. Matisse has denied this, as he has also denied the suggestion that the *Harmony* paintings were done to demonstrate his theories as propounded in *La Grande Revue*, which we reprint on pages 119 to 123. It is true that this manifesto was published in December 1908 and was doubtless written between the completion of *Harmony in Blue* and its subsequent repainting but Matisse states that the transformation was undertaken simply "to satisfy my desire for a better balance of color."[4]

The chief change Matisse made in revising the *Harmony in Blue* was, of course, to change the pale blue of the tablecloth and wall into one great sheet of brilliant cherry red—a tone completely uniform in value by comparison with the original blue which is slightly darker on the wall than on the table. He says that as usual when repainting he erased the entire area with turpentine.[5] Yet there are many traces of the original light blue left (intentionally one assumes) around the edges of the dark blue ornament which is almost untouched. Most of the

objects on the table and the chairs are also left virtually intact but the maid is largely repainted, including her shirtwaist which is now a very dark blue, and the flowers, dark red carnations and freesias, have been retouched. The landscape seen through the window is changed in one respect, thanks to a dramatic incident in the weather. A late snow fell while the fruit trees in the convent garden were still in bloom and turned the white-flowered trees still whiter.[6] The heightened contrast between the all-white trees and their green background serves to maintain the strength of this landscape rectangle against the intensified color of the interior of the room.

5 *The* Conversation, *1909*

In the fall of 1909, shortly after Matisse and his family had moved to Clamart from their home on the Boulevard des Invalides, the artist painted a second interior, the *Conversation*, page 347, which is as large and, in its way, as important as the *Harmony in Red*. Yet in spite of its size and striking design the *Conversation* is almost as unknown to younger students of Matisse as the *Luxe, calme et volupté* of 1905. Painted in 1909 it was apparently neither purchased nor exhibited nor even photographed until 1912, when Shchukin bought it and, before taking it to Moscow, lent it to Roger Fry's Second Post-Impressionist Exhibition in London in the fall of the year. Fry reproduced it in the catalog, bibliography 117. It has apparently never since been reproduced in any book or article about Matisse to this day.[7]

The *Conversation* might have served as a pendant to the *Harmony in Red*, since the two are identical in size and similar in technique. Both show an interior space with a window which occupies about the same area in the background wall. Through the window one sees a garden with trees and a building in the distance, and blossoms dotting the ground. In the *Conversation* the blossoms have grown from flowerbeds rather than having dropped from fruit trees. The drawing of the figures is similar in both pictures too: highly simplified and flat in tone with only a modicum of shading about the heads.

Matisse did not, however, deliberately paint the *Conversation* as a pendant to the *Harmony in Red*. Yet, if not precisely a pendant, it is hard to believe that the *Conversation* was not painted partially as a reaction to the *Harmony in Red*. The color, predominantly a deep blue, is comparatively sober, the composition austere and monumental. Ornament, instead of spreading throughout the canvas like a rank tropical vine, is confined to the wrought iron arabesque of the window rail and the pale stripes of the man's clothing.

When asked recently about the *Conversation*, Matisse stated simply that he had wanted to try his hand at a large composition. The figures are not intended as portraits of specific personalities though he confides that the models were, as a matter of fact, Mme Matisse and himself.[8]

Yet in spite of the artist's disclaimers and its highly abstract style, there is a curious muffled psychological life about this big painting. "Conversations" are extremely rare in Matisse's art as a whole, though several paintings of 1941 bear this title. Occasionally people bathe or dance or make music together, more rarely play a game or make love, but never,[1] or hardly ever—except in this picture—do they look one another in the eye!

6 *The Extreme Arabesque*

To return to the series of still lifes, the *Coffee Pot, Carafe and Fruit Dish* of 1909, page 346, carries to an extreme, for this period, Matisse's interest in animating the whole canvas with an active all-over arabesque. Superficially, this painting is an epitome of the *Harmony in Blue* with the chairs, window view and maid left out. To judge from our photograph, the pot, the carafe and the bowl of fruit seem overwhelmed by the flamboyant rhythm of the textile against which they are flung—the same cotton print, of course, which appears in the *Blue Still Life* of 1907 and dominates the *Harmony in Blue*. Only the angle of the textile's edge at the extreme right indicates clearly that it is performing its accustomed double role of table covering and backdrop—just as did the rug in the *Still Life in Venetian Red*. Actually, this photograph is misleading: in the original the three objects are not overwhelmed but hold their own like a trumpet and two woodwinds against a string orchestra. They are much warmer in color than the surrounding light and dark blues and, unlike the objects in the *Harmony in Blue*, they are strongly modeled with sharp high lights so that they count as volumes against surface, as one may see even on a tiny scale in the photograph of the Shchukins' Matisse room, page 25.

Matisse's chronic struggle between all-over pattern and modeled forms, between two and three dimensions, between "decoration" and "reality," is

well seen in these still lifes of 1908 and 1909. The conflict was to continue through the years to come and was often to be enriched by the struggle between the active and the static and between simplification and elaboration.

7 Matisse's Still Life as Drama

The esthetic problems raised by these still lifes of 1907-1909 and the bravura and magnificence of Matisse's solutions tend to obscure a comparatively humble and often neglected factor: Matisse loved the objects he painted. Whether they are the everyday furnishings of the dining table—flowers and their vases, fruits on their high-stemmed dishes, pots, jugs and flasks—or objects from his African and Levantine collections, or the terra cottas and plasters of his sculpture, he bore them affection and respect. He was interested not only in their sensual and esthetic qualities and the possible relationships among them but also in what might be called their characters and personalities.

The still lifes of his first fifteen years as a painter had been dominated first by Chardin, then by Cézanne. But the liberation of his style during the fauve period is accompanied by a growing originality of choice and arrangement of material in his still life. The piquant *Pink Onions*, page 76, and the *Asphodels*, page 330, lead to such post-fauve juxtapositions as the delicate little Persian ewer approaching the robust forms of the terra cotta woman, page 342, or the same ewer dwarfed among the disparate congregation of a fat brass vessel, plaster statuette, Chinese jar, beer tankard and coiling embroidered belt, page 343. The predicament of the copper pot, the wine carafe and the *compotier* struggling to keep their footing in the Baroque undertow of Matisse's favorite figured table cover, page 346, has already been noted; and the Algerian jug shepherding a flock of lemons past the form of a reclining river god from the Parthenon pediment should not be overlooked, page 342.

The wit and drama of Matisse's still life may have been largely unconscious, yet one should remember his remarks to his class taken down by Sarah Stein during this very period: "To copy the objects in a still life is nothing; one must render the emotion they awaken in him. The emotion of the ensemble . . . the specific character of every object—modified by its relation to the others . . . the tear-like quality of this slender fat-bellied vase—the generous volume of this copper must touch you . . ." Appendix A.

8 Still Lifes, 1909-1910

After the *Coffee Pot, Carafe and Fruit Dish*, Matisse did not soon again carry to such an extreme his tendency toward all-over decorative pattern, except in the *Fruit and Bronze*.[2] The still lifes of 1910 include large quiet areas which serve as a foil to and relief from ornamented surfaces. Certain paintings such as the Copenhagen *Goldfish*, page 348, and the *Red Commode*[3] contain a minimum of decorative elements as if in reaction against previous excesses.

The *Still Life with the "Dance,"* page 346, painted late in 1909[4] balances plain and ornamented areas with exceptional virtuosity. The picture is constructed with "Japanese" perspective diagonals which Matisse had not used since the *Sculpture and Persian Vase* of 1908. The three principal fields of the composition are enlivened with strongly contrasting motifs. The horizontal rectangle of the table cover with its floral pattern is broken by a miscellany of objects; the vertical rectangle of the *Dance* with its rhythmic design is interrupted by the flowers which link it, visually, to the table top. The commotion on these two planes is relieved by the severely squared-off vertical and horizontal slats of the stretcher-back at the right. Though smaller in area, the stretcher holds its own by the simplicity and sharp light-and-dark contrasts of its design. The awkward juncture of these three planes is ingeniously masked yet emphasized by the oblong box on the table's edge. The plain-colored cloth in the foreground of the table cover echoes the curving mound in the foreground of the *Dance*. Thus Matisse develops and relates a three-part polyphony on three different instruments.

Matisse had often used his own sculpture and a great variety of *objets d'art* in his paintings but this is the first time he had incorporated one of his own paintings as an important motif. The canvas in this still life is a full-sized study for the *Dance*, page 360, the great decoration which Shchukin had commissioned. It appears again in the Worcester and Moscow versions of *Nasturtiums and the "Dance"* of 1912, pages 382, 383. A photograph on page 23 shows Matisse at work on the *Still Life with the "Dance,"* the *Dance* in the background and the stretcher of another big canvas at the right.

The Copenhagen *Goldfish*, page 348, painted in 1910 or late in 1909, appears to have been a sudden and complete reaction against the florid complexities of the still lifes of 1909. On a dimly lit, absolutely plain deep purple table top set against a

background band of puce, Matisse has arranged three objects. In a bowl of dark indigo-colored water, against three vertical pink reflections and beneath a pink surface, swim three scarlet fish. To balance the fish bowl, Matisse has placed on the other side of the canvas his favorite sculpture of a reclining woman, dusty terra cotta in color. Between these two bizarrely disparate but bulky shapes stands a third, a fragile bouquet of pink, vermilion, and ochre flowers with bright green leaves rising from a blue vase on a pale blue plate. The general effect of the background is a very dark monochrome so that the brilliant isolated colors gleam like precious stones and enamels against a jeweler's velvet. This still life is a kind of nocturne in which the objects seem to shine with their own light. Later Matisse was to paint the same constellation with admirable but not quite such magical effect, pp. 165, 385.

More renowned even than the Copenhagen *Goldfish*, partly because it was the first post-academic Matisse to enter a public museum, is the *Still Life with Geraniums*, page 349, of the Neue Staatsgalerie in Munich. Here the deepening and opening up of space, already apparent in the *Still Life with the "Dance"* of 1909, is further developed. The foreground and background are tied by a great S-curved cascade of figured drapery which swings down from the top of the wall and spills forward over the table to the floor. This grand movement embraces the pot of brilliant flowers and is stabilized by the regular rhythm of the vertical palings in the background. The same studio wall appears again in the *Red Commode* of 1910 bought by Shchukin and now in the Moscow Museum. This and Morosov's handsome still life, *Fruit and Bronze*, also of 1910, have already been mentioned.

SECTION V PORTRAITS, 1907-1911

1 Characterization and Style

Most of Matisse's portraits, at least of this period of 1908-1910, are scarcely portraits at all in the strictest sense of the word. Like the portraits of Cézanne they are not so much characterizations on a psychological level as realizations of form. The only portrait which was actually commissioned, that of Greta Moll, page 351, in spite of the sitter's strong features seems no more psychologically penetrating than the *Girl with Green Eyes*, a study of a model, page 352. One cannot even assume that the physiognomy of the sitter has been recorded with any degree of accuracy. For instance at the beginning of the series, Mme Matisse, with a red kerchief around her head, page 350, has a rather small tipped-up nose. Two or three years later she appears in a Manila shawl with a long heavy straight nose, page 355. Yet, to quote the title of a homily Matisse was to deliver years later,[5] "Exactitude is not Truth," and these ten or so images of women among Matisse's family and friends and models remain among the most vivid and memorable portraits of the period.

The preceding portraits of the fauve period are so various in character that, although two of them are among the most important fauve pictures, seen as a group they seem completely absorbed in the general rather confusing formal and technical prob-

lems of Matisse's fauve painting rather than a series of related solutions of a specific problem. The *Woman with the Hat*, frontispiece, and the *Madame Matisse*, page 75, both of 1905, the artist's *Self Portrait* of 1906, page 333, and the portrait of Marguerite of the same year, page 332, differ so greatly that it is hard to assimilate them into the work of one man within so short a period. The portraits of 1908-1910 on the other hand form a consistent series in which the composition of the figure in relation to the background and to the rectangle of the picture is carefully studied and at times brilliantly solved. The sequence moves in general from compositions in which a figure is elaborated against a plain background, through paintings in which the sitter competes with the background, and then, following roughly the sequence of the still lifes of the period, a return to portraits in which the figure completely dominates the canvas.

2 The Red Madras Headdress, *1907*

The earliest, the most striking and certainly the best known of the series is the portrait of Mme Matisse wearing a turban of Indian cotton. The *Red Madras Headdress*, page 350, is usually dated 1908 or even later but was probably done toward the end of 1907. In style it seems closer to such portraits of the fauve period as *The Young Sailor*, second version,

page 335, and the *Marguerite* of 1906, page 332, than to the *Greta Moll* of 1908.

Like *The Young Sailor, II* and *Marguerite*, the *Red Madras Headdress* is painted very directly and simply against a plain background. The figure is left flat with only the slightest modeling. Within this flat silhouette the features and drapery folds are indicated with a few broad superimposed lines. There is somewhat more indication of light and shade on the hands and neck but in general the technique is that of line and flat tone used, for instance, in Japanese prints and Near Eastern ceramics which at that time Matisse was studying and collecting with increasing interest.

The *Red Madras Headdress* differs markedly and significantly from the fauve period portraits through Matisse's bold use of figured textiles: active yellow vermiculations on the vermilion headkerchief, orange leaf patterns on the dark blue gown, and lively black-and-white spots on collar, cuffs and girdle. These three kinds of ornament together with the two tear-shaped, organically patterned areas formed by the hands and the head play their counterpoint against a light blue background.

The figure itself is seated in an active counterpoise forming a strong curving diagonal which is opposed by an answering diagonal axis established by the hands and head. The effect is more brilliant and confident than any of the fauve portraits. At the same time it anticipates such decorative compositions of 1908 as the *Still Life in Venetian Red*, page 343, and the *Harmony in Blue*, page 344.

3 The Greta Moll *and Other Portraits,*
1908-1909

The very same flowered cotton print which provides the dominating motif in the *Harmony in Blue* does in fact appear as the background in the portrait of Matisse's pupil, Greta Moll, page 351. Here, reversing their roles in the *Red Madras Headdress*, the background is active, the sitter's costume subdued. The plain black skirt and the white shirtwaist support a head which struggles for survival against the strong patterns of dark, bright and pale blue—though the contest is actually less critical in the original than in the photograph, for the warm brown hair and flesh tones are generally complementary to the cold blues. Furthermore the features are more strongly modeled than those in the *Red Madras Headdress*, and this tends to rescue them

from the background just as the three objects in the *Coffee Pot, Carafe and Fruit Dish*, page 346, hold their own against the same patterned background partially through their three-dimensional rendering.

Fortunately Frau Moll has written[6] a valuable account of how Matisse painted this portrait:

Now I shall tell you how he came to paint my portrait. Corinth had painted me the summer before we went to Paris. About Christmas time we received a reproduction of the painting which we also showed to Matisse. He did not like the picture at all. He complained especially that my youthfulness did not show in it. Finally he said he wanted to do it better and since we also enjoyed the idea and could afford it we arranged that if we liked it we could get it for 1000 francs.

For the portrait I sat ten times, three hours each. When I came for the eleventh time it was finished. At first we tried out various things: with the white blouse and the large patterned blue-white cloth, "ça prend une grandeur merveilleuse" he assured me. He then told me that he was placing the canvas so that I could not watch him, since he wanted to show me the picture only at the end. It is one of the few pictures which he painted in wax[7] colors. Although I could not see the picture I watched his palette and since I knew what he was painting I found it very interesting to watch how always when he altered one color he felt forced to change the whole color scheme. The blouse which ended up greenish was at one time lavender-white. Even the black skirt was once colored yellow or greenish. . . .

I saw the picture after the tenth sitting and liked it very well. I cannot say whether it was a better likeness than the Corinth picture, but in spite of the long time he worked on it, it appeared freshly and fluently painted. But only afterwards did it receive its final vigor and form. Matisse was not satisfied. For consolation and to receive new inspiration he went to the Louvre and we had a few days' rest. There he found the Veronese portrait (not with a white blouse, that is not true). But the lady had her arms in front of her the same way I did, though her arms were rather full and round. He took them over for my portrait so that as usual he had to change the entire picture. "Ça prend une splendeur inouïe." Matisse was satisfied now and he asked us to come to see the new painting. Later on I did not notice it any more but at the first the fat arms and the heavy eyebrows I had got bothered me. We took the picture. . . .

The *Greta Moll* is on the whole more subtle and restrained than the *Red Madras Headdress*, more complex and "painterly"— for instance in the ren-

guarding her pale face with its bright green eyes. The *Girl with Green Eyes* is remarkable among Matisse's portraits for its charm of subject, color verging on prettiness and especially for its richness of pigment.

The years 1908-1909 do in fact provide a kind of oasis in Matisse's art so far as surface "quality" is concerned. Matisse has always been capable of painting with considerable sensuality of surface, but he rarely did, except for brief periods such as 1901-1903, the years now under discussion, 1918-1919 and 1926-1931. Most fauve paintings[8] have little surface quality; post-fauve works, such as *Red Madras*, for all its richness of effect, are dry and matt in surface, and so are most of the paintings of 1910 and almost all of 1911.

In the *Spanish Dancer*, page 352, the painting is again heavy and rich but the composition as a whole marks a turning point toward simplicity. In this study of a model as well as in the *Girl in Green*,[1] also in Moscow, the figures are painted against monochrome as if in reaction against the assertive backgrounds of the earlier *Greta Moll*, the *Algerian Woman*,[2] and the *Girl with Green Eyes*. Like the *Algerian Woman*, the *Spanish Dancer* is a striking, exotic subject presented with a vigor of drawing and brushing which approaches coarseness.

The little portrait of Pierre Matisse, page 354, at the age of nine, was painted, parenthetically, at Cavalière during the summer when Matisse was wrestling with ideas for the Shchukin murals. Pierre's sailor's jersey is perhaps a reminiscence of his father's *Self Portrait* of 1906, page 333, but the subtle characterization obtained by the simplest means recalls the portrait of Marguerite, page 332.

4 Three Portraits of 1910

The portraits of the following year, 1910, are more consistent and confident in style. Three of them present a three-quarter-length figure against a very simple background cut into two abstractly monochrome areas by a "floor line" slightly tilted off the horizontal. In each picture this tilting background line is subtly used to balance other diagonals in the composition.

The portrait of *Olga Merson*, page 353, is perhaps the most beautiful of the three in color. The sitter's red hair and her dress, a transparent sea-green glazed over white, are played against a background of blue and orange-brown. The "unfinished" paint-

dering of the dark green undergarment beneath the sheer white blouse. And obviously it is a more attentive characterization. The same may be said generally of the portrait of a pretty model, the *Girl with Green Eyes* painted in 1909, page 352. Here the figure is demurely frontal in pose, shifted only a little to the left to avoid a static, axial symmetry. But though the pose is quieter than that of the *Greta Moll*, not to mention the *Red Madras*, the activity of color and pattern in the *Girl with Green Eyes* is carried through *both* costume and background. The bright orange embroidered Chinese robe is seen against red to the left, green to the right. Instead of a figured textile behind the head, Matisse has placed a shelf of objects—his cast of a Parthenon torso and three strongly ornamented vases—against a light green background. The head of the model rises between these active shapes, her auburn hair

ing of the face and the great black arc streaking down the torso from chin to thigh have been criticized as evidence of failure or at least of incompleteness. The black curve does perhaps suggest an impatience, a last-moment gesture of dissatisfaction on the part of the artist. Compositionally the curve is concentric with the shorter curve of the back, and the two curves together cut across the axis of the thigh almost at right angles, forming both a counter-diagonal and a counter-curve to the sweep of the seated body. At the same time, this slashing curve is perhaps the boldest innovation in form—as distinguished from color—that Matisse had made up to this moment.[3] It is as arbitrary as some of the linear devices which the cubists were developing at that time. At one scimitar-like stroke it seems to break the image, to remove it from ordinary visual conventions both of reality and of previous figure drawing. The effect is challenging, literally iconoclastic, though cruder than similar but more organic devices in some of Matisse's later portraits such as the *Yvonne Landsberg* of 1914, page 395.

Two other portraits of 1910, the *Girl with Tulips* and the *Girl with a Black Cat*, reveal Matisse's skill in composition within the disciplined limitations he had set himself. Like the *Olga Merson* each is a three-quarter-length figure against a background divided by a tilted horizontal into two monochrome areas. The *Girl with Tulips*, page 353, a portrait of Jeanne Vaderin, is essentially a composition of curves. The oval of the face, tilted to the left, surmounts the simpler but larger arm oval which inclines to the right. The sharp or gentle curves of the hair, the choker, the necklace, the flowerpots play within and against the few severe straight lines of the table top and background. The big round bowl is a curious simile of the head and is placed at the reverse end of the arm-formed oval, as one may see by turning the picture upside down. The tulip leaves echo the arms. Humanly speaking, this image of a young neighbor in her shirtwaist elegance of 1910 is one of Matisse's most ingratiating pictures. It was his only exhibit at the Salon des Indépendants of March 1910. There it was listed as belonging to Bernheim-Jeune, but was sold to Shchukin shortly afterwards.[4] Jeanne Vaderin also posed for the extraordinary series of sculptured heads, *Jeannette*, *I* to *V*, pages 368-371.

The asymmetry and counterpoise of the *Girl with Tulips* is forsaken in the *Girl with a Black Cat*, page 354. Here, Matisse's daughter Marguerite sits in the rigid frontal pose of a Romanesque or Byzantine saint, a hieratic effect intensified by the drawing of the hand, the carmine spots on the cheeks, the heavy outlining of the features and the general flatness of the forms resulting from the almost complete avoidance of foreshortening, perspective, modeling and cast shadow.

Yet she holds in her lap not a symbol of sainthood but a large black cat. Moreover placing the cat a little to the right of the vertical median, the figure a little to the left; masking the left hand and tilting the horizontal median a few degrees: these are moves in a subtle game of tensions and balances which is far from primitive.

The color is simply disposed: dark blue dress, white blouse, ochre chair, black cat, black hair against a divided background of rose pink below, light blue green above. Only a dash of green placed like a high light on the right temple recalls Matisse's fauve color and the now remote tradition of impressionist complementaries.

5 The Manila Shawl, *1911*

Even though it was painted early in 1911, this series of portraits of women done primarily in the years 1908-1910 may be concluded with *The Manila Shawl*, page 355, a full-length portrait of Mme Matisse in Spanish costume. Though scarcely the most original of the series it does constitute a rich synthesis or resolution, technical and esthetic, of the problems which portraiture had posed for him. The flowered shawl is the center of interest, but the background though simple is not reduced to two flat planes of abstract color as in the three portraits of 1910. Instead the vertical boards of the blue studio wall are interrupted by a green-bordered rectangle which frames the head. The skirt is a deep vermilion brown, the shoes black, recalling the black of the mantilla; the shadow cast by the figure is deep green on the rose violet floor, but turns to dark blue as it climbs the light blue wall.

This shadow is remarkable not only for its sudden departure from unmodified local color but because it reinforces the sense of depth already suggested by the diagonal perspective of the wall. Yet the figure itself is almost unmodeled except at the neck and, in color, gives the effect of a two-dimensional paper doll standing in three-dimensional space—though what a magnificent paper doll!

SECTION VI FIGURE COMPOSITIONS, 1908-1910

1 Retrospect

We have followed through these years 1908 to 1910 the discoveries made by Matisse in attacking the special problems offered by the still life, the interior, and the portrait. Landscape we have scarcely touched on since, except for sketches, Matisse painted very few during these years. Their general character, though in simplified form, is represented by the view through the window in the *Harmony in Blue*, page 344, and the *Nude by the Sea*, page 359.[5]

The "subject" which interested Matisse more and more during these years was the classic problem of posing nude figures in a landscape which in the past had led to some of the greatest achievements of Renaissance and Baroque painting. It had then been revived by Cézanne, who had died in 1906, and Renoir, who was yet to paint his wonderful late compositions with "bathers" or a "Judgment of Paris."

Matisse of course had copied Poussin in the Louvre during his student days and had bought a Cézanne *Bathers* in 1899. Under the influence of Cézanne, Signac, Cross and perhaps Puvis de Chavannes, he had painted his own first figure composition, the *Luxe, calme et volupté* of 1904-1905, page 317. A year later he completed the larger and more ambitious *Joy of Life*, page 320, with its radical innovations of style in drawing and color. In *Le luxe I*, page 340, of early 1907, he narrowed the problem by reducing the number of figures to three but increasing their scale and simplifying the landscape background. In *Le luxe II*, page 341, the same elements were repainted entirely in line and flat local color. Simplification is still greater in *Music (sketch)*, page 79, painted between *Le luxe I* and *II*.

2 Compositions, 1908, 1909

A sixth painting, the *Three Bathers* of early 1907, page 338, done probably before the first version of *Le luxe*, presents the three figures this time in a horizontal frieze with variegated fauve color and a sail-flecked sea. The *Bathers with a Turtle* of 1908, page 357, is obviously based upon the *Three Bathers* but it is much larger and greatly simplified. The clouds, the sails and their reflections, all sense of weather, even the towels of the bathers have been censored. Instead the three stark figures are arranged against a triple band of sand, blue-green sea and blue sky. Their forms, painted in ochre, are modeled by

heavy violet lines as simply as in a 6th-century Byzantine mosaic. The line is not wiry and neutral as in *Le luxe II* but is inflected and supported by narrow bands of shading and some shadow. The composition is focused formally and psychologically on the small bright brown-red turtle. Quite exceptional in Matisse's work is the attitude of mingled curiosity and anxiety which he has given the standing figure. Though there is still some uncertainty in the *Bathers with a Turtle*, this impressive big picture virtually establishes the style which Matisse was to use in his figure compositions of the following two years, though the style of the huge *Dance* and *Music* of 1910 was more closely foreshadowed by the *Music (sketch)* of 1907.

The *Bathers with a Turtle* was bought by Karl Osthaus for his Folkwang Museum in Hagen, transferred to Essen, auctioned by the Nazis in 1939 and is now lent to the St. Louis Museum by Joseph Pulitzer, Jr. Consequently it is far better known than its companion-piece, the *Game of Bowls*, which was bought by Shchukin for his palace in Moscow. The *Game of Bowls*, page 356, is smaller than the *Bathers with a Turtle* and less labored in composition and drawing. Three balls, instead of a turtle, hold the attention of the three youths and give focus to the picture, which is flatter and more abstract even than the Pulitzer picture.

The smallest of the series, also bought by Shchukin, is the *Nymph and Satyr*, dated 1909, page 358. Here the subject is, for Matisse, exceptionally dramatic but again the handling is formal. The low arching figure of the nymph is repeated in the high arched form of the "satyr" and echoed by the rounded shapes in the background. The green of the landscape is broken by wedges of blue sky and the rose-colored wall which can be seen more clearly in the photograph of Shchukin's drawing-room, page 25. Another figure painting of 1909 should be mentioned, the sprawling but powerfully drawn *Nude with a White Scarf*[6] now in the Johannes Rump Collection of the Copenhagen Museum.

3 Shchukin Commissions the Dance and Music, 1909

At the end of March 1909, Sergei Shchukin definitely commissioned Matisse to paint two large decorations, *Dance* and *Music*, for the stairwell of his princely house in Moscow.

Matisse had worked as an artisan on the decorations for the Grand Palais in preparation for the Exposition of 1900; and in desperation he had proposed doing some decorative panels for a relative's house in Bohain about 1902. But the only canvas Matisse had painted explicitly as a decoration was the large *Harmony in Blue*, page 344, which, as it happened, Shchukin had bought and then lent to the Autumn Salon of 1908 where it was listed as a "Decorative Panel for a Dining-Room." The *Harmony in Blue*, which Matisse soon transformed into the *Harmony in Red*, may well have suggested to Shchukin the idea of having Matisse paint an even more ambitious decoration for his staircase. On the other hand Greta Moll remembers that Shchukin was so impressed when Osthaus bought the *Bathers with a Turtle* that he decided to commission a similar large figure piece.[7] In any case Matisse went to work on the *Dance* during the winter of 1909 and by March was able to show Shchukin a design, probably the full-scale preliminary version of the *Dance* now in the Walter P. Chrysler, Jr. collection, page 360. Shchukin was enthusiastic and took Matisse, the painter remembers, to the Restaurant Larue to discuss the matter not only of the *Dance* but also a second big panel for another wall of the stairwell. Matisse had painted a small canvas, *Music (sketch)*, page 79, in 1907 and sold it to Leo Stein. Shchukin, who visited the rue de Fleurus fairly often, had surely seen this canvas there, so that when Matisse suggested that *Music* might be the subject of the second decoration Shchukin was delighted—he was very musical, as his letter of 1912, page 134, indicates. They discussed prices: Shchukin thought Matisse asked too much—possibly he had heard that Leo Stein had paid for the *Joy of Life* a tenth of the price Matisse was now proposing for only one of the panels.[8] But Matisse stood firm, doubtless foreseeing the difficulties he would face in executing so important a commission. Finally Shchukin agreed and shortly afterwards left Paris for Moscow.[1] On the last day of March he wrote Matisse the following crucial letter:

Moscow, 31 March 1909

Dear Sir:

I find your panel "The Dance" of such nobility, that I am resolved to brave our bourgeois opinion and hang on my staircase a subject with nudes.

At the same time it will be necessary to have a second panel of which the subject might very well be music.

First page of letter to Matisse from S. I. Shchukin, Moscow, March 31, 1909, commissioning the large decorations *Dance* and *Music*. Translation below. Courtesy Pierre Matisse

I was very glad to have your reply: accept a definite order for the panel "Dance" at fifteen thousand francs and the panel "Music" at twelve thousand, price confidential. I thank you very much and hope soon to have a sketch for the second panel.

The weather in Moscow is very bad. . . .
[The entire French text is given in Appendix D.]

It is clear then that in the spring of 1909 Shchukin had already commissioned the two big panels on the basis of having seen a large preliminary version of the *Dance*—for he would not have used the word "panel" for an ordinary easel painting. At the same time he informed Matisse that he had decided to go ahead in spite of his misgivings about the propriety of hanging large paintings of nudes in the main stairwell of his respectable town house.

Shchukin's prudery, or that of his family and friends, was ultimately to become a very serious issue. By 1909 Shchukin had probably bought the robustly sexual *Nude—Black and Gold* of 1905,[2] though doubtless it was not exhibited in the public rooms of his home. The *Game of Bowls* of 1908, page 356, may already have been on view in one of his drawing-rooms, and so was the *Nymph and Satyr*, page 25; but the figures in both these panels, especially the male figures, are presented with the utmost discretion. While painting *Dance* and *Music*, Matisse went as far as he could not to embarrass his patron. In fact the nude figures are so generalized that it is not always easy to tell whether a male or female is represented. But, as will be seen, he did not go far enough.

Very likely Shchukin's letter of March 31, 1909 confirmed Matisse's decision to give up his school and residence at the Couvent du Sacré Coeur and move to Issy-les-Moulineaux. The actual move to Issy was apparently not made until the end of the summer of 1909 when, also, Matisse built a new studio at Issy big enough to accommodate the murals. During the summer at Cavalière, Matisse had worked on various figure studies, pages 161, 359, by way of preparation for the Shchukin panels.

4 *Shchukin Rejects* Dance *and* Music, *1910*

Matisse has usually given the date 1909-1910 for the *Dance*, page 362, 1910 for *Music*, page 364. Probably both were finished in the spring of 1910, or no later than the summer, since Matisse spent the end of the summer of 1910 in Germany, returning to Paris, as we have seen, only in mid-October. In the fall the *Dance* and *Music* were sent as Matisse's only exhibits to the Salon d'Automne which opened October 1, 1910. At the Salon their size, power, striking originality, and the fact that they were hung very high created a deep impression on artists and public. Shchukin was dismayed and doubtless the sensational impact of the two overwhelming canvases upon the Paris public did not reassure him. In any case he lost his nerve and informed Matisse that he could not accept them for his house in Moscow. He explained that he had just adopted two young girls[3] whose presence in his house would make the nude figures even more unsuitable than before. He feared a scandal and asked Matisse if he would not paint two smaller pictures for his bedroom for the same price, or, at least, retouch the "flute player" in *Music*. Matisse refused

to do either.[4] Furthermore he was so shocked and disappointed by Shchukin's change of mind that he found he could not work in Paris. By mid-November[5] he had left for Spain and did not return until early in 1911.

Just before he left Paris the story grew both complicated and confused. Matisse remembers[6] that Bernheim-Jeune offered Shchukin a large Puvis de Chavannes mural to put in his stairwell instead of the *Dance* and *Music*, even consulting Matisse as to how it might be installed. But Shchukin, just as he was boarding the train for Moscow, changed his mind again, canceled the purchase of the Puvis and wrote Matisse that he would take the *Dance* and *Music* after all. Probably it was after Matisse returned from Spain in January 1911 that the two mural panels, together with the two big still lifes he had painted in Spain, were packed and shipped to Moscow.[7] (Doubtless it was before the *Dance* was shipped that Matisse made the little watercolor copy, page 363, for Mme Marcel Sembat. This watercolor is sometimes mistakenly reproduced[8] instead of the big mural. Even in reproductions it can easily be identified by the broad vertical watercolor brush strokes in the upper left-hand corner.)

Matisse further states that in the fall of 1911 he visited Moscow "not to install the two panels in Shchukin's house, but to study how to place them . . ." leaving some margin of doubt as to just where the murals were at that moment.[1]

All this would seem to have been leading toward a happy ending were it not for a letter written by Shchukin to Matisse and clearly dated August 22, 1912. After a few agreeable or businesslike remarks about other paintings Shchukin leads into his subject obliquely:

In my house we have a great deal of music. Each winter there are some ten classical concerts (Bach, Beethoven, Mozart). The panel Music *ought to indicate a bit the character of the house.*

I have full confidence in you and I am sure that the Music *will be as successful as the* Dance.

I beg you to give me news of your work.

All my reservations in my two preceding letters are annulled by my telegram of last Sunday. Now you have my definite order[2] for the two panels. [The complete French text is given in Appendix D.]

It had been almost two years and nine months since March 31, 1909, when Matisse had received a letter from Shchukin giving him a "firm order"

for the *Dance* and *Music*, and a year and a half since he had had Shchukin's second confirmation and had shipped the panels early in 1911. Matisse, when asked a second time if he could explain Shchukin's letter of August 1912, threw up his hands. He had already made clear however that he had not supervised the actual installation of the panels when he was in Moscow in the fall of 1911. To judge from Shchukin's August 1912 letter the *Dance* had by then been put in place but not, apparently, the *Music* which had originally caused the most embarrassment. Ultimately both were hung, the *Music* with some slight "fig-leaf" retouching done in Moscow, and the story comes to an end.

5 *The Origins of the* Dance

What are the origins of Matisse's *Dance*? The question is important because the painting, if not Matisse's most extraordinary invention, is probably his most famous work. As is true of much of Matisse's art, the answer lies divided between sources in life and sources in art.

Of course the immediate artistic inspiration of the *Dance* in art springs from the bacchanalian round in the background of Matisse's own *Joy of Life*, pages 320, 361, which he had begun in 1905 and completed early in 1906. And back of the dancing ring in the *Joy of Life* lie suggestions taken perhaps from some of the Poussin bacchanals, possibly from Mantegna's dance of the muses in his Louvre *Parnassus*—the muse at the right in the Mantegna, who arches her back away from the circle, may be related to the similar figure in Matisse's *Dance*. Then, still further back in history, Greek vase paintings may have affected both subject and style. In the final version of the *Dance*, the strong terra cotta red of the figures against the dark plain background may well have been suggested by Attic red figure pottery.

As to the dancing which Matisse himself saw, accounts vary. Pierre Matisse states that his father was impressed by the "fast tempo and beautiful movement" of the *farandole* which he saw at the Moulin de la Galette, a popular dance hall on Montmartre.[3] "Upon being commissioned for the Shchukin decorations, Matisse decided to use this theme and immediately set to work"—a rapid sequence of inspiration and action which overlooks Matisse's previous use of the motif three years earlier in the *Joy of Life*. Georges Duthuit also ignores the *Joy of Life*, but the fact that it was painted just

after the first summer at Collioure adds some weight to his anecdote:[4] "When Matisse was working on his *Dance*, now in the Moscow Museum, he crouched ready to leap as he had done one night some years before on the beach at Collioure in a round of Catalan fishermen, far more violent in movement and aspect than the *sardagne*. Then his gesture was transferred to the canvas in accordance with rhythms entirely different from those of the surf and the sailors' dance."

Edward Steichen confirms the folk origins of Matisse's conception.[5] He visited the studio at Issy several times while the *Dance* was being painted. At that time Leo Stein was extremely enthusiastic about Isadora Duncan's dancing and insisted upon Matisse's going to see her. Matisse did not share Stein's admiration, preferring, Steichen recalls, the peasant dances which he maintained were the inspiration of the *Dance*. It is tempting to believe that Isadora Duncan's magnificently Dionysian art, which electrified Paris during 1909, must have had some effect on Matisse, who was struggling with his *Dance* that very year. Rodin, Carrière, Bourdelle, Dunoyer de Segonzac, Maurice Denis, all paid her homage in their work. Yet the dance in the *Joy of Life* was done years before Isadora's public recitals in Paris. Perhaps Matisse felt about her from the beginning, as Elie Faure eventually concluded, that her art was "didactic, wholly cultural" and "exhibited ideas, even principles, more than it expressed feelings or passions."[6] Matisse himself was too much in danger of the same dependence upon art as an activity of the cultivated intelligence.

Whatever its external origins and inner sources, the main steps in the creation of the *Dance* are clear. The general style of the picture with its large, light-toned, simplified, unmodeled figures against a flat, darker background first appears tentatively in *Music (sketch)*, page 79, and *Le luxe II* of late 1907, page 341, then more definitely in the *Bathers with a Turtle* and the *Game of Bowls*, both of 1908, pages 357 and 356. In those two large paintings Matisse's figure drawing grows heavier and more emphatic, while the background is simplified to abstract bands of earth, sea, and sky.

The full-size study for the *Dance*, page 360, completed early in 1909 seems rather uncertain in drawing—it is essentially a color study—but that Matisse used a very bold heavy line in working out the composition is clear from the big charcoal sketch,

page 361, which precedes the first painted version. The style of the drawing in the final version of the *Dance*, pages 362, 363, is further developed in the figure paintings *Bather*, page 161, and *Nude by the Sea*, page 359, done during the intervening summer of 1909.

6 *The* Dance: *Composition and Color*

How Matisse concentrates and intensifies the composition itself is revealing. The ring of six dancers in the *Joy of Life*, page 361, moves freely against an open irregular field. Their arms form a roughly symmetrical oval broken in the center foreground. Matisse now eliminates the kicking figure at the right and compresses the circle within the rectangle so that most of the figures touch the edge. The oval of linked arms has become pear-shaped, broken at the neck by the only gap between linked hands, detail, page 363, a gap which cannot quite be closed by the foreground figure though he strains forward and upward to do so. This interval suggests the tension, though on a purely physical plane, created by the narrow space between the fingertips of God and Adam in Michelangelo's Sistine ceiling *Creation of Adam*.

In the *Joy of Life* the figures rush clockwise in one direction, but in the first version of the *Dance*, the two figures at the back of the ring have lost their momentum, slowing up the rotation but, in the final version, increasing the tugging tension of the group as a whole. These two distant figures, in the *Joy of Life*, are correctly reduced in relative size but in the successive stages of the *Dance* they increase in size until they about equal the foreground figures, thereby helping to destroy a sense of depth. The intensification of gesture in each figure throughout the three recorded stages of the *Dance* is notable, especially in the two background or, better, upper figures whose awkward heavy actions are dynamically transformed.

Even the ground line is organically altered as the composition develops. In the charcoal drawing it is a mound with a circular silhouette; in the Chrysler version, page 360, the mound is divided into two humps on which the two rear dancers leap; but in the final Moscow picture the mound resumes its even curve again, dented only by the paroxysmic thrust of a dancer's foot!

Though this cannot be appreciated in halftone reproductions, the color of the *Dance* was as carefully studied as the linear rhythm. The *Joy of Life* was still fauve in its arbitrary variety of hues; in *Le luxe II* Matisse reduced his color practically to seven flat tones, and in the *Bathers with a Turtle* to only five. In the Chrysler study for the *Dance* he reduces the principal colors to three: bright blue sky, green earth and terra cotta red figures with chestnut-colored hair. These tones are all intensified in the final version. Years later, Matisse vividly described this color scheme of *Dance* and *Music* to Christian Zervos[7] as "made with a beautiful blue for the sky, the bluest of blues (the surface was colored to saturation, that is to say, up to a point where the blue, the idea of absolute blue, appeared conclusively), and a like green for the earth and a vibrant vermilion for the bodies." John Becker[8] seeing the paintings twenty years after they were finished described the sky, which may by then have darkened somewhat, as a "sapphire night-blue."

Edward Steichen[1] followed with interest how the color and line of the *Dance* changed gradually from something rather mild to its ultimate shocking power. Even Matisse himself, on more than one occasion, seems to have been alarmed by his own creation. Once he told Steichen rather uneasily how at a certain moment in the evening, as the light was fading, the *Dance* suddenly seemed to vibrate and quiver. Matisse was so disturbed by this that he asked Steichen, who at the time was deep in the scientific theory of color photography, to come out to Issy especially to observe this phenomenon and explain it, if he could. One evening shortly afterwards Matisse and Steichen watched the picture as the sun was setting. Steichen confirmed what Matisse had seen and explained that, as the light faded and at the same time grew warmer, the colors reached a balance point at which a complementary reflex within the eye made them jump and vibrate. Once he understood this, Matisse was no longer disturbed.

Purrmann remembers[2] how he was once in Matisse's studio with the *Dance* temporarily stretched out on the floor when Matisse, forgetting it was there, saw it out of the corner of his eye and jumped back in astonishment. The shock of the color had taken him by surprise. On another occasion, Purrmann[3] was present when Bonnard visited Matisse's studio. The older painter, who all during the '90s had been a far bolder artist than Matisse, now asked him why he painted the figures all one color. Matisse replied: "I know the sky throws a blue reflection on the figures and the grass a green one.

Henri-Matisse août 1909

WOMAN NURSING KNEE; A FOOT (*Nu assis; pied*). Cavalière, 1909, August. Ink, 11¹³⁄₁₆ x 9⁷⁄₁₆″. Chicago, Art Institute

Perhaps I should indicate some light and shade, but what's the use complicating my problem. It's of no value in the picture and would interfere with what I want to say."

7 *The* Music, *1910*

La musique (esquisse), page 79, painted in 1907, was certainly the starting point for the *Music* of 1910, page 364. The fiddle player in the earlier painting remains, slightly elongated but otherwise little changed, in the big canvas; and the seated piper, though changed to a singer, keeps his position at the right of the 1910 composition, at least in its early stages, page 365. The dancers in the background of the 1907 *Music*, of course, were eliminated in favor of the *Dance*.

There must have been many study drawings for *Music*. The *Woman Nursing Knee*, page 137, is probably one of them, perhaps a study for the piper, the figure next the standing fiddler. In any case, the drawing was done in August 1909, when Matisse was in Cavalière working from the model in preparation for the Shchukin decorations.

The main steps in the development of the composition of *Music* may be followed, for fortunately Matisse twice had the canvas photographed before it was finally completed.

In the first photograph, page 365, made well before the canvas was covered, the general arrangement of the five figures had already been determined. Between the fiddler at the left and the seated figure at the right, both borrowed from *Music*, 1907, three seated figures have been added, one playing the double pipes, the other two singing. The sleeping dog in the foreground is sketchily indicated and some touches of color have been brushed in.

The changes in the completed first state (second photograph, page 365) are significant: the figures are more isolated and the seated figures which originally overlapped each other by pairs are now separated. Yet, they are still related by their glances and by the curving inclination of their bodies. The drawing of the figures seems mannered, the elisions and distortions not entirely convincing. Comparing, as he must have, the *Music* at this stage with the *Dance*, Matisse could not have been satisfied. Yet his first version was by no means a sketch. Actually it was carried further than the first version of the *Dance*. *Dance "I"* still exists on a separate canvas but *Music "I"* was ruthlessly overpainted.

It may have been *Music* at this stage to which Leo Stein refers in his anecdote[4] about an alteration made by Matisse in one of the Shchukin decorations. Stein was watching Matisse as he made a number of bold revisions in the big canvas, following every stroke with the eye of a man trained in the subtleties of composition. "Once after a long pause and some silent meditation he climbed the ladder [the picture was hung high on the wall, as it was to hang in Moscow] and altered a line on the neck of one figure, flattening just a little bit a line a couple of inches long. When he came down, I said, 'I've understood everything you did before this last change, but I don't see the point of that.'

"He replied, 'I'm not surprised, because I've decided to change entirely the orientation of the figures.'"

In the final revision of *Music* every figure is indeed changed. They are now all turned toward the front, away from each other. The four seated figures are all more compactly posed, their knees drawn up close to their bodies so that they appear more isolated than ever. The drawing, too, is less varied and affected. The pretty flowers have been erased, and so has the dog, though his shape is still discernible beneath the overpainting. Throughout, everything charming and trivial has been eliminated in the interests of dignity, simplicity, and a stillness which would serve to the maximum as a foil to the thumping violence of the *Dance*.

SECTION VII SCULPTURE, 1908-1911

1 Sculpture, 1908-1909

Matisse produced rather little sculpture in 1908 and 1909 but two bronzes, the *Two Negresses* and *La Serpentine*, are among his best. A lesser piece, the *Seated Figure, Right Hand on Ground*, page 366, is modeled with a surface so ridged and gouged that even in the bronze one feels the wet plasticity of the clay. The figure is apparently a study for the much larger *Seated Nude* of about 1908.

The *Two Negresses*,[5] page 366, is Matisse's only sculptured group of figures, yet in a sense it is one figure, mirrored so that it can be seen from both sides at once, a symptom perhaps of Matisse's profoundly sculptural desire to create a work in the

round which will hold its interest from any point of view. Actually, the figures are not identical in pose and seem to have been studied from different models. The thickset, rather rigid forms are powerfully and simply modeled with few traces of Rodin or the informal freedom of Matisse's fauve period sculpture. The *Two Negresses* may well be influenced by African Negro sculpture which Matisse had been collecting for two or three years, particularly the rigid, thickset figurines of the Ivory Coast.[6]

2 La Serpentine, 1909

La Serpentine,[7] page 367, is somewhat later than the *Two Negresses* and its curving elongations suggest that it may have been done partly as a reaction to the squat, stiff solidity of the paired figures. Again, the influence of African sculpture has been proposed to explain the deformations of *La Serpentine*. It is true that the very long torso with small breasts placed so high that they seem to continue the line of the arms, the long arms and legs growing heavier toward their extremities, the flat splayed feet are all to be found in African sculpture notably of the French Sudan,[8] many examples of which entered Paris collections.

But the pose of the figure is, of course, not African, nor in any way primitive but Greek, or of the Greek tradition in Roman and later European sculpture. Generally speaking it originated in the 4th century B.C. and appears in such Praxitelean statues as the *Hermes* at Olympia and the *Satyr* of the Capitoline Museum in Rome both of which stand with gracefully curved figures, one elbow leaning on a convenient tree stump. The pose continues in the Renaissance in such figures as Pollaiuolo's famous drawing *Adam* in the Uffizi, with his wrist on hip and legs crossed at the ankles. At Arezzo, in the Church of St. Francis, Matisse had seen Piero della Francesca's similar figure, back turned, in the fresco of the *Old Age of Adam*. In terms of physical beauty *La Serpentine* might appear to be a caricature of the pensive Praxitelean pose, for Matisse was obviously not concerned with making an image of a beautiful human body. "I had to help me," he wrote[1] many years later, "a photograph of a woman, a little fat but very harmonious in form and movement. I thinned and composed the forms so that the movement would be completely comprehensible from all points of view."

Few modern sculptures have been more celebrated by anecdote or attacked by ridicule. Leo Stein[2] tells in detail the story of how the model, a well-favored girl, looked at the sculptor's work when he had finished and exclaimed, "How awfully ugly!" To draw her out, Matisse agreed. The girl studied it some more, found it fascinating, even though repellent, without in the least being able to explain why. Stein interprets her inarticulate feeling: "It was ugly when regarded in terms of expectation, but it was beautiful, somehow, when taken by itself. Not altogether beautiful because it still remained in some ways unattractive, even repulsive—but somehow beautiful."

When *La Serpentine* was shown in New York at the Montross Gallery in 1915 the reviewer for the *American Art News*[3] proclaimed it "so utterly untrue to Nature in the modeling of the form as to be a travesty." French philistinism had been even more unkind. *Le Journal*[4] published a photograph of *La Serpentine* under the headline "THEY'VE HAD IT IN ENGLAND, TOO." The caption continued:

This photograph comes to us from England. It represents a sculpture now on exhibition at the Grafton Galleries of London.

At the moment when the Salon d'Automne, the Section d'Or *and other exhibitions, cubist, futurist, draw upon French art the commiseration of people of taste who visit these museums of error, there is some melancholy comfort to be had in stating that "they've had it in England, too."*

Others far less conventional or academic found *La Serpentine* hard to take—at least at first glance. Not long after it was finished, Roger Fry, Bryson Burroughs, the enlightened but often frustrated Curator of Painting at the Metropolitan Museum, and Henry McBride called on Matisse in his studio at Issy. As they were leaving, they caught sight of *La Serpentine* for the first time. "I personally was struck dumb," Henry McBride recalls,[5] "by the Venus whose thighs were almost as thin as wires and whose lower legs were as thick as her thighs should have been. Mr. Fry, who is always equal to any social demand, murmured something felicitous enough to get us over the situation and finally got us out of the atelier. . . ." McBride, one of the most discerning American critics of modern art, then describes how he came to understand the figure's deformations only later when he chanced to see it in a "refracted light" capable of "putting in the streak of highlight on the thighs . . . and lengthening out the shadows on the lower legs. . . . Matisse

had merely 'painted' in sculpture" but when seen in a proper light "the figure which at first seemed an ineffective joke, did actually resolve itself into an excellent interpretation of form. It would have been an easy matter for Matisse to have given Mr. Fry, Mr. Burroughs and myself a helpful clue to this Venus, but the bad boy in him tempted him to keep us mystified."

It is perfectly true that *La Serpentine* can be lit so that the highlights tend to make the legs seem more naturalistic in proportion. Yet whether Matisse worked from a photograph of a fat but rhythmically proportioned figure as he says or from a live and comely model as Leo Stein recounts, or both, one must question the conclusion that the resulting figure is "merely 'painted' in sculpture" and has to be specially lighted before it becomes intelligible. The extraordinary three-dimensional interest and rhythmic vitality of the *Reclining Nude*, page 337, and the *Two Negresses* and of *La Serpentine*, herself, even when studied in different kinds of lighting, suggest that Matisse conceived and modeled his sculpture as a sculptor not as a painter. The distortions in his sculpture, the arbitrary thinning or thickening of limbs and trunks, as much as their disposition, were intended to clarify and emphasize the rhythmic movement or, as he explains it, to make it "completely intelligible from every point of view."

3 The Five Heads of Jeannette

Curiously neglected in studies of Matisse's art is one of his most extraordinary works, the five states of the sculptured head, *Jeannette*, pages 368-371. The first state has been published occasionally, the second rarely, the third and fourth only in installation or group photographs, and the fifth—and boldest— apparently not at all.[6] It is hard to understand why, since the first two states were shown in New York at the "291" Gallery in March 1912; the first four states, in the London Second Post-Impressionist Exhibition of late 1912, and in the Montross Gallery's Matisse show, New York, 1915; and the first three at Bernheim-Jeune, Paris, 1913. State V however, seems never to have been exhibited until the Paris retrospective of 1950.

Matisse believes that he made four, perhaps all five of the heads within a single year[7] at Issy-les-Moulineaux. The first two states, according to Mme Matisse, were done directly from the model, Jeanne Vaderin, "Jeannette," a young woman who was

staying at Clamart while convalescing from an illness. She also posed for the *Girl with Tulips*, page 353, shown at the Salon des Indépendants which opened in mid-March 1910. *Jeannette I* and *II* may therefore be dated as early as the winter of 1910.

States III, IV and V of *Jeannette* were done later as variations on a theme, but how much later is uncertain. State IV appears in the right-hand background of the *Red Studio*, page 162, of late 1911, and state V, or an approximation of it, in the *Still Life with a Bust*, page 384, of 1912, but Matisse sent only states I and II to New York for the "291" exhibition in March 1912.

Why Matisse did not send *Jeannette V* along with the first four states to the Post-Impressionist show in London that fall is puzzling. Possibly Roger Fry felt it to be too extreme, or Matisse himself did not urge its inclusion. It was also omitted from the Bernheim-Jeune show, Paris, 1913, and from the Montross exhibition in New York in 1915. It is true that the reproduction of the sculpture in the *Still Life with a Bust* of 1912 is so simplified that it cannot be taken as conclusive evidence that the plaster was completed, that is, was identical with *Jeannette V* as we know it today. Possibly Matisse withheld it from the exhibitions of 1912 to 1915 because he did not feel satisfied with it, and may have reworked it later,[8] though its essential lines are indeed represented in the painting of 1912.

4 Jeannette I, II, III

Jeannette I is a vigorous and broadly modeled portrait head, probably a fairly faithful likeness of a handsome aquiline face. *Jeannette II* is simpler in modeling, rounder and pudgier, with the roll of hair over the left brow somewhat fuller. It seems the least interesting of the four, but serves as a transition to—though scarcely as preparation for— *Jeannette III*.

In the third variation on the theme of *Jeannette*, Matisse begins to handle the features with greater freedom. The head has become pear-shaped with full cheeks and great puffs of billowing hair. The nose is now long, with a very heavy bridge, the eye sockets enlarged, with bulging eyes[1] and strongly modeled eyelids. The slight asymmetries which exist in every face are in *Jeannette III* exaggerated, particularly in the nose and placing of the eyes, giving a grotesque liveliness to the mask.

The differences between *Jeannette I* and *Jeannette III* suggest the differences between optic and hap-

tic types of sculpture described by Victor Loewenfeld in his studies of the sculpture of children and the blind.[2] Optic sculpture, as the term suggests, depends upon the sense of sight, haptic sculpture upon the combined sense of touch and the internal senses of muscular position and organic function. The blind in their sculpture tend to exaggerate the features of their own faces, nose, eyes, eyelids, ears, which they can feel both internally and externally but the proportions of which they cannot "correct" or control with their eyes. Furthermore, in studying the modeling of children who could see, Loewenfeld found that the sculpture of some was haptic, of others optic, so that he concluded that in perception and artistic expression people could be divided roughly into predominantly haptic and optic types. The psychiatrist Eric P. Mosse remarks in a recent article[3] that "we might be entitled to say that Loewenfeld's optic type of experiencing our surrounding world corresponds to impressionistic painting, whereas the haptic type would follow the expressionistic mode of creation."

Jeannette I, done while looking at the model, appears to be optic; but *Jeannette III*, done later without the model, seems remarkably haptic. In other words, Matisse, primarily a painter, that is, an artist dependent upon purely visual plastic means, can in his sculpture create work which is profoundly tactile, work in which the hands, in contact with the plastic clay, model forms which are comparatively independent of the eye. This is not to imply that Matisse modeled with his eyes shut but, rather, that the forms in *Jeannette III* are a compound not only of visual memory, but also of the haptic imagination, as well as of the artist's highly developed sense of form both visual and tactile.

At the same time, the modeling of *Jeannette III* resembles the faces of certain masks[4] carved by artists of the Cameroon tribes whose sculpture also seems haptic in character.[5] However, as in the cases of the *Two Negresses* and *La Serpentine*, Negro influence on Matisse's sculpture, if any, is generalized and very well assimilated.

5 Jeannette IV, V

In *Jeannette IV* the round or pear-shaped character of *Jeannette II* and *III* gives way to an exaggeration of the aquiline profile and hollowed cheeks. The nose is still heavy but now sweeps down to a beaky tip in a straight line from the forehead. The underlids of the eyes are suppressed, the upper lids

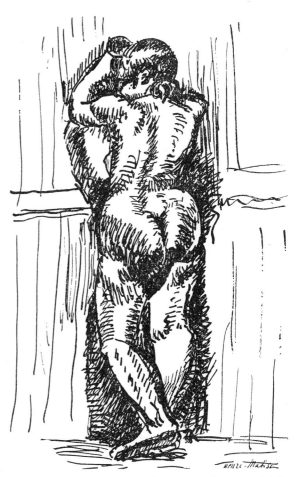

STUDY OF A MODEL'S BACK (About 1910?) Pen and ink. Courtesy Pierre Matisse

project like cornices over deep sockets without modeled eyeballs. The hair now rises from the head in plume-like rolls. The general effect is perhaps more visual than haptic, more pictorial than sculptural, with deep shadows cast by strong projections. *Jeannette IV* is picturesque in both meanings of the word.

In *Jeannette V*, page 371, Matisse returns to the pear-shaped structure of variation III for his point of departure. In fact the breast, throat and lower face in the two are identical, having obviously been cast from the same mold. The hair which had risen from the forehead of state IV like a cluster of half-inflated balloons has now floated away entirely. The other features are all emphatic versions of those in state III—except for the left eye to which we shall return. Just how Matisse has simplified, clarified and intensified the forms may be studied by com-

paring states III and V, pages 369 and 371, photographed from the same angle. The nose in the later head has become a straight semi-cylinder, the forehead a hemisphere, the details of the right eye boldly enlarged. The most extraordinary feature of *Jeannette V* is the left eye which has been reduced to a single flat plane, as if it were a patch or a monocle. This radical exaggeration of the slight differences between the two eyes of the sitter is however not uncommon in the art of the period. Perhaps it originated in the paintings of Manet and the impressionists where it was inspired objectively by accidents of light. It appears in Matisse's *Head of an Italian* of 1901, in Rouault, Picasso, and the German expressionists.[6] With them the effect may be pathetic, comical, sinister but is always an intensification of the emotional or expressive content of the image and an enlivening of its formal impact. The greater inventiveness, the more powerful impact of *Jeannette V* by comparison with state III or even the picturesque state IV is undeniable.

How Matisse himself saw his curious and original reorganization of the formal elements of the head in *Jeannette V* may be seen in the highly simplified yet explicit interpretation in the canvas *Still Life with a Bust* of 1912, page 384. At first glance the painted head seems conventional, almost chic, but when carefully compared with the original sculpture one sees that what appears to be an eye is actually the line marking the juncture of the nose and forehead; and the curve which appears to be a sweep of hair over the cheek actually encloses the undifferentiated curved area of eye, cheek and temple. The ear and the hair at the back form two more subordinate arcs. Thus the whole head becomes a system of curve and countercurve without indication of mouth or eye. *Jeannette V* is surely more haptic than *Jeannette IV* but its forms do not depend primarily either on hand or eye at an instinctive, imitative level. *Jeannette V* is a boldly conceptual work with arbitrary deformations and calculated syntheses.

The cubists by 1911 had of course gone much further than Matisse in their distortions and dislocations of natural forms. Picasso had modeled his facet-cubist head late in 1909.[7] Thereafter, until 1912, in their paintings he and Braque analyzed and disintegrated natural forms more and more. Matisse's *Jeannette III*, though it may be better

sculpture than Picasso's head of 1909, is obviously less radical in its formal innovations. *Jeannette V* however is more radical, though in the direction not of cubism but of a bold and synthetic transformation of natural forms which anticipates Picasso's big plaster heads of 1932[8] with their narrow, prominent nose-forehead and vertical fore-and-aft division of the head.

6 The Back, I, *about 1910*

The largest of Matisse's sculptures are the three versions of *The Back*, pages 313, 458, 459. In spite of their impressive size and power, it is difficult to ascertain just when they were done.[9] *The Back, I*, page 313, had previously been dated 1904 but since page 313 was printed both Matisse and Mme Matisse have decided that it was modeled in the studio at Issy to which they moved late in 1909. The relief, in plaster, appears at the right of the big canvas of early 1911, *The Painter's Studio*, page 375. Therefore 1910 would serve as an approximate dating for *The Back, I*.

The Back, I, is an over-life-size figure modeled in fairly high relief. In the London, 1912, catalog (bibl. 117, no. 1) it is listed as "Le Dos. Plaster sketch" so that at that early date Matisse may well have had in mind developing the figure further, as he did the contemporary *Jeannette* heads.

In any case *The Back II*, and *III*, throw light upon the underlying formal problems of *The Back, I*.

The Back, I may be interpreted as a study in the dynamic balance of forms on either side of the spine which, indicated by a deep furrow, follows the vertical median of the composition. The muscular bosses are not analyzed or elaborated as in *The Slave*, page 305, but are very broadly handled. The shoulders and arms are boldly exaggerated, the neck muscles suggesting the powerful tensions of the Barye *Jaguar*, page 303. The figure seems far removed from Rodin and Bourdelle, less so from Daumier's reliefs. The scale and breadth of form suggest Maillol's reliefs but Matisse's great *Back* is earthier and more vigorous than Maillol's metopes such as *Desire*,[10] with their decorative spirit and Greek reminiscences. Cézanne, had he been a sculptor, might have provided a closer analogy.

The vigorously drawn and modeled pen-and-ink study reproduced page 141 was probably done by way of research for *The Back, I*.

PART V: 1911-1913

SPAIN AND MOROCCO

SECTION 1 LIFE, 1911-1913

1 Spain, 1910-1911

At the beginning of 1911 Matisse was still in Spain where he had gone about the middle of November following his disappointment over Shchukin's refusal to accept the *Dance* and *Music*. He had been living in Seville with excursions to Cordova[1] and perhaps to other places of interest. On January 4th he wrote Gertrude and Leo Stein that he was working but would return in about a fortnight, but on the 17th he sent a second card, this time from Toledo, to say that it was snowing, that he thought the Grecos were very good but was not sure "because his brain was frozen." The concluding line of the address was "*Francia (pays tempéré)*."

He returned to France probably before the end of January bringing with him two large interiors festooned with Spanish shawls. Both look as if they might have been painted in a hotel room and both were bought by Shchukin, pages 372 and 24-25, and shipped off to Moscow, possibly, as Matisse remembers, with the *Dance* and *Music*, page 134.

2 Issy and Collioure, 1911

The Manila Shawl, page 355, a portrait of Mme Matisse, was painted after the return to Issy-les-Moulineaux—but before the Salon des Indépendants of April 1911. To that Salon he sent the portrait under the title *L'Espagnole* and a second figure painting, *La Gitane*. The former painting had already been bought by Bernheim-Jeune.

At Issy he continued on a much larger scale the series of elaborate interiors which he had begun in Seville. *The Painter's Family*, page 373, was done late in the spring and sold to Shchukin who also bought the somewhat earlier *Painter's Studio*, page 375, one of the two very large views of the inside of the atelier at Issy; its pendant, completed in the fall, is the *Red Studio*, color plate page 162. At Collioure

that summer Matisse painted a fourth large composition, the *Interior with Eggplants*, page 374. Purrmann visited Matisse and saw all the "props" that he was using in this big decoration. Of two famous but very different paintings with goldfish of 1911, the more decorative one, page 376, went to Shchukin, the other, blue and more abstract, to Germany and in 1916 to Hans Purrmann, color plate page 165. Two other blue paintings of 1911, the *Flowers with a Ceramic Plate*, page 377 and *The Blue Window*, color plate page 167, also went to Germany. The latter, done toward the end of the year, was bought by Karl Osthaus for his Folkwang Museum in Hagen.

Before the end of the year the Michael Steins also acquired "a great big new decoration about 8 x 10 feet which has necessitated rearranging our rooms entirely."[2] In October Matisse had sent only two paintings to the Salon d'Automne, a landscape and a still life both catalogued as *esquisses décoratives*.

3 Moscow, Autumn, 1911

In the fall, at Shchukin's invitation, Matisse traveled to Moscow to see the city, the collections of modern paintings, and the stairwell where his *Dance* and *Music* were to hang. He was upset by the way Shchukin hung his collection.[3] All the pictures had been glazed and then tilted at a forty-five degree angle to avoid reflections. Matisse thinks he failed to persuade Shchukin to take the glass off but the photographs of the collection taken in 1912, pages 24, 25, show the pictures unglazed and hanging normally. On the 1st of November he sent a card to Gertrude and Mr. and Mrs. Michael Stein to say that the weather was rainy, *épouvantablement*, that he wouldn't see the Czar, but was well satisfied with the trip and would be back within a week. In Moscow he did however see and study icons.[4]

4 Morocco, Winter, 1911-1912

Early in the winter of 1911-1912 Matisse and his wife went south again, this time to Tangier in Morocco. The weather was disappointing at first to the valetudinarian Matisse and even when it was fair he suffered his usual trouble painting. On March 16th he complained to Gertrude Stein,[5] "Painting is always very hard for me—always this struggle—is it natural? Yes, but why have so much of it? It's so sweet when it comes of its own accord."

Gertrude Stein received this card about three months before *Camera Work*, in New York, published her portrait, "Henri Matisse," bibl. 212. There is a significant connection between Matisse's chronic agony in painting and her observant—and stylistically appropriate—remarks about him: "One was quite certain that for a long part of his being one being living he had been trying to be certain that he was wrong in doing what he was doing. . . . Some said of him that he was greatly expressing something struggling."

It is not easy always to be sure which pictures he painted on this first visit to Tangier and which were done on his second sojourn during the winter of 1912-1913. The three garden pictures, pages 380, 381, and the three tall very narrow canvases of Moroccans in costume, page 378, apparently were painted during this first trip, and more certainly the *Window at Tangier*, page 386, bought by Morosov in 1913.

5 Issy, Summer-Fall, 1912

The Matisses stayed in Tangier until early Spring and returned to Issy too late for the Salon des Indépendants. He was in any case not yet ready to show his Tangier paintings though during the year he did sell at least one of them, *Amido, the Moor*, page 378, to Shchukin.

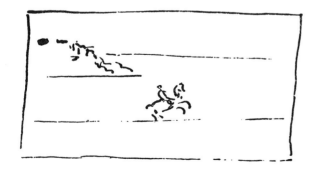

MOROCCAN LANDSCAPE WITH HORSEMAN. Pen and ink

Having been away so many months, the Matisses seem to have spent the summer of 1912 at Issy rather than at Collioure in the South; at least the important paintings of this between-Morocco period were done in the studio on the route de Clamart, among them the *Still Life with a Bust*, page 384, and the *Goldfish*, page 385, both now in the Barnes Foundation museum. The very abstract *A Path in the Woods of Clamart*, page 381, Matisse also believes to have been done at Issy during 1912 as were both versions of *Nasturtiums and the "Dance,"* pages 382, 383, the first of which Shchukin bought during the summer. In a letter of August 22 Shchukin agreed to lend his *Nasturtiums* to the Salon d'Automne but asked that the *Moroccan (Amido)* and the *Goldfish* (of 1911, page 376) be sent on to Moscow by "*grande vitesse*." This was the letter in which he assured Matisse that "all his reservations" about the *Dance* and *Music* were annulled, page 134 and Appendix D. That fall Matisse renewed his contract with Bernheim-Jeune for another three years and without any change in prices.

6 Exhibitions in Paris and Abroad, 1912-1913

In March 1912, probably before Matisse returned from Morocco, Alfred Stieglitz in New York had put on the first exhibition anywhere primarily devoted to Matisse's sculpture. The show had been selected by the artist and Edward Steichen and was enthusiastically attacked by the critics, page 149. None of the sculpture was sold and that fall Steichen[6] wrote Stieglitz that there had been some delays in returning his exhibits "so what between that and not selling anything of his sculpture [in New York] he is a little 'off.'" Steichen, in Paris, adds, "I understand he is getting rich selling everything—most of his sculpture editions sold and orders for three or four years."

To the Salon d'Automne of October 1912 Matisse sent an *Interior* lent by Shchukin, almost certainly *The Painter's Studio* of 1911, page 375, and a version of *Nasturtiums and the "Dance,"* listed as belonging not to the Russian whom Matisse had asked to lend, but to a mysterious "Dr. G. . . ."—mysterious because at the very moment the Salon opened, the version Shchukin had *not* bought, page 383, was in London, lent by the artist to the Second Post-Impressionist Exhibition at the Grafton Galleries.

The London exhibition was the second of three very important international shows presented with-

in a year during 1912-1913. The first was the *Sonderbund* exhibition at Cologne, which opened in May and ran through the summer; then came the just-mentioned London show opening in October and finally the New York "Armory Show" which opened in mid-February 1913 and was later sent on to Chicago and Boston. Matisse's participation in these epoch-making demonstrations and the resulting critical response will be described in the next section.

7 Second Moroccan Sojourn, Winter, 1912-1913

Meanwhile before the end of the year Matisse went south again to Morocco for a second sojourn of several months. Just as a year before he had written Gertrude Stein about the fine weather and his difficulty with his art he now wrote Matthew Prichard[7] from the Hôtel de France, Tangier, January 4, 1913: "Your letter gave real pleasure, above all the passage where you say that my works emanate a sense of health and hopefulness which consoles me for their imperfection. My sojourn here is very pleasant after the winters at Issy which for me were a bit dreary. Here the weather is fine almost every day and already the countryside is in flower."

In Tangier he found his old friends Marquet and Camoin and a Canadian painter who greatly admired Matisse, James W. Morrice. After some difficulty he also again found Zorah, the young girl who had posed for him the year before. The new painting *Zorah on the Terrace*, page 387, which was to form the central panel of Morosov's "triptych," is perhaps Matisse's best-known work of the second Moroccan visit. The still life, *Oranges*, now in Picasso's collection, is richer in color and the two versions of the *Riffian*, especially the one in the Barnes Foundation, far more imposing. However, the largest and most original of all Matisse's Moroccan pictures is the *Moorish Café*, page 388, done during his second expedition, then bought and greatly loved by Sergei Shchukin.

8 The Bernheim-Jeune Exhibition, 1913

Matisse returned to Paris in time for his exhibition at the Bernheim-Jeune Gallery in mid-April 1913. A dozen Moroccan paintings and many sculptures and drawings were included in this, Matisse's fourth one-man show in Paris, and the first in which sculpture had been given an important place, page

25. Also in April the Berlin *Sezession* caused a stir by exhibiting the first version of Matisse's *Dance*, page 360.

The exhibition at Bernheim-Jeune's was the occasion for a number of critical articles and reviews, the most important of which were Guillaume Apollinaire's, page 148, and Marcel Sembat's, page 160. The most admired and most controversial painting in the show was the huge *Moorish Café*. Besides that, Shchukin bought the smaller portrait of the *Riffian*, two large flower pieces and the *Zorah Standing*, pages 390, 389 right, 378. Morosov did not equal his rival's purchases but he made a formidable bid by buying the *Window at Tangier* and the *Entrance to the Kasbah* which he hung on either side of *Zorah on the Terrace*, pages 386, 387, just as they had been shown at Bernheim's, page 25. What the two Russians left of the Moroccan pictures was then or within the next few years divided among the Germans and Scandinavians. Of the three garden compositions, pages 380, 381, the *Palm Leaf* went to Oskar and Greta Moll; the *Moroccan Garden* to another German collection; the third and finest, *Park in Tangier*, was acquired later on by the Stockholm Museum. Within a few years the gigantic *Riffian* went to Tetzen Lund in Copenhagen; *Fatma, the Mulatto*, page 378, to the Swiss collector Joseph Müller of Soleure; the *Oranges*, page 389, to the Sternheim collection in Berlin. None of the important Moroccan pictures remained in France, though one of them, the *Oranges*, has recently returned to Paris as a purchase by Picasso.

9 Matisse, "A Fabulous Personage"

Marcel Sembat, Matisse's chief French supporter and the purchaser of two minor Moroccan paintings, writes amusingly about the French attitude toward Matisse's success, already reported by Edward Steichen. Sembat's article was published in *Les Cahiers d'Aujourd'hui*, bibl. 210, at the time of the Bernheim-Jeune show of 1913:

He is forty-four years old, and already he's cloaked in legend. The palaeographers imagine that to discover mythical creatures you have to explore antiquity. Nonsense! right here is a contemporary who is a fabulous personage.

He creates scandal; he creates fear; he creates pity—envy—fury. "He's a practical joker"—"Oh no! He's cracked, that's all! He's simply loony! I guarantee he's sincere!"—"Go on! He's a shocker, a charlatan! He's kidding us!"—"I tell you he's not well!"—"Him! not on your

life! He's sharp! He's making fun of us and of the public!'" "And if only that were all, mon cher! But do you know he gets whatever he asks! He sells everything he wants to! At any price he wants! they tear his pictures off the walls! A hundred thousand francs a year, I tell you!" "Nonsense!" "Word of honor! Aren't you in the know yet? There are some Russians who've bought in on the ground floor of Matisse! and some Germans! and Americans! Everything he paints, my friend! It's disgusting—revolting! And don't you know he has a chateau in the suburbs and goes horseback riding every morning at the Acacias? A swell life, what?"

Three years before, Schnerb had observed complacently that only foreigners liked Matisse; by 1913 French complacency seems to have turned to resentment against him—and later against his foreign patrons for having bought his best pictures before they had been accepted by French taste.

Perhaps the 100,000 francs was somewhat exaggerated but it is certain that for some years Matisse had been comfortably secure economically. Sembat's reference to his luxurious horseback riding is amusingly confirmed by a postcard to Gertrude Stein written early in September: "Picasso is an equestrian and we go riding together which astounds everybody."

A more objective account of Matisse is given in a long story by the American journalist Clara T. MacChesney, published in *The New York Times*, March 9, 1913. A few paragraphs describe Matisse in his Issy environment:

. . . it was with keen interest that I sought this much-ridiculed man, whose work is the common topic of many heated arguments to-day. After an hour's train ride and walk on a hot June day, I found M. Matisse in a suburb southwest of Paris. His home, the ordinary French villa, or country house, two-storied, set in a large and simple garden and enclosed by the usual high wall. A ring at the gate brought the gardener, who led me to the studio, built at one side, among trees, leading up to which were beds of flaming flowers. The studio, a good-sized square structure, was painted white, within and without, and had immense windows, (in the roof and at the side), thus giving a sense of out-of-doors and great heat.

A large and simple workroom it was, its walls and easels covered with his large, brilliant, and extraordinary canvases. M. Matisse himself was a great surprise, for I found not a long-haired, slovenly dressed, eccentric man, as I had imagined, but a fresh, healthy, robust blonde gentle-man, who looked even more German than French, and whose simple and unaffected cordiality put me directly at my ease. Two dogs lay at our feet, and, as I recall that hour, my main recollection is of a glare of light, stifling heat, principally caused by the immense glass windows, open doors, showing glimpses of flowers beyond, as brilliant and bright-hued as the walls within; and a white-bloused man chasing away the flies which buzzed around us as I questioned him. . . .

One's ideas of the man and of his work are entirely opposed to each other: the latter abnormal to the last degree, and the man an ordinary, healthy individual, such as one meets by the dozen every day. On this point Matisse showed some emotion.

"Oh, do tell the American people that I am a normal man; that I am a devoted husband and father, that I have three fine children, that I go to the theatre, ride horseback, have a comfortable home, a fine garden that I love, flowers, etc., just like any man."

As if to bear out this description of himself, he showed me the salon in his perfectly normal house, to see a normal copy which he had made at the Louvre, and he bade me good-bye and invited me to call again like a perfectly normal gentleman.

Purrmann[1] describes Matisse's collection with enthusiasm:

Besides the Renoir and Cézanne paintings, the dining room was hung all around with watercolors by Cézanne. There was the beautiful Courbet Mademoiselle au bord de la Seine, a rock landscape, a big hunting scene; the frames were antique and tasteful. He had one room marbleized; he was proud to have found a handy Italian decorative painter who still knew how to marbleize in the old fashion. . . . I often visited museums with Matisse, also in Germany. He obtained plaster casts of Benin art, Indian, Roman, Greek, and Chaldean art. But he also bought from Courbet's sister all the studies made in his youth which Courbet had left to her; there were carefully studied charcoal drawings of figures and heads, besides sketches from plaster casts with huge noses, mouths, eyes and ears. "My Lord," exclaimed Matisse, "if you would suggest this kind of work to today's young people!"

10 Matisse and the Cubists

1912 had been a cubist year with the organization of the *Section d'Or* exhibition group led by Gleizes and Metzinger who published a book, *Du cubisme*, and by the three brothers Jacques Villon, Raymond Duchamp-Villon and Marcel Duchamp. Guillaume

Apollinaire, their chief champion, was also advocating two offshoots of cubism, Orphism, a bright-colored, highly abstract style practiced by Delaunay and Kupka, and Futurism, an ebullient Italian movement which had held a sensational show in February at Bernheim-Jeune's, Matisse's own dealers.

More important still were the two cubists Picasso and Braque who exhibited only in the small gallery of D. H. Kahnweiler, where the work of their youthful follower Juan Gris could also be seen. During 1912 the two leaders were experimenting with *papiers collés* and were moving gradually from their grey-and-tan analytical cubism to the broader planes, flatter space and brighter color of synthetic cubism. Matisse was aware of their work.

By 1913 Matisse and Picasso, whose names Leo Stein had first coupled in 1906, were now known throughout the world as the leaders of the modern movement. Matisse was still the stronger in Scandinavia, Britain and the United States, but the scales were already tipping in favor of Picasso in Russia, Germany and, thanks to the Futurists, in Italy. In general Picasso was of greater interest to the younger artists and out of his cubism of 1911-1914 grew the Russian and Dutch abstract styles which were so profoundly to influence painting and the arts of design after 1920. Even Matisse was to feel the influence, or at least the pressure, of cubism during the next few years. Much later, Picasso was to repay the compliment both in his painting and sculpture of the early '30s which show that, perhaps unconsciously, he well remembered Matisse's art of the early 1910s.

11 Shchukin's Letter of October, 1913

By 1913 Picasso had for some time been Matisse's chief rival for the patronage of the two Muscovites, though Morosov could not accept cubism. In October Matisse received a letter from Shchukin which must have reassured him. It is worth quoting in full for the light it throws not only on Shchukin's enthusiasm but on Matisse's reputation among German and Scandinavian art authorities:

Moscow, 10 October 1913

Cher Monsieur!

It is two weeks since my return to Moscow and during that time I've had the pleasure of a visit from Mr. Osthaus, founder of the museum at Hagen, and again the visit of many museum directors (Dr. Peter Tessen of Berlin, Dr. H. von Trenkmold of Frankfort, Dr. Hampe of Nuremberg, Dr. Polaczek of Strassburg, Dr. Sauerman of Flensburg, Dr. Stettiner of Hamburg, Dr. Back of Darmstadt, Max Sauerlandt of Halle, and Jens Thiis of Christiania). All these gentlemen looked at your pictures with the greatest attention and everybody called you a great master ("ein grosser Meister"). Mr. Osthaus has come here twice (once for luncheon once for dinner). I observed that your pictures made a deep impression on him. I spoke of your blue still life [the Blue Window, *color plate page 167] which you had done for him, what a beautiful picture I found it, and what a great development I felt in your recent works (Arab Café, Blue Still Life, Mr. Morosov's Fatma). Jens Thiis, director of the museum of fine arts at Christiania (in Norway) spent two days in my house studying principally your pictures (the second day he stayed from ten o'clock in the morning until six in the evening). He is so taken that he hopes to buy a picture for his museum.*

The other gentlemen also asked where one could buy your pictures and I replied at Bernheim's in Paris or directly from you. Mr. Osthaus will write you his own impressions regarding your works.

The Arab Café *[page 388] arrived in good condition and I have placed it in my dressing room. It is the picture which I love now more than all the rest and I look at it every day for at least an hour.*

Mr. Morosov is ravished by your Moroccan pictures. I've seen them and I understand his admiration. All three are magnificent [page 25]. Now he is thinking of ordering from you three big panels for one of his living rooms. He is returning to Paris the 20th of October and will speak to you about it.

I hope that the portrait of Madame Matisse [page 392] will also be an important work.

The 10,000 francs I owe you for the Arab Café *you will receive in December.*

My health is good, also that of my whole family, but I am very busy.

When you have time write me a word about your work and your projects for the winter.

Also don't forget my living room. It's beginning to be a real museum of your art.

My compliments to Mme Matisse

Votre tout dévoué
Serge Stschoukine

P.S. When will the Salon d'Automne open? Are you going to exhibit?

SECTION II EXHIBITION AND CRITICISM, 1911 TO SPRING 1913

1 Paris

Matisse's *L'Espagnole*, page 355, shown at the Salon des Indépendants of 1911, had been admired even by Matisse's more conservative friends who had found the *Dance* and *Music* overpowering at the Autumn Salon of the previous year. The two *esquisses décoratives*, page 143, at the Salon d'Automne of 1911 seem to have made little impression and he sent nothing to the Indépendants the following spring.

His two entries at the Autumn Salon of 1912 were an entirely different story. The *Nasturtiums and the "Dance," I*, page 382, and *The Painter's Studio*, page 375, were both large and very striking. Steichen wrote Stieglitz[2] that Matisse "had a very swell thing at the Salon d'Automne this year—but just a little 'stunty'—however it was easily the finest thing there." Jean Puy[3] was unreservedly enthusiastic about *The Painter's Studio*.

The exhibition of Moroccan paintings at Bernheim-Jeune early in 1913, page 145, was the occasion of Guillaume Apollinaire's most often quoted remark about Matisse: "If one felt obliged to compare the art of Henri Matisse to something, one would have to choose an orange. Like it, the work of Henri Matisse is a fruit of radiant luster"—*L'Intransigeant*, April 28, 1913. Deeply involved in cubism at the moment, Apollinaire praises Matisse as a painter "who has never ceased to follow his instinct." Sembat's remarks are quoted on pages 159, 160.

2 Foreign Exhibitions, 1911-1913

By the end of 1910 Matisse was already a name to conjure with abroad, but his was a reputation based primarily on admiration generated by his collector friends and students who had known his work in Paris. His most significant work, namely his paintings, were still little known abroad. The two New York shows of 1908 and 1910 had been of drawings and prints. The Berlin one-man exhibition at the turn of the years 1908-1909 had been smothered by hostile colleagues and critics; the two or three paintings each in the Moscow *Salon de la Toison d'Or* of 1908 and the big Brighton and London exhibitions of 1910 had been early or rather mild examples; and Stockholm had been stirred in 1909 not by his own work but by that of his devout pupils.

These circumstances were radically changed dur-

ing the years 1911 to 1913. It is true that in that period he seems to have had only a single one-man show, a group of sculpture and drawings at Stieglitz' "291" gallery in New York, but in the big annual shows in European capitals, Berlin, Munich, Rome, he was now an honored though controversial participant and in three epoch-making international shows in Germany, Britain and the United States his position among living painters was indicated through the number and scale of his exhibits.

3 Sculpture at "291," New York, 1912

Matisse had frequently shown his sculpture along with his paintings. At the Salon d'Automne of 1908 for instance there were no less than thirteen bronzes and plasters. But the first show of Matisse's bronzes without paintings was organized by Edward Steichen in Paris and presented by Alfred Stieglitz at the Gallery of the Photo-Secession, 291 Fifth Avenue, in March, 1912. Steichen sent Stieglitz the following list[4]—the brackets enclose references to our illustrations.

BRONZES—less twenty percent from these prices

1 *Petite tête femme*		250. fr.
2 *Sur le tapis, femme appuyée sur les mains* [page 326]		500
3 *Etude torse* [page 326]		500
4 *Jeune fille debout*		800
5 *Le serf* [page 305]		2400

The bronzes are limited to ten of each subject.

PLASTER CASTS

Three heads being three states of the portrait of a young girl [pages 368, 369]	(Bronze of these 1000 fr. each)
L'Attention, jeune fille assise	(Bronze 1000 fr.)
Jeune fille accoudée—"*Serpentine*" [page 367]	(Bronze 1200 fr.)
Tête de Satyr (terra cotta)	1500 fr.
12 Drawings to be sold at usual price (same as last ones)	

The drawings in the previous shows had been sold at 100 francs each, Matisse paying the duty[5] if any were sold. Perhaps some of them were sold but none of the sculpture was, though a cast of the little torso study, no. 3, then or later came into Stieglitz' own collection.

The *Serf* or *Slave*, page 305, was however *almost* sold. Later, Stieglitz told the story in detail to Dorothy Norman: Arthur Lee, the American sculptor, was so enthusiastic about the *Serf* that he persuaded Gertrude Vanderbilt Whitney to go to "291" to see it. Mrs. Whitney was on the point of buying it (for $600 plus $100 expenses) but a friend, the fashionable portrait painter Howard Cushing,

who accompanied her was so aghast at her intention that she was dissuaded.

For once the New York newpaper critics[6] were unanimous: they were against Matisse as a sculptor. Said Huneker of the *New York Sun*:

After Rodin—what? Surely not Henri Matisse. We can see the power and individuality of Matisse as a painter, particularly as a draughtsman, but in modeling he produces gooseflesh. . . .

Arthur Hoeber in the *New York Globe*:

. . . Some of them, to put it very mildly, seem like the work of a madman, and it is hard to be patient with these impossible travesties on the human form. There are attenuated figures representing women [doubtless La Serpentine] *. . . which make one grieve that men should be found who can by any chance regard them with other than feelings of horrible repulsion. . . . Indeed, it is unbelievable that sane men can justify these on any possible grounds. Yet, so seriously minded a man as Roger Fry, lately connected with the Metropolitan Museum of Art, takes this same Matisse seriously, and has so expressed himself in black and white under his own signature.*

David Lloyd in the *New York Evening Post*:

There are also some plaster casts, including three states of a portrait of a young girl. The sculptor goes after the gargoyle in human nature, but then apparently realities begin to cramp him, and as in the parable, the last state is worse than the first. The exhibition continues to April 6.

The "three states of a portrait" were *Jeannette I, II* and *III*, pages 368-369.

4 Cologne and London, *1912*

At the great Cologne *Sonderbund* exhibition of international modern art, organized under the chairmanship of Karl Osthaus in May 1912, Matisse was represented by only five paintings as against Picasso's sixteen, but in the London and American sequels the tables were turned.

Under Roger Fry's aegis the Second Post-Impressionist Exhibition opened at the Grafton Galleries in London on October 5, 1912, and ran until December 31st, with some loans held over for an extension. There were over three-hundred exhibits of which Clive Bell chose the English, Boris Anrep the Russian, Fry the French. Except for a few Cézannes the show was entirely 20th century.

Matisse dominated the French group with nineteen paintings, seven sculptures, a score of drawings and many prints as against Picasso's eleven paint-

ings and three drawings. There were *Carmelina* (*La pose du nu*), page 311, and another painting of the dark period; three major fauve paintings: *The Young Sailor, II*, page 335, *The Hairdresser* (*La coiffure*), page 339, and *Le luxe, II*, page 341; several post-fauve portraits and still lifes and flower pieces including one just painted in Morocco; the *Nude by the Sea*, page 359; the big interiors *Conversation* (lent by Shchukin), page 347; *Nasturtiums and the "Dance," II* (*Les capucines*), page 383; and the *Red Studio* (*Le panneau rouge*), page 162; and the *Goldfish*, page 385. In a place of honor at the end of the last gallery hung the huge first version of the *Dance*, page 360, flanked by two Matisse bronzes. The catalog honors Matisse by a color frontispiece of the *Girl with a Black Cat*, page 354; and of thirty-nine halftones, six illustrated Matisse paintings, three his sculpture, including a plaster of the *Back*, page 313, and four of the five states of *Jeannette*, pages 368-370, reproduced there probably for the first time.

In the catalog of the first Post-Impressionist show of 1910, bibliography 116, the introduction, inspired by Fry's ideas, had emphasized the relation of modern painting—Matisse, Gauguin, even Cézanne—to primitive art. Picasso is not even mentioned. But in his foreword to the 1912 catalog, bibl. 117, Fry emphasizes the "classic" character of recent French painting as seen in Cézanne and, more abstractly, in Picasso and his followers.[7] He remarks that, "In opposition to Picasso, who is predominantly plastic, Matisse aims at convincing us of the reality of his forms by the continuity and flow of his rhythmic line, by the logic of his space relations, and above all, by an entirely new use of colour. . . . In this . . . he approaches more than any other European to the ideals of Chinese art." He recognizes what had been evident in Paris since 1908, that "on the whole the influence of Picasso on the younger men is more evident than that of Matisse."

5 The New York "Armory Show," *1913*; Chicago; Boston

The story of the "Armory Show," the International Exhibition of Modern Art, has been told too many times to need retelling here.[8] Suffice it to say that there were some sixteen-hundred works exhibited ranging historically from Ingres and Delacroix through Cézanne, Gauguin, van Gogh, Seurat, Rousseau, Redon, down to the men of the 20th century mostly of France and the United States. Arthur B. Davies, who had been one of The Eight

of 1908 (though as far as possible from the "ash-can school" in his art) was President of the Association of American Painters and Sculptors which organized the show; Walter Pach, the painter-critic, who had been living in Paris, had a good deal to do with selecting and soliciting the exhibits: generous friends of Arthur B. Davies financed the undertaking. The show, which opened February 17, 1913, and ran for a month until March 15, was attended by about a quarter of a million visitors who formed lines to see the most talked-of picture, Marcel Duchamp's *Nude Descending a Staircase*. The conservatives and academicians attacked with the usual charges of incompetence, venality, immorality, inhumanity, irresponsibility, indecency, and political radicalism but at the all-night party which closed the triumphant show John Quinn arose to silence an ironic hurrah for the National Academy, "No, no. Don't you remember Captain John Philip of the *Texas?* When his guns sank a Spanish ship at Santiago, he said: 'Don't cheer, boys, the poor devils are dying!' "9

From New York the show moved on to Chicago where it was shown not in an armory but in the Art Institute itself. Walter Pach tells of its reception there.1 It may be noted here that the art students in the Institute's school held a protest meeting and burned in effigy Matisse's *The Blue Nude*, now in the Baltimore Museum. In general Chicago and Boston, where the show went next, were less tolerant of the new art than New York. New Yorkers bought about 250 works out of the exhibition, Boston and Chicago only fifty between them.2

Matisse was represented in the Armory Show by thirteen paintings, three drawings and a large sculpture by comparison with Picasso's six paintings and one drawing, and three paintings each for Vlaminck, Derain and Braque. Matisse's list follows, with references to our illustrations in brackets.

401 *Le madras rouge.* Lent by Michael Stein [page 350]
402 *Joaquina.* Lent by MM. Bernheim-Jeune & Cie.
403 *La coiffeuse.* Lent by M. Michael Stein [page 339]
404 *Les poissons.* [?page 165]
405 *Jeune marin.* [page 335]
406 *Panneau rouge.* [page 162]
407 *Le luxe.* [page 341]
408 *Portrait de Marguerite.* [page 354]
409 *Les capucines.* [page 383]
410 *Nature morte.*
411 *La femme bleue.* Lent by Leo Stein [page 336]
635 *Le Dos, Sculpture* [page 313—should be dated 1910-12]
1064 *Flowers.* Lent by Mrs. Howard Gans
1065 *Study.* Lent by Mr. George F. Of [page 319]

In addition, there were three drawings, one of them lent by Alfred Stieglitz.

Though Duchamp received more brickbats in words and caricatures than Matisse, the older artist had his share of angry hostility. *The New York Times*, February 23, 1913, bludgeoned Matisse: "We may as well say in the first place that his pictures are ugly, that they are coarse, that they are narrow, that to us they are revolting in their inhumanity. His simplifications are so extreme. . . ."

On March 16th, the day after the Armory Show closed, the *Times* opened its columns to Kenyon Cox, an articulate academic mural painter:

Up to the time of Matisse, the revolutionaries, I believe, were for the most part sincere enough. . . . But with Matisse . . . the Cubists and Futurists . . . are making insanity pay. . . .

Getting back to Matisse . . . many of his paintings are simply the exaltation to the walls of a gallery of the drawings of a nasty boy. . . . It is my conviction . . . that Matisse has his tongue in his cheek and his eye on his pocket. . . . What I have said to you is not the opinion of a conservative. . . .

Frank Jewett Mather's review of the Armory Show in *The Nation*3 contains remarks about Matisse which need not have caused the readers of that spirited and scholarly critic surprise if they remembered his cautionary remarks about Matisse as a painter in the long encomium of his draftsmanship published in the *New York Evening Post* in 1910 (Appendix E). Now, three years later, Mather wrote in sorrow and anger over such waste of talent:

Matisse is an original and powerful draughtsman. One has only to see his crayon drawings from the nude to be convinced of that. They are of quite extraordinary potency and simplicity. His pictorial ideas, innate ones perhaps, we may grant, are either trivial, monstrous, or totally lacking. The Portrait in Madras Red [*page 350*] *illustrates his power. The torso is swung in with a quite magnificent gesture that ignores all details; for the rest, a coarse emphasis on the intentness of the face, raw color, mean surfaces—a prodigal expenditure of violent means to achieve a passing and negligible effect. . . . The more perverse expressions of Matisse's mode as expressed in bulbous nudes, empty schematic decoration, and blatantly inept still life will merely reinforce a first impression based on the work that is relatively normal. Upon the ugliness of the surfaces I must insist at the risk of repetition. Everything tells of a studied brusqueness and violence. It is an art essentially epileptic. Sincere it may be, but its sincerity simply doesn't*

matter, except as it is pitiful to find a really talented draughtsman the organizer of a teapot tempest.

One wonders if Cox and Mather had read Clara T. MacChesney's story about Matisse dispatched from Paris to the *Times* and published March 9, bibl. 56.

She prefaced her piece by remarking of her subject that "time has converted many, even of our most conservative critics and art lovers, to his point of view." In any case Matisse's request to her that she "tell the American people" that he was "a perfectly normal man" was well-timed!

SECTION III PAINTINGS, 1911

1 *The Two Spanish Still Lifes, 1911*

Though they are not the same size, the two big still lifes which Matisse painted in Seville during the winter of 1910-1911 are very much alike. And they differ in character or, rather, in degree from anything Matisse had painted before. Matisse had often used boldly figured textiles in his interior and still-life compositions, but never in such profusion. He took the flowered Spanish shawls and tablecloths which he had been collecting with almost touristic enthusiasm and draped them over the chairs, tables and a Baroque sofa in his hotel room. Flowers and fruit on the tables add to the complexity of this riotous counterpoint of pattern and color which is relieved in both pictures by plain backgrounds of wall and floor, a white flowerpot, and a white curtain blowing in from the open window at the left. The thin, transparent paint is brushed over the white sizing with an apparent speed which well conveys Matisse's excitement when confronted by the problem of controlling and harmonizing such a bedlam of assertive patterns. The larger of the two, the *Interior with Spanish Shawls* or *Seville Still Life*, is illustrated here on page 372, the smaller *Spanish Still Life* may be seen in the photograph of Shchukin's Matisse room, just to the right of the door, page 25.

2 *The Four "Symphonic Interiors," 1911*

When Matisse left Paris for Spain, he had just come back from an extended trip through Germany so that it is quite possible that these two Spanish still lifes were his first paintings since the completion of the *Music* and *Dance*. In Germany he had studied with intense interest the Munich exhibition of Islamic art with its profusion of ornamented surfaces. The vivid recent memories of this great exhibition combined with a reaction against the long, arduous and ascetic struggle for simplification in the *Dance* and *Music* may well have affected Matisse's art not only in the two Spanish compositions, but also in the series of other very large and exceedingly elaborate compositions which distinguish his painting of 1911 from that of any other year. These are[4] *The Painter's Studio*, *The Painter's Family*, and the *Interior with Eggplants*, pages 373-375, and the *Red Studio*, page 162. So large and complex are these interiors that they might reasonably be called "symphonic."

By comparison with these, *The Manila Shawl*, page 355, seems austere. Yet this portrait of Mme Matisse, painted early in 1911 just after the artist got back to Issy from Spain, is far from austere if compared with the typical portraits of 1910, pages 353, 354. Probably separated from the latest of them by the German and Spanish voyages and by at least six months of time, *The Manila Shawl* is nevertheless a kind of synthesis though scarcely a climax of Matisse's portraiture of 1908 to 1910. Therefore it is illustrated and analyzed with them out of chronological order. It is apparently Matisse's only important portrait or study of the single figure done during 1911 yet it may have suggested to him the subject of one of his most remarkable paintings, *The Painter's Family*, which involves the artist's wife and three children as motifs in an intricate ensemble.

3 The Painter's Studio, *Early 1911*

The Manila Shawl's background of vertical boarding and its dominant Spanish motif also lead into *The Painter's Studio* which was painted early in the year and is the first of the four large interiors of 1911.

In *The Painter's Studio* Matisse uses as his central focus a flower-figured screen over which he has flung a boldly patterned textile brought back from Spain. Except for the rather sparsely ornamented rug lying diagonally in the foreground, there is no other decorated surface in the picture. Linear perspective is clear and fairly consistent throughout, the diagonal rug taking the place of the diagonal fireplace and wall in the Grenoble *Interior*. A score of subordinate forms—rectangles of paintings, the open, constructed forms

of tables and sculpture stands, and the organic forms of human figures sculptured, painted or drawn—are all carefully distributed and adjusted to form a complex equilibrium within the groups, and between the groups, on either side of the central screen.

The color follows the color of the objects throughout except for the floor which is a deep violet pink and the wall a lighter shade of the same color. Against these play the ochre rug, the dark blue textile over the green screen, the foliage seen through the window and the numerous small accents of brown furniture and varicolored paintings.

The year following its completion, Shchukin bought *The Painter's Studio* and lent it to the Salon d'Automne of 1912 before it was sent to Moscow. Jean Puy saw it there and found[5] that "it inaugurated a manner less complicated, less cerebral, less dangerous than the preceding [was he thinking of the *Dance*?]." With its gentle color and casual seeming composition *The Painter's Studio* was indeed the mildest of all Matisse's large paintings of 1911.

4 The Painter's Family, *Spring, 1911*

The Painter's Family, page 373, was painted at Issy-les-Moulineaux during the spring of 1911. By May 26th Matisse was far enough along to write a couple of postcards about it to Michael Stein, far away in California. One of the cards with a little sketch is reproduced opposite through the courtesy of the owner who received them from Mrs. Stein. On the first card, above the sketch, Matisse writes with his customary anxiety:

It is well under way, but as it isn't finished, there is nothing to say—that isn't logical, but I am uncertain of its success. This all or nothing is very exhausting.

Then, on the next card:

The picture represents the living room with the fireplace in the middle and two couches on each side. On the couch at the left my wife sews on an embroidery. In the middle Pierre and Jean are playing checkers and at the right Marguerite is standing holding a yellow-bound book in her hand. She is in a black gown with white collar and white cuffs. The color is beautiful and generous. You will notice that on the wall I have put some flowers like those on wallpaper like this [drawing]. I hope to have it still in September when you come back. Best from us all to you three. Send news—H.M.

Perhaps it was because he had just then been

working on the Marguerite figure that he describes the colors of her costume while he neglects those in the rest of the picture; perhaps he felt her to be especially important. In any case, the two boys are in bright vermilion, Mme Matisse in ochre with yellow flowers. The rug, the floor, the couches are also warm in color, chestnut, dark orange, ochre with occasional accents of blue; the "wallpaper" is cream colored. In this sea of warm tones there are islands of cold—the white mantelpiece, the dark blue mirror over it and the black and white checkerboard.

The subject of the *Family* is developed from that of the *Conversation*, page 347, which presented rather generalized figures of the painter and his wife, and so is the composition with its background divided by a median rectangle around which the figures are disposed. But the *Family* is far more complex than the *Conversation*. In few paintings has Matisse shown such a *horror vacui*. Every surface is ornamented, several, such as the wall and the fireplace, with arbitrarily invented motifs of floral or leaf patterns. Only the clothes of Marguerite and the two boys, and the dark mirror offer areas of unornamented surface.

The tall, straight black figure of Marguerite is valuable for it balances the other more active figures at the center and left of the canvas thus preserving an asymmetric equilibrium which plays against the static symmetrical equilibrium of the setting. The balance is subtly adjusted by the size and placing of the objects on the mantelpiece, serving the same purpose as the subtle disbalance of the landscape and window grill in the *Conversation*.

The *Family* has sometimes been compared to Russian icons, perhaps because of the stiff elongated figure of Marguerite. Actually, Matisse had not yet been in Russia but he had quite recently come back from Munich where he had seen the exhibition of Mohammedan art. The resemblance of the *Family* to Persian miniatures[6] is quite close with its similar use of flat figures against an elaborately patterned flat perspective devoid of directional light or shadow.

5 *The* Interior with Eggplants, *1911*

Not long, perhaps, after finishing the *Family*, Matisse carried his love of all-over patterning to an extreme in the big tempera painting of the interior of his villa at Collioure in which three eggplants are conspicuous motifs. In the *Interior with Egg-*

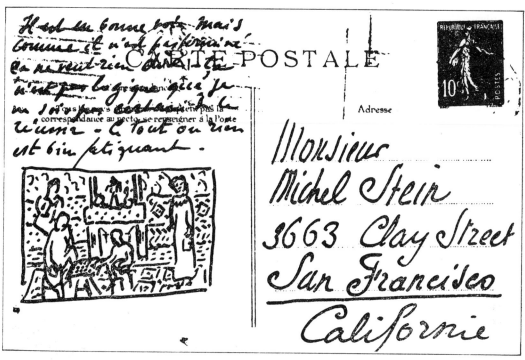

One of two postcards to Michael Stein, San Francisco, from Matisse, Issy-les-Moulineaux, May 26, 1911. The drawing represents the nearly completed *Painter's Family*, page 373. Courtesy Professor John W. Dodds

plants, page 374, the picture is again divided into three vertical sections by a central rectangle, in this case a screen like that in *The Artist's Studio*. The screen is so placed that it serves as a frame within a frame to a still-life composition with fruit and a large vase arranged on a table very much as in the *Blue Still Life* of 1907, page 331. Around the screen are disposed other rectangles formed by picture frames, a doorway, an open window and, at the left, some diagonally foreshortened portfolios, a fireplace and what is apparently a mirror reflecting the still life, the window sash and part of the screen.

Almost everywhere Matisse has painted ornamental patterns: on the tablecloth, the plaid seen in the mirror, the hanging seen through the doorway behind the screen and two different ones on the screen itself. Then over the floor and walls he spreads an invented pattern of huge five-leaved flowers and finally, as if drunk with patternizing, he repeats the big flowers as a border all around the picture.[7]

In spite of its freely placed figures, the *Family* picture had been balanced around a strong vertical axis or fulcrum formed by the fireplace. But in the *Interior with Eggplants* the screen is centered not only on the vertical but on the horizontal and diagonal axes as well, thereby greatly strengthening its centrality but weakening its function as fulcrum. We associate figures, no matter how flatly painted, with the weight of our own bodies so that in a figure painting we feel the need of a *balanced* composition of masses. In this *Interior* there are no figures; the "solid" objects are very small and all the large areas are flat planes. The perspective of these planes is freely handled in some cases, flattened out as in the background wall at the left, or the table top off which the eggplants seem to be rolling; and the perspective of floor and walls is further fused, as in the *Harmony in Red*, page 345, by running a strong floral pattern over them both. Consequently, with both depth and weight largely suppressed, Matisse used the screen not so much to balance as to centralize his composition which spreads out from this center in all directions. Turned on its side the composition still holds; in the *Family* it does not.

The three eggplants well deserve to lend their name to the canvas for, though small, they are the strongest motif in the big composition, acting in fact as a theme which is picked up again in the patterns of the tablecloth and screen. They appear again in the lightly painted *Eggplants* in the collection of Alexina Matisse. This is clearly a study for, or

153

a postscript to, the still life in the center of the big Grenoble *Interior*. Its blond color and flamboyant design recall the bravura fantasies of Louis XV ornament designers.

6 The Red Studio, *Autumn, 1911*

Of the four large interiors painted by Matisse in 1911, the *Red Studio* is the last and the boldest in design. In it Matisse abandons almost entirely the patterned surfaces which had enriched his three previous compositions to the point of excess. The *Red Studio* marks a return to a simplicity of motif and lack of ornamentation which was to last for many years, in fact almost up to 1919. The *Red Studio* is reproduced in color and analyzed on pages 162 and 163.

7 The Still Lifes of 1911

In addition to the four large "symphonic" interiors of 1911 Matisse painted a number of smaller "sonata-size" compositions which are even more celebrated. One of them, the Moscow *Goldfish*, is in the elaborate decorative style of the Grenoble *Interior with Eggplants;* others such as John Hay Whitney's *Goldfish and Sculpture* and the Le Ray Berdeau *Flowers and Ceramic Plate* are much simpler and more abstract.

In the *Goldfish*, page 376, bought by Shchukin, Matisse uses the brilliant fish as a glowing spark in the center of a profusion of flowers and leaves much as he places the shining purple eggplants as a focus in the big Grenoble decoration. The goldfish are seen again reflected on the surface of the water. The circular bowl, which catches the greenish hue of the surrounding plants, rests on a circular violet table supported by legs with a circular bracing. These five concentric circles (seen as ellipses) rest on a circular patch of dark earth around which play the pink, crimson and green of flowers.

In the other *Goldfish* of 1911, reproduced in color and analyzed on pages 164 and 165, in the *Blue Window*,[8] color plate page 167, and in the *Flowers and Ceramic Plate*, page 377, Matisse employs a striking monochrome blue background closely related in function to the red background of the *Red Studio*.

The *Flowers and Ceramic Plate* is rarely reproduced and, indeed, seems a little mysterious for all its bright color and frank rendering of the vertical boards which walled Matisse's Clamart studio. The flowers sparkle against the azure, but over the nasturtiums is suspended a deeper blue disk, floating like a toy balloon, and behind the disk hangs a curled engraving and behind it a curious long black rectangle. Surprisingly, the date is 1911, the year before *papier collé* emerged from the studios of Braque and Picasso; and the floating disk on close inspection is one of Matisse's own ceramics decorated with a drawing of a faun and nymph.

The *Flowers and Ceramic Plate*, it should be noted, was bought in 1917 by Dr. Georg Swarzenski for the Municipal Museum in Frankfort whence, thanks to Hitler and his Lucerne auction, it passed into the Berdeau collection in 1939.

SECTION IV PAINTINGS: THE FIRST MOROCCAN VISIT, 1911-1912

1 Matisse in Morocco

In North Africa Delacroix had found picturesque mystery and violence. Matisse, the least romantic of painters, found excitement too, but it was primarily visual excitement—though once, when he first went riding in Morocco, with the flowers up to his horse's nostrils, he felt strongly reminded of a passage he had read many years before in Pierre Loti's *Au Maroc*.[1] The buildings and the gardens of Tangier, the people and their clothes inspired new form and new color in Matisse's painting. He had been to Algeria for a fortnight in 1906, yet the few sketches he made there, page 328, are scarcely distinguishable from some of those made at Collioure in the same year. But the two winters in Tangier produced a deep and stimulating effect on Matisse and his art.

Unfortunately only three or four of his Moroccan pictures have found their way to America and these are in private possession.[2] Equally few are left in France[3] and there are none apparently in Britain. The Stockholm museum has an excellent landscape, page 380; the others are all hidden[4] in an inhospitable U.S.S.R.

Even Matisse is not always certain which paintings were done on the first, which on the second trip to Tangier. The three park pictures seem to have been painted in 1911-1912, at least two of the three tall narrow panels of single figures and, surely, the *Window at Tangier*. On the second trip Matisse painted *Zorah on the Terrace*, the two pic-

tures of the *Riffian*, two large flower pieces, the great *Moorish Café* and probably the *Oranges*.

There is no great difference of style between the two periods, but in general the paintings of the second visit are rather less flat and abstract and some of them, such as the *Oranges*, page 389, and the *Tangerian Girl*, page 387, bought by Sembat, are comparatively thickly painted.

2 Zorah Standing; Fatma; Amido, *1912*

Matisse studied Moroccan costumes with obvious pleasure and painted a half dozen canvases which make the most of the color and ornament and drape of these beautiful clothes. The earliest of these, three tall pictures of Moroccans standing almost life-size, form a series very new in format if not in style. They are reproduced together on page 378 but were not intended by Matisse to form a triptych.

In the *Zorah Standing*[5] the figure is posed frontally as in Holbein's *Christina of Denmark* and with something of her demure dignity; but Matisse's color could scarcely differ more from Holbein's courtly blacks. Zorah, robed in green with a black and white border, stands before a rose-red background. Her sleeve linings are white, her girdle red orange, and her slippers lemon yellow on an orange floor. A sheet of three pen-and-ink sketches of Zorah's head, page 379, now in the Gardner Museum, Boston, shows a profile and two full-face views. The latter two are obviously studies for the face in *Zorah Standing*, the one at the left naturalistically modeled with cross-hatching, the right-hand one flat and simplified like the triangular mask in the painting.

The other two standing figures, *Fatma, The Mulatto* and *Amido, The Moor*, are less formally posed, and painted with more modeling in the drapery than Matisse ordinarily used at this time. *Fatma* is now in a Swiss collection; the *Zorah Standing* (*La Marocaine*) and *Amido* (*Le Marocain*) were bought by Shchukin, the latter probably the first Moroccan picture he acquired.[6]

3 The Three Garden Paintings, *1912*

Three paintings of Moroccan gardens or parks form a second trio of identical size and similar subject matter, though very different in color and construction.

Of the three, the Stockholm *Park in Tangier*, page 380, is the most realistic in detail, the most static

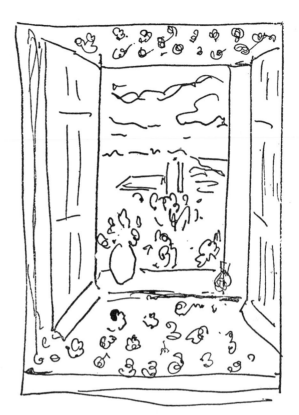

Pen and ink study for the *Window at Tangier*, page 386, made in Matisse's room in Hôtel de France, early 1912. One of five drawings by Matisse reproduced in Pierre Reverdy's *Les jockeys camouflés*, 1918

in composition and the most beautiful in color. A strong horizontal divides the background in almost equal areas. Against the lower rectangle of deep violet blue shot with pink, Matisse has painted green acanthus leaves margined with black or cobalt. The upper background is mauve pink with pale olive and muted orange foliage. The whole picture is tied together and dominated by the magenta-colored vertical of the big tree trunk at the left. Almost no bright hues are used but the sumptuous glow of the color is perhaps unsurpassed in Matisse's entire work.

Maurice Raynal[7] tells how impressed Matisse was by the magnificent trees in the Tangier gardens and by the luxuriant acanthus plants which he had never seen before except in the Corinthian capitals that he had drawn as a student. After working on the *Park in Tangier* for some time he remained dissatisfied and decided ultimately to revise and complete the painting upon his next trip to Morocco the following year. Back in Issy, Matisse kept to his resolve in spite of the admiration some of his friends

expressed for the picture. Yet, when he returned to Tangier, he found that he had underestimated his first effort and nothing could be changed: "What I thought was missing on my canvas was there all the time. . . ."

Marcel Sembat[8] recalls a very different story about another Moroccan landscape:

I know one of those garden pictures, three times repainted, and each time raised toward decoration, toward calm, toward an abstract simplicity. The first time I saw it the trees and shrubbery impressed me by their natural vitality; then the ground level was covered by a uniform tone, the plants turned to an ornamental garland of lianas, the trees even changed into the trees of a terrestrial paradise and the whole effect became one of ideal repose.

Sembat was probably referring to the *Moroccan Garden*, page 380, the most abstract of the series. It is by contrast with the deep, modulated tone of the *Park in Tangier* predominantly light and flat in color. Against a pink sky flows billowing foliage, pale grey above, blue-green and yellow-green below, accented by pale blue periwinkles. The whole composition is swept into a diagonal arabesque of smoke-puff curves tempered by the slower arcs of bending tree trunks, the large one red-brown, the smaller black.

The composition of *The Palm Leaf, Tangier*, page 381, is based neither on a vertical-horizontal structure nor a gracile arabesque. Instead the eye looks down as if from a window upon tree trunks which converge toward the center of the picture, where their crisscrossing is masked by an explosion of palm fronds. Greys and bright greens are enlivened by black bark and the terra-cotta-colored path below. Matisse remembers the place, a private garden on the plateau overlooking Tangier. He painted the *Palm Leaf*, he says,[1] in a "burst of spontaneous creation—like a flame. . . ."

4 *The* Window at Tangier

From his window in the Hôtel de France, Matisse could look out on Tangier over the gardens and orange-pink paths in the foreground to the English church[2] with its green roof and square Tudor tower and beyond to some large buildings lying under a cloudless sky. Placing a pitcher of white flowers and a jug of pink ones on the window sill, Matisse painted the *Window at Tangier*, page 386. It is very similar in its general composition to *The Blue Window*, page 167, painted in his bedroom back in Issy, though here the view is more important than the still life. In both pictures blue predominates but in the Moroccan *Window* the eye is relieved by areas of white, orange, green and dull pink; and the general effect is less arbitrary and formal.

The little known[3] *Entrance to the Kasbah*, page 386, is the same size and painted in the same style as the *Window at Tangier*. Romm[4] describes its four colors as "raspberry red, sky blue, green and pale rose."

SECTION V PAINTINGS: ISSY, SUMMER AND FALL, 1912

1 Nasturtiums and the "Dance," I *and* II

Probably the first important pictures painted by Matisse at Issy in 1912 were the twin canvases[5] called *Nasturtiums and the "Dance,"* pages 382, 383. They are quite unlike any interior or still-life compositions in Matisse's previous work. Narrow in format and over six feet high, they were conceived as decorations on a mural scale. The Moscow version originally bought by Shchukin was obviously painted first,[6] perhaps on commission. It differs from the Worcester version in its abruptly receding floor-line diagonal and emphatically three-dimensional tripod.

The tripod in the second version is not only flattened out, but its structural character is further denied by the amputation of the far leg which rests solidly on the floor in Moscow but in Worcester stops short in mid-air above the lower frame of the *Dance*. This bold abbreviation, which usefully simplifies the design, marks a new step in the liberties which Matisse felt free to take with objects.

Though the tripod has been slightly "mutilated," it and the vase of nasturtiums which it carries are the only completely visible motifs in the picture. The chair below and the *Dance* are seen only as fragments, and in the Worcester version the two dancers, which had been whole in the Moscow version, are cut by the frame. Thus Matisse plays with Japanese compositional devices which Degas had so often used before him. The *Nasturtiums and the "Dance"* should be compared with the *Still Life with the "Dance,"* page 346, to make clear how bold Matisse's composition had become since 1909.

The Worcester panel which might be designated *Nasturtiums and the "Dance," II*, stands in relation to the earlier Moscow picture much as *Le luxe, II*, page 341, and *The Young Sailor, II*, page 335, stand respectively to their first versions. All these "revisions" move toward a more abstract and integrated style; in short they clarify both Matisse's specific intentions and his general direction as an artist.

The *Corner of the Studio*[7] of 1912 may well have been intended as a pendant to *Nasturtiums and the "Dance," I*. Both were bought by Shchukin and the *Corner of the Studio* may be seen in the photograph of his dining room, page 24—no other photograph is available.

2 A Path in the Woods of Clamart, 1912?

The months between Matisse's return to Issy in the spring of 1912 and his second trip to Morocco in the fall, mark the beginning of a reaction against the flat, bright-colored style which had characterized the main line of his painting since the *Joy of Life* of 1905. Even before the end of 1911 the excessive decorative patterning of *The Painter's Family* and the *Interior with Eggplants* had given way to the unpatterned but centrifugal *Red Studio* and Whitney *Goldfish*, followed by the severely constructed *Blue Window* and, in Morocco, by the *Zorah Standing* and the *Window at Tangier*. *Nasturtiums and the "Dance,"* especially the second version, continue the flat, high-keyed color of late 1911 but they are followed by paintings in another spirit.

Among the first of the transitional works, *A Path in the Woods of Clamart*, page 381, is one of Matisse's least known canvases; indeed it may never have been published before.[1] Though the artist believes he painted this highly abstract composition in 1912, its style suggests 1914-1916. Yet it seems closely related to another "path in the woods," *The Palm Leaf, Tangier*, page 381, probably painted a few weeks or months before in Morocco. However the abstract effect of the *Palm Leaf* seems intrinsic to the subject whereas in the Clamart painting the abstraction is so arbitrary that one might easily suspect some influence of cubism, especially in the harsh angularity of the design. Yet, if *A Path in the Woods of Clamart* was painted in 1912 it would seem not so much to follow that year's late analytical cubism of Picasso and Braque as to be an anticipation of the synthetic cubism of two or three years later. Matisse's own *Goldfish* of 1915, page 169, is also similar with its arbitrary bands of light and dark.

3 The Barnes Goldfish and Still Life with a Bust, Issy, 1912

Two important canvases presumably done later in 1912 are much less abstract though quite cubist in superficial effect. Their subdued color and obvious concern with construction confirms a new direction in Matisse's art. These are the *Goldfish* and the *Still Life with a Bust*.

The change in Matisse's style which took place during 1912 is well illustrated by comparing the Whitney *Goldfish and Sculpture* of 1911, color plate page 165, with the *Goldfish*, page 385, now in the Barnes Foundation. The pictures are the same size and the same subject, but whereas the 1911 version is composed of flatly-painted, brightly-colored shapes upon a light blue field with almost no sense of depth, Matisse has composed the 1912 version with vigorously rendered solid forms disposed in the closely constructed three-dimensional dark blue space of the studio. In the Whitney version the mat on which the fish bowl, flower vase and sculpture rest is the same all-over blue as the table and background, and it is drawn parallel to the picture plane. In the Barnes picture the tannish mat is placed diagonally and its diagonal thrust-in-depth is strongly reinforced by the vigorously drawn, dark brown table, the sides of which parallel the wall of the room, thereby reinforcing its own volume and depth. The objects themselves are much more heavily outlined than were the same objects the year before, and they are placed in depth rather than side by side. Yet there are contradictions. The sculpture, for instance, is not modeled in light and shade which would greatly have increased its apparent solidity, and both floor and wall of the room are painted the same undifferentiated tone which tends to make the whole room seem a single flat plane. These contradictions, however, are as usual handled so skillfully by Matisse that by the very tensions they create, they enhance the vitality and power of the painting, while at the same time preserving that sense of the picture plane which Matisse at this period rarely forgot.

Though they are dark in tone, the warm brown of the table and over-all deep blue of the room serve admirably as background to the pale blue fish bowl with its vermilion fish, the orange flowers, the pink terra cotta, the green cloth hanging over the screen at the right and the varicolored pinks, yellows and reds of the two paintings on the wall and the garden

seen through the doorway. These brighter colors glow in the gloom like stained glass divided by leading and heavy mullions.

The *Still Life with a Bust*, page 384, also in the Barnes Foundation, is even more vigorously drawn. In fact the broad powerful sweep of the brush as it projects the shapes of objects gives this painting its chief distinction, for the color is comparatively drab. At the same time this is one of Matisse's most emphatic designs, the angular planes and curved contours overlapping and interlocking throughout the canvas in a way which superficially suggests cubism.

4 Structure and Sobriety

During the next few years, in fact as late as 1917, many of his paintings are somber in palette; a few of them[2] in fact are painted entirely in monochrome grey. Often, however, the color is deep and resonant. Though there are brilliant exceptions, in general Matisse's painting from mid-1912 to the end of 1916 is comparatively sober, even at times austere in design, color and spirit. Furthermore, although some compositions are flat abstractions, others mark a return to ordinary perspective.

The causes for the change in Matisse's style seem to have been largely but not entirely personal. He had gone through a "dark" period before, from 1901 through 1903. Deserting the bold color and drawing which about 1900 had established him as a "proto-fauve," he turned back for inspiration to the conventional modeling and brown color of the pre-impressionist mid-19th-century realists. His poverty of those early days may not only have affected his palette and led him unconsciously to paint in a more conventional and acceptable style, but it seems more likely that in his slow and tentative development he felt the need of discipline and security after several years of liberated experiment. Therefore he turned back and away from the radical modern achievements of Signac, van Gogh and Gauguin and parted company for a time from Vlaminck and Derain, not to resume his position as *avant-garde* leader until 1905. Yet, it should be remembered that during this earlier period of austere reaction he had not only the company of his own circle such as Puy, Marquet, Biette and Manguin, but also, unbeknownst to him, the parallel reaction of Picasso, whose "blue" period began in 1901 just about the same time as Matisse's "brown" period.[3] Both were doubtless affected by a general spirit of

reaction led by the old-masterish Maurice Denis and the realist Félix Vallotton, the very painters who a dozen years before had been Nabi or Symbolist rebels. Even Bonnard's paintings of the early 1900s were comparatively grey in color.

The growing importance of Cézanne in the first years of the century has been described. So has the curious way in which the belated discovery of Cézanne by Picasso and Braque led toward cubism in 1907 and consequently to Matisse's loss of leadership—even though Matisse himself had for years been studying Cézanne with an intensity and devotion barely approached by the cubists. From 1908 on Matisse had gone his own way, followed, it is true, by hosts of young foreigners but not by the Paris vanguard which had plunged deeper and deeper into the rigorous researches of analytical cubism. It would be hard to imagine anything more radically different than the angular, fragmented, ascetic grey-brown cubism of Picasso in 1911 and the flat brightly-colored, gaily decorative canvases of Matisse during the same year. It is true that lesser cubists such as Delaunay and the Futurist Severini, perhaps encouraged by Matisse's example, were reviving brilliant color, but by 1912 not only Braque and Picasso but even non-cubists such as Matisse's friend Derain were using color of unprecedented sobriety in compositions of conscientiously structural probity. In 1910 for instance, Roger Fry could think of the work of the younger Paris painters in terms of the "expressiveness" of the primitive or barbaric artist or of children. But by 1912 he frequently uses the term "classic" and even compares Derain to Poussin.[4]

In any case, structure, discipline, sobriety were more than ever in the air when Matisse returned to Paris in the spring of 1912. He must have been conscious of this atmosphere but doubtless his own art would have taken a turn toward structural emphasis anyway. Curiously, as Matisse's art grew more austere during the period 1912 to 1916, Picasso and his followers generally deserted their own ascetic discipline and painted pictures full of bright ornamental detail spread over broad flat rectangular planes of color not too far removed from Matisse's decorative compositions of 1911-1912. Thus the influences went both ways and the ways seem to have crossed about 1912 when Picasso began to add color to synthetic cubism, while Matisse was renewing his study of structure often with considerable sacrifice of decorative effect.

SECTION VI PAINTINGS: THE SECOND MOROCCAN VISIT, 1912-1913

1 Zorah on the Terrace

The change of direction in Matisse's art is again apparent if one compares the more architectonic and realistic paintings of his second Moroccan sojourn with the flatter and brighter paintings done there the year before. The *Zorah on the Terrace* illustrates the change.

Matisse had painted the young Moroccan girl, Zorah, twice on his first trip, *Zorah Standing*, page 378, and *Zorah in Yellow*, page 379. When he returned to Tangier in the fall of 1912, he wanted to paint her again, but she had disappeared. After considerable search he found her in a public house. However, she was glad to sit for him again.[5] *Zorah on the Terrace*, page 387, shows her before her place of work, seated on a dark blue rug flanked by a goldfish bowl and her slippers. Behind her is a low wall with a bright triangle of sunlight at the left, and above it a narrow band of blue sky. The effect of the figure in shadow with the bright day above her is most unusual in Matisse's painting of this decade and even in a photograph obviously adds greatly to the effect. The indications of specific light and environment, and the sense of texture and depth in her costume may be compared with the flat abstraction of her earlier portraits.

Zorah on the Terrace was bought by Morosov in 1913 and hung in his home between the *Window at Tangier* and the *Entrance to the Kasbah*. All these were the same height though the *Zorah* in the center was somewhat wider. Though they were not intended as a triptych the effect seems to have been both harmonious and magnificent, page 25.

Matisse recalls a young Jewish girl who was a companion of Zorah.[5] Possibly it was she who posed for the small painting of a seated girl in Moroccan costume which Marcel Sembat bought. Sembat's *Tangerian Girl*, page 387, is exceptionally rich and dense in surface quality, a striking contrast to the transparent painting ordinarily used by Matisse in his Moroccan pictures.

2 Flower Pieces and Still Lifes

One of the few other Moroccan pictures still remaining in France is the *Oranges*, page 389, which passed from Cassirer in Berlin to the German collector Thea Sternheim and much later, during World War II, was bought by Picasso. The bowl of oranges with three green leaves rests on a pale pink tablecloth figured with bouquets of green, yellow, turquoise and dark red. Surrounding this light-colored textile are planes of rose madder, indigo, deep purple striped with maroon, russet with olive green stripes, pink, and lavender—a tour-de-force of extraordinarily varied and beautiful color.

Matisse painted two other still lifes in Morocco, the pair of five-foot-high compositions with arums and other flowers. The more elaborate of the two,[6] dated 1913, is reproduced on page 389. Both seem rather overblown reversions to Matisse's decorative style of 1911. Very likely they were commissioned for a particular place in Shchukin's palace.

3 The Riffian

Perhaps the most imposing of all Matisse's Moroccan paintings is the gigantic *Riffian*, page 391. Bowled over by it in 1913, Marcel Sembat exclaimed:[7] "The Riffian! He's fine, that huge devil of a Riffian, with his angular face and his formidable breadth of shoulders. Can you look at this splendid barbarian without dreaming of the warriors of long ago? The Moors of the *Chanson de Roland* had that same wild demeanor!" The scale of the *Riffian*—if the figure stood up he would be over ten feet high—is matched by the splendor of its effect. Unlike the standing figures of the first Moroccan period which appear in rather vague surroundings, the Riffian is seated in a well-defined niche-like space formed by green-striped curtains flanking a yellow wall with a window-like blue rectangle; the floor is magenta. The central trapezoidal island in the picture is formed by the Riffian's coat of dark green with embroidery and frogs of bright yellow, blue and red. His brown leggings, the brown stool on which he sits and his ochre sandals offer somber complementary contrasts with the floor. His face is modeled in an almost fauve manner by a patchwork of yellow and greenish splotches.

The placing of the figure with his head and one foot pressing past the frame, his far-apart vertical legs, his pose which is both tense and rigid, and his huge size combine to create an effect unparalleled in Matisse's art. The *Riffian* is Matisse's most redoubtable figure.

A second, milder painting of the *Riffian, Standing*, page 390, shows him half-length but still in heroic scale.

4 The Moorish Café *and Marcel Sembat*

Even more than most great painters, Matisse is inconsistent. Thus one may generalize about the greater sense of structure and realism of his second Moroccan period only to be confronted by its most remarkable and original production, the very large, flat and abstract *Moorish Café*, page 388.[8]

You remember that big canvas of the Moorish Café? *I recommend it to you. All of Matisse is there. If you study it well you'll see the whole of him. But it is necessary to look at it carefully the way Ruskin looked at the Spanish Chapel.*

Those reclining figures, all the same shade of grey— such a restful grey—with their faces indicated by an oval of ochre yellow, do you know that they were not always painted that way? Listen! Above there, the fellow at the left, he used to be in red! The one beside him was blue, the other was yellow. Their faces once had features, eyes and mouth. That one there was smoking a pipe. And if you look at the bottom of the picture you will discover the traces of a former row of slippers which, lined up before the café, were once very eloquent.

Why were the slippers, the pipe, the features of the faces, the various colors of the burnooses, why have they all been melted away?

Because, for Matisse, to perfect is to simplify; because, consciously or not, as a matter of program or in spite of himself, every time he strives to improve what he has done, he achieves greater simplicity. A psychologist would not be mistaken about this: Matisse moves by instinct from the concrete toward the abstract, toward the general.

Once when I called this to his attention, he replied: "It's only that I tend toward what I feel; toward a kind of ecstasy." And my own heart leapt with pleasure, for I heard the echo of the famous passage where Th. Ribot analyzes so well the Castillo Interior *of St. Theresa. "And then," Matisse went on, "I find tranquillity."*

Marcel Sembat is writing of this largest and most memorable of Matisse's Moroccan paintings while it was still hanging in the Bernheim-Jeune exhibition of April, 1913. He goes on to recall how often throughout their years of friendship Matisse had spoken to him of *le calme*—even before the *Dance* and *Music!* He quotes Matisse's famous lines from the *Notes* of 1908: "What I dream of is an art of equilibrium, of purity, of tranquillity devoid of all troubling or depressing subject matter. . . ." Then Sembat—and Matisse—return to the big picture.

Yet in all this effort to reach the loftiest regions of serenity, the craft of painting asserts its rights. Let us savor this before the Moorish Café. ". . . *Here are my bowl of fish and my pink flower. This is what has struck me! Those big devils there for hours, contemplative, before a flower and some red fish. Now then, if I paint them red, that vermilion will turn my flower violet! But I want it pink or nothing. Instead, my fish they might as well be yellow, so far as I'm concerned; in fact, they will be yellow!"*

In concluding his reflections and exhortations about this picture Sembat returns to its general effect:

The longer you look at it, this picture of a Moorish Café, the more there rises up in you a sense of dreamy contemplation. A multitude of birds sing sweetly in their cages hanging from the ceiling. Matisse has not painted their cages: but a little of the sweetness of their singing has passed into his picture.

In his enthusiasm Sembat has neglected one important detail: it is a cerulean blue against which the six ochre-colored grey-robed Moroccans take their ease. And Sembat may not have seen the superb miniature of a *Prince and his Tutor*[1]—flat blue turbaned silhouettes on a flat salmon-pink background—painted in the year 1532 by the Saffarid master, Agha Reza. Matisse probably did, since it was shown in a great exhibition of Persian miniatures at the Paris Musée des Arts Décoratifs, June to October, 1912, not long before he returned to Tangier to paint the *Moorish Café*.

Sembat could write but Shchukin acted: he bought the *Moorish Café*—for 10,000 francs. On October 10, 1913, he wrote Matisse from Moscow:[2]

The Arab Café *has arrived in good condition and I have placed it in my dressing room. It is the picture which I love now more than all the others and I look at it every day for at least an hour.*

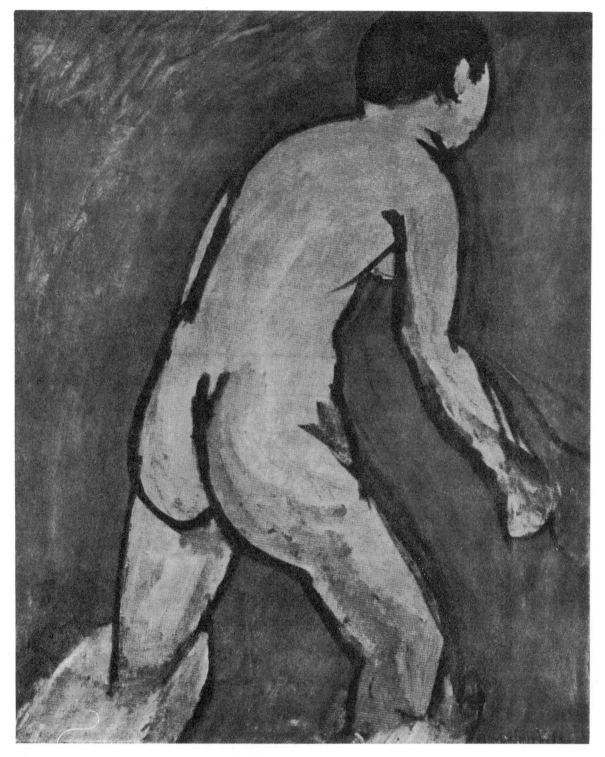

BATHER (*Baigneuse*). Cavalière (1909, summer). Oil, 36½ x 29⅛ ". New York, Museum of Modern Art

Painted as a study of the figure against a background of maximum color intensity in preparation for the *Dance* and *Music* of 1910, pages 362, 364.

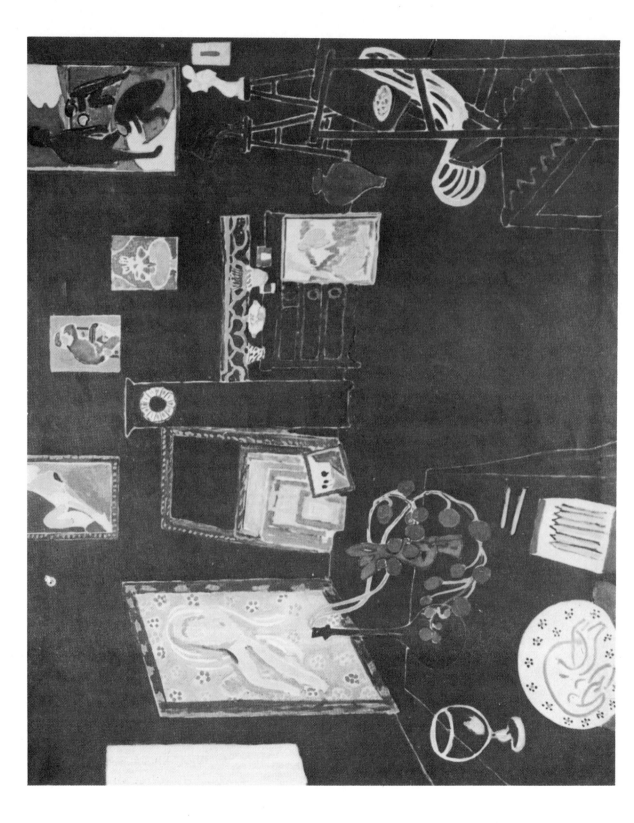

RED STUDIO (*L'atelier rouge; Le panneau rouge*). Issy-les-Moulineaux (1911). Oil, 71¼ x 86¼". New York, Museum of Modern Art, Mrs. Simon Guggenheim Fund

Of the four large interiors painted by Matisse in 1911, the *Red Studio* or *Panneau rouge* is the simplest and boldest in conception. Against a monochrome red, covering the entire canvas, Matisse has drawn in outline a perspective of the studio with the forms of tables, easels, sculpture stands, a chest of drawers, a grandfather's clock, all in the same color as their background. Among, upon, or against these monochrome outline forms he has scattered the brightly colored miniature images of his own paintings and sculptures and, on the foreground table, vine leaves growing from a bottle, and one of his own ceramic plates, all in their natural colors—a piquant and arbitrary mixture of modes.

At first glance this scattering of little shapes seems haphazard, all the more because the picture area has not been symmetrically divided.

Nothing in fact remains of the strong central rectangles which stabilize the other three big pictures, pages 373, 374, 375, except the unobtrusive outline of the grandfather's clock which stands like a one-eyed monitor regulating a calculated informality. Around this slight but effective median the other objects float on their rust-red sea like bright islands for the eye.

The *Red Studio*, one of Matisse's most daring and original inventions, was shown in the Second Post-Impressionist Exhibition in London in 1912 and at the New York "Armory Show" in 1913, then in Chicago and Boston. For years it hung in the Gargoyle Club, London; in 1949 it was acquired by the Museum of Modern Art.

Matisse's paintings represented in the *Red Studio* are, left to right: *Large Nude*, c. 1911, now destroyed; *Nude*, c. 1909, artist's collection; *Corsican Landscape*, 1898; *The Young Sailor, II*, 1906, page 335; *Purple Cyclamen*, c. 1911; *Nymph and Faun*, c. 1909; *Le luxe, II*, 1907, page 341. The two sculptures at the right are *Decorative Figure*, 1906, page 327; and *Jeannette, IV*, 1911, page 370. On the table in the foreground are one of Matisse's ceramic plates, c. 1908, and a sculpture, c. 1907.

GOLDFISH AND SCULPTURE (*Poissons rouges*). Issy-les-Moulineaux (1911). Oil, 45¾ x 39⅜ ". New York, Mr. and Mrs. John Hay Whitney (*ex* Hans Purrmann)

The three principal motifs, the bowl of fish, the flowers, the terra cotta of the *Reclining Nude*, page 337, are almost identical with those in the Copenhagen *Goldfish* of two years earlier, page 348. But instead of glowing in a purple night, the sea-green bowl with its scarlet fish, the sea-green dish and vase with its vermilion nasturtiums and the terra cotta figure sing against a translucent sky-blue field. Above them, in the background, rise a lemon-yellow door and a doorway through which one sees a garden cut by a diagonal sea-green shadow.

Actually the shapes of objects are not painted on the background; the background is painted around them and separated from them by a narrow white margin of unpainted canvas, sometimes reinforced by a black line. These margins isolate the colors, keeping them pure and without reflexive vibration as would certainly have occurred had, for instance, the goldfish been painted directly against the light green.

As in the *Red Studio*, page 162, the forms are drawn with fairly normal foreshortening, a denial of flatness which conflicts with their complete lack of modeling; at the same time the fish, flowers and sculpture are painted in local color against an abstract monochrome background. Thus two conflicts with ordinary visual experience are set in motion, two tensions which give vitality to what otherwise might be simply a supremely fresh and joyful decoration.

This is the second of six renowned paintings in which goldfish are the focal motif. The others are reproduced on pages 348 (Copenhagen), 376 (Moscow, *ex* Shchukin), 385 (Barnes), 396 (Gourgaud) and, color plate page 169 (Marx). To these might be added the great *Moorish Café* (Moscow), page 388, and the much later *Woman before an Aquarium* (Chicago), page 436. The Whitney *Goldfish* was bought by Hans Purrmann in 1916 and passed into the collection of its present owner in 1947.

164

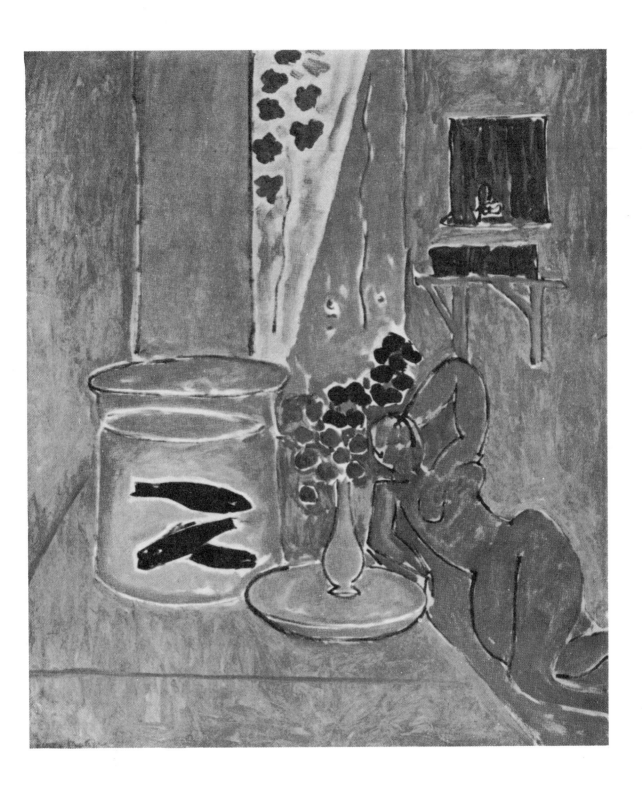

THE BLUE WINDOW (*La fenêtre bleue*). Issy-les-Moulineaux (1911, autumn). Oil, 51½ x 35⅝". New York, Museum of Modern Art, Mrs. John D. Rockefeller, Jr. Purchase Fund (*ex* Karl Osthaus; Folkwang Museum, Essen)

The *Blue Window* represents the view from the Matisses' bedroom in their villa at Issy-les-Moulineaux near Paris. On the table are a couple of vases, one with flowers, a reproduction of an ancient head, a lamp and some of Mme Matisse's toilet articles, including a yellow dish with a blue brooch. Through the window beyond the trees one can see Matisse's studio. The over-all blue is denser than in the Whitney *Goldfish* and covers not only the wall and table but trees and sky as well. Against it play the still-life objects, and the white cloud and yellow gable, too, all painted more or less in their own colors. The blue is not quite monochrome but is shot with green and modulated by dark and light tones.

The composition of the *Goldfish*, color plate on the previous page, is largely built on converging diagonals; it is centripetal and rather unstable; the objects overlap as if for security.

The *Blue Window* by contrast is all verticals and horizontals, as structural as a scaffolding, against which are hung the free forms of the still life and landscape. Each object is as isolated and simply rendered as the objects on the table of a medieval Last Supper. Yet, their isolation is subject to whimsical magic; Matisse makes trees grow out of the tops of lamp and plaster head, and not only plucks a green vase from a yellow pincushion but provides it with ornaments by means of thin black hatpins.

Matisse and Mme Matisse remember that the *Blue Window* was painted just before his first trip to Morocco during the winter of 1911-1912. He remembers too that it was first done for the famous *couturier* Paul Poiret, but the *avant-garde* dress designer found it too advanced. Whereupon Hans Purrmann persuaded his friend Karl Osthaus to buy it for his Folkwang Museum in Hagen near Essen. Osthaus, Purrmann remembers, was not entirely sure of the picture but he must have been encouraged by Shchukin's enthusiasm reported to Matisse in a letter of October 1913, Appendix D. The *Blue Window* passed with Osthaus' Folkwang Museum to Essen. Then, in 1933 it was repudiated a second time, confiscated by Hitler's order and in 1938 rescued from the cellar of Goering's *Luftministerium* by private sale to the Museum of Modern Art in New York. There in 1949 it was singled out and contemptuously attacked by another artist, Frederic Taubes, as evidence of Matisse's incompetence as a painter. *Requiescat!*

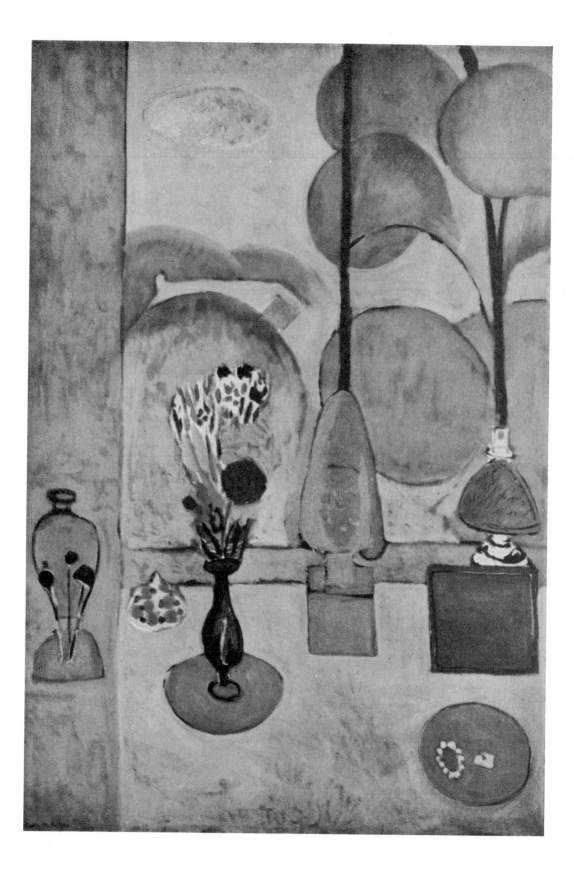

GOLDFISH (*Poissons rouges*). Paris (1915?). Oil, 57½ x 44″. Chicago, Mr. and Mrs. Samuel A. Marx (*ex* Jacques Doucet)

This, the last and most abstract of six remarkable compositions with goldfish, is closely related in subject and setting to the fifth, the Gourgaud *Interior with Goldfish* of 1914, page 396. Since the earlier is quite realistic, a comparison with it helps throw light on the more abstract composition reproduced here.

In this later canvas the artist has "moved his position" so that the table with its fish and flowers is placed in front of the grilled window railing; at the same time the table is separated from the grill and masked from the blue outdoors by a great black vertical plane, as if a narrow section of wall had been shifted like a theatre flat to the middle of the window. Thus the planes which formed the deep space of the studio—and which are rather literally represented in the 1914 picture—are here arbitrarily flattened. The sense of solidity and depth is further diminished by the free mingling of angular furniture forms and invented angular lines at the right of the picture.

Matisse had of course suppressed depth to the same degree before but less arbitrarily. Compare for instance the rendering of the table in the Whitney *Goldfish* of 1911, color plate page 165. In it the table exists largely by inference—since the fish bowl, flowers and sculpture must rest on something—and by virtue of two faintly drawn lines which indicate the corner of the table against the all-over light blue background. We can read the space but we can scarcely feel it. In the Marx *Goldfish* of four years later the visual existence of the table and its surrounding space are indicated more in detail while at the same time the artist juggles freely with the data he gives us. The perspective of the four table legs, even their visibility, is inconsistent. The table top is whitish against the black vertical, but when its corner overlaps the blue background it turns to blue itself as if it had suddenly become transparent.

Such stratagems were of course common practice among the cubists, and it seems possible that Matisse was influenced at this period by Juan Gris whom he had befriended in a time of need the year before, just after World War I had broken out. As a cubist picture the *Goldfish* does not reveal the practiced and confident mastery of a highly difficult style such as one finds in the work of Gris or Picasso in 1915. There are signs of struggle here, especially in the rather unresolved upper right-hand corner. Yet, though these may trouble the perfection of the picture, they add to its interest. In any case the *Goldfish* can hold its own as a painting beside almost any cubist work of the period.

VARIATION ON A STILL LIFE BY DE HEEM (*Nature morte d'après de Heem*). Issy-les-Moulineaux (1915, 1916 or 1917). Oil, 71 x 87¾". Chicago, Mr. and Mrs. Samuel A. Marx (*ex* John Quinn)

Not long after Matisse had recovered his student copy of the huge *Dessert* by de Heem, he decided to paint a second version. He did not go back to the Louvre to see the original but he remembered its size and laid out his new interpretation on the same grandiose scale using his own small early copy as a point of departure.

The *Variation on a Still Life by de Heem* preserves some of the original compositional lines, but the dark and light areas which zigzag across de Heem's canvas are gone and so are his deep perspectives to left and right and all the gloomy drama of his curtained background.

Instead Matisse has eliminated most of the dark tones and all the shadow. And he has compressed the composition in two significant ways; in depth: the picture has become shallow; and laterally: the proportions of the canvas are higher and this height Matisse has emphasized by imposing a strong vertical stripe down the middle where de Heem had none, and several minor verticals at the sides. The shallowness, the emphasis on the flat surface of the picture, is of course common to most of the original painting of the 20th century; the verticalism was a preoccupation of Matisse's own at this period as is corroborated by such paintings as the Marx *Goldfish*, page 169, the Phillips *Studio*, page 410, and the Detroit *Window*, page 411.

Far more than in those paintings Matisse has here made use of the crisp angles, straight edges and gradually shaded interpenetrating planes so characteristic of cubism. In fact this composition is Matisse's most cubist work.

The color of the de Heem *Variation* is as exceptional in Matisse's painting as its style. There are large areas of grey, green and ochre which seem almost fauve in their iridescent modulations but these are kept strictly in order by the cubist scaffolding and concentrated quadrangles or strips of pure black and scarlet.

JAN DAVIDSZ DE HEEM (Dutch, 1606?-c.1684): THE DESSERT (*Un dessert*). Antwerp, 1640. Oil, 58⅝ x 80". Paris, The Louvre Museum

MATISSE: Free copy of *The Dessert* by de Heem. Paris (1893-1895). Oil, 28⅞ x 39½". Owned by the artist

THE MOROCCANS (*Les Marocains*). Issy-les-Moulineaux? (1916). Oil, 70 x 110½". Owned by the artist. Color plate courtesy Albert Skira, Geneva

The Moroccans was composed from memories of the winters of 1912 and 1913 spent in Tangier. The picture is divided into three sections, separate both as regards composition and subject matter: at the upper left one sees a terrace or balcony with a pot of large blue flowers at the corner, a small mosque beyond and, above, the lattice of a pergola; below, on a pavement, is a pile of four yellow melons with their great green leaves; and at the right are half a dozen Moroccans, one of them seated in the foreground with his back turned, the others, extremely abstract in design, are reclining or crouching with burnouses drawn over their heads. These three groups might be described as compositions of architecture, still life and figures. They are like three movements within a symphony—with well-marked intermissions—or perhaps three choirs of instruments within the orchestra itself.

The three major groupings in the composition of *The Moroccans* are as isolated as the objects in the far simpler *Gourds*, page 412, and like them are ordered around an empty center and against a background which is two-thirds black with a left-hand third in color—though as Matisse remarked of the *Gourds* he was using black as a "color of light"

not darkness. The black in *The Moroccans* in fact does seem as brilliant as the lavender. Again, as in the *Gourds*, linear perspective is almost eliminated, the artist having silhouetted the objects in tiers as in an Egyptian relief. He does however diminish the more remote forms, thereby implying distance without sacrificing the clarity and immediacy of the images.

The six colors, blue, plaster white, green, violet pink, black and ochre are carefully balanced, interlocked and distributed. The two most positive of them, the green and the violet pink, are not only complementaries but are disposed on opposite sides of the canvas in vertical and horizontal areas like the large green and rose planes in the *Piano Lesson*, reproduced in the next color plate.

The analogies and ambiguities which enrich the composition of *The Moroccans* are ingenious. The four great round flowers in the architecture section echo the four melons in the still-life section. Yet these melons are so like the turban of the seated Moroccan in the figure section that the whole pile of melons with their leaves has sometimes been interpreted as Moroccans bowing their foreheads to the ground in prayer. At the same time, to complete the circle, some of the figures are so abstractly constructed as to suggest analogies with the architecture section.

Thus Matisse, in one of his greatest paintings, sets up a polyphony of both formal and representational analogues.

Piano Lesson (*La leçon de piano*). Issy-les-Moulineaux (1916 or 1917).
Oil, 96½ x 83¾". New York, Museum of Modern Art, Mrs. Simon
Guggenheim Fund

The very large *Piano Lesson* was painted by Matisse in the living room
of his villa at Issy. The artist's son Pierre sits barricaded behind the
Pleyel. Looking down on him from the wall above, as if in surveillance,
is a greatly elongated version of a painting of 1914, the *Woman on a
High Stool*, page 393. At the left the big window with open casements
looks on the garden, with its triangle of green foliage. In the lower
left-hand corner stands the artist's bronze *Decorative Figure* of 1906,
page 327.

Unfortunately Matisse cannot remember whether the *Piano Lesson*
was painted before or after the equally large but very different version
of a similar subject, the *Music Lesson*, page 419. Pierre Matisse however
is quite sure that this is the earlier of the two and was painted in the
fall of 1916, reversing Matisse's usual procedure of working from real-
istic to abstract, a sequence previously demonstrated by the pairs of
"before-and-after" canvases reproduced on pages 334-335, 340-341,
382-383, 396-169. The new sequence indicates the changing course of
Matisse's art at this time.

Few compositions by Matisse have been more rigorously simplified
and geometrized than the *Piano Lesson*. The pervasive grey background
may well have been suggested by the grey *Woman on a High Stool* and,
just as in the *Blue Window*, page 167, the monochrome of walls and
floor is here carried even out of doors in a single great plane broken by
carefully selected and isolated incidents.

Like the Whitney *Goldfish*, color plate page 165, the composition is
centrifugal with the center passive and almost empty. The vertical
green wedge of the garden at the upper left balances the comple-
mentary pink of the horizontal piano top, lower right; and the dull
blue painted female figure, clothed and Gothicly rigid in the upper
right-hand corner, wittily complements the dull brown sculptured
female figure, nude and relaxed, at the lower left. These figures,
human and geometrical, are framed or linked by a scaffolding of blue
and black bars. The painting is full of other subtle analogies and enter-
taining polarities. Besides the two intricately contrasted female figures,
the big triangle of green, as it echoes and expands the small foreground
triangle of the metronome, may be noted; and also the play between
the black arabesques of music rack and window grill. The sharp con-
verging points of green, black, pink and grey provide a valuable
moment of excitement in an otherwise disciplined calm, just as the
vigorously pyramidal metronome disturbs the general flatness of the
rest of the picture.

There are some cubist vestiges in the *Piano Lesson* but no cubist ever
surpassed the beautiful divisions, the grave and tranquil elegance of
this big picture. Nor did Matisse himself.

PART VI: 1913-1917
AUSTERITY AND ARCHITECTONICS; THE FIRST WAR

SECTION I MATISSE'S LIFE, MID-1913 THROUGH 1917

1 Summer at Issy, 1913

After his return from Morocco in the spring, followed by the excitement of the Bernheim-Jeune exhibition, Matisse seems to have spent most of 1913 painting at Issy-les-Moulineaux. There, during the summer at least, he produced surprisingly few canvases, perhaps because a single one, the portrait of his wife, page 392, took so much time and care.

The Autumn Salon opened late that year, in mid-November. Matisse's only exhibit was listed simply as *Portrait*. It was in fact the portrait of Mme Matisse over which Matisse had taken such pains. Shchukin had asked about it in his letter of October 10th, and when the Salon opened it was already listed as belonging to him. It was the last Matisse ever actually to be added[3] to Shchukin's collection and one of the best—indeed Guillaume Apollinaire called it the finest picture in the Salon, page 183.

2 Quai St. Michel, 1913-1914

In the fall of 1913, after the summer at Issy, Matisse reoccupied a studio at his old address on the Quai St. Michel. There a number of his most important works of the following years were painted. The *Interior with Goldfish* of 1914, page 396, *The Studio, Quai St. Michel* of 1916, page 410, and *The Painter and His Model*, page 413, all show the interior of this studio. Matisse continued to paint at Issy in the summers, but, as he wrote Matthew Prichard from Tangier earlier in the year, he was finding the winters there "*tellement triste.*" Therefore, since he planned not to go south soon again—and did not do so until 1916—he moved into town for the dark, cold months of the year.

At the Quai St. Michel Matisse continued to paint pictures in the comparatively somber style which had begun in the summer of 1912, notably the *Woman on a High Stool*, page 393, the grey *Nude with a Bracelet* and the dark, glowing *Interior with Goldfish*, now in the collection of Baroness Gourgaud. There also, in the spring, under exceptional circumstances and with remarkable results, he painted the *Mlle Yvonne Landsberg*, page 395.

Matisse had produced very few if any prints since the linoleum cuts and lithographs of 1906, pages 324-325. He now bought a secondhand etching press and began a long series of small drypoints and etchings, his first since a few experimental plates done ten years or so before, page 312. For the most part his subjects were portrait studies of friends and models with a few figures, page 398, and a single landscape. These he accompanied by a few monotypes, white line on black, page 399. During 1914 he also produced the superb "Second Series" of large lithographs, page 400, studies of the model which surpassed even his 1906 series in their linear concision.

3 The Second Berlin Exhibition, 1914

Though he had exhibited in Germany on various occasions, such as the Cologne *Sonderbund* show of 1912 and the Berlin *Sezession* in the spring of 1913, Matisse had had no one-man show there since the abortive affair at Cassirer's around New Year's of 1909.

Curt Glaser now came to see Purrmann in Paris with an invitation from the Gurlitt Gallery in Berlin to hold a large Matisse retrospective. Purrmann urged Matisse to cooperate and together they persuaded the Michael Steins to lend, though Marcel Sembat, still the leading French collector of Matisse, refused, Purrmann thinks because, as an ex-

perienced politician, he felt war was imminent. The Steins lent nineteen paintings[4] dating from a Corsican landscape of 1898 to the *Autumn Landscape* of 1909 and including several of Matisse's masterpieces, among them the *Self Portrait*, page 333, the *Blue Still Life*, page 331, and the *Red Madras Headdress*, page 350. The exhibition opened after mid-July but had to close because of the outbreak of war on August 1st. In 1917, when the United States entered the war, all the Michael Steins' Matisses were confiscated as enemy property. Then, to the dismay of Purrmann, Gurlitt arranged a private sale at which he bought in the paintings at nominal prices. When the war was over Purrmann, armed with the Steins' power of attorney, was able to recover almost all the paintings and return them to the Steins in Paris.[5] A short while afterwards the Steins[6] sold the Matisses to the Danish collector Tetzen Lund and the Norwegian Trygve Sagen who together had, it appears, made overtures to the Steins in 1914 about the time of the Gurlitt show.

4 War; Collioure; Juan Gris: Summer, 1914

Troubled by the increasing international tension, the Matisses stayed at Issy during the early summer. When World War I began in the first days of August, Matisse, though he was then forty-five, reported for service but was rejected. In mid-August he must have read of the British defense of his birthplace, Le Cateau, during the Allied retreat through Picardy. As the Germans neared Paris, he sent his children to Toulouse and about September 1st he and Mme Matisse rolled up his paintings and followed them, taking the boat from Nantes to Bordeaux. They stayed briefly at Toulouse and then moved on to their villa at Collioure arriving there on September 10th,[7] the day the first Battle of the Marne ended.

In Collioure he found Juan Gris and his wife who had been there all summer, and also Marquet. Gris wrote his dealer, D. H. Kahnweiler, then in Rome, how Matisse had brought word that Apollinaire and Galanis had enlisted and that Derain, it was feared, had already been wounded.[8] Gris and Matisse who had probably met in Paris now saw much of each other. "We argue so heatedly about painting," Gris wrote Kahnweiler, "that Marquet can hardly sit still for boredom." Years later Kahnweiler in his biography of Gris suggests that these conversations influenced Matisse's painting of that period.[1] In any case, Matisse took a great liking to Gris who was already beginning to suffer from tuberculosis and whose small income from his art had been cut off by the war. Kahnweiler, because of his German birth, was a refugee from France and could not help him. In mid-October Gris, Matisse and Marquet went to nearby Céret to visit the sculptor Manolo, who offered to help Gris but did not follow through.

5 Paris, Autumn, 1914

Toward the end of October[2] 1914 Matisse returned to Paris where he tried to help Gris by persuading some friends to promise a small monthly stipend in exchange for pictures, the same device he had attempted in vain on his own behalf a dozen years before. Gertrude Stein and an American dealer named Brenner agreed to put up 125 francs a month but the scheme fell through.[3] Gris came on to Paris anyway, and Matisse helped as best he could by paying Mme Gris to sit for him as a model,[4] making seven etchings of her.

Before the end of October Matisse wrote Gris[5] from Paris that Derain was in the front lines, Vlaminck had a position as *peintre militaire* at Le Havre, Gleizes and Segonzac were both wounded and La Fresnaye, a volunteer, was sick in a base hospital. The war was settling into its first grim winter of mud and trenches.

Though Matisse took no active part in the war he was deeply disturbed by it. Even under normal circumstances painting had always been hard work for him; now with the anxieties of the war, he found it impossible at times to embark on such long-sustained effort.

He was however able to work at etching and, for a time, he found distraction and comfort in music. He had played the violin since his youth but only casually during his career as an artist, as in his single uncomfortable duet with Vlaminck, page 54. Now, in the early months of the war, Matisse took to his violin again, hired a teacher named Parent[6] and fell to practicing with such obsessive devotion that at times he exhausted himself. His taste ran mostly to the classics of the Baroque period—Corelli, Vivaldi, Bach. At one time he and Pierre, who also played the violin, worked intensively on the Bach Double Concerto in D minor. About this time he drew a series of portrait studies of the violinist Eva Mudocci, page 401, who, it is said, had been Edvard Munch's *femme fatale*[7] a dozen years before.

6 *The Montross Gallery Exhibition, 1914-1915*

In the spring of 1914, Walter Pach had opened negotiations with Matisse on behalf of the Montross Gallery in New York concerning a one-man show. Matisse had been reluctant to agree because of the work required in managing the details of packing and shipping. He was moreover involved in the Matisse exhibition which Purrmann and Glaser were arranging for Berlin. Pach, however, encouraged by Arthur B. Davies, was not to be put off and Matisse finally agreed on condition that Pach himself would take care of all the practical details. War notwithstanding, Pach arrived in Paris in October to assemble the exhibition.

Matisse, in spite of his stipulations to Pach, had already started work: at Collioure, about the time he left for Paris, he received a telegram from Shchukin in Moscow, dated October 21st, consenting to lend a picture to New York. This was the *Woman on a High Stool*,[8] page 393.

During several weeks Pach saw Matisse frequently at his studio on the Quai St. Michel. Matisse seemed to be doing no painting at all but was busy with his portrait etchings for one of which Pach himself sat as a model, page 398. Pach took Matisse out to Puteaux to meet the Villon family. Matisse, already concerned about cubism, found Duchamp-Villon's ideas interesting though over-intellectual; his *Horse* Matisse compared to a "projectile." He did not see Marcel Duchamp's cubist paintings which were mostly in America at the time and he did not like Duchamp's early family portrait called the *Chess Players*. Jacques Villon was away in the army.[1]

In selecting the work for the Montross show, Matisse made the crucial decisions. At one moment Walter Pach suggested that *The Young Sailor, II*, page 335, be omitted since it had already been seen at the "Armory Show" and had proven quite indigestible to the American public. Matisse, however, insisted, arguing that the public should see the strongest pictures even though it was offended by them at first.

Matisse's first representative one-man exhibition in New York opened at the large well-lit Montross Gallery at 550 Fifth Avenue on January 20, 1915. The catalog, excepting the Moscow *Zolotoye Runo* of 1909, bibl. 162, was the most elaborate record of Matisse's work published up to that time. It included a color plate of the *Interior with Goldfish*, page 396, and thirteen other reproductions; and listed

five drawings, twenty-five etchings, all but one of 1914, two "wood engravings" of 1906, page 325, and seventeen lithographs divided between the early series, page 324, and the new series which Matisse had produced the year before, page 400. All these nearly fifty prints were shown in the first gallery. In gallery two were fourteen paintings, a few of them early, such as no. 56, the *Studio under the Eaves*, page 307, and *The Young Sailor* of 1906. Chief among the large recent paintings were *The Hat with Roses* of 1914, *Woman Seated* [*Woman on a High Stool*] which Shchukin had agreed to lend, *Goldfish*, page 396, and *Portrait* [*Mlle Yvonne Landsberg*], page 395. The third gallery presented eleven sculptures, among them *Le Serf* [*The Slave*], page 305, *Recumbent Woman*, page 337, *Nude Woman Standing* [*La Serpentine*], page 367, four states of the *Woman's Head* [*Jeannette*], pages 368-370, and the *Group of Two Women* [*Two Negresses*], page 366.

Walter Pach's calm and thoughtful article in the February 1915 issue of *The Century Magazine*, bibl. 201, might have served as a preface to the catalog of the show. The editor introduces Pach with a skeptical note which concludes: "We still wonder whether the revolt of Matisse represents genius unfettered or the shrewd play of commonplace talent." Pach answers by emphasizing Matisse's early academic training and success and justifies his recent work on the grounds of his superior sensibility:

What differentiates the sensibility of Matisse from that of others is its intensity. When the layman feels the beauty of color and design for a moment . . . when the mediocre artist gives up the struggle after a short time and contents himself (and his public) with the copy of an object, Matisse keeps up the search for a month, perhaps a year. . .

Pach concludes with a warning and a challenge:

No effort could be more futile than that of the student who took it into his head to 'paint just like Matisse.' It has been tried by clever men, and all of them have failed. The stimulus and inspiration he affords are for everyone; his means of procuring for us these experiences are personal and indivisible. For those who want to produce art, once more, the message of this painter reads clearly, that there is the great world current, with its ceaseless changes and there are the masters and nature which must be consulted. What have we in ourselves?

There were, of course, many contrary voices, both among conservative art critics and in the press. *American Art News*, January 23rd, proposed

FIGURE STUDIES (*Etudes de nu*). (Before 1918.) Pen and ink. Reproduced as an illustration in Pierre Reverdy: *Les jockeys camouflés*, Paris, La Belle édition, 1918. New York, Museum of Modern Art

that Matisse "is a paradox—for with at times his evident love of the beautiful as shown by his grace of line and infrequently his composition and color, he seems to prefer to render the ugly in an ugly way. In fact he may be called 'The Apostle of the Ugly' . . ." His paintings "violate the essential canons of art" and "a love of the morbid and ugly characterizes the sculpture . . . *Nude Woman, Standing* is so utterly untrue to Nature . . . as to be a travesty."[2]

7 American Collectors, about 1915

The February 13th issue of *American Art News* published an interesting note: "The sales from the Matisse exhibition . . . number over eighty, including sculptures, drawings, lithographs and woodcuts. The supply of several of the prints being exhausted, Mr. Montross has had to send to Paris for others. The sculptures sold include *Nude Woman Standing*, $325. . ." This sculpture, now known as *La Serpentine*, was sold to Arthur B. Davies; the grotesque fourth state of the *Woman's Head (Jeannette)*, page 370, to William Scranton Pardee. John Quinn bought *The Hat with Roses* and *The Cyclamen;* Walter Arensberg the *Portrait (Mlle Yvonne Landsberg)*.

The *Woman on a High Stool* went back to France

since it was still reserved by Shchukin. The War, however, followed by the October Revolution, prevented his ever actually acquiring the picture. The *Mme Matisse*, shown at the Salon d'Automne of 1913, was thus the last picture to be added to the greatest collection of Matisse's paintings. After the Revolution Shchukin reached France as a refugee but bought no more pictures and showed no further interest in art, an attitude which shocked Matisse who thereafter saw him very rarely.[3]

However, as early as 1913 or thereabouts, two American collectors, John Quinn and Dr. Albert C. Barnes, entered the lists. Quinn, a brilliant New York lawyer, had been stirred by the "Armory Show" during the winter of 1912-1913. He bought no Matisses at that time, but purchased two important canvases, *The Blue Nude* and the *Music (sketch)*, from Leo and Gertrude Stein and, as we have seen, two more from the Matisse show at the Montross Gallery in 1915. By the time of his death in 1925 he had a dozen Matisse paintings, including, besides the four just mentioned, the big *Variation on a Still Life by de Heem* and the *Apples*, both of 1916, pages 170, 406. Dr. Barnes, a research chemist, had made a fortune out of his formula for the antiseptic, Argyrol. In his early collecting

he had been greatly influenced by the American painter, William Glackens, and by Leo Stein from whom he bought the excellent early fauve *Still Life with Melon*.[4] During the 1920s Barnes went on to form the greatest collection of Matisses in America which he hung with fabulous numbers of Renoirs and Cézannes in the private museum of the Barnes Foundation at Merion, Pennsylvania. However, the foremost Matisse collector of the period between 1913 and 1925 was neither Russian nor American but Danish—Christian Tetzen Lund of Copenhagen, whose redoubtable activities will be reviewed on a later page together with those of his compatriot Johannes Rump.

8 Paris, Issy-les-Moulineaux, 1915-1916

During 1915 the war continued to weigh heavily on Matisse. That winter he worked at the Quai St. Michel, the rest of the year at Issy except for part of the summer at Arcachon, near Bordeaux. The period was not so much one of fecund production as of experiment ranging from the flat simplified *Still Life with Lemons* of late 1914, through the freely naturalistic *Still Life with Fruit*, both page 397, to the cubistic *Goldfish*, page 169, which he may have finished as late as 1916. Several portraits of Marguerite include an elongated bronze head, page 401, two or three rather sketch-like studies, page 402, and the semi-abstract *Head, White and Rose*, also page 402. To these may be added the somber *Italian Woman*, page 403, a painting of the model Lorette who was to pose for so many of Matisse's paintings during the next two years.

9 Paris, Issy, 1916-1917

If 1915 was a partially fallow period, the following years 1916-1917 were perhaps the greatest of Matisse's career as a painter. Among the works which can justly be called his masterpieces are two large interiors of the Quai St. Michel studio now in the Phillips Collection, page 410, and the Musée National d'Art Moderne, Paris, page 413; two of the Issy living room now in the Detroit Institute of Arts, page 411, and the Museum of Modern Art, page 175; and the big semi-abstract compositions in the collections of Mr. and Mrs. Samuel A. Marx, Henry Pearlman and the artist, pages 170, 408, 172. Besides these he painted a number of striking still lifes, pages 406, 407, 409, and several portraits including those of Michael and Sarah Stein, Greta Prozor and the great Cézanne collector, Auguste

Pellerin, pages 404, 405. Lorette, the Italian model, continued to pose for him in a long series of heads, portraits, page 227, and full-length figures, pages 412, 414. She was joined by her sisters in several paintings culminating in the great *Three Sisters* triptych, page 416.

In spite of the war Matisse's German admirers remained active and loyal. Georg Swarzenski, later the General Director of the Frankfort museums, bought the *Flowers and Ceramic Plate* of 1911, page 377, and presented it to the Municipal Museum of his city, a truly civilized gesture toward an "enemy" artist about the time Americans were patriotically driving Wagner's operas from the stage of the Metropolitan in New York because they were written by a German (even though he had been dead thirty years). In Berlin in 1916, Hans Purrmann bought his beautiful *Goldfish and Sculpture* now in the Whitney collection, page 165. Matisse's state of mind during the middle of the war is revealed in a letter[5] to the faithful Purrmann written from Issy on June 1, 1916, just as the desperate fighting around Verdun was moving toward its climax.

Cher ami,

In spite of the pleasure it gave me to receive your news I have not yet answered you. I have been working very hard recently and it has been impossible for me up to now, once I had not answered you immediately, to find the energy to take pen and paper to do so. Where are you now? I have not seen a friend these days who could have told me...

Derain, who came back yesterday, displayed a state of mind so marvelous, so grand, that in spite of the risks I shall always regret that I could not see all these upheavals. How irrelevant the mentality of the rear must appear to those who return from the front.

As I told you I have worked a great deal. I finished a canvas the sketch of which is on the back. [The Detroit Window, pages 411 and 182.] I have also taken up again a five-meter-wide painting showing bathing women [page 408]. As for other events concerning me: the painting which I gave for aid to the blind has been bought by Kelekian, and the canvas showing a Spanish glass water jug in which is dipped a branch of ivy, by Alph[onse] Kann. This is a subject which I like very much and on which I shall work again on another canvas. I have a branch of ivy which is in the process of twisting harmoniously. The still life with oranges which you asked me to reserve for you is finished [page 406]. These are the important things of my life. I can't say that it is not a struggle— but it is not the real one, I know very well, and it is with

Letter to Hans Purrmann in Germany from Matisse at Issy-les-Moulineaux, June 1, 1916: page 1 with a sketch of *The Window* now in the Detroit Institute of Arts. Courtesy Sam Salz

special respect that I think of the poilus who say deprecatingly, "we are forced to it." This war will have its rewards—what a gravity it will have given to the lives even of those who did not participate in it if they can share the feelings of the simple soldier who gives his life without knowing too well why but who has an inkling that the gift is necessary. Waste no sympathy on the idle conversation of a man who is not at the front. Painters, and I in particular, are not clever at translating their feelings into words—and besides a man not at the front feels rather good for nothing. . .

I hope your family is well. If I had not feared to be indiscreet I would have already gone there to get news about you from them.

Dear friend, I hope you will harbor no ill feelings towards me on account of the delay in my reply. Write to me, and be assured of the great comfort I derive from it.

With admiring sentiments from my whole family, believe me, with cordial sympathies,

Bien-votre,

H. Matisse

I have recently seen some nice things at Rivera's.

June 1, 1916

At the end of 1916 Matisse could stand Paris no longer and went south to the Riviera. An account of his life during the early years at Nice is given in the next biographical chapter, page 195. It should be noted here however that Nice became his home only gradually. From his first season there until 1921 he lived mostly in hotels, ready at any moment to leave. And at first he usually stayed in Nice only during the season from December to May or June. Until 1921 he continued to produce some of his most important paintings in the North, and this was overwhelmingly the case in 1917. It is true that the winter spent in Nice doubtless accelerated the relaxation of Matisse's style. Nevertheless, his first important painting done in the South, the superb *Interior with a Violin*, page 421, differs little in strength or quality from his best work produced in the North.

Matisse returned to Issy after his first season at Nice, in the late spring of 1917. There he painted the big *Music Lesson*, page 419, a realistic variant of the *Piano Lesson*, page 175. He took up again two major works which he had worked on in 1916, the huge *Bathers by a River*, page 408, and, at the Quai St. Michel, the triptych of the *Three Sisters*.

Matisse had recently bought a car and was now able to make trips around the nearby country with Pierre who acted as chauffeur. The amusing *Windshield*, page 418, was painted or at least studied while the car was parked on the road to Versailles. However the few important landscapes of the period were done from motifs around Trivaux in the Bois de Meudon, page 407, unless *A Path in the Woods of Clamart*, page 381, should also have been done at this period (see page 157).

Matisse's contract with Bernheim-Jeune had expired in September 1915. Now, in October 1917, a letter from Matisse to his dealers, Appendix C, revived their agreement for a third three-year term. His prices, which had been kept unchanged in the second contract, 1912-1915, were now more than doubled so that a canvas of figure 30, about the size of the *Montalban*, page 420, which had formerly been priced at 1500 francs, was now raised to 3500 francs. The new contract also permitted Matisse to keep half his output, the selection to be made by drawing lots. Both parties agreed not to sell to other dealers at less than a thirty percent mark-up.

In December 1917, Matisse returned to Nice for his second winter.

SECTION II PAINTINGS AND PRINTS, MID-1913 THROUGH 1915

1 *The* Mme Matisse, *1913, and the* Woman on a High Stool

In his letter to Matisse of October 10, 1913, page 147, Sergei Shchukin had expressed the hope that "the portrait of Mme Matisse would be an important picture." His wish was fulfilled. The *Mme Matisse*, page 392, turned out to be Matisse's most distinguished canvas painted in France during 1913. Mme Matisse is seen sitting on a chair in the garden at Issy. The face is drawn like an oval mask and the tailored suit seems dryly handled, yet the contours bounding and creating the figure are beautifully balanced. There is, moreover, an alertness and elegance about this portrait quite different in style and spirit from the rather stiff, dour *Manila Shawl*, page 355, for which Amélie Matisse had posed early in 1911. But the apparent assurance of the *Mme Matisse* is misleading. In 1914, a year after it was done, Walter Pach expressed his admiration for it, remarking that it looked as if the painter must have brought it off rather easily. Matisse replied, almost resentfully, that on the contrary it had required over one hundred sittings![6]

Pach knew the *Mme Matisse* only through hearsay and photographs, for Shchukin had already taken it away with him to Moscow. It had had a great success at the Salon d'Automne of 1913 where it had been Matisse's only exhibit. Guillaume Apollinaire[7] was enthusiastic about it and praised it not only as "the best thing in the Salon" but "in my opinion, with the *Woman with the Hat* of the Stein collection, the artist's masterpiece. . . " He hoped the picture, so charged with "*volupté et charme,*" might perhaps inaugurate a new period in contemporary art "from which voluptuousness has almost entirely disappeared since one cannot find it any more except in the magnificent and carnal paintings of the aged Renoir."

Apollinaire was to be disappointed: perhaps he should have expressed his wish a few months before at the show of the Moroccan pictures or in 1911.

For Matisse's next important work, the *Woman on a High Stool* done in the winter of 1913-1914, could scarcely have been less charming and voluptuous. Germaine Raynal[8] posed for the rigid, powerfully drawn figure, perched on the heavy stool. Behind her is a table of Spartan design; on it is a single sheet of white paper, and above on the wall is a drawing by Pierre Matisse of a tall vase which seems to echo, or even parody, the still figure. Except for a few touches of reluctant color, all these austere forms exist in grey monochrome. Yet though its asceticism is so forbidding as to make one smile at first, the *Woman on a High Stool* remains one of Matisse's most compelling images. Another important figure painting of the period is the *Nude with a Bracelet*[1] now in the Joseph Müller collection in Soleure, Switzerland. Masterfully composed and modeled, it is painted entirely in grey.

2 *The Portraits of Yvonne Landsberg, 1914*

Albert Clinton Landsberg,[2] a young and discriminating amateur of Brazilian nationality, had been introduced to Matisse by Matthew Prichard. In the spring of 1914 Landsberg proposed to his mother that she commission Matisse to do a portrait drawing of his sister Yvonne. Mme Landsberg would have preferred a portrait by some fashionable artist such as Orpen, Boldini or Paul Helleu, but after meeting Matisse she agreed to her son's suggestion.

Yvonne Landsberg, not yet twenty at the time, was sensitive, almost morbidly shy and rather overshadowed by an older sister; but Matisse found Yvonne interesting, won her confidence, and accepted the commission. The drawing, a full-face study of the head in pencil, was accepted with satisfaction by the Landsberg family. Prichard, enthusiastic, called it "the most beautiful contemporary drawing in the world!" Matisse then asked if Yvonne would pose for a more ambitious portrait in oils. It was agreed that while he would be entirely free to paint it as he wished, Mme Landsberg would have the option but no obligation to buy the picture.

The portrait proceeded slowly with many sittings and many diversions in the form of drawings and no less than five etchings of the subject though the extraordinary drawing, page 394, may have been a later postscript since it is dated August, 1914.[3]

At the end of the first sitting, [Yvonne's brother recalls] *the oil portrait was a strikingly recognizable portrait of*

the sitter, but it became more abstract with each sitting, and more—I then thought—like a Byzantine ikon. At each sitting the portrait became less physically but—possibly—more spiritually like my sister . . . the colour—from the first—was superb: steel blue, steel grey, black and orange and white where the canvas showed through in those mysterious white lines incised in the paint. . . .[4] These incised lines or scratches were made in the paint with the wooden ends of his paint brushes by Matisse—quite at the end of my sister's last sitting—but while the paint was still wet (for Matisse re-covered the whole canvas at each sitting).

Prichard greatly admired the finished portrait and Alphonse Kann declared it to be "magnificent" and a "masterpiece" but Mme Landsberg failed to appreciate it. The portrait of Yvonne reminded her, her son recalls, of that "masterpiece" described in Balzac's story, *Le chef-d'oeuvre inconnu*, "that became incomprehensible to everybody but the artist who created it, through his allowing himself to work on it for too long."[5]

Even now one can sympathize with Mme Landsberg's disquiet. Nothing in Matisse's previous work prepares one for the extraordinary effect of the *Yvonne Landsberg*. Doubtless at one stage the portrait resembled in style the *Mme Matisse* of the previous summer, page 392—indeed the drawing of the faces is similar—and the pose is quite close to that of the slightly earlier *Woman on a High Stool*, page 393; but the curved lines which spring from the contours of the figure remain an anomaly in Matisse's art.

These lines, though they were scratched in during the last moment of the last sitting, seem only superficially spontaneous; and though probably not premeditated[6] they appear to be systematically developed from the curves of the figure itself. Thus, the symmetrical contours of the shoulders are delicately enclosed by a heart-shaped system of hyperbolic lines. Below, the curves generated by the hip are balanced asymmetrically by those echoing the opposite thigh, while the plane of the forehead is actually prolonged toward the left by a scimitar-like curve. The effect is, on the one hand, to emphasize the figure by reiterating its forms while, on the other, to dematerialize it by extending these forms into space.

Matisse himself "explains" the striations very simply as "lines of construction which I put in around the figure in such a way as to give it greater amplitude in space."[7] Such a succinct and formal explanation might be satisfactory were it not for the

uniquely suggestive but baffling character of the painting and the exceptional circumstances surrounding its production. Perhaps Matisse will therefore forgive some speculative interpretation of the portrait.

One wonders whether Matisse may not have been influenced,[8] perhaps unconsciously, by the Italian Futurists and their theories. Matisse was on friendly terms with Gino Severini, the Paris member of the Futurist quintet, and though he had been in Morocco during the sensational Futurist painters' exhibition in Paris in February 1912, the show had been held at Matisse's own gallery, Bernheim-Jeune, at the instance of his friend, the manager Félix Fénéon, so that he must have known about it. Furthermore, the show of Futurist sculpture had been put on less than a year before, in June 1913, at the Galerie la Boëtie while Matisse was in Paris. There Umberto Boccioni, the chief Futurist artist and theorist, had again proclaimed the concept of *linee-forze*, lines of force, and announced that sculpture should "bring life to the object by making visible its prolongation into space. The circumscribed lines of the ordinary enclosed statue should be abolished. The figure must be . . . merged with space. . . ." The cubists too, without talking so much about it, had been fusing objects with their surrounding space since 1910. Finally, her brother A. C. Landsberg remembers that Yvonne and he, at the very time Matisse was painting her portrait, were attending Henri Bergson's brilliant lectures at the Collège de France in the company of Prichard. Matisse was not philosophically minded but he had had discussions about esthetics with Prichard, a student of Bergson, since 1910.[1] Bergson's *Creative Evolution* (1907) together with its soon popularized concept of existence as movement and *élan vital* may well have provided a metaphysical background or atmosphere not only for the Futurists and cubists, but for Matisse, too, in this particular painting with its suggestions of *being* as change, flux or growth.

Again, those curving lines which seem to have sprung so arbitrarily from the image of Yvonne Landsberg during her last sitting may actually be related to Matisse's preparations for her first. Her brother recollects: "On the day of the first sitting, we found that before we arrived at the Quai St. Michel Matisse had spent the whole morning making lovely drawings of magnolia flowers—or rather, *buds* (which, he said, my sister reminded him of). He had been doing this all morning, and was both-

ered by the buds opening and turning into full-blown flowers so quickly." Matisse's association of the girl with the flower is confirmed by an etching of her face, page 394, surrounded by a border of magnolia. Is it not possible, then, that at the ultimate stage of painting her portrait, Matisse felt impelled to incise a system of expanding curves which spring petal-like from the contours of the figure, especially the pendant bud-like shape made by arms and shoulders? Matisse was never given to this kind of poetic abstraction so that such an "inspiration," if it existed at all, was doubtless unconscious. Yet he probably knew something of the kinetic diagramming used both by the Futurists and by Marcel Duchamp whose *Nude Descending a Staircase* had been shown in Paris in the fall of 1912 and had even eclipsed Matisse's own paintings in the New York "Armory Show" of early 1913. Thus, if our theory is correct, Matisse was stimulated and liberated in a general way by the example of his radical younger contemporaries, and, moved by a deeply felt analogy between a budding flower and the shy, closed personality of his model, for this once transgressed the essential empiricism of his art—and his nature—to produce in the *Yvonne Landsberg* a form, a portrait and a visual metaphor of exceptional mystery and beauty.[2]

This hypothesis is confirmed by what may be Matisse's only other conspicuous essay[3] in poetic ambiguity, the bronze of 1930 called the *Tiaré*, page 461. This sculpture, inspired by a curious Tahitian plant, is at once the image of an exotic flower and a woman's head.

3 *The* Goldfish *and Other Paintings of* 1914

In color Matisse's most beautiful painting of 1914 is the *Interior with Goldfish*, page 396, showing the interior of the Quai St. Michel studio with a view across the Petit Pont to the Préfecture de Police. Strong deep blue and beige are relieved by pale greys and pinks. The only positive colors are the orange fish and the turquoise water in the bowl. The general effect of this 1914 *Goldfish* is not far removed from that of the *Goldfish* of 1912, page 385, with the obvious difference that the later picture is more realistic in light and space and its proportions are more vertical. In harmony with this format, the predominant lines of the picture, including the central motive of table and still life, are also more vertical. This verticality is present too in the *Mme Matisse* of the previous fall, page 392, and is carried

to an almost bizarre extreme in the *Woman on a High Stool*. It is just as characteristic of 1913-1914 as is the constrained, ascetic color. As late as 1915 and 1916, and even when the canvas is horizontal, Matisse continued to construct many of his pictures on a system of emphatic verticals.

In 1914 Matisse began a series of half-length portrait studies also compressed into tall narrow canvases. The *Hat with Roses*[4] is at once the most memorable and the dourest of these; others, such as *The Striped Jacket*, page 402, and the *Femme au chapeau*,[5] are more charming, with something of Manet's chic and much of his shorthand in the drawing and flat two-tone modeling. They are closely related to the narrow vertical etchings of 1914, page 398.

4 Prints, 1914

In the seven years after his lithographs and woodcuts of 1906 Matisse seems to have made very few if any prints. Then suddenly in 1914 he turned to printmaking with enthusiasm and produced eight or nine lithographs, over sixty etchings and drypoints and about nine monotypes. The cause for this unprecedented abundance of prints is not easily explained. There are some signs that he had reached a constrained moment in his painting so that he may have turned to the less arduous graphic media for relief and refreshment. He was to do this again in 1929 when for a period he almost gave up easel painting. Picasso, too, found refuge in the graphic arts for a year or so during the mid-'30s. Matisse's depression of spirit caused by the war may also have led him to work on a smaller scale in a different medium, just as it caused him to renew his interest in music and his violin.

Whatever the causes, the results, especially the lithographs and monotypes, were happy.

5 Lithographs, 1914

Like the series of 1906, the 1914 lithographs are all of the figure, seated, standing, or bust-length. They are somewhat larger and less casual in effect. The torso, *Nude, Face Partly Showing* and the superbly elegant study of the model's back *Seated Nude, Back Turned*, both page 400, are remarkable for their beautiful placing on the sheet and their concise suggestion of form—in the latter, for instance, the torso is rendered by only four lines. They are among the classics of modern lithography and among Matisse's best prints.

6 Etchings and Drypoints, 1914-1915

A large proportion of the etchings and drypoints of 1914,[6] page 398, are portraits, mostly of Matisse's friends. They include Mme Derain, Mme Galanis, Mme Gris, all wives of artists, Mme La Forge, Mme Vignier and her little daughter Irène who sat for six etchings, Mlle Yvonne Landsberg, page 394, whom he also painted, Marguerite Matisse, Bourgeat, Francis Carco, Walter Pach, several Spaniards, among them Joan Massia, Iturrino, Olivarès, and the extraordinary English museologist Matthew Prichard, page 398. Some of the etchings may have been commissioned and some of the subjects besides Mme Gris and the model Loulou may have been paid sitters. The model for the beautiful print *Woman in a Kimono*, page 398, was Mme Matisse. Besides the portrait studies there are a view of the Seine looking down on the Pont St. Michel, half a dozen plates of nude figures, page 398, and a curious sheet, no. 51, with two sketches very like the *Blue Window* composition, page 167, above a study of foliage.

Apparently Matisse planned to publish the series, or a selection from it, in an album but in the end those that were published were issued separately in small editions of five to fifteen proofs. The etchings are all small, many of them casual, even slight. Matisse worked on them with a maximum of informality and spontaneity, destroying a good many plates that did not come off. Sometimes he made preliminary drawings; sometimes, after observing the subject for several hours, he would work directly on the plate with extraordinary speed.

Walter Pach recalls very vividly how Matisse proceeded when he etched his portrait, page 398. As has been told, Pach saw a good deal of Matisse during October 1914 while arranging the exhibition which was to be held in New York at the Montross Gallery early in 1915. One afternoon he had been talking with Matisse for a couple of hours when, just as he was about to leave, the artist asked him to wait while he made an etching. Pach explained that he was already late for another engagement, but Matisse insisted that he stay just for a few minutes more. Pach acquiesced and Matisse, working directly on the plate and without any preliminary sketches, drew the portrait within five minutes. Pach who had his hand on his watch was amazed at the speed with which Matisse worked. Later, he sat again a couple of times under more

leisurely circumstances, but the results were not so satisfactory and the plates were never published.

Many of the etchings are very tall and narrow in format, probably under Japanese influence, in fact one plate, no. 14, was called "Outamaro." In the *Walter Pach* and others, the head is carried further than the rest of the figure, which is sometimes omitted entirely leaving the face placed by itself two-thirds up the narrow plate. In several other plates, such as the *Woman in a Kimono*, the design is ingeniously adjusted to its format. This print is one of the most perfect and complete of the whole series. The *Loulou in a Flowered Hat* reveals the delicate wit of Matisse's elisions; the *Three Nudes*, his drawing at a mannered but vigorous moment, page 398.

7 Monotypes, 1914

The nine known monotypes of 1914 form a very special series within Matisse's graphic art. A monotype is made by scratching a line on a plate coated with wet ink or paint and then printing with the result that the line appears white against a dark field. Only one impression can be made of each design. Obviously Matisse used his etching equipment—copper plates, ink and press—for his monotypes since they are technically perfect, with opaque, even, black backgrounds of about the size of the drypoints and etchings of the period.

The little monotype heads are quite similar to the etchings of the same years but the *Torso* and the three still lifes, notably the *Apples*, have no parallel among the ordinary copper plates.

The exquisite precision and economy of these few monotypes are well illustrated in the two examples reproduced, page 399. Matisse had good reason to be "very much pleased with those prints of his of white lines on a black background."[7]

8 Paintings, Late 1914-1915

Most of the comparatively few canvases painted by Matisse in late 1914 and 1915 are flat and abstract in style and informed by a sense of serious and sometimes uncertain experiment. *Still Life With Lemons Which Correspond in Their Forms to a Drawing of a Black Vase upon The Wall*, page 397, is the title which Matisse has recently taken some pains to compose for the painting executed late in 1914[8] and now in the Providence Museum. In this deliberately awkward and angular composition the objects and the space in which they are seen are kept as flat as any of the most abstract pictures of 1911. Like the

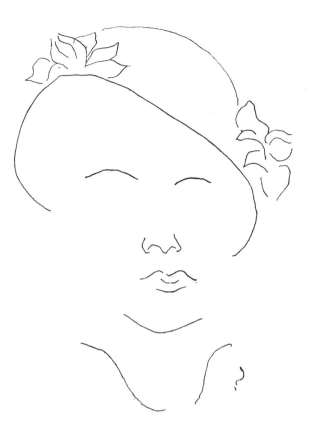

Loulou in a Flowered Hat. Paris (1914). Etching no. 41, 7 x 5″. New York, Museum of Modern Art

Goldfish and Sculpture of that year, page 165, the composition is centrifugal, the very strong silhouette of the black vase in the upper corner playing against the group of objects below. Not long after the painting was finished the two cubists, Juan Gris and Jean Metzinger, visited Matisse's studio. They studied the picture with interest but said nothing to the older painter who would have welcomed some commendation or at least comment from his juniors. Later Matisse heard they had praised to others the "extraordinary concordance" between the forms of the vase and the fruit.[1]

One of the most abstract of all Matisse paintings is the large *Composition* of 1914, usually called *The Yellow Curtain*, of which, unfortunately, no photograph is available.[2] Like the *Still Life with Lemons* it is even flatter in style than the big decorative paintings of 1911 and so abstract that one needs Matisse's help in deciphering its subject.[2]

The Yellow Curtain which Matisse significantly prefers to call *Composition*, the *Yvonne Landsberg*, the

Still Life with Lemons are very different from each other in method but all three reveal a preoccupation with abstraction. It seems probable that at least some of Matisse's experimentation in these paintings of 1914-1915 was stimulated by cubism though perhaps without his being entirely aware of it. We know that Matisse was seeing a good deal of Juan Gris and something of Metzinger, and perhaps Picasso, who was also spending the early war years in Paris. Furthermore the cubists about 1912 had abandoned the dry, monochromatic greys or tans of their analytical period for broader flat planes of positive color, often with decorative ornament involving confetti-like dots, textured or marbled surfaces and curving lines. Thus, in 1915, while the cubists were returning not only to color but to a more relaxed and decorative style, Matisse himself began to move away from his own predominantly somber tones of 1914 toward a style which was not only brighter in color but superficially at least related to synthetic cubism.

The *Head, White and Rose* is the earliest and least successful of Matisse's cubistic experiments of 1915. A realistic oil sketch of a figure in a striped blouse with a black choker and pendant about her neck, page 402, may have been the point of departure for this bust-length "portrait" with its flat simplified forms overlaid with a cage of black lines which angularize the face and extend its surfaces up into space. The effect is original and has a certain charm of color but seems essentially superficial by comparison with good cubist heads by Braque or Picasso. The sitter was Marguerite Matisse.

The *Italian Woman*, page 403, though there is some suggestion of cubism in the daring elision of the shoulder, is far more secure in style than the *Head, White and Rose*. This is perhaps the first painting of the Italian model Lorette who was to appear so often in Matisse's work of the next two years, notably in the *Lorette in a White Blouse*, page 227, in which she wears the same costume and coiffure, but with how different an effect! Here she stands, pinched in countenance, hieratically rigid in pose, her blade-like arms forming a bud shape recalling that in the *Yvonne Landsberg*, page 395, but more schematic. The drab color supports the stern and melancholy elegance of this spectral presence.[3]

The *Goldfish* of the Marx collection, color plate page 169, is far more convincing in its use of certain cubist devices of transparent planes and angular construction. Actually, long before cubism, Matisse in his fauve paintings had freely juggled and shifted the local color of objects and from 1911 on he had sometimes used arbitrarily opaque and transparent planes, but never before in a manner so resembling cubism.

9 *Four* Goldfish: *1911, 1912, 1914, 1915*

The Marx *Goldfish* is analyzed on page 168, opposite the color plate, and compared there with the Whitney *Goldfish and Sculpture* of 1911 and the Gourgaud *Interior with Goldfish* of 1914. If we now add a fourth interior with goldfish to the series, the Barnes painting, page 385, we can follow the major changes in Matisse's style over four important years. In the Whitney *Goldfish*, page 165, the whole picture seems brought up flat against the picture plane—there is almost no space perspective and though the forms are foreshortened they are not modeled and there is no sense of directional light; the local colors against the light blue background are gay and translucent. In the Barnes *Goldfish* of mid-1912 the deep perspective of the interior is clearly presented, and there is some sense of light source, of indoors and outdoors; only the uniform dark blue of floor and wall and the suppression of modeling and cast shadow keep the picture fairly shallow and at the same time set up a lively though subtle conflict between depth and flatness; the whole effect is rather somber.

The Gourgaud *Interior with Goldfish* of early 1914, page 396, marks, for the period, an extreme in Matisse's reaction toward traditional handling of perspective, modeling, light and local color. Finally, in the Marx *Goldfish* of 1915, page 169, under the stimulus of cubism, Matisse struggles with two interrelated problems: first, that of keeping his pictorial space flat while at the same time retaining the enriching complexity of objects seen in depth; and second, that of keeping his light and color flat without sacrificing dramatic contrasts of light and dark afforded in more traditional styles by strong shading and cast shadows.

Throughout all four paintings, and quite irrespective of changes in style, one can follow an increasing preoccupation with verticality, almost non-existent in the radiating diagonals and loose centrifugal forms of the Whitney *Goldfish*, but overwhelming in the black vertical which divides the Marx picture.

Not all of Matisse's paintings of 1915 are so involved with esthetic experiment. The *Still Life with Fruit*, page 397, for instance is informal and fresh in style, with warm gay color and a feeling of unpremeditated sensual reality. It may be compared with the *Still Life with Lemons*, same page. The subject is similar even to the high-stemmed fruit dish but the effect is diametrically opposite.

SECTION III PAINTINGS: PARIS, ISSY-LES-MOULINEAUX, 1916-1917

Unhappily the exact sequence of the major paintings of Matisse's great period 1916-1917 is far from clear even in Matisse's memory. For instance neither he nor Mme Matisse can remember for sure which of the two great interiors, the *Piano Lesson*, page 175, or the *Music Lesson*, page 419, was painted first. Other important works have been variously dated 1916 or 1917, and even 1915 and 1918, so that an orderly study of this period in terms of the development of Matisse's style and ideas must be postponed until more exact data are in hand. Nevertheless, over the two years a broad movement is evident, a movement from austerity of structure, line, color and sentiment toward a more relaxed and decorative art.

1 Portraits, 1916

During the winter months of 1916 Matisse painted a number of portraits. Greta Prozor, daughter of Count Prozor, was an actress who married the Scandinavian journalist and art dealer, Halvorsen. Her life-sized figure, page 405, is posed very much as was the portrait of *Yvonne Landsberg*, page 395, but in style it recalls the *Mme Matisse* of 1913, page 392, though it appears to be far less studied. In spite of the sober color, dark blue against grey, the effect seems comparatively unimpressive.

Matisse in fact rarely seems at his best or even at his ease when working on a commissioned portrait. He was determined to paint as he felt he had to without compromise. Yet, being a man of good will he must have taken as little pleasure in disappointing or offending the sitters for his occasional portraits as he had in the long trouble with Shchukin over the *Dance* and *Music*. For this reason he usually made it clear to his sitters that if the portrait should not prove satisfactory, he would gladly keep it and forego his fee. This he did, as we have seen, in the case of the *Yvonne Landsberg;* perhaps also in that of the portrait of Greta Prozor, but the portrait of Auguste Pellerin was more complicated. Matisse painted a first version which Pellerin rejected. Pellerin then asked Matisse to paint a second. Matisse agreed. When he had finished, Pellerin (who had the largest collection of Cézannes in France) decided that he had been mistaken about the first version and asked Matisse if he could not have them both—at a reduced price. Matisse refused, and Pellerin finally paid for both at double the fee for the original commission.

The *Auguste Pellerin*, page 404, is quite different in style from the Landsberg and Prozor portraits. In its frontal pose it recalls the *Italian Woman* of 1915, page 403, and, earlier still, the *Girl with a Black Cat* of 1910, page 354. The head is as formalized as a 6th-century Ravenna mosaic, yet the characterization is both vivid and subtle considering the simplicity of the means.

By comparison the portraits of Michael and Sarah Stein were labors of affection. The *Michael Stein* is rather conventional in pose, its frontal symmetry disturbed only by a slight shift off the vertical median. What chiefly distinguishes the portrait, as one can see in the photograph of Matisse at work on it, page 26, is its surprising scale, well over life-size.

The *Sarah Stein*, page 404, is more arresting. The head, which is even larger in scale, looms like an apparition out of the grey wedge-shaped form which encloses it and echoes the "V" of the neck. Yet, for all its grey spectral character and apparent sadness, the face is tenderly characterized. Curiously, the preparatory drawings, page 405, are much more formalized and schematic.

2 Still Lifes, 1916

The simplicity, the symmetry and the scale of the Stein portraits appear again in several still lifes of early 1916. Actually, the fruit in the *Oranges*[4] and the *Apples*, both page 406, is not, apparently, over life-size but by placing the bowls in the center of the canvas and eliminating all details of setting or background by which we might gauge the scale, Matisse has given the objects an effect of monumental dignity and colossal size.

A second and somewhat more schematized version of the *Apples* with a curtain at the left and a well-defined table leg was in the collection of Walter P. Chrysler, Jr.[5] Smaller, but obviously belonging to the same series, is the *Still Life with a Nutcracker* in the Copenhagen Museum.[6] It is painted in part with a heavily loaded brush though not so thickly as the *Oranges* in which Matisse has used a palette knife to plaster on the pigment, revealing an interest in surface effects most exceptional in this period.

3 The Window, *1916*

In his letter to Hans Purrmann, written at Issy, June 1, 1916, page 182, Matisse sketched a composition which he had just finished, *The Window*, page 411, now in the Detroit Institute of Arts. "Through the window of the living room," Matisse wrote, "one sees the green of the garden and a black tree trunk, a basket of forget-me-nots on the table, a garden chair and a rug with a red design. The picture is green and white with some accents, blue for the forget-me-nots, and red for the zigzag of the rug; the table is red, too. The picture is as large as the one with the goldfish[7] you have." Painting in his country house in the month of May, Matisse makes the whole picture sing with fresh clean color. Gone are the dark blues and wintry greys of the interiors of the previous four years such as the *Woman on a High Stool* and the Barnes and Gourgaud goldfish paintings, pages 393, 385, 396. Instead of the black vertical which dominates the Marx *Goldfish*, color plate page 169, a broad white vertical divides the turquoise background of the Detroit *Window* like a column of sunlight from floor to ceiling. The horizontals of the left half play against the right-hand verticals. The semi-transparency of the table top and the scalloped edges of the white curtains add to the lightness and gaiety of the composition.

4 The Bathers by a River

In his letter of June 1, 1916, to Purrmann, Matisse informs him, "I have also taken up again the painting showing bathing women." He may have begun the huge canvas *Bathers by a River* at least three years earlier,[8] since the letter implies that Purrmann had seen it at an early stage before the war; he was to work on it again in the summer of 1917 but, to judge from its style, most of what we now see belongs to 1916, page 408.

Four ochre-colored figures of women, three standing, one seated, are spread at regular intervals across the canvas which is divided into four vertical rectangles. Of the two wide outer rectangles, that at the left is filled with green foliage, that at the right, comparatively unfinished, is grey. The narrow inner verticals are black and white, marking by their overt contrast a line just to the right of the middle of the picture. The four figures and four vertical panels do not coincide but are syncopated in their counterpoint.

Just to the left of the vertical median a snake raises its head. Like the little red turtle in the big *Bathers with a Turtle* of 1908, the snake provides a certain focus for the attention of the bathers and for the eyes of the onlooker. But there is even less drama in the later picture, which is formal and static but interesting in its schematizations and impressive in its scale and monumental dignity. The *Bathers by a River* is the largest of Matisse's canvases except for the *Dance* and *Music* of 1910, pages 362, 364, and the Barnes murals of 1931-1933, pages 463, 464.

5 The Gourds *and* The Moroccans, *1916*

When asked by the Museum of Modern Art if he had any special comment to make about the *Gourds*, page 412, Matisse made two observations: he said it was "a composition of objects which do not touch— but which all the same participate in the same *intimité*," and added that "in this work I began to use pure black as a color of light and not as a color of darkness."

Matisse had painted still lifes of isolated objects before, notably the *Still Life with Lemons*, page 397, and the Copenhagen *Goldfish* of about 1910, page 348. In these two pictures the environment of the objects, that is, the table and wall, is indicated, however abstracted or adumbrated. But in the *Gourds* neither depth nor support are shown. The background is a field divided diagonally into blue and black areas. Against this the objects neither stand nor hang—they simply exist. But they exist with the utmost clarity and vividness, their shapes vigorously drawn or modeled and silhouetted against the background like the isolated loaves and utensils strewn so carefully on the table of a Romanesque Last Supper. Never before had Matisse realized the characteristic shapes of objects so emphatically or established their relationship in a composition so simple and informal yet so inevitable. A few years later, about 1920, some of the Paris *avant-garde*, having passed through cubism or abstract art, began to revalue the esthetic validity of

the object itself. The "return to the object" shortly became a watchword of the admirers of the Purists and Léger. Matisse in the *Gourds* anticipates them, just as the baffling but satisfying constellation of the objects, even to some extent their shapes, foreshadow Jean Arp's reliefs of around 1930.

The *Gourds*, painted at Issy in the summer[1] of 1916, seems in form and spirit to be a prelude to one of the great compositions of the year, *The Moroccans*,[2] reproduced in color on page 172 and discussed on page 173.

6 Studio Interiors, 1916

The green and rose-violet on black of *The Moroccans* flower again in *The Green Robe*, page 412, the strongest and most intense of the many paintings of the model Lorette which Matisse continued to make during 1916. The sweeping line of the Gandoura robe, the rich modulations of its color against the complementing violet of the chair, and the deep resonant envelope of black give this magnificent small painting as much impact as the *Gourds*, to which it is closely related in time and style.

Apparently just after he had finished *The Green Robe* Matisse began the large *Painter and His Model*,[3] page 413, since one can see the earlier painting, or a version of it, on the easel, and beyond, in the background, the model for it, posing. As in most of Matisse's artist-and-model paintings, the artist is rendered in a perfunctory way; here he appears as an ochre-colored lay figure. One looks past him, like a *repoussoir* in a 17th-century landscape, to the other more lively images in the picture.

The great central area of solid black and the well defined, solidly painted objects—notably the superbly rendered mirror on the wall—relate *The Painter and His Model* to the *Gourds* and *The Moroccans* of the same period. It seems as remote from the cubistic *Goldfish* of 1915, page 169, as it does from the rather loosely painted, linear effects of the Detroit *Window*, page 411, and the Phillips *Studio, Quai St. Michel*, page 410, of which the subject is so similar except for the absence of the painter.

The Studio, Quai St. Michel was probably painted late[4] in 1916 before Matisse's departure for his first visit to Nice at the end of the year. The easel is placed further forward in the room than in the Gourgaud *Interior with Goldfish* of 1914, page 396, a little nearer the couch where the model Lorette is lying and nearer the window through which one can see the corner of the Palais de Justice and the spire of the Sainte Chapelle. In the foreground are two chairs, face to face, one of them supporting a drawing board on which the artist had been making a study of the model (as in the photograph, page 26, of Matisse painting Michael Stein's portrait). The style is less solid and simple than in the Gourgaud *Goldfish*, more linear and free. At the same time there are few traces, except in the table, of the arbitrary cubist perspective of the Marx *Goldfish*, page 169, of the previous year. The composition is divided roughly in halves: the right-hand half, marked by insistently repeated verticals, plays against the repeated horizontals at the left just as in the closely related Detroit *Window* of the previous summer, page 411, a painting which is in fact almost a pendant to the Phillips picture in size and subject, as if Matisse had planned two interiors, summer versus winter, country versus town. The color is subtle and minor in key, autumnal with its tans and greys sharpened by the pale blue of the sky and the red of the couch cover.

7 Paintings of Lorette, 1916-1917

Lorette appears again in the *Sleeping Nude*, page 414, which is remarkable for its firm simplified modeling. The pose is almost identical to that of the same model lying on the flowered couch in *The Studio, Quai St. Michel*, but the handling is much more naturalistic. The same pose is repeated again in the often reproduced *Lorette VII* or *Black Scarf* of 1917 now in the Chrysler Collection.[5] In it the figure is seen through a semi-transparent, lacy drapery, an effect which would scarcely have interested the painter the year before.

In two striking compositions of about 1916, Matisse isolated and studied the head and arms of the reclining Lorette, contrasting the free, rhythmic curves of fingers, hair and face with an angular inlaid tray and cup of coffee. The later *Head and Coffee Cup*, probably of 1917, is reproduced on page 414.

Matisse painted numerous studies of Lorette's head alone, of which excellent examples are the canvas[6] bequeathed to the Virginia Museum of Fine Arts, Richmond, by T. Catesby Jones, and another similar head in the Norton Gallery of West Palm Beach. In this he revives a firm, sensual paint surface such as he had rarely used since his dark period of 1903, and combines it with a fluid rhythmic contour quite unlike the severe inflexible line of the previous several years. To this

same period of 1916 belongs one of the most distinguished portrait studies of this model, the *Lorette in a White Blouse*, reproduced in color on page 227.

The Moroccans is the most important but not the only evidence of Matisse's revived interest in Moslem subjects and costumes which he had neglected since his return from Morocco early in 1913. Before the end of 1916 (when he left for a half year's stay in Nice) Matisse painted a number of studies of Lorette in oriental costume and, bringing her sisters into the picture, began work on the large *Three Sisters* triptych, page 416, in which oriental and western costumes are mixed.

The White Turban, page 417, because of the frontal pose and severe demeanor of the model is the most striking of the numerous studies of Lorette in oriental headdress. It recalls the austere simplicity of the Stein portraits painted earlier in the year, page 404. The miniature golden yellow *Girl in a Turban*, page 414, with its sensuous color foreshadows the long series of odalisques which were to be so characteristic of Matisse's painting during the ensuing decades at Nice.

As in the *Head and Coffee Cup* a tray provides the focus for a composition with two figures called *Coffee*, page 415, in which Lorette in a green robe is seated on a deep red floor, while an African model in pale turquoise stands against a strong blue background. The paint is as firm, the color as dense, the drawing as vigorous as in the portraits of 1910. It is the strongest and perhaps the first of the series of group compositions of women which Matisse began in 1916 and completed the following year. In a later painting, the *Two Sisters*, page 417, recently acquired by the Denver Art Museum, Lorette, again in her white blouse, appears with her younger sister. The pigment is thinner, the drawing is delicate and less insistent than in the *Coffee*, and no traces of heavy expressionist accents remain. All three sisters are grouped in the picture of that name[7] formerly in the Pellerin and Paul Guillaume collections but that was probably painted after they had appeared in the *Three Sisters* triptych.

8 *The* Three Sisters *Triptych, 1916-1917*

The culmination of these compositions of Italian models is the large and ambitious *Three Sisters* triptych, page 416, which Matisse began in Paris late in 1916 and completed apparently in the fall of 1917 after his return from Nice and a summer spent at Issy. In the left-hand and center panels the

costumes are exotic, Lorette wearing her white turban, her sisters oriental robes; in the right-hand, and apparently later, panel, the sisters are in ordinary dress and coiffure.

The triptych form, the proportions of the rectangles and even to some extent the subject matter are derived from Japanese prints. The narrow-paneled triptych was often used by such masters as Sharaku[8] and Utamaro.[1] An even closer analogy is to be found in Toyokuni's triptych of *Woman and Attendants Watching Girls*,[2] in which three figures of women appear in each of the three panels. The word "triptych" also suggests late medieval European painting and indeed the style of Matisse's *Three Sisters* is not too far removed from the late Gothic painting of Siena which we know interested him during his visit to Italy in 1907.[3]

The formal organization of the triptych is superficially obvious. In the central canvas the figures form a pyramid dominated by the white-turbaned model. The figures in the left and right-hand panels are enclosed in parabolic curves which oppose each other with ingenious symmetry. If we except the turbaned central head, the other eight heads form a catenary curve or garland which swings irregularly down from either side toward the middle. Strong, vertical, standing figures, one to each panel, stabilize the composition symmetrically. The background of the central panel is a grey plane; that of the left is an unemphatic perspective through a rectangular door into another room (with a Sudanese sculpture on the mantelpiece). In the background of the right-hand panel is a rectangular painting, *The Rose Marble Table* done at Issy in 1917, page 407.

Within this rather formal bilateral symmetry, shape, color, perspective, scale and even style are intricately varied. The nine heads form the dominant motif with the repeated V-shapes of neck openings and bent elbows a secondary theme. Barnes and de Mazia[4] point out the interesting repetitions of black accents in the Negro sculpture, the chair legs, and the hair and stockings of the seated figure in the left-hand panel. Perhaps the most ingenious incident is the top-shaped configuration of head and arms resting on the uncompromisingly square chairback at the right.

The scale of the figures is curiously modulated, the youngest sister appearing larger in the right-hand panel than in the other two. And even the style or mode of rendering is varied. In the canvas at the right, the face of the youngest sister—with

the bangs—is painted like a late Manet, the modeling reduced to a single flat plane with features indicated by impressionist accents suggested by accidents of light. In the other two faces, the eyes and noses are drawn in with arbitrary lines and shading which do not exist in nature but do exist in many traditions of pre-Renaissance and non-European painting. The shapes of the noses in these two faces even suggest those in Negro masks, as Barnes and de Mazia[5] have pointed out. Such inconsistencies of style occurred to a remarkable degree in another important transitional work, the *Joy of Life* of 1906, page 320.

The color of the triptych is complex. The central panel is predominantly grey and brown and comparatively neutral. The bright green and yellow robe dominates the left-hand panel, but greens diminish as the eye moves from left to right giving way to complementary tones culminating in the violet and dark blue of the flowered blouse worn by the figure at the extreme right.

Undertaken in Paris in 1916 and completed[6] after long absences in Nice and Issy, the *Three Sisters* triptych marks a turning point in Matisse's art. The verticalism, though in this instance partly inspired by Japanese prints, had been generally characteristic of Matisse's composition since 1914: it now appears for the last time. The linear, archaistic rendering, particularly of all but one of the faces, though already refined, belongs to the conceptual, expressionist draftsmanship of the previous decade; but the Manet-like, sketchy shorthand of the face with the bangs at the right belongs to the tradition of visual, impressionist realism which Matisse had used in much of his fauve and pre-fauve painting and was now to revive at Nice. The great increase of patterned or ornamental surfaces in the triptych and the generally informal, fluid brushing marks a departure from the severe ascetic style of 1913-1916 for the pleasant, rather casual-seeming decorative style of the next decade at Nice.

9 *The* Music Lesson, *1917, and the* Piano Lesson, *1916*

The new relaxation and softening of Matisse's style in 1917 is dramatically demonstrated by a comparison of the *Piano Lesson*, color plate page 175, with the *Music Lesson*, page 419. These two very large canvases—they are nearly the same in size as well as in subject—were both painted in the living room at Issy-les-Moulineaux. The *Music Lesson* was begun not long before the induction of Matisse's older son, Jean, into the French Army in mid-summer, 1917.[7] The date of the *Piano Lesson*, unfortunately, is not so certain. Although it has usually been listed in 1916, Mme Matisse was inclined[8] to place it after the *Music Lesson:* that is, in her memory, the more abstract canvas was as usual painted after the more realistic one in spite of the fact that at this period the trend of Matisse's art was toward realism. Pierre Matisse however is quite certain that the more abstract of the two, the *Piano Lesson*, is the earlier, was in fact done late in 1916. The *Music Lesson* he remembers was painted quite rapidly in two or three sittings during the following summer, after Matisse's return from his first stay in Nice. In any case there can be little doubt that the more realistic version looks toward Matisse's future, the more abstract one toward his past.

The *Piano Lesson* is analyzed on page 174, opposite the color plate.

In the *Music Lesson* Jean Matisse sits reading in a chair at the lower left, taking the place of the bronze sculpture in the 1916 picture. Pierre, at the piano, has been joined by his sister Marguerite. The *Woman on a High Stool* still hangs on the wall; and now through the window Mme Matisse may be seen sewing beside the garden pool on the far side of which Matisse has painted the sculptured *Reclining Nude* of 1907, page 337, fancifully enlarged along with the foliage for the purposes of the picture. Matisse himself is perhaps represented only by his violin resting in its box on the piano. Thus the *Music Lesson* is virtually a family picture with the same four members who were present in *The Painter's Family* of 1911, page 373.

The profusion of pictorial incident added in this second version of the *Piano Lesson* is obvious enough. The change in style and in spirit is equally apparent. It may be summarized by comparing the view of the garden in the two pictures, or by pondering the visual, perhaps unconsciously symbolic, consequences of eliminating the severely pyramidal metronome in favor of the voluptuous curves of the violin resting on its patterned kerchief in its curved box. Equally significant—and entertaining—is the curious fate of the *Woman on a High Stool*. In the 1916 *Piano Lesson* she had been elongated to the slender ramrod rigidity of an early Gothic embrasure figure. In the 1917 *Music Lesson* she is casually decapitated by the frame while her body relaxes in easy, supine curves and her feet dangle.

The broad structure of the early canvas remains, but its abstract skeleton is now covered with a flesh of playful rococo curves and planes of washed-on, transparent color, not bright, but gay. Lastly, light, which had been diagrammed in a few details of the earlier picture, now plays throughout the whole canvas indoors and out, modulating surfaces already enlivened by brush stroke or linear ornament. Yet, in spite of its casual and rather busy effect the canvas is intricately organized.[1]

Several times in the past Matisse had painted pairs of pictures: *The Young Sailor, I* and *II*, pages 334, 335; *Le luxe, I* and *II*, pages 340, 341; *Nasturtiums and the "Dance," I* and *II*, pages 382, 383. In each pair the freer, more naturalistic and tentative version had come first, the final, more abstract and refined composition, second. But in these two big pictures of 1916 and 1917 the opposite is true: austere abstraction precedes a comparatively profuse and decorative realism. The reversal of sequence, the passage from the abstraction of the *Piano Lesson* to the descriptive rococo of the *Music Lesson*, is a finger post which points to the pleasant impressionism and intimate charm of the figures, the flowers and the sunlit windows that Matisse was to paint in Nice during the years to come.

The differences between the *Piano Lesson* of 1916 and the *Music Lesson* of 1917 are epitomized on a far simpler and smaller scale by the contrast between two paintings of Matisse's daughter, the *Head, White and Rose* of 1915, page 402, and the *Marguerite in a Fur Hat* of two or three years later, page 418. This is perhaps the last portrait of Marguerite painted by her father and the most arresting characterization.

10 Landscapes, 1916-1917

A couple of miles southwest of Matisse's home on the route de Clamart stretches the large park-like Bois de Meudon in which lies the tiny pond of Trivaux. Thereabouts, during 1916-1917, Matisse painted his only considerable landscapes between his last sojourn in Morocco and the first years in Nice. They are all studies of trees about the pond or looking down the handsome Allée de Trivaux. Typical of them is the Tate Gallery's *Tree near Trivaux Pond*[2] painted in tans, greens and misty blues, a modestly poetic record of the woods and weather of the Ile de France. These tree-scapes are as far removed from the challenging character of Matisse's other paintings of the period as they are from their subject matter.

Pierre Matisse believes *A Path in the Woods of Clamart*, page 381, was done about 1916 rather than in 1912 as his father has stated. *A Path* seems extraordinary for 1912, yet it is far bolder and more abstract than any of the known landscapes of 1916-1917.

The purchase of an automobile enabled Matisse to get about the countryside more than he had before. He painted a number of small views of Maintenon, Versailles, Chenonceaux and, in his enthusiasm, a view through the front of the car itself, *The Windshield*, page 418.

11 Still Lifes, 1916-1917

The Rose Marble Table, page 407, the most remarkable still life of 1917, resembles in its centralizing of a single major form the imposing *Oranges* and *Apples* of the previous year. Actually it is much larger but done softly with a muted palette and a romantic gloom as if painted at dusk.

The Lorrain Chair,[3] page 409, suggests the *Rose Marble Table* in its sparse verticality. One is reminded of the portraits of 1910, pages 353, 354, in which the sitter is placed against a flat background divided by a slightly tilted horizontal—but here, of course, the sitter is replaced by the sat-upon, a chair of great dignity and character. The blue and white arabesque of the upper background is in fact the same as that in the *Harmony in Blue* of 1908 but it is restrained and sobered as it rises from a plain grey floor. The same grey-white, scallop-edged dish of peaches appears again in *The Pewter Jug*,[4] page 409, in the Cone Collection of the Baltimore Museum, a somber harmony of dull violet, black and metallic grey, relieved by the yellow and orange of the fruit.

Although they are somewhat overwhelmed by the big compositions and interiors of 1916-1917, the still lifes of this period are among the most original and powerful in Matisse's career. They are not so complex or daring in color as the great series of 1908-1910, pages 343-349, nor so sparkling as the flower pieces of 1919, page 431, nor so sumptuous as the table-scapes of 1924, pages 441-443, but for sober dignity and grandeur of scale—not of size— they are unsurpassed in the work of Matisse or, for that matter, any of his contemporaries.

PART VII: 1917-1929

RELAXATION IN NICE AND RENEWED EXPERIMENT

SECTION I MATISSE'S LIFE 1916 (NICE) THROUGH 1929

1 Nice, late 1916 to 1918

Ever since 1910, the year after he had moved to the Clamart road near Issy-les-Moulineaux, Matisse had found the long winters in the north of France depressing. That year he had gone to Spain, the following two winters, 1911-1912 and 1912-1913, to Morocco. Reoccupying his old apartment on the Quai St. Michel, he spent the winter of 1913-1914 in town and found it more tolerable than if he had stayed in the suburbs. Then came the war which during its early years discouraged expeditions. But in December 1916 Matisse finally sought refuge on the Riviera—refuge more from winter than from the proximity of war. He arrived in Nice[5] before the end of the year and took a small room in the Hôtel Beau-Rivage overlooking the sea on the section of the Promenade des Anglais which is now the Quai des Etats-Unis.

As so often happens to sun-seekers on the Riviera, Matisse had bad weather at first. "It never stopped raining," he recalls. "Forced to work in a gloomy hotel room, I was reduced to painting my umbrella standing in the slop jar."[6] Finally he packed his bags but, on the morning he was to leave Nice, the sun came out and he unpacked—"to stay for thirty-five years" and more. In his *Self Portrait*, page 422, painted in the same room the following year, one can in fact see the "umbrella in the slop jar"; and the ready suitcase appears on the table at the right in *The Open Window*, page 420.

During his first few years at Nice he did move frequently and was always ready to leave the moment he felt bored. He rarely was, however, partly

because he ordinarily lived there only during the season from December through May, partly because he found Nice relaxing and serene, and the Mediterranean light, outdoors and in his hotel room, proved endlessly interesting. Through his white-curtained windows he could glimpse the sea and look down upon the gay and busy Promenade des Anglais.

Besson[7] and Cassarini[8] have given lively accounts of Matisse's life during his early years in Nice. His days were as regulated and disciplined as in Paris. He would rise early and after a frugal breakfast practice the violin "in a remote bathroom so as not to disturb the other guests." Then he would paint, often in his room, along the quais, in the gardens or on the Montboron, the Château, the Montalban, page 420, and other hills overlooking the city. Sometimes he would draw for an hour from casts in the Ecole des Arts Décoratifs with the director Paul Audra who had been his fellow pupil under Moreau. There he also did some modeling. In the evening he would go to the café, sometimes with Audra or with the novelist Jules Romains of whom he saw a good deal during and just after the war. For exercise he rowed assiduously at the Club Nautique—154 *sorties* in nine months, he is proud to remember.[1] The photograph of Matisse rowing in a single scull, page 26, was apparently taken in the early 1920s.

Occasionally he would travel along the coast to see friends, Bonnard at Antibes and Renoir at Cagnes, or inland to Vence where the poet André Rouveyre lived and where Matisse was to seek refuge in 1943. His children frequently came down

from Paris to visit him, Marguerite continuing to serve as model for many of his paintings.

After the summer at Issy and autumn in Paris, Matisse went south again early in December 1917. He spent a few days with Marquet and Georges Besson in Marseilles[2] and then returned to Nice about the middle of the month. Since the entry of the United States into the war Nice was more crowded than ever with Allied troops. He stayed again at the Hôtel Beau-Rivage and was joined shortly by his son Pierre, then a youth of seventeen. During the winter of 1917-1918 Matisse painted the *Interior with a Violin*, page 421, the masterpiece of his early Nice period, and a vigorous but rather awkward *Self Portrait*, page 422. We reproduce, page 26, Besson's photograph of Matisse beside the unfinished *Self Portrait*.

2 The Visits with Renoir, 1917-1918

It was on the last day of 1917, Georges Besson affirms,[3] that Matisse first called on Renoir in his villa at Cagnes. It was a troubled moment for the aged artist: he had just dismissed the young craftsman who at Vollard's insistence had been serving as Renoir's "hands" in modeling his sculpture. Renoir and Matisse became good friends. The older painter, crippled by arthritis, welcomed the visits of the younger, who often came at the end of the day, the time when Renoir began to dread his nightly bout of pain.

Early in 1918 Matisse for the first time took some of his paintings to show Renoir. According to Besson they were a view of the Baie des Anges seen through the pines of the Château,[4] the just finished *Self Portrait*, and an *Open Window*, the one reproduced on page 420 or another very similar picture,[5] the latter two painted in his room at the Hôtel Beau-Rivage. Renoir in the past had not been prejudiced in favor of the art of the *roi des fauves* but he now studied Matisse's paintings with interest, especially *The Open Window*. He was amazed at Matisse's control of strong unmixed color areas which to an impressionist were non-existent in nature and therefore almost sinful. He was astonished that the solid blue of the sea seen through the window held its place instead of jumping forward, and went into a half-genuine rage over the intense black curtain rod or valance at the top of the picture which against all good practice and common sense stayed in its proper plane. Renoir's influence may have contributed to the softening and relaxation of

Matisse's art during his early Nice period.

After Renoir's death Matisse continued to visit the villa at Cagnes occasionally. In 1925 he made a number of drawings and sketches of the garden dominated by Renoir's sculptured Venus.[6] Once Purrmann went with Matisse and was astonished at the cheap furniture, gaudy pillows and general bad taste of the interior of the villa. Matisse explained that the impressionists cared little for the quality of their furnishings and "even put tawdry frames on their own pictures."

During the winter of 1918 Matisse and Pierre moved from the Hôtel Beau-Rivage to an apartment further west along the Promenade des Anglais. A couple of months later Matisse leased a small house called the Villa des Alliés on the slopes of Montboron at the eastern edge of the city in a part of the Parc Harris which had been planted with tropical trees and flowers. There they spent the spring and the early summer of 1918. Before autumn they went back to Paris and in September Pierre followed his brother Jean into the army. He was stationed for a time at Cherbourg where his father went to see him and there made several oil sketches of the ships and docks. During 1918 five of Matisse's ink drawings were reproduced in Pierre Reverdy's *Les jockeys camouflés*. Though they were not strictly speaking illustrations the volume is sometimes considered Matisse's first illustrated book. (See Appendix G.)

3 Nice, Issy, London, Etretat: 1918-1920

When Matisse returned to Nice during the fall of 1918—he happened to visit Bonnard at Antibes on the day of the Armistice[7]—he found that the Hotel Beau-Rivage had been requisitioned for the American Army so he took rooms in the Hôtel de la Méditerranée also on the Promenade des Anglais. There he stayed for three seasons, 1919 to 1921, painting numerous views of the window with its balustraded balcony looking on the sea, page 423, or the interior with flowers and women arranged against the patterns of window shutters, upholstered chair coverings, striped tablecloths, figured wallpapers and draperies, and the red-tiled floor, pages 424, 425, 434, 435. He worked outdoors, too, painting pictures of women walking in wooded paths or sitting in a garden.

In the spring of 1919, with the war over, Bernheim-Jeune put on Matisse's first Paris one-man show since the 1913 review of his sculpture and

Moroccan paintings at the same gallery. The 1919 exhibition comprised mostly recent paintings, though two works of 1914 and one of 1916, the *Gourds*, page 412, were also included. The Paris public did not get to see any of Matisse's major masterpieces of 1916-1917 until the Georges Petit retrospective of 1931, and even then only a few. At the end of 1919 the Leicester Galleries presented what was probably Matisse's first one-man show in London, bibliography 117a.

Contrary to his usual custom Matisse brought a model north with him from Nice to Issy-les-Moulineaux for the summer of 1919. There she posed for the superb *Black Table*, page 430, and with Marguerite Matisse for the *Tea*, page 426, the largest and one of the most impressive paintings of the decade following 1917. Through an error the captions under the reproductions of these two canvases indicate that they were painted in Nice rather than Issy. Together with the *Bouquet for the 14th of July*, page 431, and some other interiors, they form a unique and brilliant group of canvases. The *Bouquet for the 14th of July*, painted to celebrate the first Bastille Day after the Armistice, was exhibited at the Salon d'Automne of 1919.

The following year, 1920, was an eventful one in Matisse's career. During the previous summer Sergei Diaghilev, the great impresario of the Russian Ballet, had proposed to Matisse that he design the settings and costumes for a new production based on Stravinsky's *Le rossignol*. Matisse agreed with some misgivings for he had never been greatly interested in the ballet, but he knew that Picasso had already proved himself a brilliantly successful designer and Derain too had just been asked to collaborate. Furthermore Matisse was urged to try his hand by Stravinsky and by Leonide Massine, the young choreographer and dancer who was in charge of the difficult task of transforming the opera into a ballet under Diaghilev's supervision. Matisse worked at his designs with his usual assiduity, often visiting nearby Monte Carlo where the Ballets Russes was spending the winter. But in the end *Le chant du rossignol* was not really successful. After the Paris season closed in June 1920, Matisse went to London with the troupe to see the performance at Covent Garden. His friendship with Massine continued but Matisse did not collaborate on another ballet until 1938 when he designed the scenery and costumes for *Rouge et Noir*.

In the summer of 1920 after coming back from London he spent several weeks at Etretat on the coast of Normandy where Courbet, Monet and others of their generation had worked. Like them, but even oftener, he painted the picturesque pierced cliffs, fishing boats drawn up on the shore and, with great distinction, a number of marine still lifes, pages 432, 433, 228. In the fall Bernheim-Jeune exhibited thirty-one of the Etretat pictures together with twenty-two painted in Nice in 1919 and a preface of five earlier canvases including the two still lifes of 1890 entitled *Mon premier tableau* and *Mon deuxième tableau*, the latter the *Books and Candle*, page 293.

4 Publications on Matisse, 1920

It is only in these days of what David Hare calls the "prenatal discovery of artists" that a lucky (or wealthy) painter occasionally achieves the distinction of a monograph before he reaches the age of fifty. In 1920 Matisse had reached that age and moreover was one of the two best-known living painters, if we except the aged Monet. Yet a few magazine articles, chapters in books[8] and dealers' exhibition catalogs were all that had been published about him. Now the tide turned. The *Nouvelle Revue Française* publishing house honored him with the first of its small, cheap and very popular monographs on living French painters, a series which was soon to produce a flood of imitations. The lively preface was written by Matisse's loyal old friend and champion, Marcel Sembat, bibliography 91. In the same year Georges Besson, who had been seeing something of Matisse in Nice, edited a second, much more ambitious book on Matisse for the publishers Crès et Cie. with many plates and appreciative essays by Elie Faure, Jules Romains and others, bibliography 84. The handsomest of the Matisse books of 1920 was however published by the artist himself, bibliography 94. It contained fifty beautifully reproduced drawings, studies of the model, done in Nice and Issy during the previous two years. These three were the first of many books on Matisse to be published, in ten or more different languages, during the succeeding years.

5 Nice and Paris, 1921-1925

When Matisse returned to Nice late in the fall of 1921 he decided to move from the rather expensive Hôtel de la Méditerranée to an apartment in the old part of town on the Place Charles-Félix. From its windows he could still see the Mediterra-

nean over the low roofs of a long barracks-like structure, Les Ponchettes, which appears in many of his paintings. He lived on the Place Charles-Félix from 1921 until 1938 when he moved to Cimiez in the hills back of the city. In the summer of 1921 he had again painted at Etretat but thereafter until 1930 he divided his time between Nice and Paris with only an occasional expedition elsewhere, such as the visit to Italy about 1925 in the company of Mme Matisse, Marguerite and her husband Georges Duthuit.

In all ways Matisse's life seems to have been calm and regularly ordered during the 1920s. He was now highly successful on an economic as well as artistic level, a great asset to his principal dealers Bernheim-Jeune, with whom he had made his fourth three-year contract late in 1920 at increased prices, Appendix C. His paintings of the years 1920-1925 appear to be perfect expressions of a serene, industrious and uneventful life, pages 434-443. Girls looking out of the window or playing the piano or violin in the apartment at Nice, or girls costumed as odalisques in oriental pantaloons and embroidered jackets, or nude, standing before patterned textiles or tiled screens, lolling on rug-strewn divans; still lifes of fruit and flowers, richly furnished interiors in which a dozen different colors, textures and patterned surfaces are magically harmonized in a hedonistic, sensual and charming art with no challenging or difficult moments—except for the painter. Some fifty lithographs, innumerable drawings and, in 1925, a few pastels also bear testimony to Matisse's industry and skill during this period, pages 439, 445.

In December 1923 Marguerite Matisse was married to the writer and Byzantinist, Georges Duthuit, who had been an admirer of Matisse for many years. Marquet was a witness and the only guests at the wedding breakfast besides the family and witnesses were the Michael Steins.[1]

6 Honors, Exhibitions, Museum Accessions, 1921-1925

In 1921, at long last, the French Government honored Matisse officially by acquiring one of his paintings for the Luxembourg Museum. Perhaps the officials had finally been impressed by Matisse's world-wide fame, and perhaps they had been reconciled by the inoffensive and traditional turn his art had recently taken. In any case the museum authorities, still affected by academic pressure, could

scarcely have found a milder or more conventional Matisse than the *Odalisque au pantalon rouge*[2]—though, it must be said, beautifully painted and quite representative of the period.

The next year, as if making an indirect comment on the Luxembourg's choice, the Grenoble Museum of Painting and Sculpture accepted as a gift the large and challenging *Interior with Eggplants* of 1911, page 374, presented in the names of Matisse's wife and daughter.

In 1921 Matisse was invited to enter another academic stronghold, the Carnegie International Exhibition at Pittsburgh, which showed his rather conventional *Portrait on Red Background*. It won no prize and Matisse was not asked to show again until 1924. The following year, however, the first Matisse entered an American museum collection, not counting the canvas, page 315, acquired about 1910 by Mrs. Gardner whose Fenway Court had not yet become a public gallery: in 1922 the Detroit Institute of Arts, under the directorship of W. R. Valentiner, bought the large and magnificent *Window* of 1916, page 411. Writing in the Institute's Bulletin, Reginald Poland reassured Detroit citizens by pointing to Matisse's sound academic training and concluded: "Surely a man . . . who in his own life is wholesome, human, sane and well ordered must be sincere and have good reason for painting as he does."[3]

Early in 1924 the Joseph Brummer Galleries presented the first important Matisse show in New York since the Montross exhibition of 1915. Fourteen paintings, some from John Quinn's collection, and some graphic art were included. Brummer, who had studied in Matisse's class in 1908, wrote the preface to the catalog, bibliography 127, emphasizing the discipline which lay behind Matisse's apparently casual art.

In 1923 the collections in the houses of Shchukin and Morosov in Moscow, which had been confiscated and turned into museums by the Soviet Government in 1918, were combined into one magnificent collection known as the Museum of Modern Western Art. It contained forty-eight paintings and two drawings by Matisse to which, in 1925, a small still life was added by purchase. In 1924 the largest retrospective of Matisse's paintings held up to that time was organized by Leo Swane of Copenhagen and sent on tour in Scandinavia. The Danish edition of the catalog lists eighty-seven canvases and contains a foreword by Swane, bibliography 114.

7 Collectors, 1917-1925

Most of the best paintings in the Scandinavian exhibition of 1924 were lent by Christian Tetzen Lund, the greatest Matisse collector of the decade between 1915 and 1925. Tetzen Lund[4] was a Jutland corn merchant who in 1878 while in Paris had grown interested in the French impressionists. Before World War I he was collecting Cézannes and had approached the Michael Steins with a view to buying some of their Matisses. Just after the war he returned to the attack and, together with the Norwegian Trygve Sagen, succeeded in acquiring the cream of their collection, including all the paintings which they had just recovered from Germany, page 178. Sagen took *The Young Sailor, I*, page 334, and *The Hairdresser*, page 339, but Tetzen Lund kept all the rest. To these he added a number of even more important Matisses including the great *Joy of Life*, page 320, the gigantic *Riffian*, page 391, as well as the earliest of the *Goldfish*, page 348, and the *Three Sisters with Negro Sculpture*, page 416.[5] In 1925 he began to sell his collection and by 1936, after his death, most of his Matisses had passed to Dr. Barnes or to his Danish compatriot, Johannes Rump.[6]

In Paris, Bernheim-Jeune continued to display Matisse's new paintings yearly in 1922, 1923, 1924. Before the exhibition of 1924 opened all but five of thirty-nine canvases had already been sold. The contract between Bernheim-Jeune and Matisse was renewed for the last time in 1923 for a period of three years, Appendix C. His prices in francs rose another forty percent but scarcely kept up with the rising cost of living.

In Paris the Michael Steins, after selling to the Scandinavians the pictures which they had recovered from Germany, began to collect again. They bought the *Woman with the Hat*, frontispiece, from the collection of Leo and Gertrude Stein who since 1914 had been selling their Matisses. Thus the Michael Steins, deprived of their own best pictures, recovered the very first of the Stein Matisses, the canvas which Sarah had been so enthusiastic about at the "fauve" Salon of 1905 but had agreed to let Leo buy and "keep for a while." A little later they added *Tea*, the most important canvas of 1919, to their collection, page 426. From Leo and Gertrude Stein, John Quinn bought *The Blue Nude* page 336, and the *Music (sketch)* of 1907, page 79, and from the Tetzen Lund collection about 1925 Dr. Barnes acquired the *Joy of Life*, page 320, the *Red Madras*

Headdress, page 350, and the *Blue Still Life*, page 331. In these ways within half a dozen years most of Matisse's best paintings of the crucial period 1905 through 1907, excepting the *Woman with the Hat*, passed out of the hands of the four Steins into other American or Danish collections. Few remained in French possession.

John Quinn, the foremost American Matisse collector of the period, died in 1925. At the auctions of his collection[7] in New York and Paris in 1926 *Music (sketch)*, page 79, went to A. Conger Goodyear, *The Blue Nude*, page 336, to Dr. Claribel Cone through Michael Stein, the *Italian Woman*, page 403, to Earl Horter, the *Variation on a Still Life by de Heem* a little later to Mrs. John Alden Carpenter in Chicago. Old friends of Matisse, Dr. Claribel Cone of Baltimore, her sister Etta, and Miss Harriet Levy of San Francisco continued to collect actively, but their purchases were for the most part small, intimate canvases. Quite the contrary was the big *Nasturtiums and the "Dance,"* page 383, bought by Scofield Thayer in 1922 from Oskar Moll and reproduced by him in the sumptuous portfolio *Living Art* published by *The Dial* in 1923. Even more important was the *Riffian*, page 391, bought from Tetzen Lund by Dr. Barnes along with the *ex* Stein masterpieces already mentioned and, in addition, the big *Music Lesson* of 1917, page 419.

It was, however, Matisse's pleasant, decorative and comparatively realistic style of 1920 to 1925 that began to attract new amateurs especially in Paris and the United States. To most of the less adventurous collectors and museum officials the Matisses of the fauve and Moroccan periods and the great architectonic canvases of 1916 still seemed too radical or, in some cases, they had virtually been forgotten since they were not much in evidence in museums or at Paris dealers and were, comparatively speaking, little reproduced during the mid-'20s. So respectable had Matisse become that on July 10, 1925, he was created a Chevalier of the Legion of Honor.

8 A Turning Point, 1925

But Matisse himself had not forgotten his own great past. The spirit of radical experiment in color and structure had lain dormant but now in 1925 it awoke. Just why is hard to say, for obviously he might have gone on with the highly successful and popular paintings which he had been producing during the previous few years. Perhaps the journey

to Italy in 1925 helped turn his attention to problems of structural form somewhat as his first trip to Italy in 1907 had done. More likely still the change was primarily an internal and self-generating reaction such as he had undergone in 1897 when he repudiated his own early academic success for the arduous career of the independent pioneer—not, of course, that Matisse faced such risks in 1925 as he had in 1897 since his reputation was by now more secure perhaps than that of any living artist. In any case the alteration in his own course was paralleled by a comparable revolution in Picasso's art. In 1925 after years of neo-classic figures and big decorative still lifes Picasso suddenly painted the frightening *Three Dancers*, the harbinger of his surrealist period.[8]

In any case, Matisse's experimental mood first reveals itself clearly in the large sculptured *Seated Nude* of 1925; it developed in the painting of 1926 and came to a climax in the amazing *Decorative Figure on an Ornamental Background* of 1927, page 449. The characteristic paintings of 1928 are once more smaller in scale and conception and in 1929 after producing a few spacious but rather mild canvases he practically stopped easel painting and did not take it up again seriously until late in 1933. Instead, at the end of the 1920s, he poured his energies into drawings and prints and sculpture. Between 1926 and 1929 he produced around fifty lithographs and in 1929 about a hundred etchings. The ten or so sculptures of 1927-1930 include several distinguished small bronzes and the two great semi-abstract reliefs, pages 458 and 459, variations on *The Back* of about 1910 (previously misdated c. 1904), page 313.

Matisse's life was uneventful (photographs page 27). His more radical recent work scarcely affected his growing popularity based upon his paintings of the years just prior to 1925. The really challenging paintings of 1926-1928 were few in number and the big reliefs remained in his studio unknown.

9 Exhibitions, 1925-1930

Among Matisse's exhibitions in the later 1920s the most important was perhaps the show arranged by Pierre Matisse at the Valentine Dudensing Gallery, New York, in January 1927. It included the great *Moroccans* of 1916, page 172, the *White Plumes* of 1919, page 427, *The Moorish Screen*, page 437, and the just completed *Decorative Figure*, page 449. The exhibition was praised by Forbes Watson of *The Arts*, and, extravagantly, by Henry McBride of *The New York Sun*.[1] McBride remarked that the public's attitude toward Matisse had changed. "For one thing, he is older than he used to be and is through with the experimental phase of his career . . . and in the work of his recent years he is so serenely and simply occupied with stating his own vision that practically everything he now puts forth may be seen to be in the great tradition that he at one time appeared to despise." These soothing remarks seem curious in the face of the very large and challenging *Decorative Figure*—and perhaps over-optimistic in view of the attacks on the same exhibition made by Royal Cortissoz of the *Tribune* who, like many of his readers, still preferred Sargent to Cézanne. In any case, the show was a success, though the two most important works went back to France. It was followed in 1929 by another Matisse show at the same gallery.

Early in the fall of 1927 another event impressed the American public much more deeply. Matisse had been represented in the Pittsburgh Carnegie International Exhibitions of 1921, 1924, 1925 and 1926 by paintings of the mildest character. In 1926 the jury, ordinarily very conservative, was inclined to award a prize to his rather minor entry, a still life entitled *Fish;* but Bonnard, who was on the jury, is reported to have opposed the award on the grounds that the picture was too insignificant to represent so great an artist, and Matisse was wisely passed by. However, the following year, the Carnegie jury did give Matisse the first prize of $1,500 for the *Fruit and Flowers*, a characteristically sumptuous still life of 1924, page 441.

Possibly the jury of 1927 was influenced by the cumulative effect of Matisse's exhibits for he was represented by no less than five paintings, all recent, and lent by Bernheim-Jeune. The jury included Eugene Speicher and Maurice Denis, who, two decades earlier in the days of the fauves, had several times damned Matisse with faint praise and even now, it was said, had opposed giving him the Carnegie prize, though probably not for the valid reasons which had moved Bonnard the year before. The award created a great stir partly because it was the first serious breach in the academic ramparts of the Pittsburgh annual. Henry McBride referred to Matisse's paintings at Pittsburgh as noncommittal and not the best he had seen. "The prize award, consequently, was a *beau geste*. It was given by some one who knew more about Matisse than what he

had just picked up in the Pittsburgh exhibition."[2] McBride was right; yet the conservative character of the still life may well have encouraged the rather conservative jury to make the award to an artist whose popular reputation was anything but conservative.

10 Matisse Collectors 1925-1930

In any case the prize given to such a safe-and-sane Matisse helped confirm his reputation among amateurs and museum officials. During the mid-and-later-1920s American collectors began to buy Matisses in considerable quantities. Among them were T. Catesby Jones, Lillie P. Bliss, page 423, Adolph and Sam Lewisohn, color plate page 227, Joseph Winterbotham, Mr. and Mrs. Chester Dale, page 440, Dr. and Mrs. Harry Bakwin, page 424, Ferdinand Howald, Duncan Phillips, Robert Treat Paine, II, page 437, Sturgis Ingersoll, Mr. and Mrs. Sam A. Lewisohn, page 443, Samuel S. White, Earl Horter, page 403. Over four-fifths of the paintings bought were of the Nice period. In fact Stephen C. Clark by 1930 had assembled the finest collection in the world of Matisse's paintings done during the previous dozen years.[3] During the same period the Misses Cone of Baltimore and Dr. Barnes continued to add numerous works of all periods to their collections. And thanks largely to the influence or generosity of collectors, American museums were also acquiring Matisses. Before 1930 the Art Institute of Chicago, the Worcester Museum, the Albright Art Gallery, Buffalo, had followed Detroit's example set in 1922. Philip Hendy had bought the *Carmelina* of 1903, page 311, for the Museum of Fine Arts, Boston, and Scofield Thayer had lent his *Nasturtiums and the "Dance," II*, page 383, to the Worcester Museum.

Many new Matisse collectors also appeared in Europe during the late 1920s especially in Scotland, England, Switzerland and even in Paris. There, too, the paintings of the Nice 1920 period were in great demand. It is significant that *The Blue Nude*, one of Matisse's greatest fauve paintings, brought only 101,000[4] francs at the Quinn auction at the Hôtel Drouot in 1926, but the following year the *Shrimps*, a still life of 1920, color plate page 228, brought 142,000[4] francs—$6,816—and in 1928 Baron Fukushima paid much more, 230,000[4] francs, for *La robe jaune*, another Nice canvas. An important exhibition of fauve paintings by Matisse, Marquet, Dufy, Friesz, Derain and Vlaminck was held at the Galerie Bing but attracted comparatively little attention. It was twenty years too soon.

Marcel Sembat, Matisse's leading French patron during his fauve period and later, died leaving his paintings, pages 329, 332, to the Grenoble museum which, thanks to the bequest of this devoted enthusiast and the Matisses' earlier gift of the big *Interior with Eggplants* remained until 1945 the most important public collection of Matisses in France.

The other veteran Paris collectors of Matisse, Michael Stein, Alphonse Kann, Robert Elissen, and Félix Fénéon were now joined by several new amateurs who bought Nice pictures. The largest Paris collections of Matisses during this period were in the private apartments of the dealers, Josse and Gaston Bernheim-Jeune and Paul Guillaume,[5] the last the collector who bought the huge *Bathers by a River*, page 408, and the *Piano Lesson*, page 175.

Had New York been more receptive, John Quinn's great collection might have passed to some public museum there. Copenhagen was luckier, or more deserving. Johannes Rump, a Danish engineer, had been Dr. Barnes' chief rival in competing for the Tetzen Lund Matisses. Early in the century Rump had collected old master drawings, but in 1912 he started to buy works by the painters of the fauve generation. About 1915 he acquired Matisse's *Place des Lices, St. Tropez*, page 314, and in 1917 the important *Le luxe, II*. When Tetzen Lund began to dispose of his collection in 1925 Rump decided to keep as much of it as he could for Copenhagen. In 1928 he gave to the State his magnificent collection of a hundred forty paintings and sculptures by French masters of the early 20th century.[6] There were sixteen Matisses in this first princely gift, including those illustrated on pages 76, 302, 314, 328, 333, 341, 348, 421. Two years later he added several of Matisse's sculptures to his collection which was housed at that time in the Ny Carlsberg Museum. Thus by 1930, Copenhagen's was second only to Moscow's among public collections of Matisse's art. New York museums had only prints and drawings.

11 Criticism, 1923-1930

During the mid-'20s there had been a number of picture books on Matisse published in France and Germany, mostly with perfunctory prefaces and haphazard illustrations. One of the most serious attempts to evaluate Matisse at this period is to be found in A. C. Barnes' *The Art in Painting*[7] of 1925. Dr. Barnes, who had already bought about half his

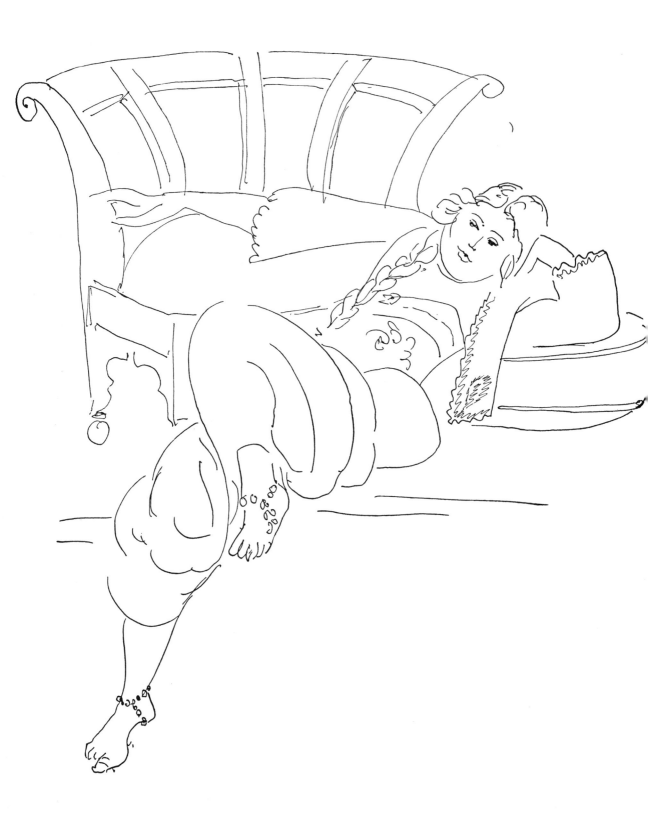

best Matisses, ranked the painter below Renoir and Cézanne but considered him by far the most important living painter as a master of "plastic means."

Carl Einstein in his *Die Kunst des 20. Jahrhunderts*, published in 1923, bibl. 15, was much less favorably inclined. Himself strongly under the influence of cubist painters and esthetics, Einstein found Matisse superficial, agreeable, "a charming technician of gay and elegant ease"; his most recent paintings clever demonstrations of "refined dexterity."

A handsome volume of plates was issued by *Chroniques du Jour* simultaneously in 1929-1930 with French, German and English texts, bibliography 85. Roger Fry, by then acknowledged to be the leading English art critic, wrote the preface for the Anglo-American edition. Twenty years earlier Fry had admired Matisse in terms of the art of primitives and children; then in his preface to the Second Post-Impressionist Exhibition, 1912, he praised Matisse's decorative unity and rhythm of design which, he suggested, approached ancient Chinese esthetics. At the same time, he emphasized Matisse's success in finding an "equivalent" for nature and described the painters of the Paris school to which Matisse belonged as "classic" because their pictures were interesting in themselves rather than for their representational or associational values. Now, in the 1930 volume[8] the critic points out that "the fundamental quality . . . which distinguishes Matisse's art . . . and gives him a very singular position in the long sequence of the European tradition of painting" is a style "based on *équivoque* and ellipsis."[1] By "ellipsis" Fry meant simply the omission of unnecessary detail without sacrifice of repre-

sentational legibility. By "*équivoque*" he meant Matisse's mastery of the "dual nature of painting," his synthesis of its descriptive and formal functions without serious sacrifice of either. He goes on to praise again his "sense of linear rhythm," his "impeccable sense of colour harmony," and his control of color in pictorial depth[2] (which had so amazed Renoir, page 196). He distinguishes between Matisse's "Rococo style" of 1920-1925 and the "stark structural architecture" of some of his work before 1917, a quality which he finds revived in certain pictures of 1927-1928.[3] For his own taste he selects the *Tea* of 1917, page 426, about which he writes the sentence quoted on page 206.

In the same year that this first book on Matisse by an English critic was published, the first American monograph on him, Henry McBride's *Matisse*, bibliography 88, appeared in New York. It was primarily a graceful and witty essay on Matisse and his American public, filled with many shrewd, unpretentious observations. McBride hails the widespread acceptance of Matisse but recalls his recent role as a rebel and expresses bitterness over the "bigoted custodians of institutions" such as museums, the last places on earth to look for "good Matisses."[4] Writing in 1929, he is still faithful to the *Decorative Figure on an Ornamental Background* of 1927, page 449, as "the greatest of them all"[5] and *The Shrimps*, color plate page 228, as "number two on my list of fine Matisses seen in America."[6] He also singles out the Gourgaud *Interior with Goldfish*, page 396, but finds "La Danse and La Musique which went to Moscow, . . . over-intellectualized and dry."[7]

SECTION II NICE—THE FIRST THREE SEASONS, 1917, 1918, 1919

1 *The General Reaction, 1912-1925*

Before embarking on a study of Matisse's paintings of the period 1917 to 1925 it is well to recall that the transformation of his style which they represent —the move toward a less strenuous, more traditional and more popularly acceptable style—had been intimated as early as 1912, had already begun in Paris toward the end of 1916 and was further developed in the summer of 1917 at Issy in such pictures as the *Two Sisters*, page 417, and the *Music Lesson*, page 419.

This change in Matisse's art should also be seen against the broad ground swell of Western art dur-

ing and just after World War I. Gradually and generally artists began to feel a reaction against the rigors and austerities of the various more or less abstract movements of the first dozen years of the century. The reaction may have been initiated by Matisse himself about 1912 in such comparatively realistic compositions as the *Zorah on the Terrace*, page 387, and the Barnes *Goldfish*, page 385, though Derain's *Window on the Park*[8] of 1912 shows that the younger painter was keeping step with Matisse. The Gourgaud *Goldfish*, page 396, of early 1914 carries the reaction toward classic realism still further though the reaction is still partial, for Matisse in

that and the following two years also painted some of his most abstract pictures. Equally significant, perhaps, is the long series of fairly realistic portrait etchings which began early in 1914.

Similar though less overt impulses toward reaction were stirring in Picasso. Probably he knew of Matisse's portrait etchings. In any case, at Avignon during the summer of 1914, he made what was possibly his first realistic drawing in some years, the portrait of a seated man,[9] and followed it in 1915 by the meticulously detailed realism of the portrait of Vollard[1] and some Ingres-like drawings of friends and ballet dancers.[1]

By 1917 Picasso was painting classic-realistic figures and compositions and by 1921 was producing more neo-classic paintings[1] than he was cubist. By 1923 and 1924 the prettiness of some of his figures[2] rivaled the charm of Matisse's odalisques and still lifes painted during the same years, pages 440-443.

Gris and some of the lesser cubists had been moving in a similar direction and so were other School of Paris painters such as Modigliani, who had dropped his cubist mannerisms by 1916. The orphist Delaunay for a brief period about 1916 had even "gone back" to Matisse.

When the war came to an end, Derain quickly took a leading role in the general reaction which now invoked the names of Courbet and Corot as well as of Ingres. Similar reactions had occurred in Italy: between 1915 and 1917 the Futurists had gone back variously to Cézanne, Giotto, Ucello and Ingres. In Germany the painters of the *Neue Sachlichkeit* hailed the names of Cranach, Baldung and Grünewald. And in America such cubists or abstract painters as Weber, Hartley, O'Keeffe and Sheeler had by 1920 turned to a more realistic vision. The Russian and Dutch abstract painters stuck to their guns while dadaists all over Europe—and in New York—laughed at everyone from the solemn *Section d'Or* cubists to the lovers of Leonardo da Vinci—but they were in the minority among men of talent.

The artists' reaction was of course part of a general reaction—literary, social, political—a desire for the safety and relaxation of "classicism," "humanism," and "traditionalism." Matisse, even more than most artists, was isolated from the social and political pressures of his time yet, however independent he may have been of post-fauve artistic currents, he was aware of them, both radical and reactionary. Even though the new direction in his art which became paramount about 1917 was pri-

marily the result of his own deep inner need for change, it must also be measured against the obvious changes in the art of his colleagues and in the sentiment of men generally.

2 Nice, 1917-1918: Hôtel Beau-Rivage

When Matisse arrived in Nice in December 1916 he felt a great sense of relief and relaxation. He had not escaped the war—for Nice was already a hospital and training center though not yet as overcrowded with military as it was to be after the United States became a belligerent—but he had escaped Paris, Paris in winter and Paris in war time. Keenly sensitive to weather and environment as his letters and postcards from Morocco, Spain and Russia prove, Matisse approached Nice tentatively and skeptically. At first he lived in hotel rooms where he was prepared at any moment to pack up and leave.[3] But in the end, Matisse stayed, as we know, for over thirty years—half years actually, for the summer and fall he ordinarily spent in the north.

Matisse's painting during his first two seasons at Nice is also marked by some uncertainty. Of course in the past he had never felt obliged to be consistent in style, indeed at certain moments such as the fauve period his art almost seems to have been produced by two men. The same seems true at times in Nice during the winters of 1917 and 1918, though the general direction is clear.

Two paintings done in his room in the Hôtel Beau-Rivage dramatically illustrate the change in Matisse's art during this transitional period. The *Interior with a Violin*, page 421, is a large, boldly constructed picture, strong in its contrasts of light and dark, the forms vigorously reinforced by heavy dark lines. The yellow chair, blue violin case, and red table cover stand out against the arbitrarily invented black of floor and walls. Through the black shutters the beach and sea dazzle in the sun. It is this excitement over effects of light, indoors and outdoors, that chiefly distinguishes the *Interior with a Violin* from the great interiors done in Paris the year before, pages 410, 413. Otherwise this superb painting is very close to them in style and belongs with them among Matisse's masterpieces.

The *Open Window*, page 420, probably painted somewhat earlier in the winter of 1917-1918, shows the same interior without the violin but with the every-ready suitcase lying on the table at the right. Like most of Matisse's Nice paintings it is much

smaller than the *Interior with a Violin;* but the style differs even more than the size. The color is brushed on rapidly and thinly over the white ground, giving the effect of a spontaneous sketch. Ornamental patterns of floor, antimacassar, wallpaper, curtain and ceiling are all brought into playful though still unobtrusive counterpoint—they had virtually been suppressed in the *Interior with a Violin.* Even the row of coat hooks are touched in as if they were Rococo ormolu. The light plays throughout the room, but it is not rendered in an impressionist technique by breaking the surfaces up into little spots of color, but by keeping the large areas of local color transparently thin, light and luminous. We have already noted the reaction of the aged impressionist Renoir, probably to this very picture when he saw it shortly after it was painted. The subject was impressionist and so, indeed, was the spirit of the picture, but the local color upset him and the unbroken black of the window valance threw him into a fit of mock anger, followed by wonder because it held its plane so well.

The *Open Window* represents not a new departure but simply a further development of the softening and relaxation approaching diffuseness which may be noted, say, in the *Music Lesson* of mid-1917, page 419, when compared with its predecessor the *Piano Lesson* of 1916, color plate page 175. The reaction against austerity was in fact already under way in 1916 before Matisse's first trip to Nice.

Yet strong traces of the austere style survived in the early Nice period not only in the great *Interior with a Violin* but in a few small figure studies such as the *Nude by a Window* in which the angular play of rectangles in perspective and diagonal cast shadows seems almost to absorb the curves of the model in an effect superficially cubist. Matisse's own *Self Portrait,* page 422, painted at the beginning of 1918, is one of the last pictures of the period which look back to the architectonic style of 1912-1916.

Among several small sculptures modeled at the Ecole des Arts Décoratifs in Nice or in his hotel room, the *Figure with a Cushion,*[4] page 424, is the most distinguished. Relaxed and graceful, it differs significantly from the dynamic *Reclining Woman* of 1907.

Though Matisse's most important canvases of these early Nice years were painted in his rooms, he also made dozens of small landscape sketches and several rather impressionist pictures of the parks and gardens of Nice with women carrying parasols or seated on the grass. One of his few large land-

scapes of the period is the handsome and vigorously composed *Montalban,* page 420, of early 1918.

Matisse's paintings of the summer of 1918 include a number of landscape studies such as the *Aqueduct at Maintenon* in the Baltimore Museum and some sketches of the shipping at Cherbourg where he went to visit Pierre in September.

3 *Nice, 1918-1919: Hôtel de la Méditerranée*

Back in Nice by November,[5] with the war just about over, Matisse began to paint with renewed energy. Indeed the year which followed was one of his most productive in quantity and freshness of invention, even though only a few of the paintings are imposing in size or new in form.

The rooms in the Hôtel de la Méditerranée to which he now moved were larger and more luxurious than the Beau-Rivage which he had left early in the year. *Interior with a Violin Case,* page 423, not only shows the difference between the two rooms but records the increased opulence of Matisse's style, its growing emphasis on rococo ornament and patterned surfaces, relieved in this picture by the violin case, the shining blacks of mirror and letter folder, and the sun-drenched blue of the sea. This painting of late 1918, with its almost feminine charm, may be compared with its more modest antecedent the *Open Window* of a year before, page 420, and the large, comparatively simplified and virile version of a very similar subject, the Copenhagen *Interior with a Violin* of early 1918, page 421. The oval black mirror reappears in a number of paintings of the period, most strikingly in the *Anemones,*[6] formerly in the Phillips Gallery.

Because of its size the *French Window at Nice,* page 425, provides a fairer competition for the great *Interior with a Violin* of two years before. In the earlier picture the pervading tone is black, in the later the whole interior behind the translucent blue blinds is saturated by light blue and violet atmosphere brought to a focus by the white blouse and brilliant scarlet pantaloons of the model. The small bright figure and sunny open shutter set against the expanse of very tall and narrow window create a magical effect of height and delicious blue coolness.

Beside this serene painting, *The Artist and His Model,* page 424, in the Bakwin collection seems minor and casual—and even more so if compared with the stately *Painter and His Model,* page 413, painted at the Quai St. Michel in 1916. Yet, though simplicity and formal grandeur are gone from this

little picture, as indeed from most of the Nice canvases, in their place there is a compensating charm of color, intimacy, spontaneity and an unpretentious mastery of complex composition.

4 The Plumed Hat

"I asked him," Margaret Scolari noted after a conversation with Matisse as they stood before *White Plumes*, page 427, in his Paris retrospective of 1931, "I asked him where in creation he'd got that hat, so he laughed welcoming the question and said he'd made it himself. He bought the straw foundation and the feathers and the black ribbon and put it together with pins on the model's head. He said he had too much black ribbon so that he had to stuff it into the crown with dozens of pins."

Matisse was indeed pleased with the hat, in fact fascinated by it, for he made scores of drawings and several paintings of the model Antoinette wearing it with various costumes, or without. In technique and composition both paintings and drawings vary remarkably. The Göteborg *White Plumes*[7] is richly painted with a background of blues, black, warm grey, and dull vermilion. In the *White Plumes*, page 427, of the Minneapolis Institute, the figure is placed against bright red with a striking but rather obvious effect. The drawings range from the rapid pen sketch in the Museum of Modern Art, reproduced page 225, to detailed descriptions of plumes and intricate embroidery even more precisely elaborated than in Baltimore's drawing, page 429.

The plumed hat series expresses a range of mood and characterization quite extraordinary for Matisse, who portrays the model almost as if she were an actress or mime assuming a variety of roles. In the *White Plumes* of the Göteborg Museum, perhaps the best of the paintings, Antoinette seems pudgily adolescent, provincial and demure; in the Minneapolis *White Plumes* she is a cold, aquiline beauty with shadowed eyes; in John Newberry's drawing she is alert and elegant, in Mrs. Helm's, rather *gamine*, both page 428; in the painting *Antoinette*, a nude, she is languorous and seductive, page 427. The strangest image of all is the drawing, page 429, of the monstrous hat, bristling and tentacular, as it settles down over the model's face and shoulders.

5 Issy, Summer and Fall, 1919; Tea

The summer and fall of 1919 at Issy-les-Moulineaux constitute a period remarkable for its large, elaborately decorative but firmly painted interiors such as *The Black Table* and the *Bouquet for the 14th of July*, pages 430, 431, and for one extraordinary garden picture, the *Tea*, page 426. So vigorous in style are those canvases that one is tempted to suppose that the northern atmosphere of the Ile-de-France had somehow had a tonic effect on Matisse after his Capuan relaxation in Nice. (*Tea* and *The Black Table* are mistakenly given a Nice provenance in the captions under their reproductions.[8])

"If I may be allowed the expression of my personal predilections," Roger Fry[9] wrote in 1929, "I would say that to my mind one of the most complete expressions of Matisse's highest powers is to be seen in [*Tea*, page 426], where the play of broadly simplified arabesques, light on dark and dark on light, are contrasted with the most surprising felicity and where a familiar scene of everyday life takes on an air of almost monumental grandeur without any sense of rhetorical falsification. The shock of the word rhetorical in relation to Matisse proves, by the by, the fundamental simplicity and sincerity of his attitude toward life."

Tea, the largest painting done during this period in Matisse's work, is a garden composition with Marguerite and a model seated. A thoroughly impressionist subject, there is little that is impressionist in the technique, no varicolored speckling or violet shadows. Only tan tree trunks and mauve spots of sunlight on the path warm the cool harmony of the green and deep blue-green of grass and crisp leaves, the sharp bright green of garden chairs, the whites and greys of the women's frocks. Local color is followed throughout as if Monet had never corrupted Manet's verdant foliage with his fuzzy iridescence. But the effect of light and, more important, of cool shade is admirably and honestly rendered. And, in addition, there are surprising touches of Matisse's pictorial wit in Marguerite's shoes and the drawing of her face; in the intent expression of the scratching dog. *Tea* is unique among Matisse's paintings. It was the last important Matisse acquired by the Michael Steins.

6 The Bouquet for the 14th of July, 1919

Perhaps the most spectacular of all Matisse's flower pieces—rivaled only by the even larger *Arum, Iris and Mimosa*, page 389, and the *Gladioli*, page 452—is the *Bouquet for the 14th of July*, page 431, painted at Issy in July, 1919. The vase is placed almost in the middle of the canvas against the bold

blue basket-and-arabesque pattern of the textile, page 344, which he had first used years before in the *Blue Still Life* of 1907, page 331. The bilateral symmetry created by the apparently central position of the vase is variously disturbed. Actually the vase is a little to the left of the middle, the table a bit to the right; then the rectangles of the portfolio and the two canvas stretchers seesaw against the background divisions of textile and wall. However, this system of balances is subordinate to the problem of keeping the flowers safely in front of the far more insistent pattern of the textile. Matisse's success is a tour de force even more remarkable, because less arbitrary, than his similar achievement in the *Coffee Pot, Carafe and Fruit Dish* of 1909, page 346. To celebrate the first 14th of July after the end of the war, Matisse, the painter, could have contrived no more fitting fireworks than this *Bouquet*.

Also painted at Issy during the summer of 1919 is the magnificent *Black Table* of the Hahnloser collec-tion. In it the pink, yellow and green of flowers against a striped blue wallpaper compete with an odalisque in light blue against a dark green screen marked with pale, heavy arabesques. All these cool colors are warmed by the ochre-brown floor and anchored by the brilliant black table. Unlike the Nice interiors the decorative detail in the Hahnloser canvas is as firmly and densely painted as in the great still lifes of 1909, page 346.

Another interior with flowers, the *Plaster Torso*,[1] in the Leigh B. Block collection in Chicago, is the same size and style as the *Bouquet for the 14th of July*; in fact it was painted at the same spot in the Issy studio. Here again the blue-figured textile, the solid structure and the generally bold and decorative design recall the great still lifes of 1908 to 1910. Among the flower pieces painted at Nice, earlier in the year, are the *Anemones with a Black Mirror*, already mentioned, and the brilliant, big *Poppies*[2] in the Tannahill collection in Detroit.

SECTION III *LE CHANT DU ROSSIGNOL,* 1920

1 Matisse Commissioned, 1919

The story of *Le chant du rossignol* produced by Diaghilev's Ballets Russes in 1920 is as complicated as its production was ill-starred. Stravinsky had begun his opera, *Le rossignol,* based on Hans Christian Andersen's fairy tale, in 1909 but it was not finished until 1914 when Diaghilev presented it with settings by Alexandre Benois at the Paris Opera. Stravinsky, dissatisfied, decided to rewrite the music as a symphonic poem but Diaghilev, with less than his usual flair, insisted that the music should be adapted for a ballet. Stravinsky reluctantly agreed.

In the summer or fall of 1919, Diaghilev and Stravinsky called[3] on Matisse at Issy-les-Moulineaux to ask him to work with them on a ballet to be produced the following spring. They proposed that he design new settings and costumes either for *Scheherazade* or for the new ballet on *Le rossignol.*

The Bakst settings for *Scheherazade* were then many years old, shabby and dated. Furthermore the voluptuous and picturesque orientalism of *Scheherazade* seemed to Diaghilev admirably suited to Matisse whose Moroccan paintings of 1911-1913 had recently been augmented by the earliest of the odalisques painted in Nice. But, after listening to Stravinsky play music from both scores on the piano, Matisse decided in favor of *Le rossignol.*

Matisse's decision may have been influenced by his liking for the young choreographer and dancer, Leonide Massine, to whom Diaghilev had consigned the choreography of the new ballet. Massine also found Matisse sympathetic and greatly admired his painting—Massine was the first owner of the *Gourds,* page 412. Matisse, however, had never designed for the theatre before and had shown little interest in the ballet which he rarely attended—although he believes[4] that Gontcharova's 1914 settings for *Le coq d'or* were indebted to his *Harmony in Red* of 1909 which had made a sensation when it arrived at Shchukin's house in Moscow, where Gontcharova was painting at the time. Like Picasso, Matisse preferred folk dance, or the popular dances to be seen at Paris cabarets, to ballet.

Nevertheless, once he had committed himself, he worked with his usual painstaking thoroughness, traveling back and forth from Nice to nearby Monte Carlo to consult with Diaghilev and Massine, whose portrait[5] he drew there. After more than the usual quarrels and difficulties, in which Matisse was little involved, *Le chant du rossignol* was given its first performance at the Paris Opera in February 1920 toward the end of the eleventh season of the Ballets Russes with Karsavina as first ballerina.

2 Reception of Le chant du rossignol, 1920

The success of *Le chant du rossignol* was mild. However W. A. Propert, the historian of the Russian Ballet, describes Matisse's designs with more admiration than he shows for the production as a whole[6]:

The great Henri Matisse had undertaken to provide the décor for this astonishing performance. There was every prospect that the mounting would be as startling as the music and dancing. He was as experienced in the treatment of large surfaces as he was scornful of precedent and tradition. But on this occasion I think he was puzzled and a little timid.

The uniform paleness of the colour was only decided on, I believe, after much searching of heart and trial of alternative schemes. It was misty, intangible, vague; the figures as they moved silently before the pale background were like spirits passing at dawn. One awaited impatiently the song of the birds and the coming of the sun.

If the fairy tale had been transformed into a tragedy, to Matisse is largely due its impressiveness in its new form.

The critics, including, it is said, some of the painters who were Matisse's rivals as ballet designers, made his efforts a butt for some malicious humor. "The women's clothes were pretty enough," Propert continues, "but it was a stereotyped prettiness which savored (as one of his colleagues put it) of the Galeries Lafayette." Yet some suggestion of department store *chinoiserie* might not have been inappropriate for the costumes and settings of a Chinese fairy tale written by a 19th-century European. We reproduce Matisse's study for the curtain, page 432.

Diaghilev, nevertheless, was not yet finally discouraged. In the spring of 1926 he made a second attempt to produce *Le rossignol* as a ballet, this time with choreography by Balanchine. Matisse's settings were used again, but Balanchine's version was no more successful than Massine's had been. A dozen years later, Massine persuaded Matisse to try his hand again at designing for the theatre: *Rouge et Noir* was a much more successful production in every way.

SECTION IV NICE, ETRETAT, 1920-1925

1 Evaluation of the Period

During the years 1920 to 1925 Matisse worked with unabated energy, producing scores of paintings and hundreds of drawings. The paintings are for the most part of a conveniently modest size, pleasant in subject matter and more conventionally realistic in style than any body of work he had produced since 1904, without at the same time sacrificing decorative charm. The composition in a single picture of a variety of decorative patterns, already highly developed in some of the paintings of 1909-1911, pages 346, 372-374, was now to be further elaborated even to the point of rather cloying excess. Yet there are many paintings in which daring combinations of patterns and (less daring) of colors are achieved with a virtuosity beyond the powers of any other living artist.

For many this period is the most attractive and satisfactory in Matisse's entire career. In fact Dr. Barnes,[7] who has analyzed Matisse's paintings more thoroughly than any other critic, suggests that he produced more individual and important canvases in 1923 than in any previous year. And, answering those who suggest that the apparently slight and casual style of much of the work done at Nice is the result of fatigue or relaxed initiative, Pierre Matisse insists that they cost his father as much painstaking effort as the earlier and more serious-seeming work. But some admirers of Matisse cannot escape the feeling that the period 1920 to 1925 is a rather unexciting and anticlimactic interim in which even the best paintings with all their charm and quiet gaiety do not approach the masterpieces of 1905 to 1916 or some of the major works of the period of renewed experiment which began in 1926. Even in the canvases of 1920, with their quite exceptional variety and novelty, there seems to be a falling off from the intensity, boldness, scale and sheer pictorial excitement which inform such pictures of 1919 as *The Black Table*, the Minneapolis *White Plumes*, *Tea* and *Bouquet for the 14th of July*.

Yet, in *Meditation*, page 434, one of the best paintings done at Nice in 1920, there are qualities which are crowded out in such a vivid tour de force as *The Black Table*, page 430. The elegantly simple painting of the white bathrobe (made all the whiter by the red candy-striped table cover and the puff of anemones), the sense of intimacy and serenity of *Meditation*, make the earlier, much larger and more

brilliant painting of a similar subject seem restless and a bit assertive.

2 Etretat, Summers, 1920 and 1921

Etretat is a Norman fishing village set on a brief stretch of beach between cliffs which look across the Channel to England. When Matisse spent a few weeks there following his return from London in midsummer, 1920, he found a whole new range of stimulating subjects to see and paint.

The soft chalky cliff to the west of Etretat beach has been hollowed out by the sea to form a natural arch vaguely resembling an elephant's trunk. The Elephant has been a subject for many earlier artists, notably Courbet and Monet, but none of them ever painted it with the variety of invention displayed by Matisse who was perhaps inspired by Hokusai's *Thirty-Six Views of Fuji*. One of the most interesting of Matisse's "views of the Elephant," the *"Caloges" at Etretat*, page 432, is as it happens owned by a Japanese museum—appropriately so, for rarely does Matisse remind one so clearly of Japanese painting as he does here in his free spotting of the black forms of the hulks drawn up on the bright beach between the foreground shadow of a house and the lowering stretch of sea. The technique and vision is, however, far closer to that of Manet in his landscape sketches and further confirms Matisse's retrospection toward the 19th century at this period.

Three of the largest of the Etretat paintings, the *Conger Eel*, the *Great Cliff at Etretat* and *The Two Rays*, are the same size and very similar in composition. In the foreground a catch of fish lies on some seaweed; to the left rises a cliff, and beyond in the distance a second low-lying promontory terminates in the Elephant with its accompanying Needle. *The Two Rays*, page 433, is perhaps the most developed of these in composition with its beautiful balance of vertical cliff past which sweeps the great receding curve of beach. The dark still life in the foreground is curiously answered by the remote black wedge of sail; otherwise the colors are pale tans, greens and aquamarines.

The weather at Etretat was often stormy so that Matisse painted a number of interiors and indoor fish still lifes. Among the most distinguished of these are the *Window at Etretat*[8] in Paul Rosenberg's collection, the *Shrimps*, color plate page 228, and the *Still Life with a Lemon*, color plate page 230, the last painted perhaps a year later in the summer of 1921.

Both still lifes are discussed in the notes opposite the color reproductions.

3 Nice, 1921

The year 1921 brought few changes in Matisse's painting. Possibly he continued to feel some reaction to the magnificent but sometimes rather excessively decorative compositions of 1919, pages 430, 431. In any case, during most of the year he maintained something of the restraint and simplicity which had appeared in such paintings of 1920 as *Meditation*, done at Nice, and the beach scenes and still lifes of Etretat.

Probably his largest painting of the year and one of the last to be done in the Hôtel de la Méditerranée is the *Interior at Nice*, page 435. Here the arabesqued wallpaper, the diapered floor, the dressing table with its slender vase and eared, oval mirror, the very tall French window with the petaled lunette above, the balustraded balcony, the view of the sea, the figure of a woman—all the elements he had painted so often and in such various combinations— are brought together, possibly for the last time and in a mood quite unusual in Matisse's work of the period. The perspective is very steep, almost as if seen from the top of a stepladder, and the space and objects are indicated with rather tentative, dark outlines. Ornamental patterns are nowhere emphasized as they are for instance in the painting of the same room done two years before, page 423. The color is pale, almost entirely grey and blue, and there are few sharp contrasts of light and dark. The whole effect is cool, dry, even a little grave but wonderfully spacious and serene.

This exceptionally pensive spirit is even more explicit in the *Woman before an Aquarium*, page 436, in the Art Institute of Chicago. Once before Matisse had painted a figure raptly contemplating goldfish. That was in a radically different composition, the great *Moorish Café* of 1912-1913, page 388. Now, in this work of ten years later, nothing remains of the grandeur and bold simplicity of that other extraordinary picture in which all ornament and all minor circumstantial detail were eliminated; nothing remains, that is, except that sense of reverie (or envy) induced by the act of watching someone simply watching a bowl "where angel forms were seen to glide."

The compositional problem in the *Woman before an Aquarium*, the balancing of still life—flowers or other objects—with a human figure, is one which

had interested the impressionists and was often to challenge Matisse from his early years at Nice on, pages 430, 434, 477, 488, 505. Here the solution is more than usually three-dimensional: the fore-shortening of the table and the modeling of the figure are carried further than was Matisse's habit at the time. Even the decorative pattern of the Moorish screen beyond is carefully subdued so that it does not compete either with the quiet pinks, greens and browns of the figure and still life or with their structure. Also exceptional here is Matisse's use of light which not only helps to build form but confirms the mood.

The *Girl in Green*[1] in the Ralph F. Colin collection, New York, was painted in the apartment on the Place Charles-Félix and is more indicative of Matisse's direction in 1921 than either the big grey *Interior* done earlier in the year or the *Woman before an Aquarium*. Again flowers and figures are balanced in a delicate equilibrium, enriched by arabesques, bright stripings and the blue sea seen through the shutters—decorative elements which appear again and again in pictures of this and the following year. Many of them however lack the relatively firm and thoughtful structure of the *Girl in Green* so that, taken as a whole, they appear repetitious and occasionally trivial. The same may be said of numerous minor flower pieces, studies of the nude and landscape sketches.

During 1921, thanks perhaps to the presence again of Marguerite in Nice, Matisse began to paint many compositions with two figures, his daughter and a model, in a park or garden or indoors, where they sit at a table, or one of them plays the violin while the other looks out over the low-lying terraces of Les Ponchettes to the sea. At first these compositions were small and comparatively simple but as the year drew to a close they grew more complex, reaching a climax in *The Moorish Screen*,[2] page 437, one of the largest and most elaborate paintings of the period. In it the frocks of the women offer almost the only relief from the busy patterns of rug, carpet, bedspread, wallpaper and the large blue and white double-arched screen (which Matisse had painted the year before in the quiet background of the goldfish picture). These varied patterns are held precariously under control by the wonderful sense of color values which so amazed Renoir, by the elimination of directional light, and by the fact that the linear character of the various patterns is largely suppressed. Instead these very different motifs are all painted in a unifying technique with soft spots or blotches so that there is little differentiation of texture or sharpness of contour. Smaller and more lyrical in color is *The Chinese Box*[3] of 1922, formerly in the Paquemont collection, Paris.

4 Landscapes

Similar surface agitation, but in outdoor subjects, is to be seen in the several paintings Matisse made of street celebrations looking down from a balcony. The *Festival of Flowers* in the Cleveland Museum is perhaps the richest of them, the *Carnival at Nice* in the Baltimore Museum the most vibrant. The subject, a busy street seen from above, is of course one which Pissarro and Monet liked to paint in emulation of some of the Japanese Ukiyoye school woodcuts. And these street scenes of Matisse with their rapid sketchy detail and effects of light and movement are impressionist, in the general sense of the word. But such a picture as the *Festival of Flowers, Nice*, page 438, has none of the fuzzy surface effect of the typical Pissarro boulevard. Matisse is concerned primarily neither with light nor with atmosphere but with the general effect of things, objects, that have their own colors which the painter can keep if he wants to without disintegrating them in a general shimmer. Each touch of the brush refers to the specific color of a tree, a hat, a flag or a dress. But these touches are sparsely distributed over the white ground of the canvas so that actually the effect of light is more brilliant than in a Renoir or Monet. More important still, the colors are selected with such intuitive taste that the eye moves from one to the other with delight; and with a sense of order, too, for Matisse anchors the perspective lines, as they rush toward a vanishing point, by means of the vertical architecture at the left much as he used the vertical cliff (with its horizontal striations) in *The Two Rays* at Etretat, page 433.

The Olive Grove (with a model at an easel), page 438, is less vibrant but more distinguished in color and firmer in surface. The grey-green trees weave an arabesque against blue sky and mauve hills as they cast puce shadows across the grass. Their subtle harmonies are sharpened by the model's ochre and orange hat and violet smock.

5 Checker Game and Piano Music, 1923

The *Checker Game and Piano Music* of 1923, page 439, is even more complex than the *Moorish Screen* of late 1921. Again there are three patterns on the floor

and two aggressively striking ones on the walls. In addition there are the stripes of the tablecloth and the boys' blazers, the bright spots of hardware on the chest of drawers, the pictures on the wall, the violins hanging on the clothespress, the rosettes on either side of the sheet music and, for good measure, the squares of the checkerboard are gratuitously repeated on the base of Michelangelo's *Slave*! Such an inventory may help one to understand Matisse's self-set problem in composing such a picture. Furthermore he had deepened the perspective and introduced a definite sense of light and cast shadow which were largely absent in the *Moorish Screen*. These suggestions of depth and light, though they add visual complexity, actually help to stabilize the composition: the far corner of the room is not only emphasized by the strong perspective diagonal of the rug border at the left but is also weighted by the ballasting clothespress. Around this *armoire* the other three masses—the piano group, the table group, and chest of drawers—are disposed. They form the other three corners of a virtual "square-on-plan." A comparison with a remarkably similar subject, *The Painter's Family*, page 373, of a dozen years before, is enlightening, particularly in the handling of space. Doubtless the later and smaller painting displays greater virtuosity in combining eastern decorative patternizing with western traditions of pictorial depth and directional lighting.

Matisse was of course conscious of the resemblance in subject between the *Family* of 1911 and the *Checker Game and Piano Music* of 1923—although in the later picture a model and her two brothers have taken the place of Mme Matisse, Marguerite, Jean and Pierre. Indeed he may have intended an informal demonstration of the changes which the years had brought in his technical and esthetic goals. He does not however seem to have been aware of the similarity between the *Checker Game and Piano Music* and Cézanne's *Girl at the Piano* or *Overture to Tannhäuser*,[4] page 18, which he surely saw at Morosov's house in Moscow in 1911, if not at Vollard's before Morosov bought it. The resemblance between the subjects of the two pictures is striking, but no less than the similar interplay of patterns—the striped rug, the flowered slipcover of the armchair, the oriental arabesque of the wallpaper—around the girl in white at the piano, the figure sewing and the solid-toned furniture.

Matisse's renewed interest in atmosphere, depth and three-dimensional forms led him about 1921 to begin drawing once more with charcoal in soft chiaroscuro technique. The *Interior with Boys Reading*, page 439, is primarily a composition study for the painting reproduced on the same page and is still vigorously linear in detail, but in other drawings of the first half of the '20s the forms are fully modeled and established in depth with at times an almost academic effect of light and shadow. This technique was also adopted in many of his lithographs of the period, for instance the *Nude in an Armchair*, page 445.

6 Odalisques,[5] 1923-1924

Of the numerous paintings of "odalisques," models more or less draped in oriental costumes, done by Matisse in the early 1920s, two of the most completely realized are in American museums. The *Odalisque in Green Pantaloons* in the Cone Collection of the Baltimore Museum is distinguished by its beautiful but rather somber harmony of dull blue and dark red background behind the figure clothed in pink and blue-green. The harmonizing of bright greens and yellows, scarlet, turquoise and ochre around the nude figure with its black accents makes the *Odalisque with Raised Arms*, page 440, now lent by Chester Dale to the Chicago Art Institute, one of Matisse's most brilliant paintings of the period 1920-1925.

The Hindu Pose, page 441, in the Stralem collection, a third odalisque of 1923, is less sparkling and voluptuous than the Dale painting but more daring in composition and color. The figure in yellow and white pantaloons is posed against a blue textile decorated with black and white squares. To her right a large bouquet of violet flowers in a green vase rests on a red and yellow mat and is seen against a chestnut-brown field. Across the background, above and around the figure and bouquet, ranges from left to right an extraordinary sequence of pale violet, green and black, saffron, scarlet and pink, violet, black, chartreuse and pale grey. Matisse has kept the background space very shallow, so that superficially the effect is like one of Picasso's decorative cubist paintings of about 1915, though it is more directly anticipated by Matisse's own *Oranges* of 1912, page 406. The stiff pose of the figure, the vagueness of her support and the general absence of shadow add to an impression of abstract flatness quite exceptional in his paintings of this date.

The realistic modeling and lighting of the *Oda-*

lisque with Magnolias of 1924, page 440, is more characteristic of the period. Here the carefully composed figure reclines on a yellow and green striped couch and is shielded by a screen divided by brown-gold verticals into panels of violet with deep blue ornament. The salmon-pink fruit in the foreground beckons across the voluptuous body to the heavy white blossoms pinned on the screen. What might have been explicit eroticism in the image seems diffused into a luxurious, generalized sensuality, intimate yet objective. "Matisse has affirmed[6] that before the most voluptuous models his attitude is no different from what it is before a plant, a vase or some other object"—which recalls Corot's insistence that his feelings were the same whether he was painting a woman's breast or a bottle of milk.

7 Still Lifes and Interiors, 1924-1925

Among the paintings of 1924-1925, the most characteristic are the sumptuous still lifes and studio interiors. The richest of the table compositions were painted in 1924. They include *Apples on a Pink Tablecloth*[7] now in the Chester Dale Collection on loan to the Art Institute of Chicago, the *Roses* in the Columbus, Ohio, Gallery of Fine Arts, the *"Histoires juives"*[8] in the S. S. White collection, Philadelphia, and the Bernheim-Jeune *Fruit and Flowers*, page 441, which won Matisse the first prize at the Carnegie International of 1927. In all these the objects—fruit, flowers, books, parakeets, vases—are ranged on a figured tablecloth against an elaborately ornamental wallpaper or screen. Depth and roundness are well indicated and the painting is further enriched by the light and shadow which play over the table top. In subject matter and complexity they resemble some of the still lifes of 1907 to 1910, pages 331, 343, 346, but there is about these later paintings a certain soft sweetness which may ravish but sometimes cloys.

The interiors of 1924 are painted with the same wonderful appetite for color and ornament but, though they are more complex, they surfeit less because they are more spacious both in their two-dimensional composition and in depth. The window, which one can see at the end of a vista—after the eye has passed over the elaborate foreground still life and under the ornate half-drawn oriental hanging and past a flowered screen—the window, esthetically, lets in both light and air. The *Interior with Flowers and Parrots* in the Cone Collection[1] of the Baltimore Museum is the largest and most magnifi-

cent of these, but the *Still Life in the Studio*, illustrated here, page 442, is very similar. In the latter, not only the plain, light, square windowpanes but the dark phonograph horn at the right and wedge of floor at the left provide some tonic salt for the visual banquet. In this picture Matisse has paid himself an amusing floral tribute: in the distance, just above the bouquet in the foreground, one can see the image of the artist reflected in the mirror.

The still lifes of the following year are more easily digestible: the patterning is restrained and rarely agitates both table and background. The *Still Life on Table*[2] in the Henry P. McIlhenny collection is perhaps the grandest. In *La nappe rose*,[3] of the Glasgow Art Gallery, a *compotier* and a vase of flowers compete symmetrically behind rows of cherries and lemons. Simpler and more intimate but livelier in its spatial diagonals is *The Pink Tablecloth*, page 443, of the Lewisohn collection. Here Matisse is especially happy not only in the relationships of space and color but in the special mixture of wit, tact and poetry with which he sometimes chooses and combines his still life objects: in this picture lemons with their dark green leaves, a pineapple which reclines luxuriously in a basket, and a vase of anemones.

8 Lithographs, 1922-1925

In 1922 Matisse, who had done almost no lithography since 1914, began to work in that medium again and by the end of 1925 had produced about fifty prints, averaging around ten a year. They are all studies of models, nude, scantily costumed as odalisques or dressed in summer frocks as they sit beside bouquets of flowers or recline on couches, much as in the paintings of the period.

The series of nudes of 1922 are done in outline but are smaller in scale and feeling and generally more conventional than the great series of 1914, page 400. The costumed figures which follow are drawn with greater detail and by 1923 there are lithographs in which the figure is modeled with a maximum of chiaroscuro relief, though rarely in so soft a style as many charcoal drawings of the period. These highly modeled figures reach a climax in the series of very large prints which begin in 1924 with two versions of the *Nude in an Armchair*, L 54 and L 55,[4] and culminate in the final version of that print, L 63, illustrated on page 445, and the handsome, highly finished *Odalisque in Striped Pantaloons*, L 64,[5] both of 1925. From the same year but at the opposite end of the scale in size, technique and

formality is the amusing study of legs, lithograph no. 71, page 445, which Matisse published even though he was dissatisfied with the line of the left calf which he has canceled out by hatching. Another lithograph of 1925, the large *Veiled Odalisque* (*Chemise arabe*, L 70) is one of the subtlest of all Matisse's prints in its rendering of transparencies.[6]

Matisse's etchings and drypoints of the early 1920s are mostly small line studies of the model. It was not apparently until 1929 that he once more turned his concentrated attention to the copper plate.

SECTION V RENEWED EXPERIMENT: SCULPTURE AND PAINTING, 1925-1929

1 The Sculptured Seated Nude, 1925

Except for the head of Marguerite of 1915 and three minor bronzes made during the early days at Nice, page 424, Matisse had done no sculpture since the *Jeannette* variations of about 1910-1912, pages 368-371.

Then in 1925, unexpectedly, he produced one of his most ambitious sculptures, the large *Seated Nude*.[7] This bronze—it was cast in 1927—is important not only among his sculptures but also because it marks the change which was to come over his work as a whole during the second half of the decade, a reaction against the soft, ingratiating and comparatively realistic style of the previous five years.

The pose of the bronze *Seated Nude* may first be found in a charcoal drawing[1] of 1923 and the painted *Odalisque with Raised Arms*, page 440, and is further developed in the three large lithographs just mentioned, which culminate in the *Nude in an Armchair* of 1925, illustrated on page 445. In the drawing of 1923 the figure is optically foreshortened with very large thighs and an upper body which is diminished in girth but rather elongated. In the lithographs[2] the foreshortening is corrected so that the figure appears normal in proportions.

The pose of the sculpture is fundamentally the same but the effect is radically different because there is no armchair to support the torso which leans back, teetering precariously on its round tuffet. Matisse might have corrected this lack of balance in various ways: by weighting the legs for instance, shortening the torso or raising it to a vertical position, or bringing the arms forward with hands clasped around the raised knee. Instead he does the opposite. He keeps the hands clasped behind the head, elongates the torso and even tilts it further back so the sense of tension and unbalance is increased.[3] After years during which Matisse turned out hundreds of figure drawings and paintings in which the pose ranges from an easy stance to an indolent sprawl, the strained pose of the sculptured *Seated Nude* comes as a surprise. The whole character of the figure is different, too. With her masculine proportions and vigorous, angular lines she seems far removed from the voluptuous odalisques who precede her.

2 Painting, 1926-1927

The departure from the soft, comparatively naturalistic style of 1920-1925 reveals itself more gradually in painting than it did in the bronze *Seated Nude*. The *Odalisque with a Tambourine* of 1926, color plate page 233, is an excellent example of the new vigorous character of Matisse's painting. In it and in the earlier canvases of 1927 there is no diminution of decorative brilliance. In fact the color is denser and almost acidly intense. At the same time the drawing is more arbitrary, the figures more schematically or abstractly composed. The atmospheric depth and softness of 1925 and earlier have disappeared.

3 The Decorative Figure on an Ornamental Background, 1927

The bright, flat color and rather geometrized drawing come to an extraordinary climax in the painting which the Musée d'Art Moderne in Paris lists "abstractly" as *Figure décorative sur fond ornemental* but which is sometimes called the *Odalisque with a Straight Back*, page 449. The charcoal study, page 448, shows Matisse's point of departure for the *Decorative Figure on an Ornamental Background*. In the painting itself the figure is arbitrarily compressed into a structure resembling a quarter pyramid, the rigidly rectilinear back and thigh forming the right angle. The nearer arm has been raised to serve as a horizontal beam; the right leg and further arm act as buttresses, the foreshortened left leg receding abruptly from its huge knee to stabilize the base.

Why such a willful figure? The answer is two-

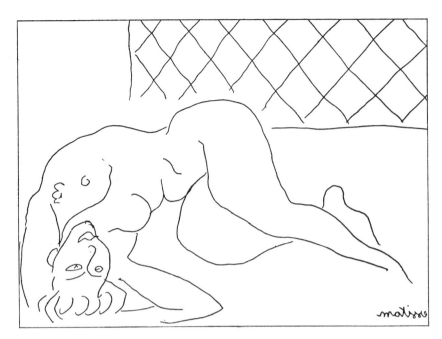

Reclining Nude, Head Down. 1929. Etching no. 129, 3½ x 4⅛". New York, Museum of Modern Art

fold. First, there is Matisse's general interest at the moment in structural forms even if they involve the distortion of natural forms. Second, there are the exigencies of this particular picture in which Matisse confronts himself with his favorite problem of object versus background. In this case the background is without much question the most outrageously overwhelming the artist had ever contrived. Inspired by the most flagrant and bombastic French Baroque wallpaper, Matisse intensified to a maximum its brown and orange arabesque which surrounds areas of the harshest blue in the centers of which cluster pink and red roses. Not satisfied, he has further adorned the wall with a bright green-and-yellow gold Baroque mirror[4] (which he had used so chastely on a white wall in *The Painter and His Model* ten years before, page 413) and has placed in front of it a green plant in a blue-and-white china tub. The carpet is laid out in strips ranging from scarlet and light blue on pink to grey and black under the figure. On this he has deposited a bright green bowl with bright yellow lemons and, to keep the corner busy, a flower-decked pillow. All these gratuitous incidents superimposed on the wall and floor serve to break up and confuse the patterns on these surfaces so that the eye can find no security even in the repetition of ornamental motif—a comfort afforded in such earlier compositions as the

Harmony in Red, page 345, and the *Coffee Pot, Carafe and Fruit Dish*, page 346.

In such a phantasmagoria the curves of a normal female figure would have been absorbed, but the architectonic lines and three-dimensional structure of this figure defend her visual integrity staunchly, though in the end Matisse had to smudge over the background to insure the survival of her contours on the far side.

Visually the *Decorative Figure* is a garish, violent, and upsetting picture. The rather mild problems which Matisse had been posing for himself during the previous five years are here suddenly exacerbated almost to the point of burlesque. *Luxe, calme et volupté* have disappeared and in their places discomfort, excitement and tension reign. The bronze *Seated Nude* of the year before had expressed Matisse's rebellion against ease and softness; this big odalisque adds a revolt against charm and good taste. It represents a triumph of art over factitious vulgarity. Yet because the picture is so clearly an act of will in a field of artifice, the victory seems Pyrrhic.

4 Reaction and Retrospection, 1927-1928

In any case the climactic struggle was short-lived for both reaction and relaxation were to set in shortly. A certain austerity survives in the *Ballet Dancer* and

the *Woman with a Veil* of 1927. In the *Ballet Dancer*, page 447, uncompromising blues, blacks and whites dominate a composition from which all decorative pattern has been eliminated. The paint itself, deliberately coarse, dense and lacking in "quality," offers a surface as unvoluptuous as calcimine, but the eye, kept at a distance, receives an image of clarity and simple strength such as had been very rare in Matisse's painting since 1916.

The *Woman with a Veil*, page 446, is more agreeable in surface and subtler in color but it too retains a strong sense of structure in the pose and drawing. In the *Lemons on a Pewter Plate*, page 450, the decorative arabesque returns in the backdrop though it is still handled with great simplicity; and the paint is laid on thickly, with a certain sensuality which Matisse had spurned in the *Dancer* of the same year. The simplicity of this still life again reminds one of certain paintings of 1916 such as *The Lorrain Chair*, page 409.

Some of the paintings of 1928 continue to suggest retrospection on Matisse's part. *The Sideboard*, page 450, is as direct a challenge (or homage) to Cézanne as was the *Blue Still Life* of 1907, page 331, but it is simpler, more personal in style and less interesting. The russet fruit and blue cloth and china are ranged upon a blue-green sideboard. The background is solid blue with a pale pink vertical molding at the left. The whole effect is that of disciplined and serenely confident mastery deliberately confined to a subject which should be recognizable to all as most typical of Cézannesque classicism. It is not surprising that the Luxembourg accepted it the year after it was painted.

The *Harmony in Yellow*, page 451, is reminiscent, even in the title, of the great *Harmony in Blue* of 1908 and its sequel the *Harmony in Red* of 1909, pages 344, 345. The composition of the three pictures poses the same general problem and involves the same elements: the table with still life on it, the figure at the right, and the background formed of a large and very bold decorative pattern. The pink-and-yellow-bordered blue pattern used in the 1928 painting is actually based on the same original as that in the *Decorative Figure on an Ornamental Background*, but here it is simplified and kept in place largely by masking it down the center by a yellow and white curtain. Yellow appears again around the checkerboard and the stripes of the figure's costume. The tray is yellow green, the vase a green blue. In spite of its flat, bright color and active design, tact, taste, and virtuosity have largely reasserted themselves in the *Harmony in Yellow*.

The *Gladioli*, page 452, formerly in the collection of the late Alphonse Kann, and its pendant, *Asters*,[5] are the largest flower pieces Matisse had painted since the two big Moroccan pictures of 1913, one of which is illustrated on page 389. By comparison with those quite similar canvases the *Gladioli* and *Asters* seem somewhat overblown, yet, though they appear to be retrospective in inspiration, they also look forward to the comparatively large and spacious compositions characteristic of 1929.

5 *Rococo, again, 1928*

Whether or not Matisse consciously intended to challenge some of his greatest paintings of a decade or two before, and whether or not he succeeded, it is clear that the adventurous, experimental spirit of 1926-1928 produced the most memorable paintings of the decade. During 1928 however the power and distinction of such very different canvases as the big *Decorative Figure*, *The Sideboard* and the *Harmony in Yellow* gave way once again to a more consistent style, intimate, bright and ingratiating. The *Seated Odalisque*, page 448, is one of the best of a dozen smallish canvases which offer minor and, as it were, domesticated versions of the overwhelming *Decorative Figure* of the previous year. The figure—more often there are two—the floor, the wallpaper, even the Venetian mirror on the wall are all present but a formidable Baroque has been reduced to a charming Rococo, sharper in color, more vigorous in drawing, crisper in detail, more compact in composition than the Rococo of 1920-1925 but essentially the same in spirit. Matisse had again lowered his sights to a more comfortable range.

6 *The détente, 1929*

The paintings of 1929 are generally larger, simpler and freer in drawing and brushing than the long series of small, decorative odalisque compositions of 1928. Furthermore, they are quite few in number and remarkably varied in character. The *Nude By a Window*, in the Vladimir Horowitz collection, page 452, though very similar in composition to the Nice paintings of half a dozen years before, is cleaner, more sparkling in color and light. The *Grey Nude*, page 454, a fluently drawn figure posed diagonally against a simple background of sea-green tiles seems as remote as it could be from the busy, brilliant little odalisques of the previous year.

Similar in style and scale is the *Portrait in the Moorish Chair*, page 453, which is probably Matisse's largest painting of the '20s, yet one of his least known. Perhaps because it is "unfinished" he has never really released it except once to Tériade for a color reproduction in *Verve*.[6] Doubtless if he had not struck an equilibrium which satisfied him he might have carried the surface and detail further. As it is, the unpainted figure forms a white silhouette against rectilinear shapes of green and scarlet with a band of mauve tiles above. In its spacious serenity it is related to the *Grey Nude*.

A uniquely transitional work is the *Girl in a Yellow Dress*, page 455, painted mostly in 1929[7] but finished in 1931 during a period when Matisse was working almost exclusively upon graphic art and mural painting. The shuttered window, the patterned floor and walls are commonplaces of Matisse's Nice iconography, but the pose and position of the model and the color orchestration are new. The gown is lemon yellow with greenish shadows and the salmon red tiles of the floor are separated from the lavender paper by a green dado; the blinds are ochre—a sultry, unusual harmony. The symmetrically frontal pose of the full-length model right in the middle of the canvas is a device Matisse had very rarely, if ever, used since the Moroccan figures of 1911-1913. Here, with all the prettiness of the setting and costume, the effect is piquant rather than formal or monumental.

SECTION VI GRAPHIC ART AND SCULPTURE, 1926-1930

1 *Lithographs, 1926-1930*

The score or so of lithographs of 1926-1930 reflect to some degree the reaction toward the bolder, more experimental spirit which generally marks the painting and sculpture of that period. The brilliant outline portrait[8] of the pianist Alfred Cortot is the most striking print of 1926 but the very large, fluently drawn and delicately modeled *Reclining Odalisque*, L 81, page 445, is more characteristic.

Most of the lithographs published in 1927 are devoted to a new subject for Matisse—the ballet dancer—inspired perhaps by his renewed contact with Diaghilev's Russian Ballet on the occasion of the revival of *Le chant du rossignol* with Balanchine's choreography. In this series, most of which was issued in the portfolio *Dix Danseuses*, the ballerina is conventionally costumed in the classic short tutu. Matisse draws her standing, seated or reclining but, curiously, never dancing or practicing at the bar. His technique varies from strongly modeled figures resembling the painting *Ballet Dancer*, page 447, to spontaneous line drawings, sometimes with deformations and syncopations more radical than any in the lithographs of the earlier 1920s.

Possibly Matisse published no stones in 1928,[1] but the twenty or so lithographs of 1929 cover subjects which appear in his paintings of 1928 and, in any case, more than make up for a year's lapse in what by now had become an annual production of ten or a dozen prints.

More than half the lithographs of 1928 or 1929 are studies of the model seen from various angles as she reclines on a couch surrounded by patterned textiles, flowers, the familiar brass stove, and Louis XV table. One of several variants is the arabesque design formed by furniture and a foreshortened figure seen from above in the *Reclining Nude, II, with a Stove*, page 460.

The most remarkable lithographs of the period are without question the vivid, sharply modeled compositions in which details of figure and furniture and flowers are more elaborately rendered than in any other mature works of Matisse. In the *Odalisque in a Tulle Skirt*, page 460, the transparent texture of the garment, the inlay of the Moorish chair and tabouret are precisely simulated not only in detail but in color values, that is, the black-and-white equivalents of color. *The White Boa*, L 123,[2] a portrait study of the same model, is equally remarkable for its almost photographic effect of light, color and texture but, on close inspection, one finds that the detail has been suggested with extraordinary economy. The *Odalisque in a Tulle Skirt* may be compared with the strikingly different rendering of a rather similar subject, the drawing *Odalisque with a Moorish Chair*, page 202, of the same year.

The lithographs of 1930 are few in number and during the ensuing decade Matisse seems very rarely if ever to have touched a lithographic stone.

2 *Etchings and Drypoints, 1929*

The year 1929 is extraordinary in Matisse's career for its quantity of etchings and drypoints. In 1914, page 398, he had made some fifty[3] plates and in the

early 1930s he was to produce perhaps his greatest etchings, the twenty-nine illustrations for the *Poésies de Stéphane Mallarmé*, page 466. But in 1929, alone, he seems to have made well over one hundred plates. Almost all of them are small and some are rather slight but they provide us with a remarkable record of Matisse's draftsmanship at its purest. There are a few fairly elaborate compositions related to the paintings and lithographs of models surrounded by furniture and figured textiles. Of these the often reproduced *Nude with Parrots*,[4] E 180, is typical.

The tensions and balances between figure and object, or figure and décor, which Matisse so often studied are reduced to their simplest ratios in the *Reclining Nude, Head Down*, page 214, and in two dozen variations on the familiar subject of the girl with goldfish. Such linear epitomes may be compared with their opposites done in the same year such as the lithograph, *Odalisque in a Tulle Skirt*, page 460. At no other time did Matisse exhibit such extreme differences of technical and esthetic approach to the representation of nature within the limitations of black and white. Yet the compositional problems are virtually the same in both extremes.

Writing shortly after these etchings of 1929 were done, Claude Roger-Marx[5] describes Matisse's technical procedure. "The first sketch is done with a brush on copper or varnish; then the etching point, always in the presence of the model, extracts from these indications the essential lines. . . ." The extreme spontaneity of some of the etchings may be explained by Florents Fels' quotation of a statement which he attributes to Matisse: "I made some of my etchings, after hundreds of drawings and research studies in the definition of form. Then I executed the plates with my eyes shut."[6] This may well be true of a few plates. Drawing "blind," as many artists know, does result in remarkable fluency and spontaneity, but Matisse's long preparation is of greater significance than his having closed his eyes after the image was deeply ingrained in his memory. Earlier accounts such as Pach's, page 186, seem more convincing and at least closer to Matisse's ordinary procedure.

3 Drawings, *1926-1930*

The most characteristic drawings of the late 1920s are a long series of line studies[7] of one or a pair of odalisques reclining on a pillowed divan or sitting in or near a curious Moorish chair with a splayed circular back. Some of these are studies for the many small odalisque canvases of 1928. The *Odalisque with a Moorish Chair*, reproduced page 202—it does not seem to have been adapted for a painting—is fresh in composition and striking in the way the drawing is placed on the paper, almost always an important factor in the esthetics of Matisse's graphic art. There are also figure drawings and several handsome studies of interiors done in the atmospheric, smudged charcoal and stump of the early '20s, but these are fewer in number than the line drawings. A more schematic analysis of form may be seen in the *Reclining Nude*, page 456.

4 Sculpture, *1927-1930*

Between 1900 and about 1912 Matisse produced over thirty pieces of sculpture, one or more practically every year. Then, excepting the tall narrow head of Marguerite in 1915 and three minor bronzes done at Nice about 1918, he stopped until 1925. The second great period of Matisse's sculpture begins then with the large *Seated Nude* of 1925 and continues until 1930 with the *Stout Head* of 1927, the *Reclining Nude II* and *III* of 1928-1929, two tiny torsos of 1929, the two over-life-size reliefs, *The Back*, *II* and *III*, probably of about the same year, the *Tiari* and the *Venus in the Shell* both of 1930 after Matisse's return from Oceania.

The *Stout Head, Grosse tête*—one cannot use "fat head" in English though that is the literal translation—offers an amusing contrast to the last head he had done, the thin, Giacomettesque *Marguerite* of 1915, page 401. But aside from its bulkiness the later piece, page 456, is radically different in style. The rough Rodinesque modeling is completely gone and in its place is a smooth, generalized surface as solid and broadly "classic" as a Maillol head but with more character, both formal and physiognomical.

5 Reclining Nude, II *and* III, *1929?*

Thanks to previous confusions the two bronzes *Reclining Nude*, *II* and *III* were numbered and reproduced in reverse order on page 457. Matisse has very recently clarified[8] the sequence but too late to correct our error, which had been printed. The sequence is important for it is clear that *Reclining Nude, II* is much closer in design to *Reclining Nude, I* of 1907, page 337, than is the low-lying *Reclining Nude, III*.

It is perhaps a little misleading to have labeled the two sculptures done in the late '20s as "states" of the 1907 bronze, since they are so different and even lie in the reverse direction. However, *Reclining Nude, II* is clearly a development of the figure done over twenty years before which, it will be remembered, was itself the end of a series of studies of the same pose going back through *The Blue Nude*, page 336, to figures in the *Joy of Life*, page 320, and even in *Luxe, calme et volupté*, page 317, of 1904-1905.

The modeling of *Reclining Nude, II*, page 457 bottom, is more severe and arbitrary than in the *Reclining Nude, I* and its effect is more monumental partly because of certain shrewd exaggerations such as the columnar left upper arm, partly because it is quiet rather than turbulently active.

In the *Reclining Nude, III*, page 457 above, the robust forms of both *I* and *II* are deflated, the breasts and hips suppressed, the arms diminished, especially the towering elbow. The tubular-shaped torso, on either side of which are long parallel grooves, increases the curiously stream-lined effect of lassitude and mannered elegance.

The drawing reproduced on page 456 is apparently a study for the *Reclining Nude* bronzes. Its angular analysis of the figure throws a revealing light upon the forms of the two sculptures.

6 The Back, II *and* III, *1928-1929?*

The reinterpretation of a much earlier subject occurs again even more explicitly in two very large reliefs which Matisse probably completed about 1928-1929,[1] though they may be considerably earlier or later. *The Back, I* of about 1910, a powerfully modeled, rather Cézannesque figure had been the artist's most imposing early work of sculpture; *The Back, II* and *The Back, III*, even larger in scale, occupy the same position in his later sculpture, though they remained unexhibited and unpublished and almost unknown until they were shown in the big Lucerne and Paris retrospective exhibitions of 1949 and 1950. *Back, I* is reproduced on page 313 with the date "1904?" which with the help of Mme Matisse can now definitely be corrected to "about 1910." *Back, II* and *III* are reproduced on pages 458, 459.

The fact that *The Back, I* was listed as *Le Dos, Plaster Sketch* when it was shown in London in 1912 suggests that even then Matisse had in mind some further development of the work. *The Back, II* obviously stands about half way between the first and third versions. The curving counterpoise of the early figure is almost abandoned for a vertical stance with only a slight bend of the right leg to balance the turned head and raised left arm. Matisse has further emphasized verticality by introducing a fall of long straight hair which serves as a kind of external spine. The lost profile of the breast is fused with the scapula by means of angular simplifications suggesting early cubism. The forms seem hewn out of the medium—probably plaster—as if with an adze.

In *The Back, III* Matisse further simplifies the form. The rough-hewn planes of the second version now give way to rounded surfaces. The right arm is fused with the trunk and, except for the most abstract indications of the hand and turn of the head, all detail has been suppressed. Yet these vestigial details effectively accent the inflected contours and disturbed symmetries of this columnar architecture in human form.

7 Sculpture, *1930*

Two small but distinguished pieces of 1930 complete Matisse's sculpture, excepting the crucifix, page 524, and unless he is withholding certain works as he has sometimes done in the past. The *Venus in a Shell*, page 461, is related in style to the *Reclining Nude, II*, the distortion and compression of the raised elbows carrying upward the columnar torso.

Matisse modeled the *Tiari*, page 461, very shortly after his return from Oceania during the summer of 1930; in fact it is perhaps his only work done during the ensuing decade to be inspired by a characteristically Tahitian form. The forms of the large tropical flower called *tiari* or *tiaré* Matisse has made into a sculpture suggesting a woman's head surmounted by a strange headdress. To underline this visual conceit or pun he originally placed a necklace around the neck of the flower-head. Though Matisse himself was ordinarily as far removed as an artist could be from surrealism, the surrealists were in 1930 the most active, conspicuous and creative group of artists then working in Paris. One of their favorite devices was the double image. Matisse's *Tiari with a Necklace* with its ambivalent and rather disturbing forms might well have been shown in an exhibition of surrealist sculpture just as the flower itself could have counted as a surrealist *objet trouvé*. The ambiguous name of this sculpture as well as its shape has led to misunderstandings: it has been listed as "tiara," or even *Head with a Tiara*[2] as often as *Tiari* or *Tiaré*.

PART VIII: 1930-1939

FROM THE BARNES MURALS TO THE *ROUGE ET NOIR*

SECTION I MATISSE'S LIFE, 1930-1939

1 *Tahiti, Spring, 1930*

For over fifteen years Matisse had traveled very little except from Paris to Nice and back again. Around 1920 he had gone several times to the coast of Normandy and once to London and about 1925 to Italy. Now, in 1930, he made several long voyages of many thousands of miles.

For many years he had dreamed of traveling to the South Seas and in March he set sail by way of New York and San Francisco. "I have always been taken," he wrote Escholier, "by the character of the light which bathes the objects of my contemplation, and often I had asked myself during my meditations, what would be the particular quality of the light in the Antipodes.

"I stayed there three months absorbed by my surroundings without a thought in my head in front of the novelty of everything I saw, dumbfounded, yet unconsciously storing up a great deal."

Matisse did no painting in Tahiti, but made a number of drawings: flowers and foliage, the shore with palm trees and an outrigger canoe drawn up on the beach, or the schooner *Papeete* moored to a little wharf and, most remarkable, a rocking chair of elaborate 19th-century design.[3]

These sketches and impressions, "*emmagasinant inconsciemment,*" as he put it, he was to draw upon later for a piece of sculpture, page 461, some of the Mallarmé illustrations, page 467, a tapestry cartoon, page 475, and the "lagoon" abstractions in *Jazz*, page 500, but very few if any paintings grew explicitly out of this journey.

In Tahiti Matisse saw something of the German film director, F. W. Murnau, who was at work with Robert Flaherty on *Tabu* and who took the photograph of Matisse reproduced on page 28. Once when traveling about the archipelago by boat Ma-

tisse landed on an islet inhabited only by a single guard. When Matisse gave his name the guard greeted him enthusiastically[4] under the illusion that he was Auguste Matisse, the academic marine painter, an error which Matisse had hoped to scotch when he hyphenated his name many years before. (A final, tragi-comic confusion occurred in September, 1931, when upon Auguste Matisse's death, headings in several of the more philistine newspapers announced that it was Henri who had died. Thereafter, whenever long habit permitted, Matisse dropped the hyphen from his signature.)

Matisse did not return through the United States but sailed directly from Tahiti to Marseilles by way of Suez.

2 *The Carnegie Jury, Autumn, 1930*

In 1927 Matisse had won the first prize at the Carnegie International Exhibition. He now accepted an invitation to serve on the jury to select the prizewinners of the 1930 Carnegie show. He and his fellow jurymen[5] including Bernard Karfiol and Glyn Philpot were met in New York by the Carnegie Director, Homer Saint-Gaudens, early in October and conducted to Pittsburgh where they gave the first prize to Picasso's handsome classic *Portrait of Madame Picasso*. Matisse himself was represented in the exhibition by three canvases.

After the festivities Matisse returned to New York where he was taken by René d'Harnoncourt, acting for the Carnegie International, to visit the homes of many private collectors. He was pleased by the number of Matisses he found there, though he was not always entirely content with the settings in which his canvases were hung.

Meanwhile the greatest American collector of Matisse's paintings had asked Matisse to visit the

Barnes Foundation, even, it is said, originally proposing that he abandon his Pittsburgh engagement to do so more promptly. When Matisse arrived at Merion, Dr. Barnes is reported to have greeted him with the dramatic announcement that he had long awaited the artist's coming since it was he who must do the murals in the great hall of the Foundation's museum. Matisse, who had come primarily to see the collection, hesitated. He did not feel that he could make up his mind at that busy moment without a good deal of further study of Dr. Barnes' proposal.

Before he left America he also visited the second most important Matisse collection in the country, that of Miss Etta Cone in Baltimore. Her sister, Dr. Claribel Cone, had died recently so that Miss Etta[6] proposed to Matisse that he make a posthumous portrait drawing of her. This he did, page 470, completing it together with one of Etta Cone in 1934.

3 The Barnes Murals; the Mallarmé Etchings; the Rockefeller Center Invitation, 1930-1933

Matisse then returned to France but was back in Merion about the end of the year. There he pondered with his usual care the very difficult problem of painting a decoration for the lunettes over the three great French windows of a gallery already crowded with large masterpieces. Finally, in January 1931, he agreed to accept the commission, Dr. Barnes assuring him that he should paint whatever he wished.

During 1930 Matisse had already accepted another commission of almost equal importance and, for Matisse, certainly more novel. Albert Skira of Lausanne, a publisher of fine books which were ultimately to rival those of Vollard, proposed to Matisse that he illustrate a great new edition of Mallarmé's poems. The invitation came at a good moment, for Matisse's interest in easel painting was obviously at a low ebb. Even in 1929 he had been giving most of his time to sculpture and printmaking and in 1930 his restlessness and renewed curiosity had led him to several long transoceanic voyages. To have returned to easel painting again when he came back to Nice early in 1931 might have seemed a serious anticlimax. Fortunately, he could look forward to two important and challenging new projects, the Barnes mural and the Skira *Poésies de Stéphane Mallarmé*. The *Mallarmé* he worked on largely in the summer and fall in the

north where he could be near the printer and by 1932, after the most painstaking effort on the part of Matisse, Skira and their collaborators, the magnificent book was finished and published. The Barnes mural which occupied most of three winters in Nice proved even more arduous.

When Matisse returned from Merion to Nice early in 1931 he took an abandoned film studio at 8, rue Désiré Niel, big enough to accommodate the $11\frac{1}{2}$ by 42 foot mural. By June he was fairly well on in the design but felt it would take him about a year to complete it, after which he would still want to keep it a month or so just to be sure it was right before he delivered it.[7] As he had expected, he did finish it in 1932 but only to find upon checking that the measurements he had been given and had been working with for over a year were wrong. Nevertheless when he returned to Nice in the fall of 1932 he began all over again, not just making revisions and adjustments but developing an entirely new design. The second Barnes mural was finished in April 1933 and the following month was shipped from Nice to Merion and put in place, Matisse himself making the trip to supervise the installation. Both Matisse and Dr. Barnes were pleased.[8] But Matisse was also exhausted by the long strain. When he returned to Europe he went to Abano Bagni near Venice to take the cure. While there he once again visited the Giottos at Padua.

In 1932 while he was in the midst of his work on the Barnes decoration, Matisse received an invitation to undertake another important mural commission. At the suggestion of Mrs. John D. Rockefeller, Jr. and Nelson Rockefeller, Rockefeller Center, which was then under construction in New York, asked Matisse, along with Picasso and Diego Rivera, if he would submit preliminary designs for murals to be installed in the entrance hall of the huge RCA building, the central structure of the Rockefeller Center group. The invitation was brought to Matisse by John R. Todd, head of the construction company, and Raymond Hood, one of the architects. They had in mind that the mural should be painted on canvas in tones of black, white and grey upon the general theme "New Frontiers— March of Civilization."

Todd and Hood explained the scheme of decoration to Matisse but before they could come to any precise terms the painter made clear that he did not think his work could be seen to good advantage in such a public place where bustle and confusion

ROCKING CHAIR (*Chaise à bascule*). Tahiti (1930, spring). Pen and ink. Owned by the artist. From *Dessins de Matisse, Cahiers d'Art*, 1936

would interfere with the quiet, reflective state of mind which he felt necessary for the appreciation of his paintings. Also, he could not promise to complete the mural within a period of two years. Under the circumstances he did not feel that he could honestly accept the commission.[9] Picasso did not accept either and Rivera's mural was ultimately removed. Murals by Frank Brangwyn and José Maria Sert now decorate the great entrance hall.

4 *The Four Retrospectives, 1930-1931*

The early years of the 1930s were remarkable not only for the two great commissions, the Barnes mural and the Skira *Mallarmé*, but also because they witnessed no fewer than four comprehensive retrospective exhibitions of Matisse's art. There had not been a large Matisse exhibition since the show of some eighty paintings organized in 1924 to tour the Scandinavian museums. The first of the four big shows to again display Matisse's art at full length was assembled by the dealer Justin Thannhauser for his galleries in Berlin in the late winter of 1930. Eighty-four paintings, fairly well distributed over the previous forty years, were supplemented by twenty bronzes, over fifty drawings and a hundred prints.

French dealers followed suit as soon as they could. Etienne Bignou collaborated with Josse and Gaston Bernheim-Jeune in organizing a huge show of some 145 paintings which opened at the newly reorganized Georges Petit Galleries in June 1931.[1] The exhibition included only one sculpture, the bronze *Seated Nude* of 1925, and an uncatalogued miscellany of drawings and prints. Two-thirds of the paintings were of the recent Nice period, so commercially important at the time, leaving the twenty-five years

221

before 1917 inadequately represented. Even such easily available masterpieces as *The Moroccans* and the *Piano Lesson*, color plates pages 172 and 175, were omitted, perhaps because of their inconvenient size. In any case, the show was of great importance to the Paris public since, incredible though it may seem, Paris had had no chance to see a Matisse retrospective since 1910, and there were by 1930 only two canvases in Paris museums, both of them recent pictures, pages 198, 450.

Later in the summer some of the paintings just shown in Paris traveled to Basle where they were augmented by important early canvases lent from German and Swiss collectors, fifteen bronzes not seen in Paris, and many prints from the Stuttgart museum.

In November 1931 the Museum of Modern Art in New York gave its first large European one-man show to Matisse. It was not so big as the preceding exhibitions in Berlin, Paris and Basle but every effort was made to make it a well-balanced retrospective covering all media and giving adequate representation to the periods before Nice. Moscow and Dr. Barnes, as usual, were unwilling to lend but nevertheless over half the paintings dated from before 1917. The exhibition was received with enthusiasm by most of the New York critics, but Cortissoz of the *Herald Tribune* stuck to his conservative guns. He found the *Still Life with Peaches* of 1895, page 294, "delightful" and "charming" but little thereafter drew even condescending praise. Matisse's drawing generally "marked by fundamental incertitude, is often curiously thin and wiry," the paintings were "crude, weak in craftsmanship," and "slovenly in design." Granted that his "freshness of attack" and some "skill in the arrangement of color" marked Matisse "as a man of talent," there remained "a certain lightness and unimportance about the work. . . . After all, a number of static representations of the figure and a number of pleasing flower pieces seem small enough baggage for an artist to have accumulated after forty years of labor." Cortissoz concluded that Matisse "might profitably have stayed a little longer in the atelier of Bouguereau."[2] Such a review sounds as if it might have been written about 1910, except that it was much less discerning than those of Huneker and Mather actually published in that year, page 115. But most of the other critics of 1931, notably McBride, Jewell, Vaughan and Watson wrote with generous praise of Matisse's achievement,[3] and

Meyer Schapiro analyzed the persistence of impressionist attitudes and techniques in Matisse's art in a valuable article in *Androcles*.[4]

5 *Praise and Slander, 1930-1935*

During the early 1930s publications on Matisse increased in number and importance. The volumes by Fry and McBride, published about the turn of the decade, have been mentioned, page 203, and the catalogs of the large retrospective shows in Berlin, Paris, Basle and New York in 1930 and 1931 added copious though sometimes inaccurate documentation, bibls. 111, 145, 110, 131. In 1931 the French periodicals, especially *Les Chroniques du Jour*, bibl. 159a, and *Cahiers d'Art*, bibl. 158, got out special numbers, the latter remaining to this day the most useful one-volume collection of reproductions of Matisse's work prior to 1931.

In 1933, about the time Matisse's mural was installed at the Barnes Foundation, Scribner's published *The Art of Henri-Matisse* by Albert C. Barnes and Violette de Mazia, bibl. 78. A volume of over 450 pages, it presents a detailed examination of Matisse's "plastic means" and formal analyses of particular paintings more thorough and objective than any ever bestowed upon a living painter before or since. The insistently empirical method results at times in some repetition and tedium but there are many discerning and even eloquent passages. Dr. Barnes and his collaborator found Matisse's best pictures well distributed throughout his career but, as has been noted, page 208, they picked out 1923 as perhaps his finest vintage—and, curiously, 1923 was apparently the date of the latest Matisse canvas in the Barnes collection, excepting of course the big mural.

Unlike most writers of monographs on living painters, Dr. Barnes is restrained in his praise of Matisse. He explicitly describes the artist's limitations which place him below Giotto, El Greco, Titian, but do not prevent his surpassing Picasso, a comparison elaborated in Barnes' earlier volume *The Art in Painting*, bibl. 8. *The Art of Henri-Matisse* is dedicated to Leo Stein.

An extended study from a very different point of view, Alexander Romm's *Henri Matisse*, was published in Moscow in 1934 and 1935 followed in 1937 by an English translation, bibl. 89a. Romm, at that time one of the leading Soviet critics, presented a generally sympathetic analysis of Matisse's art based on long first-hand knowledge of the great

paintings in the Museum of Modern Western Art, but he saves his reputation—and perhaps his skin—by references to Matisse's "bourgeois estheticism" and "hedonistic outlook" in "the epoch of imperialism." He concludes with what ten years later might have been a very dangerous suggestion that Soviet artists could learn something from Matisse's mastery of color, form and "the laws of decorative rhythm."

Romm was obviously torn between his admiration for Matisse's art and his obligations as a Marxian critic. No such dilemma vitiated the criticism of Thomas Craven who devoted a chapter to Matisse in his *Modern Art*, bibl. 10a, published in New York in 1934. Writing in the depth of the depression, Craven appealed to American philistinism, puritanism and suspicion of foreigners with raucous rhetoric. His imaginary account of how Matisse went about painting his favorite subject, "the odalisque in the hotel bedroom," is a malicious burlesque but shrewdly effective. It comes midway in an essay which begins with the suggestion that Matisse looked like a Polish Jew and ends with the accusation that he "has kept his art aloof from modern life."

Meanwhile "*petit-bourgeois*" puritanism, philistinism and hatred of foreigners had triumphed politically in another country. Craven could write, could flatter insular or timid prejudice, but Hitler could act. The year before Romm and Craven published their strictures on Matisse, Hitler had swept his paintings and those of other modern artists from the walls of German museums on the charge that they were a decadent, bolshevistic hoax foisted on the German people by gangs of effete intellectuals, misguided museum officials and international Jewish dealers. Thus German museums which had been the first to acquire his canvases twenty years before were now purged of them all. A few were hidden and survived but most of them were eventually sold to "decadent" foreigners.

6 Paintings and Commissions, 1935-1938

With the *Poésies de Stéphane Mallarmé* published in October 1932 and the second Barnes mural finished and delivered in May 1933, Matisse began gradually to give more time to his easel painting. A few canvases are dated in those two years, most of them small, and not a great many more in 1934 though in that year he painted the large interior called *The Magnolia Branch*, page 469, which Etta Cone

bought. During the early '30s a young Russian, Lydia Delectorskaya, began to serve as Matisse's model. Later she was to become, and remain, his loyal secretary and buffer against intrusion.

The year 1935 was more and variously productive. Mme Marie Cuttoli, in an effort to rehabilitate French tapestry design,[5] had commissioned a number of leading painters to make cartoons for Aubusson and Beauvais weavers. Matisse joined Rouault, Picasso, Dufy, Léger, Lurçat and Braque in collaborating with her, basing his design, page 475, on a drawing done in Tahiti. Another commission came from George Macy of New York, who asked Matisse to make illustrations for a special edition of James Joyce's *Ulysses*. Six soft-ground etchings, together with reproductions of preliminary drawings, were published by the Limited Editions Club, page 474.

Matisse's most characteristic canvases of 1935 are compositions of the single nude figure, notably *The Dream* and the *Pink Nude*, pages 471, 473. To 1935 and 1936 belong many smaller and more intimate figure studies. Two of the best are *Blue Eyes*, page 471, and *Girl in Red Chair*, page 476, both in the Cone Collection of the Baltimore Museum. It was also during these two years that Matisse produced a long and most ingeniously varied series of ink drawings of his studio with a model—often including his own mirrored self portrait, page 250.

In 1936 and again in 1937 and 1938 a score or more of Matisse's canvases, most of them very recent, were exhibited at the Paris gallery of Paul Rosenberg who had signed a contract with him in 1935 and remained his principal dealer until 1940 and the war. In 1936 Matisse gave his Cézanne *Three Bathers*, page 18, to the Musée de la Ville de Paris, at that time housed in the Petit Palais. "Accept it," he wrote the museum's director, his friend Raymond Escholier, "I beg you, as a pardonable testimonial of my admiration for this work which has never ceased to grow since I acquired it." The full letter is quoted on page 40. Matisse had bought the Cézanne in 1899 out of the poverty of his youth. In the following year, 1937, Floury published Escholier's book on Matisse, bibl. 83, an amiable and not always orderly study, but valuable because it was written in close collaboration with the artist who provided the author with many useful written notes.

Some of the numerous easel paintings of 1937 to 1939 maintain the simplified style of the nudes of

1935; others are elaborately decorative compositions with flowers and models in oriental or "period" costumes but with a modern Parisian chic, page 235. The most characteristic canvases of 1938-1939, pages 478-481, involve two models in long gowns seated against a background of philodendron, the palmate leaves of which had held Picasso's interest in several of his large paintings of 1932. At the end of the decade come a few still lifes and interiors with striking black backgrounds, page 485.

In the later 1930s Matisse was again busy with a number of commissions, large and small. In 1937, along with many European and American artists, he made a design for the Steuben Glass Company of New York, page 482; in 1938 he painted an overmantel for the living room of Nelson Rockefeller in New York, page 479. His large decorative canvas entitled *Music* was done in the spring of the following year and bought by the Albright Art Gallery of Buffalo, page 481.

Matisse's most important commission of these years came from the Ballet Russe de Monte Carlo, successor to Diaghilev's great company. In 1937 Massine persuaded Matisse to design the settings and costumes for *Rouge et Noir*, page 483, a ballet created by Massine with the music of Shostakovich's First Symphony. The ballet was first performed in Monte Carlo in May 1939, and later in Paris and New York with great success, Matisse's abstract designs harmonizing admirably with Massine's "symphonic" choreography.

7 Collectors and Museums in the 1930s

Collecting everywhere during the 1930s was considerably diminished by the world-wide depression and the generally disturbed condition of the European world. Matisse's art however offered complete artistic refuge from the unhappy economic and political realities of the period, and he won a good many new collectors (but few great ones) in Switzerland, Scandinavia, Holland, Britain and the United States. Barnes seems to have stopped collecting Matisses in the early 1930s for a decade or more and in any case apparently never acquired any Matisse easel painting produced between 1923 and 1940.

Etta Cone however continued to buy actively and in 1934 published a magnificent catalog, bibl. 108, of the collection which she and her sister, Dr. Claribel Cone, had assembled in Baltimore. The catalog of the Cone Collection lists thirty-two oils by Matisse, mostly of the 1920s, eighteen drawings in addition to seventy-eight studies for the Mallarmé etchings and eighteen bronzes. Of Matisse's easel paintings completed between 1930 and 1935 Miss Etta bought three of the four most important, the *Girl in a Yellow Dress*, page 455, the big *Magnolia Branch*, page 469, and the *Pink Nude*, page 473.

Many Matisses were added to New York collections but Stephen Clark's group of canvases of the first decade of Nice remained the finest in the world, bibl. 192b, though not so numerous as Barnes' or Etta Cone's. In the mid-1930s a young New York collector, Walter P. Chrysler, Jr., began to add Matisses to his rapidly growing collection of modern painting, bibl. 152a. By 1940 he had acquired ten canvases including two of the most important in America, the full-size study of 1909 for the *Dance*, page 360, and the big *Piano Lesson*, page 175.

In 1931 Miss Lillie Bliss bequeathed her two Matisses, page 423, to the Museum of Modern Art. They were the first canvases to enter the collection of a public museum in New York which thus started to catch up with Chicago's Matisse collection. Thanks to the bequest of Frank Stoop in 1933, the Tate Gallery in London also began to form its Matisse group, Appendix F. In 1937, the year of the Paris World's Fair, Raymond Escholier acquired for his museum the first version of *The Dance*, page 463, the three huge lunettes which had been painted for the Barnes Foundation but rejected because the canvas had been incorrectly measured; and in 1938 the Luxembourg added a third Matisse to the national collections of France, the *Decorative Figure on an Ornamental Background*, page 449, which Henry McBride had so greatly admired when it was shown in New York a decade before, page 203.

Meanwhile in Germany, Hitler, surpassing Stalin's hostility toward modern art, had begun to dispose of Matisse's paintings along with other examples of "*entarteter Kunstbolschewismus.*" Early in 1939 the Essen Museum's *Blue Window*, page 167, was ransomed privately, that is virtually bootlegged, out of the cellar of Goering's *Luftministerium* to the Museum of Modern Art in New York; and that summer a number of other Matisses from German museums, including the *Bathers with a Turtle*, page 357, and the *Flowers and Ceramic Plate*, page 377, were auctioned off by the Nazis at Lucerne. (For some reason the great *Still Life with Geraniums*, page 349, escaped the purge and after a long period

Opposite: THE PLUMED HAT. Nice (1919). Ink, 14⅜ x 18½". New York, Museum of Modern Art

LORETTE IN A WHITE BLOUSE (*Lorette—blouse blanche*). (1916?) Oil, 21 x 18″. New York, Mrs. Sam A. Lewisohn

From 1915 to 1917 Matisse made many paintings of the Italian model Lorette. Some were studies of the figure, in costume or nude; and some were virtually portrait studies of which the *Lorette in a White Blouse* is one of the best. Limiting his colors, Matisse poses the figure easily and simply against the rectangle of the chair back and the green background. He develops an interesting contrast between the two areas of black, passive and simple in the skirt, sinuously active in the curling hair. The restricted color scheme and lack of patterned ornament are characteristic of Matisse's severe and often abstract style of 1916, but the sense of informal actuality anticipates the more realistic, easy and intimate art of the coming years. Lorette appears again in paintings illustrated on pages 403, 410, 412-417.

SHRIMPS (*Les crevettes*). Etretat (1920). Oil, 23¼ x 28¾″. New York, Dr. and Mrs. David M. Levy

During the weeks spent at Etretat in the summers of 1920 and 1921, Matisse painted several still lifes unsurpassed in his work for certain traditional qualities of color and surface. Two of the most beautiful of these are the *Shrimps*, opposite, and the *Still Life with a Lemon*, reproduced in the following color plate.

One must not look in these two canvases for the radical innovations in color and composition which had made Matisse the leader of the *avant-garde* fifteen years before. In the *Shrimps* only the emphatic dark outlines of the forms and the tilting of the table up towards the vertical remain from Matisse's previous style, and these devices had of course been used by van Gogh and Gauguin with greater boldness, by Cézanne with more intuitive conviction. Far more than to them, Matisse looks back to Manet in these still lifes, just as he recalls Manet's brilliant shorthand in his beach-and-seascapes of Etretat, pages 432-3.

In earlier still lifes, the *Pink Onions* of 1906 and the *Blue Window* of 1912 for instance, color plates pages 76 and 167, Matisse had not only composed with colors of high intensity but, in so doing, had deliberately abandoned sensual qualities of surface for a certain ascetic dryness. In the *Shrimps* Matisse recovers an elegance of surface in keeping with the quietly distinguished color.

STILL LIFE WITH A LEMON (*Nature morte au citron*). Etretat (1921?). Oil, 23⅝ x 28¾ ". Greenwich, Connecticut, Mr. and Mrs. Richard Deutsch

Just as Matisse had employed a pale vermilion oval as the center of his *Shrimps* (on the previous page), he uses an even more concentrated yellow oval as a focus for the composition of his *Still Life with a Lemon*. The lemon controls, dominates the welter of sea food on the green island in the foreground.

A lemon also plays an important role in a similar subject, the *Still Life with Lemons Which Correspond in Their Forms to a Drawing of a Black Vase upon the Wall*, page 397, which Matisse painted in 1914 in a style and spirit diametrically opposed to what one finds in this picture of

only five or six years later. Here Matisse's composition is interesting but not austerely diagrammatic as it was in the rather doctrinaire earlier canvas. Even more than in the *Shrimps* he accepts the ordinary facts of vision, and even more boldly challenges Manet's mastery of values and suggested surfaces. The perspective of the table top is more "normal" than that of the *Shrimps*, the forms presented simply and, excepting the glass pitcher, without heavy outlines.

This glass pitcher lives a life apart, isolated from the other objects by a pale enveloping beam of light. As in so many of his still lifes, Matisse seems to establish a relationship among the objects considerably more dramatic than in his compositions of figures. The table becomes a stage; the fish, mussels, lobster, pitcher and lemon, actors. But the drama is visual and pictorial, not psychological.

ODALISQUE WITH A TAMBOURINE (*Odalisque au tambourin*). (1926). Oil, 28 x 21 ". New York, Mr. and Mrs. William S. Paley

During the years 1925-1926 an important change of direction occurred in Matisse's art. The previous turning point had come in 1917 after Matisse began to work in Nice. At that time his painting as a whole grew gradually more "realistic," that is, closer to ordinary traditional vision. Pictures such as the *French Window* of 1919, page 425, and *The Two Rays* of 1920, page 433, however handsome in themselves, might almost have been painted fifty years before. Then, as the early 1920s passed, Matisse's style grew even softer and richer, more atmospheric and at the same time more rococo, pages 437-442.

The vigorous, simplified modeling and rather uncomfortable tensions of the bronze *Seated Nude* of 1925, page 444, mark the first important signs of a new form and spirit. And one of the first paintings to reveal Matisse's new direction is another seated nude, the *Odalisque with a Tambourine* of 1926, a year in which Matisse painted rather little, perhaps because it was a year of change. A comparison with a characteristic picture of similar subject, the *Odalisque with Raised Arms* of 1923, page 440, clarifies Matisse's later reaction. The differences are not yet radical but the greater naturalism of his drawing and modeling in the earlier painting is evident, and so is his more conventional handling of background which in the 1926 *Odalisque* is flattened and arbitrary in perspective, especially at the right. The surface of the canvas is further emphasized by its pigment which is dense, dry and opaque, and quite different from the soft brushing of previous years. More significant still is the color, so tart and intense that only the intransigent green and yellow chair saves the figure from being crushed between clangorous complementaries of scarlet and blue green.

The following year was to bring even more radical investigation of color and composition, pages 447, 449. After a period of relaxation, Matisse, the bold experimenter, had revived.

LADY IN BLUE, early state. (1937, February 26.)

LADY IN BLUE (*Grande robe bleue, fond noir*). Nice, 1937 (April). Oil, 36½ x 29″. Philadelphia, Mr. and Mrs. John Wintersteen

The *Lady in Blue* should perhaps be known by the title it bore when it was first exhibited in Paris: *Grande robe bleue, fond noir.* Painted in the early spring* of 1937, Matisse began, as usual in this period, with a comparatively realistic first state reproduced here, above. Then, passing through much trial and error, particularly in the background, he arrived at this composition which, with its bilateral symmetry and starched, crisp curves, is almost as flat as a playing card and as formal as a 16th-century court portrait. Against a background of scarlet, yellow and black—each at its maximum intensity— Matisse spreads the violet-blue gown, a daring gesture not only because of the problem of making the blue stay in place but because the bright flat colors combine with the subject matter to give an effect verging on prettiness. Yet certain devices such as the exaggeration of the hands, especially the right hand with its extraordinary beads, and the conversion of the white drawings on the wall to yellow and blue save the painting from conventional *chic* without sacrificing the frank gaiety, charm and elegance which are part and parcel of Matisse's art of this period.

*For photographs taken at ten different stages, February 26 to April 6, in the painting of the *Lady in Blue*, see the *Magazine of Art*, July, 1939.

234

PINEAPPLE AND ANEMONES (*Ananas et anémones*). Nice, 1940 (completed February 24). Oil, 29 x 36". New York, Mr. and Mrs. Albert D. Lasker

In the *Pineapple and Anemones* Matisse's style of early 1940 is seen at its most perfect. Matisse presents a still life of reds, whites, yellows and violets against an arabesque of complementary green and magenta-pink, stabilized by the orange quadrangle of the table top. The color, excepting that of the pineapple, is brushed on thinly permitting the white sizing of the canvas to shine through with transparent luminosity. The drawing of the objects and their placing on the canvas seem as casual and easy as the way the paint is applied.

As in many other still lifes Matisse balances two dissimilar objects on the table plane, in this case a vase of flowers and the group around the pineapple. Obviously it is the pineapple which is the pampered darling of the painter's eye, its body resting in a padded basket, its head of leaves circled by a halo formed by the basket's lid. The pineapple is further emphasized by its thick texture of vermilion paint, each lozenge of which is accented by a dab of blue-white pigment, the only departure from the thin glazing of the rest of the canvas.

The subject matter—a vase of anemones and a basket with a pineapple—is identical with that of *The Pink Tablecloth*, page 443, one of the most perfect still lifes of the mid-'20s. In 1925, as *The Pink Tablecloth* suggests, Matisse was painting with greater realism of texture, light and depth than at any time in his mature career. In the later picture here reproduced, the texture of the objects—again excepting the pineapple—is undifferentiated; there is luminosity but almost no sense of directional light; the forms are practically unmodeled, and the background is an abstract plane of color without depth. Yet there is little obvious distortion of form or perspective. The style is almost as simple as that of the *Pink Onions* of 1906, page 76, but not so childlike.

That early still life was so artificially naïve that it seems to have half-embarrassed even Matisse himself; but the *Pineapple and Anemones* is very far from naïve: it is a demonstration of complete synthesis after fifty years of study and ceaseless research in which academic, impressionist, quasi-primitive, arbitrarily abstract, and comparatively realistic styles were all put to the test. In this charming and delicious picture one can feel—in spite of Matisse's probable protest—no sense of struggle but only effortless mastery.

237

THE EGYPTIAN CURTAIN (*Intérieur au rideau égyptien*). Vence, 1948 (early). Oil, 45⅝ x 35″. Washington, Phillips Gallery

At Vence in the winter and spring of 1948 Matisse completed seven large canvases of interiors, the culmination of his easel painting of the 1940s. Not until after the Vence chapel, pages 514-527, was finished did he produce any more oil paintings.

Of the seven *The Egyptian Curtain* is the most original and striking in effect. During 1947 Matisse had studied and restudied the problem of composing an interior with table and window in a series of eight smaller paintings, among them the *Blue Interior with Two Girls*, page 504, and several larger works. *The Egyptian Curtain* is the final statement of his solution and much the most daring.

Instead of following the obvious and comparatively easy formula of leaving his bright window rectangle simply as part of his background wall with the table in front, he has hung a curtain right up against the front plane of the picture and placed the table, spatially, between it and the window. And what a curtain! A barbaric modern Egyptian cotton with the most aggressive and indigestible pattern. And, one might also exclaim, what a window! In all Matisse's score upon score of views through windows the most astonishing is this explosive palm tree with its branches whizzing like rockets from the point where the black window mullions cross.

Matisse sets the bristling palm and the strident curtain side by side in direct competition with each other. Adjoining each, he places the serene dish of pomegranates on its pink table to serve as a kind of referee who tries to keep the hopelessly adjacent contestants apart, at least in depth.

The struggle is further complicated by the fact that the palm tree is not only dynamic but dazzling. The yellow stems, the green and blue-black leaves against white set up a vibration which the curtain can oppose only through the scale of its brutal design. The radiant effect of the tree is enhanced by the black shadow cast by the dish, but the shape and size of this shadow offer support to the curtain. Yet in the end the neutrality of the still life as a third force is preserved by the complete independence of its color scheme—orange, pink and pale blue—which is as isolated from the other two areas as they are from each other.

Clearly Matisse is not concerned here with that armchair serenity which once, long ago, he declared to be his goal. Instead he challenges the sensibility of the beholder by balancing dissonances, tension against tension. Compare the turbulent excitement of *The Egyptian Curtain* with the tranquility of the *Blue Window* of 1912, color plate page 167, or the charming improvisations of the *Open Window*, Collioure, 1905, color plate page 73.

Matisse painted *The Egyptian Curtain* within a year of his eightieth birthday.

of hiding now hangs in the Haus der Kunst in Munich—the Neue Staatsgalerie, for which it had been bought in 1912, having been bombed in 1944.)

8 Paris, 1939; War

When Matisse came up to Paris early in the summer of 1939 he attended the performance of *L'étrange farandole*, the name temporarily given the ballet *Rouge et Noir* for which he had designed the settings. The capital was if anything less disturbed by rumors of war than it had been the summer before. The debates between the *munichois* and *anti-munichois* still raged—but that year there was to be no Munich.

When war actually came early in September, Matisse was far from sharing the general apathy, though as always he was peculiarly indifferent to political events. He had spent most of the summer hard at work in the Hôtel Lutétia, but when France declared war, he left Paris immediately[6] for a few days' stay at a country inn on the road to Chartres. However, toward the end of the month he traveled to Geneva to see the great exhibition of paintings from the Prado Museum and shortly after the middle of October he was back in Nice at the Hôtel Régina in the Cimiez quarter where he had moved in 1938. There he worked steadily for the rest of the year, producing among many other works, the self portraits, page 484, and *La France*, page 485. Doubtless the tricolored costume suggested the title *La France*: the painting itself seems as remote as possible from the military predicament of France in December 1939.

SECTION II THE BARNES MURAL

1 The Barnes Mural: Preliminary Problems

When Matisse traveled back to Merion at the end of 1930 to study the location of the mural which Dr. Barnes wanted him to paint in the central gallery of his museum, he found himself faced with serious technical and esthetic problems. On one side of the room are three great windows about eighteen feet high above which the mural was to be, page 465. This wall above the window cornices is carried up about three feet and is then divided into three lunettes by the pendentives of three minor vaults, one above each window, which penetrate the main barrel vault of the gallery. Through the windows one sees the green of the grass and trees whose foliage almost masks out the sky except during the winter months. On the end walls are hung some of the best pictures in the collection including Cézanne's large *Bathers*, the greatest of his *Card Players*, the Seurat *Poseuses* and several Renoirs. Between the windows themselves are Picasso's *Composition* of 1906, the large painting with the peasant carrying a basket of flowers, and at the left, Matisse's own gigantic *Riffian* of 1913, page 391.

Opposite the window wall at the level of the lunettes is an arcaded balcony or mezzanine from which one can see the murals at eye level. But from the main floor of the gallery one has not only to look up toward the lunettes at an uncomfortable angle but face the considerable glare from the windows themselves. Thus Matisse had to meet the handicap of an awkward perspective and the competition both of nature, seen through the bright windows, and art in the form of some of the greatest masterpieces of the past hundred years of painting.

The studio in Nice which Matisse took early in 1931 to paint the mural for the Barnes Foundation was very large; indeed it is said to have been built originally as a film studio. Yet it was not high enough to hang the great stretch of canvas at the same level it was to take in the Foundation hall. However, seen from the opposite side of the studio, the mural appeared approximately on the level it was to be when viewed from the mezzanine of the museum gallery; and it was primarily at this level that the design was conceived although Matisse made perspective studies of the mural as it was to be seen from the main floor, too. He explained to Dorothy Dudley[7] in 1933:

From the floor of the gallery one will feel it rather than see it, as it gives the sense of sky above the green conveyed by the windows. . . . It is a room for paintings: to treat my decoration like another picture would be out of place. My aim has been to translate paint into architecture, to make of the fresco the equivalent of stone or cement. This, I think, is not often done any more. The mural painter today makes pictures, not murals.

Apropos of this architectural preoccupation Miss Dudley asked Matisse about Puvis de Chavannes,

Opposite: HEAD OF BAUDELAIRE. Etching illustrating *Le tombeau de Charles Baudelaire*, page 136 of *Poésies de Stéphane Mallarmé*, Lausanne, Albert Skira, 1932. Page size 13 x 9¾". New York, Museum of Modern Art, Abby Aldrich Rockefeller Print Room

241

who had been largely responsible for the modern theory and practice of "keeping the wall flat" in mural painting, a departure from the Renaissance-Baroque tradition of breaking the wall surface by means of illusionistic perspective and lighting. Puvis had demonstrated his principles in his flat, pale grey, green and blue murals in the Panthéon. Matisse answered: "The walls of the Panthéon . . . are of stone. Puvis' paintings are too soft in feeling to make the equivalent of that medium. If one had a diamond, say, one would set it in metal, not in rubber. . . ." In other words, Puvis had not gone far enough.

Matisse broke with tradition in still another way. Except in Mexico, modern murals were ordinarily designed in small *maquettes* or models. These small designs were then squared off and enlarged more or less mechanically to the full scale. Matisse went about the Barnes mural in quite a different way, as he explained in some notes prepared for Raymond Escholier:[8]

Perhaps it would be important to make clear that my mural is the result of a physical encounter between the artist and some fifty-two square meters of surface of which the spirit of the artist has had to take possession; it is not the result of the usual modern procedure of projecting or blowing up a composition more or less mechanically on a surface so many times bigger by means of tracings.

A man with his searchlight who follows an airplane in the immensity of the sky does not traverse space in the same way as an aviator. . .

The photograph, page 462, of Matisse at work laying out the design on the full-scale surface explains his statement that his mural was generated by a "*corps à corps de l'artiste et cinquante-deux mètres carrés de surface.*"

He had, of course, as he stated to Margaret Scolari,[1] made numerous studies from the model and taken many notes while watching dancers by way of preparation for the mural. And no doubt he had made composition studies, too; but the final composition itself was first laid out by standing on a bench and drawing the great sweeping lines of the ten-foot-high figures by means of a charcoal point on the tip of a six-foot stick. In the photograph, page 462, taken at the start of the long struggle, one can see that already Matisse has made certain erasures and revisions. But this was only the beginning. The changes went on week after week, month after month. Soon his legs began to tire from incessant

climbing up and down benches and ladders so that he had to hire an assistant to do some of the "leg work" while he directed from below.[2] This help was especially necessary when the time came, after mid-1931,[3] to surround the grey figures with color. The colors were tried out not by painting on the canvas but by cutting out sheets of painted paper which were then fastened to the canvas around the contours of the figures. These too had to be changed again and again as the composition developed.

2 *The Barnes Mural, First Version, 1931-1932*

The subject chosen by Matisse for the Barnes mural was *The Dance*, the same as that which he had used for one of the Shchukin panels in 1909-1910. Not unnaturally, early stages of the first version of the Barnes *Dance*, pages 462, 463 top, show certain close resemblances to the design of the Shchukin *Dance* of twenty years before. In fact the dominant figures in each of the three lunettes are borrowed directly from the three foreground figures of the big Moscow canvas. They are simply moved farther apart and divided by the two pendentives of the vaulting and the two reclining figures beneath the pendentives. To these five figures, all completely visible, are added three others who roughly resemble the two background dancers in the earlier picture, but with one remarkable difference: they have leapt so high that they have more or less passed out of sight.

As the composition of the first version of the mural—now in the Musée de la Ville de Paris—developed, its early dependence on the great Shchukin *Dance*, page 362, gradually diminished. The photographs which Matisse had taken at various stages, page 463, show that the two figures leaping up behind the pendentives disappeared entirely, and as the bands of color are worked in, the recumbent figures gradually arouse themselves until they too are almost on their feet. Meanwhile all six remaining figures have grown in size until the lunettes can no longer contain any of them, a further departure from the Moscow composition in which only a single foot breaks the margin of the canvas. Yet one thing still remains from the Moscow *Dance* and that is the predominant movement of the figures from right to left.

This leftward movement however is counteracted by the wide blue bands which form diagonals leaning toward the right just behind each of the three dominant figures. Apparently Matisse had at first thought of a monochrome background[4] but later he

decided upon three flat colors: black, bright sky blue and rose pink. At first the colors were more fragmented and their diagonal lines were set at 45-degree angles. In the finished composition the color is simplified and organized and the diagonals rise more steeply; wide black bands lean toward the left behind each of the two middle pendentives and separate three areas of pink which themselves are crossed and divided by the three blue bands mentioned above. Thus thrust and counterthrust of flat color bands form a counterpoint to the movement of the figures.

The Shchukin *Dance* had been a circular movement of figures around a knoll or mound of earth. The Barnes *Dance, I*, though there are lateral trends both to left and right, is extraordinary in its sense of movement *upwards*. One can follow the development of this from one stage to another, in the lines of the background, in the figures which rise from the ground, in the dancers which leap above and behind the curves of the arches.

In the Shchukin *Dance* the figures had been bright terra cotta red against strong blue sky and green earth. In the Barnes mural the figures are light stone grey—almost the same grey as the vaulting. Partly because of their neutral flatness they seem to exist on the same two-dimensional plane as the wall itself. At the same time their background is made to seem only a few inches behind them by means of a narrow shadowlike band or contour which surrounds them, a darker blue on the blue background, a darker pink on the pink. This contour band and its effect may be seen in the close-up detail, page 465.

3 The Barnes Mural, Second Version, 1932-1933

As has been recounted, the mistake in measuring the wall in the Foundation was discovered only after the mural was completed. The error consisted in allowing the soffits of the pendentives only about half their actual width so that the width of the whole mural was shortened even though the shape of the lunettes remained unchanged. After over a year's work a lesser, or a less precise, artist might have made a few minor adjustments and passed on to some less tedious undertaking. But Matisse, instead, began all over again, moved in part by Dr. Barnes' apologies and eager exhortations.

By the end of November 1932 the new design, *Dance, II*, was well advanced, page 464, plate A.

Matisse had gone back to his original intention of including eight figures. Two of them he placed on the "ground" at the springing of the now correctly widened pendentives. The other six are divided two by two among the three lunettes. At this stage the two outermost dancers are the only remaining vestiges of the figures used in the first version, but by the end of January 1933 one of these, at the extreme left, had been revised so that he moves inwards not outwards, page 464, plate B. This reversal is significant. In the first version, from its very inception, the general movement of the figures was toward the left but now, in the second version, the action moves from both sides toward the center, and in the middle lunette the figures seem to rotate within a circle. Thus in spite of the violent action of most of the figures the composition as a whole is more static and self-contained, an effect increased of course by the two seated figures out of whose bodies the pendentives seem to grow.

By May, when the second version was finally completed, the background, page 464, plate D, had been brought into harmonious contrast with the figures: in the middle, the lines of the pink and blue area between the blacks are predominantly vertical; at the left and right they tend to lean outwards, counteracting the inward thrust of the figures.

4 The Barnes Mural—Analogies and Reactions

Matisse called these murals *The Dance*, yet the action of the figures is so violent that it calls to mind not an ordinary ballet or popular dance or even the more strenuous *sardane* or *farandole* which were said to have inspired the Shchukin mural, but rather some frenzied, Dionysian game or tumbling act or perhaps a savage pyrrhic dance or gladiatorial miming, since the figures seem paired in single combat. Pollaiuolo's great 15th-century engraving of a melee of naked fighting men comes to mind or, even more, his mural of dancing figures at Arcetri near Florence. Both Matisse and Pollaiuolo had studied Greek vase painting. Specifically, the leaping figure at the extreme left in state XXV of the second version, page 464, plate B, is close to the running athletes or warriors on Attic black-figure ware of the 6th century B. C. In the final stage this dancer is softened and feminized as are all the figures.

More original is the extraordinary mingling of freedom and control exercised by Matisse in modulating through several months of trial and error the lower figure of the pair in the middle lunette. Ma-

tisse's concern for the shapes of voids left by the figures, their triple relationship to each other, to the solid forms of the figures, and to the divisions of the colored background is also well displayed in the gradual transformation of this middle group.

Some have felt that the Barnes murals are rather dry and over-studied, especially by comparison with the simpler and more powerful impact of the earlier Shchukin *Dance*. When Dorothy Dudley suggested that they seemed calculated, Matisse responded quickly: " 'Calculated' is not the right word. For forty years I have worked without interruption; I have made studies and experiments. What I do now issues from the heart. All that I paint is produced that way. I feel it." One is reminded of Matisse's refutation a quarter century earlier of such critics as Denis and Gide who asserted that his art was the product of rational and theoretical procedures. Confronted by one of Matisse's pictures, Denis had to admit that it would have been far more difficult to have composed it by rational calculation than intuitive means.[5] Yet, passing over semantic confusions, there seems to be a real difference in effect between *The Dance* of 1910 and *The Dance* of 1932 or 1933: the earlier picture, though it too was the re-

sult of over a year's recurrent study, gives a sense of dynamic spontaneity; the later compositions, of perfect control and resolution.

The powerful, varied, even paradoxical effect of *The Dance* of 1933 is amusingly though unconsciously demonstrated in the enthusiastic reactions of both Matisse and Barnes just after the mural was installed. When he returned to France after the final trip to Merion, Matisse reported to Dorothy Dudley:[6]

As soon as I saw the decoration in place I felt that it was detached absolutely from myself, and that it took on a meaning quite different from what it had had in my studio, when it was only a painted canvas. There in the Barnes Foundation it became a rigid thing, heavy as stone, and one that seemed to have been spontaneously created at the same time as the building . . .

Barnes said, "One would call the place a cathedral now. Your painting is like the rose window of a cathedral." [Matisse then showed Miss Dudley photographs of the mural in place seen from below, page 465.] *When one looks at it from this angle,* [he remarked,] *one would say, too, it is like a song that mounts to the vaulted roof.*

SECTION III THE MALLARMÉ ETCHINGS, 1931-1932

1 Matisse's First Illustrated Book

In 1930 Albert Skira, an enterprising young publisher of Lausanne, asked Matisse if he would make the illustrations for a new edition of Stéphane Mallarmé's poetry. Picasso had already agreed to illustrate the *Métamorphoses* of Ovid for Skira but subscriptions were slow and the depression following the American crash of November 1929 was beginning to spread and deepen. Nevertheless Matisse, matching Skira's courage with his own, decided to go ahead. In 1918 Matisse had permitted his friend the poet Pierre Reverdy to reproduce some drawings in *Les jockeys camouflés*, pages 155 and 180, but he had never designed illustrations for a book before and thus was well behind his colleagues and rivals, Bonnard, Maillol, Rouault, Derain and Dufy, not to mention Picasso, who already had three or four illustrated volumes to his credit as well as a dozen portrait frontispieces done for various books of poetry. Picasso also had two great books in progress, the Ovid for Skira and Balzac's *Le chef-d'oeuvre inconnu* for Vollard, so that Matisse again found him-

self implicitly in competition with the prodigious Spaniard just as he had in 1919-1920 when he designed *Le chant du rossignol* for Diaghilev. Unlike the artists mentioned above, Matisse never designed a book for Vollard.

2 Technical and Esthetic Problems

Matisse set about his task of illustrating the *Poésies de Stéphane Mallarmé* with more than his usual care and fastidious logic. Years later he described[7] his approach:

As for my first book—the poems of Mallarmé.

Some etchings, done in an even, very thin line,[8] without shading, so that the printed page is almost as white as it was before the etching was printed.

The design fills the page without a margin so that the page stays light, because the design is not, as usual, massed toward the center but spreads out over the whole page.

The right-hand pages carrying the full-page illustrations were placed opposite left-hand pages which carry the text in 20-point Garamond italic. The problem was then to balance the two pages—one white, with the etching, and

one comparatively black, with the printing. [See page 467.]

I obtained my goal by modifying my arabesque in such a way that the attention of the spectator should be interested as much by the white page as by his expectation of reading the text.

I might compare my two pages to two objects chosen by a juggler. His white ball and black ball are like my two pages, the light one and the dark one, so different yet face to face. In spite of the differences between the two objects the art of the juggler makes a harmonious ensemble before the eyes of the spectator.

However, before juggling his pages, Matisse had to invent and develop his designs. He felt genuine sympathy for Mallarmé's verse but he wanted to create an "equivalent" not only to the typography of the page but to its poetry too. "The plastic artist," he wrote, "to make the most of his gifts must be careful not to adhere too closely to the text. On the contrary he must work freely, his own sensibility enriched through contact with the poet he is to illustrate."[1]

3 *The* Mallarmé *in Progress*

Adelyn Breeskin, Director of the Baltimore Museum of Art, in her valuable article *Swans by Matisse*[2] has described in detail how Matisse went about inventing and perfecting the etching illustrations for *Le cygne*. Matisse had rarely been fanciful in his art. Even for his illustrations of Mallarmé's poetry he now turned to nature rather than to his imagination. A snapshot, page 466, shows him sketching a swan on one of the lakes in the Bois de Boulogne. The photographer, Pierre Matisse, recalls that one of the swans resented the artist's attentions, attacked the boat and had to be beaten off with an oar. One of the sketches of a swan swimming is reproduced, but it was the image of the swan moving to the attack with wings outspread that most impressed Matisse. Of this formidable apparition he made several studies the full size of the page, working on the actual printer's proofs of the book.

In a study, page 466, lower left, the wings and body of the swan are decoratively composed and rendered with some detail, even to the modeling of the muscles. A second drawing, traced from the first in reverse—so that the ultimate etching would face in the right direction—reduced the design to line (not illustrated). This served as the basis for the etching itself, a trial proof of which was printed di-

Etching illustrating *L'après-midi d'un faune*, page 85 of *Poésies de Stéphane Mallarmé*, Lausanne, Albert Skira, 1932. Page size 13 x 9¾″. New York, Museum of Modern Art

rectly on a proof of the book's page so that it could be controlled and corrected with the utmost precision, page 466, lower right. This first plate, however, was rejected, and so was the second and a third showing the swan in flight. His fourth design satisfied Matisse and was used as the published illustration, page 467.

The swan etching was printed opposite a blank page but we reproduce, page 467, the illustration for *La chevelure, vol d'une flamme* together with the page of text opposite. This small halftone on glossy paper offers a poor representation of the handsome pages of the original but it does give some idea of the exquisite balance which Matisse achieves between his etchings and the text pages, not, as he explains, simply a visual or formal balance but a far subtler balance involving the literary interest as well as the typographical appearance of the text. The other twenty-seven plates were studied with equal care. The Cone Collection of the Baltimore Museum of Art includes seventy-eight studies and fifty-two etchings, many of them proofs of discarded plates.

4 A New Iconography

Though the etchings for Mallarmé's poems are absolutely consistent in style, they vary in subject matter to the same extent as the poems themselves and therefore mark a considerable expansion of Matisse's previously rather limited iconography. Some of the motifs are drawn from earlier works of Matisse. For *Apparition* Matisse drew a *"fée au chapeau"* very close to the *Antoinette*, one of the studies of the girl in a plumed hat of 1919, page 427. For *Les fenêtres* he adapted the drawing of the schooner *Papeete* he had made from his window in Tahiti and was to use again for the cartoon of the tapestry, page 475. Other and more surprising motifs are the bow of the ship with a lookout used for *Brise marine*, page 467, the fist closed over a shaft for *Le guignon*, the Ionic capital amid foliage for the sonnet cycle *Hommage*, and the marvelous arabesque of hair tumbling down from an inverted face to illustrate *La chevelure, vol d'une flamme*, page 467. The etchings for *L'après-midi d'un faune* recall in subject the nymphs of the *Joy of Life*, page 320, but they are freshly conceived, as are the figure designs for the *Hérodiade*.

For *Le tombeau d'Edgar Poe* and *Le tombeau de Charles Baudelaire* Matisse drew the faces of the two poets. Working of course from a composite memory image of daguerreotypes and other portraits, he designed linear masks of extraordinary distinction. The Baudelaire etching, an image of almost hypnotic fascination, is surely one of Matisse's few works in which his latent powers of character analysis and synthesis are fully expressed. It is reproduced here, as in the original, on a left-hand page (page 240).

5 *The* Mallarmé *Published, 1932*

In October 1932, one hundred forty-five copies of the Mallarmé were published in three editions: thirty copies on *japon impérial* paper, enriched with extra sets of the etchings with *remarques*, ninety-five copies on d'Arches vellum paper and twenty copies *hors commerce*. Throughout the long, slow, meticulous work of production Lacourière, the great printer of etchings, and Skira himself had worked closely with Matisse. Marie Harriman of New York helped finance the heavy costs by taking the American allotment; but, published at the depth of the depression, the book sold very slowly.

Matisse had reason to be proud of his part in the *Poésies de Stéphane Mallarmé*, one of his happiest works in any medium and one of the most beautiful illustrated books ever printed; but, with his habit of modest, matter-of-fact understatement, he remarked: "After concluding these illustrations for the poems of Mallarmé I would like simply to state: This is the work I have done after having read Mallarmé with pleasure."[3]

SECTION IV PAINTINGS AND DRAWINGS, 1931-1935

1 *Paintings, 1931-1933*

Voyages in 1930, the twice-painted Barnes mural of 1931-1933 and the exacting work on the Mallarmé illustrations, 1931-1932, seem to have kept Matisse almost entirely from his easel during these years. He did date the *Girl in a Yellow Dress*, page 455, 1929-1931 but to judge from several drawings and etchings of 1929, this important canvas was largely painted in the earlier year. There are in addition a very few small canvases of 1931 and 1932.[4]

Beginning in 1929, Matisse had made drawings and prints of the model in a long Persian coat with pantaloons held in at the waist by a wide sash. This costume appears oftener than any other motif in his graphic art of 1930 and 1931. And in the latter year he painted the small canvas reproduced here as *The Persian Robe*, page 468. In its style and richness of surface and detail it might easily have been done in late 1928; indeed, it may have been Matisse's first canvas undertaken since 1929.

The *Girl in a Persian Costume* of the following year 1932, page 468, is very different in character from its predecessor. Possibly the elimination of detail in both the Mallarmé illustrations and the Barnes murals affected Matisse's style when he turned for this parenthetical respite to easel painting. In any case the complete absence of modeling, the extreme simplicity of detail, the broad, easy-flowing line carry one back twenty years to the Moroccan figures of 1911-1912, pages 378, 379, and, earlier still, to *The Young Sailor, II*, of 1906, page 335. Yet actually the picture of 1932 looks forward, not back. Its two-dimensional simplicity, its obvious charm, even a certain *chic* which Matisse had not cared to approach before, anticipate many of the most characteristic paintings of the next fifteen years.

The few figure paintings of 1933 and 1934 are less pure in style. The *Nude in a White Robe*, page 468, calls to mind the subject matter and quiet elegance of the *Meditation* of 1920, but the handling of light and modeling is less specific, the detail broader, the drawing freer and less absorbed by the painting, the artist's attitude toward nature generally less humble.

2 *Portrait Drawings*

During the '30s Matisse made a number of portrait drawings which by their vigorous characterizations and formal strength recall such earlier works as the *Shchukin* of 1912, page 24. Among them are the *Etta Cone*[5] and *Claribel Cone* of 1933-1934, the *Henry de Montherlant*[6] and *Thomas Whittemore*,[6] both of 1937, and his own series of self portraits of the same year.

Matisse had agreed to do the posthumous drawing of Dr. Claribel Cone in Baltimore when he visited Etta Cone there in the fall of 1930, but he did not complete it until 1934, working from memory and photographs. The preliminary studies are half-lengths,[7] quite as stylized in drawing as an archaic Greek head. These he abandons in the final drawing for an impressive double life-size, full-face portrait of the head alone. The physiognomy is idealized, or at least generalized, and doubtless recalls the youthful appearance of the redoubtable intellectual and collector when Matisse first came to know her through Sarah Stein almost thirty years before. The warmth and affection of this characterization are far removed from Picasso's monumental and more realistic outline drawing of Dr. Claribel done in 1922.[8]

3 The Magnolia Branch, *1934*

In the same year he finished the Cone portrait drawings, Matisse painted *The Magnolia Branch*, page 469, now the largest of his paintings in the Cone Collection and the first of several big decorative canvases done during the 1930s. The general effect of rather softened contrapuntal patterns recalls the 1920s, but the scale of the painting, about five feet square, and the elimination of directional light and all modeling (except in the dog) recall the large decorations of a quarter century earlier, pages 372, 374.

The pigment of *The Magnolia Branch* is matt, the color restrained except for the single sharp accent provided by the scarlet book. The still life with its blue vase and dark green leaves rises against a background of lavender wallpaper and a blue-bordered hanging. On the lowest stratum, the grey dog on his white, green and blue-checkered bed interrupts the coral-pink tiles which Matisse painted so often in this decade.

4 *Nudes, 1933-1935*

Drawings and paintings of the nude predominate in Matisse's art from 1933 to 1936. One of his most beautiful figure motifs appears in the large drawing *Seated Nude, Head on Arms*, usually dated 1933, but more probably of 1935.[1] Photographs exist of the five preliminary but quite complete studies for this drawing in which Matisse reworked the figure, the rhythm of its volumes and the rapport of its contours. Some of these "states" are revised on the same sheet, others are begun anew, and any one of them might seem a beautiful and successful achievement to a less self-critical master. We reproduce the fifth and most abstract study, page 470. The final state, like the earlier ones, is more realistic in style; it is beautifully summarized in an etching, presumably of the same year, page 470.

Blue Eyes, page 471, a painting of the model's head and arms, is closely related in pose to the drawing of the *Seated Nude*. It is remarkable for its compact composition and intimate, pensive mood.

Of the nudes of 1935 two are among the most memorable in Matisse's later painting. *The Dream*, page 471, like *Blue Eyes*, is a head-and-arms composition but much more impersonal and abstract. The rounded chalky pink of the figure forms a triangle against the bright blue plaid; the yellow hair and black corner wedges of background serve as minor color accents.

5 *The* Pink Nude, *1935: Trial and Error*

The *Pink Nude* of 1935 is interesting not only for its size and exceptional degree of abstraction but also because Matisse documented it with no less than twenty-one photographs of the work in progress.[2] Six stages are reproduced here, page 472, together with the completed picture, page 473, and two of many studies in charcoal made directly from the model before or during the time the canvas was painted.

Matisse began to work on the canvas of the *Pink Nude* perhaps around the first of May. Photograph I, of May 3, shows the figure lying on a monochrome couch with the raised elbow framed by a

large pillow. Behind her a wall at the right recedes to form a corner with the back wall which is parallel to the picture plane. Otherwise, all the straight lines in the composition are more or less on the diagonal. Back of the couch stands a baroque chair with a vase of flowers. The figure, posed with a slight torsion, is based on drawings similar to the charcoal study reproduced, page 473.

Photograph VI, May 23: during the ensuing fortnight Matisse, little by little, simplifies the contours of the figure, so that irregular organic lines tend to become straight, or simple geometrical curves. He begins to exaggerate the size of the limbs and eliminates the foreshortening of the legs and right arm so that the figure seems flatter. Depth is further suppressed by eliminating the receding background wall at the right and by raising the far edge of the couch thereby further enclosing the figure within a frame. Certain details are untouched, notably the head and the chair with its flowers. As photograph VI shows, Matisse has adopted the pinned paper technique of making revisions which he had used so extensively while composing the Barnes murals. On the same day, May 23, he made a charcoal study of the model in the same pose but from the other side. The couch on which she lies is patterned by a square plaid not yet represented in the painting.

Photograph IX, May 29: within the next five days Matisse further simplified the limbs—note the lines of the thighs for instance—and enlarged them so that by now both feet and one elbow have been pushed beyond the edge of the canvas. Space is further flattened by suppressing the receding diagonal of the foot of the couch. The silhouette of the figure and the composition as a whole have been enlivened by pinning almost vertical stripes of paper over the couch. These virtually cancel out the foreground diagonal of the near side of the couch.

Photograph XI, June 20: the centrifugal growth of the figure has now reached its limits. Excepting the right arm, the limbs are now immensely long and heavy, the belly attenuated as if it might shortly be stretched beyond the breaking point. There is now a strong, vertical movement in the limbs; the parallel already established between left upper arm and the right calf is maintained, but both are swung to a near-vertical paralleling the stripes of the couch cover. To counter this strong movement, the slightly tilted vertical stripes have been neutralized by corresponding horizontals making a simple plaid.

For the first time the chair and flowers have been touched: they have been moved a little to the right to make room for the raised knees.

Photograph XIII, September 4: apparently Matisse turned the canvas to the wall during much of the mid-summer, but photograph XII of August 20 (not reproduced) shows that a strong reaction had begun. By September 4, photograph XIII, the figure has pulled itself together. The three huge limbs have shrunk to almost normal size and the torso has thickened. The right arm however has grown to a towering vertical which is reinforced by the head now altered for the first time since the picture was begun, and raised to an upright position. The slightly slanting plaid pattern of the couch cover has also been rectified so that it parallels the margins of the canvas and the tile pattern of the background wall. The only strong diagonals left are now the shifted but still parallel left upper arm and right lower leg. In other words, the whole composition has been stabilized and the proportions of the figure generally brought back toward normal. Matisse must have felt fairly well advanced since he has torn off the papers and committed himself in paint to all these recent changes. Only the dark chair back is still in paper. But he was far from finished.

Photograph XVIII, September 15: by September 6th, photograph XIV (not reproduced), a counter-reaction had begun, perhaps because the picture now seemed too tame and conventional. Anyway, Matisse began first to thin the torso. The next day, photograph XV (not reproduced) he moved the head back to a slanting position. By September 11th, the legs and left arm were growing again. For a brief moment the twisted counterpoise of photograph I was resumed and exaggerated, then partially suppressed. Photograph XVIII of September 15th shows the figure "at its greatest geographical extent." Elbows, hands, knees and feet break all four borders of the canvas at no less than six places. So long are the limbs and so angularized and active their arrangement that the figure has taken on the aspect of a swastika which has been split in two and then connected by a torso. Two days later the angles of knees and elbows are even more pointed and once more the twisting of the torso is increased. Four weeks pass before photograph XX (not reproduced) in which the pose is virtually the same but the knees and elbows are rounded, the tension of the trunk modified. By October 16th, the limbs have retracted and the whole figure has relaxed: and by

the end of the month the *Pink Nude* or the *Grand nu allongé (fond carré)* was finished, page 473.

6 A Complex of Balances

The completed picture, the *état définitif* as Matisse wrote on photograph XXII, represents the final resolution or, better, balancing of a number of tensions and conflicts: between organic and geometrical shapes, between curved lines and straight, between plain surfaces and patterned surfaces, be-

tween the acknowledged flatness of the canvas and depth suggested by the background and the foreshortening of the figure, between repose and activity in the position of the figure, between the warm tones of the flesh and cold blue of the couch cover, and finally, between two kinds of reality, the complex, three-dimensional reality of the woman lying on a couch in a room and the two-dimensional reality of the flat rectangular cloth covered—after so long a struggle—with paint.

SECTION V COMMISSIONS, 1935-37: ILLUSTRATIONS, TAPESTRY, GLASS

1 The Ulysses Etchings, 1935

After his great achievement of the Mallarmé etchings Matisse seems to have produced very few prints during the 1930s. There are a few single etchings such as the *Seated Nude, Head on Arms*, page 470, and a couple of linoleum engravings of about 1937, but apparently no lithographs at all.

In 1935 or just before, George Macy, the New York publisher, decided to ask Matisse if he would illustrate a new edition of James Joyce's *Ulysses* for the Limited Editions Club of New York. Macy had already published for the Club, Aristophanes' *Lysistrata* with Picasso's etchings and O. Henry's *The Voice of the City* illustrated by George Grosz.

Macy, in Paris, through an intermediary, phoned Matisse in Nice, made his proposal and asked him how many etchings he could provide for $5,000.[3] Matisse replied that he was interested but wanted to think it over and would call him back the following morning. Matisse had not previously read Joyce's huge novel and had only the slightest knowledge of its Dublin background. Nevertheless the next morning, Macy relates, Matisse phoned to say that he had got hold of a copy of Stuart Gilbert's translation of *Ulysses* and had paged through it the night before. Macy recalls that, to his astonishment, Matisse remarked that he had observed how Joyce's *Ulysses* was divided into episodes corresponding to Homer's *Odyssey* and would Macy agree therefore to his making six etchings based on Homer's *Odyssey* which could then be published in the Joyce volume.[4] Macy accepted the suggestion and Matisse went to work.

The six subjects which Matisse chose to illustrate were a landscape of Ithaca and five episodes—Calypso, Aeolus, the Cyclops, Nausicaä and Circe. And for his medium he chose soft-ground etching,

which permitted him to combine line with tone.

Perhaps the most original and convincing of Matisse's six plates is the *Blinding of Polyphemus*, the climax of the Cyclops episode. Matisse had twice done extended research in violent movement, for the *Dance* of 1910 and the Barnes murals of 1931-1933, but he had apparently never studied the phenomenon of physical agony. With his very considerable knowledge of the past it is not unnatural that he should have turned to a pioneer expert in the rendering of pain and violence, Antonio Pollaiuolo. During the years around 1460 the Florentine master had both painted and sculptured a subject close to his heart, Hercules crushing the life out of Antaeus. The bronze group of *Hercules and Antaeus* in the Bargello is perhaps better known than the little panel in the Uffizi, but it was the latter which Matisse studied in his drawing of 1935, page 474, plate A. He then rescued the gasping Antaeus from the grip of Hercules and laid him on his back to serve as Polyphemus, plate B—the half-erased face and the arms are quite close to Pollaiuolo, but the relaxed back is not, that is, not yet. "There he lay," Homer tells us, "with his great neck twisted to one side, conquered, as all men are, by sleep."

Then Matisse ingeniously adapted the prone figure to the vertical format of the book page by raising the legs to a vertical and arching the back (as Pollaiuolo had done), both of which intensify the effect of spasmodic shock and agony as Ulysses drives home his fiery stake, plate C. The etching, plate D, was based upon this third drawing but, though the print covers the page handsomely, it becomes a mere diagram of violence by comparison with the convincing *furia* of the final study.

Fortunately George Macy reproduced in facsimile from two to five of the pencil studies for each of

NUDE IN THE STUDIO (*Nu*). 1935. Pen and ink, 17¾ x 22⅜". New York, Nelson A. Rockefeller

the six illustrations and bound them in with their respective etchings, an interesting break with the conventions of the orthodox illustrated book, and a valuable augmentation, in this case, since the studies are often superior to the finished etchings which generally seem rather dry.

2 *The Tapestry for Mme Cuttoli, 1935*

It was also in 1935 that Matisse accepted Mme Paul Cuttoli's commission to design a cartoon for a tapestry, page 475, to be woven by the famous artisans of Beauvais or Aubusson. These historic tapestry factories had been nationalized in the 19th century but had long suffered from the routine mediocrity of the cartoons. In 1930 Marie Cuttoli, a woman of taste,

energy and influence, invited a number of the best artists in France to help her restore the artistic quality and prestige of the industry. The artists responded wholeheartedly but their approach varied as did their understanding of the techniques and esthetics of tapestry weaving. Rouault for instance produced a magnificent composition of flowers in his usual highly complex technique of oil and pastel. The Aubusson weavers accepted it as a challenge and with astonishing virtuosity and many months' labor executed a facsimile of a Rouault painting so perfect that it fooled the eye. Braque's cartoon was also simply one of his handsome big still lifes which, however, because of its flat composition and comparative simplicity of surface, could be reproduced

by the Beauvais weavers with happier consequences.

Matisse on his part studied the problem carefully and submitted a large canvas entirely different from any of his paintings. The design, based on a drawing he had made in Tahiti—and used once before for one of the Mallarmé etchings—was a frankly decorative composition, rather simply painted and admirably studied to serve as a tapestry cartoon.[5] It was executed in a low warp weave by the Beauvais craftsmen and exhibited in France and America along with tapestries by Braque, Dufy, Léger, Lurçat, Picasso and Rouault.

3 The Design for Steuben Glass

A year or so later, in 1937, John M. Gates, Director of Steuben Glass, Inc. of New York, showed Matisse some of his company's engraved crystal. Matisse grew interested and suggested that he himself would like to try his hand at a design.[6] Consequently, with Matisse's initiative and Gates' enthusiastic response, Steuben commissioned not only Matisse but twenty-six other artists, European and American, to design motifs for a series of bowls and vases which was completed by 1940.

For the motif of his design Matisse chose the youth blowing the pastoral double pipes who had appeared in his work as early as the *Joy of Life* of 1907 and during the 1930s and '40s was ordinarily occupied in playing to a sleeping nymph. Matisse's rather freely drawn design was carefully engraved in glass by the Steuben craftsmen; the vase, in an edition of six priced at $1,000 each, is, like most of those designed by the other artists, characterized by neo-classic neatness of execution, page 482.

SECTION VI PAINTINGS AND DRAWINGS, 1935-1939; *ROUGE ET NOIR*

1 Drawings, 1935-1936

In 1935 Matisse began the long series of large pen drawings, the bulk of which were done in 1936 and constitute perhaps his most distinguished work of that year. The *Nude in the Studio*, reproduced here, is characteristic. Rarely if ever before had Matisse drawn, and composed as he drew, with such elaborate virtuosity. The foreshortened figure, the main motif of the drawing, flows in a diagonal curve down across the paper between a variety of deftly abbreviated patterns. At the upper left her image is reflected in a mirror and in the lower right it appears a third time on the artist's sketch board. The artist himself is here represented only by his thumb and finger holding the pen; in other drawings he appears in the mirror, a conceit which Matisse varies in a dozen amusing ways—devices which are at the same time serious demonstrations of the artist's attempt to involve himself within the very space he renders as a draftsman. Many similar drawings were reproduced in 1936 in a special number of *Cahiers d'Art*[7] along with an essay by Christian Zervos and a poem to Matisse by the broad-minded surrealist, Tristan Tzara.

2 Paintings, 1936-1938

Matisse also made many portrait paintings and studies of his Russian model Lydia Delectorskaya during these years. It is she who appears in the painting *Blue Eyes* of 1935 and the *Lydia*[8] of 1936, for which there is a beautiful ink study in the Cone Collection of the head rising above a cascading jabot, p. 253. Of several small paintings of a model the *Girl in Red Chair*, page 476, is remarkable for its brilliant concentrated color and the drawing of the hands.

The year 1937 brought a profusion of decorative paintings of models in various elaborate costumes —*robes de style*, long Persian coats, or Rumanian blouses—seated beside bouquets of flowers or against the many-fingered leaves of philodendrons.[1] Princess Elena Galitzin, a dark-haired beauty, sat for many of these "costume pieces" such as the elegant small canvas reproduced on page 476; the blonde Lydia appears in many others including the handsome *Lady in Blue*, color plate page 235.

The *Ochre Head* is exceptional in 1937 for its composition, for although it is as flat in modeling and lighting as the others, the diagonal opposition between the head in the foreground and the dark pitcher of flowers on the mantelpiece gives a sense of spatial depth, while a certain psychological depth is suggested by the relation between the all-over ochre-colored face in the foreground and its analogue in the portrait drawing framed on the wall, a drawing, incidentally, of which several variants exist on paper. The *Ochre Head* is reproduced on page 477.

3 The Conservatory, 1938

Matisse continued to use the flat, decorative, rather abstract style of the *Lady in Blue* in many of the figure paintings of the succeeding three years. Early in March 1938 he finished a canvas called *The Conservatory*[2] or, simply, *Composition*, page 478. Though modest in size this painting is important for it initiates a series of compositions which pose the problem of contrasting, balancing and harmonizing the figures of two seated models.

The theme of course was not new in Matisse's work: two girls appear in many pictures of the early Nice period, notably in *The Moorish Screen* of 1921. But in those canvases the figures are esthetically passive, static and casually naturalistic as in most impressionist interiors. The paired odalisques of 1928 are used more positively, but in none of the two-figure compositions of the 1920s does Matisse employ the figures in the same active yet calculated relationship as in the Pulitzer *Conservatory* or its large sequels, the Nelson Rockefeller decoration and the Buffalo Gallery's *Music*.

The Conservatory is in fact the result of a long-drawn-out struggle which began in November 1937 and was not finally resolved until early March 1938. The rapport between the figures and the balance between figures and background were revised again and again.[3] Because the colors are quite even in value, the painting seems rather grey in a halftone reproduction. Actually it is subtle in color by comparison with the very bright paintings of late 1937. The figure at the left is blue, the other yellow; the floor is orange; the wall, behind the big green leaves, pale mauve.

4 The Overmantel for Nelson Rockefeller, 1939

In the fall of 1938 Matisse was commissioned to paint a composition for the overmantel of Nelson A. Rockefeller's apartment in New York. For his principal theme he used the motif of the two seated girls he had already studied so precisely in the Pulitzer *Conservatory*. For the Rockefeller panel, page 479, he now arranged the figures in graceful opposing curves in the upper part of the tall panel which he had divided into halves of contrasting color. Below them appears another pair on either side of the fireplace itself. One of these is singing, resting her music on the "real" mantelpiece which also supports the arms and head of the other girl who has closed her eyes. A study for the lower pair is reproduced on page 478.

The finished painting maintains an appropriate balance between informality and elegance and the color is gay, though Matisse may not have calculated the effect of the surrounding dark ochre-brown paneling upon the complementary violet of the gown at the right which tends to come forward off the wall. The Rockefeller decoration was begun in mid-November[4] and finished less than three weeks later in early December.

5 The Buffalo Music, 1939

A few months afterwards, in March 1939, Matisse began the large square canvas called *Music*, pages 480-481, in which two figures of girls appear again. The photographs of the work in progress reveal Matisse's struggle with the composition. One of the many concurrent problems was to harmonize the relationship between the figures. By the 17th of March, plate A, Matisse felt far enough along with the drawing to fill in the main areas with color. The girl with the guitar forms a sweeping continuous curve in contrast with the somewhat cramped and angular counterpoise of the left-hand figure.

During the following few days the left-hand figure asserts herself, shifts her position to form a second big semicircle in direct opposition to the curve of the other figure, plate B. These almost tangential curves are obviously awkward. At least Matisse seems to have thought so, for by April 4th he straightens the left-hand figure to a rather stiff vertical position, plate C.

Four days later, in the finished picture, the figure at the left has relaxed. Both figures are now rather frontal and quite similar in pose so that instead of forming a contrast they repeat each other harmoniously though still differentiated in color and costume. The painting in the left background which had tended to overemphasize the vertical dividing line between the figures is suppressed and the philodendron leaves are now carried all the way across in an unbroken frieze. *Music*, probably Matisse's most important painting of 1939, was bought the following year for the Albright Art Gallery, Buffalo, by its director, Gordon Washburn.

6 A Prophetic Scissors-and-Paste Composition, 1938

A good deal of Matisse's time during 1938 was taken up with his designs for the ballet *Rouge et Noir* which the Monte Carlo company had commissioned on the initiative of Leonide Massine. An account of the

successful outcome of this enterprise is given a few pages further on but we reproduce on page 482 a memento of the undertaking, a composition of a dancer dedicated to Massine by Matisse. The work itself is minor but its scissors-and-paste technique and abstract style are of great significance, for Matisse here anticipates some of his most characteristic achievements of the 1940s: the *Jazz* portfolio, pages 500-501, the designs for the windows of the Vence chapel, page 514, and the numerous *papier découpé*[5] compositions of 1949-1950. It was also, of course, more immediately related to the costume designs for the *Rouge et Noir* and, at the same time, looks back past the cover design for the first issue of *Verve* in 1937 to the cut paper cartoons for the background of the Barnes mural, page 463.

7 Interiors with a Black Background, Four Self Portrait Drawings, Late 1939

Later in 1939 Matisse painted a number of striking pictures of a much simpler and more severe character—an effect accentuated by the use of large areas of black. The best known of these is the handsome *Reading Girl against a Black Background* now in the Paris Musée National d'Art Moderne.[6] In it and in the hitherto unpublished *Daisies*, page 485, Matisse turns once again to the balancing of figure against vase of flowers, a problem which had often challenged him before. The *Daisies* is not so comfortable in composition as the more conventional *Girl Reading*, but its tensions are livelier, its color bolder and more abstract. The blue and white daisies are placed beside a pale green vase and yellow lemons on a white table. At the right is the edge of a bright blue curtain. In the halftone reproduction, the radiant flowers dominate the composition, but in the original the seated figure, painted in a strong red monochrome, holds its own. All these sharply clean-cut shapes and positive colors shine out against a solid black background.[7]

Of the many smaller pictures of this period one of the most striking both in title and composition is *La France*, page 485, painted toward the end of the year 1939, three months after France had declared war. The tendency toward bilateral symmetry already seen in the *Lady in Blue* of two years before, page 235, is here carried to an extreme. Only the green feathers of the headdress disturb the hieratic pose of the picturesque red-white-and-blue figure against a bright yellow background.

In October 1939 Matisse drew a series of self

THE WHITE JABOT (*Le jabot blanc*). 1936. Pen and ink. Baltimore Museum of Art, Cone Collection

portraits four of which are reproduced on page 484. The striking differences between these four images raise fundamental questions about Matisse both as a draftsman and a portraitist. Eight years later, in a statement written for the catalog of his exhibition at the Philadelphia Museum of Art, Matisse answers these questions and goes on to make some penetrating observations about draftsmanship and portraiture in general. He called his statement *Exactitude is not Truth*. It is reprinted in Appendix H and is worth careful reading.

8 Rouge et Noir; Massine's Symphonic Ballets, 1933-1939

The book and choreography which Massine devised for the ballet *Rouge et Noir* is highly abstract as befits dancing to symphonic music. *Rouge et Noir* was not the first of its kind, for in 1933 Massine had created *Les présages* with Tchaikowsky's Fifth Symphony and *Choreartium* based on Brahms' Fourth, and in 1938 a ballet inspired by, and danced to, Beetho-

ven's Seventh. All these ballets are ambitiously, sometimes pretentiously, grandiose and philosophical in concept, but two of them, *Les présages* with André Masson's setting and *Rouge et Noir* for which Matisse was now to do the designs, provided opportunities for collaboration between a great choreographer and two of the best living French painters. They made visual the rhythm and forms of symphonic music, music conceived without theatrical or narrative or picturesque intention (contrary to Berlioz' Symphonie Fantastique which Massine had also choreographed).

The outline of the book which Massine invented for *Rouge et Noir* was given in the New York program, April 1940, as follows:

1ST MOVEMENT (*Aggression*): *Man, symbolizing the poetic spirit, is pursued and overtaken by brutal forces.*

2ND MOVEMENT (*Field and City*): *The men of the city encounter the men of the field and bear them off.*

3RD MOVEMENT: *Woman parted from Man is tormented in her solitude by an evil spirit.*

4TH MOVEMENT: *Man eludes the brutal forces and finds Woman again. But joy is short-lived, for in freeing himself from his worldly enemies he is conquered by destiny.*

This "eternal struggle between the spiritual and material forces in Man" was to be danced by groups in different colors: two figures in white are the poetic hero and heroine; the Black leader and his followers represent evil destiny; the Red dancers, allied with the Black, are also malevolent; Yellow represents material activities; Blue, spiritual.

9 *Matisse's Designs for* Rouge et Noir, *1938*

When Matisse started to compose the Barnes mural, *The Dance*, pages 462-465, he took as his point of departure the *Dance*, page 362, painted for Shchukin twenty years earlier. Now, confronted by the problem of designing the setting for *Rouge et Noir*, he turned back to the Barnes *Dance* of some seven years before, even employing the same *papier découpé* technique he had used in studying the mural composition. In the Barnes Foundation gallery, page 465, where *The Dance* was installed, the intersection of the small transverse vaults over the windows with the main vault of the ceiling had created an effect of pointed arches when seen in flat projection. For the backdrop of *Rouge et Noir*, page 483, Matisse now adapted not only a free version of these

three pointed arches, but also the broad flat planes of pure color between the arches which he had used as backgrounds for the dancing figures in the mural. The effect resembles a great white Gothic arcade with yellow-soffited arches. Under the central arch is a blue triangle; to the left of it running "behind" the column, the background is red, to the right it is black.

The costumes are even more abstractly conceived than the setting. All the dancers wear fleshings or tights in the colors of their respective "parties," enlivened by short flame-like strips which wind and flicker around the figures, page 483. In this way the forms of the dancers—to the satisfaction of balletomanes—are completely revealed by the tights; at the same time they are "abstracted" from reality by the flamboyant tongues which have neither organic relation to the human figure nor any resemblance to traditional costume—though they do serve somewhat to relate the figures to the quasi-gothic backdrop.

10 Rouge et Noir *performed, 1939*

Matisse began work on his designs at Nice early in the winter of 1937-1938. The first performance of *Rouge et Noir* took place in Monte Carlo in May 1939 with Alicia Markova as the Woman (one of her greatest roles); Youskevich as the Man; Marc Platov as Destiny, leader of the Blacks; Frederic Franklin, leader of the Red or Town group; Krassovska, leader of the Yellow or Country group; and Panayev as chief of the Blue faction. Early in the summer, Paris saw the ballet under a new name *L'étrange farandole* but in New York, the following season, the original title was resumed.

Rouge et Noir had a considerable success. Shostakovich's romantic and rhythmically vigorous music admirably supported Massine's choreography with its restless, rushing movement alternating with almost static groupings. Lovers of the traditional, romantic or classic ballet found Matisse's costumes somewhat uniform, cold and impersonal, but they were wonderfully designed for dancing and well suited to the spirit of Massine's choreography. Their bright strong colors moving rhythmically against the noble arches of the background created an effect of great abstract beauty and unsurpassed brilliance.[8] *Rouge et Noir* was a triumph for Matisse.

PART IX: 1939-1951

SECOND WORLD WAR; BOOKS; THE CHAPEL AT VENCE

SECTION I BIOGRAPHY, 1939-1951

1 War—Cold and Hot, 1939-1940

In the fall of 1939, after the outbreak of World War II, Matisse went south to Nice as was his custom. Before the end of October[1] he was once more established in his apartment at the Régina, formerly a huge Victorian hotel in Cimiez, to which he had moved in 1938. During the ensuing winter of the "cold war" he painted with his usual energy producing canvases of great gaiety and charm such as the *Pineapple and Anemones*, color plate page 236, and the *Woman in a Yellow Armchair*, page 486. Although he was deeply disturbed by the war there is no apparent evidence of anxiety in his work nor was there to be later when affairs grew much worse. However he had taken certain precautions such as storing a number of his paintings in the vaults of the Banque de France in Paris.[2]

In March, 1940, he wrote Paul Rosenberg that he expected to come up to Paris about the end of April. Shortly before that Rosenberg visited him in Nice to select his share of the paintings Matisse had completed in the previous months.[3] By May 5th[4] Matisse was in Paris at his apartment, 132 Boulevard Montparnasse.

On May 17th the Germans struck. The withdrawal from Dunkirk was under way by May 26th.

Matisse had remained in Paris until May 19th and had secured a Brazilian visa and a steamer passage for Rio de Janeiro, sailing from Genoa June 8th. In Paris just as he was leaving the travel agency a curious incident occurred: he ran into Picasso on the street. The two painters greeted each other as old friends and chatted for a few moments about the threatening French débacle. Picasso placed the blame with cryptic accuracy, *"C'est*

l'Ecole des Beaux-Arts!"—a remark which deeply impressed Matisse.[5] With an artist's metaphor Picasso had well summed up the conservative, inflexible, unimaginative grand strategy of the Maginot line on which France was now foundering. Later in the war Matisse was himself to castigate the Beaux-Arts spirit in a radio broadcast right under the nose of Pétain.

About May 20th Matisse left Paris for Bordeaux where he spent a few anxious days with Paul Rosenberg. By May 25th[6] he had gone farther south and had taken rooms overlooking the harbor of Ciboure across the Nivelle delta from St. Jean de Luz. It was at this moment that he decided not to leave France. The mad scramble of refugees he had seen in Bordeaux and was now witnessing near the Spanish border moved him to change his mind.

By June 14th Paris had fallen but the Germans did not occupy the South. Matisse made his way from Ciboure slowly east across France along the Pyrenees. Early in July[7] he was in St. Gaudens. By August 2nd, by way of Carcassonne he had reached Marseilles. There, by coincidence he met his daughter, Marguerite Duthuit, who was arranging with Mme Eugene Jolas to take her child to her husband Georges Duthuit, lecturing in the United States.

2 Nice during the War, 1940-1942

Finally on August 27, 1940, Matisse was back in Nice in his rooms in the Hôtel Régina. He had not felt well during the previous months and to his anxiety over the war were added distress and worry over his formal separation from Mme Matisse. He was however well looked after by Lydia Delectorskaya who had been his model since the early 1930s

and now served him as secretary and housekeeper. And he continued to paint.

A week or less after his return to Nice he wrote Pierre Matisse in New York:

Nice, September 1, 1940
I am trying hard to settle down to my work. Before arriving here I had intended to paint flowers and fruits—I have set up several arrangements in my studio—but this kind of uncertainty in which we are living here makes it impossible; consequently I am afraid to start working face-to-face with objects which I have to animate myself with my own feelings—Therefore I have arranged with some motion picture agents to send me their prettiest girls—if I don't keep them I give them ten francs. And thus I have three or four young and pretty models whom I pose separately for drawing, three hours in the morning, three hours in the afternoon. This keeps me in the midst of my flowers and my fruits with which I can get in touch gradually without being aware of it. Sometimes I stop in front of a motif, a corner of my studio which I find expressive, yet quite beyond myself and my strength and I await the thunderbolt which cannot fail to come. This saps all my vitality.

I have seen Bussy very little; he had guests, Gide, etc., literary people, that is, quite a strange crowd to me, so I stay at home. Nevertheless, if I had not written I would have gone to have a cup of tea with them—but I cannot chat and be intimate in their circle in which one does not understand painting. They are absorbed by the war and politics and that tires me and interests me very little.

I shall take a look around Cannes or St. Raphaël with a view to moving there in case of need. I am expecting a bird dealer who will, I hope, relieve me of a part [of my collection]. It is not the necessity of doing these things which preoccupies me, but the uncertainty in which we are living and the shame of having undergone a catastrophe for which one is not responsible. As Picasso told me: "It's the Ecole des Beaux-Arts!" If everybody had minded his own business as Picasso and I did ours, this would not have happened.

I hope I shall start painting again soon, but that overwhelms me so—I have to invent and that takes great effort for which I must have something in reserve. Perhaps I would be better off somewhere else, freer, less weighed down. When I was at the other frontier and saw the endless march of those escaping I did not feel the slightest inclination to leave. Yet I had a passport with a visa in my pocket for Brazil. I was to leave on June 8th via Modane and Genoa, to stay a month in Rio de Janeiro. When I saw everything in such a mess I had them reimburse my ticket. It seemed to me as if I would be deserting. If everyone who has any value leaves France, what remains of France?

Within a few weeks unexpected shortages began to occur. He wrote Pierre:

Nice, September 18, 1940
No more canvas, no more colors! The amateur painters grabbed everything before the artists began to think of it. Bonnard has nothing. He is resigned, saying: "If I can't paint any more, I'll do water colors." I got busy and now he has canvas.

Meanwhile Pierre Matisse had been asked by Mills College in California whether his father might not be willing to come to America to take a teaching position. Matisse replied October 11th expressing his appreciation but refusing the invitation. He had given the matter careful thought, although his "feelings about leaving France at this time" were "quite decided."

In December he was visited by Varian Fry, the chief American agent for the Emergency Rescue Committee. Fry[8] offered to help him get a visa and passage for the United States explaining to him that even if the Germans did not persecute him as a "doyen of degenerate art," he might well starve before the war was over. Matisse again refused, though he told Fry that he had heard that Picasso had already left for Mexico. Fry assured him that this was not true but, on the contrary, that Picasso was back in Paris. Whereupon Matisse got in touch with Picasso, sent him a power of attorney, and asked him to see what had happened to his pictures in the Banque de France: Picasso reported that they were safe.

Matisse's health however continued to decline. He was eager to paint but found by October that he could work only four hours a day. During the winter an internal illness developed and grew worse. Finally in March he was taken to a hospital in Lyons where he was operated on for an intestinal occlusion. A postoperative infection set in and after a long and dangerously stubborn reluctance on the patient's part he was persuaded to go under the knife a second time by Marguerite Duthuit who had come to Lyons to take charge of her father. Because of the delay the surgeon was not optimistic but by May Matisse was well enough to return to Nice.

Before he left the hospital in Lyons Matisse received a letter from his son Pierre in New York informing him that Rouault was at Juan-les-Pins and, like Bonnard, was feeling the shortage of artists' materials. In the confusion of the war Matisse had not known that his old companion from the days of

Moreau's studio had sought refuge on the Riviera only a few miles from Nice. Matisse promptly wrote to Nice to have Rouault supplied from his own reserves of poppy seed oil.

Back in Nice at the Régina, in May 1941, Matisse found that his ordeal in Lyons had left him seriously handicapped in physical strength and nervous stamina. Damage to the muscular wall of one side of the abdomen caused him permanent weakness so that he could hold himself erect only for limited periods.

Yet he was convalescing in comparative safety and comfort, well cared for by Madame Lydia and an able and devoted nurse, a young Vendéenne, who later on, as Sister Jacques, was to play an important role in the undertaking of the Vence chapel. Soon his creative energies began to revive and he found that he could work again though confined to his bed most of the time.

Varian Fry[1] called on Matisse again in August, some three months after he had returned from Lyons. He found the artist in good spirits and took a number of photographs of him at work or resting in the Régina. The one reproduced here on page 30 shows Matisse completing a big decoration, apparently a cartoon for a tapestry, a woodland scene with a faun playing his double pipes to a sleeping nymph. To the left of the decoration, beyond the step-ladder, may be glimpsed the *Still Life with a Shell*[2] of November, 1940. The brushes neatly piled within the curved seat of an African stool, the excellent light, the profusion of plants, the artist's well-pressed clothes suggest that Matisse's orderly and commodious habits of life had been little changed by the war. At Fry's request, Matisse along with Gide and Maillol joined the French committee of patrons[3] of the Emergency Rescue Committee.

Though he lived very quietly, Matisse was by no means isolated in Cimiez. A good many other artists and old friends lived not too far away. André Rouveyre, the writer and caricaturist, lived at Vence, Gide at Roquebrune; Bonnard continued to work during the war at Le Cannet, near Cannes, and Rouault, as we have seen, was at Juan-les-Pins.

The Swiss border was still comparatively open and several of Matisse's paintings of 1940-1941 were reproduced in Pierre Courthion's *Le visage de Matisse* published in Lausanne in 1942. One of them, *Oysters*, painted in Nice at the end of 1940 was bought by the Basle museum. Albert Skira, the Swiss publisher, visited Matisse late in 1941 and, on Matisse's initiative, they began to plan the great illustrated volume, *Florilège des Amours de Ronsard*. Martin Fabiani, the successful "occupation" publisher, came down a little later from Paris to consult Matisse about other illustrated books including de Montherlant's *Pasiphaé*. Drawings and book illustration were work which Matisse could do most conveniently sitting up in bed. Louis Carré, the dealer, also visited him and took back to Paris quite a number of drawings which were exhibited there in 1941.

In April 1942 Matisse wrote Pierre Matisse[4] that he had had a veritable *floraison* in his drawing and hoped soon to achieve the same thing in painting. That Matisse could paint in bed, as well as draw, is recorded in André Ostier's photograph, page 29. Taken late in the summer of 1942 it shows Matisse at work in the Hôtel Régina on one of his best-known canvases of the period, the *Dancer and Armchair, Black Background*, page 488. In the foreground is the model (a Turkish princess) and between her and the painter is the chair with fruit and a coffee cup resting on its seat. Both the model in her blue costume and the curious chair with its free organic curves Matisse painted again and again in 1942. Another of Ostier's photographs, taken at the same time, shows Matisse's cages where he kept scores of tropical birds which, curiously, almost never appear in his paintings or drawings. Their number had been greatly reduced by the food shortage.

During these years Matisse continued to hear occasionally from or about Picasso in Paris. Early in the summer of 1942 a friend arrived from Paris bringing with him a painting by Picasso as a gift to Matisse from the artist.[5] It may have been on this occasion that Matisse and Picasso exchanged paintings—for the first time since 1907.

3 Matisse and "Vichy" France

Picasso meanwhile was steadily gaining a position in Paris as a symbol of the resistance to the invaders and to their Vichy collaborators. His role during the war was largely passive but nevertheless influential for he, a foreigner, the painter of *Guernica*, and the chief of all *entarteten Kunstbolschewisten* had chosen to remain in Paris in spite of the Germans and in spite of the malicious hostility of conservative critics like Camille Mauclair or embittered reactionary colleagues like Maurice Vlaminck. Thus, even though Picasso remained politically inactive, his legend grew to heroic proportions.[6]

Matisse, too, had refused to leave France in her downfall but continued to live and work quietly in Nice and, later, in Vence. He had never been politically active in his life and the war did not change his habits. Over seventy, and an invalid, he could scarcely have played a part in the resistance anyway. And fortunately the Vichy government, which actively courted Bonnard, disturbed Matisse very little. Doubtless he was still considered too radical—the followers of Pétain and Hitler were often not far apart in their artistic prejudices. Nor was Matisse, like his old companions, Maillol, Derain and Vlaminck, involved at all by flattering German efforts to compromise leading French artists. They had stayed in occupied France and were subject to very different pressures.

4 Radio Broadcasts, 1942

Early in 1942 Matisse gave two interviews over the radio of "Vichy" France. The first broadcast, completely non-political in character, began with an account by Matisse of how the modern painters of each period influenced the popular vision of the succeeding generation. He then answered several simple, fundamental and sometimes difficult questions beginning with: "Why do you paint, M. Matisse?" His reply is given among other excerpts from this broadcast in Appendix I.

A little later but still in the winter of 1942 he gave a second broadcast interview which must have sounded highly tendentious in Vichy France where reactionary thought-control was already beginning to tighten under German pressure. The whole broadcast, of which excerpts are given in Appendix I, is a sustained and virulent attack on the French academic Beaux-Arts system.

How consciously subversive of the reactionary Vichy atmosphere was Matisse—and, for that matter, his interviewer—in this broadcast? Perhaps the interviewer was naïve or perhaps he was a Free-France sympathizer. As for Matisse the answer may be indicated by his twice having quoted in letters to his son Pierre, Picasso's explanation of the plight of France: "*C'est l'Ecole des Beaux-Arts!*" On the other hand, Matisse may merely have been expressing his profound and bitter hostility toward French academicism. In any case he did not broadcast again.

However passive Matisse may have been politically, it seems that he did not entirely escape the reactionary abuse released by the German occupa-

tion and Vichy collaboration. André Lhote, a minor cubist but a distinguished critic, teacher and defender of the French classical tradition, stayed in Paris during the occupation. In December 1944, shortly after the Liberation, he wrote in *Tricolor*:

Never, never was independent art . . . exposed to more idiotic annoyances or ridiculed in terms more absurd. Those who defended it saw themselves accused of perverting youth; indeed, they were practically offered hemlock. "Into the ashcan with Matisse!" and "To the booby hatch with Picasso!" were the fashionable cries. Rouault and Braque were no better off; only Bonnard, for some unknown reason, was tolerated. More than ever, there was talk of French clarity, order, and moderation.

5 Vence, 1943

In the South of France, Matisse may not even have heard of these disturbances. During the early years of the war he had suffered anxieties and tribulations but they had been chiefly personal, caused by his health or by his domestic situation, both of which had now become stabilized. In spite of all circumstances, public or private, he had been able to go on working in comparative quiet and safety. Even in 1943, when the war dangerously disturbed his security, he quickly adjusted himself. Early in that year, with North Africa in the hands of the Allies, Nice became a potential target and in March the Cimiez suburb suffered an air raid. The Régina, a large, conspicuous building on a hill, seemed a more and more hazardous home. Matisse, therefore, moved up to the ancient hill town of Vence, five miles inland and about twenty miles by road from Nice. He took a small villa called Le Rêve on the outskirts of the town reached by a steep climb up the route de Saint-Jeannet. There he stayed until the war was over, and afterwards, in fact, until the beginning of 1949.

6 Mme Matisse and Marguerite Duthuit in the Resistance

For some of Matisse's family, however, the war was not so passive. Mme Matisse and Marguerite had come up from Toulouse to Paris after the fall of France. They worked in the underground movement and in 1944 Marguerite was sent to Brittany to help with the preparations for the Allied invasion. She was captured by the Germans, tortured, and sent off to Germany in a prison train bound for the Ravensbruck camp. An allied air raid made

possible her escape before she arrived at her destination. Mme Matisse who had been typing incriminating papers was also caught and condemned, as an accessory, to six months' imprisonment at Troyes.

7 *Painting and Graphic Art during the War Period: A Summary*

Matisse's paintings of the war period 1939-1945 are extremely varied in subject and style. During the previous decade he had been primarily a figure painter and several canvases of the "cold war" period such as *La France* and the *Sleeping Woman* series are focused upon the model in costume, pages 485, 486, but during the early 1940's his most characteristic canvases are still lifes, color plate page 236, pages 487, 489, or interiors in which figures are subordinate to a decorative ensemble, pages 486, 491.

Certain series of paintings of the period are virtually variations on a theme. Among these are the small compositions of two seated models, page 487, of 1941. These are succeeded in the following year by a similar series of a dancer resting on an armchair, often with another empty chair nearby, page 488; and in 1942 by half a dozen small vertical canvases with a robed model seated in a lofty shuttered interior, page 489. Early in 1943 while still at Nice he painted compositions of exceptional complexity in dry, bright colors, page 491, but his characteristic work of 1944, page 492, is rather dark in palette. In 1944 he was commissioned by an Argentine diplomat, Señor Enchorrena and his wife, to decorate a double door which he completed only after many fresh starts about 1946. (Two early stages are reproduced on page 493.)

Matisse's style during the early 1940s is generally more abstract than that of the previous decade and much more so than that of the early 1920s. Space is flattened, light generalized, color ordinarily frank and gay though often relieved by large areas of shining black.

During the war years he drew, as always, incessantly. Almost two hundred of his drawings of 1941-1942 were reproduced in 1943 by Martin Fabiani, the most active publisher of art books in Paris during the German occupation. For this volume, called *Dessins: thèmes et variations*, Matisse's friend Louis Aragon wrote a long introduction. The following year Fabiani published Matisse's illustrations for Henry de Montherlant's *Pasiphaé; Chant de Minos (Les Crétois)*, page 494, which apparently had been initiated before the war. Other illustrated

volumes were also in preparation, pages 270-274.

8 *Books on Matisse during the War*

Aside from Aragon's long essay, just mentioned, little critical writing about Matisse appeared in France during the war, though in 1943 Le Chêne brought out a handsome portfolio of color plates of his paintings of 1939-1943, bibl. 101. Marguerat of Lausanne issued Pierre Courthion's *Le visage de Matisse*, bibl. 82a, in 1942. In 1944 two important books on Matisse were published in Stockholm. Isaac Grünewald, the leading Swedish painter and stage designer of his generation, had been one of Matisse's most successful Scandinavian pupils during the time of the "Académie Matisse," page 116. His *Matisse och Expressionismen*, bibl. 86, is rich in lively observation and reminiscence. Leo Swane's *Matisse* is a succinct, scholarly account written by the distinguished Director of the Copenhagen Museum, bibl. 92. It contains, besides other valuable material, nine memoirs of Matisse's school by Per Krohg and other Scandinavian pupils; and it is dedicated to the two great Danish collectors, Tetzen Lund and Johannes Rump, many of whose Matisses are now among the chief glories of the Copenhagen museum.

9 *Post-War Exhibitions: Paris, London, Brussels, Nice, 1945-1946*

Early in the summer of 1945, with the war over, Matisse came up to Paris for the first time since 1940. He had not exhibited at the Salon d'Automne, the "Liberation Salon," of 1944 or, rather, he was not listed in the catalog. Actually it appears that Picasso had Matisse's *Oranges* which he had recently bought, page 389, hung in the Salon so that Matisse[8] would be represented. Now at the Autumn Salon of 1945 Matisse was honored by being given the only one-man show by a living artist, a retrospective of thirty-seven paintings, most of them done during the war period.

Picasso had been similarly honored at the Salon d'Automne of the previous year and now toward the end of 1945 the two old and now friendly rivals were celebrated together by simultaneous one-man shows in London at the Victoria and Albert Museum. Matisse's exhibition was retrospective and included paintings dating from 1896. Though they excited some admiration, they were quite eclipsed in the attention of the conservative London public by the Picasso show which, confined to his latest

and most violent period, generated riotous controversy. This two-man exhibition was shown again in Brussels in May 1946.

A few months earlier, in February 1946, the Union Méditerranéenne pour l'Art Moderne organized an exhibition of Matisse's recent paintings in Nice, twenty years after he had first come to that city, and further honored him by naming him, along with Bonnard, honorary co-president of the Union.

10 Matisse in Films, 1946

Matisse appeared in two films in 1946. *L'art retrouvé* (*Art Survives the Times*), produced by Les Actualités Françaises, was a post-Liberation newsreel in which Matisse figures briefly.

The second film, entitled *Matisse* or *A Visit with Matisse*, is a valuable documentary study of the artist made in Paris and Vence. Matisse is seen talking about several of his pictures one of which, *The Rumanian Blouse* (Musée National d'Art Moderne), is studied in a series of photographs showing fifteen stages in its development. The most valuable sequences, partly in slow motion, show Matisse drawing, first a flower which he has just plucked in his garden and then the head of his grandson.

Matisse himself learned something from this film. He told Rosamond Bernier, *Vogue*, February 1949:

There was a passage showing me drawing in slow motion. Before my pencil ever touched the paper, my hand made a strange journey of its own. I never realized before that I did this. I suddenly felt as if I were shown naked—that everyone could see this—it made me deeply ashamed. You must understand this was not hesitation. I was unconsciously establishing the relationship between the subject I was about to draw and the size of my paper. Je n'avais pas encore commencé à chanter.

Matisse was produced by François Campaux under the auspices of the Department of Cultural Relations of the Ministry of Foreign Affairs and was widely seen abroad. The director was André Leveille. Thus Matisse, in still another medium, had been recognized officially as a valuable national asset and an "article of export."

11 Matisse in the New Musée National d'Art Moderne

In 1947, Matisse was elevated to the rank of Commander of the Legion of Honor—he had been named a Chevalier in 1925. More important, the French Government, after decades of neglect and delay, made a real effort to make up for lost time in purchasing representative groups of paintings by Matisse, Rouault and Braque. For this purpose, Georges Salles, the progressive new Director-General of the museums of France, secured considerable funds and gave his full support to Jean Cassou, the enlightened Curator-in-Chief of the Musée National d'Art Moderne. This new institution, which now superseded the old Musée du Luxembourg, was housed in the Palais de New-York, a wing of the huge Palais de Chaillot originally built for the Paris Exposition of 1937. The Luxembourg, the collections of which were now passing to its successor, already owned three Matisses, the *Odalisque in Red Trousers*, the *Sideboard*, page 450, and the big *Decorative Figure on an Ornamental Background*, page 449, acquired respectively in 1921, 1929 and 1938. Cassou now, in 1945, added two large and important early canvases, *Le luxe, I* of 1907, page 340, and *The Painter and His Model* of 1916, page 413, and, in addition, a nude of about 1920 and four paintings of the period 1939-1941.

12 Paintings; Illustrated Books; Decorative Designs: 1946-1950

The year following the end of World War II was more remarkable for the public honor and attention shown Matisse than for any important addition to his *oeuvre*. Now over seventy-five years of age, he might well have rested on his oars, especially as he had never entirely recovered from his operations of 1941 and was still bed-ridden most of the day. Bored by reading exaggerated rumors of his ill-health he insisted that he was not *un malade* but *un mutilé*. In any case, for Matisse the habit of work was so deep-rooted and his creative vitality so strong that he once more began to produce paintings and graphic works with a fecundity which would have been surprising in a man half his age.

Matisse made several large figure paintings in 1946, notably *The Lady in a White Gown* and *Asia*, but even less than in the first half of the decade did the human figure play an important role in his postwar easel pictures. The series of splendid large interiors in vertical format begins in 1946 with the *Interior in Yellow and Blue* (in the French Embassy at Washington), page 502, and culminates in the spring of 1948 with such compositions as the *Egyptian Curtain*, color plate page 239, the *Plum Blossoms, Green Background*, page 505, and above all the magnificent *Large Interior in Red*, page 507. Many of the

best of these canvases were reproduced in color in a special issue of Tériade's *Verve* entitled *Vence 1944-48*, bibl. 164.

In spite of the brilliant late flowering of his art in the easel paintings of 1947-1948, Matisse continued to collaborate in an extraordinary number of illustrated books and portfolios, though most of his share of the work had been done earlier. In 1946 three books with his illustrations were published: Reverdy's *Visages*, Marianna Alcaforado's classic *Lettres portugaises*, page 499, and Tristan Tzara's *Le signe de la vie*. The first two not only contained many lithographs by Matisse but the volumes themselves were designed, laid out and decorated by the illustrator. Besides the Baudelaire *Fleurs du mal*, page 498, the year 1947 saw the publication of André Rouveyre's *Repli*, illustrated and designed by Matisse; *Les miroirs profonds*, a collection of essays, largely about Matisse, with his decorations and illustrations, and, most important, *Jazz*, bibl. 48, a portfolio of stencil reproductions after Matisse's brilliant and poetic compositions in cut-and-pasted paper, pages 500-501, brought out by Tériade. In the same year Skira issued the second of Matisse's two greatest illustrated books, the *Florilège des Amours de Ronsard*, pages 496-497. Matisse had undertaken the Ronsard with the Swiss publisher early in the war and it had passed through seven years of extraordinary misadventures. From 1947 on Matisse also produced many very large brush-and-ink drawings quite unlike any he had done before in their scale and carrying power, page 508.

Among his designs for the decorative arts were three large cartoons for tapestries done in 1946, one for the Gobelins, two for the Beauvais factories. About 1947 he designed some large stenciled linen hangings for A. Ascher, Inc. of London, page 510, and, two years later, a rug for Alexander Smith, Inc. of Yonkers, New York, page 510.

13 *The Vence Chapel and other works, 1948-1951*

In 1948 Matisse was seventy-eight years old. After he left Vence for Paris in the early summer of that year he painted no more canvases until the middle of 1951. Instead he devoted almost all his energies to the creation and decoration of the new Chapel of the Rosary for a chapter of Dominican nuns at Vence, pages 514-527. The story of this most recent and, possibly, culminating achievement of Matisse, together with some of its implications, is recounted in the last section of this book, page 279.

In 1948 for the end wall of a side aisle of the modern church at Assy, Matisse designed a half-length figure of St. Dominic, page 511, which served almost as a preliminary study for the more important tile murals at Vence. During interims between work on the Vence chapel he also made a great many drawings and compositions in cut-and-pasted paper of a purely secular nature such as the *Torso*, page 509, and *The Thousand and One Nights*, page 512.

14 *The Return to Nice: Matisse's 80th Birthday, 1949*

In January 1949, just after his seventy-ninth birthday, Matisse moved from Vence where he had lived since 1943 back to the Régina in Nice, so that he could work in two big rooms in his apartment which together were almost exactly the size of the interior of the proposed chapel. The plans for the architecture of the chapel were completed by fall and the cornerstone laid in December 1949. The models which Matisse exhibited at the Maison de la Pensée Française in the summer of 1950 showed designs for the murals that were practically final, though the chapel was not to be completed until June 1951.

Matisse celebrated his eightieth birthday on December 31, 1949 in Nice in his apartment at the Régina.

15 *Matisse Exhibitions, 1948-1949: Philadelphia, Paris, Lucerne, Nice*

The world did not let the event pass unnoticed. In the years just before and after the anniversary, great exhibitions were held in Europe and America more or less as celebrations of the occasion. The Philadelphia Museum of Art led off with a great retrospective organized by Henry Clifford in the spring of 1948. Alas, neither the Philadelphia show nor any other of the large retrospectives of the past twenty years or so has included pictures from the three geatest collections of Matisses, those in Moscow, Copenhagen and Merion, the last only a half hour's ride from Philadelphia itself. Dr. Barnes not only refused to lend but attacked the museum with his usual gusto. The valuable Philadelphia catalog, bibl. 152, included unpublished writings by Aragon, Clifford and Matisse himself. Unfortunately Matisse's extraordinary paintings of early 1948 could not be included in the Philadelphia show but they were exhibited in February 1949 at Pierre Matisse's in New York with great acclaim.

In the summer of 1949 the Musée National d'Art

Moderne in Paris showed his work of the previous two years, bibl. 142: *papiers découpés*, the two tapestries and two printed linen panels with Polynesian themes, the big brush-and-ink drawings, the brilliant canvases of interiors and still lifes and the recent illustrated books, altogether an impressive demonstration of Matisse's sustained creative fertility. Before the Paris show closed, the Lucerne Museum opened a far greater exhibition, a retrospective of 308 items, beginning with a still life of 1890 and including an excellent survey of his sculpture. Though very weak in works representative of the immediately previous years, it remains the most comprehensive exhibition of Matisse's work ever held.

The year 1950 opened with a retrospective organized by the Union Méditerranéenne pour l'Art Moderne in the Nice municipal Galeries des Ponchettes. The catalog, bibl. 135, which contains Cassarini's lively account of Matisse's life on the Riviera, announced: "*Par cette exposition la Ville de Nice a tenu à rendre hommage au Grand Peintre Henri Matisse, Commandeur de la Légion d'Honneur, son hôte depuis 1916.*"

16 Matisse at the Maison de la Pensée Française, 1950; Japan and Germany, 1951

The chief Matisse exhibition of 1950 was presented in Paris in the large galleries of the Maison de la Pensée Française, a Communist dominated institution, during the late summer. Louis Aragon, one of the leading Party writers of France and a devoted friend of Matisse, wrote a pleasant preface to the catalog in which he compared Matisse's art to a French garden. The show was rather unshapely and poorly installed, but was distinguished by its inclusion of the *maquettes* for the Vence chapel, their first public showing, and of no less than fifty sculptures, among them—and for the first time—all five states of the *Jeannette*, pages 368-371, and all three versions of the big relief *The Back*, pages 313, 458, 459. Also shown for the first time since its disappearance early in 1905 was the very important canvas *Luxe, calme et volupté*, page 317.

Aragon and, even more, Picasso[1] had persuaded Matisse to exhibit at the quasi-Party cultural center but Matisse's inclusion of the Vence chapel models was very much his own doing and is pondered later, in the discussion of the chapel.

It may be noted here that Picasso had preceded Matisse with a large exhibition at the Maison de la Pensée Française. Ironically it was Picasso, a conspicuous Party member since 1944, and not the non-political Matisse, who had just been the chief butt of a savage article against the decadent art of the West by Vladimir Kemenov, published in VOKS.[2] Matisse's painting had even been defended by the Communist Aragon in 1946 in a poetic though somewhat specious essay entitled "*Apologie du Luxe,*" bibl. 103. But no critic dared raise his voice in the U. S. S. R. in the 1940s to point out, as Alexander Romm had in 1935, that Matisse had something of value to teach even the Soviet masters of Socialist Realism. In one important if rather perverse way the ancient rivalry of Matisse and Picasso is being maintained by the Soviet authorities: it appears that just fifty-two works by each, formerly exhibited in the Museum of Modern Western Art, have been retired from public view.[3]

In the spring of 1951 the National Museum in Tokyo and the newspaper Yomiuri Shimbun, brought a large Matisse exhibition to Japan. During the same period a Matisse show was held in Hamburg and Düsseldorf by the Office of Cultural Affairs of the High Commissariat of the French Republic in Germany.

17 Museums and Collectors

In 1949 the Musée National d'Art Moderne, having partially made up for lost time by its acquisitions in 1945, now acquired[4] the chief masterpiece of Matisse's most recent painting, the *Large Interior in Red* of 1948, page 507. The Paris museum had within five years greatly enriched its Matisse collection though it was still far surpassed by Moscow, Merion and Copenhagen. Meanwhile a new contender, Baltimore, had entered the field. Etta Cone died in August 1949 leaving the collections formed by her sister Claribel and herself to the Baltimore Museum of Art. The Cone Collection includes forty-three Matisse paintings mostly of the Nice period but with several earlier works, among them the *Blue Nude*, page 336. More remarkable still are the eighteen bronzes, one hundred thirteen drawings and hundreds of prints; groups which, taken as a whole, far surpass those of any other museum.

During the 1940s Duncan Phillips bought the superb *Studio, Quai St. Michel*, page 410, and the *Egyptian Curtain*, color plate page 239, for the Phillips Collection in Washington, and Dr. Barnes, who had previously acquired no Matisses painted after 1923, bought two paintings, one of about 1941, the

other of 1947. In 1951, two important Matisses were presented to the Philadelphia Museum, the portrait of *Mlle Yvonne Landsberg*, page 395, as part of the Louise and Walter Arensberg Collection, and the *Moorish Screen*, page 437, one of the best paintings of 1921. The Museum of Modern Art in New York added to its collection the *Piano Lesson*, page 175, and the *Red Studio*, page 162. The *Two Sisters*, page 417, was bought by the Denver Art Museum in 1950.

Among private collections in the United States two were especially distinguished for their accession of Matisses during the 1940s: Mr. and Mrs. Samuel A. Marx of Chicago bought three famous canvases of 1916, page 406 and color plates pages 169, 170; and Mr. and Mrs. Albert D. Lasker of New York, half a dozen more recent paintings including those reproduced on pages 434, 442, 490 and color plate page 236. Joseph Pulitzer, Jr. of St. Louis bought the important *Bathers with a Turtle* of 1908, page 357, and Leigh B. Block of Chicago a number of representative canvases, mostly of the 1940s. Meanwhile Mrs. Michael Stein, Stephen C. Clark and Walter P. Chrysler, Jr. had largely dispersed their groups of Matisses, Mrs. Stein's *Woman with the Hat*, frontispiece, passing into the Haas collection in San Francisco. Early in 1951 Harriet Lane Levy, an old friend of both Sarah Stein and Matisse, died, leaving her Matisse collection, including the renowned *Girl with Green Eyes*, page 352, to the San Francisco Museum of Art, Appendix F. Though most of these Matisse acquisitions are American, it should be noted that the most important available work by Matisse done during the past three years, the *Zulma*, page 513, was bought by the Copenhagen Museum in 1950.

The esteem in which Matisse is held in America may be gauged by the fact that no less than 97 of his paintings and 26 sculptures are owned by the public museums of the United States. The list, as of 1951, is given in Appendix F, together with Matisses in Canadian, English and Scottish museums.

In concluding this very cursory review of the recent exhibitions and acquisitions of Matisse's art, public and private, a curious coincidence presents itself: the two greatest collections of Matisse's art are, it seems, withheld from public study and enjoyment. The neuroses of collectivism in Moscow and private enterprise in Merion have produced strange bedfellows. When will the Museum of Modern Western Art and the museum of the Barnes Foundation open their doors?

As the writing of this book nears its end, its subject is giving generous assistance to the Museum of Modern Art in New York, which, with the enthusiastic support of the Cleveland Museum of Art, the Art Institute of Chicago, and the San Francisco Museum of Art, is assembling a collection of Matisse's art for public exhibition in those four cities during the season of 1951-1952. The catalog, bibl. 131b, records this most recent demonstration of American admiration for Henri Matisse.

SECTION II MATISSE'S CRITICAL POSITION SINCE THE WAR[5]

The big retrospectives of 1948-1949-1950 in Philadelphia, Nice, Lucerne and Paris and a small but important show of his recent canvases at Pierre Matisse's gallery in New York in 1949 gave new opportunities for critical appraisal of Matisse's achievement. Matisse had emerged from the war with a moral position, a prestige, second only to that of Picasso among the artists active in France. And his artistic position among the younger artists of Paris was much stronger than it had been before the war. During the two decades between 1920 and 1940 Matisse had continued to rank as one of the greatest living French painters but he had not been a leader of the young to nearly the same degree as Picasso, Léger, the abstract painters around Mondrian, the surrealists such as Miro, Arp, Ernst and Dali, or even his own contemporary, Rouault. However sought after his new paintings were by collectors, the younger artists and critics of the 1930s tended to think of him as an established painter with a great past but little current significance. The *Lady in Blue*, page 235, is one of Matisse's representative paintings of 1937: it was finished a few days before Picasso began his *Guernica*. No one of course thought of comparing them. But even Matisse's major works of the 1930s such as the Barnes mural and the settings for the *Rouge et Noir* can scarcely compete with the the black and white fury of *Guernica*.

In the art of post-war Paris and its outposts on the Riviera, *Sturm und Drang* had practically disappeared. Picasso, who had drawn his frightful

Charnel-house in 1945, was within a couple of years engaged in painting lively pastoral frolics on mural-size canvases, or small ones on ceramic plates and vases. Rouault, the stern religious moralist, announced that now, in his advanced years, he was going to paint more like Bonnard and Matisse. Surrealism, too, with its Freudian poetry and prose, had disintegrated along with such lesser but significant groups as the Neo-Romantics and the painters of geometric abstractions in the tradition of Mondrian.

It is significant that in 1946 the Communist Aragon should have defended Matisse under the title *Apologie du Luxe*[6] and that in 1949 Georges Duthuit,[7] in a subtle and beautiful essay called *Matisse and Byzantine Space*, should have pointed out that the "well-meaning intentions" of the socialist realists in their efforts to create a "communal" art "are drastically cancelled by sterile techniques which make their work incomparably more remote from the masses than the exceptional creations painted by Matisse."

Just after the war the most talked-of younger painters were talented eclectics like Tal Coat, Pignon, Bazaine, Gischia, Marchand—men mostly in their forties who depended variously upon their seniors Picasso, Bonnard—and Matisse. They wanted to paint, to use color and line, without program or dogma, and for them the art of Matisse served as a beacon even when the form or color of some other master appeared to be a stronger influence upon the individuals. Edouard Pignon[8] for instance finds the color of Matisse "impossible to translate into black and white" and praises his painting as a thing to "meditate upon for its purity of color and admirable economy of means."

As the decade wore on, the work of these painters and their companions grew generally more abstract (except for a few who tried conscientiously to submit to Communist dictation). In fact abstract painting for the first time became the strongest movement in Paris. It was not however the ruled line abstraction of Mondrian, but its opposite, the free arabesque of early Kandinsky mingled with the crystalline iridescence of Villon or the sweeping calligraphy of Magnelli and the younger leader, Hans Hartung. Of the living "old masters," it was Matisse again, especially in his latest work, who perhaps stood closest to the new wave of abstraction.

Jean Bazaine is not the greatest of the younger painters but he is characteristic enough to make his opinion of Matisse significant. In 1949 he stated to Robert Vrinat[1] that without wishing to establish a categorical hierarchy of values he preferred Matisse to all others, and admired him for the power and expressiveness which he gave to line, to the arabesque. He emphasized his astonishing capacity for creation and renewal as demonstrated in his recent works.

Gischia, more conservative, praises Matisse for his "love and use of color for itself and his drawing, always bound essentially to a model, but not to imitate it so much as extract from it all possible artistic riches."[2]

Neither painter refers to the fact that Matisse had himself become an "abstract" artist during the 1940s. Many of his cut-and-pasted-paper designs such as the "lagoons" in *Jazz* are virtually pure abstractions though remotely related to organic or geographical forms.

These remarks about Matisse were made apropos of the comprehensive exhibition of his paintings, drawings and cut-and-pasted-papers of 1947-1948 which had just opened in Paris in June 1949. Some of the best of this exhibition, including the finest paintings of early 1948, had already been shown in New York at Pierre Matisse's early in 1949. There this late flowering of Matisse's art was received with general astonishment and delight. The most enthusiastic review was written by Clement Greenberg. Greenberg is given at times to somewhat reckless exaggeration, but his criticism is significant in part because he is also a painter closely associated with the most conspicuous new American movement of the 1940s called variously abstract expressionism or symbolic abstraction or, simply, the "New York School"—though the movement is nation-wide and particularly active on the West Coast. Whatever its label, the movement involved some of the most vigorous younger talents in American painting—such men as Pollock, Baziotes, de Kooning, Motherwell, and the late Arshile Gorky. In spite of the abstract appearance of their paintings these artists did not think of themselves as abstract painters. Far more than their work indicated they were striving for an art in which natural forms, including human figures, would once more *emerge* but without any sacrifice of spontaneity or of the direct impact, purity and reality of the painted surface as the primary instrument of their emotions. For these American painters as well as for their French colleagues Matisse began to have a special significance.

STILL LIFE (*Nature morte*). Nice, 1941 (October?). Pen and ink. From *Dessins: thèmes et variations:* Theme G, variation 5

The year before, Greenberg had been involved in a controversy with George L. K. Morris, another younger writer, painter and collector who had developed within the cubist tradition during the 1930s. The argument was opinionated, as is fitting in a debate between painter-critics, but throws some light on the conflicting but changing attitudes toward Matisse. Greenberg led off with an article, "The Decline of Cubism," in the *Partisan Review* of March 1948. Cubism, in Greenberg's mind, included all the abstract movements of the previous forty years, a serious historical confusion which does not however becloud his essential question as to *"why the Cubist generation and its immediate successors have . . . fallen off in middle and old age, and why belated Impressionists like Bonnard . . . could maintain a higher consistency of performance during the last fifteen years. . . . And, finally, why Matisse, with his magnificent but transi-* *tional style, which does not compare with Cubism for historical importance, is able to rest so securely in his position as the greatest master of the twentieth century, a position Picasso is further than ever from threatening."*

In the June 1948 issue of the *Partisan Review* George L. K. Morris calls Greenberg's article "irresponsible" and compares it to a tennis tournament in which *"Umpire Greenberg charts the last rounds somewhat as follows: the expected champions (Picasso, Braque, Arp, etc.) have lost their punch, and no new blood is coming along—so to everyone's surprise, a couple of Old Timers (Matisse, Bonnard), who have been relying all these years on poky lobs and drop shots rather than spectacular rushes to the net, were the ones to reach the finals after all. I do not feel that anything as elusive as the ultimate values of contemporary art can be graded as simply as this, certainly not without considerable substantiation. And such a prearranged result might prove highly irritating to a*

different referee, who thought he saw Matisse pass out of the tournament in love sets around 1917."

To this, in the same issue, Greenberg writes a "Reply." Concerning Morris' opinion that Matisse passed "out of the tournament in love sets around 1917" Greenberg feels that anyone with a real " *'instinct for pictorial structure' would have been unable to write that. This is what happens when literal a priori dogmas about the historically necessary are consulted instead of the pleasure and exaltation to be experienced from painting. Historical necessity does operate, but not with the consistency here expected of it."*

The Philadelphia exhibition could not include Matisse's paintings of 1948 such as the *Egyptian Curtain*, page 239, and *Large Interior in Red*, page 507. When these were shown in New York in February of the following year, Greenberg wrote in *The Nation*:[3]

The supremacy of Matisse among living painters is a consolation, but it also offers a peculiar problem. Picasso and Braque painted in the decade 1909-1920 what I think are by and large the most important pictures so far of our century. Yet neither appears to be the complete painter by instinct or accomplishment that Matisse is—the brush-wielder and paint-manipulator par excellence, the quiet, deliberate, self-assured master who can no more help painting well than breathing. Matisse may at times execute superficial work, he may do so for years, but he will never lack

sensuous certainty. I do not think we can say the same of Picasso or Braque. . . .

However genuine the pleasure received from Matisse's later canvases, it had to be conceded that this pleasure had begun to thin out and that the emotion which had moved us in his masterpieces of the years before 1920 was being replaced by virtuosity. Yet it was always to be expected that some glorious final statement, such as those Titian, Renoir, Beethoven, Milton had issued, would come from him—all the more in so far as his art, pre-cubist in essence if not in inflection, seemed less involved in the crises that had overtaken post-cubism in the early thirties and better able, precisely because of its greater conservatism, to produce a second flowering.

This expectation has not been disappointed. . . . The present show at Pierre Matisse's (through February) of paintings done in 1947 and 1948 and of drawings and paper cut-outs done since 1945 offers a most effective refutation of those who may still doubt that Matisse is the greatest living painter.

Greenberg's enthusiasm may be balanced by a remark made by another young American painter and writer, Robert Motherwell: "Matisse may be the greatest living painter but I prefer Picasso: he deals with love and death."[4] To which one might reply, on the same level, yes, but Matisse deals with love and life.

SECTION III PAINTING AND DRAWING, 1940-1945

1 *Paintings, 1940*

The "cold war" winter of 1940 was a fecund period for Matisse, the painter. For instance during three weeks in February he finished at least four canvases, including the *Striped Blouse and Anemones*[5] of February 5th, now in the Cone Collection; the *Interior with a Spanish Vase*[6] of February 13th, now in the Leigh B. Block collection, Chicago; the *Persian Robe and Still Life* of February 19th,[7] and the *Pineapple and Anemones*,[8] color plate page 236, finished February 24th. The color reproduction of the *Pineapple and Anemones* reveals something of the extraordinary fluency and transparency of Matisse's style at this period—quite unlike the dense color and angular structure of the black-background pictures of the previous year, page 485.

The *Woman in a Yellow Armchair*, page 486, painted in March, is, among the many interiors of this period, a comparatively simple and spacious com-

position in which a gaily clad girl is but one of a number of decorative motifs. In this canvas the green skirt, the yellow chair, the mauve flowers against black, the light green sideboard in the background, are all played against the blue of the floor—a blue which Matisse washed out completely twice before he was satisfied with a third attempt.[1]

Matisse's paintings of the autumn of 1940, after he had returned to Nice, are much simpler and more severe in style. Perhaps he was affected by worry and his oncoming illness; perhaps, too, he felt some reaction against the free and sometimes rather voluble style of the first quarter of the year. In any case the smocked and embroidered blouse which had served as one of the many decorative elements in the complex interiors of February and March, the *Woman in a Yellow Armchair*, for instance, played a very different role in September. It then became the most important motif in a number

of flat, stylized, close-up compositions of the single figure against a bright scarlet background. The prettiest of them is the *Rumanian Blouse*[2] in the Musée National d'Art Moderne in Paris; a second is the often reproduced *Sleeping Girl*.[3] The *Sleeping Woman*, illustrated[4] on page 486, is a third variant. The design reminds one of the continuous organic curves of Jean Arp's abstract reliefs, but the drawing of the head and arm suggests an unusual intensity of feeling. It is one of the strangest and most moving of Matisse's paintings of the war period.

The *Still Life with a Shell*[5] of November and the *Still Life with Oysters*[6] in the Basle Museum are both brilliant in color but, as in the *Sleeping Girl*, the color is not so much decoration as it is a means of emphasizing the abstract severity of the design.

2 Compositions with a "Dialogue," 1941-1942

Matisse's failing health during the winter, followed by his hospitalization in Lyons from March to May 1941, seriously limited his work but by June he was painting again and had begun the long series of small interiors with two seated girls, or a girl seated beside an empty chair, perhaps the most characteristic motif used by Matisse during 1941-1942.

The *Conversation* of December 1941, like the two-figure compositions of 1939 such as *Music*, page 481, again posed for Matisse one of his favorite problems, that of establishing a subtle balance on either side of a virtual or invisible fulcrum. In the *Conversation*,[7] page 487, the figure in yellow against red at the right would dominate the figure in blue against a black background at the left were it not for the fact that not only does the black visually outweigh the red, but the light-and-dark contrast of the figure against the black is far more active than that of the figure against the red. Thus a disbalance between figures is neutralized by a compensating disbalance between value contrasts. Another often reproduced painting of the two girls, one blonde, one brunette, is *The Two Friends*,[8] in the Musée National d'Art Moderne in Paris. It is composed as a flattened pyramid about a central axis.

In 1942 paintings with a model dressed in a blue dancer's costume continue these "conversation pieces" but with an empty chair, or rather a chair holding various still-life assemblies. This chair however is of a *rocaille* design in carved wood so lively and so "organic" that it easily holds its own against the figure. So much indeed was the painter taken

with it that it appears close-up and solo in a larger painting of 1946, page 504.

The most definitive of these chair-and-dancer dialogues, dated September 1942, is reproduced on page 488 and again, in an unfinished state, in André Ostier's photograph on page 29. The variety of color, as one can see from Matisse's own color analysis, page 488, is extremely limited. Not counting the small, rather pale spots of orange and green fruits, there are only six hues: the lemon yellow of both chairs; the black of the floor; the whites of the coffee cup, the dancer's costume, and the stripes of floor and background; the strong blue of the wall, the costume, and the arms of the chair; the whitened cadmium red flesh tones of the dancer, and the bright cadmium red of her chair frame. Other paintings of the same period are very much more complex in color, for instance the very similar but somewhat earlier composition reproduced in plate IX of the Le Chêne[1] portfolio.

In the same month, September 1942, Matisse painted a series[2] of half a dozen variations on the theme of a small robed figure seated in an armchair beside a very tall French window, shuttered or opening upon a view of the distant sea. The format is upright and narrow, which, with the striping of the background, further enhances the verticality of the composition. Though the scene is essentially the same throughout the series, Matisse takes the greatest liberties with the color of the background. In *The Black Door*, reproduced on page 489, the wall is pink, in others it is red, green and ochre, blue, or black and pink. The figures and costumes change too: only the red and lemon yellow armchair remains the same. Doubtless it served as a constant about which Matisse developed his variables in color and design.

Among the other interiors with figures of 1942 are a series of the dancer in blue, seated alone, a number of small half-length studies of girls painted with the modest virtuosity of a Manet sketch, and the *Idol*, page 490, which belongs with the interiors of the following year.

3 Still Lifes, 1941-1942

The still lifes of the period are well represented in the Musée National d'Art Moderne in Paris. The *Marble Top Table*[3] of September 1941 suggests the spotty, casual all-overish composition of the fauve period but the somewhat later *Red Still Life with*

VEILED WOMAN (*Femme à la voilette*). Nice, 1942 (January).
Pen and ink. From *Thèmes et variations:* Theme N, variation 6

making an enormous effort in drawing. I say *effort*, but that's a mistake, because what has occurred is a *floraison* after fifty years of effort. . . ."

Fortunately Matisse's drawings of this period were copiously published in 1943 by Fabiani with a discerning, affectionate and poetic preface by Louis Aragon in a volume entitled *Dessins: thèmes et variations*. Matisse called it ". . . a motion picture film of the feelings of an artist. A suite of successive images resulting from the realization of a given theme on the part of the creator."[5] The 170 drawings are arranged in a suite of seventeen movements or "themes" lettered A to P. Each theme is developed in from three to eighteen variations.

We reproduce nearby only two of the drawings. The fifth variation of theme G which comprises a series of elaborate still-life compositions was drawn late in 1941, p. 265. The familiar pewter jug stands in front of the round platter with the handles, and to the left and right are sprays of magnolia—all motifs which were to appear a little later in the painting *Red Still Life with Magnolia*, page 487.

Of the sixty-five reproduced drawings done in January 1942, we illustrate the sixth in series N, based on the theme of a figure in a necklace and oriental veil.[6] In it not only gesture and character but even transparency are suggested with style and economy.

5 *Still Lifes, 1943*

Among the still lifes painted by Matisse early in 1943 before he moved from Nice to Vence, the *Tulips and Oysters*,[7] with its white and red flowers against black, is perhaps the most striking. But one of the most subtle and original of all his paintings of this period is the *Lemons against a Fleur-de-lis Background*, page 489. The objects themselves—six lemons, yellow, green-and-yellow and pale green; the squat little Chinese vase with its bouquet of tiny pink and blue flowers and long green blades—float together on the white raft of the mantelpiece in a sea of pink, above and below. A vase of similar shape and the same color had appeared in the upper left-hand corner of the *Red Still Life with Magnolia* of 1941, page 487, but then it had been a flat blue-green shape applied to a flat red surface. But in this picture the vase is modeled, turquoise in light, violet in shade, and casts a pale violet shadow on the lemons. The effect is magical and tender, a baffling contradiction of the bright, almost brutal directness of the earlier still life.

Magnolia, page 487, is one of the driest and most severely formal of all Matisse's compositions. As symmetrically organized as a quattrocento altarpiece of a Madonna and four saints, the white flower, with its pale green leaves and vase, stands circled by a halo-like platter and flanked by a turquoise blue vase and lavender jug at the left, blue flowers and a white shell at the right. In November, between these two still lifes, Matisse painted the sparse, crisp, delicately colored *Ivy, Flowers and Fruit*[4] of the Lasker collection.

4 A "Floraison" of Drawing, 1941-1942

The still lifes, interiors and figures of 1941 and 1942, even more than usual, are but the visible top of a great iceberg of effort. Beneath them, supporting them, though comparatively tentative, obscure and private, lie score upon score of drawings. Matisse was always drawing, but now the quantity and quality of his work in crayon and ink made an impression even upon himself (who was ordinarily so dissatisfied). From Nice, on April 3, 1942, he wrote Pierre in New York: "For a year now I've been

6 Interiors with a Seated Girl, 1942-1943

The most characteristic paintings of the winter of 1942-1943 are a series of increasingly elaborate red, white and blue interiors with a dark-haired girl seated to the left of a table of still life. (The model for the first of the series was Matisse's former nurse who had not yet become Sister Jacques of the Dominican Nuns at Vence.)

The *Idol* of December 1942, page 490, is the biggest, simplest and earliest of the series: the white-clad figure is seated against a bright cadmium red, diamond-patterned background; the flowers, orange and little green vase on a black table are all set against a blue background. The effect is quiet and large.

In the *Michaela* of January 1943, page 491, the curves of the yellow-gowned girl are carried across the picture by the green, curving leaves of the plant. They—the calm girl and the still plant—are surrounded and almost overwhelmed by violent zigzags of red and ultramarine, producing an extraordinarily lively tension between curve and angle, quiet and agitation.

Matisse lets his love of ornament run riot in the third of the series, *The Lute*, page 491, finished in February. There are only eight colors in the painting, all but one of saturated brilliance. Wallpaper, carpet and table are bright red, broken by a blue panel in the wall behind. The flowers are violet as is the K pattern on the mauve-white dress. The leaves and girl's hair are green (against the complementary red). The color is routine for Matisse's palette of this period, but to match this polyphony of pattern one must go back of the complex interiors of 1940, past the big *Decorative Figure* of 1927, page 449, *The Moorish Screen* of 1921, page 437, to the *Interior with Eggplants* and the *Family* picture of 1911, pages 374, 373. Yet *The Lute*, unlike most of those earlier canvases, is not a large picture. Perhaps only its banality of subject matter, dryness of design, and obvious simplicity of color make tolerable so much busyness within a picture less than two by two-and-a-half feet in area. Later, in 1946, Matisse put a decorative border around it and blew it up to many times its original size for use as a tapestry design.

In March Matisse painted the fourth of the series, the often reproduced *Tabac Royal*[8] in the Lasker collection. It is almost as elaborate as *The Lute*. Matisse, as if surfeited with the dry, flat patternizing of the earlier picture, emphasizes the third dimension by composing the picture on a diagonal with the lute on a chair, down-stage right. He had also made use of a third-dimensional effect in a still life painted in the same month, the *Lemons against a Fleur-de-lis Background*, page 489.

7 Vence

These were among the last canvases to be painted by Matisse in Nice for five years. In March 1943, as has been related, he left the Hôtel Régina for Vence where he continued to draw—flowers, models, a portrait of Apollinaire[1]—and to work on his book illustrations, but he seems for a year or so to have painted rather little. The few paintings of 1944[2] suggest a change of mood from the rather strident color and assertive design of much of the work of 1942-1943. They are comparatively softened in style and character.

The large *Girl Reading*[3] of March now in the Honolulu Museum is probably the most important painting of 1944. The model, Annélies, dressed in orange, is seated against a green chair and flanked by anemones and white tulips. The blue-black table and dark blue background are striped with chalky white. The tones are mixed, the drawing rather free and sketchy, the effect intimate but somber.

During 1944 Matisse was commissioned by the Argentine diplomat, Señor Enchorrena[4] and his wife who were stationed in occupied Paris, to decorate a door leading from their bedroom to the bath. The inner door was a single piece which became the central panel of a triptych when the outer double door was opened. The commission caused Matisse endless difficulty even though his patrons sent the actual doors down from Paris to Vence. First he tried to adapt an old motif, the idyllic theme of the sleeping nymph contemplated by a faun, page 493, in this case without the double pipes which had appeared in previous versions, pages 30, 162. But the shape of the door was awkward, the flanking panels an unaccustomed complication. By the end of June he had developed one composition far enough to try some color but it did not satisfy him.[5] He wiped it out and tried again and again, but finally laid it aside for a while. He took it up again in the fall, this time with a new theme, Leda and the Swan. In February he wrote Pierre Matisse that he had been working on the door for three months. The lower illustration on page 493 reproduces a photograph taken March 28, 1945, but not the completed state as indicated by the caption.[6] This decidedly unhappy state of the decoration was

soon wiped out as clean as its predecessors. Mme Enchorrena, hearing that Matisse had erased her decoration many times, began to fear after several years' wait that it would never be finished. Some time in 1946 or 1947 she wrote that she was coming to Vence to express her misgivings. When Matisse heard this he set to work in a frenzy and finished the doors just in time. Then he collapsed in a state of nervous exhaustion.[7] The design, however, had finally satisfied its creator.

Louis Aragon in his *Apologie du Luxe* writes amusingly about the Leda door which he saw early in 1946 "*. . . Luxe, calme et volupté . . . Mais n'ouvrez pas la porte: Madame est dans son bain. Pour moi, c'est devant Léda que je rêve.*"[8]

Matisse painted rather little during the rest of 1945. The small but handsome *Interior with a Blue Portfolio*[1] suggests no new departures. In this year *Verve* devoted a special number to Matisse's paintings of 1941 to 1944, bibl. 163. Other more important works illustrated or decorated by Matisse were now in preparation and new ones undertaken. They were to absorb much of his time between 1945 and 1948.

SECTION IV ILLUSTRATED BOOKS, 1941-1950

1 The Canon

Matisse's illustrated books occupied a great deal of his time and energy and, taken together, count among his great achievements of the 1940s. These and the other publications decorated or illustrated by Matisse have been listed by William S. Lieberman in Appendix G.

Some of the volumes often considered illustrated books do not really belong in this category at all. The *Dessins: thèmes et variations* published by Fabiani in 1943 with a preface by Aragon is simply a great collection of reproductions of Matisse's drawings done in the previous two years and it has already been described on page 268. The same may be said of the smaller collections of drawings reproduced in *Hommage*, No. 2, published in Monaco in 1944, and *Les miroirs profonds* brought out by Pierre à Feu for the Galerie Maeght, Paris, in 1947.

In a special class are the two magnificent special issues of *Verve* devoted to Matisse. *Verve*, no. 13, entitled *De la couleur* was published in 1945 and contains not only color reproductions of Matisse's paintings of 1941 to 1944 and his own diagrams analyzing the palette of each picture, but also covers, title page and frontispiece reproduced in color stencil from his scissors-and-paste compositions. These had been designed by Matisse in the summer of 1943, especially for this issue of *Verve*, which because of the German occupation could not be published until after the liberation. Upon *Verve's* double number 21-22 entitled *Vence 1944-1948* Matisse worked even more closely with Tériade, the publisher, designing the cover and forty full-page drawings of fruits and leaves which are interspersed among the color reproductions. On a title page in his own handwriting Matisse summarizes the contents: "*Ces tableaux ont été peints à Vence entre 1944 & 1948. J'ai dessiné les ornements dans le jardin. Henri Matisse.*" Thus Matisse helped transform a valuable and beautiful documentation of his paintings into a work of art—but scarcely an illustrated book.

Matisse's own canon of what constituted an illustrated book is very strict, perhaps too strict. Writing in 1946[2] he mentioned de Montherlant's *Pasiphaé* of 1944 as his second illustrated book, thus eliminating Reverdy's *Les jockeys camouflés* of 1918 and Tzara's *Midis gagnés* of 1939, in both of which were reproduced a number of his drawings; drawings, however, which were not related to the text. And he even omits the Joyce *Ulysses* of 1935, for which he did etchings specifically intended as illustrations. Perhaps he overlooked the *Ulysses* for the simple reason that he had no part in designing the book or working closely with printer and publisher, having merely agreed by long distance telephone to do six etchings on a given subject for a given amount, page 249. Such a procedure is very different from the long, arduous and intimate collaboration involved in the creation of the *Poésies de Stéphane Mallarmé*, pages 466-467, which he writes of as his first illustrated book, page 244—and the only one before the *Pasiphaé*.

2 The Eight Books of the 1940s

Matisse's illustrated books of the 1940s are eight in number. Apart from *Jazz*, which is unique, the three largest and most important were all got under way fairly early in the war: de Montherlant's *Pasiphaé; Chant de Minos* was undertaken some years before its publication in 1944; the *Ronsard* was be-

gun in 1941 and published after seven years in 1948; and the *Poèmes de Charles d'Orléans* in the winter of 1942-1943 to be published only in 1950.

The four smaller books were all, apparently, initiated after 1943 and all published within a few months of each other: Pierre Reverdy's *Visages* and the *Lettres portugaises* in 1946; the Baudelaire *Fleurs du mal* and André Rouveyre's *Repli* in 1947. To these Matisse might possibly add Tristan Tzara's *Le signe de vie* published in 1947 with its single etching of a girl's face and six reproductions of figure drawings; he would scarcely have included Elsa Triolet's *Le Mythe de la Baronne Mélanie* of 1945 which merely reproduces two drawings. The eighth book, *Jazz*, published in 1947, is in a sense primarily a portfolio of superb reproductions but Matisse himself insists that they really are illustrations to the text written by himself.

Ordinarily these books are listed in the order of publication, as in Appendix G, but they will be described here more or less in the sequence of their undertaking for, though they were often revised during the years between inception and completion, their essential character was inherent in each volume from its beginning.

It is worth noting that whereas Vollard had dominated the production of fine illustrated books up until about 1940, after that date Skira, a Swiss, and Tériade, a Greek, led the field. Matisse never completed a book for Vollard but during the 1930s he had done the great Mallarmé for Skira and magazine covers for both Skira's *Minotaure* and Tériade's *Verve*.

3 *De Montherlant's* Pasiphaé, *1937?-1944*

Matisse had drawn Henry de Montherlant's portrait in 1937[3] and about the same period began to experiment with linoleum engraving.[4] It is reported that in that year Vollard had conceived the idea of having Matisse illustrate a book of de Montherlant's poetry. In 1944 Martin Fabiani, who was able to publish books in Paris during the German occupation, brought out de Montherlant's book of poems *Pasiphaé; Chant de Minos (Les Crétois)* designed by Matisse and illustrated by linoleum engravings.

In the *Pasiphaé*, Matisse mastered the *lino*,[5] technically and esthetically for book illustration. He writes of the special problems he had to solve:[6]

My second book: Pasiphaé *de Montherlant.*

Engravings on linoleum. A simple white line upon an absolutely black background. . . .

Here, the problem is the same as that for the 'Mallarmé,' but the two elements are reversed. How can I balance the black page without text against the comparatively white page of typography? By composing first with the arabesque of my drawing, but also by bringing the engraving page and the facing type page together so that they form a unit. Thus the engraved part and the printed part will strike the eye of the beholder at the same moment. A wide margin all the way around both pages masses them together. [Pages 34-35 of the Pasiphaé *are reproduced on page 494.]*

At this stage I had a definite feeling of the somewhat sinister character of this black and white book. However, books generally seem that way. But in this case the big page almost entirely black really seemed a bit funereal. Then I thought of the red initials. That idea caused me a lot of work for, after starting out with capitals that were picturesque, fantastic, the inventions of a painter, I changed to more severe and classic initials, more in accord with the elements of typography and engraving already in hand.

So then: Black, White, Red—Not so bad. . . .

This book, because of the numerous difficulties of the architecture, took me six months' work, all day and often at night, too.

As is true of all Matisse's best illustrated books, the literary imagery of the writer stimulated him to the invention of visual images quite different from any he had created before. To the phrase ". . . *l'angoisse qui s'amasse en frappant sous ta gorge*" Matisse responds with a single beautifully inflected line which flashes down the black page like a streak of revealing lightning, page 494.

4 *The* Florilège des Amours de Ronsard, *1941-1948*

The story of the extraordinary trials and misadventures which befell the Matisse-Skira *Florilège des Amours de Ronsard* during its seven years' gestation is told in detail by Albert Skira himself.[7] Briefly, in the fall of 1941 a few months after Matisse returned from the hospital in Lyons, Skira came down from Geneva to Nice to see him. Matisse then told Skira that for a long time he had wanted to illustrate an anthology of Ronsard's love poems. He had already made his choice of the poems from the 1578 edition of the *Amours* and, remembering their great *Mallarmé* of ten years before, page 466, he hoped that Skira, too, would want to collaborate again in this new venture. Skira was flattered and enthusiastic and in spite of the war and the fall of France, ready to go ahead.

Matisse had in mind a book with about thirty

lithographs, and Skira concurred. It would be printed in Switzerland and as soon as he felt well enough and had made some progress on the book, Matisse hoped to go to Zürich to see it through the lithographer's and the press.

Matisse began work by cutting up an ordinary edition and pasting the verses into a large-paged scrapbook in which he could make sketches and study the preliminary layout. Once the distribution of the text was determined, trial proofs of the text of the whole book were printed in 24-point Garamond italic so that Matisse could work, as usual, directly on proof pages in making his drawings in lithographic crayon. It was soon clear, however, that the type selected was not suitable: Matisse's drawings required a character stronger and "more luminous."

After much searching, Skira finally discovered a font of rather worn Caslon Old-Face which satisfied both Matisse and himself. The book was then composed all over again in Caslon, a tedious process since the number of characters in the old font was so limited. Five more proofs of the entire text were pulled for Matisse's use. Matisse then set to work to prepare the final version of his drawings. The work went slowly, partly because Matisse kept adding to the number of designs. When Skira last saw him in the winter of 1942-1943, he had papered the wall of his studio with studies. "*Hein*," said Matisse, happily, "We're making progress! But I don't know when I can stop myself!"

Then the Germans occupied Vichy France and and were driven out by the Allies so that it was not until 1945 that Skira heard from Matisse that the Ronsard was finished and that he was eager to see it come out. When Skira finally saw the *maquette* in 1946 it was so much larger that he was "stupefied at the importance" of the work Matisse had done. Skira now moved back to Paris and the composition of the type began a third time. The aged, worn and rounded characters made endless trouble in the composing room. After eight months of exasperating work the printing of the text pages was completed in May 1947 and made ready for the lithographers, Mourlot Frères, page 496. These master lithographers were just about ready to begin printing the illustrations from the stones when it was discovered that all the pages had turned yellow over the summer. The whole edition had to be scrapped, and by now the ancient Caslon was too worn for further use.

Matisse went back to Vence frustrated, but not

before trying out a new color for the lithographs which thereupon required a slightly toned paper. The special paper was ordered from the Papeteries d'Arches, but to find another font of obsolete Caslon was far more difficult. The type foundries of Paris, Brussels, Amsterdam were ransacked in vain. Finally, by great good luck, Skira found Caslon's own original dies or molds in a foundry in Basle and a brand new casting of the font was made especially for the book.

Meanwhile the inexhaustible Matisse had taken advantage of the delay to change thirty of the lithographs so that it was only in the spring of 1948 that the Ronsard was finally published with a total of 126 lithographs instead of thirty as originally planned. Even then the distribution was held up while Matisse refined the design of the decorated cardboard box in which the book was to be packed.

Such a tale of quixotic perfectionism and "inefficiency" might have had little but a moral value. Fortunately Matisse and Skira and their collaborators, the printers Kundig of Geneva and Girard of Paris, and the lithographers Mourlot—and should not one add William Caslon?—had produced a masterpiece.

The *Ronsard* is magnificent in scale, with *quarto Jésus*, grey-tinted pages as big as a tabloid newspaper's. The reproductions here show typical compositions of facing pages. The drawings, wonderfully free in style, sometimes extend almost the full height of the page or boldly spread across the sheet beneath the text, page 496, without regard for margins. Matisse had absorbed himself in Ronsard's poetry; his illustrations, sometimes employing metaphors such as the prancing leaf-satyrs seen here, page 497, harmonize perfectly with the vernal grace of style and whimsically erotic sentiment of the 16th-century master (to whom even Queen Elizabeth paid homage).

5 *The* Poèmes de Charles d'Orléans, *1943-1950*

Charles, Duke of Orléans, was, after François Villon, the foremost lyric poet of 15th-century France. Captured at Agincourt, he spent twenty-five years of luxurious captivity in England, practicing the courtly arts of venery and poetry. Five hundred years later, Henri Matisse paid Charles d'Orléans a most elaborate homage: he selected and with his own hand copied out a century or so of Charles' poems and then adorned the manuscript with col-

ored crayon decorations and portraits. The *Poèmes de Charles d'Orléans* was begun at least as early as 1943 and published by Tériade early in 1950.

The paltry pair of reproductions on page 495 fail not only to represent the scale, color and generous profusion of the original pages but also tend to make one forget that an illustrated book is an experience, a work of art, which like music is to be enjoyed in a sequence of time. Turning the leaves of the *Charles d'Orléans* we come first on a prelude of four end pages of grey crayon fleur-de-lis with green veins, about half a dozen to a page but varied in number and order. Then comes the frontispiece, a noble portrait of Charles himself in brown crayon opposite the title page of blue crayon manuscript with red borders. (The portrait is dated 3/43, the month in which Matisse painted the *Lemons against a Fleur-de-lis Background*, page 489, just before leaving Nice for Vence.) The fleur-de-lis motif, which of course refers to Charles, a royal duke and father of a king, is repeated on page nine and again on page ten, in grey with olive-green hatchings, opposite the first *rondeau* in Matisse's pen-and-ink manuscript surrounded by a crayoned frame of grey, ochre and red pink. Then follow a series of *fleurdelisé* left-hand pages, each in different pairs of colors, opposite decorated *ballades*, *rondels*, and *chansons*. Four or five times the poem pages are interrupted by striking portrait drawings of ladies in court costumes but it is the series of variations on the fleur-de-lis which makes the book extraordinary. We reproduce pages 68-69 with a *chanson* surrounded by an interlace of ochre, grey and pink, opposite brown and green fleur-de-lis.

Possibly the effect of the *Poèmes de Charles d'Orléans* is both too elaborate and too casual. In no other of Matisse's books does one feel the same sense of the artist's pleasure in his work as he plays here his subtle games with children's crayons. The manuscript text is touching, too, but Matisse's modern manuscript, though characterful enough, seems too informal, his crayon ornament perhaps too coarse and profuse really to harmonize with the polished ingenuity and intricate grace of the poet's rhymes and meters, not to mention his sentiment.

6 Baudelaire's Les fleurs du mal, *1944-1947*

Matisse began work on the illustrations[8] for Baudelaire's *Les fleurs du mal* at Vence in 1944, but the book was not published until 1947. Publication was delayed by one of the accidents which so often beset

the production of fine illustrated books in France. A hot, dry summer dried out Matisse's lithographic crayon drawings so that the craftsman at Mourlot's dampened the sheets slightly before transferring the drawings to the stones. When proofs were pulled it was found that the paper had expanded, altering the proportions of the designs. Fortunately Matisse had had photographs made of the drawings; otherwise, according to Louis Aragon, who explained the incident at the back of the book, eight months' work would have been lost. Photo-lithographic reproductions were then made instead, with little visible disadvantage.

There are thirty-three of these photo-lithographs in the Baudelaire, mostly heads of women such as the illustration for *Sed non satiata* reproduced here, page 498. One of Matisse's most unforgettable images was the mask drawn for Mallarmé's *Tombeau de Baudelaire*, page 240, yet Matisse's illustrations for Baudelaire's own poetry seem inadequate. This handsome head of a Negress, for instance, is scarcely a match for the "*bizarre déité*," the "*démon sans pitié*," of the poet's own dark passion. Nevertheless Matisse did not spare himself for, besides the lithographs, he drew dozens of initial letters like the "B" shown here and many calligraphic abstract designs in line which were reproduced by wood engravings. One of them is illustrated.

7 The Lettres portugaises, *1946; Books by Reverdy, 1946 and Rouveyre, 1947*

The *Lettres portugaises*, page 499, in English usually called the *Love Letters of a Portuguese Nun*, by Marianna Alcaforado, were somewhat better suited to Matisse's talent. Their pathetic sentiment is agreeably adorned by Matisse's initials and leaves in violet crayon but the brown crayon portraits of the hooded authoress which are inserted among the letters—though charming variations on a sad-eyed theme, page 499, seem far from adequate equivalents for the passionate text. The covers, the layout, the entire design of this intimately charming little book were Matisse's work, in consultation with the publisher, Tériade.

Matisse designed completely two books of poetry by friends of his. Years before, in 1918, some of his early drawings had been published in Reverdy's *Les jockeys camouflés*, pages 155, 180. For Reverdy's *Visages* Matisse now designed an edition with fourteen brown crayon heads of girls, initials and linoleum cut tailpieces. *Visages* was published by

Editions du Chêne in 1946, limited to 250 copies.

A year later du Belier brought out André Rouveyre's *Repli*, a cycle of poems in two parts. For the first part, "*Retourner*," Matisse drew six female heads; for the second, "*Revoir et survivre*," six male heads, all in dark grey lithographic crayon on pale grey paper with red initial letters and linoleum cut flower motifs for *culs-de-lampe*. The cover design was a stencil reproduction of a scissors-and-paste decoration, yellow on white.

The books with lithographic illustrations such as the *Ronsard*, the *Lettres portugaises*, the Baudelaire and the Reverdy *Visages* offered problems of design which Matisse solved according to principles he outlined in 1946 (see Appendix J).

8 Jazz, *about 1943-1947*

Matisse concluded the text which he wrote to accompany *Jazz* with this sentence: "I pay my respects to Angèle Lamotte and Tériade—their perseverance has sustained me in the creation of this book." *Jazz* was not published until the fall of 1947 but Matisse already had it under way in Vence before the end of the war, for Tériade's devoted collaborator on *Verve*, Angèle Lamotte, who had helped encourage the venture, died early in 1945; and well before that Matisse had completed a scissors-and-paste frontispiece for the *Verve* "*De la couleur*" issue, a *Fall of Icarus* dated June 1943, which is clearly an early version of the *Icarus*, page 500, reproduced in *Jazz*. Tériade's connection with Matisse's *papiers découpés* goes back still further to 1937 when Matisse used the technique for the cover of the first issue of *Verve*. In this cover design the scissored or torn paper is used essentially as a decorative frame for an ink drawing. The following spring, as we have seen, Matisse made a *Dancer* entirely out of cut paper, page 482. Previously he had used cut paper extensively in designing the Barnes murals, page 463, and in at least one easel painting, the *Pink Nude* of 1935, page 472, but in these paintings, of course, the pinned-on sections of paper were purely a technical device to facilitate revisions in the composition.

9 *Matisse and the Collages of Cubists, Dadaists, Silhouettists*

This utilitarian purpose has also been proposed to explain the origin of cubist *papiers collés* back in 1911, but Picasso has denied this, stating that they were always intended to be what they are: pictures in their own right.[1] The cubists had of course used scissors, too, as well as paste, in their *papiers collés* but never with the virtuosity developed by Matisse.

Matisse's use of cut-and-pasted paper is in fact radically different from that of the cubists thirty years before. He is indifferent to the esthetic and psychological conceits which involved both cubist and, subsequently, dadaist *collages* both of which Louis Aragon brought together under the title *La peinture au défi*.[2] Matisse's *papiers découpés* are as pure in intention as they are in technique and they are completely controlled. Unlike the cubists who used scraps rescued from wastepaper baskets or the dadaists who cut up old mail-order catalogs, Matisse was not even satisfied with the best commercial colored papers: he had his own papers painted with gouaches of his own choosing and then proceeded with his scissors.

In one sense Matisse's *papiers découpés* are closer to the silhouettes of the early 19th century than they are to cubist *papiers collés* for, once the colored paper was in hand, the scissors became the sole instrument used to define the shape of the individual image; but where the expert silhouettist prided himself on cleverly concealing evidences of his technique, Matisse, with that modest respect for the medium which characterizes his generation, never tries to conceal the stroke of his scissors. In the text for *Jazz* he writes under the heading *Drawing with Scissors*: "To cut to the quick in color reminds me of direct cutting in sculpture. This book has been conceived in that spirit."

10 Jazz: *the Text and Subject Matter*

Jazz was published in September 1947 as a book of nearly 150 pages. Matisse himself wrote the text pages which reproduce his handwriting very large, a few words to a page. There were twenty plates or "illustrations." Though five or six pages of text come before every stencil there is little obvious relation between them. They were intended more as a kind of interstitial padding to rest the eye between bouts with the dazzling plates. Matisse explains in a preface to the text itself:

These pages are only an accompaniment to my colors, just as asters help in the composition of a bouquet of more important flowers. THEIR FUNCTION IS THEREFORE PURELY VISUAL.

What can I write? I cannot fill these pages with the Fables of La Fontaine as I did, when I was a law clerk. . . .

I can therefore only jot down some remarks, notes which I have made during my life as a painter. I ask for them, from whoever should have the patience to read them, the indulgence which is generally accorded to the writings of painters.

The bulk of the text is composed of poetic or philosophical reflections on arranging flowers, the airplane, drawing, art, belief in God, hatred, love, happiness and the future life. Besides first and last paragraphs and the comparison of scissors to the sculptor's chisel already quoted, there is only one line referring to the specific subject matter of the prints and that concerns lagoons. (Bibl. 48, 48a.)

At the end of the text, under the heading *Jazz* he summarizes the general subject matter or, better, the inspiration of the illustrations:

The images presented by these lively and violent prints came from crystallizations of memories of the circus, of popular tales or of travel.

The circus predominates: *The Clown, The Cowboy, The Knifethrower, The Codonas* (a team of trapeze artists) and two related fantasies, *The Burial of Pierrot* and *The Nightmare of the White Elephant.* There are poetic abstractions such as *The Heart* and *Destiny* and several abstract compositions among them three called *The Lagoon.*

11 Four Plates from Jazz

In the text of *Jazz,* under the heading *Lagoons,* Matisse wrote: "Mightn't you be one of the seven wonders of the Paradise of painters?" Matisse had himself journeyed to Tahiti, popularly considered a kind of paradise, and there he traveled privately among the smaller islands and remote lagoons. But the shapes of his lagoon motif are perhaps closer to patterns of seaweed—they seem more nearly botanical than geographical abstractions. In any case leaf shapes which apparently he had first explored in the *Conservatory* and *Music* of 1937-1939 fascinated Matisse, pages 478, 481. He used them repeatedly in *Jazz* and in many other scissors-and-paste compositions of the period, including magazine covers, textiles, a rug, page 510, and above all in the double window of the Vence chapel, page 517, above.

The Lagoon, page 500, plate XIX in *Jazz* is the third design of that name. In it the "leaves" are cut in half or, perhaps, lobed only on one side. Their colors are blue, cherry red, yellow green, blue and black on a large pale grey rectangle. In plate XIV, the black cowboy ropes his black steer against vertical panels of blue, yellow, green, white and blue, page 501. The white elephant, plate IV, a scalloped, lemon-yellow shape outlined by black "leaves," encloses a prancing, scarlet-streaked, blue-starred nightmare. In both prints the animals are highly abstract silhouettes yet their essential shapes and movements are expressed.

The Icarus, page 500, one of the simplest images in the series, is perhaps the subtlest poetically. In an earlier version Matisse had shown Icarus, his heart a red star, shooting down a blue diagonal path between black star-studded skies. Here, in the final version, his heart is reduced to a palpitating scarlet dot which scarcely animates his dangling limbs as he falls through deep blue infinity.

SECTION V PAINTING, DRAWING, CUT-AND-PASTED PAPER, 1946-1950

1 Figures and the First Large Interior, 1946

Fresh, bright color at maximum saturation, unmodeled and often unmodulated surfaces, flattened space and emphatic design characterize most of Matisse's easel painting of 1946. Possibly the unprecedented brilliance of some of his cut-and-pasted paper designs affected his palette, for this is the period of the *Jazz* portfolio.

Two striking paintings of costumed models are the best known canvases of the year. The *Girl in the White Gown*[3] in the John Cowles Collection, Minneapolis, and the large *Asia,* page 503, in the Tom May collection are both painted in ochre, scarlet, white and violet with green, blue and black accents. The former is conventional in pose, the latter mannered, with suggestions of Persian miniatures, though more in the drawing than in the rather relentless color.

Among the important still lifes of the post-war period *The Rocaille Chair,* page 504, is more retrospective in style though in its composition, a close-up of the sinuous contours of a carved *rocaille* chair, it is striking enough.

The same chair appears in the background of the *Interior in Yellow and Blue,* page 502, perhaps the first of the great series of large interiors which came to a climax in the spring of 1948. This canvas of 1946 is drier and cooler than the later compositions, in fact it resembles a deft, very large drawing in heavy

black lines upon an ochre yellow canvas with ultramarine rectangles in two opposite corners. The third color, green, is confined to the leaves, the tumbler and the stripes on the melons—the only local color in this curious picture which for all its sparseness does not seem meager. The *Interior in Yellow and Blue* now hangs in the French Embassy at Washington.

2 Small Interiors with Two Girls, 1947

The year 1947 is marked in the history of Matisse's paintings by the brilliant variations on the theme of an interior with a window in the upper right-hand background and two girls seated behind a table. Eight of these are reproduced in color in *Vence 1944-1948*, bibliography 164. The canvases are not large but they admirably display Matisse's freedom and virtuosity in handling color. Some are rather conventional but others take every liberty with local color. In the *Blue Interior with Two Girls*, reproduced on page 504, the cool blue- and black-striped background almost overwhelms the yellow dress and green leaves. The black window framing is shot with extraordinary magenta hatchings hot as electric filaments. The variation entitled "*Le silence habité des maisons*" is black, with figures, table and flowers all in yellow-edged blue, a nocturne interior made eerie by the bright summer day seen through the garden window. In color, perhaps the most inspired variation is the one with a night-blue window view set off by the fresh coral colored "L" of the interior wall. Both are also reproduced in color in *Vence 1944-1948*.

The other paintings of 1947 are also interiors, with a nude or fruit taking the place of the two girls. They are mostly more violent in color and seem to prepare the way for the larger compositions of the following year. But before proceeding to his paintings of 1948 his drawings of this period should be considered.

3 Secular Drawings, 1947-50. Chinese Analogies

The drawings of 1947-1948 are not only closely related to the paintings of the period in motif—interiors with flowers and fruits—but rival them in scale and power. In fact they are quite unprecedented in Matisse's graphic art, overwhelming even such a work as the fauve *Seated Nude*, page 325, in their black-and-white boldness of effect. Early in his career Matisse had used brush and ink for sketching but since that time his drawing has been largely confined to pencil, crayon, charcoal-and-stump, or pen-and-ink.

The *Dahlias and Pomegranates*, reproduced on page 508, is rather simpler in subject than most of these big drawings but it well demonstrates the certainty with which Matisse wielded his big brush and the carrying power of the result. It is not insignificant that in a canvas of 1948, page 507, Matisse makes one of these brush drawings hold its own against a larger oil painting.

Without the benefit of the millennium-old, exquisitely disciplined tradition of Far Eastern brush-and-ink painting behind it, the *Dahlias and Pomegranates* would doubtless seem brash and unsophisticated beside a Sung or Ashikaga still life. Yet the modulation of the ink and the spotting of blacks suggest that rhythmic vitality which Hsieh Ho, about the year 500, pronounced the first principle of good painting.[4]

Matisse during the 1940s seems to have come nearer the Chinese in his drawing than ever before. In the garden at Vence and later in Nice he made scores upon scores of drawings of leaves, observing not only their endless variation of form and distribution on the branch within a given species but also the characteristic changes of shape caused by growth or withering. Thus, like the philosopher-poet-painters of the T'ang and Sung, he mastered essential forms and relationships in so far as Western individual sensibility can penetrate essentials discerned and defined in China by many centuries of cumulative knowledge. Some of these leaf studies are reproduced as decorations in *Vence 1944-1948*.

The sense of the ink-loaded brush passing confidently over the paper is strong again in the *Torso—Back View* of 1950, page 509. The *Lydia* of 1949, page 277, a big pen-and-ink drawing, is an exceptionally interesting example of many hundreds of studies of models' heads made during the decade. The most important of Matisse's drawings of 1948-1950 were of course the studies for the Vence chapel murals which are themselves gigantic drawings, pages 518-523. In 1951 he published a series of aquatint heads in a broad, brushed line.

4 The Large Interiors of Early 1948

The great series of large interiors painted by Matisse in the post-war period begins with the *Interior in Yellow and Blue* of 1946, page 502, is continued in the *Red Interior with a Blue Table* of 1947 and in six magnificent canvases of 1948, *The Egyptian Curtain*,

color plate page 239, *The Pineapple*, page 506, the *Plum Blossoms, Green Background*, page 505, the *Plum Blossoms, Ochre Background*, the *Black Fern* and the climactic *Large Interior in Red*, page 507. Fortunately, all but one of them may be studied in good, large color plates in *Vence 1944-1948*.

The Egyptian Curtain, the culmination of the interior-with-window compositions which occupied Matisse almost exclusively in 1947, is discussed in detail opposite color plate page 239. Three other canvases of 1948 form a group in which plant forms dominate an interior composition in which a seated girl plays a subordinate role. These are the *Black Fern* in the Leigh B. Block collection, Chicago, and the two plum blossom pictures one of which, in the Albert D. Lasker collection, we reproduce on page 505.

In the *Plum Blossoms, Green Background* Matisse divides and balances his field between the bright red table top (which extends to the girl's dress) and the bright green "wallpaper" with a black leaf pattern. Two secondary colors, also in flat planes, are the strong ultramarine of the vertical panels on the wall and the bowl in the foreground; and the pale grey of the vases and chair back. These flat tones are then both broken and linked by the vibrating pink of the plum blossoms and the bright yellow of the flowers and pears. Thus three pairs of colors, red and green, blue and grey, pink and yellow, each pair balanced and performing different functions, are all united in one handsome harmony.

The Pineapple, page 506, is unique in the group; indeed the concentration upon a single object recalls the still lifes of 1916-1917 such as *The Lorrain Chair*, page 409, and *The Rose Marble Table*, page 407. The prevailing background tones are orange and red with a green curtain at the right. Against this rests the blue and green disc of the table surmounted by the pale blue wrapping paper. The immediate background of the pineapple is a dull pink below and lemon yellow above. Thus the pineapple, itself a surprisingly subtle grey and white, serves as a wittily modest bull's eye in a target of brilliant surrounding colors. Of all the series *The Pineapple* is the most fluid in form, the freshest in color, the most abstract in effect.

5 *The* Large Interior in Red, *1948*

The *Large Interior in Red*, page 507, is not only the climax, it is also the epitome of Matisse's painting of the years 1946-1948 with its clearly drawn forms,

LYDIA. Nice, 1949. Pen and ink, 17¼ x 14⅝". Inscribed: *à John Rewald / aout 50*. New York, John Rewald

strong flat color and suppression of deep space in favor of excitement kept close to the plane of the canvas. The bilateral symmetry of the composition is as courageous as it is inescapable: the two big rectangles formed by the painting (*The Pineapple*) and the big drawing balance each other on either side of a straight black axial line; the two curve-legged tables with their array of flowers are divided by the rectilinear Dutch chair, and, below, on either side, are the two completely curvilinear animal skin rugs. But the symmetry though deliberately formal is not static: in each of the three pairs the right-hand unit is larger and heavier, but the balance is restored by the black and white activity within the big drawing and by its stronger value contrast against the background.

What is most striking of course about the painting is what cannot be seen in the halftone: its overwhelming redness. It is not a dead even red: evidence of the brush's passage enlivens the surface and the cadmium is modulated in certain areas by vermilion tones. But the general effect is of a red which pervades not only the whole background of

floor and wall but also the two tables and much of the painting on the wall.

Possibly Matisse had in mind the *Red Studio* of 1911, color plate page 162, when he painted this *Interior in Red*. In both pictures the objects—paintings on the wall, tables, chairs—float on a sea of red, but the *Red Studio* is centrifugally scattered in composition, a central axis only slightly indicated. The 1948 canvas is classically, almost rigidly constructed. In both, the furniture exists as black outlines drawn on the red, but in the early picture the perspective of the room is also drawn, whereas in the recent work objects are left to float, the depth of the room being implied not rendered. The space of the 1948 *Interior* is in fact closer in effect to that of the *Goldfish and Sculpture* of 1911, color plate page 165, but is even bolder in its elisions, just as the picture as a whole, if one discounts the important factor of time, is a more uncompromising performance.

Of course the *Goldfish* and *Red Studio* were more conspicuous acts of daring in 1911 than the *Large Interior in Red* was in 1948. But daring is a comparative virtue and generally a youthful one. In this, his greatest canvas of the decade, Matisse, within a year of his 80th birthday, makes a statement which transcends daring by demonstrating, rather, the balance and the serene clarity of his vision and mastery of his art. This is not to say that he no longer had need of courage or that he had passed beyond creative audacity. His courage and audacity were now simply to be shown in other media than easel painting and, perhaps, for a grander purpose than secular delight.

In the three years after the completion of the *Large Interior in Red* in the spring of 1948 Matisse devoted most of his creative energy to the design and decoration of the Chapel of the Rosary at Vence.

6 Cut-and-Pasted Papers, 1947-1950

Matisse gave most of his creative energy to the Vence chapel, but not all. Besides many secular drawings he continued to make compositions by cutting and pasting papers which he had had colored with flat gouaches under his own supervision. Many of them were studies for the chapel windows but others are purely secular in subject and constitute his most important non-religious work of the period beginning in June 1948, when he stopped his easel painting, and June 1951, when the chapel was finished.

Over a score of *papiers découpés* dating from 1947 and 1948 were included in the Matisse exhibition of 1949 at the Musée National d'Art Moderne in Paris.[5] Some of these were quite close to the *papiers découpés* which had been reproduced in *Jazz*. We reproduce one of the smallest and best of them, the *Negro Boxer*, page 513. The image is again the abstract multi-fingered "leaf" form but, at the same time, it is a black figure in motion, feinting, weaving, jabbing, against the background of a bright red "squared circle" on green.

At the Maison de la Pensée Française[6] the following year Matisse exhibited three very large cut-and-pasted papers catalogued as gouaches and all done in 1950. These were *The Dancer*, not illustrated, *Zulma*, a large nude, page 513, now in the Copenhagen Museum, and *The Thousand and One Nights*, page 512. The last is virtually a twelve-foot frieze of small, brilliant *papiers découpés* of various motifs arrayed between rows of hearts mingled, in the upper right-hand corner, with the lettering: ELLE VIT APPARAITRE LE MATIN/ELLE SE TUT DISCRETEMENT.

SECTION VI DESIGNS FOR DECORATIVE ARTS, 1940-1950

Photographs taken by Varian Fry in mid-1941, page 30, show Matisse at work on a big tapestry cartoon of a grove of trees with a faun piping to a sleeping nymph in the foreground. The tapestry itself never seems to have been woven although the cartoon appears to have been intended as a design for a pendant to the *Window at Tahiti* tapestry of 1936, page 475.

In 1946 Matisse received commissions for at least three tapestry cartoons.[7] One of them, *Woman with a Lute*, woven in 1949 at the Gobelins factory, is virtually an enlargement of *The Lute*, a bright, dry, flat and elaborate painting of 1943, page 491. The other two, woven by the Beauvais craftsmen in 1947 and 1948, are more original. Entitled *Polynesia: The Sky* and *Polynesia: The Sea*, they form a pair of hangings about six by ten feet in size. The cartoons were cut-and-pasted paper motifs based on his memories of Tahitian flora and fauna. The bird, fish and leaf forms were distributed in monochrome silhouettes over a plain field with a decorative border. For the first time Matisse had completely abandoned his

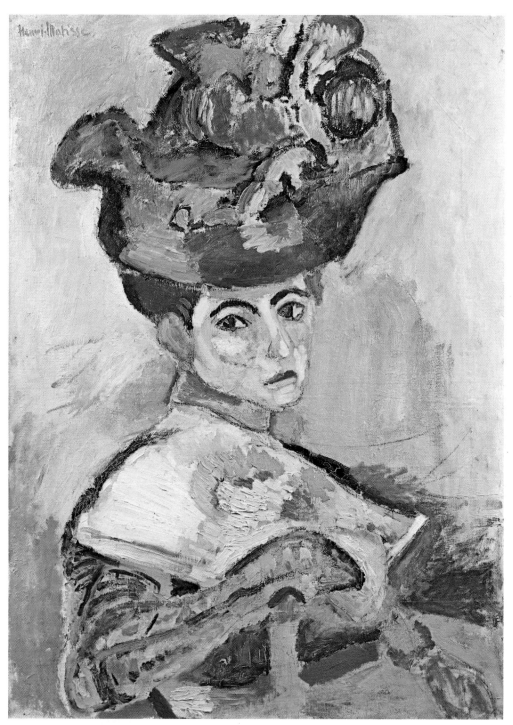

WOMAN WITH THE HAT (*Femme au chapeau; Madame Matisse*). Paris (1905, autumn). Oil, 32 x 23½". San Francisco, Mr. and Mrs. Walter A. Haas. See pages 55–59, 62.

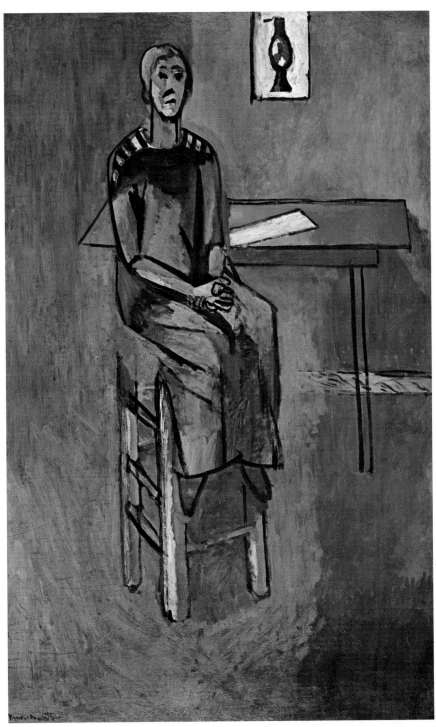

WOMAN ON A HIGH STOOL (*Femme au tabouret*). Paris (1913–14, winter). Oil, 57⅞ x 37⅝″. New York, The Museum of Modern Art, gift of Mr. and Mrs. Samuel A. Marx, the latter retaining life interest. See page 184.

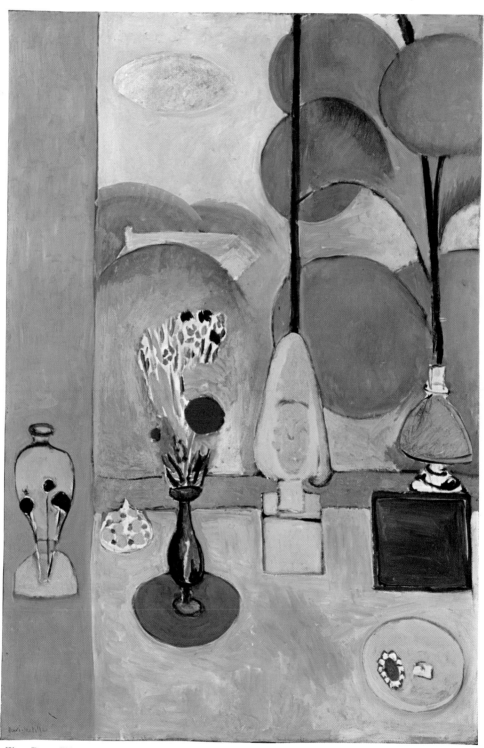

THE BLUE WINDOW (*La fenêtre bleue*). Issy-les-Moulineaux (1911, autumn). Oil, 51½ x 35⅝".
New York, The Museum of Modern Art, Abby Aldrich Rockefeller Fund. See page 166.

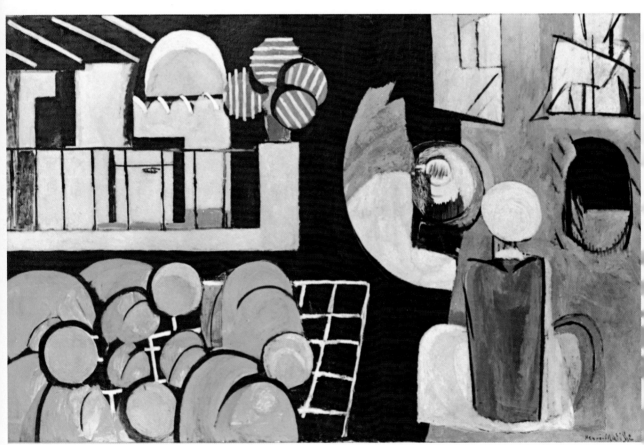

THE MOROCCANS (*Les Marocains*). Issy-les-Moulineaux? (1916). Oil, 71⅜ x 110". New York, The Museum of Modern Art, gift of Mr. and Mrs. Samuel A. Marx. See page 173.

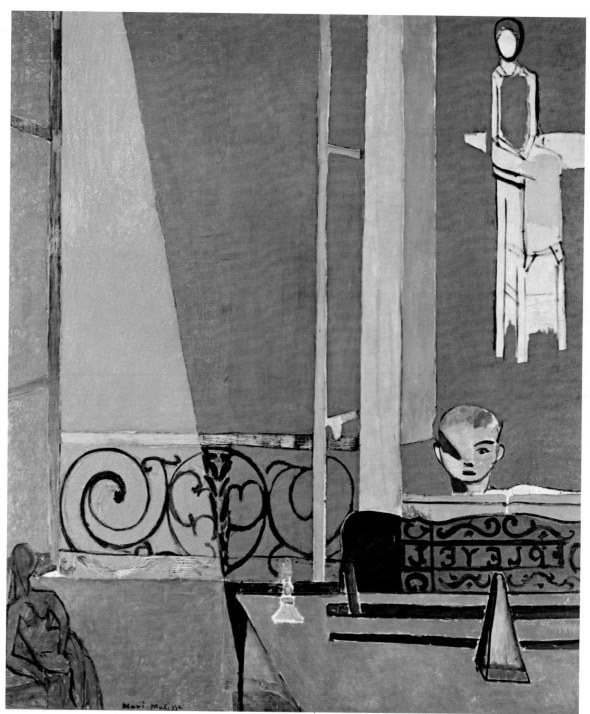

PIANO LESSON (*La leçon de piano*). Issy-les-Moulineaux (1916 or 1917). Oil, 96½ x 83¾″. New York, The Museum of Modern Art, Mrs. Simon Guggenheim Fund. See page 174.

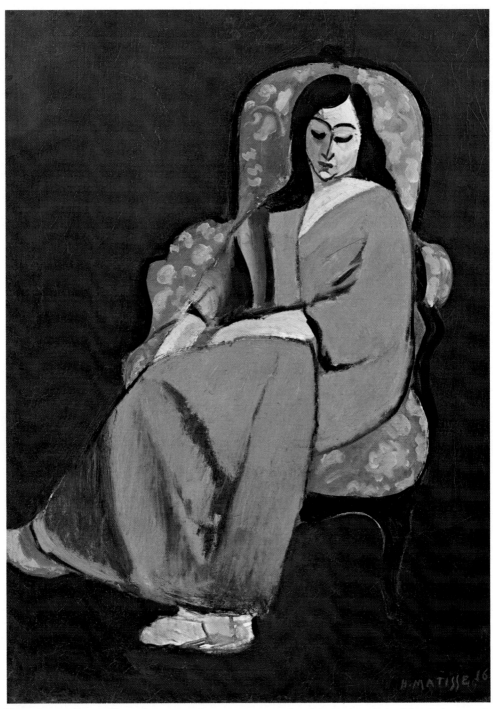

THE GREEN ROBE (*La robe verte; Laurette sur fond noir*). Paris, 1916. Oil, 28¾ x 21½".
New York, Mr. and Mrs. Pierre Matisse. See page 191.

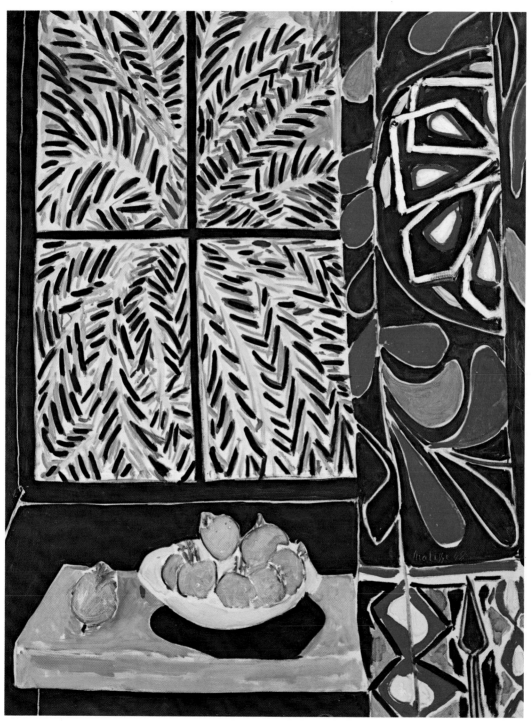

EGYPTIAN CURTAIN *(Intérieur au rideau égyptien)*. Venice, 1948 (early). Oil, 45⅝ x 35″. Washington, D.C., The Phillips Collection. See page 238.

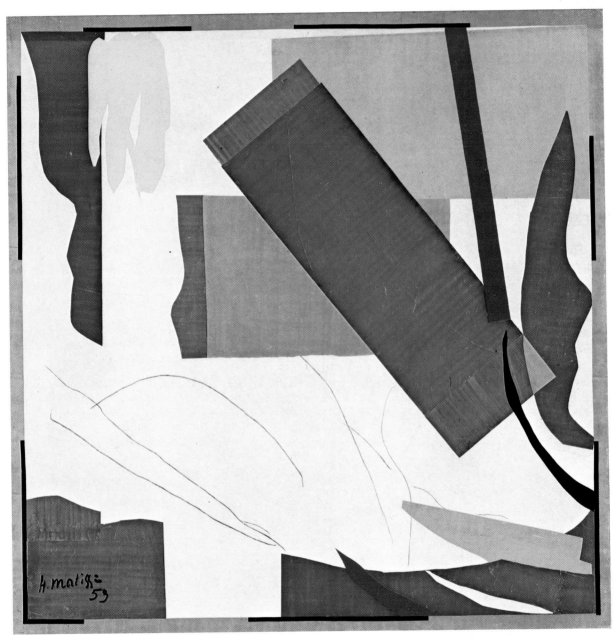

MEMORY OF OCEANIA (*Souvenir d'Océanie*). Nice, 1953. Gouache and crayon on cut and pasted paper on canvas, 112 x 112⅞″. New York, The Museum of Modern Art, Mrs. Simon Guggenheim Fund. Although Matisse made *Memory of Oceania* in 1953, two years after the publication of the original edition of *Matisse: His Art and His Public*, the picture is included here to represent with a major example the last great phase of the artist's work.

drawings and easel paintings as bases for his tapestry cartoons.

About 1947 the London merchants A. Ascher, Inc. commissioned Matisse to make designs for linen wall hangings and kerchiefs. The two large "Ascher Panels" (Henry Moore also designed two) were closely related to the two Beauvais tapestries in motif and name. *Océanie—le ciel*, and *Océanie—la mer*, page 510, were however quite different in character. They were long narrow hangings about five by twelve feet in natural linen on which Matisse's Tahitian motifs were printed in white by silk screen stencil. The matt, opaque white and the slight intaglio of the silk screen impression against the sand-pale linen made a subtle and unusual effect. In 1949 Matisse designed a silk screen "mural scroll" for Katzenbach and Warren, Inc., New York.[8]

About the same period, in 1948, the hundred-year-old firm of Alexander Smith, Inc., carpet manufacturers of Yonkers, near New York, engaged Matisse to design a rug, page 510. A number of misunderstandings over a period of two years were finally resolved to Matisse's satisfaction, though not until an entire edition of the rug had been scrapped. Matisse developed his design with scissored paper variations on his favorite philodendron leaf motif. The effect is the opposite of that in the sparse, pale Ascher panels. On a field of vermilion, crimson and maroon quartering Matisse has arranged overlapping leaf forms, brilliant yellow, grey, and black in the crowded center, blue and black in the corners.

SECTION VII THE CHAPEL AT VENCE

1 Sister Jacques and Brother Rayssiguier

The story of the Vence chapel has often been told.[9] Even before the designs were well under way rumors were spreading—perhaps one should call them legends—as to how and why the chapel was undertaken. It was even reported that Matisse was donating the chapel as a votive offering to fulfill a vow taken at the time of his operations in Lyons in 1941. Actually his illness in 1941 did play an important part in the origins of the chapel but in quite another, less pious and more human manner. While he was recovering in Nice he had a handsome and devoted nurse who, it is said, had intended shortly to become a nun, but actually postponed taking the veil so that she might finish guarding his convalescence. After tending Matisse in Nice, she sat as his model for drawings and paintings such as the *Idol*[1] of 1942, page 490; she was herself interested in painting.

Later on, in the mid-'40s, she had come to Vence as Sister Jacques,[2] a Dominican novice, to serve in the conventual rest home for tubercular girls called the Foyer Lacordaire. The convent, as it happened, was on the route de Saint-Jeannet, just opposite Matisse's Villa le Rêve so that Sister Jacques used often to walk across the road to visit Matisse. One day she brought him a watercolor design of a stained glass window for the proposed new oratory of the convent, the old one having been destroyed by fire. Matisse encouraged her, made some suggestions, offered to help her and then became so interested in the problem that before long he himself was designing windows.

About this time Brother L. B. Rayssiguier, a Dominican novice, came to Vence for his health. He had had some architectural training and was at the same time interested in modern painting. He called on Matisse and "talked so long and so well about the chapel that Matisse abruptly offered to do it himself."[3] Together they worked out the plans, Rayssiguier supplying architectural and liturgical knowledge, Matisse the creative vision of the whole chapel as a work of art down to the last detail of furniture and decoration. Matisse also helped by underwriting a considerable part of the costs.

The Catholic Church or, rather, the Dominican order soon recognized the importance of Matisse's participation. Father M. A. Couturier, the distinguished Dominican entrepreneur of modern religious art came down from Paris to consult with the nuns, Matisse and Brother Rayssiguier; Auguste Perret, the only French architect of Matisse's own age and eminence, was enlisted as consultant.

2 The Church at Assy: its Significance

Father Couturier had for some years past been serving as artistic advisor in a far more ambitious enterprise, the decoration of the Church at Assy in the Haute-Savoie, which had been undertaken in 1937 by a courageous local churchman, Canon Devémy. In 1939 Devémy had persuaded Rouault to design some stained glass windows and, in 1943,

Bonnard agreed to paint an altarpiece. By 1945 Léger was at work on the mosaics of the façade, Lurçat on a huge tapestry for the apse. In 1947 Braque and Lipchitz received commissions for sculpture. Thus, step by step, the obscure, provincial church at Assy had enlisted the services of half the most famous living artists, all of whom apparently for the first time had been offered and had accepted ecclesiastical commissions.[4] Among the artists Rouault was, in fact, the only practicing Catholic but, as Couturier insisted, when art is involved, even Catholic art, piety is no substitute for talent.[5]

This achievement of the Abbé Devémy and Father Couturier was of course a revolutionary program directly in opposition to the timidity and blindness which had led the Catholic Church to ignore even so devout a Catholic and so great a Christian artist as Georges Rouault for almost fifty years. Assy represented not merely an artistic rebellion within the Church, it also had political implications in a country where the artist and intellectual have great prestige.

Léger's mosaic and Lurçat's tapestry were the largest and most conspicuous works of art at Assy. Shortly before accepting his commission, Léger, just back from his war years in New York, had declared his membership in the Communist Party; Lurçat had been an active party worker since the mid-thirties. Their reputations had been made years before as modern painters working in more or less abstract manners and their art was in 1945 still as far from the socialist realism enjoined by orthodox Stalinists as it was from the banal *bondieuseries* of the Place St. Sulpice. Thus by conferring patronage on Léger and Lurçat as well as on Braque, a cubist, and Lipchitz, a Jew and an expressionist, the Church at least on this occasion had not only demonstrated its tolerance and advanced taste but had struck a shrewd blow in the desperate struggle between Catholicism and Communism for the influential good will of the artists and intellectuals of France. Matisse was also to be involved in this conflict.

3 Matisse's St. Dominic at Assy, 1948

In 1948 when the Abbé Devémy with the encouragement of Father Couturier invited Matisse to paint an altarpiece for the Church at Assy he accepted. At the time he was in the midst of his designs for the Vence chapel so that the half-length

St. Dominic for Assy, page 511, is little more than a parenthetical variant of the great *St. Dominic* of Vence with the additional grapevine ornament to the left and right of the figure. Drawn in heavy black outline on yellow tile, it is placed at the end of the south side aisle where it serves as a pendant to Bonnard's altarpiece in the north aisle. As the work of the most famous living French artist Matisse's *St. Dominic* added important prestige to the demonstration at Assy.

4 "Une église gaie!"

When the writer visited Matisse in Paris during July 1948 he found him deeply involved in the chapel. One wall of his bedroom was covered with dozens of small, brightly colored scissors-and-paste compositions like those assembled in the frieze on page 512. On the other two walls were many of the very large brush-and-ink drawings like that reproduced on page 508. Matisse explained that one wall was a rough equivalent of the stained glass window façade of the chapel, the other two represented the two chapel walls with murals which were to be in black line on white. At the foot of the artist's bed was a rough model which clarified this highly original concept. Matisse, who spoke of the chapel with extraordinary animation and enthusiasm, quoted with delight the exclamation of one of the Dominicans—was it Father Couturier?—"*Enfin nous aurons une église gaie!*"

The development of the designs for the Vence chapel is described briefly a few pages further on. The photograph, page 514, above, taken of the model shows that the architecture and the general layout of the murals and windows had been established by November 1948, about a year after Matisse first became involved in the undertaking and some six months after he had given up easel painting. Early in 1949 he moved from Vence back to his apartment in the old Régina at Nice, where by a lucky chance two of his rooms, together, were almost exactly the size and proportions of the little chapel. Standing in the doorway between them he could study his designs at the proper scale and distance.

Meanwhile articles about the chapel were beginning to appear. Late in 1948 Joseph A. Barry wrote a detailed story for *The New York Times Magazine*[6] in which Matisse made clear that his interest in the chapel was in no sense a gesture of repentance after sixty years of producing a hedo-

nistically pagan art. "In my own way," Matisse told Barry, "I have always sung the glory of God and His creation. I have not changed." Barry was impressed by Matisse's intense seriousness of purpose: "This will be a chance to apply the researches of my whole life"; at the same time, Matisse expressed the desire to give his work "the lightness and joyousness of springtime which never lets anyone suspect the labors it has cost."

By the end of the year the designs were so far crystallized that construction was begun. On December 12, 1949, with considerable ceremony, Monsignor Rémond, venerable Bishop of Nice, laid the cornerstone.

5 *The Communists and the Chapel, 1950*

Six months later, perhaps well before that, the mural designs and the exterior decorations had been perfected as the photographs of the models on page 515 show. These photographs were taken for the writer at the big Matisse exhibition held in Paris from July through September at the Maison de la Pensée Française. The location of the show was significant. The Maison de la Pensée Française is not officially a Communist institution but it is dominated by Communist writers and intellectuals and has the reputation of being a Communist cultural center. After a long campaign of persuasion by the Communist poet, Louis Aragon, cogently supported by Picasso, Matisse reluctantly agreed to exhibit there—but with an important condition: the chapel models were to be included in the show. Matisse must have known that to hold the first public exhibition of his designs for the Chapel of the Rosary at the Maison de la Pensée Française would prove confusing alike to Catholics, Communists and the general public. Unquestionably Matisse welcomed, if he did not deliberately intend, this ambiguous impression for, with all his political innocence, he was fully aware by 1950 that he was the center of a struggle. His interest in the chapel was artistic, not religious in any orthodox sense and he did not want his interest to be used for proselyting purposes by the Catholics. On the other hand he had not the remotest intention of allying himself with the Communists as Léger—and, far more conspicuously, Picasso—had done.

Perhaps it was not only his desire to demonstrate his independence that prompted Matisse to exhibit his chapel designs in a Communist atmosphere. A well authenticated anecdote[7] suggests that his sense of humor may also have been at work. It seems that shortly after the first model of the chapel had been constructed Louis Aragon paid Matisse a visit. As usual they carried on a lively and friendly conversation. After an hour or so Matisse pointed to the corner of the room where the chapel model was resting on a table. "You haven't said a word about my chapel," Matisse complained mischievously. "Don't you like it?" Aragon had seen the model out of the corner of his eye as he entered the room but had decided to ignore the offensive object. Even now at Matisse's insistence he refused to turn his head to look at it. Finally Matisse in mock anger picked up an inkwell from his bed-table and threatened Aragon. "Go and look at that model or I'll brain you!" he said, laughing in some irritation. Aragon yielded to his host and looked at the model for a minute in silence. Finally the Communist remarked: "Very pretty—very gay—in fact, when we take over we'll turn it into a dance hall." "Oh no, you won't," Matisse snapped. "I've already taken precautions. I have a formal agreement with the town of Vence that if the nuns are expropriated the chapel will become a museum, a *monument historique!*"

Later, when the chapel models were exhibited at the Maison de la Pensée Française, Aragon ignored them in his preface to the catalog—except to point out that the nude figures of Eve and Zulma (page 513) in the exhibition made "a strange pendant for the chapel of the Dominican nuns decorated by Matisse during the very same period."

6 *The Architecture of the Chapel*[8]

Matisse's interest in the chapel had originally been aroused by the problem of the stained glass windows which Sister Jacques had laid before him, it seems, late in 1947. It was natural therefore that the glass should at first have been his chief concern. As he worked with Brother Rayssiguier gradually developing the design of the whole chapel he kept the glass as the dominant source not only of light but color. The rest of the interior he kept white except for the altar and its furniture and the huge monochrome drawings on the walls and, at first, on the floor.

The needs of the nuns were simple but for liturgical purposes they needed to be separated as a group from their charges and from such members of the lay public as might attend mass. The chapel, as the sketched plan shows, was therefore designed as a

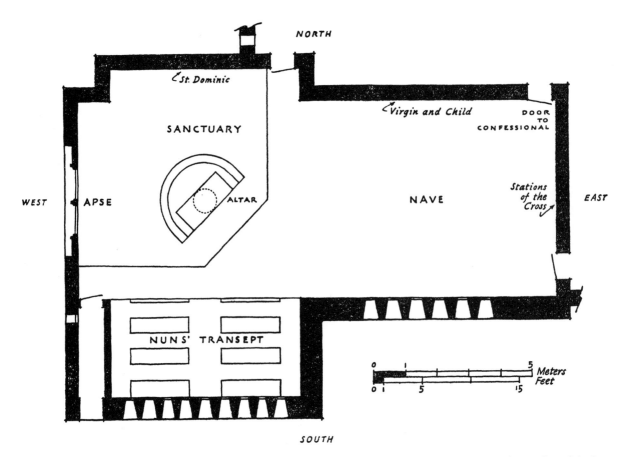

PLAN OF THE CHAPEL AT VENCE: Since no plan by the architects themselves is available, this approximate plan of the interior has been drawn up for the convenience of the reader by Edward L. Mills. The plan is based on photographs and the article by Brother L. B. Rayssiguier in *L'Art Sacré*, July-August, 1951

thick blunted "L" with the long arm forming the little nave for a congregation of eighty, the short one forming a transept with stalls for about twenty nuns. Nave and transept are thus masked from each other but both offer a full view of the altar which is placed on a diagonal in the sanctuary at the intersection of the axes of nave and transepts, so that it half faces both congregations. The sanctuary is raised a step above the floor and the altar itself rests on a podium two steps higher.

The scale is small: the interior is 15 meters or not quite 50 feet long, including the shallow "apse," and 10 meters or about 33 feet across at the transepts. Both the nave and the nun's transept are 6 meters or about 20 feet wide. The ceiling is 5 meters or 16 feet 9 inches high in the nave, the height of a step less in the sanctuary. The chapel is oriented with the apse and altar at the west end, a practice both ancient and unorthodox.

7 The Decoration of the Chapel

Our plan and the photographs of the models on pages 514-515 make clear the arrangement of windows and wall paintings. Tall, narrow, round-headed windows occupy most of one long façade looking south, six to the nave, nine to the transept. To diminish the heat of the southern exposure these narrow windows are divided by deep fins or embrasures which serve as vertical louvers.

Opposite the nave windows is the mural of the *Virgin and Child* and, opposite the transept windows, the great figure of *St. Dominic*. In the center of the shallow square apse is a pair of much wider windows looking west and opposite them, at the east end of the nave, and well above eye level, are the fourteen *Stations of the Cross* in a single great composition.

The models reproduced on page 514 record early stages of some of the designs. The upper photograph

taken at Vence, November 1948, shows that Matisse at one time had intended to decorate the floor with huge rosettes and asterisks, outlined in red. These were abandoned later for the small black lozenges inlaid at the corners of the square marble floor slabs, leaving the floor white and plain to receive and reflect the colored light of the windows.

The exterior of the chapel is white, too. The roof is decorated with a big double saw-toothed design in blue tile and is surmounted by a wrought iron spire and cross, pages 515, 527.

8 The Windows

In the course of two years Matisse made, it is said,[1] three complete full-scale designs for the two rows of narrow windows in the long southern façade. One of the early designs, poorly reproduced in the middle of page 514, was inspired by the lines of the Apocalypse in which St. John describes the Heavenly Jerusalem: "And the foundations of the city were garnished with all manner of precious stones. . . . And the street of the city was pure gold, as it were transparent glass."—*Revelation* 21:19 and 21. Later, as the model photographed in November 1948 shows, the windows were reduced from nineteen to fifteen and the Heavenly Jerusalem design with its radiations and all-embracing rainbow-like curves was abandoned. In its place Matisse invented a series of "tree-of-life" designs with big ovate leaves placed in pairs on either side of the narrow mullion-like embrasures as if growing out of a stalk or trunk, page 514, below, and page 517, below. The leaves are alternately bright golden yellow and deep sapphire blue against a grass green background which changes to gold at the top. These six nave windows are slightly over a foot wide and 15 feet 8 inches high; the nine in the nuns' transept are not so high since they begin above the stalls at the sides with a raised aisle in the middle.

The coupled windows of the apse are much wider, measuring 35½ inches across by 14 feet 7 inches high; and they are much more complex in design, page 517, above. Bright yellow philodendron-like leaves are laid against freely disposed deep blue oval cactus shapes. Between these one sees a field of green below, then, higher up, sky blue until the climbing pattern reaches the lower edge of a brilliant sun disc which cuts across the tops of both windows. There is also a small window beside a vestibule door (not illustrated) with a grey fish—the Ἰχθύς symbol of Christ—caught in a net with

HAND WITH BOOK, study for the St. DOMINIC, Vence chapel (Main de St. Dominique, chapelle de Vence). Nice, 1949. Pen and ink. Owned by the artist

a blue star above.[2] The glass for the chapel was manufactured by Paul Bony of Paris under Matisse's exacting supervision.

9 Murals

The three major and two minor mural paintings or, better, mural drawings on glazed tiles are identical in technique. After numerous preparatory studies carried on in some cases over a period of a couple of years, Matisse drew the final designs on full size cartoons divided into squares the exact size of the tiles. The unglazed tiles were then brought from the kilns of the ceramist Bourdillon at Aubagne near Marseilles and laid out on the floor of the artist's big studio in the Régina. Matisse himself then drew with a brush the heavy black lines of the design directly on the tiles which were returned to the kilns for glazing before being set in place on the walls.

In reproducing the murals, pages 518, 520, 522, zinc line cuts have been used to preserve the brilliant whiteness of the background, even though the

lines of the tiles have come out too strong and black. The photographs on pages 516 and 523 correct this faulty impression.

10 The Stations of the Cross

Picturing the Stations of the Cross as a continuous narrative in one composition is not common historically, and is very rarely used in modern Catholic churches as a substitute for the fourteen separate Stations. On a great panel, page 520, about ten feet high by seventeen feet wide Matisse paints, one might almost say writes, the story. He begins the narrative in the lower left-hand corner with Station 1, *Christ before Pilate* and carries the numbered scenes across and over the head of the door with Station 5, *Simon of Cyrene Carrying the Cross* (a study for which may be seen in the photograph on page 30). With *Veronica's Veil*, Station 6, the sequence moves toward the left and is then reversed at the top of the panel with Station 10, *Christ Stripped of His Garments. Christ Nailed to the Cross*, Station 11, and *The Descent from the Cross*, Station 13, flank the central *Christ on the Cross*. The Passion ends with *The Entombment*, Station 14.

As can be seen by comparing the two of the many sequential studies for the *Christ before Pilate*, reproduced p. 521, with the final version, Matisse has reduced his scenes to the veriest shorthand. The drawing is almost savagely abrupt, scratched and rough, the whole effect painful and anti-decorative as befits a picture of the brutal and heroic story of

Study for the VIRGIN AND CHILD AND ST. DOMINIC, a ceramic tile panel for the door to the sacristy, Vence chapel. Cut-and-pinned paper, 1949? Owned by the artist

Calvary. So concentrated and elliptical is the style that for the non-Catholic, who does not know the iconography of the Stations by heart, a written gloss is almost necessary before some of the scenes become legible; but to most Catholics, generally conditioned by the banal sweetness of ordinary modern Stations, Matisse's version though intelligible must be shocking in its terse austerity.[3] Obviously it was not Matisse's intention here to please.

11 The Virgin and Child

Pendant in size to the Calvary, but diametrically different in sentiment is the *Virgin and Child* on the adjacent wall of the nave. Matisse is said to have abandoned six completed designs before arriving at a satisfactory conclusion in the seventh. Some of the early studies for the Virgin show a graceful, rather Gothic figure with heavy star-spangled drapery.[4] At another moment the ornament was eliminated from the drapery and the figure was flanked by rows of alternating flowers and stars to fill out the long rectangular panel. The composition at this stage may be seen in the model reproduced at the top of page 514. Then the stars and flowers gave way for a time to regular x-shaped sprays of leaves, page 519, left. In the final version the Virgin takes a severely frontal position as she supports the standing Child whose arms are spread to form a cross. Huge cloud-like rosettes and an AVE take the place of the decorative stars or leaves. The black lines on the tiles are broad and sweeping, the forms ample.

Concerning the mural Father Couturier[5] quotes an observation made by an old woman on the road outside the chapel: "It is much better that the Holy Virgin should have no face—that way each may see her as he wishes."

12 St. Dominic

The third mural, the huge *St. Dominic*, towers behind the altar as he faces the nuns' transept. Father Couturier served as the model for this stately figure which Matisse studied in scores of drawings.[6] The fall of the drapery, the proportions of head to cowl to robe, the hand holding the book, all seem so simple and right in the finished figure yet they were drawn over and over again, with a pen, page 283, with a brush at arm's length, page 522 (below), at half scale with charcoal at the end of a seven-foot bamboo pole, page 31, and, finally, at full scale, over fifteen feet high, page 522.

VIRGIN AND CHILD WITH ST. DOMINIC, over entrance to vestibule. Painted and glazed tiles, c. 18 x 42″

Something of the monumental effect of the *St. Dominic* may be felt in the photograph, page 523, taken by Cartier-Bresson during the ceremony of the consecration. The drawing is modest, quiet, free of all bravura. The figure is flat and linear, without bulk, color, texture, substance, or detailed features, its transparency curiously enhanced by the faint square line of the tiles. It seems the very image of a spiritual presence as it towers, serene and powerful, over the busy clergy.

13 Minor Tile Compositions

Besides the three big murals of the interior Matisse designed two small tile compositions for the outside of the chapel. Over the twin windows of the west or apse façade he set a tondo of the *Virgin and Child*, page 286, and over one of the doors into a vestibule or sacristy, a composition, this page, with the head of St. Dominic on one side of a small radiant cross and on the other a remarkably simple and expressive image of the Virgin and Child—just the two heads with His arm raised to Her shoulder— drawn with six sure lines.

14 The Altar and Its Furniture

The altar, a cylinder surmounted by a rectangular slab, and its two-stepped podium are built of warm travertine-like *pierre romaine du Gard*. The composition is extremely simple but beautifully proportioned. Its heavy geometrical forms support, and are adorned by, six brass candlesticks of extraordinary slenderness flanking an even slenderer cross. The linen altar cloth with an embroidered fish motif after Matisse's design may be seen in the photograph on page 516. Matisse also designed the brass pyx.

15 The Crucifix

Matisse must have approached the problem of portraying the crucified Christ with a certain hesitation, so completely different in spirit was it from his usual subject matter. In any case it is not strange that he turned to the past for help, though it is surprising that he should have studied especially that most appalling of all crucifixions, the Calvary panel of Matthias Grünewald's Isenheim altarpiece. Many of Matisse's preparatory designs show that he studied Grünewald's *Christ*, particularly the legs and feet as may be seen in the big drawing just above Matisse in Gómez Sicre's photograph, page 30.[7]

However there is little trace of Grünewald's Christ either in the final version of *Christ on the Cross*, number twelve of the Stations, or in the Christ of the altar crucifix. A photograph on page 524 shows Matisse modeling the crucifix. The completed work seems remote from all Renaissance or late Gothic precedents. The elongated simplified figure is closer by far to primitive peasant crucifixes in bronze or wrought iron from the Pyrenees or Tyrol. The attenuation seems however less pathetic in effect than elegantly ethereal, especially as the figure hangs from a very tall slender cross. Matisse's crucifix seems closer to Antonello da Messina's mystical *Crucifixion* of 1477 in London than to Grünewald's frightful cadaver at Colmar.

16 The Chasubles

In the designs for the chasubles Matisse was more at home, so much so that he is said to have designed nineteen of them though only a few have actually been executed in silk. They offered essentially decorative problems which Matisse solved beautifully

with scissored images of symbolic palm leaves, quatrefoils, halos, fish, stars and crosses. Two of the paper patterns put together with paste and pins are reproduced on page 525; a finished chasuble in yellow, green and black is worn by the priest in the adjacent photograph. Many of the other chasuble designs are white on black or black on pink. Hanging on the walls of the artist's studio they look like gigantic nine-foot butterflies.[8] Matisse is also said to have designed some copes.

17 The Door to the Confessional

Of the architectural details of the chapel perhaps the most beautiful is the door of the confessional placed below and to the right of the mural of the *Virgin and Child*, page 516. The door, page 526, in carved wood painted white without effacing the wooden texture, is divided into eight panels with different designs of connected disc and lozenge shapes. There is about it some suggestion of Coptic or Arab pierced screens or of BaKuba palm fibre "velvets" from the Belgian Congo of which Matisse owned superb examples.[1] But these folk art analogies are fundamentally different because their patterns are both complex and regular whereas the ornament of Matisse's door is artfully irregular, simple and free-hand with a curious effect of ingenuous spontaneity, even of accident. Matisse also

designed the choir stalls, the front panels of which are decorated with a kind of checkerboard relief in carved wood.

18 The Spire

The slender cross-tipped metal spire which rises high—and, it seems, precariously—over the chapel belongs, rather, in the symmetrical and elegant tradition of European wrought iron. Between the recurved footings of the spire hangs a small bell.

19 The Chapel Completed, 1950-1951

Matisse had virtually completed the designs for the Vence chapel early in 1950 but he was busy during the year painting the full-scale mural drawings on tiles or supervising the execution of the stained glass, the metal spire, the altar furniture and the construction of the building. There were delays, technical difficulties, lack of money, though Matisse advanced considerable funds so that the work could proceed. In the winter of 1950-51 a storm damaged the structure. Even a few days before the consecration and public opening of the chapel work had not been completed.

20 Consecration of the Chapel, June 25, 1951

Finally, on the appointed day, June 25, 1951, the Chapel of the Rosary at Vence was ready. Matisse's physician had forbidden him to go up for the ceremonies but he received congratulations in his bed in Nice. His son Pierre Matisse, however, was present throughout the day to represent his father.

The celebrations began at 9:30 in the morning with formal inauguration of the Avenue Henri-Matisse, formerly the route de St. Jeannet which led up from the town of Vence to the chapel. Emile Hugues, deputy mayor of Vence, made an eloquent short speech[2] in which he compared Matisse's chapel murals to handwriting and quoted a Chinese master of the Han period "who said that when one married ink and skill the five colors appeared of their own accord." He asked the artist to accept the renaming of the street as token of the ancient town's gratitude for his having chosen it as "the site of his affirmation of spirituality." Pierre Matisse then accepted from the mayor his father's diploma of honorary citizenship and formally opened the Avenue Henri-Matisse by cutting a tricolor ribbon, page 31.

The consecration of the chapel followed. Monsignor Rémond, Bishop of Nice, officiated, assisted

VIRGIN AND CHILD, apse façade over coupled windows. Painted and glazed tiles, 55¾" in diameter

by the other clergy including Father Couturier and Father Régamey, editor of *L'Art Sacré*. Among the congregation, besides Pierre Matisse and his wife and daughter, was the devoted Hans Purrmann who had come all the way from Switzerland for the occasion.

The little chapel was beset by a crowd far too large to be admitted and the full machinery of modern publicity added to the excitement—radio microphones, movie cameras, reporters, and press photographers, among the last, fortunately, the acute Cartier-Bresson, some of whose documents we are privileged to reproduce on pages 516 and 523.

21 *Matisse's Message to the Bishop*

In spite of the hubbub, the occasion was a triumph for the aged artist and for the nuns and churchmen who had had the vision and courage to commission him. Some of them, naturally, hoped that he would make some explicit profession of faith. He did not do so. But he did send a message to Bishop Rémond which Father Couturier read:

Your Excellency:
I present to you in all humility the Chapel of the Rosary of the Dominican Sisters of Vence. I beg you to excuse my inability to present this work to you in person since I am prevented by my state of health: the Reverend Father Couturier has been willing to do this for me.

This work has taken me four years of exclusive and assiduous work and it represents the result of my entire active life. I consider it, in spite of its imperfections, to be my masterpiece. May the future justify this judgment by an increasing interest over and above the high significance of this moment. I count, your Excellency, upon your long experience of men and your wisdom to judge an effort which issues from a life consecrated to the search for truth.
Henri Matisse

22 *The Bishop's Response*

To this the Bishop replied with discernment, discretion and Christian charity. He and Matisse had had a long conversation several days before and had, it seems, understood each other. Monsignor Rémond[3] said in part:

. . . The human author of all that we see here is a man of genius who, all his life, worked, searched, strained himself, in a long and bitter struggle, to draw near the truth and the light. . .

Remember the parable, "it is not he who conceals the

talents granted him by God, so as to guard them selfishly, who deserves to be rewarded, but he who at the price of much labor and suffering, having made the talents he received bear fruit, returns them to God on the day of accounting. Then truly he deserves to be called: good and loyal servant."

23 *Matisse's Position*

Matisse in his message to the Bishop of Nice had made no explicit reference to religion at all. Nor is religion or the Church mentioned in Matisse's preface to the *Chapelle du Rosaire*,[4] the booklet on the chapel published at the time it opened. In spite of this a Reuters dispatch from Vence, dated June 25th, completely falsified Matisse's carefully and clearly implied position. Published in *The New York Times*[5] and other papers, the Reuters correspondent stated that Matisse had "sent a message to the Bishop declaring that building the chapel had renewed his faith in God." In the account of his message to the Bishop he is falsely quoted by the correspondent as having said, "I started this work four years ago, and as a result I know now I believe in God." The correspondent then climaxed his pious fantasy by stating that Matisse had "promised the chapel as an expression of gratitude" because he had been "nursed back to health by Franciscan [*sic*] sisters."

Monsignor Rémond had accepted Matisse's scrupulously guarded statement in the same spirit that it was made, but less than a month later *La Vie Catholique Illustrée*[6] published the story of the chapel under the headline in quotes "EVERY TIME I WORK, I BELIEVE IN GOD." These words were, it is true, written by Matisse but at another time and in a very different context. Among the miscellaneous notes he prepared for *Jazz*, published in 1947, appears the following paragraph:

WHETHER I BELIEVE IN GOD? *Yes, when I work. When I am submissive and modest, I feel somehow aided by someone who makes me do things which are beyond me. However, I do not feel towards him any obligation because it is as if I were before a magician whose tricks I cannot see through. Consequently I feel deprived of the benefits of the experience which ought to have been the reward of my own effort. I am ungrateful without remorse.*

24 *"For religious art . . . a revolution"*

The writer has not seen Matisse's chapel nor, as yet, any detailed criticisms of it. It is apparent that the architecture is somewhat awkward in plan and

uncertain in scale. Nevertheless the interior seems far more than completely successful in achieving what Matisse had modestly proposed, namely "to balance a surface of light and color against a solid white wall covered with black drawings." Even those who might be inclined to be unsympathetic toward the idea as a whole appear to be deeply impressed by the result as a work of art—and a work of devotion, however qualified. Picasso is said to prefer the *Stations of the Cross* to anything else in the chapel. Others pick out the altar for special praise, or the chasubles, or the extraordinary door to the confessional. All find admirable the magical blue-green radiance which plays throughout the white interior.

The enthusiasm of René Gaffé, the Belgian critic and collector, is especially significant, coming as it does from a man who has in the past shown much more interest in Picasso, Miro, de Chirico and Delvaux than in Matisse and his generation. Gaffé writes:[7]

Vence? I find that it is for modern religious art what 1789 was for France, that is to say a revolution. A revolution perfectly successful, and of a total purity. And what a light spreads across those admirable green and yellow windows! Never has Matisse seemed to me so young!

25 "... the course that I am still pursuing"

And to Matisse, approaching his eighty-second birthday (but full of plans for new paintings, new stained glass windows, new prints, even new sculpture), should be given the last word about this most recent achievement. His statement published in the *Chapelle du Rosaire* is not only an introduction to that shining monument but, in its way, a moving profession of his personal faith.

LA CHAPELLE DU ROSAIRE

All my life I have been influenced by the opinion current at the time I first began to paint, when it was permissible only to render observations made from nature. All that derived from the imagination or memory was called "chiqué" and worthless for the construction of a plastic work. The teachers at the Beaux-Arts used to say to their pupils, "Copy nature stupidly."

Throughout my career I have reacted against this attitude to which I could not submit; this struggle gave rise to the divers alterations of my course during which I searched for means of expression beyond the literal copy—such as divisionism and fauvism.

These rebellions led me to study each element of construction separately: drawing, color, values, composition; to explore how these elements could be combined into a synthesis without diminishing the eloquence of any one of them by the presence of the others; and to construct with these elements, combining them without reducing their intrinsic quality; in other words to respect the purity of the means.

Each generation of artists looks differently upon the production of the previous generation. The paintings of the impressionists, constructed with pure colors, proved to the next generation that these colors, while they might be used to describe objects or the phenomena of nature, contain within them, independently of the objects that they serve to express, the power to affect the feelings of those who look at them.

Thus it is that simple colors can act upon the inner feelings with all the more force because they are simple. A blue, for instance, accompanied by the shimmer of its complementaries, acts upon the feelings like a sharp blow on a gong. The same with red and yellow; and the artist must be able to sound them when he needs to.

In the chapel my chief aim was to balance a surface of light and color against a solid white wall covered with black drawings.

This chapel is for me the ultimate goal of a whole life of work and the culmination of an enormous effort, sincere and difficult.

This is not a work that I chose but rather a work for which I have been chosen by fate towards the end of the course that I am still pursuing by my researches. The chapel has afforded me the possibility to realize them by uniting them.

I foresee that this work will not be in vain and that it may remain the expression of a period in art, perhaps already surpassed, though I do not believe so. One cannot be sure about this today before the new movements have come to fruition.

Whatever weaknesses this expression of human feeling may contain will fall away, but there will remain a living part which will unite the past with the future of plastic tradition.

I trust that this part, which I call my revelation, may be expressed with sufficient power to be fertilizing and so return to its source.

Henri Matisse

PLATES

The following plates are arranged roughly in chronological order. For purposes of easy comparison and to conform with the text, works in the same medium and of about the same date are grouped together.

Preceding these plates there are three other classes of illustrations: the color reproductions of paintings among which are reproduced a few related halftones; the documentary and comparative material; and the line cuts of drawings and prints distributed throughout the text

The captions include information in the following order:

TITLE: in English, followed by French and, occasionally, English variants. Most titles are fairly arbitrary and many were invented by dealers and writers.

PLACE where work was done: very rarely indicated on the work but is given whenever known.

DATE: if placed in parentheses, does not appear on work. Month, or season of year, and day are given when known.

DIMENSIONS: in inches; height precedes width. For etchings, plate size; for lithographs and drawings, paper size unless otherwise indicated; for sculpture, base included if part of cast.

PRINT NUMBERS: the numbers given lithographs, etchings and drypoints are those generally used by Matisse; they are listed in the unpublished catalog of Matisse's prints by Carl O. Schniewind. A definitive catalog by Marguerite Duthuit is in preparation.

FORMER OWNERS: because of their historical importance, names of collectors who owned the work before 1920 are given whenever known, following the word *ex.* Names of early collectors who owned more than one or two Matisses are abbreviated as follows:
 Braun: Heinz Braun, Munich
 Kann: Alphonse Kann, St. Germain-en-Laye
 Moll: Oscar and Greta Moll, Berlin
 Morosov: Ivan A. Morosov, Moscow
 Osthaus: Karl Osthaus, Hagen, Westphalia

Purrmann: Hans Purrmann, Berlin and Speyer

Quinn: John Quinn, New York

Sagen: Trygve Sagen, Norway

Sembat: Marcel Sembat, Grenoble and Paris

Shchukin: Sergei I. Shchukin, Moscow

L. Stein: Leo D. Stein, Paris. (The Matisse paintings which hung in the apartment of Leo Stein and his sister Gertrude on the rue de Fleurus before 1914 were always listed in the exhibitions of 1910-13 as lent by L. D. S. or Leo Stein.)

M. and S. Stein: Michael and Sarah Stein, Paris

Tetzen Lund: Christian Tetzen Lund, Copenhagen

COLOR: References are given to color reproductions in publications ordinarily available in libraries. The following abbreviations are used:

Aragon: Louis Aragon. *Apologie du Luxe*. Geneva, Skira, n. d.

Braun: *Paintings and Drawings of Matisse*. Introduction by Jean Cassou. Paris, Braun & Cie

Du Chêne: *Matisse, Seize Peintures, 1939-43*. Paris, Du Chêne, 1943

Courthion: Pierre Courthion. *Visages de Matisse*. Lausanne, 1942

Escholier: Raymond Escholier. *Henri Matisse*. Paris, Floury, 1937

Faber: *Matisse*. Introduction by Jean Cassou. London, Faber and Faber, n. d. *also* New York, Pitman, 1950

Fry I: Roger Fry. *Henri-Matisse*. New York, E. Weyhe [1930]

Fry II: Roger Fry. *Henri-Matisse*. Paris, Chroniques du Jour, 1935

Lejard: André Lejard. *Matisse*. Paris, Hazan, 1948

Moscow: *Museum of Modern Art, Moscow—35 selected masterpieces from the Museum of Western Art in Moscow*. New York, New York Graphic Society [1935?]

Moscow II: *Musée de l'art occidental moderne à Moscou*. Moscow, Editions d'Etat Art, 1938

Romm: Alexander Romm. *Henri Matisse*. Leningrad, Ogiz-Izogiz, 1937

Skira: *History of Modern Painting, Vol. 2, Matisse-Munch-Rouault*. Geneva, Skira, 1950

Swane: Leo Swane. *Henri Matisse*. Stockholm, Norstedt & Söners, 1944

Vanity Fair: *Vanity Fair's Portfolio of Modern French Art*. Introduction by R. H. Wilenski. New York, Vanity Fair, 1935

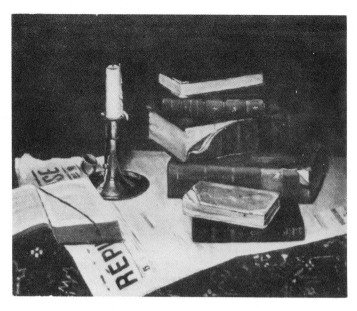

BOOKS AND CANDLE (*Nature morte aux livres*). Bohain-en-Vermandois, 1890.
Oil, 15 x 18⅛″. Owned by the artist

STUDY OF A CAST OF THE CAPITOLINE "NIOBID" OR "GANYMEDE"
(*Dessin de Niobide*). Paris, Ecole des Beaux-Arts?
(c.1892? dated 1890.) Charcoal. Owned by the artist

Copy of the DEAD CHRIST by Philippe de Champagne, 1602-1674 (*Le Christ d'après Philippe de Champagne*). Paris (c.1895). Oil,
26 x 75⅝″. Owned by the artist

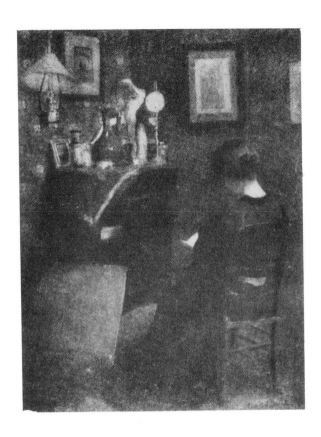

Above: WOMAN READING (*La liseuse*). Paris (1894). Oil.
Rambouillet, Château

STILL LIFE WITH PEACHES (*Nature morte aux pêches*).
Paris, 1895. Oil, 18⅛ x 13⅜″. Baltimore Museum of Art,
Cone Collection

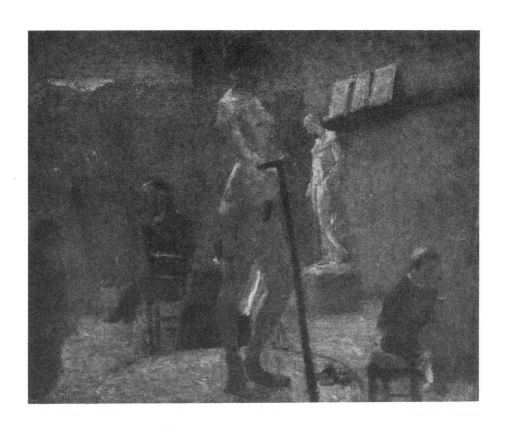

Above: GUSTAVE MOREAU'S STUDIO (*Atelier de Gustave Moreau*). Paris (1894 or '95). Oil, 25⅝ x 31⅞". Paris, Galerie Maeght. Color: Aragon, pl. 6

FIGURE STUDY (*Académie*). Paris, Gustave Moreau's studio. Charcoal?

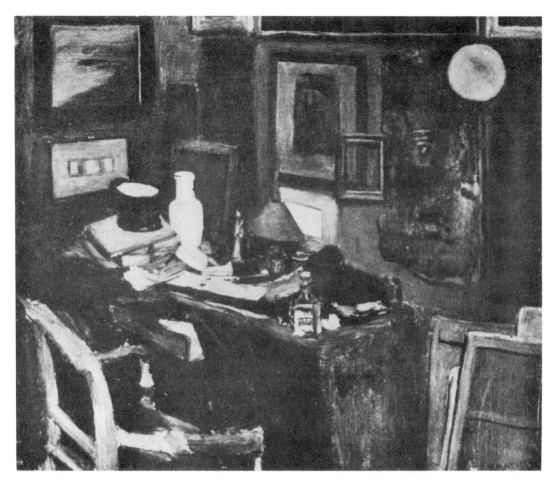

INTERIOR WITH A TOP HAT (*Nature morte au chapeau haut-de-forme*). Paris (1896). Oil, 31½ x 37⅜″. Owned by the artist

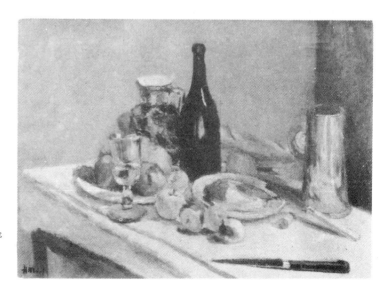

STILL LIFE WITH A BLACK KNIFE
(*Nature morte au couteau noir*).
Paris (1896, early). Oil.
(*Ex* Thénard, Paris)

THE BRIDGE (*Le pont*). Paris, 1895. Oil, 12⅞ x 16¼″. Inscribed:
à Emile Wéry / souvenir amical / H. Matisse 95. New York, Leonard
C. Hanna, Jr.

ROCKS AND THE SEA (*Marine*). Brittany (1897, summer).
Oil, 25⅝ x 21¼″. Owned by the artist

CLIFFS AT BELLE-ILE (*Rochers, Belle-Ile*). Brittany, 1896 (summer). Oil, 18⅛ x 31⅞″. Owned by the artist

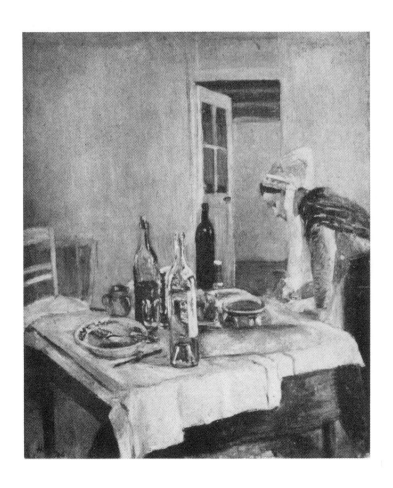

Above: BRETON SERVING GIRL (*La serveuse bretonne*). Brittany,
1896 (summer). Oil, 35⅞ x 30″. Owned by the artist

THE OPEN DOOR (*La porte ouverte*). Brittany, 1896 (summer).
Oil. Palo Alto, California, Mrs. Michael Stein

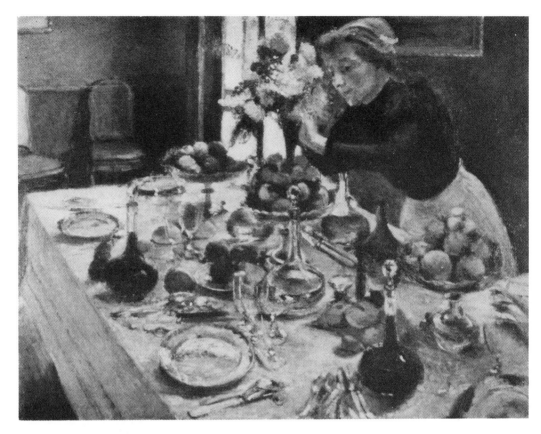

DINNER TABLE (*La desserte*). Paris (1897, early). Oil, 39½ x 51½". Hollywood, Mr. and Mrs. Edward G. Robinson (*ex* Curt Friedmann, Berlin). Color: *Verve*, no. 4, p. 115

APPLES (*Nature morte aux pommes*). Paris, 1897. Oil

Above: ROOM IN AJACCIO (*Chambre, Ajaccio*). Corsica (1898).
Oil, 31½? x 37⅜″? Owned by the artist. Color: Braun, pl. 1

TREE (*Arbre*). Corsica (1898). Oil, 15 x 18⅛″.
Paris, Mme Albert Marquet

THE OLD MILL, AJACCIO (*Le vieux moulin*).
Corsica (1898). Oil, 14½ x 17¾″.
New York, Pierre Matisse Gallery

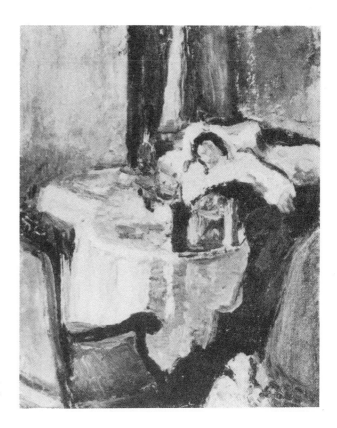

THE INVALID (*La malade*). Toulouse (1899, early).
Oil, 18⅛ x 15″. Baltimore Museum of Art, Cone
Collection (*ex* L. Stein)

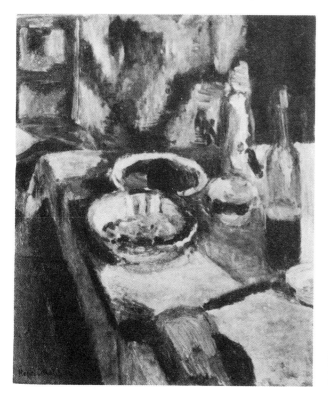

STILL LIFE (*Nature morte*). (1899?) Oil, 18⅛ x 15″.
New York, Museum of Modern Art, gift of
Gen. A. Conger Goodyear

STILL LIFE AGAINST THE LIGHT (*Orange Still Life; Nature morte à contrejour*). Paris (1899). Oil, 29⅜ x 36½″. Owned by the artist

STREET IN ARCUEIL (*Rue à Arcueil*). Arcueil (1899?). Oil, 8⅝ x 10⅝″. Copenhagen, Statens Museum for Kunst, J. Rump Collection (*ex* J. Rignault, Paris)

INTERIOR WITH HARMONIUM (*Intérieur à l'harmonium*). Paris (1900?). Oil, 28⅞ x 21¾″ Owned by the artist

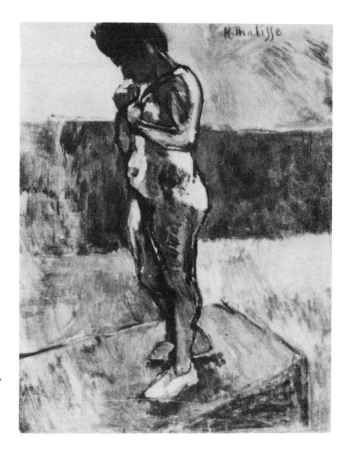

THE MODEL. Paris (c.1900, Académie Carrière?).
Oil, 29½ x 22⅞″. Paris, Galerie Katia Granoff

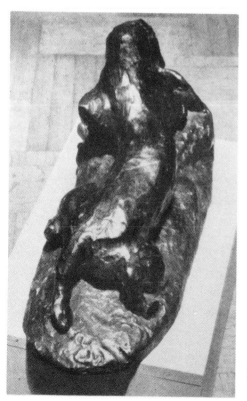

JAGUAR DEVOURING A HARE—AFTER BARYE (*Jaguar dévorant un
lièvre—d'après Barye; Le tigre*). Paris (1899-1901). Bronze, 8⅝″ high.
Owned by the artist

MALE MODEL—SKETCH (*Académie d'homme—esquisse*). Paris (c.1900). Oil

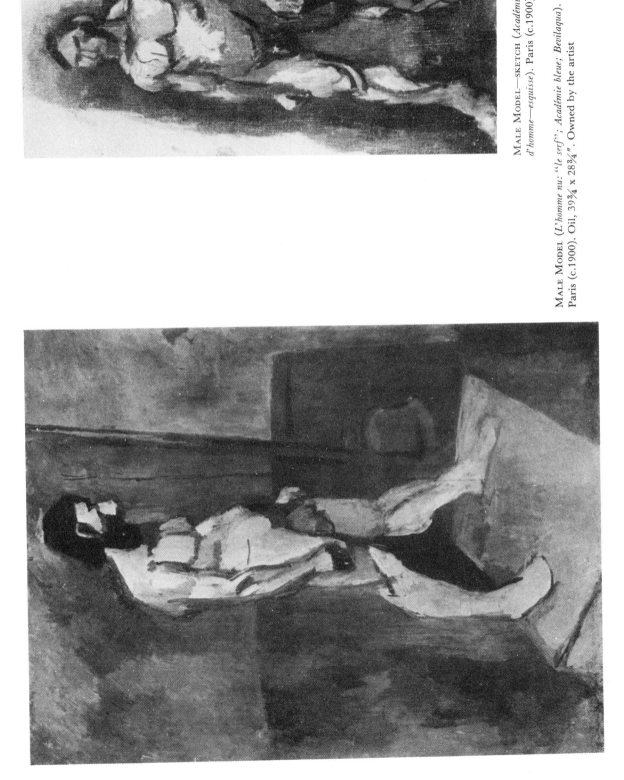

MALE MODEL (*L'homme nu: "le serf"; Académie bleue; Bevilaqua*). Paris (c.1900). Oil, 39¾ x 28¾". Owned by the artist

304

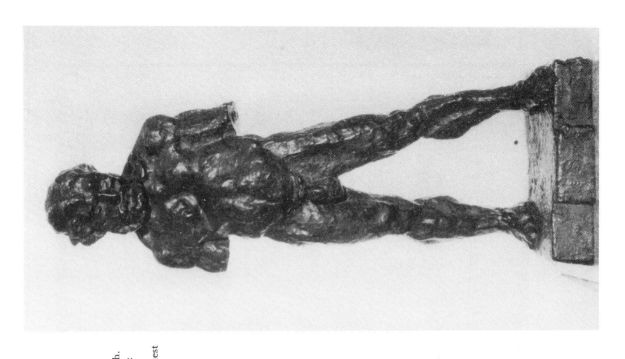

THE SLAVE (*Le serf*). Paris (1900-03). Bronze, 36¼" high. Baltimore Museum of Art, Cone Collection. Other casts: Chicago, Art Institute, Edward E. Ayer Collection; San Francisco Museum of Art, Harriet Lane Levy Bequest

MADELEINE, I (*Madeleine, 1er état*). Paris (1901). Bronze 23⅝" high. Baltimore Museum of Art, Cone Collection. Another cast: San Francisco Museum of Art, Harriet Lane Levy Bequest

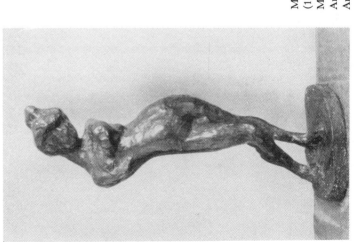

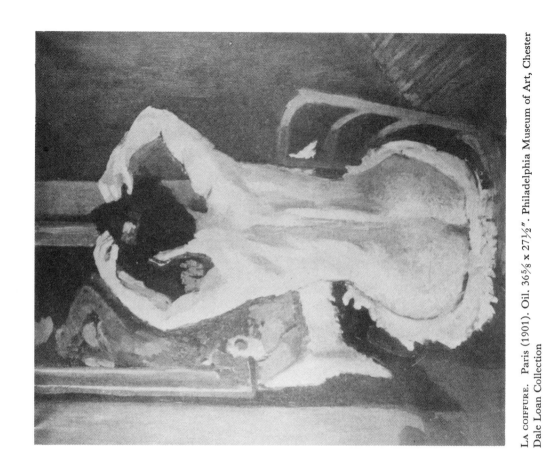

LA COIFFURE. Paris (1901). Oil. 36⅝ x 27½". Philadelphia Museum of Art, Chester Dale Loan Collection

CORNER OF THE STUDIO (*Coin d'atelier*). Paris (c.1900). Oil. Paris, private collection. Color: Braun, pl. 2

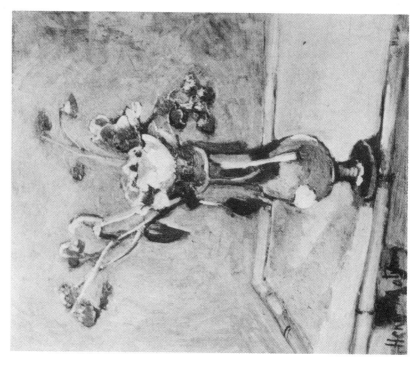

BOUQUET ON A BAMBOO TABLE. Bohain-en-Vermandois (1902, early). Oil, 21½ x 18⅛". New York, Museum of Modern Art, gift of Mrs. Wendell T. Bush

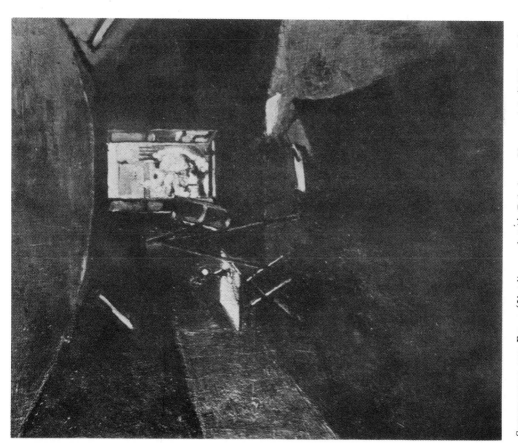

STUDIO UNDER THE EAVES (*L'atelier sous le toit*). Bohain-en-Vermandois (1902, early). Oil, 21⅝ x 18⅛"

Above: The Path in the Bois de Boulogne. Paris, 1902. Oil, 24¾ x 31⅛". Moscow, Museum of Modern Western Art (*ex* Shchukin)

Trees near Melun (*Arbres près de Melun*). Melun (1901) Oil, 17¾ x 14¾". Belgrade, Museum of Art and Archeology, gift of Bernard Berenson

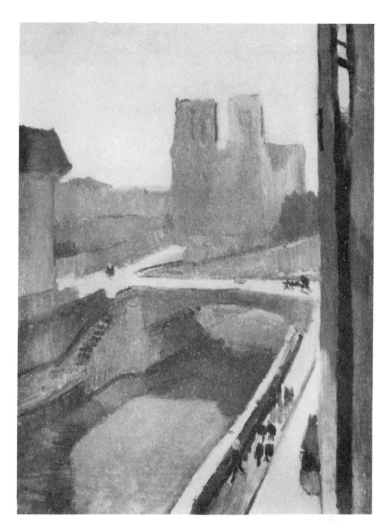

Notre Dame in the Late Afternoon (*Notre Dame*). Paris, 1902. Oil, 28½ x 21½″. Buffalo, Albright Art Gallery

Below: The Chézières Road (*Route de Chézières*). Vallors-sur-Ollon, Switzerland (1901, spring). Oil, 9⅞ x 13¾″.

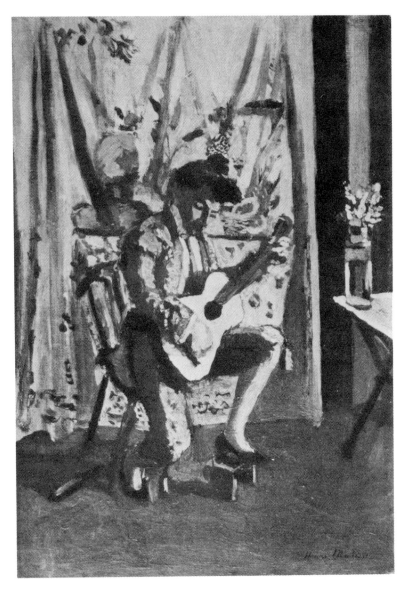

GUITARIST (*Mme Matisse*). Paris (1903). Oil, 21½ x 15″. New York, Mr. and Mrs. Ralph F. Colin (*ex* Braun)

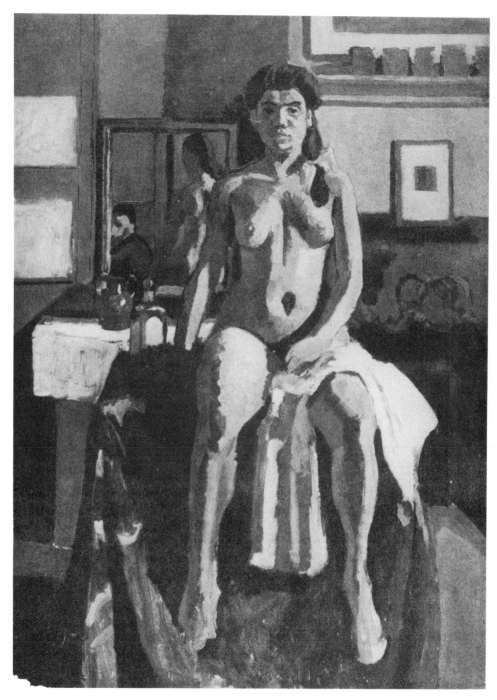

CARMELINA. Paris (1903). Oil, 31½ x 25¼″. Boston, Museum of Fine Arts

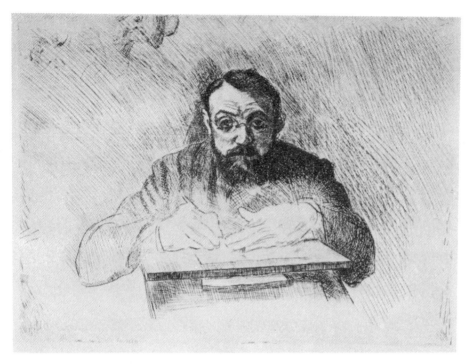

SELF PORTRAIT, ETCHING (*Portrait de l'artiste*). Paris (c.1904). Etching no. 52, 5⅞ x 7⅞".
Philadelphia, Mr. and Mrs. Carl Zigrosser

TWO WOMEN IN STREET COSTUMES (*Deux femmes en ville*). Paris (c.1904). Drypoint no. 56B, 5¹³⁄₁₆ x 3¹⁵⁄₁₆". New York, Museum of Modern Art

TWO NUDES, TWO HEADS OF CHILDREN—STUDIES (*Deux nus, deux têtes d'enfant—études*). Paris (c.1905). Drypoint no. 55B, 5⅞ x 4". New York, Museum of Modern Art

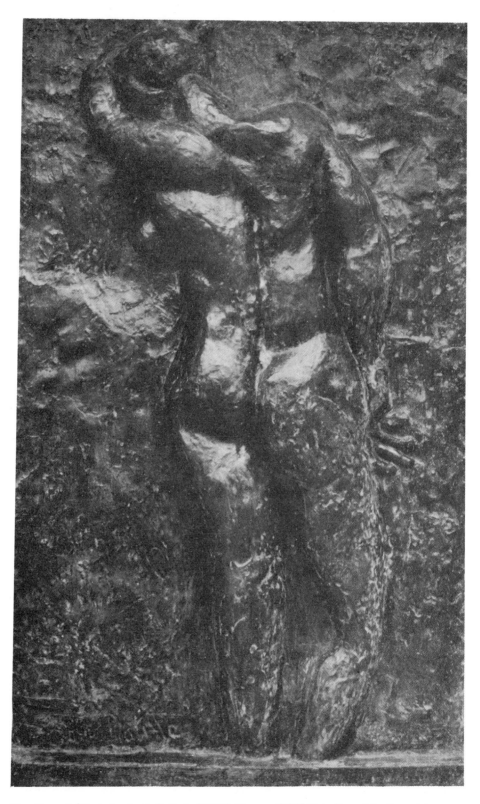

THE BACK, I (*Nu de dos, 1er état*). Paris (1904?). Bronze, 74⅜″ high. Owned by the artist

PLACE DES LICES, ST. TROPEZ. St. Tropez
(1904, summer). Oil, 20¼ x 21⅝".
Copenhagen, Statens Museum for
Kunst, J. Rump Collection

Below: STILL LIFE WITH A PURRO, I (*Nature
morte au purro, I*). St. Tropez (1904,
summer). Oil, 23⅝ x 28¼". London?
private collection

Above: THE TERRACE, ST. TROPEZ
(*La terrasse*). St. Tropez (1904, summer).
Oil, 28¼ x 22¾". Boston, Isabella
Stewart Gardner Museum, gift of
Thomas Whittemore

STILL LIFE WITH A PURRO, II (*Nature
morte au purro, II*). (1904 or '05.) Oil,
10¾ x 14". New York, Mr. and Mrs.
John Hay Whitney

BY THE SEA (*Golfe de St. Tropez*).
St. Tropez (1904, summer). Oil

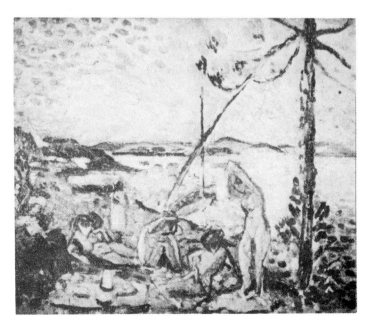

LUXE, CALME ET VOLUPTÉ—STUDY. St. Tropez
(1904, summer). Oil, 15 x 21½″. New York,
Mr. and Mrs. John Hay Whitney

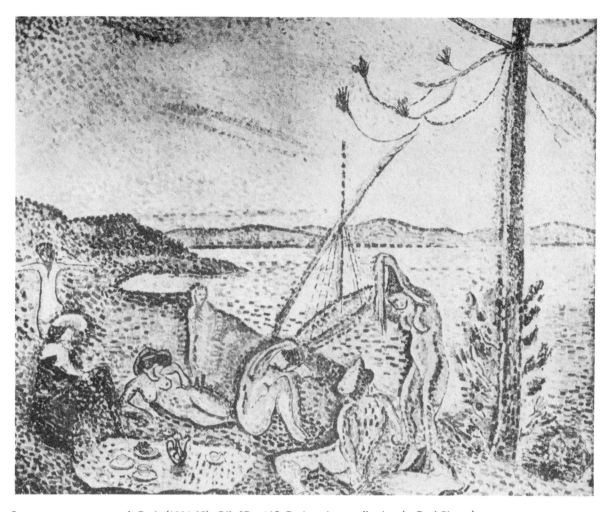

LUXE, CALME ET VOLUPTÉ. Paris (1904-05). Oil, 37 x 46″. Paris, private collection (*ex* Paul Signac)

HARBOR OF COLLIOURE (*Port de Collioure*). Collioure (1905). Watercolor, 5⅛ x 8¼″. Baltimore Museum of Art, Cone Collection

OLIVE TREES, COLLIOURE (*Les oliviers*). Collioure (1905?). Oil, 18 x 21¾″. Owned by the artist

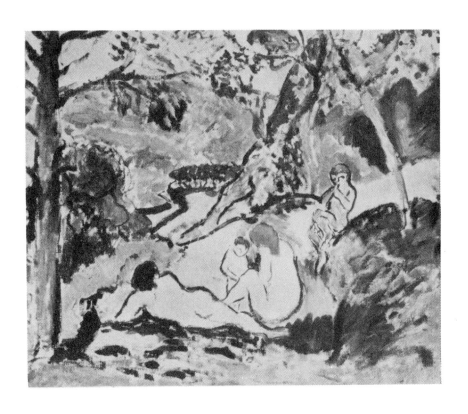

Above: PASTORAL. (1905.) Oil, 18 x 21¾". Paris, private collection. Color: Skira, p. 25

NUDE IN A WOOD (*Nu dans les bois*). (1905?) Oil, 16 x 13". New York, George F. Of

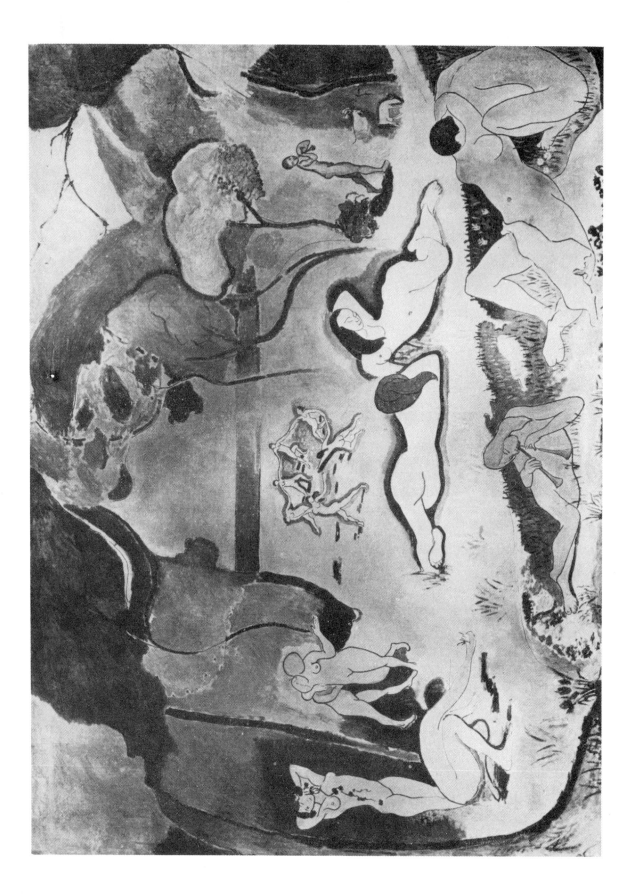

Opposite page: Joy of Life (*Bonheur de vivre; Joie de vivre*). Paris (1905-06). Oil, 68½ x 93¾″. Merion, Pennsylvania, Barnes Foundation (*ex* L. Stein; Tetzen Lund)

Left: Joy of Life—study. Paris (1905, autumn). Oil, 16⅛ x 21⅝″. San Francisco, Mr. and Mrs. Walter A. Haas (*ex* M. and S. Stein)

Left, below: Nude with Pipes—study for the Joy of Life (*Etude pour le Bonheur de vivre*). Paris, 1906. Pen and ink, 18 x 23¾″

Below: Girl with Ivy in Her Hair—study for the Joy of Life (*Etude pour le Bonheur de vivre*). Paris (1905 or '06). Pen and ink

Below, right: Joy of Life, detail: standing girl (*Bonheur de vivre, détail*)

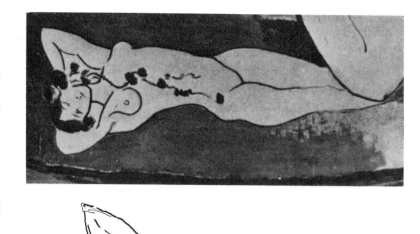

SEATED WOMAN (*Femme assise*). (c.1906.) Brush and ink study for a linoleum cut. (From George, bibl. 96, pl. 17)

NUDE IN A CHAIR (*Nu endormi dans une chaise*). (c.1906.) Pen, brush and ink, 25¾ x 18⅛". Chicago, Art Institute (*ex* Braun)

Seated Model, Hands Clasping Knee (*Figure assise*). (1906?) Pencil, 13 x 8½″. New York, Metropolitan Museum of Art, gift of Mrs. George Blumenthal, 1910

Seated Nude Leaning on Her Arm (*Nu assis appuyé sur le bras*). (c.1907?) Pencil, 12 x 9″. New York, Metropolitan Museum of Art, Alfred Stieglitz Collection, on loan to Museum of Modern Art

HEAD OF RECUMBENT FIGURE (*Tête renversée*). Paris (1906). Lithograph no. 5, 13¾ x 10¾" (design with signature). New York, Museum of Modern Art

HALF-LENGTH NUDE, EYES CAST DOWN (*Nu, mi-corps*). Paris (1906). Lithograph no. 2bis, 17⅞ x 9½" (design). New York, Museum of Modern Art

SEATED NUDE (*Nu assis*). Paris (1906, early). Linoleum cut, 19¼ x 15½". New York, Museum of Modern Art, gift of Mr. and Mrs. R. Kirk Askew, Jr.

TORSO WITH A HEAD (*Torse avec tête*). (1906.) Bronze, 8⅝" high. New York, Metropolitan Museum of Art, Alfred Stieglitz Collection, on loan to Museum of Modern Art

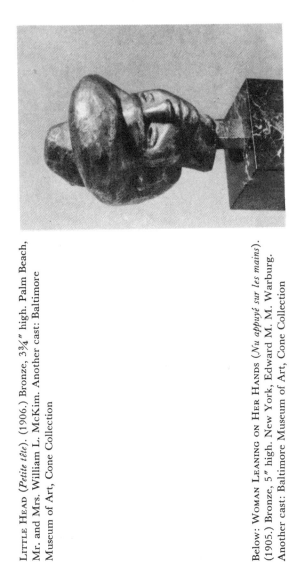

LITTLE HEAD (*Petite tête*). (1906.) Bronze, 3¾" high. Palm Beach, Mr. and Mrs. William L. McKim. Another cast: Baltimore Museum of Art, Cone Collection

Below: WOMAN LEANING ON HER HANDS (*Nu appuyé sur les mains*). (1905.) Bronze, 5" high. New York, Edward M. M. Warburg. Another cast: Baltimore Museum of Art, Cone Collection

Decorative Figure (*Figure décorative*). (1906.) Bronze, 28⅜″ high. New York, Dr. and Mrs. Harry Bakwin

Standing Nude (*Nu debout*). (1906.) Bronze, 19″ high. New York, Buchholz Gallery

STREET IN ALGIERS (*Alger, paysage*). Algiers (1906, February). Oil, 13⅜ x 16⅛". Copenhagen, Statens Museum for Kunst, J. Rump Collection (*ex* Tetzen Lund)

Below: BROOK WITH ALOES. Collioure (1907). Oil, 28¾ x 23⅝". Houston, Mr. and Mrs. John de Menil (*ex* Kann)

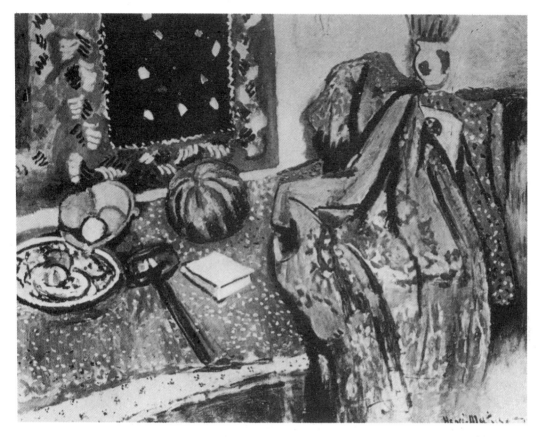

ORIENTAL RUGS (*Le tapis rouge*). Collioure (1906). Oil, 35 x 45¾″. Grenoble, Musée de Peinture et de Sculpture (*ex* Sembat)

STILL LIFE WITH A PLASTER FIGURE (*Nature morte et statuette*). Collioure (1906). Oil, 21¼ x 17¾″. New Haven, Yale University Art Gallery

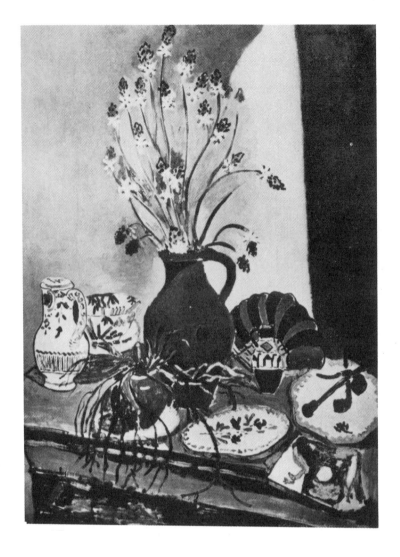

Above: STILL LIFE WITH ASPHODELS (*Nature morte aux asphodèles*).
(**1907**.) Oil, 44⅞ x 34¼″. Essen, Folkwang Museum (*ex* Osthaus)

THE ROSE (*La rose*). Paris (1907?). Oil, 16 x 12½″. New York,
Pierre Matisse Gallery (*ex* Moll)

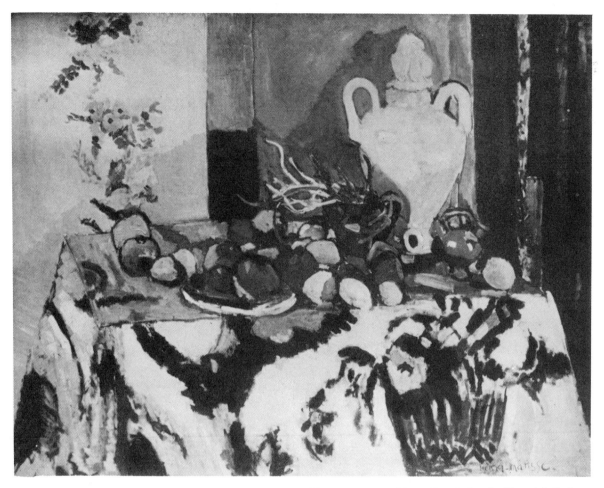

BLUE STILL LIFE (*Nature morte bleue*). Paris (1907). Oil, 35 x 45¾″. Merion, Pa., Barnes Foundation (*ex* M. and S. Stein; Tetzen Lund)

Above: MARGUERITE READING (*Portrait de Marguerite; La liseuse*). (1906.) Oil, 25¼ x 35⅝″. Grenoble, Musée de Peinture et de Sculpture (*ex* Sembat)

MARGUERITE. (1906 or '07.) Oil. Paris, Pablo Picasso

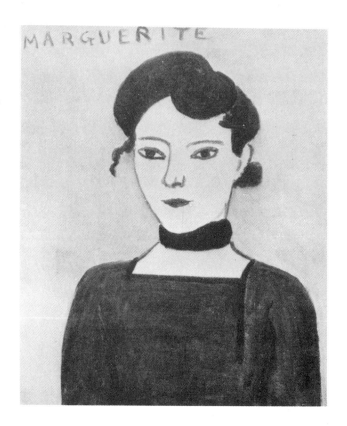

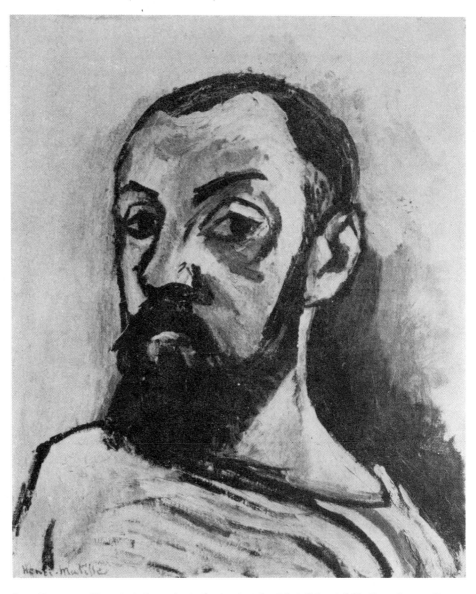

SELF PORTRAIT (*Portrait de l'artiste*). Collioure (1906). Oil, 21⅝ x 18⅛". Copenhagen, Statens Museum for Kunst, J. Rump Collection (*ex* M. and S. Stein; Tetzen Lund). Color: Skira, p. 27

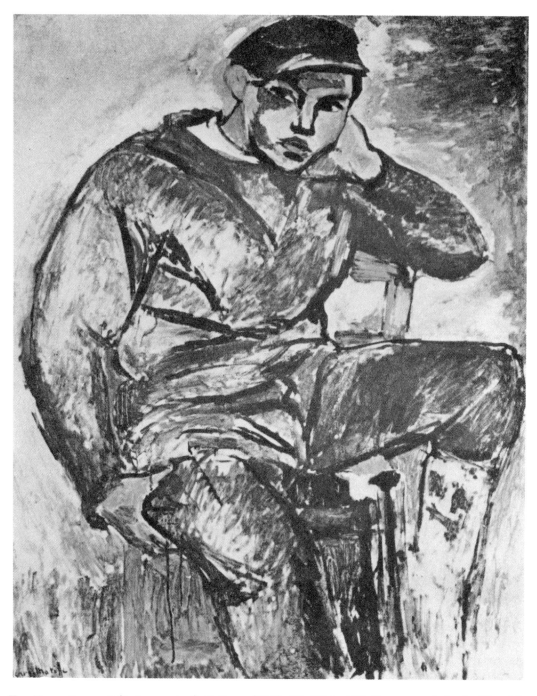

THE YOUNG SAILOR, I (*Le jeune marin, I*). Collioure (1906). Oil, 39½ x 31″. Norway, art dealer (*ex* M. and S. Stein; Sagen). Color: Braun, pl. 3

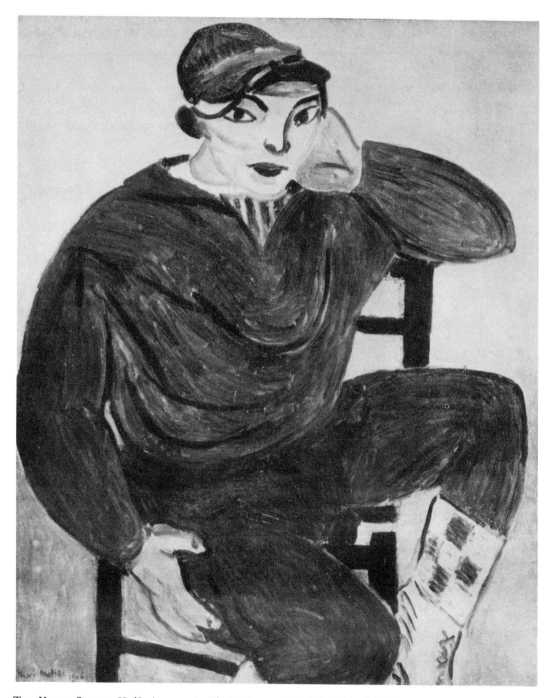

THE YOUNG SAILOR, II (*Le jeune marin, II*). Collioure, 1906. Oil, 39⅜ x 31⅞". Basle, Hans Seligman. Color: Skira, p. 30

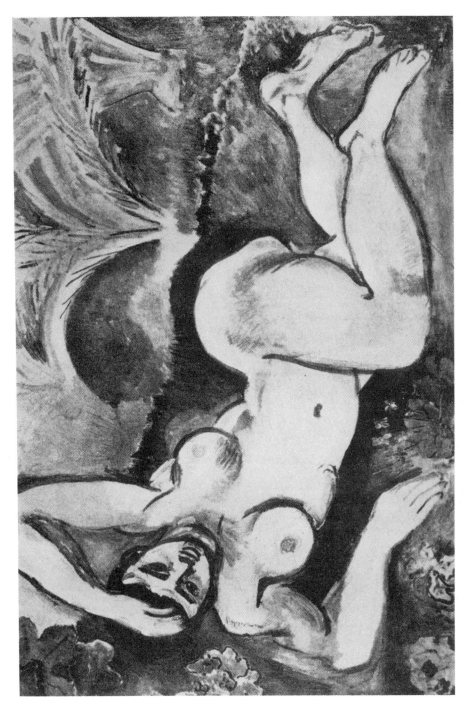

THE BLUE NUDE (*Le nu bleu—souvenir de Biskra*). Collioure (1907, early). Oil, 36¼ x 55⅛". Baltimore Museum of Art, Cone Collection (ex L. Stein; Quinn)

RECLINING NUDE (*Nu couché*). Paris (1907?). Ceramic tile, 4 x 5″. Great Neck, N. Y., Max Weber

RECLINING NUDE, I (*Nu couché, 1er état*). Collioure (1907). Bronze, 13½″ high, 19¾″ long

Left: Cast belonging to Museum of Modern Art, New York, acquired through the Lillie P. Bliss Bequest

Below left: Cast belonging to Baltimore Museum of Art, Cone Collection

(Another cast, not illustrated: Buffalo, Albright Art Gallery, Room of Contemporary Art)

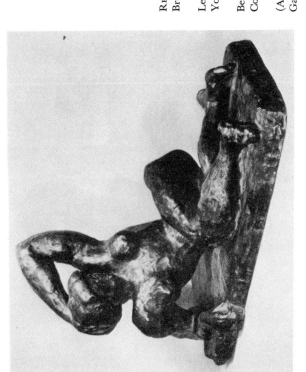

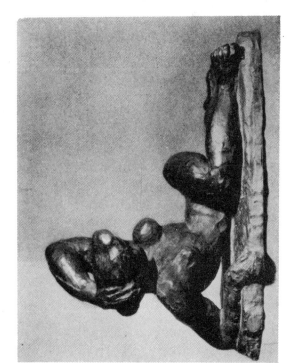

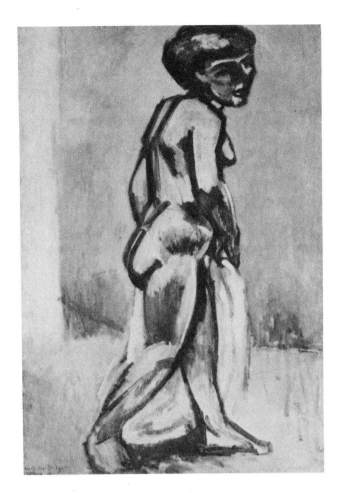

STANDING MODEL (*Nu debout*). 1907. Oil, 36 x 25″.
Rio de Janeiro, Mme Carlos Martins (*ex* A. B. Davies)

Below: THREE BATHERS (*Baignade*). Collioure (1907,
summer). Oil, 23⅝ x 28¾″. Minneapolis, Putnam
D. McMillan (*ex* Moll)

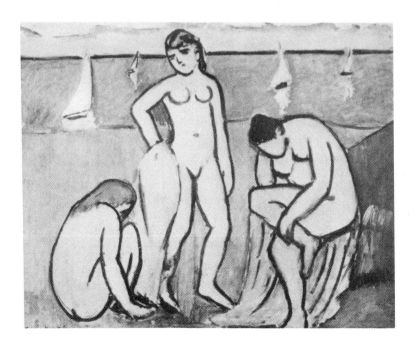

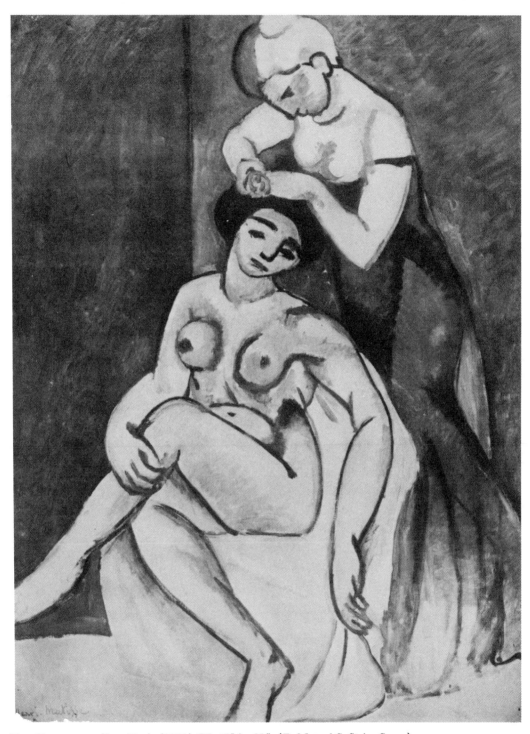

THE HAIRDRESSER (*La coiffure*). (1907.) Oil, 45⅝ x 35″. (*Ex* M. and S. Stein; Sagen)

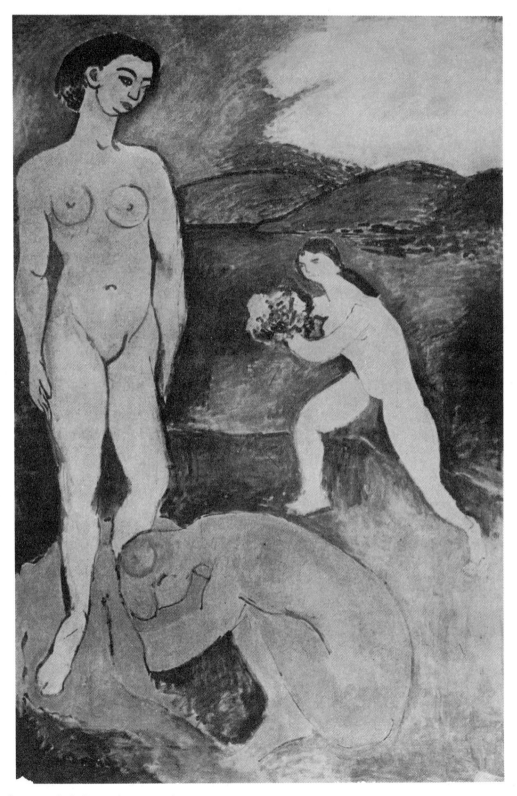

LE LUXE, I. Collioure (1907, early). Oil, 82¾ x 54⅜″. Paris, Musée National d'Art Moderne. Color: Braun, pl. 4

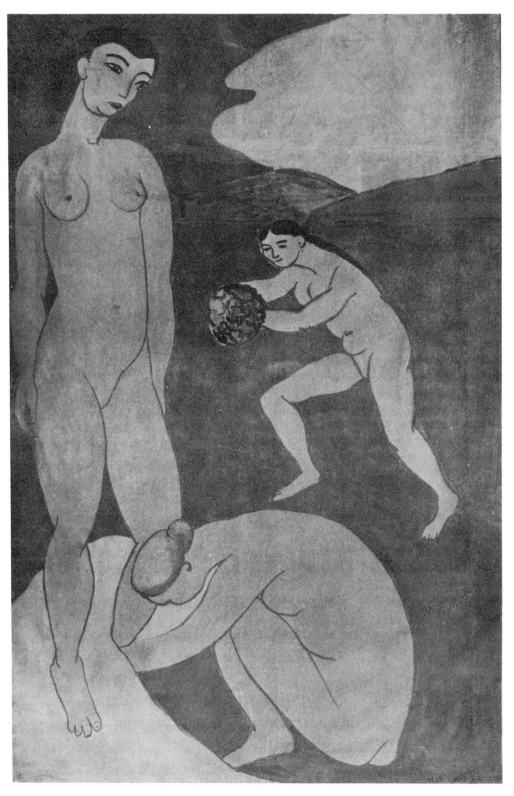

LE LUXE, II. Paris (1907 or '08). Casein, 82½ x 54¾". Copenhagen, Statens Museum for Kunst, J. Rump Collection

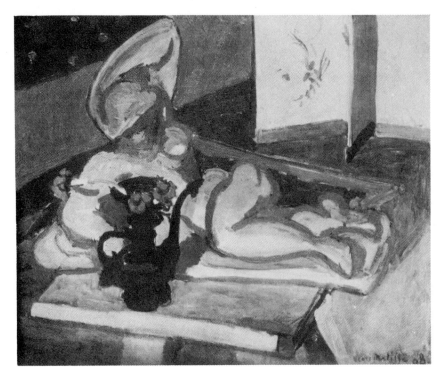

SCULPTURE AND PERSIAN VASE (*Sculpture et vase persan*). 1908. 23⅝ x 29″. Oslo, National Gallery (*ex* Tetzen Lund)

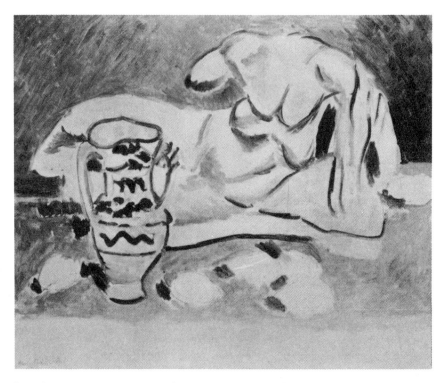

STILL LIFE WITH A GREEK TORSO (*Nature morte au torse grec*). Paris, 1908. Oil, c.25 x 30″

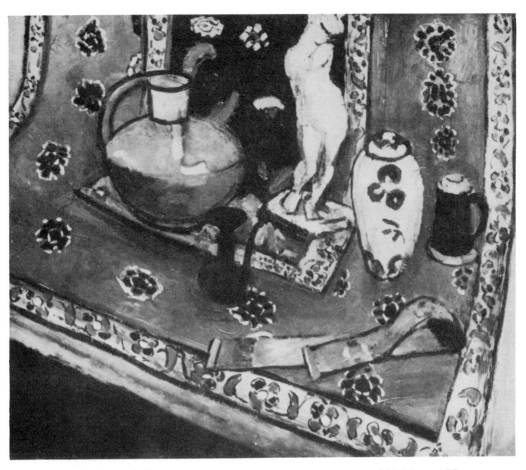

STILL LIFE IN VENETIAN RED (*Nature morte en rouge de Venise*). 1908. Oil, 35 x 41⅜". Moscow, Museum of Modern Western Art (*ex* Shchukin)

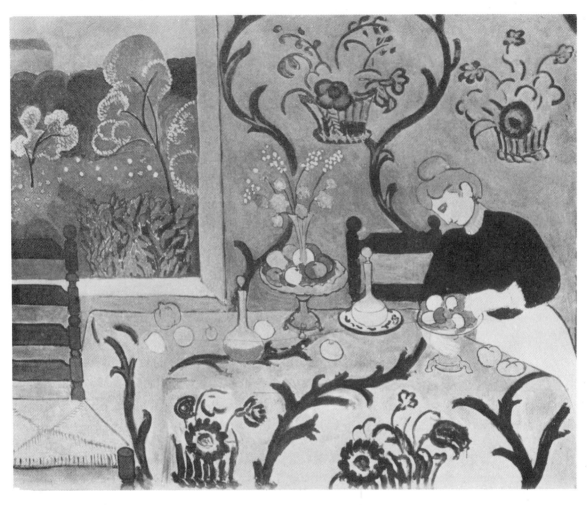

HARMONY IN BLUE (*La desserte—harmonie bleue*). Paris (1908, spring). Oil, 69¾ x 85⅞". (Sold to Shchukin, then largely overpainted spring 1909, cf. HARMONY IN RED)

Section of textile used as a motif by Matisse in the background of HARMONY IN BLUE, HARMONY IN RED, and paintings on pages 331, 346 top, 351, 409 top, and 431

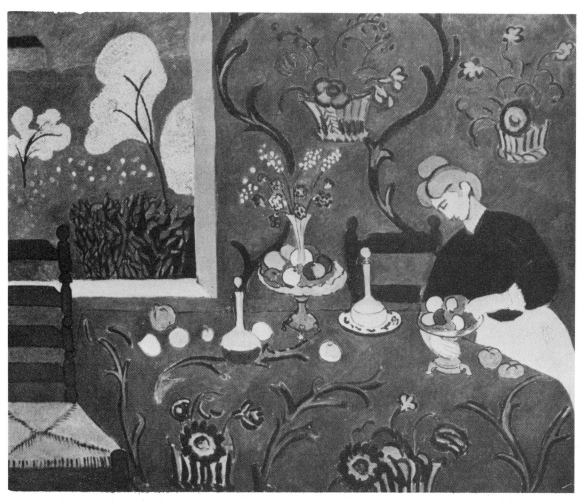

HARMONY IN RED (*La chambre rouge; La desserte—harmonie rouge*). Paris (begun 1908, spring, as HARMONY IN BLUE; repainted 1909, spring; dated 1908-). Oil, 69¾ x 85⅞″. Moscow, Museum of Modern Western Art (*ex* Shchukin). Color: Lejard, **pl.** 3 (poor); Moscow II

345

COFFEE POT, CARAFE AND FRUIT DISH (*Cafetière, carafe et compotier*). 1909. Oil, 34⅝ x 46½".
Moscow, Museum of Modern Western Art (*ex* Shchukin)

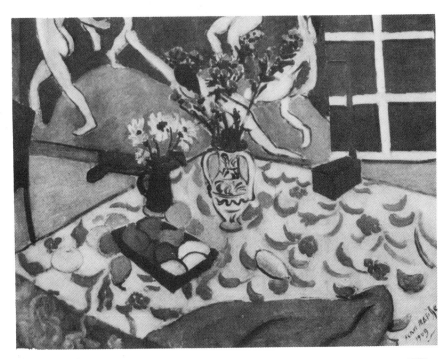

STILL LIFE WITH THE "DANCE" (*Nature morte à "La danse"*). Issy-les-Moulineaux, 1909
(autumn). Oil, 35½ x 41¾". Moscow, Museum of Modern Western Art (*ex* Morosov)

346

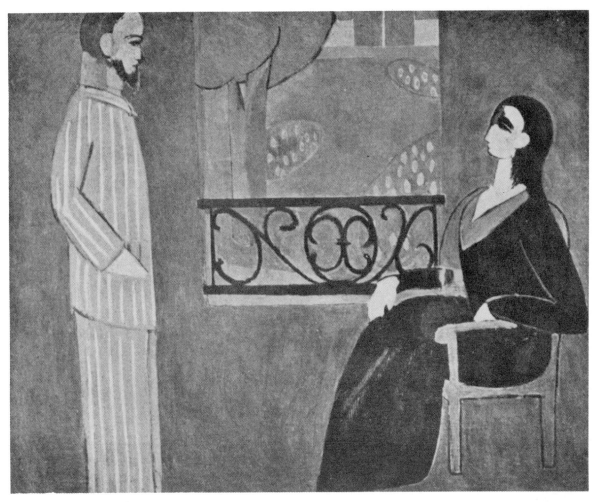

CONVERSATION. Paris (mid 1909). Oil, 69¾ x 85½″. Moscow, Museum of Modern Western Art (*ex* Shchukin)

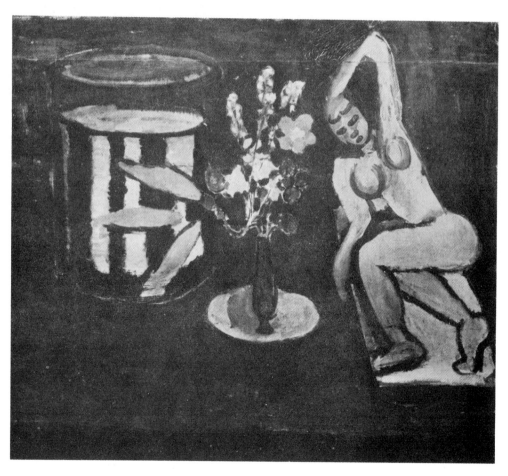

GOLDFISH (*Poissons rouges*). (1909 or '10.) Oil, 32¼ x 36¾". Copenhagen, Statens Museum for Kunst, J. Rump Collection (*ex* Tetzen Lund). Color: Skira, p. 45

STILL LIFE WITH GERANIUMS (*Nature morte aux géraniums*). Issy-les-Moulineaux, 1910. Oil, 36⅝ x 45¼″. Munich, Neue Staats-galerie (*ex* von Tschudi, Munich)

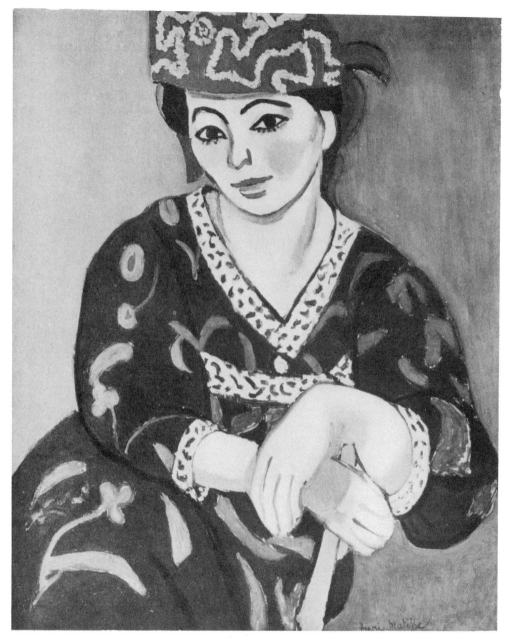

RED MADRAS HEADDRESS (*Mme Matisse; Madras rouge*). Paris (1907 or '08). Oil, 39¼ x 31¾". Merion, Pa., Barnes Foundation (*ex* M. and S. Stein; Tetzen Lund)

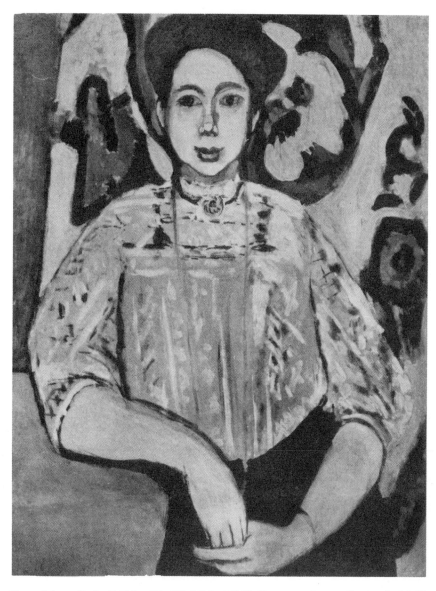

GRETA MOLL. Paris, 1908 (early). Oil, 36½ x 28¾″. Houston, private collection (*ex* Moll)

GIRL WITH GREEN EYES (*La femme aux yeux verts*). Paris (1909, autumn). Oil, 26 x 20". San Francisco Museum of Art, Harriet Lane Levy Bequest

SPANISH DANCER (*L'espagnole au tambourin*). 1909. Oil, 36¼ x 28¾". Moscow, Museum of Modern Western Art (*ex* Shchukin)

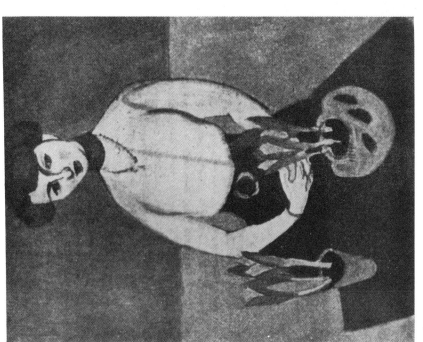

Above: Girl with Tulips (*Jeanne Vaderin; La jeune fille aux tulipes*). Issy-les-Moulineaux, 1910. Oil, 36¼ x 28¾". Moscow, Museum of Modern Western Art (*ex* Shchukin)

Right: Olga Merson (*Femme au corsage vert*). (1910.) Oil, 39½ x 32". New York, Mrs. Bernard Reis

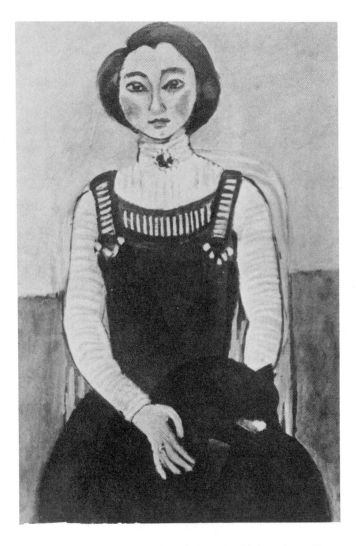

Above: GIRL WITH A BLACK CAT (*Marguerite Matisse; Jeune fille au chat*). 1910. Oil, 37 x 25¼". Owned by the artist

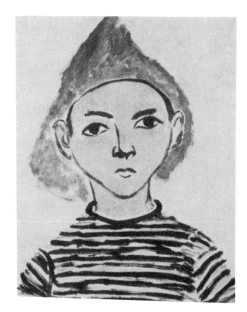

PIERRE MATISSE. Cavalière (1909, summer). Oil, 16 x 13". New York, Pierre Matisse

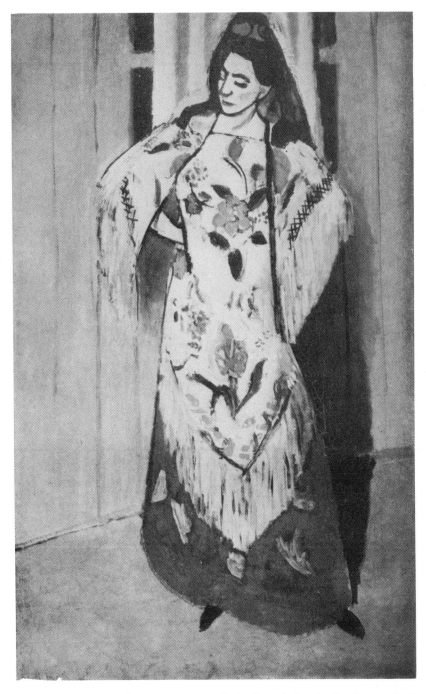

THE MANILA SHAWL (*Mme Matisse au châle de Manille*). Issy-les-Moulineaux, 1911 (early). Oil, 44⅛ x 27½″. Monte Carlo, Gaston Bernheim de Villers. Color: Skira, p 47

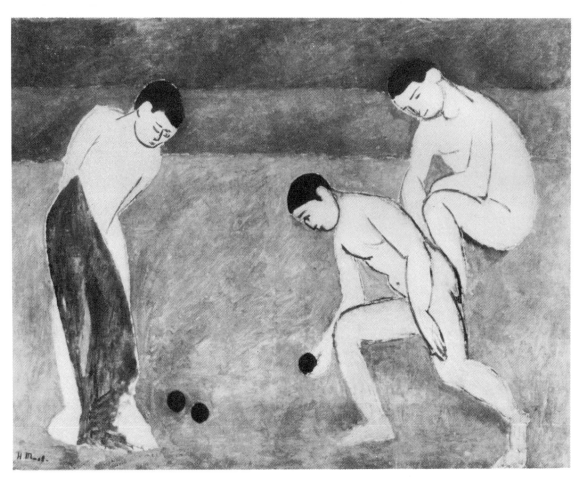

GAME OF BOWLS (*Les joueurs aux boules; Jeu de balles*). 1908. Oil, 46⅛ x 57⅞". Moscow, Museum of Modern Western Art (*ex* Shchukin)

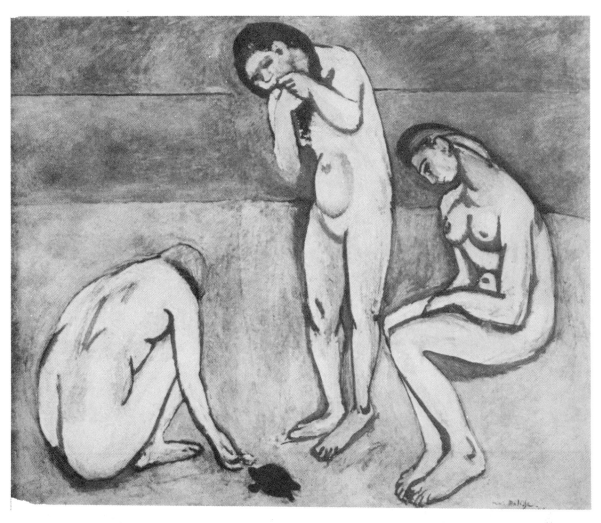

BATHERS WITH A TURTLE (*Baigneuses à la tortue*). 1908. Oil, 70½ x 86¾". St. Louis, Mr. and Mrs. Joseph Pulitzer, Jr. (*ex* Osthaus; Folkwang Museum, Essen)

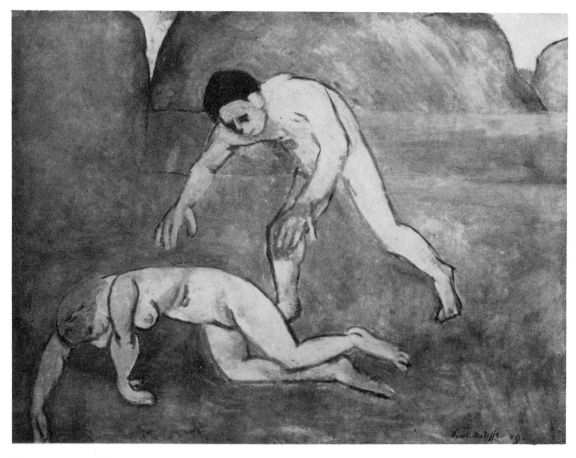

Nymph and Satyr (*La nymphe et le satyre*). 1909. Oil, 35 x 46⅛". Moscow, Museum of Modern Western Art (*ex* Shchukin)

NUDE BY THE SEA (*Nu au bord de la mer*). Cavaliè.e (1909, summer). Oil

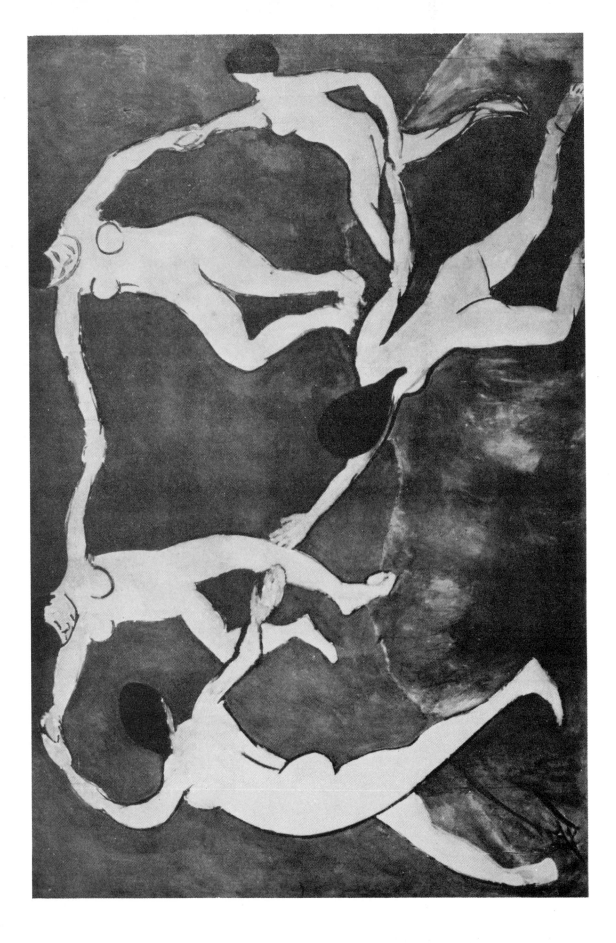

Opposite page: DANCE—STUDY (*La danse—esquise*). Paris (1909, early). Oil, 9 x 12'. Philadelphia Museum of Art, on loan from Walter P. Chrysler, Jr.

Left: JOY OF LIFE (1905-06), detail: the ring of dancers (*Bonheur de vivre, détail*). See p. 320

Below: DANCE—STUDY (*La danse—étude*). Paris (1909, early). Charcoal. Paris, private collection

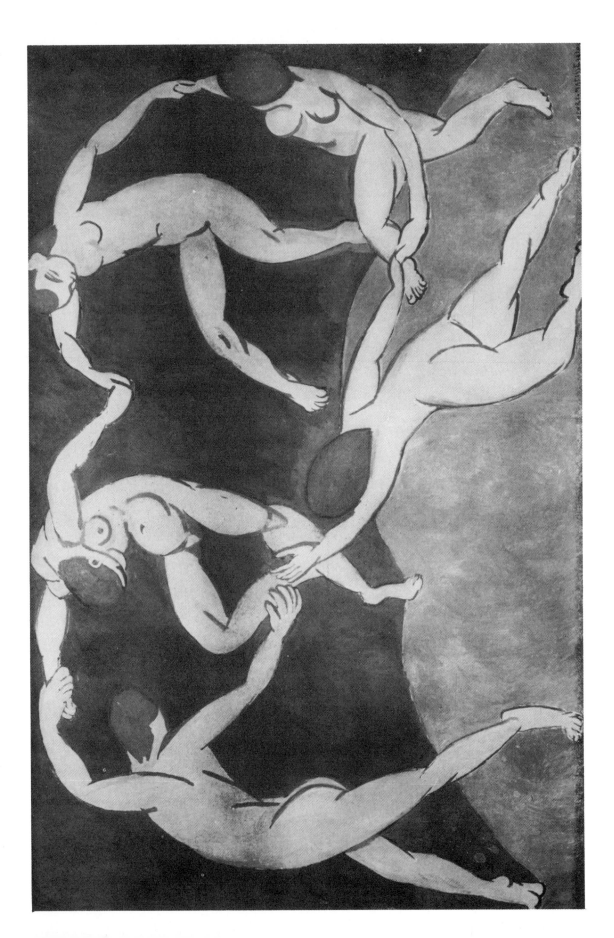

Opposite page: DANCE (*La danse*). Issy-les-Moulineaux. 1910. Oil, 8'5⅝" x 12'9½". Moscow, Museum of Modern Western Art (*ex* Shchukin)

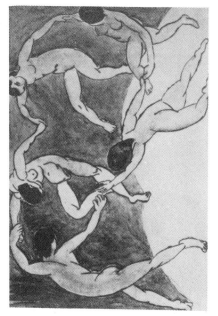

DANCE (*La danse*). Issy-les-Moulineaux (1910 or '11). Watercolor, 11¾ x 17½". Paris, Mme Marcel Sembat?

Left: Detail of DANCE (Moscow)

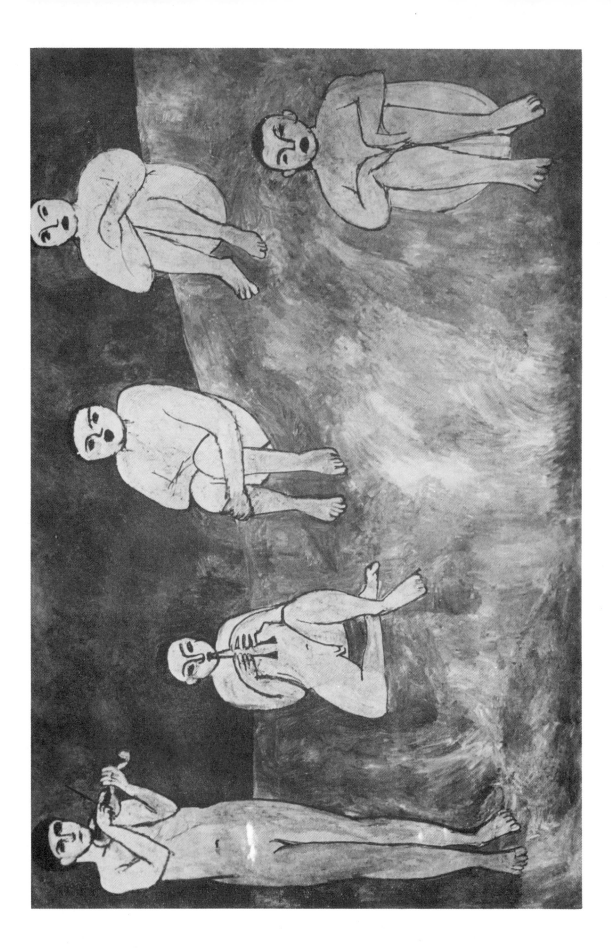

Opposite page: Music (*La musique*). Issy-les-Moulineaux, 1910. Oil, 8'5⅝" x 12'9½". Moscow, Museum of Modern Western Art (*ex* Shchukin)

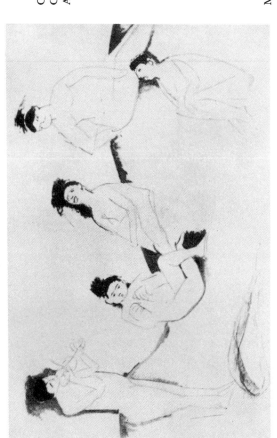

Music—early state (*La musique—1er état*). (1910)

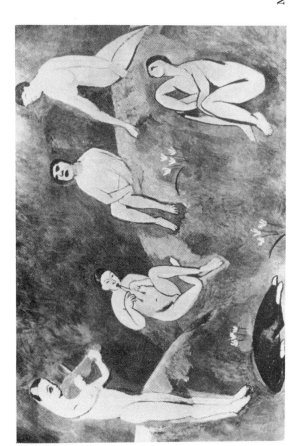

Music—unfinished state (*La musique—2me état*). (1910)

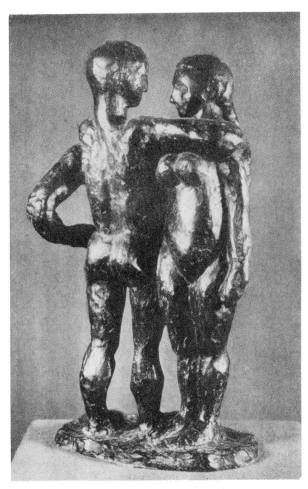

Two Negresses (*Deux négresses*). (1908) Bronze, 18½″ high.
New York, Dr. and Mrs. Harry Bakwin. Another cast:
Baltimore Museum of Art, Cone Collection

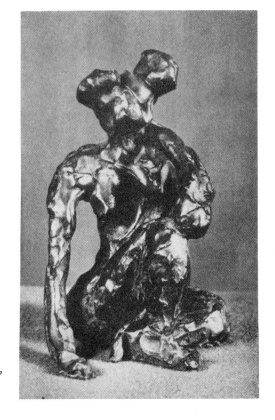

Seated Figure, Right Hand on Ground (*Nu accroupi, main droite à terre*). (1908?) Bronze, 7½″ high. Owned by the artist

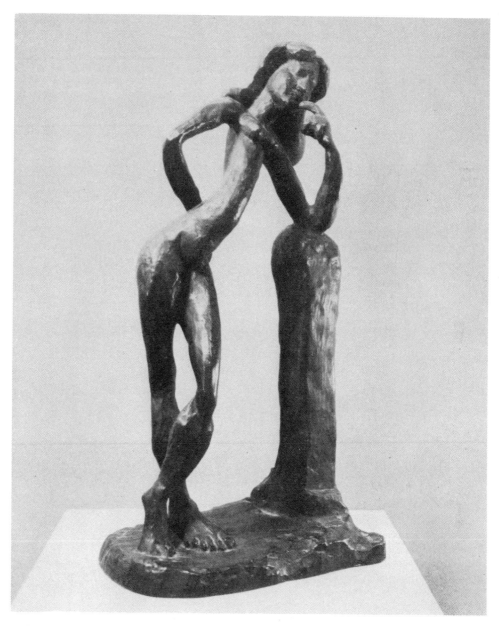

LA SERPENTINE. Issy-les-Moulineaux (1909). Bronze, 22¼″ high. New York, Museum of Modern Art.
Another cast: Baltimore Museum of Art

JEANNETTE, II (*Jeanne Vaderin, 2me état*). Issy-les-Moulineaux (1910). Bronze, 10¼″ high. Owned by the artist.

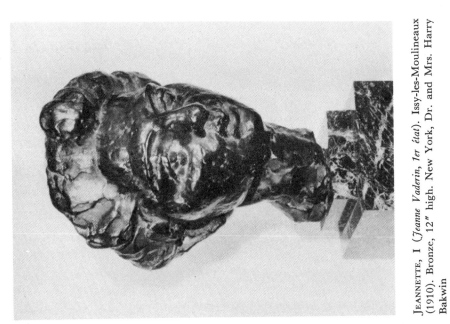

JEANNETTE, I (*Jeanne Vaderin, 1er état*). Issy-les-Moulineaux (1910). Bronze, 12″ high. New York, Dr. and Mrs. Harry Bakwin

Jeannette, III (*Jeanne Vaderin, 3me état*).
Issy-les-Moulineaux (1910-11). Bronze, 24⅜" high.
Owned by the artist

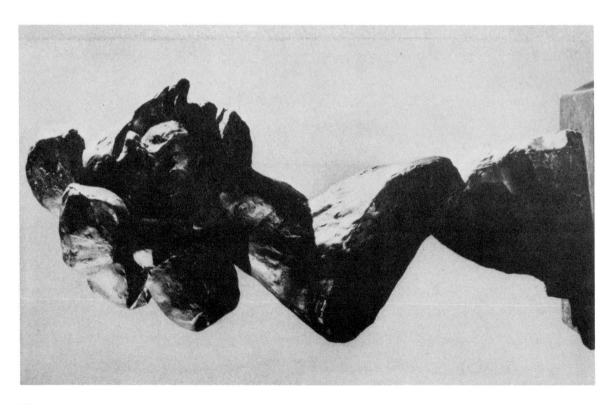

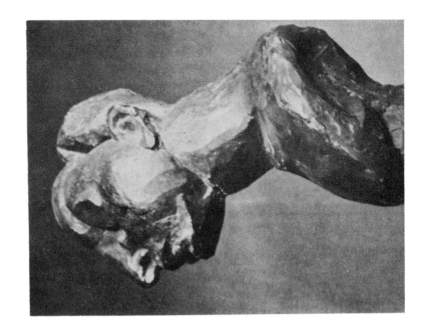

Above, right: JEANNETTE, IV (*Jeanne Vaderin, 4me état*). Issy-les-Moulineaux (1910-11?). Bronze, 24" high. New Haven, George Heard Hamilton

Above, left: JEANNETTE, IV—profile

JEANNETTE, V (*Jeanne Vaderin, 5me état*). Issy-les-Moulineaux (1910-11?). Bronze, 22⅞" high. Toronto, Art Gallery

JEANNETTE, V—profile

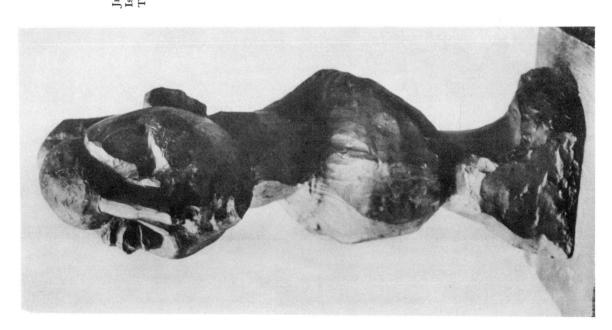

INTERIOR WITH SPANISH SHAWLS (*Nature morte—Séville*). Seville (1911, early). Oil, 35⅜ x 46⅛".
Moscow, Museum of Modern Western Art (*ex* Shchukin)

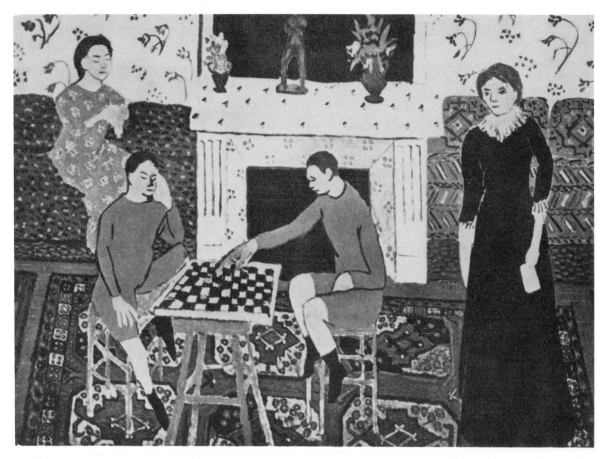

THE PAINTER'S FAMILY (*La famille du peintre; Portrait de famille*). Issy-les-Moulineaux (1911, spring). Oil, 56¼ x 76⅜″. Moscow, Museum of Modern Western Art (*ex* Shchukin). Color: Moscow, pl. XXIII; Romm, opp. p. 32 (poor)

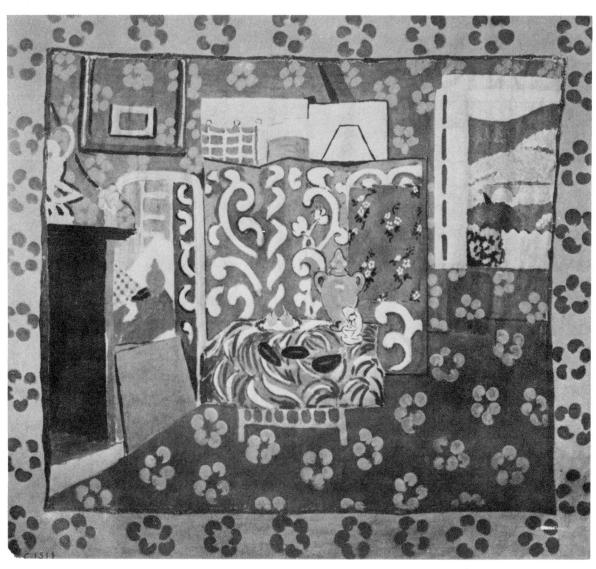

INTERIOR WITH EGGPLANTS (*Nature morte aux aubergines*). Collioure (1911). Tempera (détrempe), 82¾ x 96⅛″. Grenoble, Musée de Peinture et de Sculpture

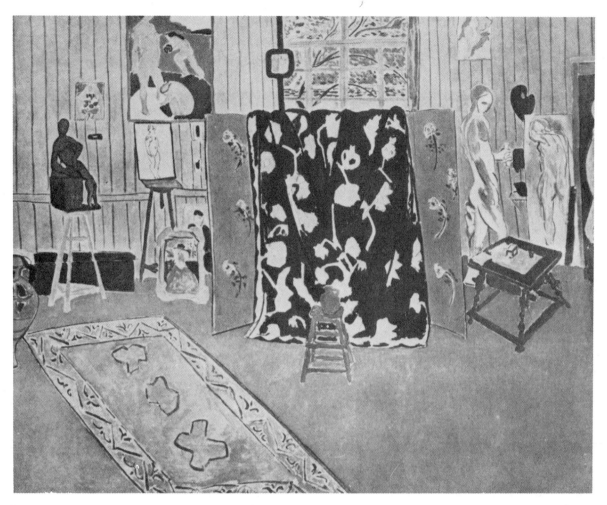

THE PAINTER'S STUDIO (*L'atelier du peintre*). Issy-les-Moulineaux (1911). Oil, 69¾ x 82¼″. Moscow, Museum of Modern Western Art (*ex* Shchukin). Color: Moscow, pl. XXV

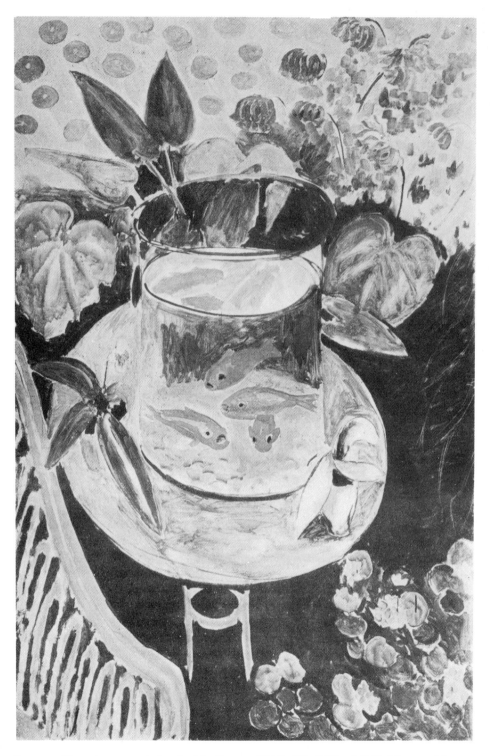

GOLDFISH (*Les poissons rouges*). Issy-les-Moulineaux (1911). Oil, 57⅞ x 38⅝″. Moscow, Museum of Modern Western Art (*ex* Shchukin). Color: Moscow, pl. XXIV; Romm, opp. p. 48

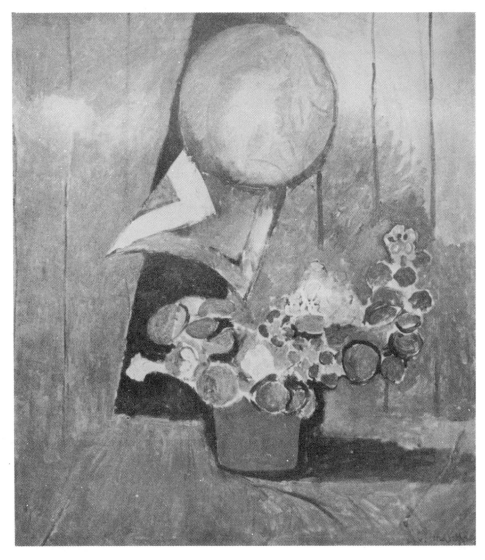

FLOWERS AND CERAMIC PLATE (*Fleurs et céramique*). Issy-les-Moulineaux (1911). Oil, 36¾ x 32½".
Palm Beach, Mr. and Mrs. LeRay W. Berdeau (*ex* Georg Swarzenski; Städtisches Museum, Frank-
furt-a-M.)

FATMA, THE MULATTO (*La mulâtresse Fatma*). Tangier (1912? early). Oil, 57⅞ x 24". Switzerland, private collection

ZORAH STANDING (*Zorah debout; La marocaine*). Tangier (1912, early). Oil, 57½ x 24". Moscow, Museum of Modern Western Art (*ex Shchukin*). Color: Romm, frontispiece

AMIDO, THE MOOR (*Le marocain*). Tangier (1912, early). Oil, 57⅞ x 24". Moscow, Museum of Modern Western Art (*ex Shchukin*)

THREE STUDIES OF ZORAH (*Zorah: trois études*). Tangier, 1912. Pen and ink, 12⅜ x 9¾". Boston, Isabella Stewart Gardner Museum

ZORAH IN YELLOW (*La robe jaune*). Tangier (1912, early). Oil, 32 x 25". Chicago, private collection

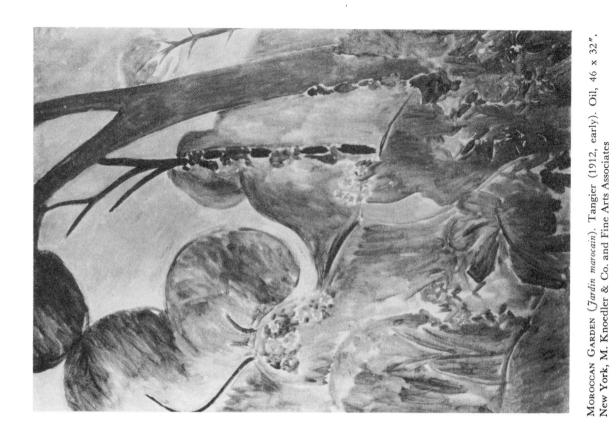

MOROCCAN GARDEN (*Jardin marocain*). Tangier (1912, early). Oil, 46 x 32". New York, M. Knoedler & Co. and Fine Arts Associates

PARK IN TANGIER (*Paysage marocain, Tanger*). Tangier (1911-12, winter). Oil, 46½ x 31½". Stockholm, National Museum. Color: Skira, p. 48

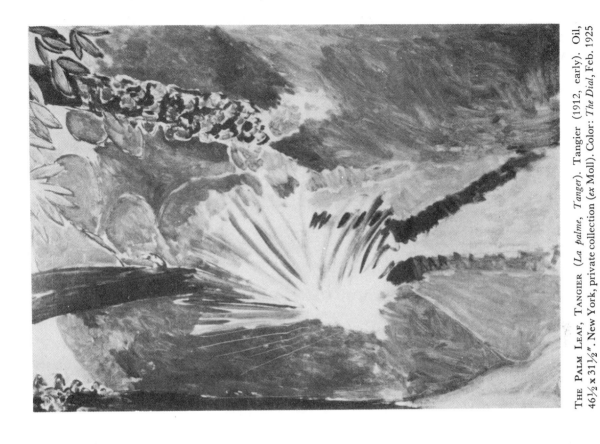

THE PALM LEAF, TANGIER (*La palme, Tanger*). Tangier (1912, early). Oil, 46½ x 31½". New York, private collection (*ex* Moll). Color: *The Dial*, Feb. 1925

A PATH IN THE WOODS OF CLAMART. Issy-les-Moulineaux (1912? 1914-16?). Oil, 36¼ x 28¾". Owned by the artist

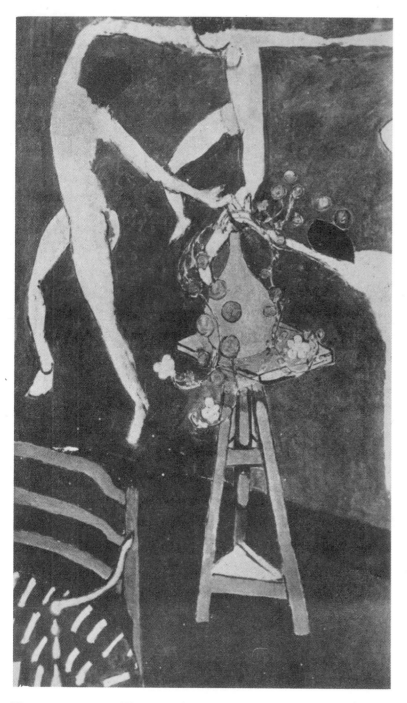

Nasturtiums and the "Dance," I (*Les capucines à "La danse," 1ère version*). Issy-les-Moulineaux (1912, summer). Oil, 75⅝ x 44⅞". Moscow, Museum of Modern Western Art (*ex* Shchukin)

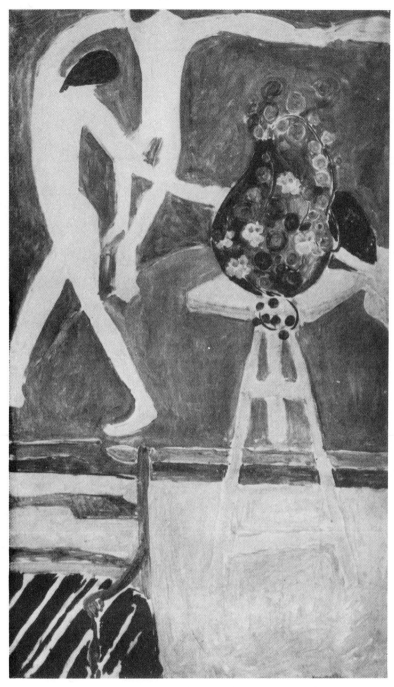

NASTURTIUMS AND THE "DANCE," II (*Les capucines à "La danse," 2me version*). Issy-les-Moulineaux (1912, summer). Oil, 74⅞ x 45″. Worcester, Massachusetts, Art Museum, anonymous extended loan (*ex* Moll). Color: *Living Art*, New York, 1923, pl. 3

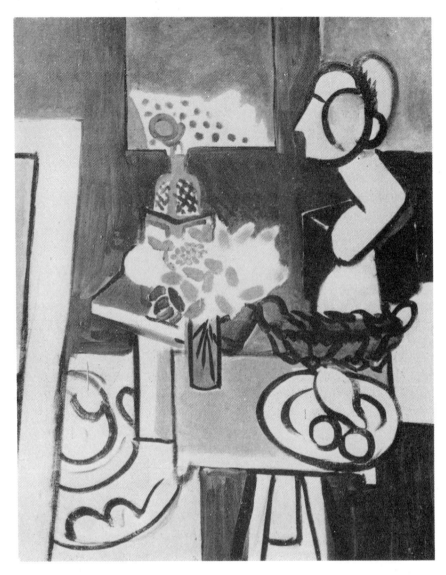

STILL LIFE WITH A BUST (*Nature morte au buste de plâtre*). Issy-les-Moulineaux (1912, summer or autumn). Oil, 39½ x 31¾". Merion, Pa., Barnes Foundation

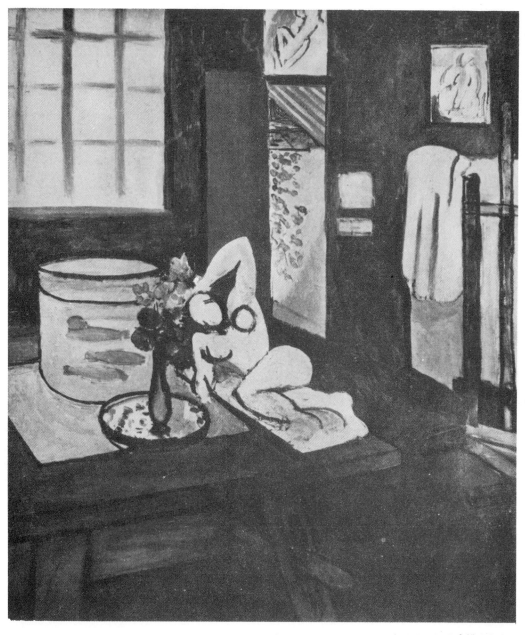

GOLDFISH (*Poissons rouges: Intérieur*). Issy-les-Moulineaux (1912, summer or autumn). Oil, 46 x 39¾". Merion, Pa., Barnes Foundation

WINDOW AT TANGIER (*Paysage vu d'une fenêtre, Tanger*). Tangier (1912, early).
Oil, 45¼ x 31⅛". Moscow, Museum of Modern Western Art (*ex Morosov*).
Color: Romm, opp. p. 64 (poor)

ENTRANCE TO THE KASBAH (*La porte de la Kasbah*). Tangier (1912). Oil, 45⅝ x
31½". Moscow, Museum of Modern Western Art (*ex Morosov*)

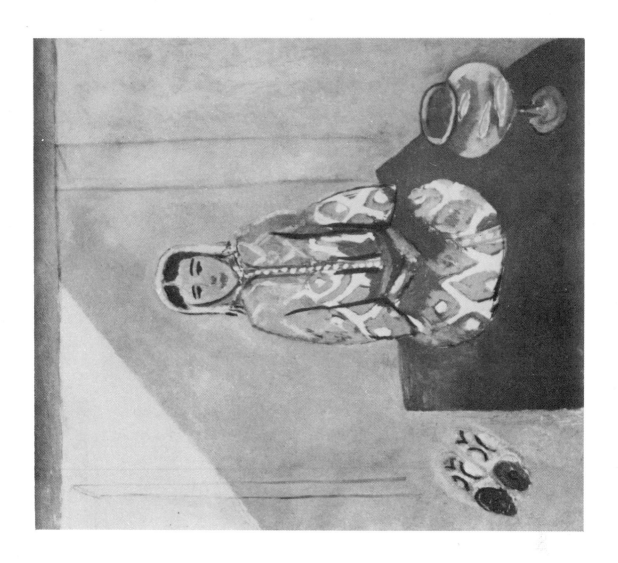

Right: ZORAH ON THE TERRACE (*Sur la terrasse*). Tangier (1912, autumn). Oil, 45⅝ x 39⅜". Moscow, Museum of Modern Western Art (*ex Morosov*)

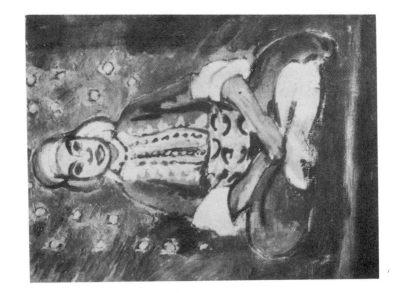

TANGERIAN GIRL (*La marocaine*). Tangier (1911-12, winter or 1912-13, winter). Oil, 13¾ x 10⅝". Grenoble, Musée de Peinture et de Sculpture (*ex Sembat*)

387

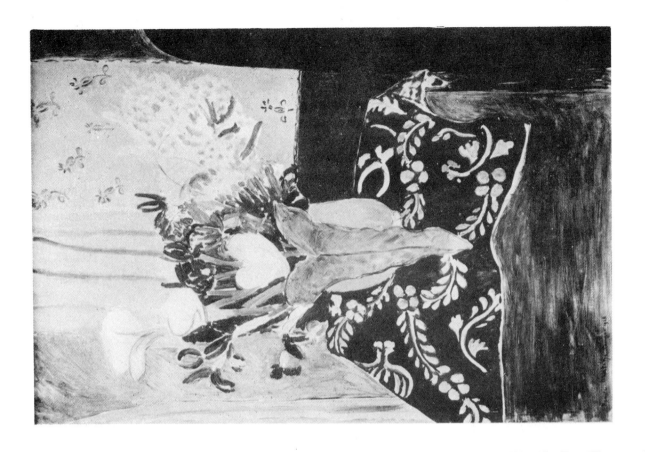

Opposite page: MOORISH CAFÉ (*Café maure; Café arabe*). Tangier (1912-13, winter). Oil, 69¼ x 82¾". Moscow, Museum of Modern Western Art (*ex* Shchukin)

Right: ARUM, IRIS AND MIMOSA (*Nature morte*). Tangier, 1913 (early). Oil, 57⅞ x 38⅝". Moscow, Museum of Modern Western Art (*ex* Shchukin)

Below: ORANGES (*Nature morte aux oranges*). Tangier (1912). Oil, 37 x 33⅛". Paris, Pablo Picasso (*ex* Thea Sternheim, Berlin). Color: Aragon, pl. 3; Braun, pl. 5

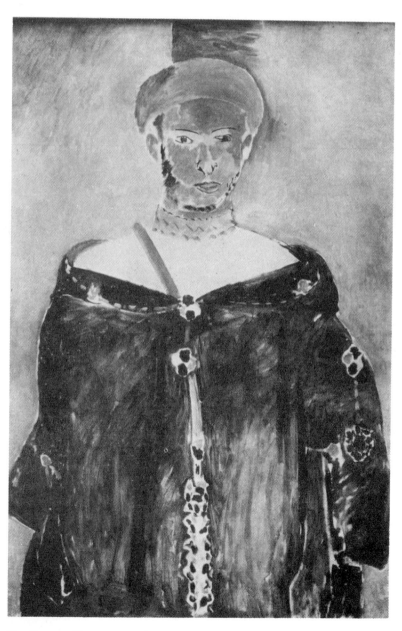

THE RIFFIAN, HALF-LENGTH (*Le marocain; Le riffain debout*). Tangier (1913, early). Oil, 57½ x 38⅝". Moscow, Museum of Modern Western Art (*ex* Shchukin)

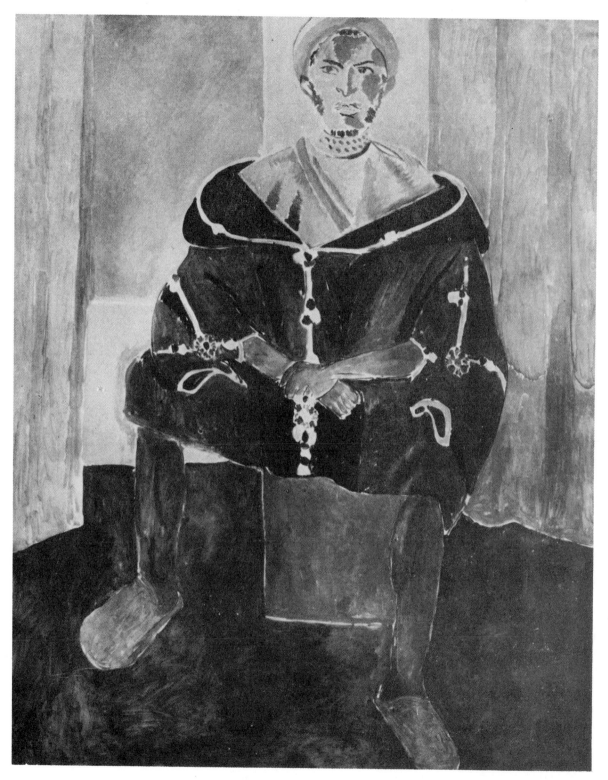

THE RIFFIAN (*Le riffain assis*). Tangier (1913, early). Oil, 79 x 62¾″. Merion, Pa., Barnes Foundation (*ex* Tetzen Lund)

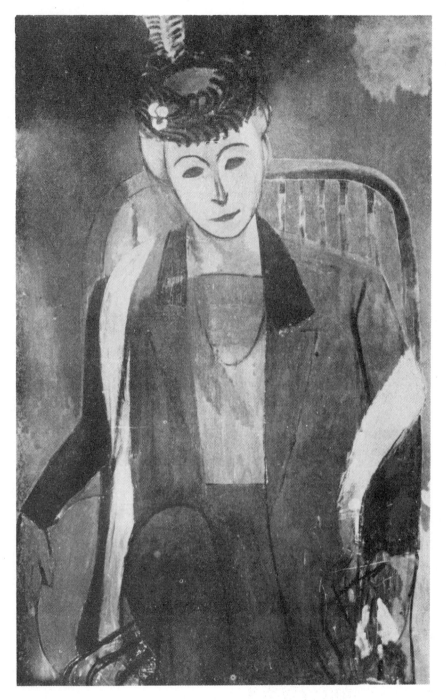

MME MATISSE. Issy-les-Moulineaux (1913, autumn). Oil, 57⅞ x 38¼″. Moscow, Museum of Modern Western Art (*ex* Shchukin)

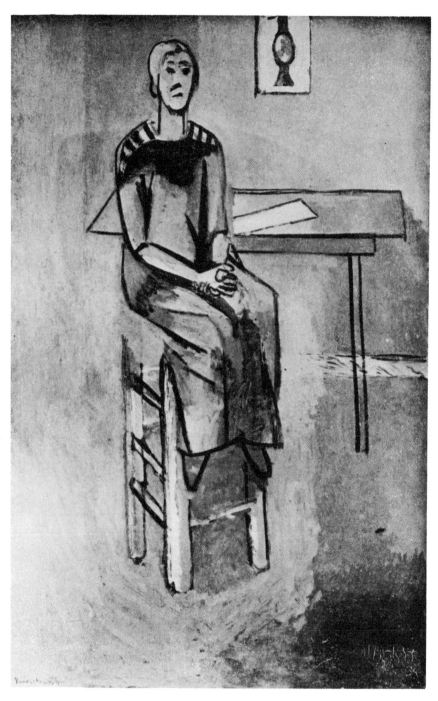

WOMAN ON A HIGH STOOL (*Femme au tabouret*). Paris (1913-14, winter). Oil, 57½ x 36⅝″. Owned by the artist (*ex* Shchukin)

MLLE YVONNE LANDSBERG. Paris (1914, spring). Etching no. 16, 7⅞ x 4⅜″. New York, Metropolitan Museum of Art

MLLE YVONNE LANDSBERG. Paris? 1914, August. Pencil, 20¼ x 16¾″. Owned by the artist

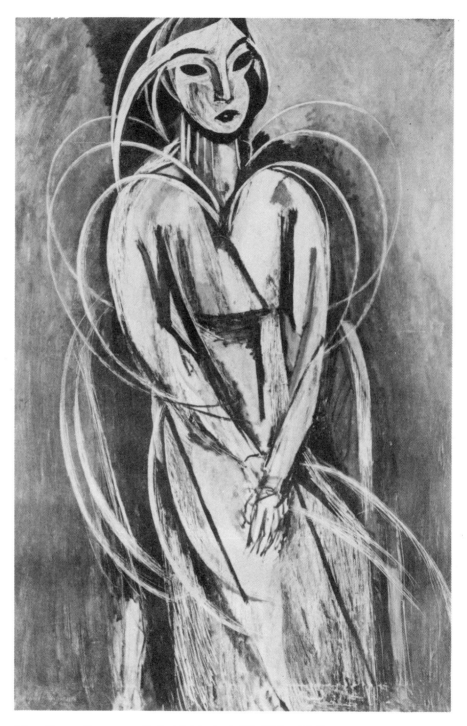

MLLE YVONNE LANDSBERG. Paris, 1914 (spring). Oil, 57¼ x 42″. Philadelphia Museum of Art, The Louise and Walter Arensberg Collection

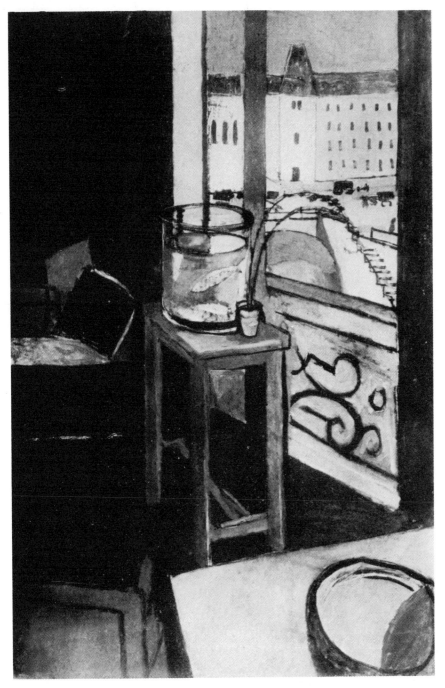

INTERIOR WITH GOLDFISH (*Le bocal aux poissons rouges*). Paris (1914, early). Oil, 56¾ x 38⅝".
Paris, Baroness Napoléon Gourgaud

STILL LIFE WITH LEMONS WHICH CORRESPOND
IN THEIR FORMS TO A DRAWING OF A BLACK
VASE UPON THE WALL (*Nature morte de citrons
dont les formes correspondent à celles d'un vase
noir dessiné sur le mur*—H. M.; *Still Life with
Bowl and Book*). (1914, autumn.) Oil,
27¼ x 21¼″. Providence, Rhode Island
School of Design, Museum of Art

Below: STILL LIFE WITH FRUIT (*Courgette, bananes,
pommes et oranges*). (1915.) Oil, 18 x 29½″.
New York, David Rockefeller (*ex* Quinn)

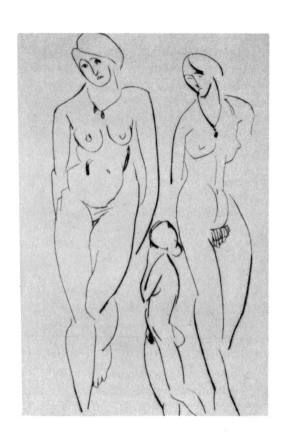

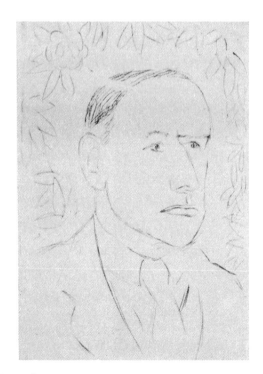

398

Opposite page

Above, left: WOMAN IN A KIMONO (*Mme Matisse*). Paris (1914). Drypoint no. 13, 5⁵⁄₁₆ x 2⅜". New York, Museum of Modern Art

Above, right: THREE STANDING NUDES (*Trois nus debouts*). Paris (1914?). Etching and drypoint no. 50, 5¾ x 3⅞". New York, Museum of Modern Art

Below, left: MATTHEW STEWART PRICHARD. Paris (1914). Etching no. 38bis, 7⅛ x 4¾" (trial proof). New York, Museum of Modern Art

Below, right: WALTER PACH. Paris (1914, autumn). Etching no. 33, 6⅜ x 2⅜". New York, Museum of Modern Art

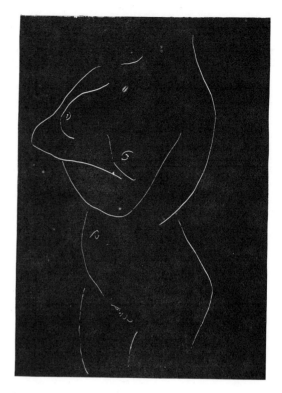

TORSO, ARMS FOLDED (*Torse aux bras croisés*). Paris (1914?). Monotype, 6¾ x 5". New York, Museum of Modern Art

APPLES (*Pommes*). Paris (1914). Monotype, 3⅝ x 5⅝". New York, E. Weyhe

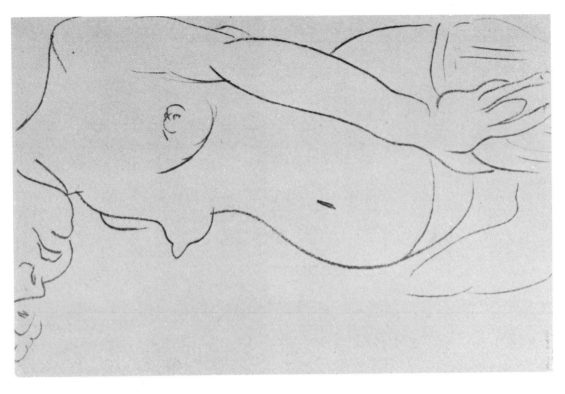

Nude, Face Partly Showing (*Nu au visage coupé*). Paris (1914). Lithograph no. 15, 19¾ x 12" (design). New York, Museum of Modern Art

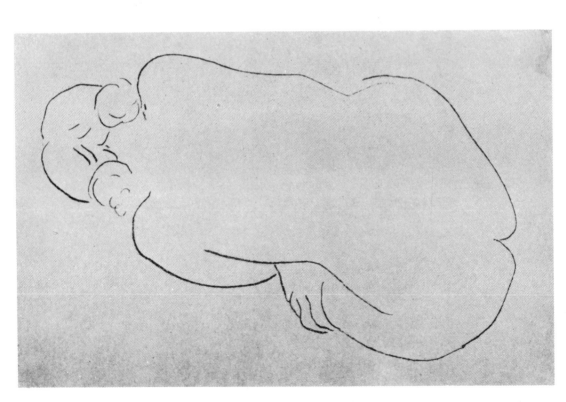

Seated Nude, Back Turned (*Nu vu de dos*). Paris (1914). Lithograph no. 19, 19¾ x 13" (stone)

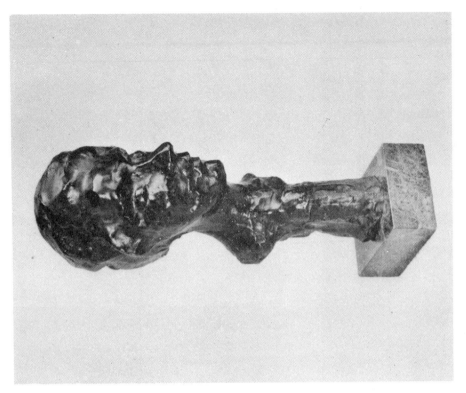

HEAD OF MARGUERITE (*Marguerite*). (1915?) Bronze, 12⅝″ high.
Owned by the artist

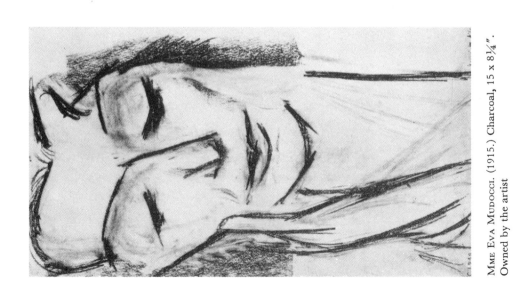

MME EVA MUDOCCI. (1915.) Charcoal, 15 x 8¼″.
Owned by the artist

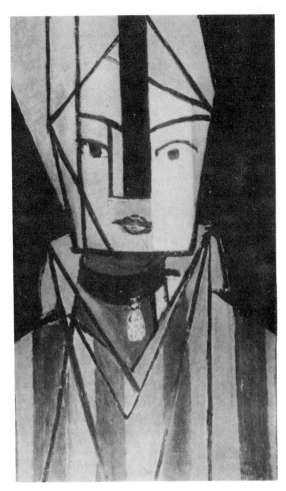

HEAD, WHITE AND ROSE (*Tête, blanche et rose*). (1915?) Oil, 29 x 17⅜". Owned by the artist

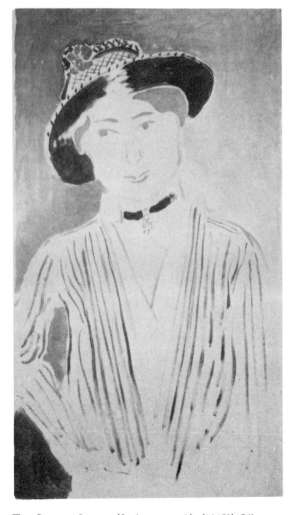

THE STRIPED JACKET (*La jaquette rayée*). (1915?) Oil

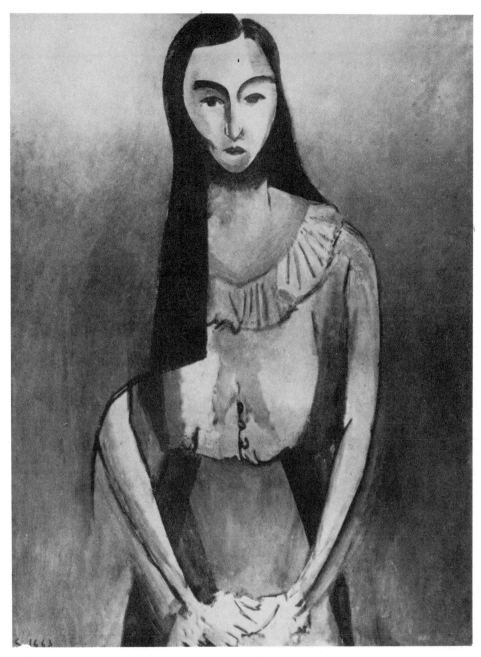

ITALIAN WOMAN (*L'italienne*). (1915, late?) Oil, 45¾ x 35″. Santa Monica, California, Mrs. Ruth McC. Maitland

AUGUSTE PELLERIN. Paris (1915 or '16, winter). Oil

SARAH STEIN. Paris, 1916 (early?). Oil. Palo Alto, California, Mrs. Michael Stein

404

Sarah Stein—study for the portrait. Paris, 1916. Charcoal. Inscribed: *à Mad^e Michel Stein / hommage respectueux / Henri-Matisse 1916*. Palo Alto, California, Mrs. Michael Stein

Mme Greta Prozor. Paris (1916). Oil, 57½ x 37¾". Owned by the artist

ORANGES (*Coupe d'oranges*). Issy-les-Moulineaux (1916, spring.) Oil. Paris, M. Ellisen

APPLES (*Les pommes*). (1916.) Oil, 46 x 35". Chicago, Art Institute, gift of Samuel A. Marx (*ex* Quinn)

406

Right: THE ROSE MARBLE TABLE (*La table de marbre rose*). Issy-les-Moulineaux, 1917. Oil, 59 x 39⅜". (*Ex Kann*)

TREE NEAR TRIVAUX POND (*Arbre près de l'étang de Trivaux*). Issy-les-Moulineaux? (1916?) Oil, 35½ x 28¼". London, Tate Gallery. Color: Faber, p. 8.

Opposite page: BATHERS BY A RIVER (*Women at a Spring; Baigneuses*). (Worked on at Issy-les-Moulineaux, 1916, 1917; begun earlier.) Oil, 8'7" x 12'10". New York, Henry Pearlman

Right: THE LORRAIN CHAIR (*La chaise lorraine aux pêches*). (1916 or '17.) Oil, 51⅝ x 35". Solothurn, Switzerland, private collection. Color: Skira, p. 51

Below: THE PEWTER JUG (*Le pot d'étain*). Issy-les-Moulineaux? (1916 or '17.) Oil, 36¼ x 25⅝". Baltimore Museum of Art, Cone Collection

THE STUDIO, QUAI ST. MICHEL. Paris (1916). Oil, 57½ x 45¾″. Washington, Phillips Collection

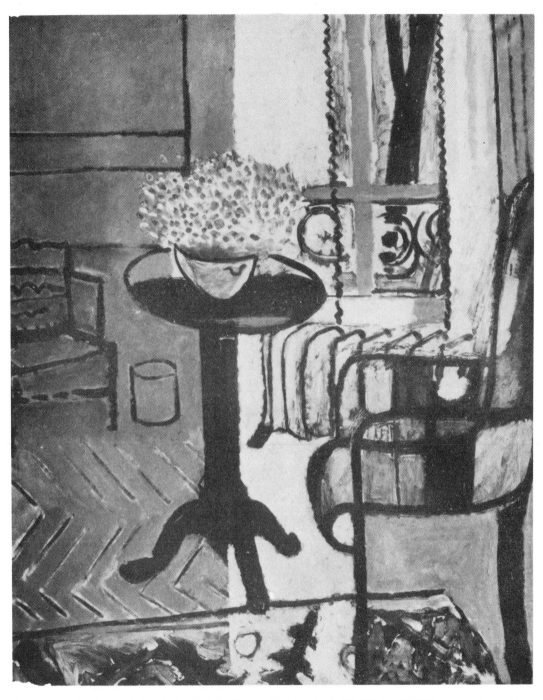

THE WINDOW (*La fenêtre; Intérieur*). Issy-les-Moulineaux (1916, spring). Oil, 57½ x 45¾″. Detroit Institute of Arts

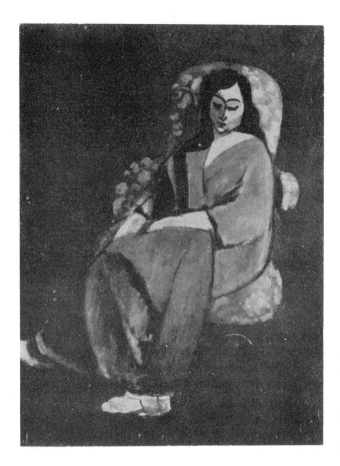

THE GREEN ROBE (*La robe verte; Laurette sur fond noir*).
Paris, 1916. Oil, 28¾ x 21½″. Owned by the artist

Below: GOURDS (*Les coloquintes*). Issy-les-Moulineaux,
1916 (summer). Oil, 25⅞ x 31⅞″. New York,
Museum of Modern Art (*ex* Leonide Massine)

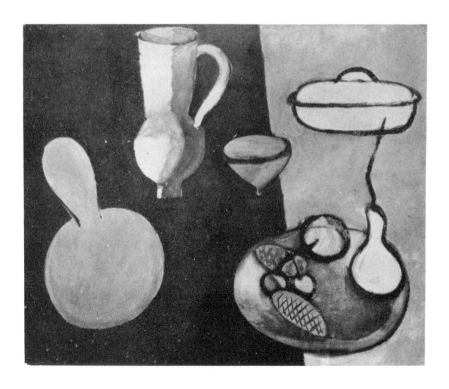

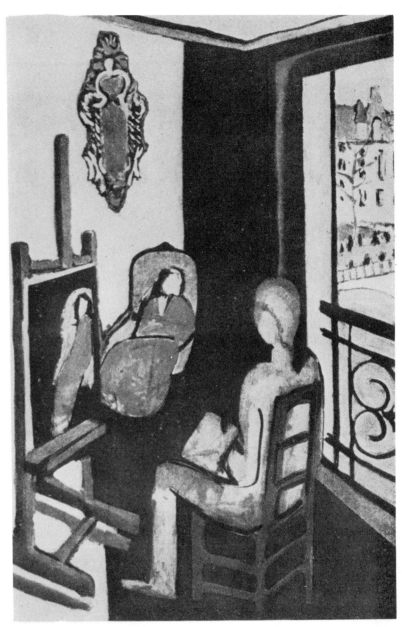

THE PAINTER AND HIS MODEL (*Le peintre et son modèle*). Paris (1916). Oil, 57⅞ x 38¼″. Paris, Musée National d'Art Moderne. Color: Aragon, pl. 8; Lejard, pl. 4 (poor); Faber, p. 11 (poor)

HEAD AND COFFEE CUP (*Tête et tasse à café*). Paris (1917?).
Oil

GIRL IN A TURBAN (*Femme au turban*). (1916?) Oil,
8¾ x 6¼″. New York, private collection

SLEEPING NUDE (*Nu endormi*). Paris (1916?). Oil, 37⅜ x 76¾″

Coffee (*Le café*). Issy-les-Moulineaux (1916?). Oil, 40 x 25½″. (*Ex* Tetzen Lund).
Color: *Art News*, May 15, 1941, cover

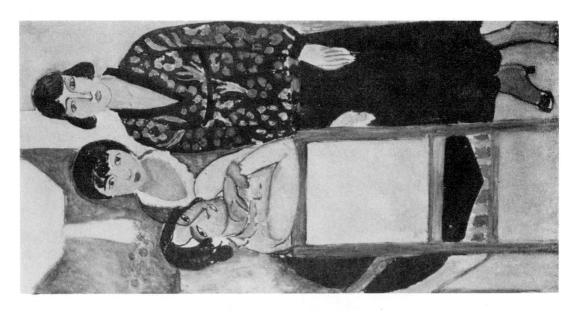

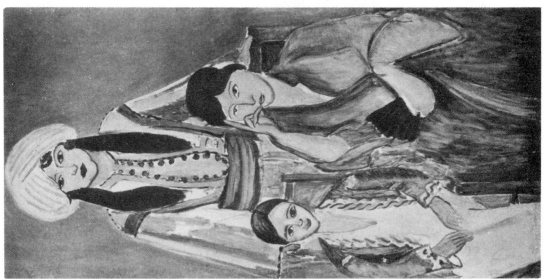

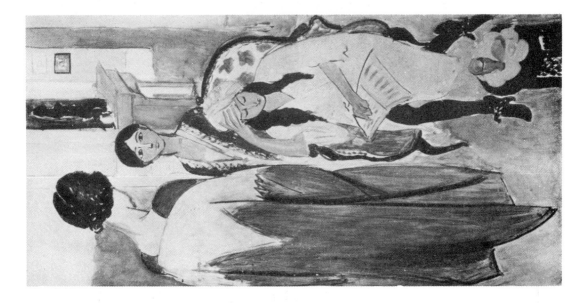

THREE SISTERS, TRIPTYCH (*Les trois soeurs, triptyque*). Paris (1916, autumn, and 1917, second half).
Oil, each panel, 77 x 38″. Merion, Pennsylvania, Barnes Foundation (left-hand panel *ex* Tetzen Lund)

Left: THREE SISTERS WITH NEGRO SCULPTURE (*Trois soeurs à la sculpture nègre*)

Middle: THREE SISTERS WITH GREY BACKGROUND (*Trois soeurs au fond gris*)

Right: THREE SISTERS AND "THE ROSE MARBLE TABLE" (*Trois soeurs à "La table de marbre rose"*)

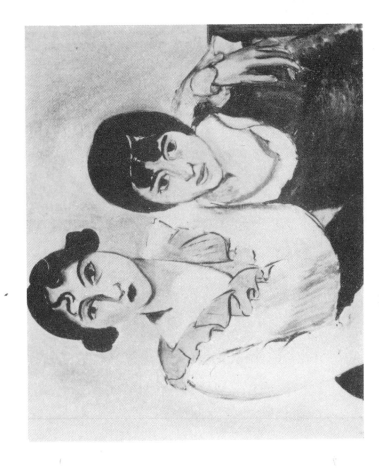

TWO SISTERS (*Les deux soeurs*). (1917?) Oil, 24 x 29″. Denver Art Museum, Helen Dill Collection

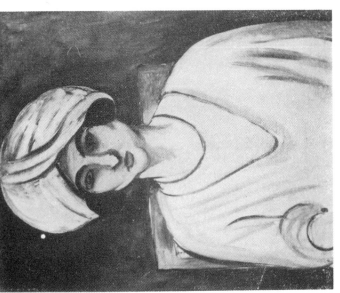

THE WHITE TURBAN (*Le turban blanc*). (1916?) Oil, 31⅞ x 25⅝″. Baltimore Museum of Art, Cone Collection

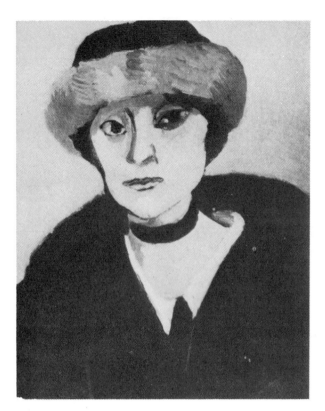

MARGUERITE IN A FUR HAT (*Marguerite au chapeau de fourrure*).
(c.1917-18.) Oil

THE WINDSHIELD (*Le pare-brise*). Near Villacoublay? (1917.) Oil, 15¼ x 21¾″. Cleveland,
Mrs. Malcolm L. McBride

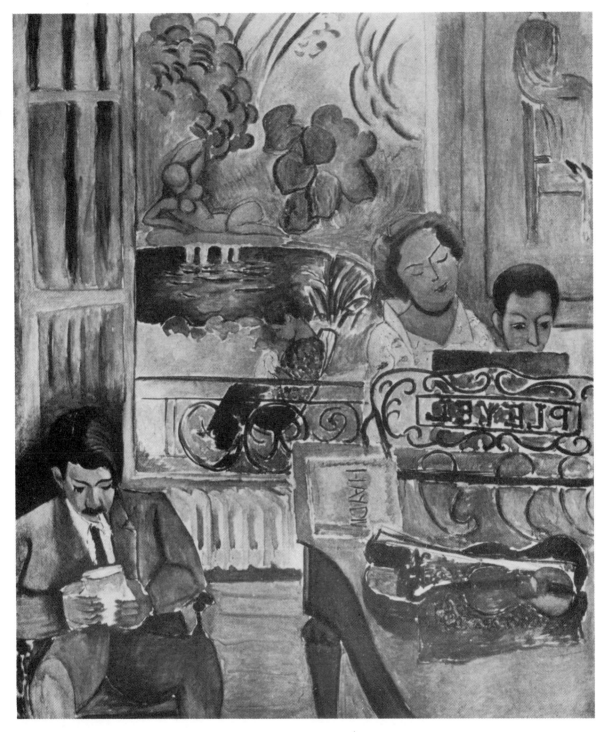

Music Lesson (*La leçon de musique*). Issy-les-Moulineaux (1917, summer). Oil, 96 x 82½″. Merion, Pennsylvania, Barnes Foundation

THE OPEN WINDOW (*La fenêtre ouverte*). Nice (1917, late?). Oil, 25⅝ x 21¼″. Switzerland, private collection

Below: MONTALBAN (*Paysage Montalban*). Nice (1918, spring?). Oil, 28¾ x 35¾″. Lebanon, New Jersey, Alexina Matisse

INTERIOR WITH A VIOLIN (*Intérieur au violon*). Nice (1917-18, winter). Oil, 45¾ x 35″. Copenhagen, Statens Museum for Kunst, J. Rump Collection. Color: Skira, p. 53; Swane, opp. p. 102

SELF PORTRAIT (*Portrait de l'artiste*). Nice (1918, early). Oil, 25⅝ x 21¼". Owned by the artist

NUDE BY THE WINDOW (*Nu debout*). Nice (1918? early). Oil, 16⅛ x 10⅝"

INTERIOR WITH A VIOLIN CASE (*Intérieur; L'étui à violon*). Nice (1918-19, winter). Oil, 28¾ x 23⅝". New York, Museum of Modern Art, Lillie P. Bliss Collection

THE ARTIST AND HIS MODEL (*L'artiste et son modèle; L'atelier*). Nice (1919?). Oil, 23⅝ x 28¾″. New York, Dr. and Mrs. Harry Bakwin (*ex* Quinn)

FIGURE WITH A CUSHION (*Figure au coussin*). Nice (1918). **Bronze, 5⅛″ high.** Baltimore Museum of Art, Cone Collection

FRENCH WINDOW AT NICE (*Les persiennes*). Nice (1919). Oil, 51¼ x 35″. Merion, Pennsylvania, Barnes Foundation

Tea (*Le thé*). Nice (1919). Oil, 55 x 83″. Hollywood, Earl L. Stendahl (*ex* M. and S. Stein)

WHITE PLUMES (*Les plumes blanches*). Nice (1919). Oil, 29 x 24".
Minneapolis Institute of Arts. Color: *Vanity Fair*, pl. 22

ANTOINETTE. Nice (1919). Oil, 26 x 19¾".
(*Ex* Etienne Bignou, Paris)

The Plumed Hat (*Le chapeau à plumes*). Nice, 1919. Pencil, 20½ x 14".
Grosse Pointe Farms, Michigan, John S. Newberry, Jr.

The Plumed Hat (*Le chapeau à plumes*). Nice (1919). Pencil, 21 x 14¼".
East Hampton, Long Island, Mrs. George Helm

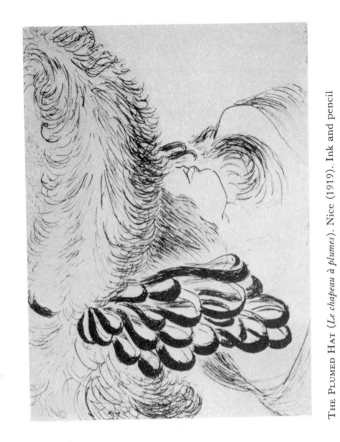

The Plumed Hat (*Le chapeau à plumes*). Nice (1919). Ink and pencil

The Plumed Hat (*Le chapeau à plumes*). Nice (1919). Pencil,
14½ x 9½". Baltimore Museum of Art, Cone Collection

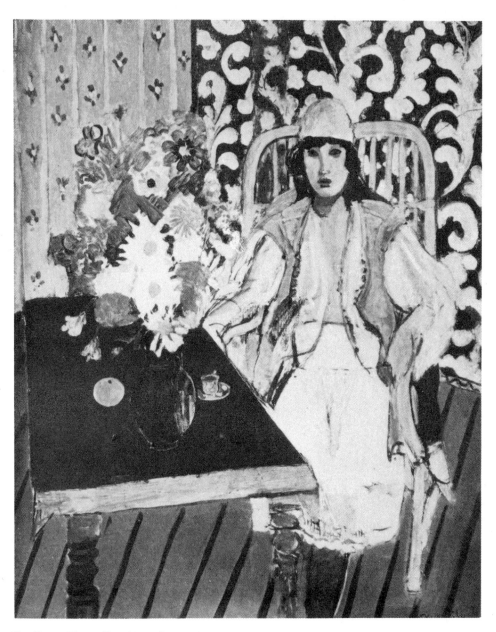

THE BLACK TABLE (*La table noire*). Nice (1919). Oil, 39⅜ x 31⅞". Winterthur, Hahnloser Collection.
Color: Courthion, frontispiece

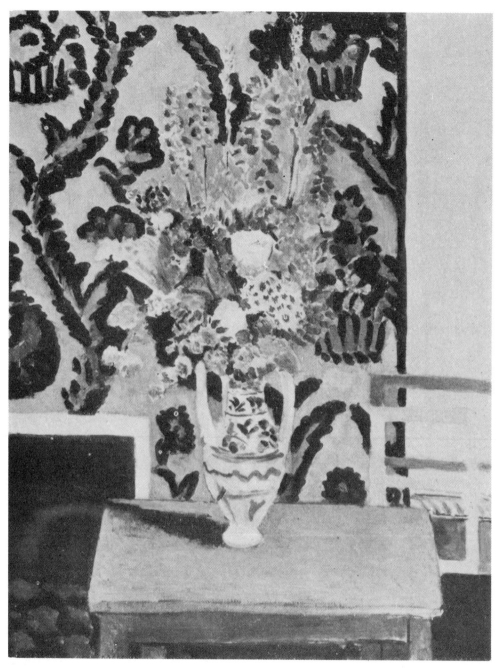

BOUQUET FOR THE 14TH OF JULY (*Fleurs, 14 juillet*). Issy-les-Moulineaux (1919, July). Oil, 45¾ x 35″
Monte Carlo, Gaston Bernheim de Villers

"Caloges" at Etretat (*Falaises d'aval; Les caloges*). Etretat (1920). Oil, 20⅞ x 25¼". Kurashiki, Japan, Ohara Museum

The Song of the Nightingale, Ballet Russe, 1920—study for the curtain ("*Le chant du rossignol*"—*étude pour le rideau*). Nice (1919 or '20). Pencil and ink, 12½ x 17½". Hartford, Wadsworth Atheneum, Lifar Collection

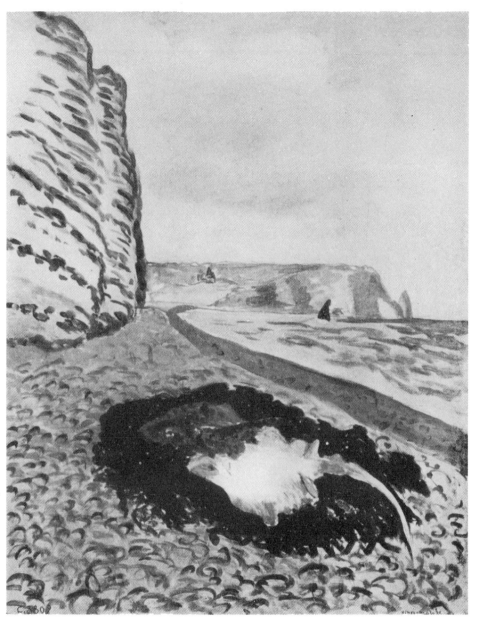

THE TWO RAYS (*Les deux raies*). Etretat (1920). Oil, 36¼ x 28¾″. West Palm Beach, Florida, Norton Gallery and School of Art

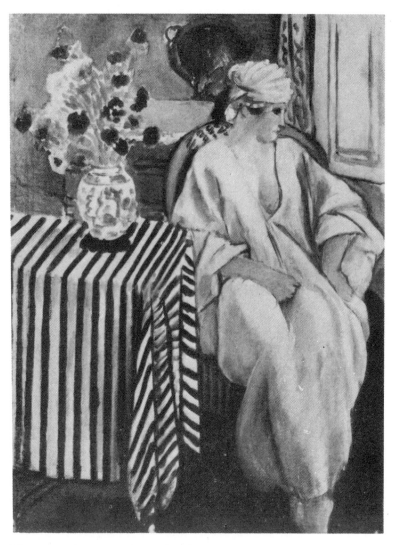

MEDITATION (*Après le bain*). Nice (1920). Oil, 28⅜ x 21¼". New York, Mr. and Mrs. Albert D. Lasker

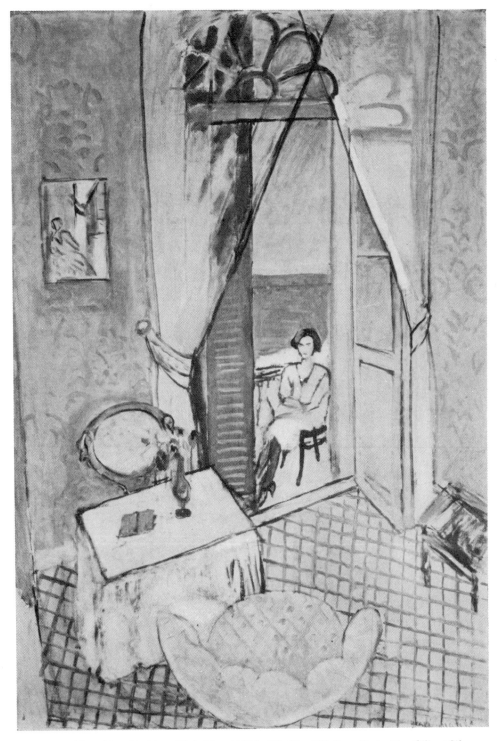

INTERIOR AT NICE (*Grand intérieur, Nice*). Nice (1921). Oil, 52 x 35″. New York, Mrs. Gilbert W. Chapman

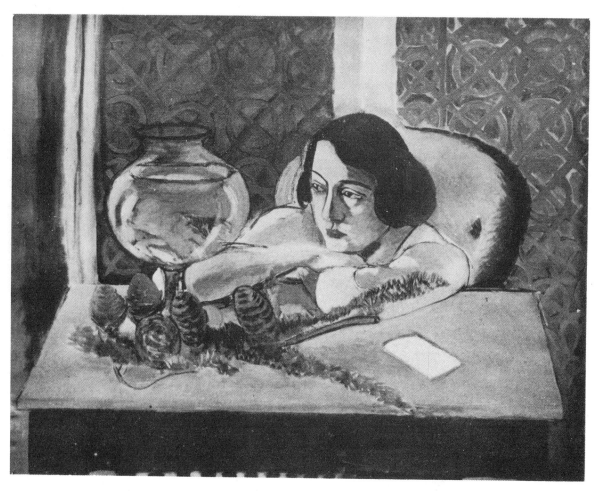

WOMAN BEFORE AN AQUARIUM (*Femme et poissons rouges*). Nice (1921). Oil, 31½ x 39″. Chicago, Art Institute, Helen Birch Bartlett Memorial

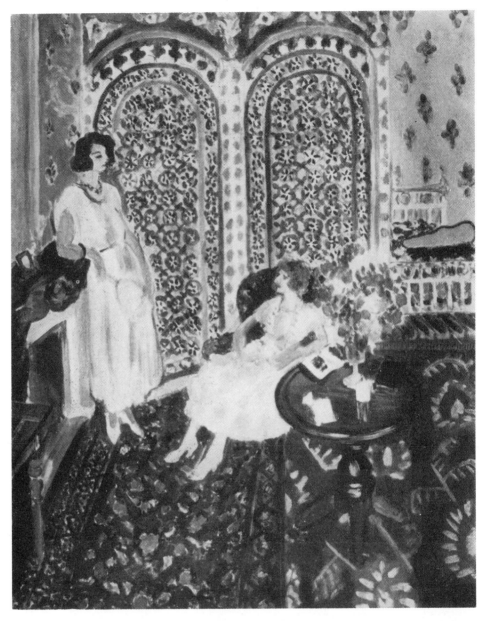

THE MOORISH SCREEN (*Le paravent mauresque*). Nice (1921, late). Oil, 36¼ x 29″. Philadelphia Museum of Art, Lisa Norris Elkins Collection

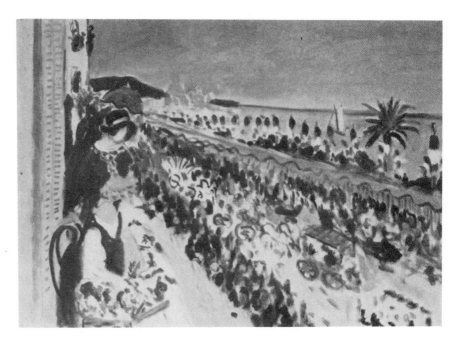

FESTIVAL OF FLOWERS, NICE (*Fête des fleurs*). Nice (1922). Oil, 25⅝ x 36½". Cleveland Museum of Art

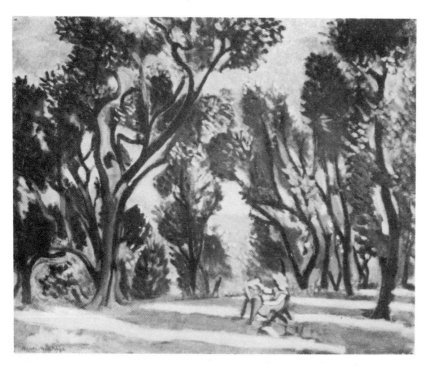

THE OLIVE GROVE (*Peintre dans les oliviers*). Nice (1922?). Oil, 23⅝ x 28⅜". Baltimore Museum of Art, Cone Collection

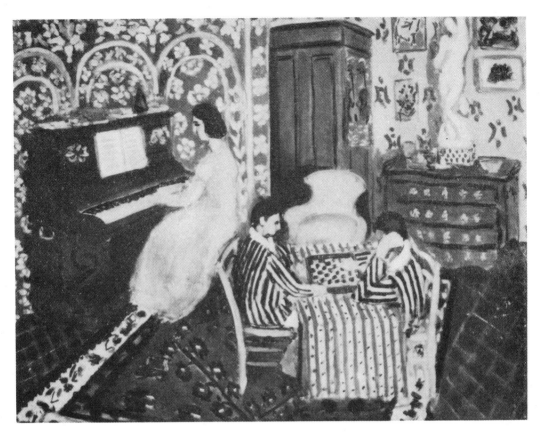

CHECKER GAME AND PIANO MUSIC (*Les joueurs de dames*). Nice (1923). Oil, 29 x 36½″. Private collection

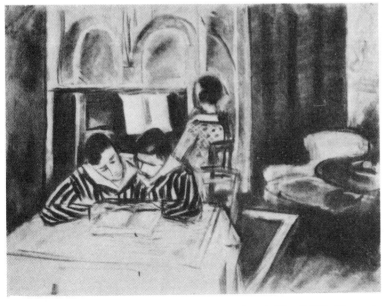

INTERIOR WITH BOYS READING (*Intérieur, deux garçons lisant*). Nice (1923). Charcoal and stump, 18½ x 24¾″

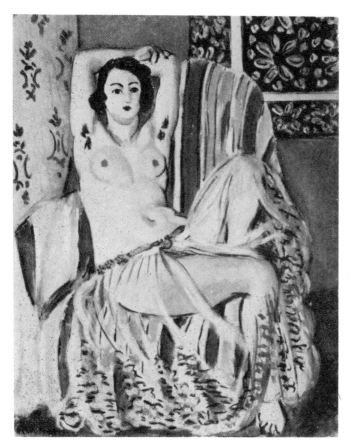

ODALISQUE WITH RAISED ARMS (*Odalisque aux bras levés*). Nice (1923). Oil, 25½ x 19¾". Chicago, Art Institute, Chester Dale Loan Collection. Color: McBride, bibl. 88, frontispiece

Below: ODALISQUE WITH MAGNOLIAS. Nice (1924). 23⅝ x 31⅞". Paris, private collection. Color: *Verve*, no. 3, pp. 78-79

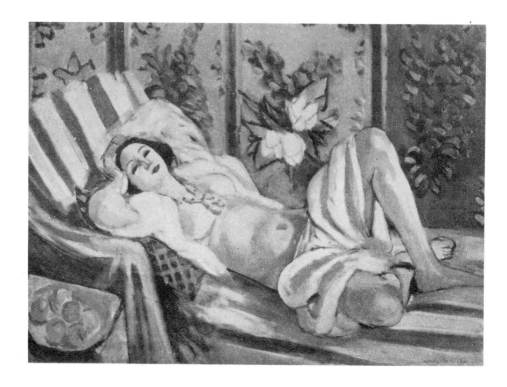

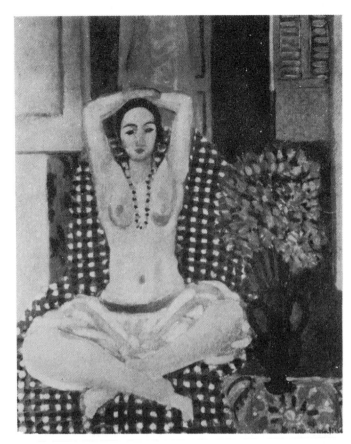

THE HINDU POSE (*La pose hindoue*). Nice (1923). Oil, 28½ x 23⅜″. New York, Mr. and Mrs. Donald S. Stralem. Color: *Vanity Fair*, pl. 21; *Time*, April 5, 1948 (poor)

Below: FRUIT AND FLOWERS (*Compotier et fleurs*). Nice (1924). Oil, 28¾ x 36¼″. Paris, private collection

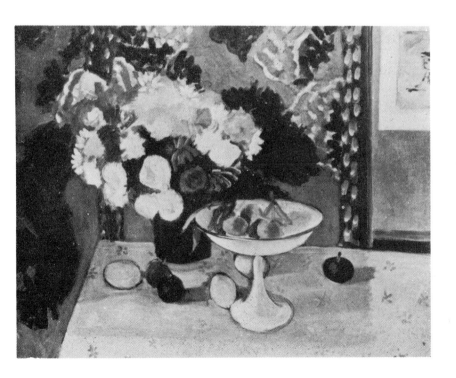

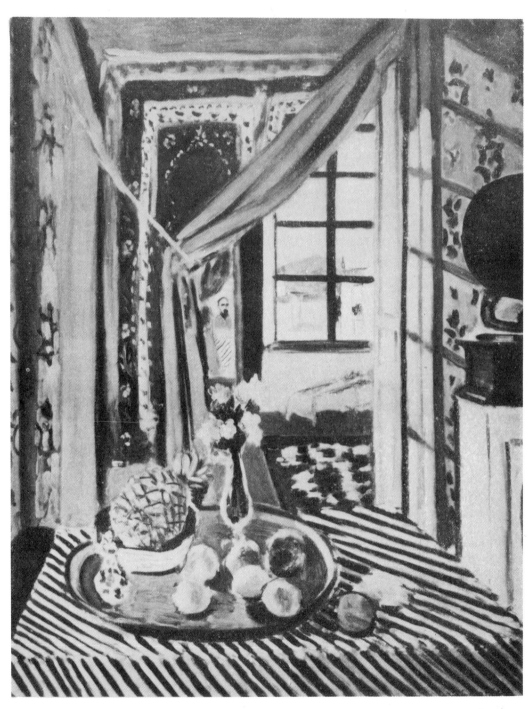

STILL LIFE IN THE STUDIO (*Nature morte dans l'atelier*). Nice (1924). Oil, 39 x 31½″. New York, Mr. and Mrs. Albert D. Lasker

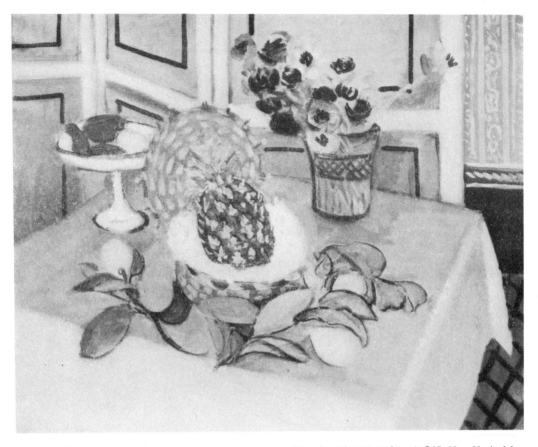

THE PINK TABLECLOTH (*La nappe rose; Citrons et anémones*). Nice (1925). Oil, 25⅝ x 31⅞″. New York, Mrs. Sam A. Lewisohn

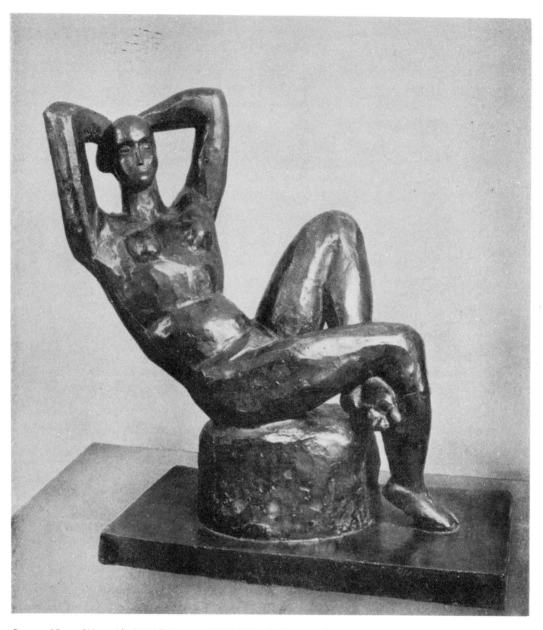

SEATED NUDE (*Nu assis*). (1925.) Bronze, 31½″ high. Baltimore Museum of Art, Cone Collection

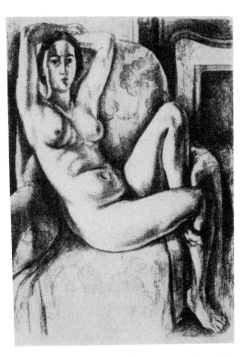

STUDY OF LEGS, II (*Etude de jambes, II*). (1925.) Lithograph
no. 71, 8⅛ x 19¾″ (design). Baltimore Museum of Art,
Cone Collection

NUDE IN AN ARMCHAIR (*Grand nu au fauteuil*).
(1925.) Lithograph no. 63, 25 x 18⅛″ (design).
New York, Walter Pach

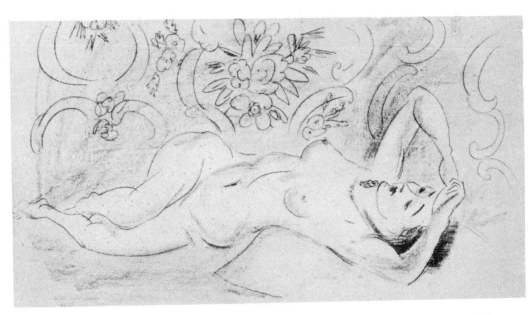

RECLINING ODALISQUE (*Odalisque allongée*). (1926.) Lithograph no. 81, 17⅛ x 31½″. New York, Museum
of Modern Art

445

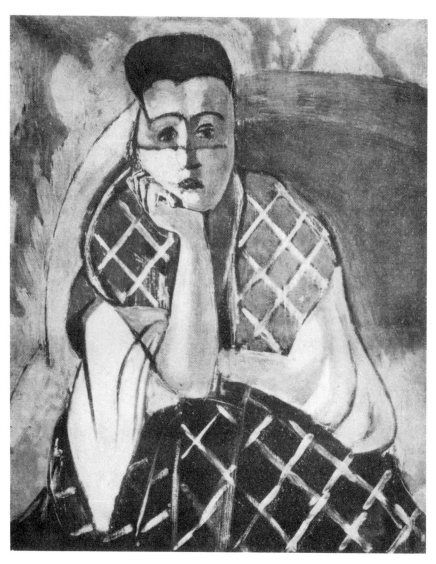

WOMAN WITH A VEIL (*Femme à la voilette*). (1927.) Oil, 24 x 19¾″. New York, Mr. and
Mrs. William S. Paley. Color: Fry, II, p. 8

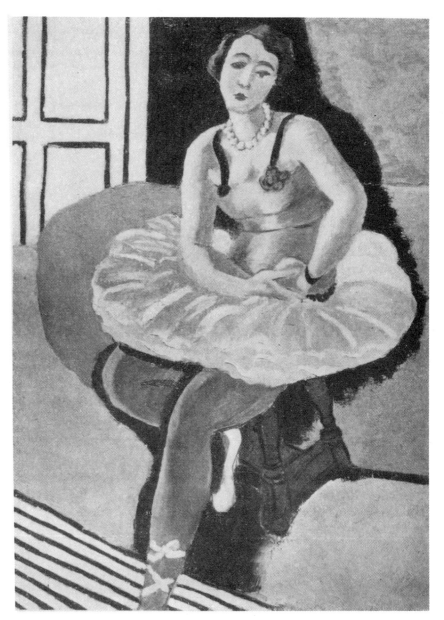

BALLET DANCER (*Danseuse*). Nice (1927). Oil, 31⅞ x 23⅝″. Baltimore Museum of Art, Cone Collection. Color: Fry, II, p. 17

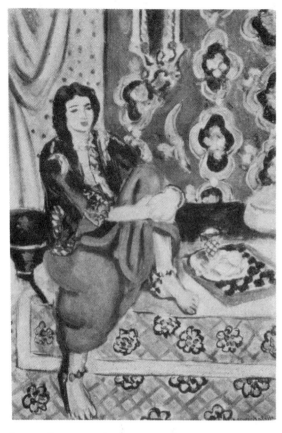

Seated Odalisque (*Odalisque assise*). Nice (1928). Oil,
21⅝ x 15″. Baltimore Museum of Art, Cone Collection

Study for the Decorative Figure (*Etude pour Figure
décorative*). Nice, 1927. Charcoal, 24½ x 18¾″.
Owned by the artist

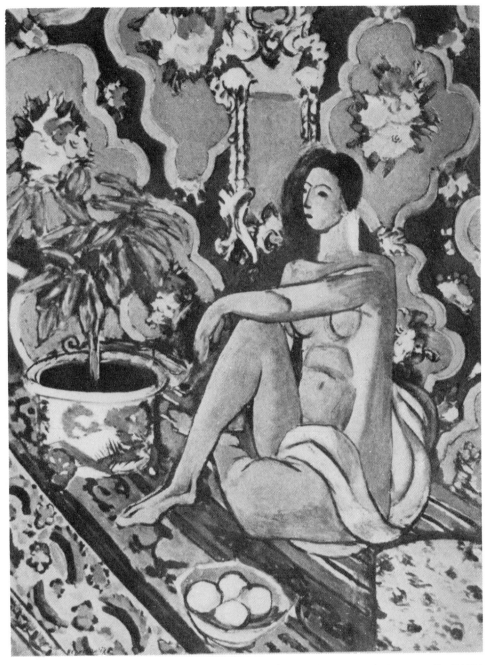

DECORATIVE FIGURE ON AN ORNAMENTAL BACKGROUND (*Figure décorative sur fond ornemental*). (1927.) Oil, 51½ x 38⅜″. Paris, Musée National d'Art Moderne. Color: Braun, pl. 15; Skira, p. 55 (poor)

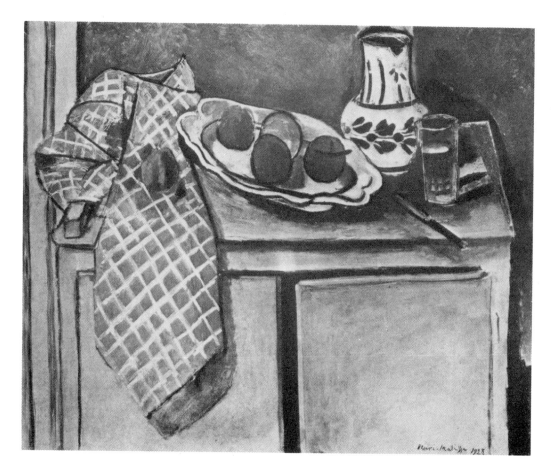

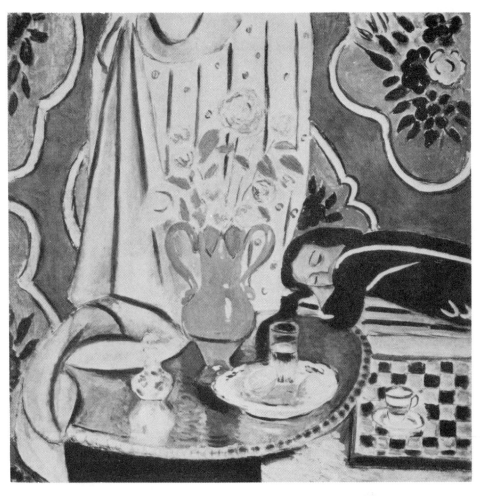

HARMONY IN YELLOW (*Harmonie jaune*). Nice (1928). Oil, 34⅝ x 34⅝". Color: Fry, I, p. 20

Opposite, above: LEMONS ON A PEWTER PLATE (*Citrons sur plat d'étain*). (1927.)
Oil, 21½ x 25¾". New Canaan, Connecticut, Mr. and Mrs. Lee Ault

Opposite, below: THE SIDEBOARD (*Le buffet*). Nice, 1928. Oil, 28¾ x 36¼".
Paris, Musée National d'Art Moderne. Color: Braun, pl. 16; Fry, I, p. 27
(poor); Lejard, pl. 8 (poor); *Studio*, June, 1939

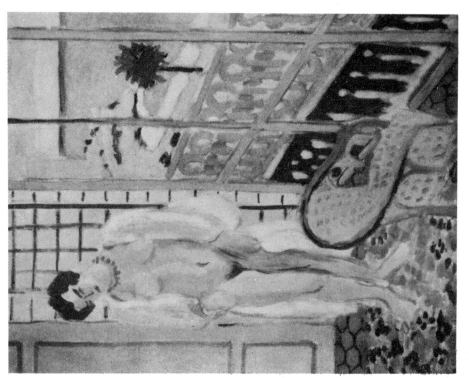

NUDE BY A WINDOW (*Nu près de la fenêtre*). Nice, 1929. Oil, 25¾ x 21½". New York, Vladimir Horowitz

Left: GLADIOLI (*Les glaïeuls*). 1928. Oil, 61 x 39⅜". New York, A. P. Rosenberg and Co.

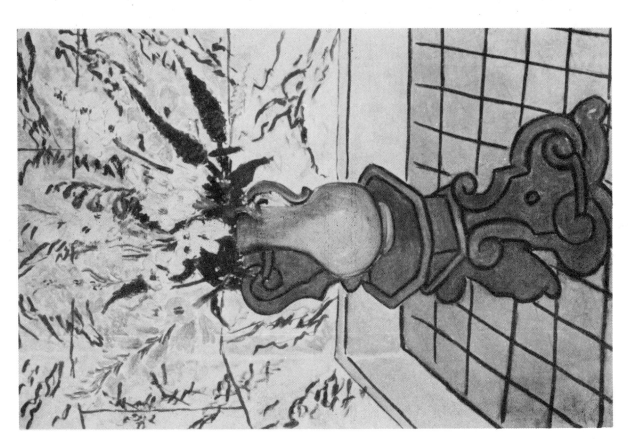

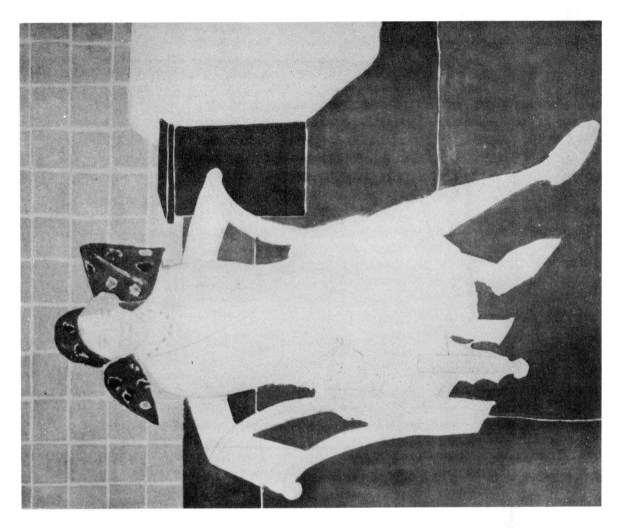

PORTRAIT IN THE MOORISH CHAIR (*Portrait*). Nice (c.1929). Oil, c.6 x 5'. Owned by the artist. Color: *Verve*, no. 3, p. 80

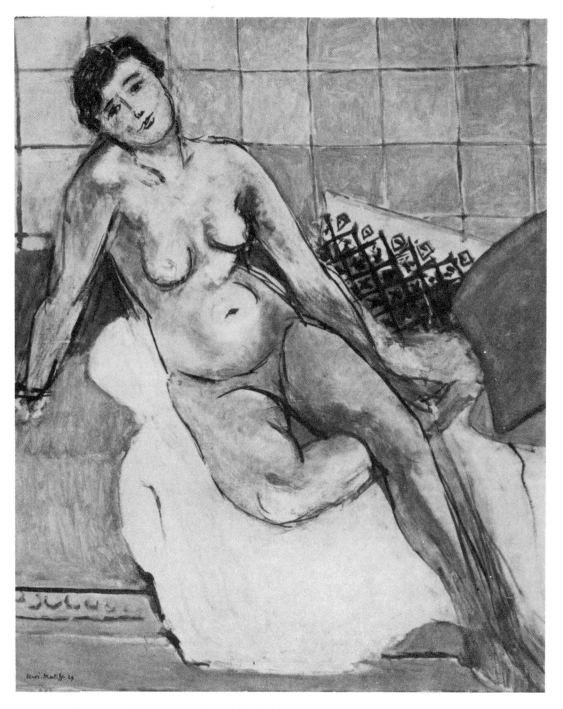

GREY NUDE (*Grand nu gris*). Nice, 1929. Oil, 40⅛ x 32¼". Owned by the artist

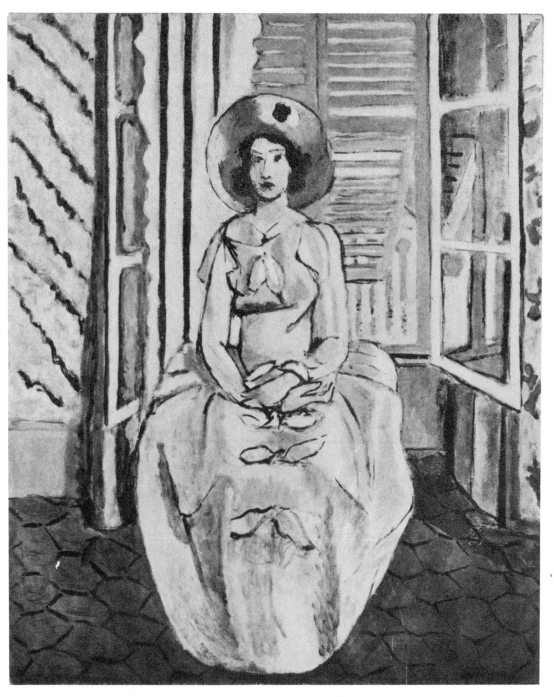

GIRL IN A YELLOW DRESS (*Jeune fille en jaune*). Nice, 1929-31. Oil, 39⅜ x 32″. Baltimore Museum of Art, Cone Collection

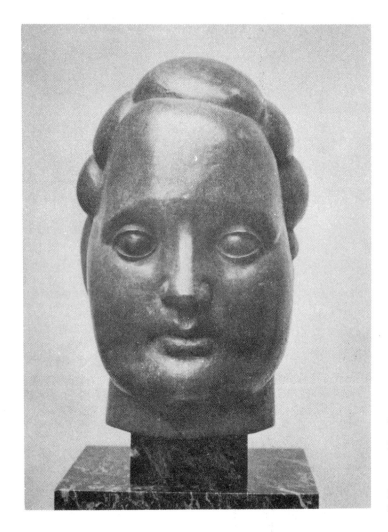

STOUT HEAD (*Grosse tête*). (1927.) Bronze, 12⅝″ high. San Francisco Museum of Art, Harriet Lane Levy Bequest

Below: RECLINING NUDE. Nice? (c.1928). Charcoal, 19½ x 24½″

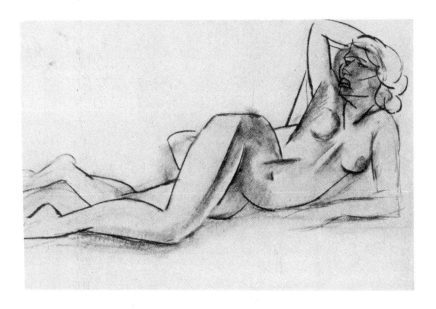

456

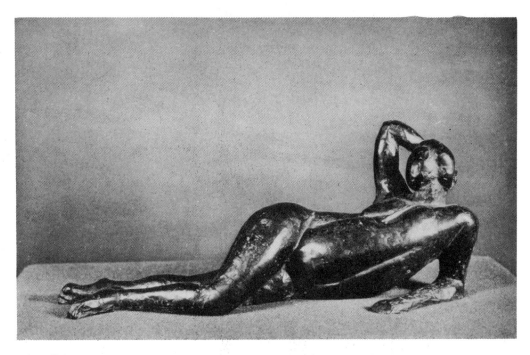

RECLINING NUDE, II (*Nu couché, 2me état*). Nice (1929?). Bronze, 7⅞″ high. Baltimore Museum of Art, Cone Collection

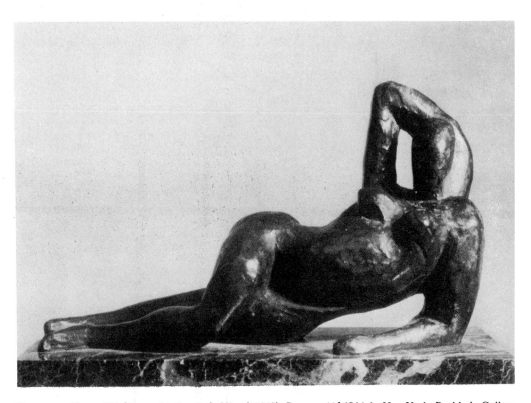

RECLINING NUDE, III (*Nu couché, 3me état*). Nice (1929?). Bronze, 11¼″ high. New York, Buchholz Gallery

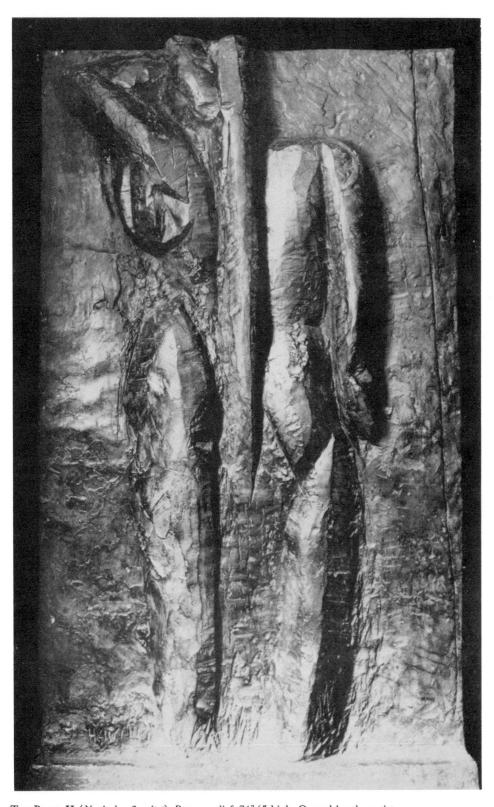

THE BACK, II (*Nu de dos, 2me état*). Bronze relief, 74⅜″ high. Owned by the artist

THE BACK, III (*Nu de dos, 3me état*). (1929?) Plaster relief, 74⅜″ high. Owned by the artist

Above: Odalisque in a Tulle Skirt (*Hindoue à la jupe de tulle*). Nice (1928 or '29). Lithograph no. 107, 11¼ x 15" (design)

Reclining Nude, II, with a Stove (*Nu renversé, II—au réchaud*). Nice (1928 or '29). Lithograph no. 120, 21⅝ x 17¾" (design). Baltimore Museum of Art, Cone Collection

TIARI (*Le tiaré*). (1930.) Bronze, 8½″ high. New York, Buchholz Gallery. Another cast (with a necklace): Baltimore Museum of Art, Cone Collection

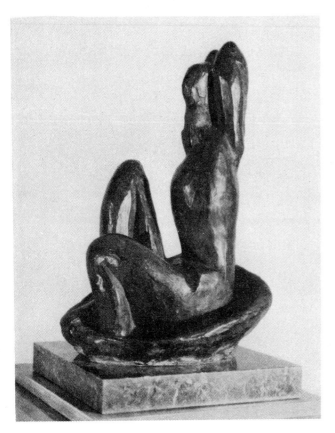

VENUS IN A SHELL (*Vénus à la coquille*). (1930?) Bronze, 13″ high. Baltimore Museum of Art, Cone Collection

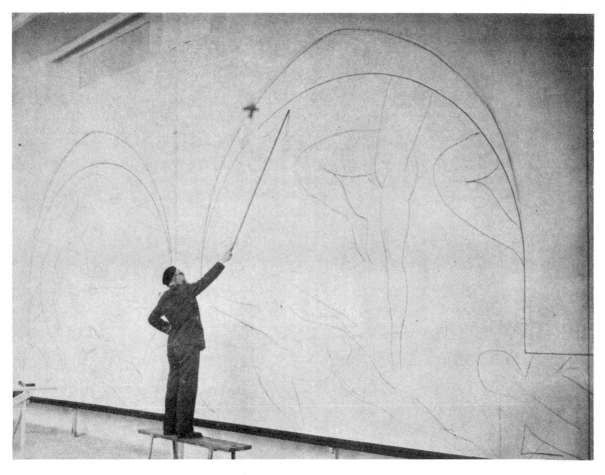

Matisse in a disused film studio in Nice, 1931, outlining the first version of THE DANCE, the mural commissioned by the Barnes Foundation, Merion, Pennsylvania, but now in the Musée d'Art Moderne de la Ville de Paris. Photograph courtesy *Art News*

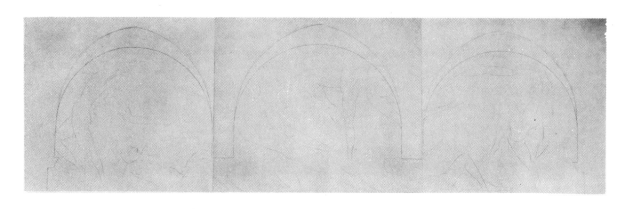

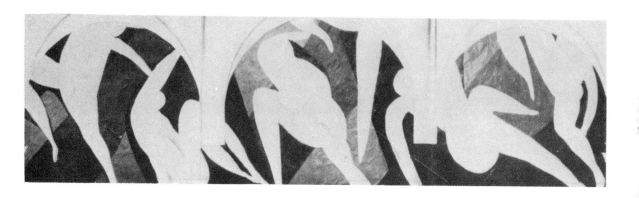

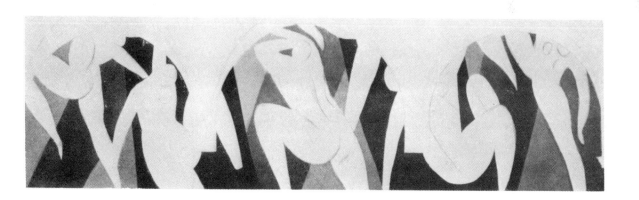

THE DANCE, I. (1931-32.) Oil, 11′8½″ x 42′1″. Paris, Musée d'Art Moderne de la Ville de Paris. Above: early stage (1931).
Center: intermediate stage. Below: completed work (1932, spring)

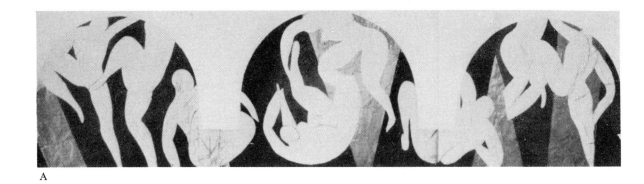

A

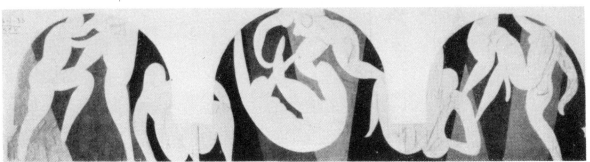

B

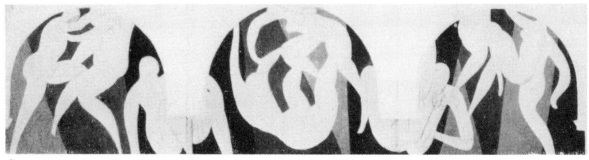

C

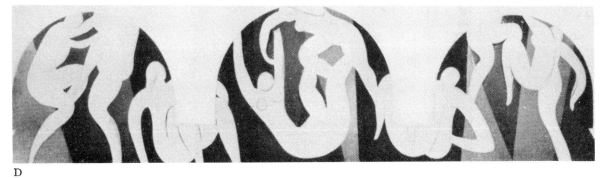

D

THE DANCE, II. (1932-33.) Oil, 11′8½″ x c.47′. Merion, Barnes Foundation. Four stages: A. 28 November 1932. B. 26 January 1933. C. 4 February 1933. D. 7 April 1933 (complete except for minor changes in central lunette). (From *Cahiers d'Art*, 1935, 1-4, p. 13.) Color: Fry, II, p. 24

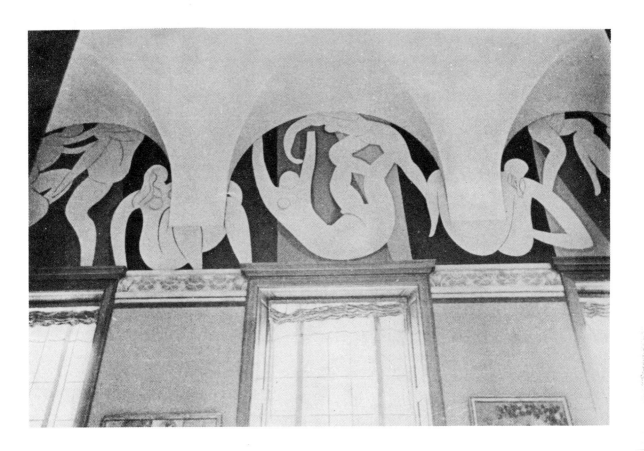

Above: THE DANCE, II, in the Barnes Foundation seen from
the floor of the gallery 18 feet below. The mural occupies three
lunettes, each above a tall French window. Between the win-
dows are hung, at the left, Matisse's *Riffian*, 1913 and, at the
right, Picasso's *Composition* (with two peasants), 1906

THE DANCE, II, detail of central lunette, about 5 x 6′

465

THE MALLARMÉ ETCHINGS, 1930-1932

Poésies de Stéphane Mallarmé, published by Albert Skira, Lausanne, 1932, with 29 etchings by Matisse, page size 13 x 9¾". New York, Museum of Modern Art, Abby Aldrich Rockefeller Print Room.

On this page are studies for the etching illustrating *Le cygne*.

Matisse sketching a swan in the Bois de Boulogne. Photo: Pierre Matisse

Studies of a swan made from life. Pencil. Baltimore Museum of Art, Cone Collection

Study for the first rejected plate. Pencil. Baltimore Museum of Art, Cone Collection

The first of three rejected plates. Etching. Baltimore Museum of Art, Cone Collection

Page 123, etching for *Le cygne* final state, as printed

Page 43, etching for *Brise marine* (*Sea breeze*)

Pages 128-129, with etching for the sonnet (page 131) beginning "*La chevelure, vol d'une flamme*" ("Tresses, flight of flame")

Above, left: THE PERSIAN ROBE (*La robe persane*).
1931. Oil

Above, right: GIRL IN A PERSIAN COSTUME (*Femme au costume persan*). 1932. Göteborg, Director
H. G. Turitz. (From Swane, bibl. 92)

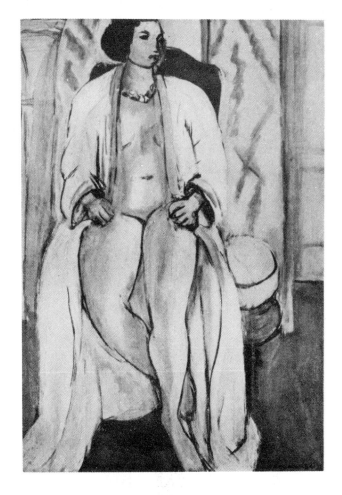

NUDE IN A WHITE ROBE (*Nu à la robe blanche*). (1933.)
Oil

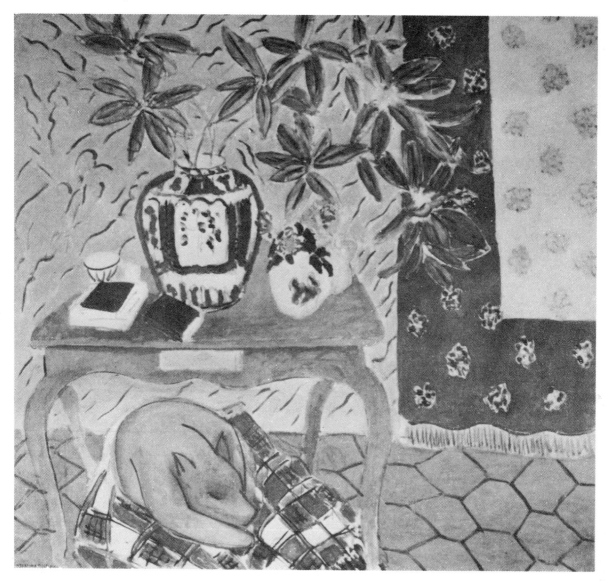

THE MAGNOLIA BRANCH (*La branche de magnolia*). Nice, 1934. Oil, 60¾ x 65¾". Baltimore Museum of Art, Cone Collection

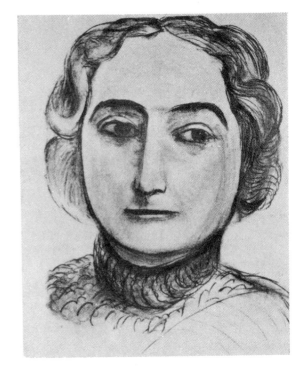

Dr. Claribel Cone. 1933-34. Charcoal, 23¼ x 16″. Baltimore Museum of Art, Cone Collection

Below: Seated Nude, Head on Arms, 5th state (*Nu assis, tête appuyée sur les bras, 5me état*). (1935?) Charcoal

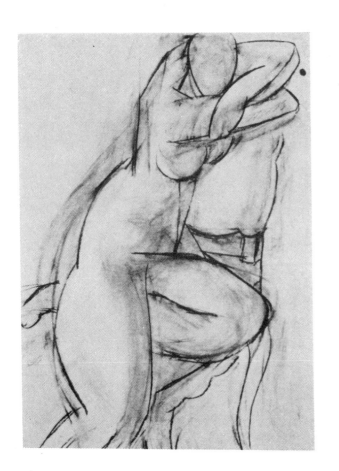

Seated Nude, Head on Arms (*Nu assis, tête appuyée sur les bras*). (1935?) Etching no. 210, 5½ x 4¼″

Above: THE DREAM (*Le rêve*). 1935. Oil, 31⅞ x 25⅝". Owned by the artist. Color: Escholier, p. 121

BLUE EYES (*Les yeux bleus*). 1935. Oil, 15 x 18". Baltimore Museum of Art, Cone Collection

State I, May 3

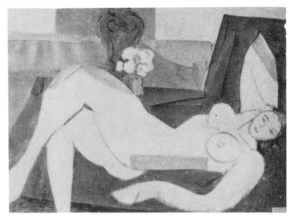

State VI, May 23

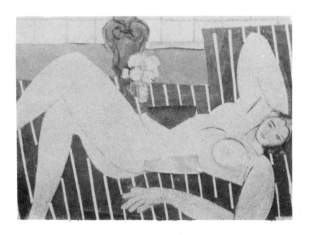

State IX, May 29

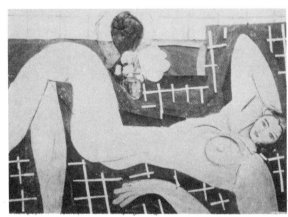

State XI, June 20

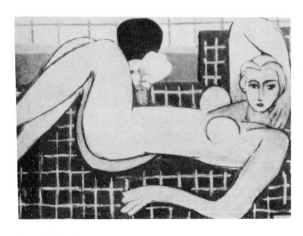

State XIII, September 4

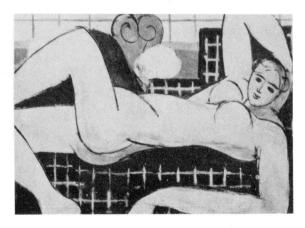

State XVIII, September 15

PINK NUDE, 1935, six of twenty-two photographs of work in progress

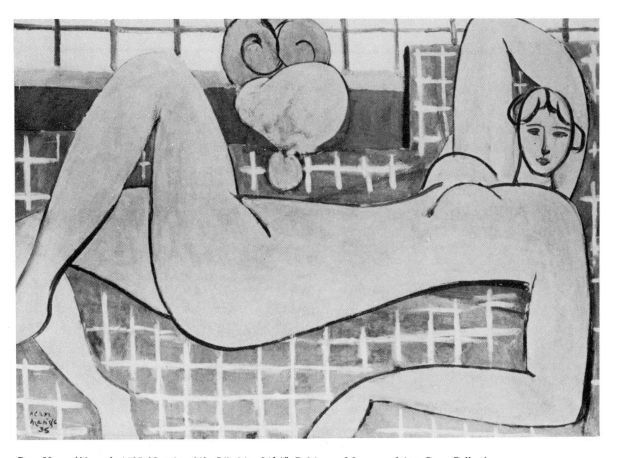

PINK NUDE (*Nu rose*). 1935 (October 30). Oil, 26 x 36½". Baltimore Museum of Art, Cone Collection

PRELIMINARY STUDY FOR THE PINK NUDE,
1935 (*Etude pour le Nu rose*). Charcoal

INTERIM STUDY FOR THE PINK NUDE, 1935
(*Etude pour le Nu rose*). 1935, May 23.
Charcoal, 13¼ x 18½". Baltimore Museum
of Art, Cone Collection

A

A. HERCULES AND ANTAEUS (after the painting of about 1460 by Antonio Pollaiuolo in the Uffizi Gallery, Florence). 1935. Crayon?

B. SECOND OF FIVE STUDIES FOR THE BLINDING OF POLYPHEMUS

C. FIFTH STUDY, II, FOR THE BLINDING OF POLYPHEMUS

D. THE BLINDING OF POLYPHEMUS (*L'aveuglement de Polyphème*). Illustration for *Ulysses* by James Joyce, New York, Limited Editions Club (George Macy), 1935. Soft ground etching, 10⅝ x 8¼″. New York, Museum of Modern Art

B

C

D

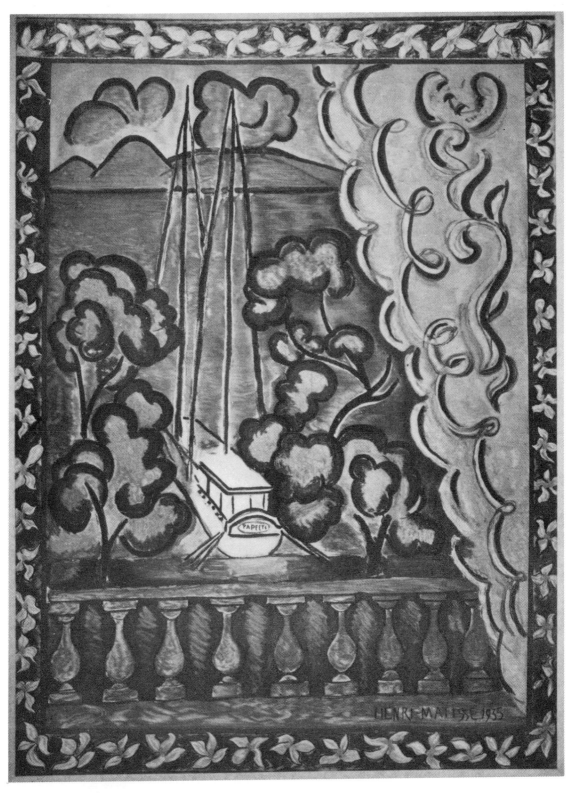

WINDOW AT TAHITI (*Fenêtre à Tahiti*). (c.1936, after a cartoon of 1935 by Matisse.) Tapestry, Beauvais low warp. Paris, Mme Paul Cuttoli

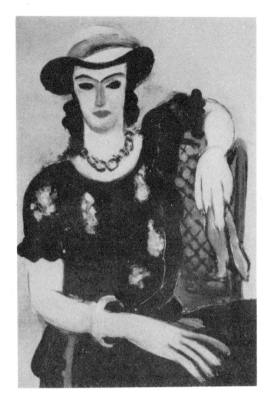

GIRL IN RED CHAIR (*Femme à la chaise rouge*). 1936
(August). Oil, 13⅜ x 9¼". Baltimore Museum of
Art, Cone Collection

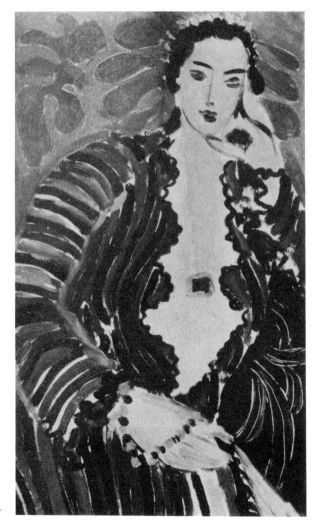

ELENA. 1937. Oil, 21⅝ x 13"

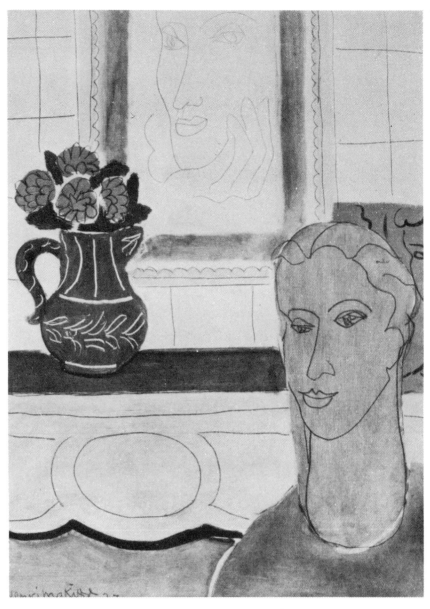

THE OCHRE HEAD (*Tête ochre*). 1937. Oil, 27 x 23½". New York, Miss Lily Pons

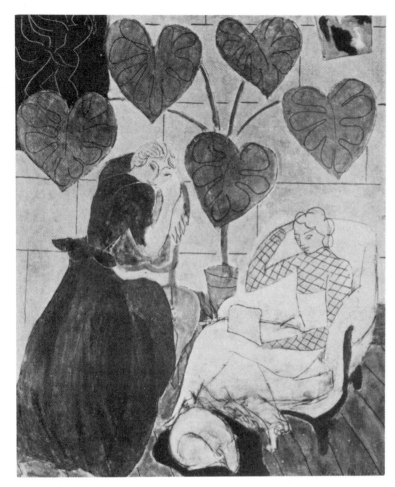

THE CONSERVATORY (*Le jardin d'hiver*).
Nice (1937-38, completed March 3).
Oil, 29 x 23⅞″. St. Louis, Mr. and
Mrs. Joseph Pulitzer, Jr. Color: *Verve*,
no. 3, p. 77

STUDY FOR THE NELSON A. ROCKEFELLER
OVERMANTEL DECORATION. Nice, 1938,
October. Charcoal. (From *Cahiers
d'Art*, 1939, 1-4, p. 18)

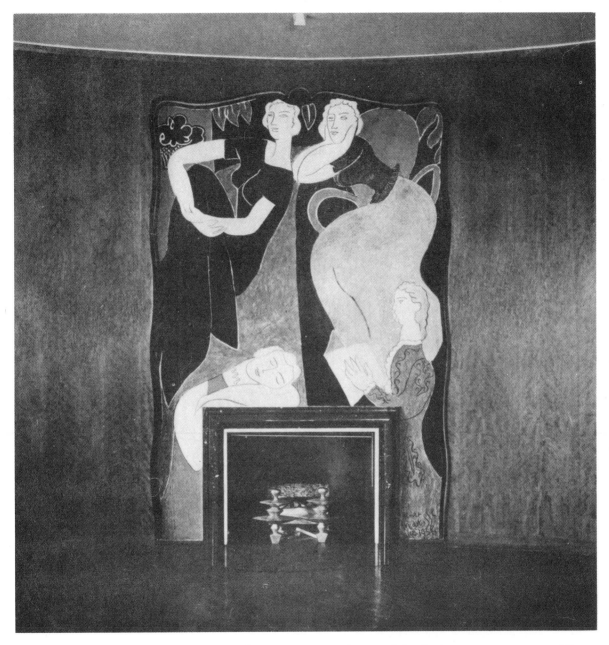

OVERMANTEL DECORATION (*Décoration pour cheminée*). Nice, 1938 (autumn). Oil, c.9′3″ x 6′. New York, Nelson A. Rockefeller

Music, 1939, progress photographs:

A. March 17

B. March 22

C. April 4

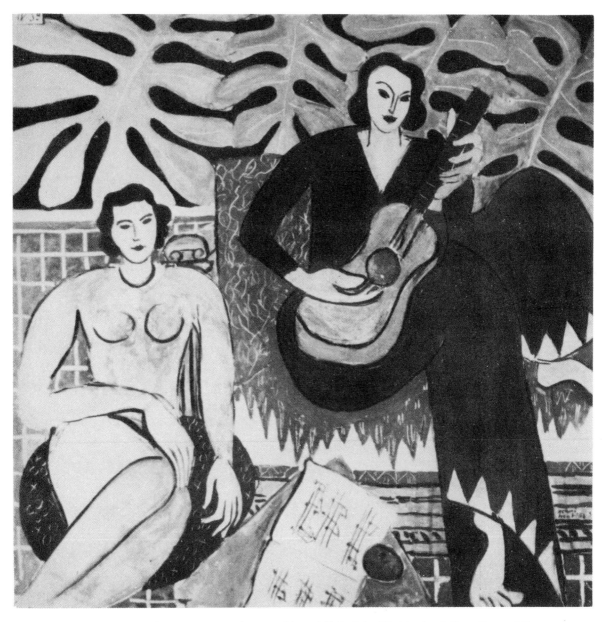

MUSIC (*La musique*). Nice, 1939 (completed April 8). Oil, 45¼ x 45¼". Buffalo, Albright Art Gallery, Room of Contemporary Art

Design for Steuben Glass, New York (*Projet pour Steuben Glass*). Nice (c.1938). Pencil

Vase by Steuben Glass, New York, etched with design by Matisse (*Vase de verre Steuben*). (1939.) 14¾" high

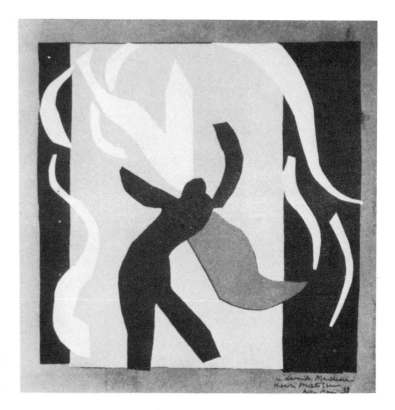

THE DANCER (*Danseur*). Nice, 1938,
May 1. Cut and pasted paper. Inscribed:
*à Leonide Massine / Henri Matisse /
Nice 1er mai 1938*

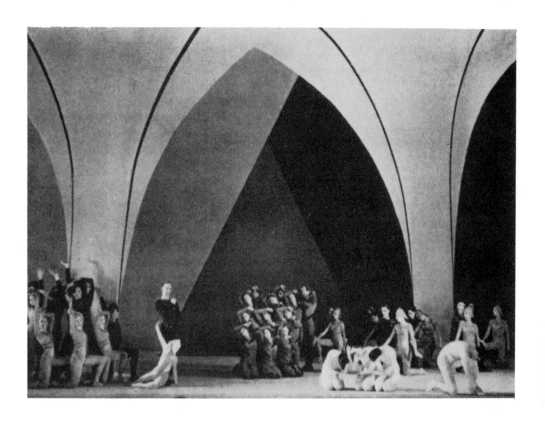

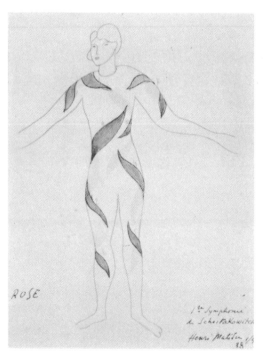

"ROUGE ET NOIR", Ballet Russe de Monte Carlo; Monte Carlo, May 1939; Paris, June 1939 (under title "L'étrange farandole"). Choreography by Massine; music by Shostakovich; settings and costumes by Matisse. Top: Performance photograph. Left: Costume design, Nice, May 1, 1938. Right: Matisse signing curtain; dancer in costume (from *Le Point*, bibl. 161, p. 45-141, courtesy Braun et Cie.)

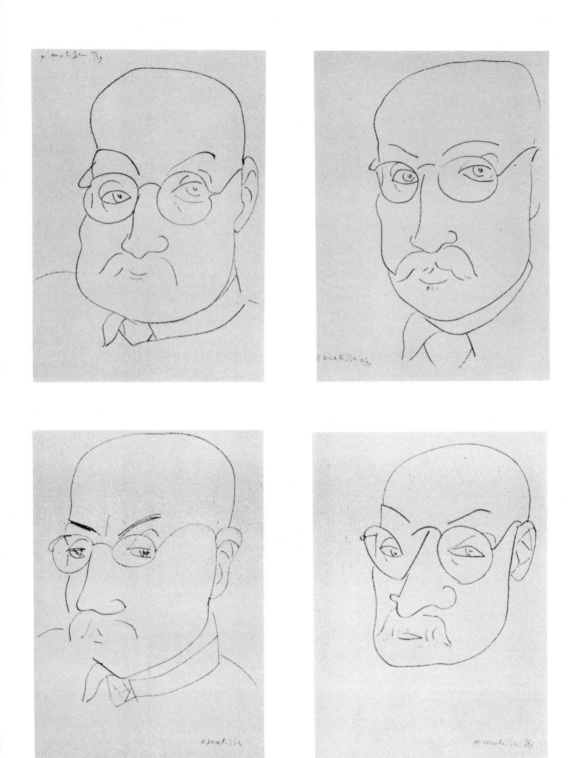

FOUR SELF PORTRAITS (*Quatre portraits de l'artiste*). 1939, October. Crayon, each 14½ x 10¼". Owned by the artist, courtesy Philadelphia Museum of Art

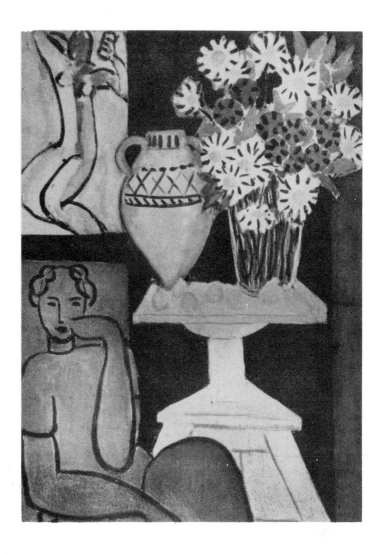

Above: DAISIES (*Marguerites*). Paris, 1939 (summer). Oil, 36 x 26″.
Chicago, private collection

LA FRANCE. Nice, 1939 (completed December 1).
Oil, 18⅛ x 15″. Color: *Verve*, no. 8

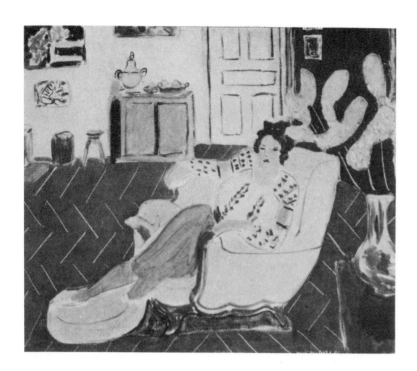

Above: WOMAN IN A YELLOW ARMCHAIR (*Intérieur, femme assise dans un fauteuil jaune*). Nice, 1940 (March). Oil, 21¼ x 25¾". St.-Jean-Cap-Ferrat, W. Somerset Maugham

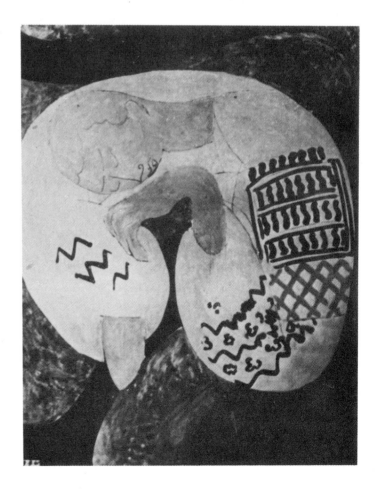

SLEEPING WOMAN (*Femme endormie*). Nice, 1940 (September?). Owned by the artist

486

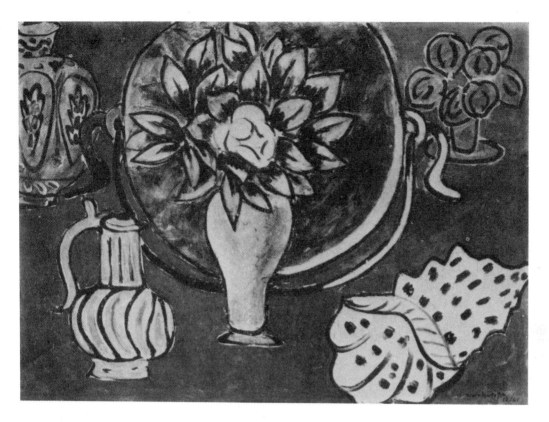

RED STILL LIFE WITH MAGNOLIA (*Nature morte rouge au magnolia*). Nice, 1941, December. Oil, 29 x 39″. Paris, Musée National d'Art Moderne. Color: Philadelphia Museum of Art, *Matisse*, 1948, cover; *Verve*, no. 13, p. 35; *Time*, April 5, 1948

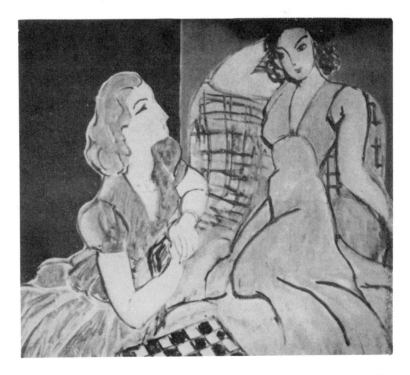

CONVERSATION. Nice, 1941 (December). Oil, 21¼ x 25⅝″. Color: Du Chêne, pl. VI; Braun, pl. 22

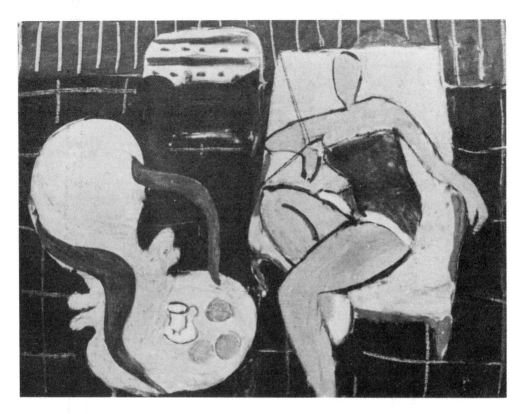

DANCER AND ARMCHAIR, BLACK BACKGROUND (*Danseuse, fond noir, fauteuil rocaille*). Nice, 1942, September. Oil, 19¾ x 25⅝″. Lebanon, New Jersey, Alexina Matisse. Color: *Verve*, no. 13, p. 42-43; Lejard, pl. 19; *Time*, April 5, 1948

Color analysis by Matisse of DANCER AND ARMCHAIR, 1942. Pen and ink. (From *Verve*, no. 13, p. 41.)
1, ivory black; 2, lemon yellow; 3, ultramarine;
4, flesh tones: light cadmium red and white;
5, pure light cadmium red; 6, green; 7, orange;
8, pure white

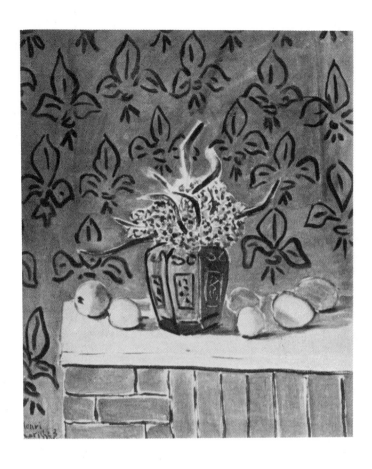

Above: LEMONS AGAINST A FLEUR-DE-LIS BACKGROUND (*Citrons sur fond rose fleurdelisé*). Nice, 1943, March. Oil, 25¾ x 19¾". New York, Miss Loula Lasker. Color: *Verve*, no. 13, p. 53; *Art News Annual*, 1952

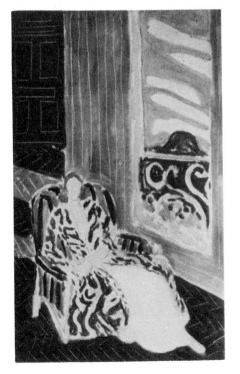

THE BLACK DOOR (*La porte noire*). Nice, 1942, September. Oil, 24 x 15".
Color: *Verve*, no. 13, p. 19

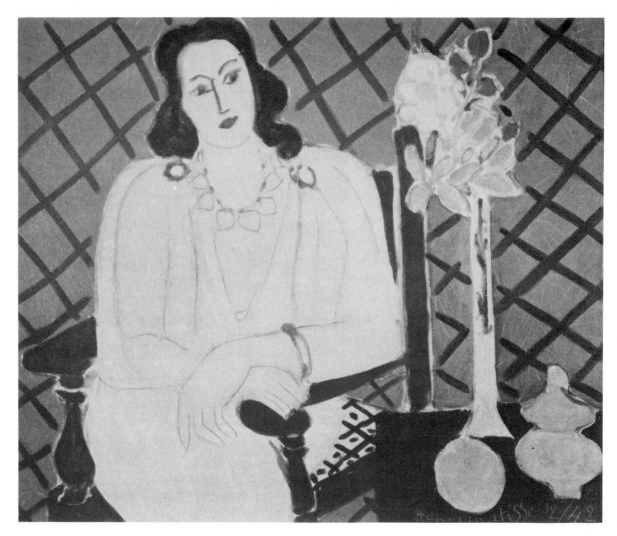

IDOL (*L'idole*). Nice, 1942, December. Oil, 28 x 36″. New York, Mr. and Mrs. Albert D. Lasker. Color: *Verve*, no. 13, p. 46-47; *Art News Annual*, 1952

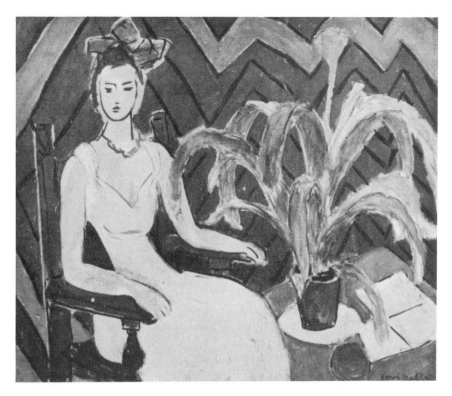

MICHAELA. Nice, 1943, January. Oil, 23 x 28″. New York, Mrs. Maurice Newton. Color: *Verve*, no. 13, p. 30-31

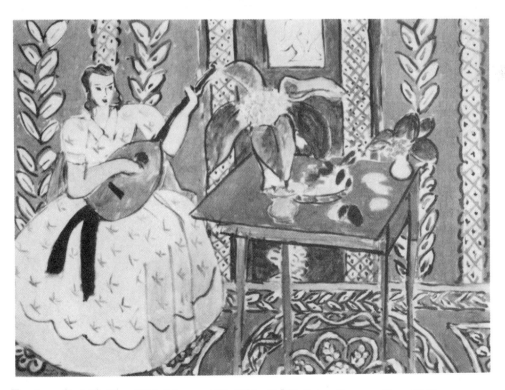

THE LUTE (*Le luth*). Nice, 1943, February. Oil, 23⅝ x 31⅞″. Color: *Verve*, no. 13, p. 22-23

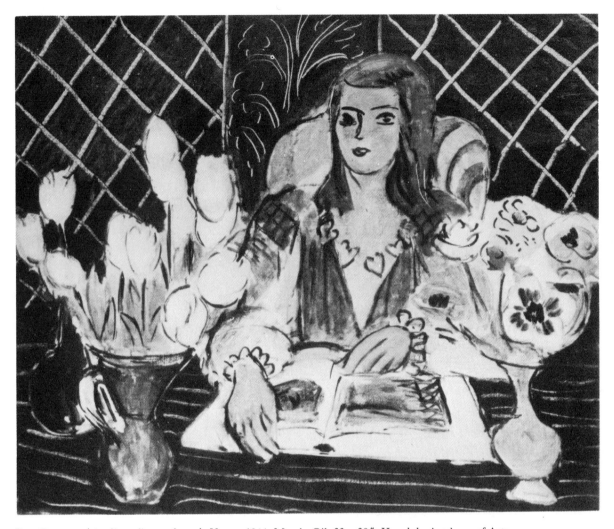

GIRL READING (*Annelies, tulipes, anémones*). Vence, 1944, March. Oil, 33 x 38″. Honolulu Academy of Arts

Painted doors commissioned by Señor and Señora Enchorrena, Paris.
Right: Central panel, early state, June 29, 1944, with Nymph and Faun.
Below: Completed state, March 28, 1945, with Leda and the Swan

Pages 34-35 in Henry de Montherlant: *Pasiphaë: Chant de Minos (Les Crétois)*, Paris, Fabiani, 1944 (initiated by Vollard? in 1937?). The illustration to the line "... L'angoisse qui s'amasse en frappant sous ta gorge..." is one of 18 original linoleum cuts, white line on black; the initials, also by Matisse, are white line on red. Page size 12¾ x 9¾". New York, Pierre Matisse

Opposite: *Poèmes de Charles d'Orléans*, Paris, Tériade, 1950 (undertaken in Nice, 1942-43). The entire book designed by Matisse, with the text in his handwriting and decorated with his lithographs in colored crayon. Above: Frontispiece portrait of Charles, 1943, and title page. Below: Pages 68–69. Page size 16⅛ x 10½". New York, Museum of Modern Art, Abby Aldrich Rockefeller Print Room

FLORILÈGE DES AMOURS DE RONSARD

(Anthology of the *Amours* of Ronsard), Paris, Skira, 1948 (undertaken in Nice, 1941). Contains 126 original lithographs in brown crayon on grey-tinted paper. Page size 15⅛ x 11″. New York, Museum of Modern Art, Abby Aldrich Rockefeller Print Room

Matisse at the lithographers Mourlot Frères retouching a lithographic stone for the *Ronsard*. The head on which he is working appears on page 166 of the book. Photo courtesy Albert Skira

Pages 26-27

Pages 154-155

Matisse's hand with a capital "P", Caslon Old Face, used in the *Ronsard*. Paris, c.1947. Photo courtesy Albert Skira

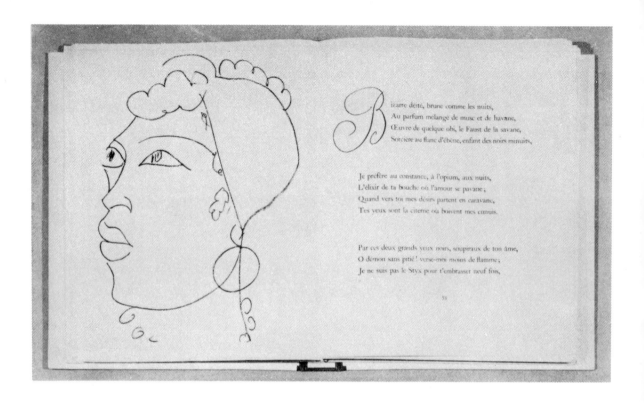

LES FLEURS DU MAL

Above: Illustration and partial text of the poem "Sed non satiata," pages 52 and 53 in Charles Baudelaire: *Les fleurs du mal*, Paris, February 1947, La Bibliothèque Française. The illustration is one of 33 reproductions in brown ink of lithographic drawings begun by Matisse in Vence, 1944. Initials and decorations in wood engraving after Matisse's drawings. Page size 11 x 9″. New York, Pierre Berès.

Left: Wood engraving after an ink drawing by Matisse, page 64

LES LETTRES PORTUGAISES

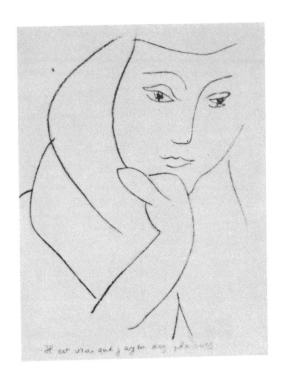

Below: Pages 24-25 of Marianna Alcaforado: *Les lettres portugaises* (Love Letters of a Portuguese Nun), Paris, Tériade, 1946. Initials and decorations are in violet; portrait heads in brown. Twenty original lithographs and decorations, design of covers, typography, etc., by Matisse. Page size 10⅝ x 8¼". New York, Pierre Matisse.

Right: Portrait of the nun, page 57

JAZZ: twenty stencil plates after compositions in gouache on cut-and-pasted paper, designed as illustrations for Matisse's book of the same name. Begun at Vence about 1944, published by Tériade, Paris, 1947. New York, Museum of Modern Art, Abby Aldrich Rockefeller Print Room, gift of Henri Matisse

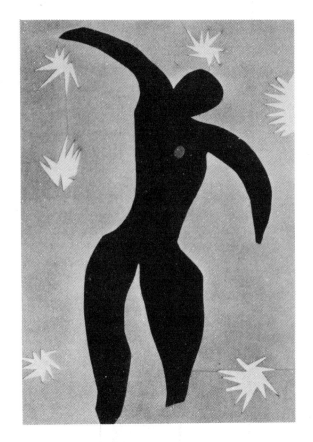

8. Icarus (*Icare*). 16¼ x 10¾″ (design).
Color: *Time*, April 15, 1948

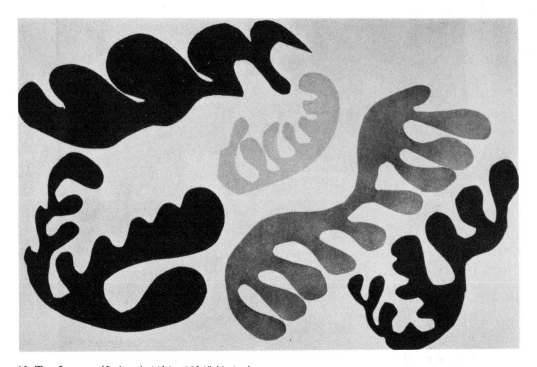

19. The Lagoon (*Le lagon*). 16⅛ x 25¼″ (design)

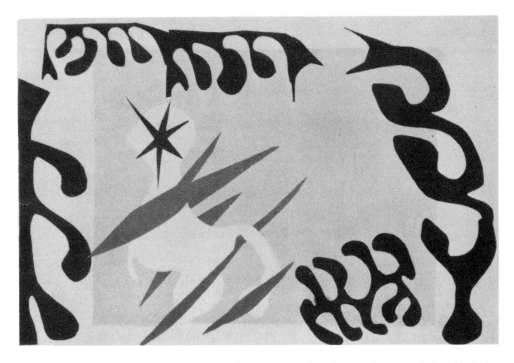

4. THE NIGHTMARE OF THE WHITE ELEPHANT (*Le cauchemar de l'éléphant blanc*). 16¼ x 25¼″ (design)

14. THE COWBOY (*Le cow-boy*). 16⅝ x 25⅝″ (design)

INTERIOR IN YELLOW AND BLUE (*Intérieur jaune et bleu*). Vence (1946). Oil, 45⅝ x 35¾″. Owned by the artist. Color: *Verve*, no. 21-22

ASIA (*L'Asie*). Vence, 1946. Oil, 45¾ x 32". Beverly Hills, California, private collection. Color: *Verve*, no. 21-22

Above: BLUE INTERIOR WITH TWO GIRLS (*Deux fillettes dans l'intérieur bleu, fenêtre rouge*). Vence, 1947. Oil, 25¾ x 21¼". Palm Beach, Florida, Arthur Bradley Campbell. Color: *Verve*, no. 21-22

THE ROCAILLE CHAIR (*Le fauteuil rocaille*). Vence, 1946. Oil, 36¼ x 28¾"

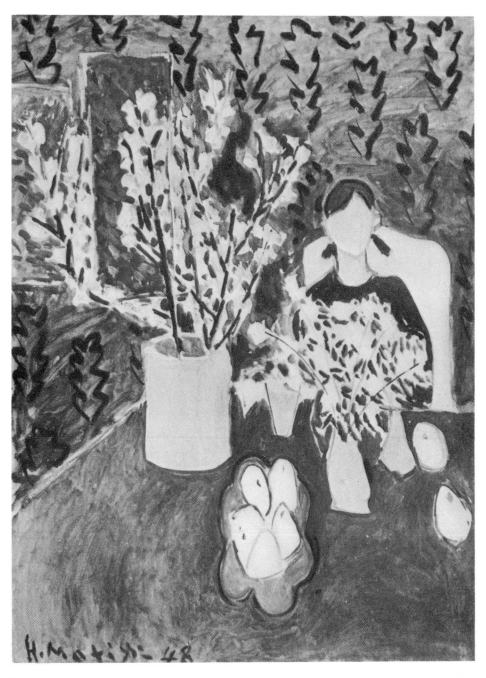

PLUM BLOSSOMS, GREEN BACKGROUND (*La branche de prunier, fond vert*). Vence, 1948 (early). Oil, 45⅝ x 35″. New York, Mr. and Mrs. Albert D. Lasker. Color: *Verve*, no. 21-22

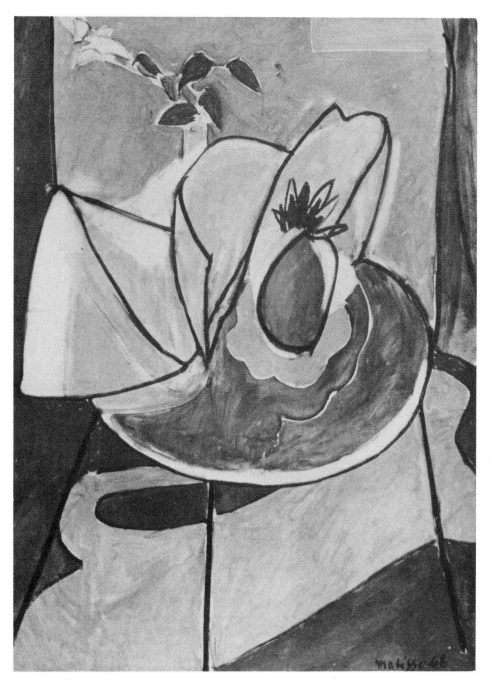

THE PINEAPPLE (*L'ananas*). Vence, 1948 (early). Oil, 45⅝ x 35″. New York, Pierre Matisse Gallery.
Color: *Verve*, no. 21-22

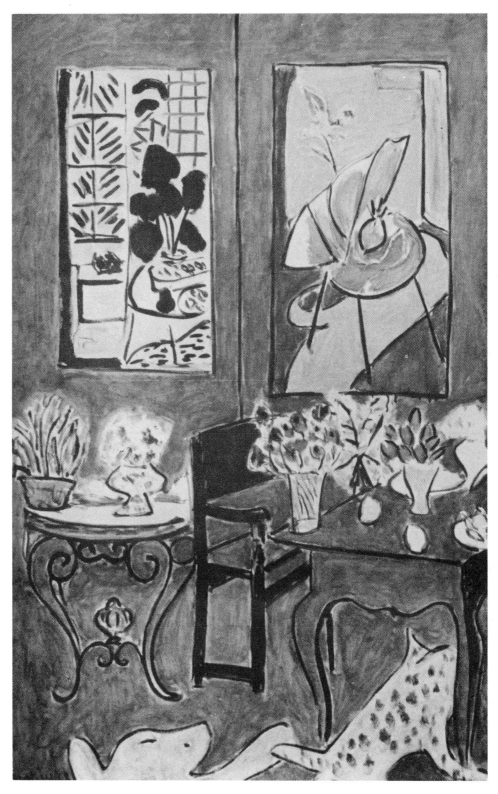

LARGE INTERIOR IN RED (*Le grand intérieur rouge*). Vence, 1948 (early). Oil, 57½ x 38¼″. Paris, Musée National d'Art Moderne. Color: *Verve*, no. 21-22

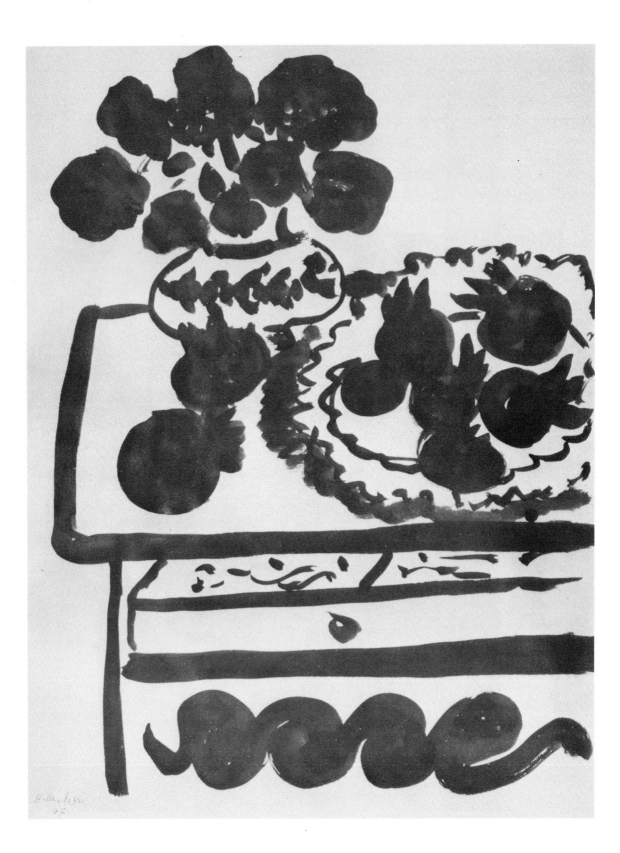

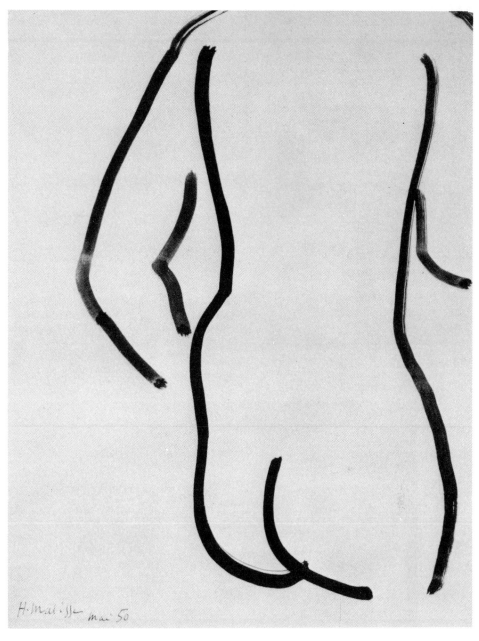

TORSO—BACK VIEW (*Torse de dos*). Nice, 1950, May. Brush and ink, 20½ x 15¾″. Owned by the artist

Opposite page: DAHLIAS AND POMEGRANATES (*Dahlias et grenades*). Vence, 1947.
Brush and ink, 30⅛ x 22¼″. New York, Museum of Modern Art

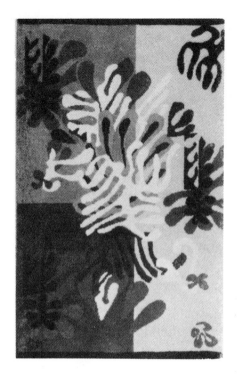

MIMOSA. Deep pile rug, 58 x 36″. Designed by Matisse in 1949, with revisions 1951, for Alexander Smith and Sons, Yonkers, New York. Executed with approval of the artist, 1951

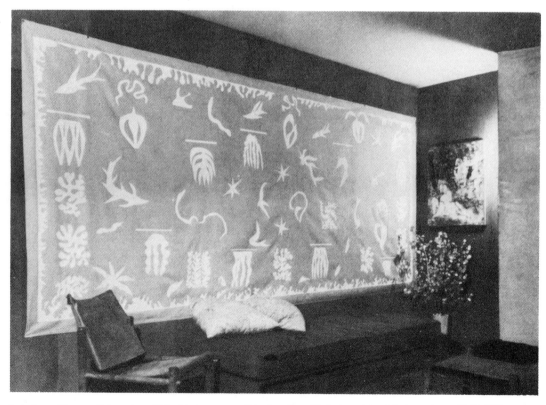

Interior with a wall hanging, *Océanie—la mer*, an "Ascher Panel" designed by Matisse about 1947. Silk screen stencil on natural linen, 65 x 150″. New York, Buchholz Gallery

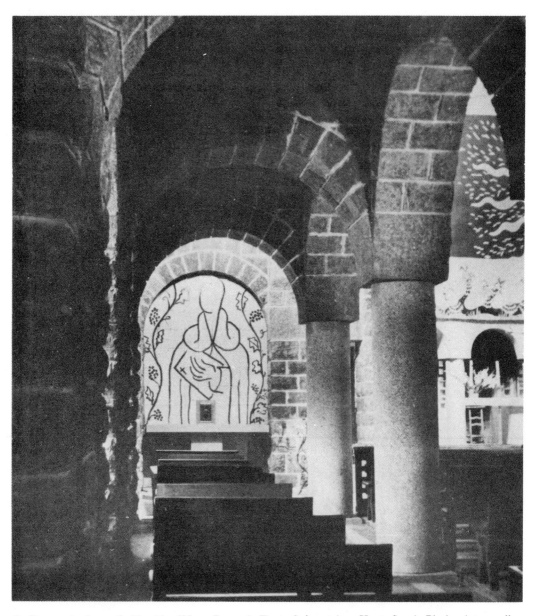

St. Dominic in the south side-aisle of Notre-Dame-de-Toute-Grâce at Assy, Haute-Savoie. Black paint on yellow tile, glazed. 1948. Church begun 1937, consecrated 1950; Canon Devémy, responsible ecclesiastic; Maurice Novarina, architect; Father M. A. Couturier, artistic supervisor

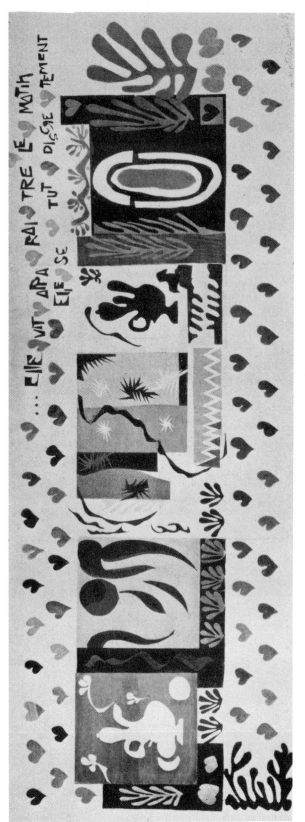

THE THOUSAND AND ONE NIGHTS (*Les mille et une nuits*). Nice, 1950, June. Gouache on cut-and-pasted paper, 54¾ x 147¼". Owned by the artist

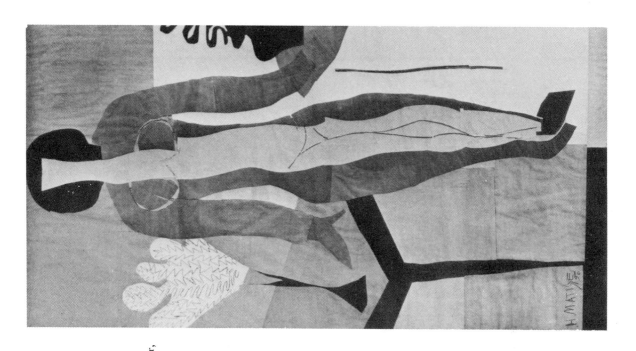

ZULMA. Nice, 1950 (first half). Gouache and crayon on cut-and-pasted paper,
93¾ x 52⅜". Copenhagen, Statens Museum for Kunst

NEGRO BOXER (*Boxeur nègre*). (1947?)
Gouache on cut-and-pasted paper,
12⅝ x 10". Owned by the artist.
Color: cover of catalogue *Henri
Matisse, oeuvres récentes, 1947-1948,*
Paris, [1949], Musée National d'Art
Moderne

THE CHAPEL AT VENCE

The Chapel of the Rosary of the Dominican Nuns of Vence, consecrated June 25, 1951. The chapel interior is about 20' wide and almost 17' high in the nave, about 50' long over-all. Unless otherwise noted, reproductions are from *Chapelle du Rosaire des Dominicaines de Vence par Henri Matisse*, Vence, 1951

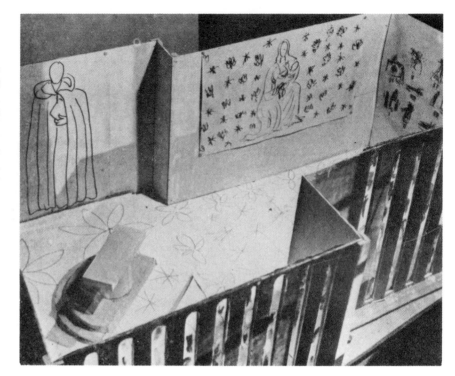

Above: An early model of the Vence chapel, 1948, showing altar, floor decoration, ST. DOMINIC, VIRGIN AND CHILD and windows. Photo *The New York Times*, Nov., 1948

Left: "Heavenly Jerusalem" design for windows, 1948. Courtesy *Vogue*

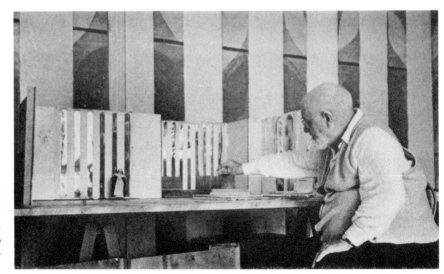

Matisse with model showing windows of nave, nuns' transept and apse; background: window cartoons with "Tree of Life" design. 1949. Photo Robert Capa-Magnum, courtesy *Look*

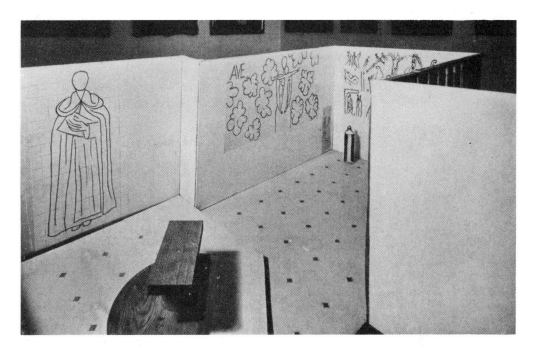

Model of the interior, 1950, from the same direction as below, showing the altar, the Sᴛ. Dᴏᴍɪɴɪᴄ, the Vɪʀɢɪɴ ᴀɴᴅ Cʜɪʟᴅ and part of the Sᴛᴀᴛɪᴏɴs ᴏғ ᴛʜᴇ Cʀᴏss. Photos on this page taken by Marc Vaux at the Matisse exhibition, Maison de la Pensée Française, Paris, July-September, 1950

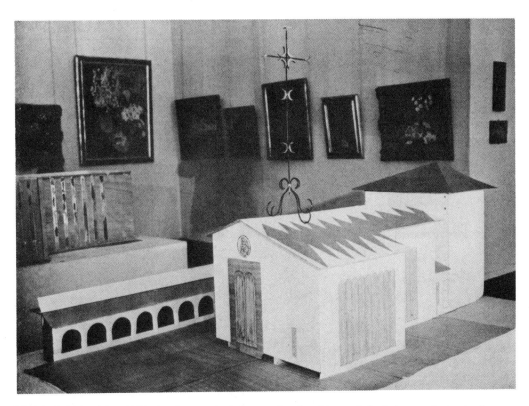

Model of the exterior, 1950, showing, to the left, apse façade with coupled windows and a tondo above; and, to the right, the nine windows of the transept reserved for the nuns and, beyond, the end of the row of six windows of the nave

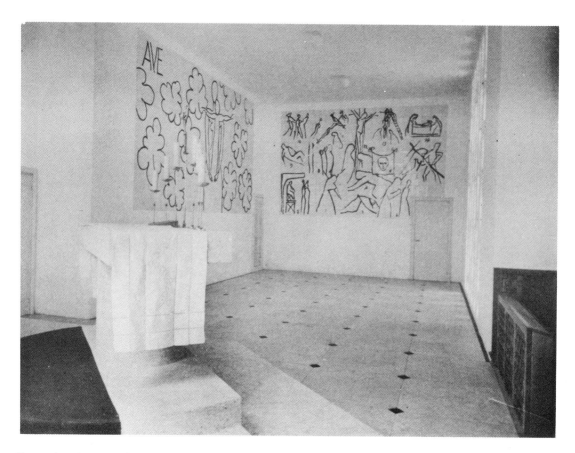

Vence chapel: interior looking toward STATIONS. Altar cloth with fish design at left; nuns' stalls at right. Photo Hélène Adant

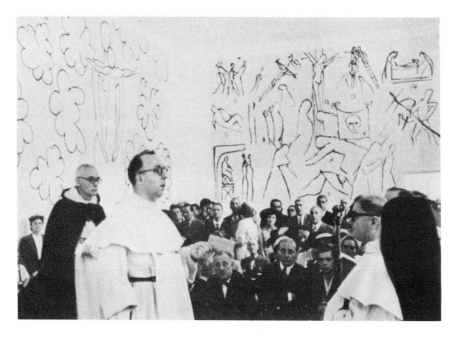

Consecration of chapel, Father Couturier in background at left. Photo Cartier-Bresson, courtesy *Harper's Bazaar*

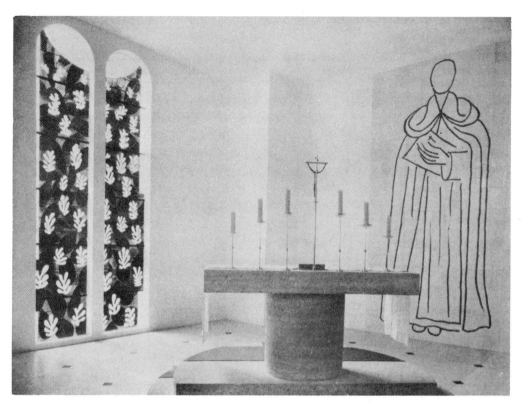

Vence chapel: the altar with Matisse's crucifix and candlesticks; the coupled windows at the left; the St. Dominic at the right. Photo Hélène Adant

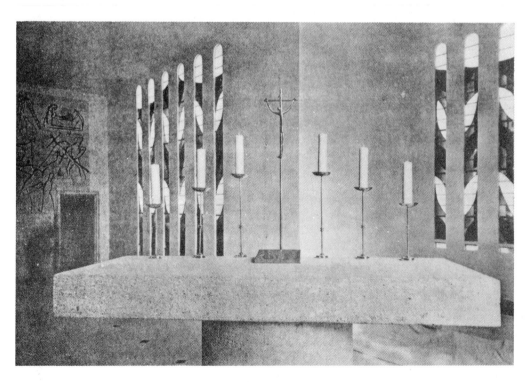

Looking over the altar toward the six windows of the nave and, to the right, three of the nine windows of the choir

Opposite page: Vence chapel: V<small>IRGIN AND</small> C<small>HILD</small>. Painted and glazed tiles, c.10 x 21'

Matisse drawing a study for the Virgin's head. Photo Hélène Adant, courtesy *Art News*

Matisse working on leaf decoration of V<small>IRGIN AND</small> C<small>HILD</small>, 1949. Photo Robert Capa-Magnum

Opposite page: Vence chapel: STATIONS OF THE CROSS.
Painted and glazed tiles, c.10' x 17'6". The stations are:

1. CHRIST BEFORE PILATE
2. CHRIST RECEIVING THE CROSS
3. CHRIST'S FIRST FALL
4. CHRIST'S MEETING WITH HIS MOTHER
5. SIMON OF CYRENE CARRYING THE CROSS
6. VERONICA WIPING THE FACE OF CHRIST
7. THE SECOND FALL
8. CHRIST EXHORTING THE WOMEN OF JERUSALEM
9. THE THIRD FALL
10. CHRIST STRIPPED OF HIS GARMENTS
11. CHRIST NAILED TO THE CROSS
12. THE DEATH OF CHRIST
13. THE DESCENT FROM THE CROSS
14. THE ENTOMBMENT

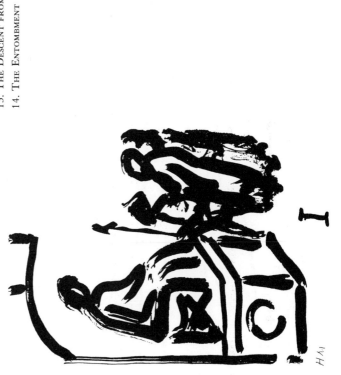

Later study for CHRIST BEFORE PILATE

Early study for CHRIST BEFORE PILATE

Vence chapel: St. Dominic. Painted and glazed tiles, c.15'6" high

Preliminary drawing for St. Dominic. Brush and India ink on paper, 63 x 33½". Owned by the artist. Photo M. Bérard

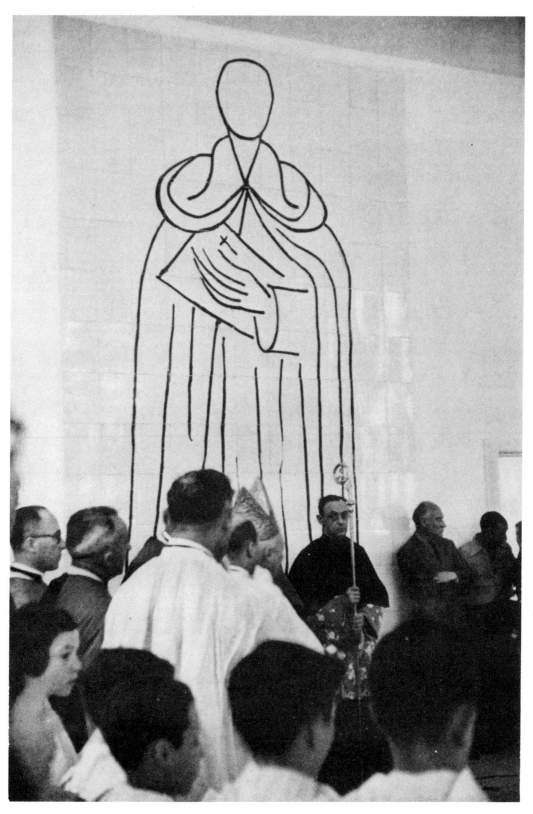

Vence chapel: consecration with St. Dominic in background. Photo Cartier-Bresson, courtesy *Harper's Bazaar*

The altar crucifix, Vence chapel

Matisse modeling crucifix for the Vence chapel. Photo Hélène Adant, courtesy *Art News*

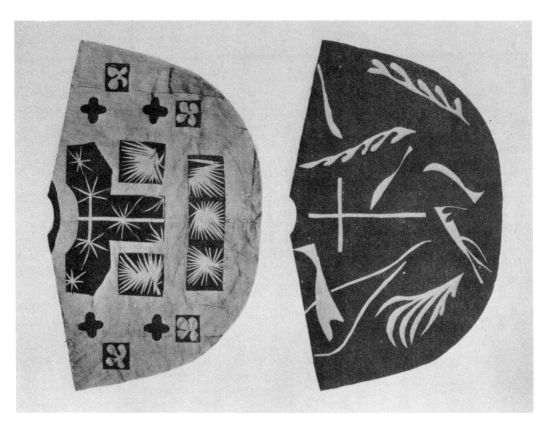

Designs for chasubles, gouache on cut-and-pasted paper

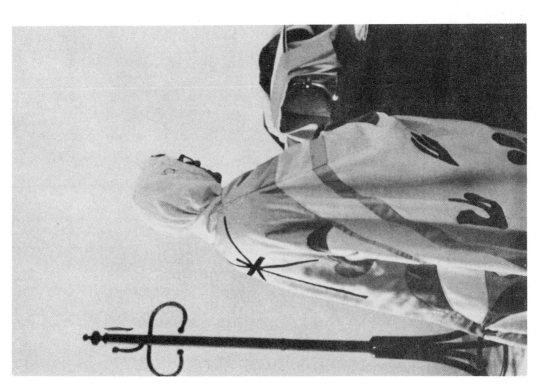

Vence chapel: priest in the vestry wearing chasuble designed by Matisse.
Photo Cartier-Bresson, courtesy Magnum Photos

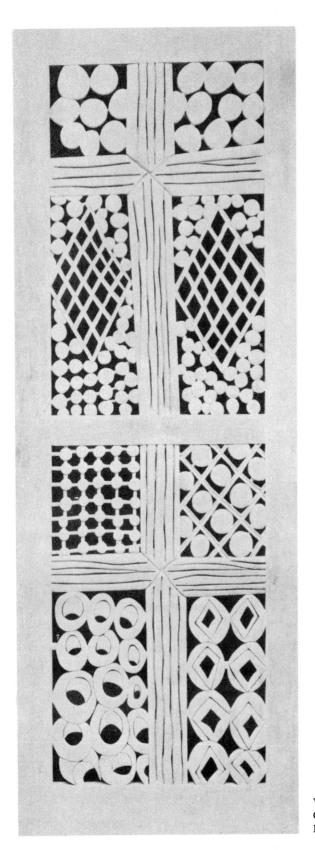

Vence chapel: door to the Confessional.
Carved wood rubbed with white.
Photo M. Bérard

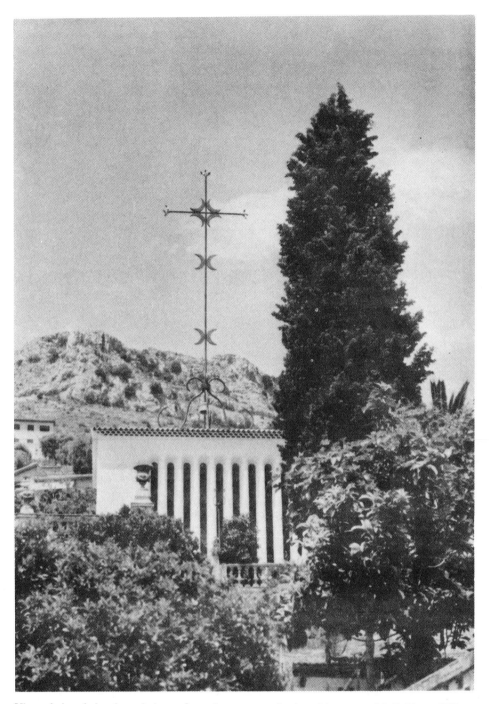

View of chapel showing windows of nuns' transept and spire with cross and bell. Photo Hélène Adant, courtesy *Art News*

NOTES

NOTES TO PLATES

Additions and corrections to plates. Important changes are marked with an asterisk.

30 Matisse, Hôtel Régina: *for* 1947 *read* 1949.

*313 The Back, I: *for* Paris (1904?) *read* Issy-les-Moulineaux (c.1910). (Plate should follow p. 367, *Cf.* p. 142.)

330 The Rose: *for* Pierre Matisse Gallery *read* private collection.

334 Section of textile: photo courtesy *Art News*.

340, 341 Le luxe, I *and* II: *add* color, Skira, bibl. 21, pp. 22, 23

360 Dance-study: *for* 9' x 12' *read* 8'6½" x 12'9"

*375 The Painter's Studio: *for* (1911) *read* (early 1911). Chronological sequence of pages should be: 372, 375, 373, 374. (For list of objects represented in *The Painter's Studio* see note 5 to p. 152.)

380 Moroccan Garden: dated 1912; now owned by Mr. and Mrs. Samuel A. Marx, Chicago.

406 Apples: *read* gift of Mr. and Mrs. Samuel A. Marx.

*426 Tea: *for* Nice (1919) *read* Issy-les-Moulineaux (1919, summer). (*Tea* should follow, pp. 427-9.)

*430 The Black Table: *for* Nice *read* Issy-les-Moulineaux.

439 Interior with Boys Reading: *add* Pierre Matisse Gallery.

*457 Reclining Nude, II *should read* Reclining Nude, III Reclining Nude, III *should read* Reclining Nude, II (*Cf.* p. 217.)

484 Self Portraits: for artist's analysis see Appendix H.

*493 Painted doors: *for* Completed state *read* Intermediate state. *Add:* Completed 1946-47.

502 Interior in Yellow and Blue: *add* Washington, Embassy of the French Republic, courtesy His Excellency, The Ambassador and Mme Bonnet.

503 Asia: *for* private collection *read* Mr. and Mrs. Tom May.

518 Virgin and Child: lines between tiles are too black.

520 Stations of the Cross: lines between tiles are too black.

522 St. Dominic: lines between tiles are too black.

524 The crucifix: figure is bronze; cross, polished brass.

526 Door to the confessional: *for* rubbed with white *read* painted white.

299 *Dinner Table*, 354 *Pierre Matisse*, 440 *Odalisque with Magnolias*, 489 *Lemons . . .*, 490 *Idol*, 505 *Plum Blossoms . . .*, 507 *Large Interior . . .*, 510 *Mimosa* are reproduced in color in *Art News Annual* XXI, 1952.

CORRECTIONS TO COLOR PLATES: 66 general tone too red; 79 sky too blue; 165 background too violet; 167 background too pale; 170 side margins cropped; 228 pinks and blues too bright; 233 red too bright, green too dull; 236 background should be redder; 239 blue and green in window should be brighter.

NOTES TO TEXT

Notes are arranged under page numbers in continuous sequences of 1 to 9.

"Bibl." refers to Bibliography, pages 564-574.

"Questionnaire I," etc., refer to one of seven series of questions submitted through various channels to Matisse or members of his family. The answers were either written or taken down as notes during conversation.

Questionnaire I. Submitted to Matisse through Mrs. Bertha Slattery Lieberman and through letter, 1945. Answered directly and in conversations with Mrs. Lieberman.

Questionnaire II. To Matisse; answered in conversation with Monroe Wheeler, March 1950.

Questionnaire III. To Mme Georges Duthuit (Marguerite Matisse), April 1950. Same questions as in II. Answered directly in writing.

Questionnaire IV. To Matisse and Mme Matisse through Pierre Matisse; incorporates several letters and questionnaires submitted July-September 1950. Answered in writing and conversation through Pierre Matisse.

Questionnaire V. To Matisse through John Rewald, August 1950. Answered in conversation with John Rewald.

Questionnaire VI. To Matisse through John Rewald, March-April 1951, including many questions on the *Dance* and *Music* of 1910. Answered in conversations with Mr. Rewald.

Questionnaire VII. To M. and Mme Matisse through Pierre Matisse, July 1951. Answered principally by Mme Matisse in conversations with Pierre Matisse, July-September, 1951.

PAGE 13

1 Facts from Questionnaires II and III.

2 Matisse ordinarily used the name Henri Matisse until 1904 though his name often appeared as H.-E. Matisse or Henri-Emile Matisse as in the early Salon catalogs. In the 1904 catalog of the Salon d'Automne he began to use the hyphenated Henri-Matisse in order to avoid confusion with the well-known marine painter Auguste Matisse. After the latter died in 1931 Matisse dropped the hyphen whenever he could remember to do so.

3 Matisse, *Jazz*, bibl. 48.

4 When this drawing was selected by John Rewald in 1951 from a stack of similar exercises in Matisse's possession, the artist recalled that he had done it in the "Cours Yvon" at the Ecole des Beaux-Arts, Paris. The date 1890 on the drawing would, however, indicate the Ecole Quentin de La Tour

at St. Quentin since Matisse did not work in the Paris school before the end of 1891. However, the date may have been added much later and may be wrong or simply an approximation.

Since the above paragraph was set, word has come from Matisse's secretary that the date 1890 is old. The probability that the drawing was done in St. Quentin is therefore greatly increased.

5 Reproduced in *Cahiers d'Art*, bibl. 158, p. 230.

PAGE 14

6 The date usually given is 1892, but Matisse feels sure it was late in 1891. His daughter Mme Georges Duthuit confirms 1892—Questionnaire III.
7 Tériade, bibl. 77.
8 Escholier, bibl. 83, p. 30.

PAGE 15

9 Escholier, bibl. 83, p. 31.
1 Matisse, bibl. 50.
2 The copy of the "Niobid" reproduced on page 293 may have been done at this time though it is dated 1890.
3 Guenne, bibl. 57a, p. 214.

PAGE 16

4 Guenne, bibl. 57a, p. 215, asked Matisse "*Fréquentiez-vous les Expositions des impressionistes?*" To which Matisse replied, "*Non, je ne connus les oeuvres de ceux-ci qu'à l'ouverture de la Collection Caillebotte.*" More recently Matisse has denied this (Questionnaire IV), stating that he had seen the impressionists at Durand-Ruel's and Vollard's before 1897.

Huyghe, bibl. 22, p. 97, writes that Rouault once showed some Cézanne watercolors to Moreau who expressed some appreciation for them. Romm, bibl. 89a, p. 19, states that Matisse himself was impressed by two Cézanne pictures brought into Moreau's studio by "Lenaret," doubtless Moreau's pupil, Georges Linaret.
5 Rewald, bibl. 29a, p. 422.
6 Soby, bibl. 211a, p. 94.

PAGE 33

7 Pierre Matisse to the author, 1951.
8 Escholier, bibl. 83, p. 38.

PAGE 35

9 Questionnaire IV. Pierre Matisse informs me that Russell *gave*, rather than sold, *two* van Gogh drawings to Matisse.
1 Matisse to Margaret Scolari, Paris, June 1931.

PAGE 36

2 Matisse's *Dinner Table* of 1897, page 299, does in fact closely resemble in subject and composition Vuillard's *Vuillard Family at Lunch* of 1896 now in the collection of Mr. and Mrs. Ralph F. Colin, New York. Vuillard's design in this picture is more sophisticated with its patterning of light and dark and greater awareness of the shapes of voids and solids; and so is his rather mannered drawing.

PAGE 37

3 Rewald, bibl. 205a, p. 30.
4 This and other facts about Matisse's life during these years are based largely upon answers to Questionnaires II and III.

CORRECTION: It was at Fenouillet, a village near Toulouse, that the Matisses lived early in 1899, *not* at Fenouillet in the Pyrenees as stated on page 37.
5 Bibl. 33, p. 43. Though Gertrude Stein gives an unflattering description of Madame Matisse's face she is most complimentary about her carriage—and her character.
6 *Testimony against Gertrude Stein*, bibl. 64, p. 3.

PAGE 38

1 Escholier, bibl. 83, pp. 77-78.
2 Escholier, bibl. 83, p. 43; Guenne, bibl. 57a, p. 33.

J. T. Soby gives me the exact wording of Delacroix's injunction: "If you are not competent to make a sketch of a man who has thrown himself out of a window, during the time he is falling from the fourth floor to the ground, you will never be able to produce great masterpieces"—translated from Charles Baudelaire: *La vie et l'oeuvre d'Eugène Delacroix*, Paris, 1928.
3 Escholier, bibl. 83, p. 43.
4 September 9, 1950, while answering the author's questionnaire IV of August 23.

PAGE 39

5 Questionnaires II and IV. About then or later Matisse bought a van Gogh drawing from Vollard.

PAGE 40

6 Escholier, bibl. 83, p. 17.
7 Puy, bibl. 28, p. 70.

PAGE 41

1 Questionnaire I.
2 Weill, bibl. 35a, p. 77.
3 Guenne, bibl. 57a, p. 219.
4 Quoted from *Testimony against Gertrude Stein*, bibl. 64, p. 5. Gertrude Stein, bibl. 33, p. 45, had told another version of the incident.

PAGE 42

5 *Le Point*, bibl. 161, p. 20-116.
6 Several of Marguerite Matisse's paintings and Jean Matisse's sculptures are in the Cone Collection of the Baltimore Museum of Art, bibl. 108.
1 Duthuit, bibl. 13, pp. 27-28.
2 Duthuit, bibl. 13, p. 28.

PAGE 43

3 Weill, bibl. 35a, p. 73.

PAGE 45

4 Bibl. 64, p. 5. Matisse states that the collector was Herr Freudenberg and that he still owns the painting (1935). In 1930, however, the *Dinner Table* had for many years been in the collection of Dr. Curt Friedmann who, I believe, had been the original purchaser.

PAGE 46

1 The *Dinner Table* was probably no. 881, *Les préparatifs*, in the catalog of the Salon de la Nationale of 1897. Later,

Matisse usually called it *La desserte*, though *Le dessert* would seem a better title.

PAGE 47

2 Bibl. 21, p. 13, wrongly dated 1900.

3 Matisse confirmed this fact when answering Questionnaire IV. Signac's essay was not published in book form until after Matisse returned to Paris in February 1899. (Bibl. 31a.)

PAGE 48

4 Matisse is certain that both the Dumbarton Oaks *Sideboard and Table* and the Baltimore *Fruit Dish and Glass Pitcher, I* were painted in Toulouse in 1899 (Questionnaires II and III) but he has not indicated which he did first.

5 *Fruit Dish and Glass Pitcher, II* was bought by Theodore Schempp at auction in Paris early in March 1951. It had been in the Boch collection, The Netherlands. This picture may be a study which Matisse intended to carry further but stopped when he found that he had obtained what he wanted.

6 Reproduced in *Les fauves*, bibl. 140 (no. 95).

7 Reproduced in Philadelphia catalog, bibl. 152, pl. 2.

8 For instance the *Standing Nude*, dated 1901, reproduced in Philadelphia catalog, bibl. 152, pl. 6.

1 L. Stein, bibl. 34, p. 180. This and subsequent quotations from Leo Stein: *Appreciation: Painting, Poetry and Prose*, copyright 1947, are used with the permission of Crown Publishers, Inc.

Hans Purrmann, bibl. 205, apropos of Bevilaqua and *The Slave*, states that Matisse "in a little notebook such as laundresses use, used to keep an account of all the money he paid his models; but after some time when the total rose so high as to alarm him, he stopped making further entries but kept right on working."

2 *Cahiers d'Art*, bibl. 158, p. 236.

PAGE 49

3 Questionnaire II.

4 For instance the *Meyer de Haan*, 1889, Mrs. Q. A. Shaw McKean, Boston, and the *Women of Arles*, 1888, Art Institute of Chicago, both illustrated, Museum of Modern Art, First Loan Exhibition, 1929, pl. 36, 40.

5 *Cahiers d'Art*, 1929, p. 260 (Duthuit, bibl. 177).

6 *Op. cit.*, p. 268.

PAGE 50

7 Letter to Pierre Matisse, July 16, 1942.

8 Questionnaire I.

PAGE 52

1 According to Maurice Denis, Rodin offended the conscientious Matisse by telling him: "Fuss over it, fuss over it. When you have fussed over it two weeks more, come back and show it to me again." André Gide, *Journal*, Vol. I, New York, 1947, p. 174. Matisse did not "come back."

2 Facts about Matisse's early sculpture from Questionnaires II and III.

3 To the Salon d'Automne of 1904 Matisse sent two plaster busts, one called *Etude*, the other *Femme*.

4 *The Back, I*, which can now be dated about 1910, is discussed on page 142.

PAGE 53

5 A photograph of the boathouse is published in the *Art News Annual*, 1952, bibl. 157a.

6 For instance a watercolor painted by Signac at Arles in the very year 1904 and now in the Museum of Modern Art, New York.

7 The letter is dated only with the month and day but the year is surely 1904. Van Rysselberghe was a well-known Belgian Neo-Impressionist and friend of André Gide. Letter quoted through the courtesy of John Rewald.

8 An account of the sale of the *Dinner Table* is given by Matisse in *Testimony against Gertrude Stein*, bibl. 64, p. 5. Gertrude Stein's story is quite different, bibl. 33, p. 47.

PAGE 54

9 *Luxe, calme et volupté* was removed from St. Tropez to the mountains in 1943 to protect it during the allied invasion. It was included in the Matisse exhibition at the Maison de la Pensée Française in 1950, bibl. 146, and in *Le fauvisme* at the Musée National d'Art Moderne, 1951, no. 94, bibl. 144; it was dated 1903 in both catalogs and was not reproduced in either catalog. The little study for *Luxe, calme et volupté* had been reproduced before, notably in Fry II, bibl. 85a, though with no indication of its significance.

1 In April 1905, as a token of his admiration, Matisse gave Cross a small canvas dedicated with *"profonde sympathie."* The picture, formerly in the Fénéon collection, will be published by John Rewald in his forthcoming book, *The History of Post-Impressionism.*

2 1904 is often given as the date of Matisse's first stay at Collioure. Mme Matisse was there briefly late in 1904 but Matisse and the family did not arrive till the following spring. Questionnaire III.

PAGE 55

3 Quoted by Dorival, bibl. 12, p. 74.

4 *Ibid.*

PAGE 56

5 *La Grande Revue*, Dec. 15, 1905, quoted in Huyghe, bibl. 22, p. 105.

6 Bibl. 13, p. 35. I now believe Duthuit to be correct in the date and place if not in all details. I owe him and his publisher, Wittenborn, Schultz, Inc., of New York, an apology for having contradicted him, bibl. 13, p. VIII. I had been misled.

7 Bibl. 214, p. 35.

8 Vauxcelles does not mention Marque or Donatello. However at the Indépendants of 1906 Marque did exhibit a fountain group entitled *Ebats des enfants* which may indeed have been the "group of little cherubs" referred to by Duthuit, op. cit. Marque also exhibited a bronze *Torse d'enfant* at the Salon d'Automne of 1905.

9 Bibl. 28, pp. 62-63.

10 Bibl. 173a, p. 402.

Burgess writes: "At first, the beginners had been called 'the Invertebrates.' In the Salon of 1905 they were named 'the Incoherents.' But by 1906, when they grew more pervid, more crazed with theories, they received their present appellation of Les Fauves."

11 *Recollections of a Picture Dealer*, bibl. 215a, p. 202.
1 L. Stein, bibl. 34, p. 158.
2 Purrmann, bibl. 205, p. 185.

PAGE 57

3 L. Stein, bibl. 34, p. 188.
4 L. Stein, bibl. 34, p. 153.
5 L. Stein, bibl. 35, p. 15, 17.
6 Bibl. 33, pp. 41-42.
7 L. Stein, bibl. 34, pp. 158-159.

PAGE 58

8 Quoted by Kimball, bibl. 191, p. 37.
1 Bibl. 64.
2 J. F. Schnerb in *Chronique des Arts*, bibl. 209a.
3 Purrmann, in letters to the author, 1950-1951.

PAGE 60

4 These were exhibited at the Salon de la Nationale and the Indépendants; cf. *Grande Plage* p. 37 and *Baigneuses* p. 39 in François Fosca, *Maurice Denis*, Paris, 1924.
5 Maurice Denis: "La réaction nationaliste," bibl. 11.

PAGE 61

6 Berr de Turique: *Raoul Dufy*, Paris, 1930, p. 80.
7 Reproduced McBride, bibl. 88, pl. 49.
8 Reproduced Wilenski, bibl. 37, pl. 50b.
1 Reproduced bibl. 131, pl. 10.

PAGE 63

2 Bibl. 186a.
3 Reprinted in *Théories*, bibl. 11, pp. 203-210.

PAGE 64

4 In a letter to Emile Schuffenecker, August 14, 1888. *Paul Gauguin, Letters to His Wife and Friends*, ed. by M. Malingue, Cleveland and New York, World Publishing Co., 1949, p. 100. Also *Lettres de Gauguin*, Paris, 1946, p. 134.
5 *Art et Critique*, August 23, 1890, reprinted in bibl. 11, p. 1.

PAGE 81

6 Bibl. 34, p. 161.

PAGE 82

7 Angrand was one of the secondary French Neo-Impressionists, Ranson a minor Nabi. "Cloisonnisme" was a name applied in 1886 to some of the painters in Gauguin's circle who painted in flat tones bounded by definite lines like cloisonné enamel. Signac's letter, dated "Paris, 14 janv. 1906," is quoted here through the courtesy of John Rewald. Mr. Rewald has also shown me a letter of about the same moment from Cross to the Belgian "Néo," van Rysselberghe, in which he refers to a report in *Le Journal* of Matisse's having sent a large picture to the Salon des Artistes Français—the most conservative of the four Salons. The report was doubtless a joke but Cross' remark that "Signac doesn't approve" the big picture "for all kinds of good reasons" was all too true.
8 Bibl. 13, p. 61.
9 Conversation with the writer, 1950.
1 The glass plates were later sold to Vizzavona and many
have been broken. The albums have since passed into the archives of the Bibliothèque Nationale.
2 *Chroniques du Jour*, bibl. 159a, p. 16. I have not seen a copy of the Druet catalog and know nothing of the success of the exhibition.
3 Matisse says March 1906, Questionnaire IV.

PAGE 83

4 The *Yellow Jug* originally hung in the collection of Leo and Gertrude Stein. CORRECTION: There are 43 not 66 paintings in the Cone Collection, see p. 557.
5 Matisse cannot remember definitely whether *The Blue Nude* was shown at the Indépendants. Henry Kahnweiler, who has a reliable memory, writes me that he feels fairly sure he saw it there; and it is described circumstantially as at that Salon by Gertrude Stein, bibl. 33, p. 21. In any case Matisse believes that he painted the picture at Collioure early in 1907.
6 Matisse, Questionnaire II, says the Italian trip was in 1906, but Mme Duthuit, Questionnaire III, in consultation with Mme Matisse, says 1907, a date confirmed definitely by Walter Pach in conversation with the author.
7 Bibl. 26, pp. 116-17.
8 Purrmann, bibl. 205, p. 192.
9 Matisse's enthusiasm for Siena is confirmed by Apollinaire's remarks about Duccio, p. 102.
1 Puy, bibl. 28, p. 65.

PAGE 84

2 Bibl. 35, p. 53.
3 Bibl. 34, pp. 170-172, courtesy Crown Publishers, New York.
4 Bibl. 25a, p. 107.

PAGE 85

5 Bibl. 34, p. 175.
6 Barr, bibl. 167a, p. 56.

PAGE 86

7 Bibl. 28, p. 70.

PAGE 87

8 *La Grande Revue*, April 10, 1908, reprinted in *Théories*, bibl. 11, p. 225 ff. The quotation occurs on p. 234.
9 Bibl. 175.
10 Matisse now does not remember the incident but he apparently did describe a Braque to Louis Vauxcelles as "*fait de petits cubes*" and then drew a sketch to illustrate his words. See Vauxcelles, bibl. 214, p. 35. Marquet and Guérin, who were on the jury, each had the privilege of overruling the rejection of a single painting. Both chose to save a Braque but the artist, angered, withdrew all seven of his entries and showed them later at Kahnweiler's new gallery. See H. R. Hope, *Georges Braque*, New York, Museum of Modern Art, 1949, p. 33.

PAGE 88

1 Matisse, Questionnaire IV.
2 Professor Gilbert Highet of Columbia University has pointed out to me that iconographically the *Joy of Life* is a mixture of *Bacchanale* with wildly dancing figures, a girl

twining ivy in her hair, etc., and *pastorale* with woodwind music, goats, etc. Occasionally, at a vintage festival for instance, the two could be associated. Daphnis and Chloë occurred to him also as a possible source for Matisse's ideas.

3 Giorgione's *Fête Champêtre*, in the Louvre, an idyll with figures in contemporary costumes, was of course familiar to Matisse: is it a coincidence that Giorgione's distant piping goatherd in the right-hand background reappears in the *Joy of Life*?

PAGE 89

4 Barnes and de Mazia, bibl. 78, p. 240.

PAGE 90

5 Matisse is himself rather confused on this subject—perhaps as a result of various published misstatements. Matisse, Questionnaire II, supported by Mme Duthuit, Questionnaire III, and Barnes, bibl. 78, p. 367, says he first studied Islamic art at the Munich exhibition of Moslem art in 1903 in spite of the facts that he did not go to Munich in 1903 and that there was no Moslem exhibition held there in that year. Matisse did however make a special trip to Munich in 1910 to see the great exhibition of Islamic art.

PAGE 91

6 In *Le Point*, bibl. 161, p. 36-132.

PAGE 92

7 Barnes and de Mazia, bibl. 78, p. 242.
8 Fry, bibl. 85a, pl. 9.
1 Reproduced in Philadelphia, bibl. 152, pl. 19 and Barnes, bibl. 78, p. 244; also, New York, 1951, bibl. 131b, p. 15.·

PAGE 93

2 Barnes and de Mazia, bibl. 78, analyze this complex canvas with such elaborate detail, patience and enthusiasm that the reader had best turn to their book, especially to the rhapsody on page 378 where words do not fail them.

PAGE 94

3 Questionnaire IV: Matisse is quite sure, Mme Matisse not certain.
4 Questionnaire V.
5 Reproduced *Cahiers d'Art*, bibl. 158, p. 27.
6 Reproduced Fry, bibl. 85a, pl. 6, and Escholier, bibl. 83, p. 33. Sometimes called *Femme au chapeau* and confused with the *Woman with the Hat*.
7 Color reproduction in Duthuit, bibl. 13, opp. p. 98.
8 Reproduced Barnes, bibl. 78, p. 245.
1 The first version of the sculptured *Reclining Nude* having been damaged, the second version, page 337, has recently been listed as *Nu couché, 1er état*, bibl. 146, no. 92, to distinguish it from two much later bronzes, *Nu couché, 2me état* and *Nu couché, 3me état*, reproduced here on page 457.

The sculpture *Reclining Nude, I* of 1907 is obviously developed from a draped figure listed in the Paris 1950 catalog, bibl. 146, as "*80. Nu couché à la chemise, 1905. H. O. 14.*" I could not secure a photograph of this bronze in time to reproduce it. It is the first, mildest and most naturalistic of the four figures which include, besides *Reclining Nude I*, page

337, *Reclining Nude II* and *III* of about 1929, page 457. A cast of the 1905 bronze at the Buchholz Gallery measures 5½″ high by 12″ long.
2 Matisse to Margaret Scolari, Paris, 1931.
3 Hans Purrmann reports that *The Blue Nude* was the result of a friendly competition with Derain as to who could paint the best figure in blue. When Derain saw Matisse's *Blue Nude* he conceded his defeat and destroyed his canvas. Letter of March 3, 1951, to the author.
4 L. Stein, bibl. 34, p. 162, calls it "The Blue Woman . . . but really a pink woman in blue scenery." There is a blue and violet rectangle under the figure and some blue-green leaves at the left but everywhere else in the "scenery" other colors prevail. Actually it is the drawing and modeling of the figure which is conspicuously blue.
5 See note 5 to page 83.

PAGE 95

6 Gertrude Stein, bibl. 33, p. 21. Curiously (and uncomfortably) Miss Stein refers to *The Blue Nude* as the "figure of a woman lying in some cactuses." In the winter of 1913 *The Blue Nude* was burned in effigy by the students of the Art Institute of Chicago when exhibited there after the New York "Armory Show."
7 *Painting and Sculpture in the Museum of Modern Art*, bibl. 131a, p. 57.
8 Questionnaire III.
1 Questionnaire IV.
2 Bibl. 115.
3 Questionnaires II, III, IV.

PAGE 96

4 Bibl. 213a, p. 920.

PAGE 97

5 For instance the male *académie* recently reproduced in a Japanese catalog, bibl. 154.

PAGE 98

6 Bibl. 162.
7 Bibl. 159.
8 This drawing is dated 1906 in Sembat, bibl. 91, p. 21, but many of the other dates in this first book on Matisse are wide of the mark by many years.
1 Reproduced in Duthuit, bibl. 13, p. 1.
2 Since "*bois*" are listed in the catalog of Matisse's show at Druet's which opened March 19, 1906, and the *Seated Woman* is a study for one of Matisse's three "woodcuts"—actually linoleum cuts—I venture to date this drawing early in 1906. The *Nude in a Chair* I date on a basis of style, because I believe the model to be the same as the one in the painting *La Gitane* of 1906, (Duthuit, bibl. 13, opp. p. 98) and because the folding studio chair appears in several of Matisse's datable works of 1906, for instance the linoleum cut, Philadelphia, bibl. 152, pl. 202.
3 See *Le Point*, bibl. 202a, Marquet number, also Duthuit, bibl. 13, p. 13, 14.
4 The eight copper plates numbered 52, 54, 55A, 55B, 56A, 56B, 56 bis, 57 appear to me to be early, that is about 1903? to 1906, in spite of their numbers following those of the numerous etchings of 1914.

5 Dated c.1900 in the Philadelphia catalog, bibl. 152, pl. 205. Claude Roger-Marx believes his first etchings and drypoints were done about 1903, bibl. 206, p. 146.

PAGE 99

6 The head of the girl with the hair ribbon in this plate seems closely related to the painting of a child's head now I believe in the Joseph Müller collection, Soleure, and usually dated 1906.

7 This first series of lithographs may have totaled as many as 19 stones to judge from the unpublished notes of Henri Petiet and Carl Schniewind who list them with the lithographic plate numbers of 1 to 12, adding several *bis* numbers. Actually I have seen originals or photographs of only ten and of this number only half a dozen are commonly met with in spite of the fact that the whole series is listed by Petiet and Schniewind as having been published in editions of twenty-five. This number is confirmed by the inscriptions on all the proofs I have examined.

The series is usually dated 1906-1907 but all the proofs I have seen are consistent in style (except the unique "plate 10 and 29") and are printed on the same size and quality of paper in the same size edition. Furthermore an artist ordinarily completes such a series before publication so that I suspect the entire series was done within a brief period. The big Matisse show which opened at the Galerie Druet in March 1906 included "*lithographies*" so that some at least, and possibly all of the series actually published, were done early in the year 1906, perhaps after the *Joy of Life* was completed but before the Druet show and the Salon des Indépendants.

The unique lithograph, curiously numbered "plate 10 and 29," reproduced in *Cahiers d'Art*, bibl. 158, fig. 91, is usually dated 1907 and sometimes included in the early series from which however it differs completely in style, more closely resembling such abstract figures as those in the big painting *Bathers by a River*, page 408. Since Matisse seems to have done no other lithographs before 1914, the blanket date 1906-1907 has, I suppose, been used to include all the early lithographs, both this unique stone of 1907 and the long homogeneous series of 1906.

8 Though it may instead be an experiment preceding the figure series.

1 However, many of Munch's numerous woodcuts not only antedate but far surpass Matisse's three prints in every respect except boldness of drawing and decorative pattern. Their originality and variety of design were beyond Matisse's powers at this time and their psychological and emotional depth lay quite outside the range of Matisse's art. See F. B. Deknatel: *Edvard Munch*, the Institute of Contemporary Art, Boston, 1950, plates 132, 136, 140, 142, 147, 150, 155.

2 The linoleum cuts are listed in the Druet exhibition as "*bois*" (*Chroniques du Jour*, bibl. 159a, p. 16) and as "*gravures sur bois*" in the catalog of the Salon des Indépendants of 1907, items nos. 5244, 5245, 5246. In spite of these descriptions, the prints are now considered to be linoleum cuts: the two surfaces can give much the same impression. These three "woodcuts" constituted half of Matisse's exhibits at the Indépendants of 1907; the other three entries comprised two drawings and a mysterious "*Tableau No. III*."

3 *La Grande Revue*, bibl. 175a, p. 145. The large woodcut was number 5244 in the exhibition catalog.

4 Reproduced in Duthuit, bibl. 13, p. 1 and Philadelphia, bibl. 152, pl. 202.

PAGE 100

5 Appendix A, section on Sculpture.

6 Vollard, bibl. 215a, p. 249; Huyghe, bibl. 22, pp. 122, 136, 163; Copenhagen, bibl. 115, nos. 169-175.

PAGE 101

7 Bibl. 166.

PAGE 102

8 G. Stein, bibl. 33, pp. 77-78.

PAGE 105

9 G. Stein, bibl. 33, pp. 114-115. Miss Stein says the wreath arrived in Clamart but Matisse corrects her, bibl. 64, p. 6, placing the arrival at Boulevard des Invalides, and thereby confirms the date of the occasion.

10 Letter from Morris Carter, Director of the Isabella Stewart Gardner Museum, Boston, 1951. Prichard's museum reforms consisted chiefly in removing plaster casts of antique sculpture from the main galleries, organizing gallery or docent talks, and instituting curatorial card files with small photographs of each object for quick identification. Mr. Carter reports that Prichard in England toward the end of his life became convinced that he could control the weather. Once on an outing in Kew Gardens he was heard to remark to one of his young friends: "Would you mind taking charge of the weather, old chap? I should like to read for a bit." He died in 1936.

1 Letter from Frau Greta Moll, April 20, 1951.

PAGE 106

2 Until his collection was confiscated and he had to leave Russia after which he apparently lost his interest in painting.

3 Bibl. 25a, p. 143.

4 Bibl. 129 (1936, *La Danse*).

5 Sembat, bibl. 91, p. 19. Venice, *Lady on a Terrace* may be seen at left of lower illustration on p. 24 of this book.

6 In an interview with Tériade now published in the *Art News Annual*, New York, bibl. 77, Matisse tells how Morosov would go to Vollard's and ask to see "a very beautiful Cézanne" whereas Shchukin would ask to see all the Cézannes available and would then make his own choice.

PAGE 107

7 Bibl. 209a.

8 The Library has courteously permitted me to examine these postcards, and quote from them.

PAGE 108

9 Bibl. 205, p. 186.

1 Bibl. 192, columns 238-239. Could M. O. be Max Osborn? Purrmann (1950) cannot remember clearly what was in the show but believes the *Red Madras Headdress*, page 350, was included. The review in *Kunstchronik* is only a little more detailed.

PAGE 109

2 This account of the 1910 trip to Munich is based on Hans Purrmann's long letters to the author of Sept. 20, 1950 and March 3 and July 1, 1951; also his article in *Das Werk*, 1946, bibl. 205.

3 *Die Ausstellung von Meisterwerken Mohammedanischer Kunst in München, 1910*. Munich, Bruckmann, 1912.

4 Purrmann has mislaid a second photograph in which Marquet appears in place of Weisgerber.

5 Gertrude Stein Collection, Yale University Library.

PAGE 110

6 In the Art Institute of Chicago.

7 Benedict Nicolson's scholarly article in *The Burlington Magazine*, bibl. 199, has provided me with this and some other valuable information about Matisse in pre-1914 England.

8 *Burlington Magazine*, XII: 272, Feb. 1908.

9 June 10-August 31, 1910. Clive Bell told me of this generally overlooked exhibition in 1950 and Derik Roger, Art Assistant at the Brighton Art Gallery and Museum, kindly sent me a catalog which contains a long introduction by Robert Dell and a list of 200 paintings besides many drawings and prints, bibl. 112.

1 Bibl. 112.

2 Bibl. 116.

PAGE 111

3 B. Nicolson, bibl. 199, p. 13, note 15.

4 C. Lewis Hind: *The Post-Impressionists*, London, 1911, page 42. When Hind first heard the name Matisse, he assumed the speaker was referring to Auguste Matisse, the marine painter, whose name had already caused Henri-Matisse to hyphenate his.

5 Hind, *op. cit.*, pp. 60-61.

6 French collectors gave Manet's *Olympia* to the Luxembourg in 1889, after it was reported that an American collector was about to buy it. It was not transferred to the Louvre until 1907. Wilenski, bibl. 37, pp. 98, 218.

PAGE 112

7 Bibl. 35, pp. 15-18.

PAGE 113

8 The letter, quoted here with the permission of Edward Steichen, Miss Georgia O'Keeffe and the Yale University Library, is undated but was written before Steichen's cablegram of February 4, also in the archives of the Alfred Stieglitz Collection at Yale, bibl. 211c. The Matisse exhibition at Cassirer's did not take place until a year later but Purrmann may well have placed some drawings there as early as the end of 1907.

1 Long quotations from their criticisms are given in *Camera Work*, bibl. 175. Selections are quoted here.

2 Bibl. 175, pp. 10, 11.

3 Bibl. 175, p. 12.

4 Bibl. 175, p. 12.

PAGE 114

5 Bibl. 175, pp. 11, 12.

6 With the kind permission of the editor of *The Nation*.

PAGE 115

7 *New York Sun*, reprinted in *Camera Work*, Vol. XXX, p. 49, bibl. 175.

8 Bibl. 102.

1 Reprinted in *Camera Work*, bibl. 175 (1910), p. 51.

2 Reprinted in *Camera Work*, bibl. 175 (1910), p. 53.

3 Mrs. Norman has kindly permitted me to read and quote from her typescript.

4 Bibl. 175 (1910), pp. 47-53.

PAGE 116

5 Reprinted in *Camera Work*, 1910, no. 31, pp. 46-47.

6 After these words were transcribed it was reported that the Metropolitan Museum plans a great Cézanne exhibition for the season of 1951-1952.

7 "Armory Show," 1913. *Camera Work* published five photographs of his oils in a Special Number, August 1912, bibl. 212.

8 Museum of Modern Art, 1931, bibl. 131.

1 The longest first-hand accounts of Matisse's school have been published by Purrmann, bibl. 204a; Grünewald, bibl. 86, and Swane, bibl. 92. To Swane's book nine Scandinavian painters contributed their brief recollections of the school. In addition, letters written in 1950-1951 from Frau Moll, Carl Palme and Hans Purrmann, all of them Matisse's pupils at, or near, the beginning of the class, have added generously to my information. Notes taken by Margaret Scolari of conversations with Joseph Brummer and Maurice Sterne in 1931 and my own conversations with Max Weber and Mr. Sterne in 1950 have furnished further valuable details. Mrs. Michael Stein's record of some of Matisse's remarks made to his students during 1908 are published in full in Appendix A.

2 The only exact date I have heard for the opening of the school is January 6 or 7, 1908, given me by Max Weber. Greta Moll and Carl Palme also confirm early January as the date of the opening. Others mention 1907. Undoubtedly preparations for the class were made and perhaps some informal teaching was carried on during the fall of 1907, even though the *Académie* itself did not open until after the end of the year.

3 See Edmund Hausen: *Hans Purrmann*, bibl. 188a.

4 Max Weber left New York to study in Paris in 1905. He first saw Matisse in 1907 at one of the public studios where artists went to draw from the model, perhaps La Grande Chaumière or Colarossi's. Joseph Brummer was working there too. Matisse was pointed out to Weber by a young German who spoke of him with awe as "a second Ingres." Purrmann later introduced Weber to Matisse and brought him to the Steins'. Max Weber studied in Matisse's class from January through July 1908.

5 Patrick Henry Bruce, 1880-1930, is often spoken of along with Purrmann as one of the two young painters who joined Mrs. Stein in forming the class. Later, about 1913, Bruce was associated with Delaunay and the Orphists and exhibited at the New York "Armory Show" in that year and with the Société Anonyme in New York in 1920. Purrmann speaks of Sarah Stein and Bruce as among the original members of the class. Weber recalls that it was he who introduced Bruce.

6 Lists of the "charter members" of the class differ. Purrmann, letter of March 3, 1951, mentions Sarah Stein, Oskar

and Greta Moll, Bruce, Jean Biette and an American woman whose name he has forgotten (who was she?). Greta Moll lists Mrs. Stein, Bruce, Weber, Oskar Moll and herself. Palme's roster (letter of March 28, 1951) includes "Sally" Stein, Purrmann, Weber, Bruce, Leo Stein (apparently an error) and himself. He left Paris at the end of April and when he "returned at the end of May 1908, Mr. and Mrs. Oskar Moll and Miss von Knierien (a young Baltic lady) had joined our circle."

Alfred J. Frueh, later to win fame as the American caricaturist, Al Frueh, worked in Matisse's class in 1908-1909.

7 Bibl. 33, p. 82.

8 Carl Palme, the distinguished Swedish painter and printmaker, met Leo Stein through the sculptor David Edström, and Stein introduced him to Matisse. Palme was in the class from January 1908 through most of the spring, in January 1909, briefly, and from the end of September 1910 to the end of May 1911. He is the author of a book of reminiscences *Konstens Karyatider*, bibl. 201a.

PAGE 117

1 After Carrière's class closed about 1900, Matisse and some of his circle worked from the model in Biette's studio. Perhaps Matisse was now returning the favor, rather than taking his old companion as a student. Purrmann alone mentions Biette as a member of the class.

2 Grünewald, bibl. 86, p. 120, lists the names of fifteen Swedes and ten Norwegians.

3 Adolphe Basler, *Jahrbuch der Jungen Kunst*, 1924, p. 342, bibl. 167b.

4 Purrmann, letter to the author, March 3, 1951.

5 Palme, bibl. 201a; letter of March 28, 1951.

6 Grünewald, bibl. 86, p. 103.

7 Grünewald, bibl. 86, p. 104.

8 Bibl. 92.

PAGE 118

1 Notes taken by Margaret Scolari in conversation with Maurice Sterne, 1931.

2 Purrmann, bibl. 204a.

3 Conversation with Max Weber, 1950.

4 Joseph Brummer, preface to 1924 Matisse catalog, bibl. 127.

5 Joseph Brummer in conversation with Margaret Scolari, 1931.

6 Conversation with Max Weber, 1950.

7 Maurice Sterne in conversation with Margaret Scolari, 1931.

PAGE 119

8 Bibl. 40.

PAGE 124

1 Matisse confirmed the fact that the first version was a *Harmony in Green*, Questionnaire II.

2 As is true of other of Matisse's most important paintings the exact date has been obscured. The *Harmony in Blue* was certainly exhibited in the Salon d'Automne, October 1908. However, the fruit trees seen through the window are in bloom, suggesting that the painting was begun if not fin-

ished in the spring. Matisse, when asked, did not deny this, (Questionnaire IV.) That this is not trivial evidence is proven by the fact, confirmed by Matisse himself (Questionnaire IV), that the trees in *Harmony in Red* were painted *white* as a spontaneous gesture after a late snowfall in the early spring of 1909. (Both Matisse and Mme Matisse confirm the snow story but are not entirely clear as to whether this occurred in the spring of 1909—which seems more reasonable—or in the spring of 1908, in which case Matisse would have carried it in his memory until the following year.) That the *Blue Harmony* was completed in the first half of 1908 is confirmed by Max Weber in a very circumstantial anecdote of his being present in Matisse's studio late in the spring of 1908 when Odilon Redon made a call. Weber, deeply impressed by this meeting of two masters, vividly remembers how Matisse deferentially turned the *Harmony in Blue* around so that the older painter could give his opinion which Weber, who had discreetly withdrawn to the other end of the studio, could not hear. Both Matisse and Mme Matisse (though she was still living on the Quai St. Michel) deny emphatically that Redon ever came to the studio. Weber left Paris about August 1, 1908, but returned in time to see the *Harmony in Blue*, he feels absolutely sure, for the *second* time at the Salon d'Automne. (Conversation with Max Weber, June 1950.) In any case the *Harmony in Blue* was certainly seen well before the October 1st opening of the Salon by Shchukin who bought it in time to have his name, abbreviated to "Sch.," appear in the catalog as the owner.

3 That the tablecloth was indeed whitish-blue with a darker blue pattern and baskets is proven by comparing the photograph of *Harmony in Blue* taken by Druet in 1908 with a photograph of the *Harmony in Red*: the blue pattern has not been repainted and Matisse left traces of the whitish-blue field around the edges of the pattern when he repainted the canvas red. The color reproduction published by the Museum of Modern Western Art confirms this.

PAGE 125

4 Questionnaire IV.

5 Questionnaire II. Matisse expanded his answer by telling Monroe Wheeler how not long before their conversation he had twice completely washed out the color of the floor in a canvas, the *Woman in a Yellow Armchair*, page 486, before painting it a third time.

PAGE 126

6 See note 2 to page 124.

7 Since this paragraph was written the *Conversation* was reproduced in *Art News*, v. 49, no. 6, p. 25, October, 1950 to illustrate an article by Clive Bell.

8 Questionnaire IV.

1 I have not gone through all the book illustrations to confirm this.

PAGE 127

2 Museum of Modern Western Art, Moscow, *ex* Morosov, bibl. 122, no. 352. Reproduced in photo on page 28 and in bibl. 158, fig. 34.

3 Museum of Modern Western Art, Moscow, *ex* Shchukin, bibl. 122, no. 326. Reproduced in view of Shchukin's Matisse room, page 24 and in Fry, bibl. 85a, pl. 18.

4 The Matisses moved to Issy-les-Moulineaux in the fall of 1909. This still life, painted in the Issy studio and dated "1909," was therefore done toward the end of the year.

PAGE 128

5 Bibl. 49; reprinted Appendix H.

PAGE 129

6 Letter to author, April 20, 1951. "About Christmas time" refers to 1907.

7 *Wachsfarbe:* Matisse assured Frau Moll that the painting would last since he would not overpaint but would wipe out with benzine any color he wanted to change.

PAGE 130

8 A notable exception is the *Blue Still Life* of 1907.

1 Reproduced Fry, bibl. 85a, pl. 13.

2 *L'Algérienne,* dated 1909, Musée National d'Art Moderne, Paris, lent by Musée des Arts Décoratifs, *ex* Guy de Cholet. Reproduced in bibl. 93, opp. p. 33.

PAGE 131

3 Matisse occasionally leaves exposed corrections in drawing: the right elbow and left breast of *The Blue Nude,* p. 336, the right arm of the 1909 *Bather,* p. 161, the face of this same portrait of Olga Merson; but these are obviously revisions, not arbitrary additions.

4 Apparently the *Girl with Tulips* was not published at the time and may not even have been photographed in Paris: the only reproduction now available is a small halftone published in Moscow in 1923, bibl. 121, p. 69. Consequently this portrait, one of Matisse's most distinguished, is one of his least-known.

PAGE 132

5 Another landscape of 1909, *Collioure,* formerly Knoedler and Co., New York, is reproduced in bibl. 111, p. 11.

6 Reproduced in Swane, bibl. 92, fig. 18.

PAGE 133

7 Letter of April 20, 1951 to the author.

8 Barnes and de Mazia, bibl. 78, page 368, give 1,200 francs as the price originally paid for the *Joy of Life.*

1 Matisse's account of the conversation *chez* Larue was given to John Rewald in answering Questionnaire IV.

PAGE 134

2 Reproduced, Sembat, bibl. 91, p. 19.

3 Questionnaire IV.

4 Questionnaire VI.

5 Matisse sent a card from Seville, Nov. 20, 1910 to Gertrude Stein. Yale University Library, Gertrude Stein Collection.

6 In more detail: Matisse recalls, Questionnaire VI, that Bernheim-Jeune asked Matisse himself to propose to Shchukin the purchase of the Puvis de Chavannes in place of the *Dance* and *Music* and to advise the Russian how the 15-meterlong mural could be divided to fit the stairwell. How Matisse was to be recompensed is not clear. (The Puvis was the cartoon-study for the mural in the library of Amiens.)

When Shchukin changed his mind and canceled the purchase of the Puvis, he took Matisse's *Spanish Dancer,* page 352, as part of the transaction. Gaston Bernheim de Villers cannot remember the incident clearly.

7 Questionnaire VI: to be precise, Matisse told John Rewald that he sent the four pictures to Moscow after the closing of the Salon d'Automne, but that would have been November 8, 1910, when Matisse had still two months and a half of Spain ahead of him. The two still lifes were, beyond much question, the *Interior with Spanish Shawls,* page 372, and a similar picture, the *Spanish Still Life,* both done in Seville early in 1911. Both may be seen in the views of Shchukin's Matisse room, pages 24, 25.

Hans Purrmann states that he helped Matisse dismantle and roll the two Shchukin panels for shipping since he had arranged to have them shown in Germany, but he cannot remember the year. Letter to the author, March 3, 1951.

8 E.g. Barnes and de Mazia, bibl. 78, no. 43.

1 Matisse, Questionnaire VI, believes the panels were not in Moscow when he was there. Could they have still been in Germany for the exhibition Purrmann remembers but of which I can find no other record? There can be no question as to Matisse's having been in Moscow in the fall of 1911 since he sent a postcard to the Steins postmarked Nov. 1, 1911.

2 It is hard to believe that Shchukin's "*commande definitif [sic] pour les deux panneaux*" can refer to the *Dance* and *Music.* The "two preceding letters" and "the telegram of last Sunday" would of course clear up the question, but they are not available.

At first reading "*les deux panneaux*" might be taken to refer to "*le maroquain [sic] et les poissons d'or*" but these are easel pictures, pages 378 (*Amido, the Moor*) and 376 (*Goldfish*), which Shchukin calls "*tableaux*" whereas the *Dance* and *Music* were "*panneaux,*" that is big mural panels, the term Shchukin uses for *Music* earlier in the letter and repeatedly in his letter of March 31, 1909 commissioning the two decorations. Furthermore it seems clear, though not entirely conclusive, that "*le maroquain et les poissons d'or*" had already been bought along with the "*Capucines à la danse.*" No other pair of *panneaux* or for that matter *tableaux* seems to have been under consideration in the summer of 1912, though Shchukin did buy a pair of big Moroccan flower pieces in 1913. Words and circumstances therefore suggest that in some way Shchukin had reopened the question of the *Music* and possibly the *Dance* but, in this letter of August 22, 1912, was confirming his *commande* for the third time.

PAGE 135

3 Bibl. 129, *La danse* (1936).

4 Bibl. 13, page 91.

5 Conversation with the author, 1950.

6 Paul Magriel: *Isadora Duncan,* New York, 1947, p. 59.

PAGE 136

7 Bibl. 158, p. 346.

8 Bibl. 168, p. 281.

1 Conversation with the author, 1950.

2 Purrmann, bibl. 204a.

3 Bibl. 204a.

PAGE 138

4 Bibl. 34, p. 122.

5 *Two Negresses* was shown at the Autumn Salon of 1908, no. 922, *Groupe de deux jeunes filles*, and is dated 1908 in the Cone catalog, bibl. 108, plate 120b, *Deux soeurs;* 1909 in the Paris catalog 1950, bibl. 146, no. 97, *Deux négresses;* a bronze cast appears in the still life *Fruit and Bronze* of 1910 bought by Morosov, repro. Zervos, bibl. 93, p. 45.

PAGE 139

6 Picasso's rather similar painted composition, the *Two Nudes* of late 1906, Barr, bibl. 167a, p. 52, was apparently not influenced by Negro sculpture, but the two figures in his *Friendship* of 1908, Barr *op. cit.* p. 61, certainly were. They were bought by Shchukin, and Matisse may have seen them before they were sent to Moscow.

7 *La Serpentine* was mistakenly dated "about 1914" by me in the Museum of Modern Art, 1931 catalog, bibl. 131, no. 159, an error followed by Swane, 1944, bibl. 92, fig. 52; but changed to 1910 in his catalog of the Rump collection, bibl. 115, no. 163. Edward Steichen recalls that he took the famous photographs of Matisse at work on *La Serpentine*, page 23, in the studio at Issy-les-Moulineaux soon after he occupied it. This would date it not earlier than the fall of 1909, though possibly as late as 1910. Paris 1950, bibl. 143, no. 98, dates *La Serpentine* 1909.

8 For instance the Sudan figures in the collections of Tristan Tzara, reproduced in J. J. Sweeney: *African Negro Art*, New York, Museum of Modern Art, 1935, no. 16; and of Baron von der Heydt reproduced in E. von Sydow: *Kunst der Naturvölker*, Berlin, B. Cassirer, 1932, p. 139.

1 Questionnaire I.

2 Bibl. 34, p. 132.

3 Jan. 23, 1915. The Feb. 15th issue recorded that it had been sold for $325. Noted by Olive Bragazzi.

4 October 18, 1912, p. 2, col. 5. Found and transcribed by Margaret Miller.

5 Bibl. 88, pp. 14, 15.

PAGE 140

6 State I, plaster, was published in the Montross catalog, 1915, bibl. 130, no. 70; and in the Museum of Modern Art catalog, 1931, bibl. 131, no. 156. States I, II, III, IV are reproduced collectively in the catalog of the London 1912 show, bibl. 117; I and III in an installation photograph of the Bernheim-Jeune exhibition of 1913, *Chroniques du Jour*, bibl. 159a. Since the recent exhibition of these heads in Lucerne, 1949, bibl. 119, and Paris, 1950, bibl. 146, there may have been some further publication.

7 The catalog of the Paris 1950 show, bibl. 146, dates all five 1900, perhaps a casual French error for 1910. In no previous publication can I find any date except in the Museum of Modern Art catalog of 1931, bibl. 131, in which I guessed "about 1908" for *Jeannette I*. In ascertaining the dates of the sculptures as given here, Matisse was questioned twice, Questionnaires V and VI, Mme Matisse once, Questionnaire VII.

8 When asked if he had not completed *Jeannette V* after 1912, Matisse agreed that it was possible. Questionnaire VII.

1 After having studied briefly the photographs of *Jeannette*, *I-V*, the psychiatrist Dr. Eric P. Mosse wrote me the following note on the subject of the eyes in states III and V: "The problem of the 'bulging eyes' and accentuation of the orbita seems to me a projection of the sculptor's own feelings into his object. I have seen that every so often the artist unconsciously paints his own features into the faces of his objects. The most spectacular example is that of a caricaturist to whom fate gave an exceedingly big nose and who, in an act of retaliation, projects this nose on to everyone's face he is drawing. (Without this facial distortion of his own he possibly would never have become a caricaturist.) I have never seen a good photograph of Matisse's own face so do not know the size and form of his own orbital arcs; however, a more important source of these exaggerations may be that in the act of concentrating to revive the inner image, the *feeling of his own strained eyes is projected* into the sculpture of the girl."

PAGE 141

2 Victor Loewenfeld, *The Nature of Creative Activity*, New York, 1939; also L. Münz and V. Löwenfeld, *Plastische Arbeiten Blinder*, Brünn, 1934.

3 "Psychological Mechanisms in Art Production" in the *Psychoanalytical Review*, Vol. 38, No. 1, Jan. 1951, p. 73.

4 For instance the large Cameroon mask reproduced as no. 328 in J. J. Sweeney: *African Negro Art*, Museum of Modern Art, New York, 1935.

5 Cf. *Museum of Modern Art Bulletin* (New York), Vol. 2, no. 6-7, p. 4, Mar.-Apr. 1935.

PAGE 142

6 Compare Matisse's *Head of an Italian*, 1901, in Fry II (1935) bibl. 85a, pl. 2; Rouault's *Make-up, Cirque Forain*, 1911, in J. T. Soby: *Georges Rouault*, Museum of Modern Art, New York, 1945, p. 56; Rouault's *Portrait of Lebasque*, 1917, in *Painting and Sculpture in the Museum of Modern Art*, bibl. 131a, p. 47; the upper right-hand head in Picasso's *Les Demoiselles d'Avignon, op. cit.*, p. 85; Schmidt-Rottluff's *Emybildnis*, 1919, and *Christus*, 1918, in W. R. Valentiner, *Schmidt-Rottluff*, Leipzig, 1920, pl. 19 and 26.

In connection with the problem of disparate eyes in *Jeannette V* and expressionist painting Dr. Eric P. Mosse writes me: "Though one cannot completely dismiss the possibility of an actual difference between the two eyes in the girl and Matisse's having only accentuated this intriguing fact, I am rather inclined to think of a different explanation. Of course, you are familiar with the fact that in most individuals there is a right or left preponderance in seeing. Since, as we know from children's drawings, functional importance becomes formal and spatial importance, we would think that here again Matisse projects this specific feeling of his own body into his sculpture." Dr. Mosse implies that to judge from *Jeannette V* Matisse's *right* eye is the dominant. He continues:

"I am not sure how much you will agree with this. The discovery of the difference in the two halves of everybody's face is surely an important phenomenon, its emphasis a tempting challenge for every artist. But I wonder if it would explain the problem. Modern art became so much the expression of the artist's inner feelings, so much a projection of them, that an object or a face seems to serve only as a field or vehicle for such expression."

7 *Painting and Sculpture in the Museum of Modern Art*, bibl. 131a, p. 267.

8 Barr, bibl. 167a, pp. 179, 180; also Jean Cassou: *Picasso*, Paris, Braun, 1937, plate 54. Picasso's *Still Life with a Plaster Bust* of 1932 with its flowers and fruit dominated by one of his own sculptures, upper right, has perhaps more than a coincidental resemblance to Matisse's *Still Life with a Bust*, page 384. Compare *Cahiers d'Art*, June 1932, page 48.

9 Answer to Questionnaire VII was brought to New York by Pierre Matisse just as these pages were going to press and after page 313 with the reproduction of *The Back, I* and the date "1904?" had been printed. This dating for *The Back, I* is from the catalog of the Paris, 1950, Matisse retrospective, bibl. 146, which lists *No. 77 Nu de dos, 1er état, bas relief, 1904*, a date apparently too early by at least five years.

10 The large relief *Desire* is usually dated 1904 and may possibly have influenced Matisse who (Questionnaire III) came to know Maillol in 1905 during the first summer at Collioure which is not far from Banyuls, Maillol's winter home. *Desire* is reproduced in *Painting and Sculpture in the Museum of Modern Art*, New York, 1948, p. 238.

PAGE 143

1 Card to Leo Stein postmarked "Sevilla 22, Nov. 1910." This and the two cards of January 4 and 17 are in the Yale University Library, Gertrude Stein Collection.

2 Letter postmarked January 5, 1912, from Michael Stein to Claribel Cone in Baltimore. I should appreciate information as to which big picture this was. It may have been simply a loan from Matisse.

3 Matisse in conversation with John Rewald, answering Questionnaire VI.

4 Card in the Gertude Stein Collection, Yale University Library, postmarked "Moscow 111.11" which the Russian authorities at Yale, kindly questioned by Donald C. Gallup, assure us means November 1, 1911.

Much later, in 1947, Matisse stated: "I understood Byzantine painting at Moscow, before the icons." *Art Présent*, bibl. 47, p. 23.

PAGE 144

5 Postcard, Yale University Library, Gertrude Stein Collection.

Both versions of the *Nasturtiums and the "Dance"* were certainly exhibited before the end of 1912 but I have no definite evidence as to just how much earlier they were painted.

Matisse's date of 1912 for *A Path in the Woods of Clamart* is not accepted by Pierre Matisse who dates it about 1916. I have not seen the original.

6 Letter received early in December 1912; now in the Alfred Stieglitz Collection, Yale University Library.

PAGE 145

7 Letter preserved in the Isabella Stewart Gardner Museum, Boston, and quoted through the courtesy of the Director, Morris Carter.

PAGE 146

1 Bibl. 205.

PAGE 148

2 Letter received Dec., 1912. Yale University Library.

3 Bibl. 28, p. 131. Puy describes "une grande toile couverte de belles teintes apaisantes: un intérieur d'atelier avec des tapis, un paravent et, sur le mur, quelques tableaux . . ." as having been shown at the Indépendants. Matisse showed two portraits in 1911 and nothing at the Indépendants of 1912, but Puy's description fits perfectly the big *Intérieur* shown at the Salon d'Automne of 1912 and listed as belonging to Shchukin.

4 Yale University Library, Alfred Stieglitz Collection. The printed catalog, of which Dorothy Norman has a photostat, lists an additional bronze, no. 5, *Torso*. See bibl. 132b.

5 With Steichen's list was a copy of a customs invoice with valuations of the bronzes put at about twenty-five percent below selling price which would about have taken care of duty if any were sold. "291" was accepted by the U. S. Government as an educational institution and was permitted to bring in bronze sculpture under bond.

PAGE 149

6 Their criticisms are reprinted in *Camera Work*, no. 38, bibl. 175.

7 See also B. Nicolson in a recent *Burlington Magazine*, bibl. 199.

8 Walter Pach, bibl. 26, and Walt Kuhn, bibl. 191a.

PAGE 150

9 Pach, bibl. 26, p. 203.

1 Pach, bibl. 26, pp. 193-197.

2 Pach, bibl. 26, p. 197.

3 Reprinted in *For and Against*, F. J. Gregg, ed. bibl. 187a.

PAGE 151

4 After much discussion with the patient Mme Matisse, Questionnaire VII, the sequence of the four big compositions of 1911 now seems fairly certain. She is sure that *The Painter's Studio* was done at Issy soon after the return from Spain, that is, in the late winter or early spring. *The Painter's Family* is definitely dated by Matisse's postcards of May 26 to Michael Stein which indicate, in spite of Matisse's discouragement, that it is nearly finished. The *Red Studio*, Mme Matisse feels sure, was done at Issy in the fall, possibly before the trip to Moscow in November.

The date of the *Interior with Eggplants* is somewhat more problematical. It has always been dated Collioure, 1911, which still seems to me reasonable, though Mme Matisse suggests that it may have been earlier. Purrmann, however, writes me that he visited the Matisses at Collioure in the summer, he believes, of 1911, and remembers seeing the objects which Matisse was painting in the big canvas.

A fifth very large painting, apparently of 1911, is known to me only in the cursory version which appears at the left of the *Red Studio*, page 162. This is the pink or rose-colored canvas with a nude in a chair surrounded by rosettes which relate it to the *Interior with Eggplants* of 1911. Mme Matisse states, 1947, that it has been destroyed, bibl. 152, p. 38, note, where it is called *Grand Nu à la Colle* [sic].

PAGE 152

5 Bibl. 28, p. 131.

The paintings shown in *The Painter's Studio* are, from left to right, *Purple Cyclamen*, *Le luxe II*, page 341; on the floor, the

Girl with Green Eyes, page 352, probably just back from London with corner pads still on the frame; and above to the right of the room, the bright version of the *Nu à l'écharpe blanche* of 1909; *The Back*, plaster relief of c. 1910, page 313; and, at the extreme right, the edge of the big study for the *Dance*, page 360. The bronze sculpture at the left is the *Decorative Figure* of 1906, page 327.

6 For instance Bihzad's miniature of the Princess Shirin, Herat School, about 1500, reproduced in F. R. Martin: *The Miniature Painting of Persia and India, 8th to 18th Centuries*, London, Quaritch, 1912, Vol. 2, pl. 67.

PAGE 153

7 This flowered border has been removed or hidden by a frame, a deletion of which Matisse strongly disapproves, Questionnaire VII.

PAGE 154

8 Matisse and Mme Matisse, Questionnaire VII, are fairly confident that it was done in 1911 before the first Moroccan visit. Dr. Köhn of the Folkwang Museum, Essen, can find no definite record in his files but from his own memory believes that the picture arrived at Hagen, the original home of the Museum, in 1911. Purrmann also is inclined to 1911.

1 Told to Tériade, bibl. 77.
2 *Moroccan Garden*, p. 380 (purchased by Mr. and Mrs. Samuel A. Marx, Chicago, since p. 380 was printed); *The Palm Leaf, Tangier*, p. 381; *Zorah in Yellow*, p. 379.
3 *Oranges*, p. 389; *Tangerian Girl*, p. 387, and a *View of Tangier* in the Musée de Peinture et de Sculpture, Grenoble.
4 Five inquiries through official and unofficial channels have failed to indicate that anyone has seen the paintings of the Museum of Modern Western Art, Moscow, since 1947.

PAGE 155

5 Painted on first Moroccan trip, Questionnaire V.
6 In his letter of August 22, 1912 (Appendix D), Shchukin asks to have "*le maroquain*" shipped to Moscow. This must refer to *Amido* since the other two paintings of a Moroccan man, pp. 390, 391, were done in 1913.
7 Bibl. 21, pp. 46, 47.

PAGE 156

8 Bibl. 91, p. 10.
1 "création spontanée, comme une flamme—dans un élan. . . ." Questionnaire V.
2 Matisse, Questionnaire V.
3 Though photographed by Druet this painting seems never to have been reproduced before.
4 Bibl. 89a, p. 45.
5 The date of these two canvases is not entirely certain. Both were exhibited during the fall of 1912; and purchase of the earlier was confirmed by Shchukin in a letter of August 25th. Since he would scarcely have been in Paris during the preceding unseasonable month, it seems probable that one, and perhaps both, were painted early in the summer of 1912.
6 Confirmed by Matisse, Questionnaire V. When asked why he painted a second version Matisse replied: "Because such a thing is quite natural: the conception is not the same, *ça m'a emballé comme couleur*."

PAGE 157

7 No. 332 in the Moscow catalog, bibl 122, and there dated 1912. It is the same size as the *Nasturtiums and the "Dance," I.*
1 Matisse asked especially that this canvas be included in the exhibition of his work to be held at the Museum of Modern Art, November 1951. He dates it 1912. Pierre Matisse, however, dates it 1915-1916.

PAGE 158

2 Such as the *Nude with a Necklace* of 1914 in the Müller Collection, Soleure, Switzerland, bibl. 158, fig. 44.
3 Picasso's defeated withdrawal to Barcelona, Matisse's to Bohain, both in 1902, have been noted, pages 41, 84.
4 Bibl. 85, p. 17. Fry had in mind such pictures as Derain's *Window on the Park* of 1912, shown at the Second Post-Impressionist Exhibition, London, and now in the Museum of Modern Art, bibl. 131a, p. 51.

PAGE 159

5 Questionnaire V.
6 The other is reproduced in Schacht, bibl. 90, p. 68.
7 Bibl. 210, p. 194.

PAGE 160

8 For stylistic reasons and lacking evidence to the contrary, I had placed the *Moorish Café* in Matisse's first Moroccan visit, but the painter, Questionnaire VII, states that it was done in the winter of 1912-1913.
1 Reproduced pl. XVII in Marteaux and Vever: *Miniatures persanes*, Paris, 1913. Margaret Scolari's researches, with the help of Florence Day of the Metropolitan Museum of Art, turned up this remarkable Persian analogue—if not actually a direct source—for the *Moorish Café*.
2 See page 147.

PAGE 177

3 See page 180.

PAGE 178

4 "MATISSE PAINTINGS, Michael Stein Collection sent to Gurlitt 1914"—a list sent to a member of the Cone family about 1918 and preserved in the archives of the Cone Collection, Baltimore Museum of Art. Page references in brackets refer to illustrations in this book.

	Size in cm.	Date
Arbres fruitiers Corse (fruit trees in blossom)	46x38	1897
Nature Morte cafetière (still life coffee pot)	73x60	1899
Pont Saint Michel (Saint Michel bridge Paris)	55x46	1902
Primevère (pot de fleur) (Pot of flowers)	73x60	1902
Paysage du Midi (landscape trees)	55x46	1905
Portrait de femme (female head) [p. 75]	41x33	1905
Portrait d'homme (male head)	39x28	1905
Oliviers (olive trees)	55x46	1905
La gitane (female torso)	55x46	1906
Paysage de Collioure (landscape) [p. 70]	55x46	1906

Nature morte bleue (still life with table)
[p. 331] 116x89 1907
Portrait d'un Marin (portrait of sailor)
[p. 334] 100x81 1907
Portrait de l'artiste (portrait of the artist)
[p. 333] 55x46 1907
Les Oignons (onions on a table) [p. 76] 55x46 1907
Portrait au Madras rouge (portrait with
red headdress) [p. 350] 100x81 1907
Collioure à travers les arbres (landscape
foliage) 92x65 1907
La Coiffeuse (two female figures) [p. 339] 116x89 1907
Nature Morte, Le Bronze (Still life with
bronze) 73x60 1908
Paysage d'automne (landscape autumn
effect) 73x60 1909

5 Purrmann to the author, letter of September 20, 1950.

6 Leo Swane, letter to the author, June 30, 1951, says this occurred in 1918. Purrmann also says the Steins sold the pictures recovered from Germany to the Scandinavians. Sembat, bibl. 91, published in 1920, lists the ex-Stein pictures he reproduces as owned jointly by Tidzen Lung [*sic*] and Trygve Sagen. Cf. also, Swane's article in *Tilskueren*, Copenhagen, 1922, bibl. 212b. At that time, 1922, Swane writes that Sagen had not yet taken his share which included *The Young Sailor, I*, page 334, which later passed to the Norwegian Consul Krag, and *The Hairdresser*, page 339, which was later resold in Germany—where is it now? Tetzen Lund's great Matisse collection is discussed further on, page 199.

7 Letter from Juan Gris to D. H. Kahnweiler, Collioure, September 11, bibl. 189a, p. 28.

8 Kahnweiler, bibl. 189a, p. 28.

1 Kahnweiler, bibl. 189a, p. 29.

2 A telegram for Matisse from Shchukin was received at Collioure, October 21.

3 Kahnweiler, *op. cit.*, p. 30. Matisse blamed Gertrude Stein and quarreled with her, bibl. 64, p. 7. Fortunately Léonce Rosenberg began to buy from Gris early in 1915.

4 Kahnweiler writes me, March 3, 1951, that Josette Gris sat for Matisse in Collioure, autumn 1914. The etchings, plates 26-32, are of her.

Mme Gris, herself, told W. S. Lieberman, 1951, that all the etchings of her were done at the Quai St. Michel.

5 Quoted in a letter of October 30, 1914, to Kahnweiler, bibl. 189a, p. 30.

6 Gaston Bernheim de Villers, bibl. 74a. Matisse paid for his violin lessons with drawings.

7 She appears in the lithograph *Violin Concert* of 1903 reproduced in F. B. Deknatel, *Edvard Munch*, Boston and New York, 1950, p. 31, and, apparently, in other more melodramatic prints and paintings.

PAGE 179

8 Pierre Matisse has the telegram and identified the picture for me.

1 Conversation with Walter Pach, March 1951, and Pach, bibl. 26, pp. 145-146.

PAGE 180

2 Found and transcribed by Olive Bragazzi.

3 According to Pierre Matisse.

PAGE 181

4 Barnes and de Mazia, bibl. 78, p. 236.

5 Quoted with the kind permission of the owner, Sam Salz.

PAGE 183

6 Told to the writer, April 1951. See also Pach, bibl. 26, p. 219.

7 *Le Salon d'Automne*, 1913, reprinted in bibl. 166a, pp. 178-179.

PAGE 184

8 According to Pierre Matisse who recalls that he himself made the drawing of the vase on the background wall. Germaine Raynal was the wife of the critic Maurice Raynal.

1 The *Nude with a Bracelet* is reproduced in Zervos, bibl. 158a, p. 57, where it is dated, I believe incorrectly, 1912; and in the Basle catalog, bibl. 110, "no. 34 Grisaille," dated 1915. An etching of this figure in reverse exists, plate 59B; dated by Petiet, August 1914. My dating, 1914, is further confirmed by the catalog of the Matisse show at Bernheim-Jeune's in 1919, bibl. 137, where the painting is listed under the year 1914 as: 2. *La femme au bracelet* 75 x 61 cm.

2 Mr. Landsberg has been kind enough to write me, May 1951, a long and valuable account of the Yvonne Landsberg portraits. Several quotations as well as much data are taken from this letter with his permission. I then sent him, with some trepidation, my rather speculative interpretation of the oil portrait. He replied, June 1951, giving his own somewhat similar interpretation. Mlle Landsberg, educated in England and France, later married a member of the Brazilian Foreign Office; Mr. Landsberg has become an American citizen.

3 This drawing and its date are puzzling since Mr. Landsberg says his family returned to Brazil before August 1914. Furthermore the face seems a caricature of that in the etching and the painting reproduced on the same and opposite pages.

4 In his second letter, June 1951, Mr. Landsberg recalls that at the time of his sister's portrait, Matisse "was very much pleased with those prints of his of white lines on a black ground." These were the monotypes, page 399, each a unique impression done by scratching the line on a surface coated with wet ink or paint and then printing.

5 Mme Landsberg might have been interested in Picasso's illustration of Balzac's story done in the late 1920s. His etching of the mad painter at work upon his "masterpiece" shows a realistic model seated beside a canvas of swirling lines which remind one of those in Matisse's *Mlle Landsberg*, though of course carried further toward complete abstraction. Reproduced in Barr, bibl. 167a, p. 145.

6 A. C. Landsberg in his letter of June 1951 remarks: "It is my impression that the impulse to draw these lines . . . only came to Matisse during the last sitting (when possibly he may have felt that he had reached a 'dead end,' and had to do something drastic—something his conscious reason could not help him with)."

7 Letter to the author, June 22, 1951. The original French: *Les lignes dans le portrait de Mlle Landsberg dont vous me parlez dans votre lettre sont des lignes de construction que j'ai mis autour de la figure de façon à lui donner plus d'ampleur dans l'espace.*

8 The possibility of Futurist influence upon the Yvonne Landsberg portrait has occurred to Marcel Duchamp as well as to the author. For Futurist theory and reproductions see Umberto Boccioni: *Pittura, scultura futuriste*, Milan, "Poesia," 1914.

1 Duthuit, bibl. 13, p. 2.

2 Mr. Landsberg's interpretation, written in response to mine, is more "humanly dramatic": "To me these fierce, white 'grafiti' have come to represent something like the aura of a chrysalis—of a being who, for long, has been concentrating its steadily growing powers in secret.

"The wings are still folded because this individual is not yet fully formed. But, already, it is almost so. Sensitive and increasingly aware of the crowded loneliness of existence, all this untapped vitality is waiting—with patience and impatience—to take flight. How hungry for life the still vague hands are!

"With everything superfluous eliminated, already formidably 'streamlined,' nothing, when the time comes, will keep this phenomenon, with all its unknown potentialities, from spreading its wings for the unique adventure —for its own self-surpassing yet tragically inadequate fulfillment in freedom and death. (In other words, in this picture, as in many works of art of importance, 'typical' and 'general' truth about life is reached through intense attention to a *particular and individual* manifestation of it.)"

3 In the freedom of his old age Matisse has given us the poetic fantasies of *Jazz*, pp. 501-502.

4 Reproduced Quinn catalog, bibl. 133, p. 74.

5 Reproduced *Formes*, bibl. 188b, fig. 1.

6 The data about these etchings is based on the unpublished but elaborately studied catalog of Matisse's prints prepared by Carl Schniewind, Curator of Prints at the Art Institute of Chicago. Mr. Schniewind worked in consultation with the French expert, Henri Petiet, but has not been able to check his listing against the material held by Mme Duthuit, Matisse's daughter, who is preparing a definitive catalog. The original numbering of Matisse's early lithographs and etchings is confusing and omissive. The etching numbers begin with prints apparently all of 1914, which are continued through No. 51. Nos. 52-57 are in my opinion a group of early prints of about 1903 to 1906. Then the 1914 series is resumed in the six prints numbered by Schniewind and Petiet 58, 58bis, 59 A, B, C and 59bis. Some of the series begun in 1914 may extend into 1915.

7 A. C. Landsberg, in a letter to the author, June 1951. Mr. Landsberg is writing definitely of the spring of 1914. That summer, before the war started in August, he left for Brazil not to return to Paris for several years. Since it seems unlikely that Matisse would have spread these few prints over many months I question the usual broad dating of 1914-1915 and believe it more likely, though not certain, that all were done in the spring of 1914.

8 This *Still Life with Lemons, etc.* is listed under the year 1914 as "1. *Les citrons*, 70 x 54 cm." in the catalog of the Matisse exhibition, Bernheim-Jeune, Paris, May 2-16, 1919.

1 Matisse: Questionnaire V.

2 It may be seen on the rear wall of a photograph of the Matisse show, Paris, 1931, *Cahiers d'Art*, bibl. 93, last plate. Through a window one can see the oval pool in the garden at Issy with a great mass of foliage curving against the sky. The curtain at the left was actually red but, as he told Margaret Scolari (1931), Matisse painted it a bright yellow which he felt necessary "to express his excitement and pleasure at the contrast of trees and sky and to complement their blue and green contrasting tones."

3 Pierre Matisse believes the *Italian Woman* to date from 1916-1917, but its color and drawing are quite unrelated to any of the studies of Lorette ordinarily dated 1916-1917. In style it seems to me to be of 1915, closely related to but earlier than the Pellerin and Stein portraits of late 1915 and early 1916. A study for the Pellerin portrait, apparently dated 1915, is reproduced in Fry, bibl. 85, p. 32.

4 The *Oranges* may be dated early 1916 since it is referred to in Matisse's letter to Purrmann, June 1st, 1916.

5 Bibl. 152a, plate 121.

6 Bibl. 115, no. 107, ill.

7 The *Goldfish* of 1911, page 165, which Purrmann writes me he had just bought from a Berlin dealer.

8 Pierre Matisse thinks it may even have been started as early as 1910, the time of the *Dance* and *Music* which are almost identical to it in size. Pierre Matisse remembers, incidentally, painting some of the background of the *Bathers by a River*—only a little of it, however, for his father soon found his stroke unsatisfactory. Conversation with Pierre Matisse, 1950.

1 Mme Matisse, Questionnaire VII.

2 Painted in the fall of 1916: Mme Matisse, Questionnaire VII.

3 Painted in the fall of 1916: Mme Matisse, Questionnaire VII.

4 Mme Matisse, Questionnaire VII.

5 Bibl. 152a, no. 119, ill.

6 Reproduced McBride, bibl. 88, pl. 21.

7 Reproduced Sembat, bibl. 91, p. 61.

8 H. G. Henderson and Louis V. Ledoux: *The Surviving Works of Sharaku*, New York, 1939. Sharaku's actor and wrestler triptychs are confined to one or two figures to each panel.

1 Though not a tall narrow panel of a triptych, Utamaro's *Three Geisha* is an interesting analogue. It is most conveniently reproduced in Upjohn, Wingert and Mahler: *History of World Art*, New York, 1949, pl. 651.

2 *Japanese Prints in the Ledoux Collection*, Princeton, 1950, No. 54 A, B, C.

3 I have in mind the flat, decorative, rather mannered style of late 14th-century masters such as Bartolo di Fredi and Andrea Vanni. Sienese, like other European triptychs, ordinarily had a wide central panel flanked by narrower shutters.
4 Bibl. 78, p. 401.

PAGE 193

5 *Op. cit.*, pp. 273, 404.
6 For both iconographic and stylistic reasons I believe that the left-hand and central panels were begun and perhaps carried fairly well toward completion in the studio on the Quai St. Michel before the end of 1916. The mantelpiece with the Sudanese figure was in that studio. The right-hand panel was done there too but, I believe, probably eight or more months later. In the interim, Matisse had spent the first five months of 1917 in Nice and three months more at Issy in the summer, during which he painted *The Rose Marble Table* which appears in the background of the right-hand panel. Mme Matisse, Questionnaire VII, confirms the fact that *The Rose Marble Table* was brought into the Quai St. Michel studio after the summer of 1917. The chronology is important for it helps explain the change of style which appears in the right-hand panel, especially the Manet-like head of the youngest sister. The European dresses of the models in the right-hand panel further differentiate it from the other two with their oriental costumes and coiffures.
7 Pierre Matisse in conversation, 1950. Mme Matisse and Jean Matisse confirmed this date in 1951.
8 Questionnaire VII.

PAGE 194

1 Barnes and de Mazia, bibl. 78, devote ten pages (389-398) to an elaborate formal analysis of the *Music Lesson*.
2 *Arbre près de l'étang de Trivaux*. London, Tate Gallery, 35½ x 28¼″. About 1916. Color reproduction in Cassou (Faber), bibl. 104a, pl. 3. *Paysage de Trivaux* is reproduced in Courthion, bibl. 82, plate XXV, and *Allée de Trivaux* in Sembat, bibl. 91, page 55.
3 *The Lorrain Chair* is reproduced in color in Skira, bibl. 21, p. 51, and dated 1916. This is perhaps the correct date but the rather rich painting of the fruit and the decorative background suggest 1917. It is wrongly dated "about 1927" in Lucerne, bibl. 119, no. 87, reproduced.
4 *The Pewter Jug* is variously dated 1915, 1916, 1917, 1918. A very similar painting, almost certainly a study for *The Pewter Jug*, was listed under the year 1917 in the Bernheim-Jeune Matisse exhibition catalog of 1919 with the entry "7. *Les pêches* 50 x 40″." This study was shown again in 1949, and reproduced in the Lucerne catalog, bibl. 119, no. 49, *Le pot d'étain* 50 x 40 cm, 1917.

PAGE 195

5 J. Cassarini, bibl. 135, p. 18. The date, December 1916, for Matisse's first arrival in Nice is confirmed by Pierre Matisse, but Besson, bibl. 161, p. 39-135, and letter to the author, June 26, 1951, believes it was December 1917. Besson was in Marseilles and Nice at that period and gives circumstantial details. Apparently he was not aware at that time or has since forgotten that Matisse had been in Nice the year before.

6 J. Cassarini, bibl. 135, p. 18.
7 Besson, bibl. 161.
8 Cassarini, *op. cit.*
1 Cassarini, *op. cit.* p. 21.

PAGE 196

2 Letter from M. Besson to the author, June 26, 1951. In this letter M. Besson reaffirms his belief that Matisse's first trip to Nice was in December 1917. At Marseilles Matisse stayed at the Hotel Beauvau where he painted a little portrait of Besson dated December 1917, on the back. Matisse left Marseilles December 15th for Nice, where he stayed at the Beau-Rivage, and there made a second portrait of Besson in thirteen sittings beginning January 10, 1918.
3 Besson, bibl. 161, p. 41-137.
4 Probably the painting reproduced in *Cahiers d'Art*, 1931, bibl. 158, fig. 64.
5 Besson, *op. cit.*, p. 26-122, reproduces the *Interior—Nice*, Philadelphia Museum of Art, Gallatin Collection, as the picture shown to Renoir. Purrmann writes me that Matisse recently identified a photograph of *The Open Window*, p. 420, as the picture. Either one would correspond to Renoir's remarks.
In 1942 Matisse tried to explain the "charm" of his "open window" paintings—see Appendix I.
6 George, bibl. 96, plates 5-8; Courthion, bibl. 82, pl. LI.
7 Cassarini, bibl. 135, p. 19.

PAGE 197

8 Notably in Willard Huntington Wright's *Modern Painting*, bibl. 38.

PAGE 198

1 Letters from Michael Stein, Paris, December 17, 1923, and Gabrielle Ossorio, December 18, to Etta Cone, Baltimore.
2 Reproduced in Barnes, bibl. 78, p. 310 and Scheiwiller, bibl. 4a, pl. XII.
3 Bulletin of the Detroit Institute of Arts, October 1923, p. 5.

PAGE 199

4 Leo Swane, letter to the author, June 30, 1951. See also bibl. 114a and 212b.
5 Besides these four pictures Tetzen Lund owned fifteen other Matisses including the following from the Michael Stein collection: *Self Portrait*, p. 333, *Mme Matisse*, p. 75, *Red Madras Headdress*, p. 350, *Blue Still Life*, p. 331, *Pink Onions*, p. 76.
6 For J. Rump see page 201 and bibl. 115.
7 Bibl. 133.

PAGE 200

8 See Barr, bibl. 167a, pp. 124-142.
1 January 7, 1928, reprinted in McBride, bibl. 88, p. 28.

PAGE 201

2 *The New York Sun*, October, 1927, reprinted in McBride, bibl. 88, p. 28.
3 Bibl. 192b.

4 André Fage: *Le collectionneur de peintures modernes*, Paris, 1930, p. 61. *The Yellow Dress* is reproduced in color in *Formes*, bibl. 188b, opp. p. 4.

5 Bibl. 185.

6 Bibl. 115.

7 Bibl. 8, p. 312-316.

PAGE 203

8 Fry, bibl. 85, p. 32.

1 Fry, *op. cit.*, p. 32.

2 *Op. cit.*, pp. 36, 37.

3 *Op. cit.*, pp. 47, 48.

4 McBride, bibl. 88, pp. 10, 16.

5 *Op. cit.*, p. 17.

6 *Op. cit.*, p. 19.

7 *Op. cit.*, p. 21.

8 Museum of Modern Art, bibl. 131a, p. 51.

PAGE 204

9 Now in the Fogg Museum, Harvard University. Reproduced in Barr, bibl. 167a, p. 261.

1 Barr, *op. cit.*, pp. 95-97, 100, 102, 106, 114-120.

2 Barr, *op. cit.*, pp. 128, 129

3 Even later during his several years' stay at the Hôtel de la Méditerranée, 1918-1921, he was prepared to leave at any moment he felt bored. Conversation with Margaret Scolari, 1931.

PAGE 205

4 A canvas with the model in the same pose as this bronze is reproduced in the collection of Walter P. Chrysler, Jr., bibl. 152a, no. 122, *Nu*, 1917-1918, 29 x 36½".

5 He was with Bonnard at Antibes the day of the Armistice.

6 Repro. in Museum of Modern Art, 1931, bibl. 131, pl. 51.

PAGE 206

7 Color reproduction in Skira, bibl. 21, p. 52.

8 In spite of its style I had listed *Tea* as having been painted in Nice because it was catalogued under "Nice 1919," only a year after it was painted, in the Bernheim-Jeune exhibition of 1920. *The Black Table* I had also placed in Nice because of the model, Antoinette, who had sat for the *White Plumes* in Nice. Pierre Matisse has explained that, in the summer of 1919, quite exceptionally, Matisse brought his model up from Nice to Issy.

9 Bibl. 85, p. 50.

PAGE 207

1 Reproduced, Philadelphia, 1948, no. 49, bibl. 152.

2 Reproduced, bibl. 131, no. 51.

3 Pierre Matisse to the author.

4 Questionnaire II.

5 Matisse's drawing of Massine dated Monte Carlo, April 28, 1920, is reproduced in the souvenir program of the Russian Ballet's twelfth season, Paris, bibl. 166e.

PAGE 208

6 W. A. Propert: *The Russian Ballet in Western Europe, 1909-1920*, p. 60-61. See also Robert Lawrence: *The Victor Book of Ballet Music*, New York, 1950, Simon and Schuster, pp. 369-373. The best documentation I have found is in the photographs published in the souvenir program of the Ballets Russes, twelfth season, Paris and London, spring 1920, bibl. 166e.

7 Barnes and de Mazia, bibl. 78, p. 197.

PAGE 209

8 Reproduced in Paris catalog, 1931, bibl. 145, opp. p. 30.

CORRECTION: *Interior at Nice*, 1921: the color is sandy and pale salmon as well as grey and blue.

PAGE 210

1 Reproduced in *The Lillie P. Bliss Collection*, Museum of Modern Art, New York, 1934, no. 45; and McBride, bibl. 88, pl. 35.

2 *The Moorish Screen* is often dated 1922 but it is reproduced in Vildrac's *Nice, 1921: seize peintures*, bibl. 95, and was included in the Bernheim-Jeune Matisse show which opened February 23, 1922, an early date to include paintings of that year.

3 Georges Petit catalog, bibl. 145, opp. p. 36.

PAGE 211

4 Matisse states, Questionnaire I, that he does not remember this Cézanne: if it exerted any influence upon his 1923 pictures of a girl playing a piano, he was not aware of it. Matisse's pastel, *Piano Lesson*, in the Middleton collection, Dundee (McBride, bibl. 88, no. 9) is even closer to the Cézanne *Overture to Tannhäuser* than the *Checker Game* reproduced here. Morosov bought the Cézanne from Vollard in 1908. See A. H. Barr, Jr.: "Cézanne d'après les lettres de Marion à Morstatt," in *Gazette des Beaux-Arts*, Jan. 1937.

5 The term "odalisque" was rarely applied to these orientalized figures by Matisse until after the middle of the decade. Those reproduced in the Crès book of 1923, bibl. 84, bear other and less exotic titles: for instance when the painting captioned *Figure voilée au fauteuil rayé vert*, pl. 41 in the Crès publication, was lent by Chester Dale to the big Paris retrospective of 1931 it was catalogued as *Odalisque aux bras levés*, bibl. 145, no. 103. It is now called *Odalisque with Raised Arms*, p. 440.

PAGE 212

6 Louis Aragon, bibl. 102, p. 3.

7 Reproduced in McBride, bibl. 88, no. 42.

8 Museum of Modern Art, 1931, bibl. 131, no. 65 and Philadelphia, 1948, bibl. 152, no. 63.

1 Catalog, bibl. 108, pl. 55; *Painting in Paris*, Museum of Modern Art, 1930, pl. 58, and 1951, bibl. 131b, p. 28.

2 Philadelphia, 1948, bibl. 152, no. 64.

3 Reproduced in *Die Kunst*, Berlin, October 1929, and in color postcard published by the Glasgow Art Gallery.

4 L 55 is reproduced in *Cahiers d'Art*, bibl. 93, 1931, p. 91, bottom row, center cut.

5 L 64 is reproduced in Museum of Modern Art, 1931, bibl. 131, pl. 140.

PAGE 213

6 L 70 is reproduced in Museum of Modern Art, bibl. 131, pl. 139.

7 The *Seated Nude* is dated 1925 in the catalog of the Cone Collection, bibl. 108, and Paris, 1950, bibl. 146, no. 104.

1 The charcoal drawing of 1923 is reproduced in Crès, bibl. 84, pl. 56. It may be a study for the painting *Odalisque with Raised Arms*, p. 440, in the Chester Dale Collection.

2 A painting of 1924 closely related to these lithographs is reproduced in Fry, bibl. 85a, pl. 45.

3 The reclination and instability of this figure or, rather, its pose come to a climax in a very large charcoal drawing, *Europa*, of 1928, reproduced in Fry, bibl. 85, p. 31, in which the figure is stretched almost prone upon the back of the bull, but still keeps her hands clasped behind her head and her left leg drawn up so that the foot is still tucked under the right knee. Doubtless Matisse was not aware of this entertaining and doubtless psycho-symbolic transformation of a pose which he must have drawn, painted and modeled dozens of times between 1923 and 1929.

PAGE 214

4 Obviously Matisse cherished this mirror which appears in several other paintings and in the upper photograph on page 27.

PAGE 215

5 Reproduced in color in *Verve*, vol. I, no. 4, p. 99.

PAGE 216

6 Vol. I, no. 3, p. 80. Matisse cannot now remember even the decade in which this unique picture was painted though he does recall the light in which the model sat. However a photograph of Matisse, taken about 1929, shows him seated with this painting hanging on the wall behind him and the chair appears in scores of paintings, drawings and lithographs of 1928-1929, p. 460 for instance.

7 The *Yellow Hat*, a painting of the same model in the same hat also dates from 1929, color reproduction in Cassou, bibl. 104, pl. 17.

8 Reproduced in Museum of Modern Art, 1931, bibl. 131, no. 142.

1 Perhaps mistakenly, Schniewind, bibl. 209b, lists no lithographs in 1928, though other sources do: *Cahiers d'Art*, bibl. 158, p. 312 reproduces L 113, 116, 118, 120 and dates them 1928.

2 Reproduced in Swane, bibl. 92, fig. 49.

3 Marguerite Duthuit-Matisse's *Catalogue raisonné* of Matisse's etchings will, it is hoped, give us more exact information. My figure of "over a hundred" is based upon the incomplete and unpublished catalog of Carl Schniewind who had access to Henri Petiet's notes but not to Mme Duthuit-Matisse's material.

PAGE 217

4 *Nude with Parrots*, dated December 1929, is reproduced in Museum of Modern Art, 1931, bibl. 131, pl. 129; and, along, with two other etchings of 1929, in *Chroniques du Jour*, bibl. 159a, next to last gravure plate.

5 Bibl. 206, pp. 139-157.

6 Fels, bibl. 84a, p. 50.

7 Many are reproduced in Thannhauser, bibl. 111.

8 Questionnaire VII, was forwarded in June 1951, but the question about these two bronzes was not answered until September. Matisse then stated definitely that the higher of the two bronzes reproduced on page 457 as "III" was in fact the earlier and should be listed as "II." I was led to press my question, because the Paris 1950 catalog, bibl. 146, which contains the most complete accessible list of Matisse's bronzes, seemed to me to have reversed the correct order of the two, as well as misdating them both by a couple of years. I believe that Paris, 1950, entry "111. *Nu couché 2e état*, 1931. H. 20" should have read: 111. *Nu couché 2e état*, 1929? H. 29; and "112. *Nu couché 3e état*, 1932. H. 29" should have read: 112. *Nu couché 3e état*, 1929. H. 20. I suspect that the dates in the Paris 1950 catalog may be for the first bronze casts. A photograph of Matisse working on state III, the lower, more elongated of the two figures, is reproduced in the Thannhauser catalog issued in February, 1930, bibl. 111. The caption states that the photograph was taken in 1929. Courthion also dates state III 1929, bibl. 82, p. 58, pl. LVIII; the Cone Collection catalog, bibl. 108, plate 123a, dates it 1928. A bronze of state III was exhibited at the Brummer exhibition opening January 5, 1931—I have a publicity photograph of it—so that it must have been cast no later than 1930.

A bronze of state II was lent by Mr. and Mrs. Sam A. Lewisohn to the Museum of Modern Art exhibition which opened in November 1931, so that state II may have been cast later than state III, thus adding to the confusion.

A draped figure, "*Nu couché à la chemise*, 1905," no. 80 in Paris, 1950, bibl. 146, actually anticipates *Reclining Nude, I* of 1907 in pose but is much more subdued and classic.

PAGE 218

1 As late as September 1951 neither Matisse nor Mme Matisse nor Pierre can recall just when these two very large and important reliefs were done. The date 1929 given the *Nu de dos, 3e état*, in the Paris 1950 catalog, bibl. 146, no. 109, may be as wrong as the year 1904 which the same catalog gives to *The Back, I* which was surely done between the end of 1909 and 1912. Pierre Matisse and Margaret Miller have independently suggested an affinity between II and III and the figures in the *Bathers by a River*, page 408. My own reason for accepting the date 1929—though with a large question mark—rests on the somewhat similar transformation of the early *Reclining Nude, I* into *II* and *III* about 1929. On the other hand, the five *Jeannette* variations of 1910-1912, especially the style of *Jeannette V*, page 371, suggest that *The Back, II* and *III* may indeed be much closer in date to *The Back, I* of about 1910, especially the rather cubist *Back, II*.

2 I was responsible for this error in the catalog of the Museum of Modern Art Matisse exhibition in 1931, bibl. 131, no. 161, illustrated in profile.

PAGE 219

3 Three ink drawings made in Tahiti are reproduced in *Cahiers d'Art*, bibl. 98, pp. 71, 73, 77; and in Cassou, bibl. 104.

The notes by Matisse on Tahiti written for Escholier are quoted from bibl. 83, p. 138.

4 Pierre Matisse to the author, 1951.

5 A photograph of the Carnegie jury of 1930 with Matisse was reproduced in an article in *The Arts*, November 1930, p. 65 ff.

PAGE 220

6 A letter from Mrs. Michael Stein, Paris, January 2, 1931, to Etta Cone refers to Matisse's recent visit to Baltimore, and

the drawing of Claribel which Matisse intended to make. Archives of the Cone Collection, Baltimore Museum of Art.

7 Conversation with Margaret Scolari, Paris, June 1931.

8 Cf. Dorothy Dudley, bibl. 176, p. 303.

PAGE 221

9 Based on Raymond Hood's account of the conversation with Matisse.

1 Bibl. 145. For Thannhauser exhibition cf. bibl. 111; for Basle, bibl. 110; for New York, bibl. 131.

PAGE 222

2 "A Modern Frenchman at Full Length" by Royal Cortissoz in the *New York Herald Tribune*, Nov. 8, 1931.

3 See E. A. Jewell, *The New York Times*, Nov. 3; H. McBride, *The New York Sun*, Nov. 7; Malcolm Vaughan, *New York American*, Nov. 8, 1931.

4 "Matisse and Impressionism," bibl. 208.

PAGE 223

5 See W. S. Lieberman: "Modern French Tapestries," *Metropolitan Museum of Art Bulletin*, Jan. 1948.

PAGE 241

6 This and the subsequent facts about Matisse's whereabouts in the fall of 1939 were provided by Alexandre Rosenberg after consulting the letters his father, Paul Rosenberg, received from Matisse.

7 Bibl. 176, p. 299. This interview with Matisse was held in May 1933, just before the second version of the mural was to be shipped to America. Quotations courtesy *Hound and Horn*, Lincoln Kirstein, editor.

PAGE 242

8 Bibl. 83, p. 141.

1 Ms. notes of a conversation with Matisse, Paris, June 1931.

2 Told to the writer by Pierre Matisse, 1951.

3 Matisse told Margaret Scolari, Paris, June 1931, that he had not yet decided on the color of the background.

PAGE 243

4 Matisse to Margaret Scolari, June 1931.

PAGE 244

5 L. Stein, bibl. 34, p. 161.

6 Bibl. 176, p. 303.

7 Bibl. 46, pp. xxi-xxii.

8 W. S. Lieberman informs me that Matisse used a sapphire point, very sharp and smooth, for the Mallarmé etchings.

PAGE 245

1 Quoted by Breeskin, bibl. 172b, p. 622.

2 Bibl. 172b.

PAGE 246

3 Breeskin, bibl. 172b, p. 622.

4 I know only of one each, the *Figure à la robe persane*, 1931, Fry, bibl. 85a, plate 49, reproduced here as *The Persian Robe*,

ana the canvas called *Ung flicka*, 1932, Swane, bibl. 92, p. 40, reproduced here as *Girl in a Persian Costume*.

PAGE 247

5 The portrait drawing of Etta Cone is reproduced on p. 10, and six preliminary stages on pl. 96, of *The Cone Collection*, bibl. 108.

6 The de Montherlant drawing is reproduced in Besson, bibl. 81, pl. 29; the Whittemore, pl. 34.

7 Three of them are reproduced in *The Cone Collection*, bibl. 108, pl. 95.

8 *The Cone Collection*, bibl. 108, p. 22.

1 A letter from Matisse to Etta Cone dated September 19, 1935, encloses photographs of six "states" of this drawing *Seated Nude, Head on Arms*. Furthermore, the letter refers to the *Blue Eyes*, a painting always dated 1935, as having been done prior to the drawings, though from the same pose. Fry, bibl. 85a, reproduces the second and final states, pl. 59; the first state is reproduced by Romm, bibl. 89a. Both date the drawing or its studies 1933.

2 The set of the 21 photographs may be seen in the archives of the Cone Collection, Baltimore Museum of Art. Eight were reproduced in Fry, bibl. 85a, pl. 57: these are states 1, 2, 8, 9, 11, 12, 15, 18 but, curiously, not the finished picture.

PAGE 249

3 This account of his negotiations with Matisse was given the author by Macy in conversation, May 1951.

4 That Matisse himself, alone and unaided, should have recognized the esoteric structural and symbolic parallelisms between *Ulysses* and the *Odyssey* in a few hours' reading seems incredible but Macy vouches for it and recalls that Marguerite Matisse later confirmed this prodigy. W. S. Lieberman observes that it would be more reasonable to suppose that Matisse, who knew a number of *avant-garde* writers including his own son-in-law Georges Duthuit, could already have heard about the parallelism. Indeed he might even have consulted one of them after receiving Macy's call.

PAGE 251

5 Two paintings very similar to the tapestry, one in oil, one in tempera (*détrempe*), were exhibited under the title *Fenêtre à Tahiti* at Paul Rosenberg's in May 1936. The one illustrated in the catalog, bibl. 148, completely reverses the design of the tapestry (except for the name on the stern of the boat) and was therefore doubtless used as the cartoon.

6 *Designs in Glass by Twenty-Seven Contemporary Artists*, bibl. 212a.

7 Bibl. 98.

8 Besson, bibl. 81, pl. 22.

1 Color plates of four characteristic paintings of 1937 are published in Cassou, bibl. 104. *Blue Dress in Ochre Armchair*, pl. 18; *The Amber Necklace*, pl. 19; *Anemones and Woman*, pl. 20—of this last composition Matisse painted many variations; and the *Rumanian Blouse*, pl. 21, now in the collection of Miss Mary E. Johnson, Cincinnati.

PAGE 252

2 The color reproduction in *Verve*, vol. I, no. 3, p. 77, was made of *The Conservatory* in an earlier state. *Jeune femme*,

Besson, bibl. 81, pl. 32, a single figure seated before the same big philodendron plant, may have served as a point of departure for *The Conservatory*. It was finished November 4, 1937, just a week before *The Conservatory* was begun.

3 Pierre Matisse has about twenty progress photographs of *The Conservatory*.

4 Pierre Matisse owns a set of photographs showing the Rockefeller panel at various stages dated from November 16 to December 2. Several charcoal studies are reproduced in *Cahiers d'Art*, bibl. 158, pp. 16-18.

PAGE 253

5 The Paris, 1949, catalog, bibl. 142, p. 12, states that Matisse used *papier découpé* for the first time for the curtain of the ballet *L'étrange farandole* (the *Rouge et Noir*). Actually he had used this technique, probably for the first time, in studying the Barnes mural in 1931, p. 463, and again in the *Pink Nude* of 1935, p. 473. He used it also for the first issue of *Verve*, published late in 1937. All these *papiers découpés* were however translated into other media in their final form, that is, into mural or easel paintings, theatre settings and costumes, or, in the case of the magazine cover, stencil reproductions. This small scissors-and-paste picture dated May 1, 1938, and presented to Massine may well be the first *papier découpé* which Matisse permitted to survive as an independent work of art.

6 Reproduced poorly in color in Lejard, bibl. 101, pl. 10.

7 I have not seen the *Daisies* but notes on the colors and general effect have been given me by Alexandre Paul Rosenberg.

PAGE 254

8 In addition to the official programs, accounts of the *Rouge et Noir* are noted in Cyril Beaumont, *Supplement to the Complete Book of Ballets*, London, 1942; Grace Robert, *The Borzoi Book of Ballets*, New York, 1946; Robert Lawrence, *Victor Book of Ballets and Ballet Music*, New York, 1950; *Le Point*, bibl. 161.

PAGE 255

1 Letter to Paul Rosenberg, October 30, 1939. Alexandre Rosenberg has kindly gone through his father's correspondence with Matisse during 1939-1940 to establish the dates of the painter's moves.

2 Picasso also did this, early in the summer of 1939.

3 The author received a letter from Paul Rosenberg dated Paris, April 25, 1940, enclosing small snapshots and descriptions of seven paintings by Matisse, five of them dating from January 6 to March 6, 1940. Two, undated, may be somewhat later.

4 Letter to Paul Rosenberg.

5 Matisse quoted this remark twice in letters to Pierre Matisse written from Nice in the fall of 1940.

6 Letter from Matisse in Ciboure, May 25th, to Pierre Matisse in New York. He also wrote Paul Rosenberg from Ciboure, April 28th. His Ciboure address was 38 Quai Maurice Ravel.

7 Letter of July 3 to Pierre Matisse.

PAGE 256

8 Varian Fry: *Surrender on Demand*, New York, 1945, pp. 156-157.

PAGE 257

1 Fry: *op. cit.*, p. 226.

2 Reproduced, Besson, bibl. 81, pl. 52, and Philadelphia, bibl. 152, no. 85 (with several inches at the bottom of the canvas missing).

3 Fry, *op. cit.*, p. 219.

4 Letter dated Nice, April 3, 1942.

5 Letter from Matisse, Nice, June 7, 1942, to Pierre Matisse. Pierre Matisse believes the picture to have been one of the portrait heads of Dora Maar.

6 Cf. Barr, bibl. 167a, pp. 226, 245.

PAGE 258

7 He sent Pierre Matisse copies of the scripts in a letter dated Nice, March 13, 1942. The broadcasts had been given about two months before.

PAGE 259

8 Picasso confirmed this incident in a conversation with Pierre Matisse, summer 1951.

PAGE 262

1 According to Pierre Matisse.

2 "Aspects of Two Cultures," VOKS, no. 52, pp. 20-36, 1947.

3 I should welcome evidence to the contrary but as late as 1951 inquiries made by the *New York Times* confirmed the fact that the Museum of Modern Western Art was still closed.

4 At this time the French Government also bought the *Interior in Yellow and Blue* which now (1951) hangs in the French Embassy in Washington.

PAGE 263

5 In this section I have not attempted to summarize the critical writing about Matisse but rather to indicate by a few references and quotations Matisse's position in the minds of artists and critics especially among the younger generation.

PAGE 264

6 Bibl. 103.

7 *Transition 49*, bibl. 178.

8 *Art Présent*, bibl. 156, p. 29.

1 "Hommages à Matisse" in *L'Age nouveau*, Paris, July 1949, no. 39. See also the other articles in the special section entitled *Présence de Matisse*, bibl. 204.

2 *L'Age nouveau, op. cit.*

PAGE 266

3 Bibl. 187.

4 Remark made in a speech at an artists' club on East 8th Street, New York, 1950.

5 Dated photograph reproduced in Besson, bibl. 81, pl. 48.

6 Dated photograph reproduced in Besson, bibl. 81, where it is titled *La grande urne hispano-mauresque*, pl. 47; also reproduced in Philadelphia, 1948, bibl. 152, pl. 84.

7 Dated photograph reproduced in Besson, bibl. 81, pl. 45.

8 Dated photograph reproduced in Besson, bibl. 81, pl. 49.
1 Matisse to Monroe Wheeler, 1950.

PAGE 267

2 Reproduced in color in Lejard, bibl. 101, cover and pl. 12.
3 Philadelphia 1948, bibl. 152, pl. 82; and in color in Aragon, bibl. 103.
4 The poor photograph here reproduced is the only one available.
5 Besson, bibl. 81, pl. 52.
6 Reproduced in color in Skira, bibl. 21, p. 58.
7 Color reproduction in Lejard, bibl. 101, pl. VI, and in Cassou, bibl. 104, pl. 22. For a very similar composition see Besson, bibl. 81, pl. 55.
8 Color reproduction in *Verve*, bibl. 163, p. 33, and Lejard, bibl. 101, pl. 13.
1 Bibl. 101: *Danseuse assise dans un fauteuil*, dated 8/42.
2 Four of the series are reproduced in color in *Verve*, bibl. 163, pp. 12, 15, 17, 19, together with Matisse's own color diagrams of each canvas.
3 Philadelphia, bibl. 152, no. 86.

PAGE 268

4 Reproduced in Philadelphia, bibl. 152, no. 87, and in Besson, bibl. 81, pl. 54.
5 Letter to Pierre Matisse, Feb. 1945.
6 The same motif appears in the painting *Femme à la voilette* also dated January 1942, reproduced in color in Lejard, bibl. 101, pl. VII.
7 Color reproduction in Lejard, bibl. 101, pl. XVI.

PAGE 269

8 Reproduced in color, *Verve*, bibl. 163.
1 Drawings of 1944 dating from February and March, including portrait heads of André Rouveyre who lived in Vence, and a posthumous likeness of Guillaume Apollinaire, were published in *Hommage*, No. 2, bibl. 160.
2 *Nature morte aux roses de Noël et aux saxifrages*, reproduced in color, *Verve*, bibl. 163, p. 38; also *Jeune femme à la pelisse* in Aragon, bibl. 103.
3 Color reproductions in Aragon, bibl. 103, titled *Annélies;* Lejard, bibl. 105, pl. 18, titled *Annélies, tulipes, anémones*. A variant in vertical format showing the same model but with the table and background a continuous violet tone is reproduced in Cassou, bibl. 104, pl. 24.
4 In an undated letter of 1945 to Pierre Matisse, Matisse refers to "Madame de Fernandese Enchorrena."
5 Pierre Matisse has lent the author photographs of the Enchorrena door: of the *Nymph and Faun* version, one is dated 29. VI. 44, the other 13. VII. 44. The progressive photographs of the second version, *Leda and the Swan*, begin late in 1944 and finish March 28, 1945.
6 The photograph suggests that this was the final version but Pierre Matisse informs me that Matisse wiped it out, too, and did not complete the version until some time in 1946-1947. The colors in the state of March 28, 1945 are: Leda and her swan, white and lemon yellow against a red background with blue spots on white below.

PAGE 270

7 Reported by Pierre Matisse.
8 Bibl. 103. Aragon concludes: '*La porte s'est rouverte, vers la chambre, et voici devant Léda passer la dame dans son peignoir, toute mouillée, qui éclabousse la peinture, dans la vapeur qui vient de la salle de bain. 'Mes pantoufles!' crie-t-elle. 'Où sont mes pantoufles?'* '
1 Color reproduction in *Verve*, bibl. 163.
2 Bibl. 46, p. XXII.

PAGE 271

3 Reproduced in Besson, bibl. 81, pl. 29. Some candid remarks by Matisse about the Montherlant drawings and portraiture in general were published in *Beaux-Arts*, bibl. 67 (Aug. 27, 1937).
4 A linoleum engraving of a girl's head, dated 1938, was published in *XX Siècle*, no. 4, 1938. Linoleum engraving or *lino* is ordinarily a white line engraving quite different in effect from the linoleum cut, a relief, black line medium which Matisse is said to have used for his three "woodcuts" of 1906, page 99.
5 Matisse, writing in 1946, bibl. 46, p. XXIV, analyzes the special character of the white line linoleum engraving which he calls "lino":

"The *lino* should not be used as a cheap substitute for the woodblock for it gives a special character to a print, quite different from that of wood engraving and for this reason it should be studied for itself.

"I often think of this medium as comparable to that of a violin with its bow: a surface and a gouge—four taut strings and a chord of horsehair.

"The gouge, like the bow, is directly controlled by the sensibility of the engraver. . . . The least distraction during the tracing of a line involves an involuntary pressure of the fingers upon the gouge and changes the character of the line. Similarly, only a slight pressure of the fingers which hold the bow of the violin changes its tone from soft to loud. . . ."
6 Bibl. 46, p. XXII.
7 "Histoire d'un livre" in bibl. 211, p. 10-14.

PAGE 273

8 Several of the studies, including one for the head of the Negress, page 498, are reproduced in *Les miroirs profonds*, bibl. 87.

PAGE 274

1 In reply to the writer's question. Cf. Barr, bibl. 167a, note to p. 80.
2 Paris, Librairie José Corti, 1930.

PAGE 275

3 Color reproduction in *Verve*, bibl. 164.

PAGE 276

4 *Ch'i Yün Shêng Tung*, rhythm and vitality; this is to be obtained through the second rule or canon, *Ku Fa Yung Pi*, significant brushwork. William Cohn: *Chinese Painting*, New York, Phaidon, 1950, p. 35.

PAGE 278

5 Catalog, bibl. 142, nos. 1-21.
6 Catalog, bibl. 146.
7 All three are reproduced in *Horizon*, London, August 1949, following p. 120.

PAGE 279

8 The design, *Arbre en fleur*, originally in cut-and-pasted paper, was printed by silk screen on a horizontal cross-shaped field on canvas 5′ x 6′3″ in size. The edition was limited to 200 copies at $360 apiece. Mural scrolls by Calder, Miro and Matta were also included in the series. All four compositions are reproduced in color in *Mural Scrolls*, Introduction by James Thrall Soby, Katzenbach and Warren, Inc., New York, 1949.
9 A brief and presumably authoritative statement of the history of the chapel is given in *L'Art Sacré*, bibl. 157b, p. 30. Joseph A. Barry wrote a lively account of the work in progress for *The New York Times Magazine*, December 26, 1948, bibl. 72. Valuable additional information appeared in Rosamond Bernier's article in *Vogue*, bibl. 168b. Popular journalism had its fling in *Match*, Paris, 1950, bibl. 192a.
1 Matisse identified the model for Pierre Matisse. It has also been suggested that Sister Jacques was the model for the nun in the *Lettres portugaises*, page 499, and for the *Virgin* in the Vence chapel mural, pp. 518, 519. I do not know Sister Jacques' original name; it is said that she came originally from the Vendée and that her father, a retired army officer, lived in Vence. *L'Espoir de Nice*, June 26, 1951, describes her as modestly disclaiming any important role in the initiation of the chapel and adds that "at dawn she leaps upon her motorcycle" to visit the sick.
2 *L'Art Sacré*, bibl. 157b, p. 30.
3 *L'Art Sacré*, bibl. 157b, p. 30.

PAGE 280

4 See *L'Art Sacré*, Paris, Oct. 1950, special number 1-2 on Assy with articles by M. A. Couturier and J. Devémy, especially the former's "*La leçon d'Assy*"; also Richard Douaire: "Pilgrimage to Assy—an Appraisal" in *Liturgical Arts*, New York, Feb. 1951; and M. A. Couturier: "Religious Art and the Modern Artist" in *Magazine of Art*, Nov. 1951.
5 See also P. R. Régamey: "*Les possibilités chrétiennes des artistes incroyants*" in *La Vie Intellectuelle*, Paris, March 1951.
6 Bibl. 72.

PAGE 281

7 Told by Matisse to a friend of the author.
8 The most precise account of the architecture is "*Le plan de la Chapelle*" by Fr. L. B. Rayssiguier, O. P., in *L'Art Sacré*, bibl. 157b, pp. 20-23. The most complete illustrations are to be found in *L'Art Sacré* and in *Chapelle du Rosaire*, bibl.

106a. Further details are given in *Nice-Matin*, June 26, 1951, bibl. 173.

PAGE 283

1 *L'Art Sacré*, bibl. 157b, p. 30.
2 Reproduced in *L'Art Sacré*, bibl. 157b, page 11.

PAGE 284

3 Since these words were written, Father Couturier has published his own eloquent reflections on Matisse's *Stations* in *L'Art Sacré*, bibl. 157b, pp. 24-26.
4 *L'Art Sacré*, bibl. 157b, p. 9.
5 *L'Art Sacré*, bibl. 157b, p. 19.
6 Cf. the nine studies reproduced in *Chapelle du Rosaire*, bibl. 106a.

PAGE 285

7 Even closer to Grünewald are the second pair of studies reproduced in *Chapelle du Rosaire*, bibl. 106a. The same booklet reproduces a study of the hands of the Virgin in the *Annunciation*, another panel of Grünewald's altarpiece.

Picasso had also studied Grünewald's *Calvary* in a series of drawings of 1932 published in *Minotaure*, no. 1, 1933, pp. 30-32.

PAGE 286

8 Picasso was so struck by the chasubles that he urged Matisse to make some designs for Spanish bullfighters' capes. Noted by Pierre Matisse.
1 Two of Matisse's Congo "velvets" are illustrated as nos. 578, 579 in the catalog *African Negro Art*, edited by J. J. Sweeney, New York, Museum of Modern Art, 1935.
2 Quoted in *Nice-Matin*, bibl. 173.

PAGE 287

3 *L'Art Sacré*, bibl. 157b, pp. 6-9.
Another paragraph of Bishop Rémond's speech should be quoted:

It seems to me that here the artist tries to reduce to a minimum the material aspect of his art, the artifices of his profession, the learned forms which are accessory or irrelevant. He wishes by the schematic simplicity of his drawing to suggest only the idea. This he expresses by a line which is as stripped, as direct, as childlike as possible with the intention of being better understood and more expressive.

4 Bibl 106a. Matisse's preface is translated in full on p. 288.
5 June 26, 1951.
6 July 15, 1951.

PAGE 288

7 In a letter to James Thrall Soby, Oct. 15, 1951.

APPENDICES

APPENDIX A: MATISSE SPEAKS TO HIS STUDENTS, 1908: NOTES BY SARAH STEIN

Sarah Stein (Mrs. Michael Stein) was one of Matisse's staunchest friends and supporters from 1905 until she and her husband left Paris in the 1930s.

In 1908 during the early days of the "Académie Matisse," pages 116-118, she patiently took down many of the teacher's remarks to the class and individuals. Her notes are here published, it appears for the first time, through the courtesy of her friend Professor John W. Dodds of Stanford University.

Mrs. Stein's title and text are unchanged except for a very few typographical corrections and a few headings and subheadings in brackets inserted by the editor.

<div align="right">A. H. B., JR.</div>

A GREAT ARTIST SPEAKS TO HIS STUDENTS

[DRAWING]

[*Study of Greek and Roman sculpture*]

The antique, above all, will help you to realize the fullness of form. I see this torso as a single form first. Without this, none of your divisions, however characteristic, count. In the antique, all the parts have been equally considered. The result is unity, and repose of the spirit.

In the moderns, we often find a passionate expression and realization of certain parts at the expense of others; hence, a lack of unity, consequent weakness, and a troubling of the spirit.

This helmet, which has its movement, covers these locks of hair, which have their movement. Both were of equal importance to the artist and are perfectly realized. See it also as a decorative motive, an ornament—the scrolls of the shoulders covered by the circle of the head.

In the antiques, the head is a ball upon which the features are delineated. These eyebrows are like the wings of a butterfly preparing for flight.

[*Study of the model*]

Remember that a foot is a bridge. Consider these feet in the ensemble. When the model has very slender legs they must show by their strength of construction that they can support the body. You never doubt that the tiny legs of a sparrow can support *its* body. This straight leg goes through the torso and meets the shoulder as it were at a right angle. The other leg, on which the model is also standing, curves out and down like a flying buttress of a cathedral, and does similar work. It is an academy rule that the shoulder of the leg upon which the body mainly is resting is always lower than the other.

Arms are like rolls of clay, but the forearms are also like cords, for they can be twisted. These folded hands are lying there quietly like the hoop-handle of a basket that has been gradually lowered upon its body to a place of rest.

This pelvis fits into the thighs and suggests an amphora.

Fit your parts into one another and build up your figure as a carpenter does a house. Everything must be constructed—built up of parts that make a unit: a tree like a human body, a human body like a cathedral. To one's work one must bring knowledge, much contemplation of the model or other subject, and the imagination to enrich what one sees. Close your eyes and hold the vision, and then do the work with your own sensibility. If it be a model assume the pose of the model yourself; where the strain comes is the key of the movement.

You must not see the parts so prosaically that the resemblance of this calf to a beautiful vase-form, one line covering the other as it were, does not impress you. Nor should the fullness and olive-like quality of this extended upper arm escape you. I do not say that you should not exaggerate, but I do say that your exaggeration should be in accordance with the character of the model—not a meaningless exaggeration which only carries you away from the particular expression that you are seeking to establish.

See from the first your proportions, and do not lose them. But proportions according to correct measurement are after all but very little unless confirmed by sentiment, and expressive of the particular physical character of the model. When the model is young, make your model young. Note the essential characteristics of the model carefully; they must exist in the complete work, otherwise you have lost your concept on the way.

The mechanics of construction is the establishment of the oppositions which create the equilibrium of the directions. It was in the decadent periods of art that the artist's chief interest lay in developing the small forms and details. In all great periods the essentials of form, the big masses and their relations, occupied him above all other considerations—as in the antique. He did not elaborate until that was established. Not that the antique does not show the sensibility of the artist which we sometimes attribute only to the moderns; it is there, but it is better controlled.

All things have their decided physical character—for instance a square, and a rectangle. But an undecided, indefinite form can express neither one. Therefore exaggerate according to the definite character for expression. You may consider this Negro model as a cathedral, built up of parts which form a solid, noble, towering construction—and as a lobster, because of the shell-like, tense muscular parts which fit so accurately and evidently into one another, with joints only large enough to hold their bones. But from time to time it is very necessary for you to remember that he is a Negro and not lose him and yourself in your construction.

We have agreed that forearms, like cords, can be twisted. In this case much of the character of the pose is due to these forearms being tied tight in a knot, as it were, not loosely interlaced. Notice how high upon the chest they lie; this adds to the determination and nervous strength of the pose. Don't hesitate to make his head round, and let it

outline itself against the background. It is round as a ball, and black.

One must always search for the desire of the line, where it wishes to enter or where to die away. Also always be sure of its source; this must be done from the model. To feel a central line in the direction of the general movement of the body and build about that is a great aid. Depressions and contours may hurt the volume. If an egg be conceived as a form, a nick will not hurt it; but if as a contour, it certainly will suffer. In the same way an arm is always first of all a round form, whatever its shades of particular character.

Draw your large masses first. The lines between abdomen and thigh may have to be exaggerated to give decision to the form in an upright pose. The openings may be service-able as correctives. Remember, a line cannot exist alone; it always brings a companion along. Do remember that one line does nothing; it is only in relation to another that it creates a volume. And do make the two together.

Give the round form of the parts, as in sculpture. Look for their volume and fullness. Their contours must do this. In speaking of a melon one uses both hands to express it by a gesture, and so both lines defining a form must determine it. Drawing is like an expressive gesture, but it has the ad-vantage of permanency. A drawing is a sculpture, but it has the advantage that it can be viewed closely enough for one to detect suggestions of form that must be much more definitely expressed in a sculpture which must carry from a distance.

One must never forget the constructive lines, axes of shoulders and pelvis; nor of legs, arms, neck, and head. This building up of the form gives its essential expression. Particu-lar characteristics may always heighten the effect, but the construction must exist first.

No lines can go wild; every line must have its function. This one carries the torso up to the arm; note how it does it. All the lines must close around a center; otherwise your drawing cannot exist as a unit, for these fleeing lines carry the attention away—they do not arrest it.

With the circle of brows, shoulders, pelvis, and feet one can almost entirely construct one's drawing, certainly indi-cate its character.

It is important to include the whole of the model in your drawing, to decide upon the place for the top of the head and base of the feet, and make your work remain within these limits. The value of this experience in the further study of composition is quite evident.

Do remember that a curved line is more easily and se-curely established in its character by contrast with the straight one which so often accompanies it. The same may be said of the straight line. If you see all forms round they soon lose all character. The lines must play in harmony and return, as in music. You may flourish about and embroider, but you must return to your theme in order to establish the unity essential to a work of art.

This foot resting upon the model stand makes a line as sharp and straight as a cut. Give this feature its importance. That slightly drooping bulge of flesh is just a trifle that may be added, but the line alone counts in the character of the pose. Remember that the foot encircles the lower leg and do not make it a silhouette, even in drawing the profile. The leg fits into the body at the ankle [?], and the heel comes up around the ankle.

Ingres said, "Never in drawing the head omit the ear." If I do not insist upon this I do remind you that the ear adds enormously to the character of the head, and that it is very important to express it carefully and fully, not to suggest it with a dab.

A shaded drawing requires shading in the background to prevent its looking like a silhouette cut out and pasted on white paper.

SCULPTURE

The joints, like wrists, ankles, knees, and elbows must show that they can support the limbs—especially when the limbs are supporting the body. And in cases of poses resting upon a special limb, arm or leg, the joint is better when exagger-ated than when underexpressed. Above all, one must be careful not to cut the limb at the joints, but to have the joints an inherent part of the limb. The neck must be heavy enough to support the head (in the case of a Negro statue where the head was large and the neck slender the chin was resting upon the hands, which gave additional support to the head).

The model must not be made to agree with a preconceived theory or effect. It must impress you, awaken in you an emotion, which in turn you seek to express. You must forget all your theories, all your ideas before the subject. What part of these is really your own will be expressed in your expression of the emotion awakened in you by the subject.

It can only help you to realize before beginning that this model, for instance, had a large pelvis sloping up to rather narrow shoulders and down through the full thighs to the lower legs—suggesting an egg-like form beautiful in volume. The hair of the model describes a protecting curve and gives a repetition that is a completion.

Your imagination is thus stimulated to help the plastic conception of the model before you begin. This leg, but for the accident of the curve of the calf, would describe a longer, slenderer ovoid form; and this latter form must be insisted upon, as in the antiques, to aid the unity of the figure.

Put in no holes that hurt the ensemble, as between thumb and fingers lying at the side. Express by masses in relation to one another, and large sweeps of line in interrelation. One must determine the characteristic form of the different parts of the body and the direction of the contours which will give this form. In a man standing erect all the parts must go in a direction to aid that sensation. The legs work up into the torso, which clasps down over them. It must have a spinal column. One can divide one's work by opposing lines (axes) which give the direction of the parts and thus build up the body in a manner that at once suggests its general character and movement.

In addition to the sensations one derives from a drawing, a sculpture must invite us to handle it as an object; just so the sculptor must feel, in making it, the particular demands for volume and mass. The smaller the bit of sculpture, the more the essentials of form must exist.

PAINTING

When painting, first look long and well at your model or subject, and decide on your general color scheme. This must prevail. In painting a landscape you choose it for certain beauties—spots of color, suggestions of composition. Close

your eyes and visualize the picture; then go to work, always keeping these characteristics the important features of the picture. And you must at once indicate all that you would have in the complete work. All must be considered in interrelation during the process—nothing can be added.

One must stop from time to time to consider the subject (model, landscape, etc.) in its ensemble. What you are aiming for, above all, is unity.

Order above all, in color. Put three or four touches of color that you have understood, upon the canvas; add another, if you can—if you can't set this canvas aside and begin again.

Construct by relations of color, close and distant—equivalents of the relations that you see upon the model.

You are representing the model, or any other subject, not copying it; and there can be no color relations between it and your picture; it is the relation between the colors in your picture which are the equivalent of the relation between the colors in your model that must be considered.

I have always sought to copy the model; often very important considerations have prevented my doing so. In my studies I decided upon a background color and a general color for the model. Naturally these were tempered by demands of atmosphere, harmony of the background and model, and unity in the sculptural quality of the model.

Nature excites the imagination to representation. But one must add to this the spirit of the landscape in order to help its pictorial quality. Your composition should indicate the more or less entire character of these trees, even though the exact number you have chosen would not accurately express the landscape.

[*Still life*]

In still life, painting consists in translating the relations of the objects of the subject by an understanding of the different qualities of colors and their interrelations.

When the eyes become tired and the rapports seem all wrong, just look at an object. "But this brass is yellow!" Frankly put a yellow ochre, for instance on a light spot, and start out from there freshly again to reconcile the various parts.

To copy the objects in a still life is nothing; one must render the emotion they awaken in him. The emotion of the ensemble, the interrelation of the objects, the specific character of every object—modified by its relation to the others—all interlaced like a cord or a serpent.

The tear-like quality of this slender, fat-bellied vase—the generous volume of this copper—must touch you. A still life is as difficult as an antique and the proportions of the various parts as important as the proportions of the head or the hands, for instance, of the antique.

CRITICISM [remarks addressed to individual students]

This manner of yours is a system, a thing of the hand, not of the spirit. Your figure seems bounded by wires. Surely Monet, who called all but the people who worked in dots and commas wire-draughtsmen, would not approve of you—and this time he would be right.

In this instance the dark young Italian model against a steel-gray muslin background suggests in your palette rose against blue. Choose two points: for instance, the darkest and lightest spot of the subject—in this case the model's black hair and the yellow straw of the stool. Consider every additional stroke in addition to these.

This black skirt and white underskirt find their equivalent—in your scheme—in ultramarine blue with dark cobalt violet (as black), and emerald green and white. Now the model is a pearly, opalescent color all over. I should take vermilion and white for this lower thigh, and for this calf—cooler but the same tone—garance and white. For this prominence of the back of the forearm, cool but very bright, white tinged with emerald green, which you do not see as any particular color now that it is placed.

Your black skirt and red blouse, on the model stand, become an emerald green (pure) and vermilion—not because green is the complementary of red, but because it is sufficiently far away from red to give the required rapport. The hair must also be emerald green, but this green appears quite different from the former.

You must make your color follow the form as your drawing does—therefore your vermilion and white in this light should turn to garance and white in this cooler shadow. For this leg is round, not broken as by a corner.

Thick paint does not give light; you must have the proper color-combination. For instance, do not attempt to strengthen your forms with high lights. It is better to make the background in the proper relation to support them. You need red to make your blue and yellow count. But put it where it helps, not hurts—in the background, perhaps.

In this sketch, commencing with the clash of the black hair, although your entire figure is in gradation from it, you must close your harmony with another chord—say the line of this foot.

There are many ways of painting. You seem to be falling between two stools—one considering color as warm and cool, the other, seeking light through the opposition of colors. Had you not better employ the former method alone? Then your blue background will require a warmer shadow; and this warm, black head against it, a warmer tone than this dark blue you have chosen. Your model stand will take a warmer lighter tone; it looks like pinkish, creamy silk in relation to the greenish wallpaper.

Cézanne used blue to make his yellow tell, but he used it with the discrimination, as he did in all other cases, that no one else has shown.

The Neo-Impressionists took different centers of light—for instance, a yellow and a green—put blue around the yellow, red around the green, and graded the blue into the red through purple, etc.

I express variety of illumination through an understanding of the differences in the values of colors, alone and in relation. In this still life, an understanding of cadmium green and white, emerald green and white, and garance and white, give three different tones which construct the various planes of the table—front, top, and the wall back of it. There is no shadow under this high light; this vase remains in the light, but the high light and the light beneath it must be in the proper color relation.

APPENDIX B: APOLLINAIRE'S "MEDAILLON: UN FAUVE"

In the archives of the Gertrude Stein Collection, Yale University Library, is preserved a copy in Leo Stein's hand of a short sketch of Matisse, entitled *Médaillon: un fauve* and signed Pascal Hédégat, one of the pseudonyms of Guillaume Apollinaire. Leo Stein's copy is "attested" by Matisse himself with the initials "H. M." Apollinaire's piece was written when Matisse was thirty-nine years old, or in 1909. It is published here, perhaps for the first time, with the kind permission of the Yale University Library, James T. Babb, Librarian.

Frantz Jourdain, mentioned by Apollinaire, was President of the Salon d'Automne where Matisse and the fauves exhibited; Alexandre Cabanel, 1823-1889, was a successful academic painter and Director of the Ecole des Beaux-Arts under Napoleon III.

MEDALLION: A FAUVE

Born at Cateau, Nord, on December 31, 1869, M. Henri Matisse at the age of thirty-nine years is one of the leaders of that group of painters called, by those whom they scare, *the fauves*.

It should be added that one judges them sometimes with great difficulty. Therefore, while many critics find the nickname *fauve* too mild for M. Henri Matisse, and call him *fauvissime* or *wildest beast*, M. Frantz Jourdain, who is more reasonable without being more discerning, likes to compare him with Cabanel. To tell the truth, M. Henri Matisse is an innovator, but he renovates rather than innovates. One's view must have got extremely foggy, must have been unusually affected by objects which are more artificial than artistic, before one could be disagreeably dazzled by the purity of design and colors of M. Henri Matisse.

Bearded and masking a glance full of malice behind gold-rimmed eyeglasses, M. Henri Matisse lives sometimes in Paris, sometimes in Collioure. This fauve is shrewd. He likes to surround himself with objects of old and modern art, precious materials, and those sculptures in which the Negroes of Guinea, Senegal or Gabun have demonstrated with unique purity their frightened emotions.

This pleasant Amphitryon, assisted in his task by an exquisite wife who, because he is the fauve, has become the fauvette, often entertains friends. Without being lavish his table is delicious. Good humor and the play of three children add to the charm which emanates from intimate association with the master from Cateau.

Pascal Hédégat
(Guill. Apollinaire)
True Copy
H. M

APPENDIX C: CONTRACTS BETWEEN MATISSE AND BERNHEIM-JEUNE

Messrs. Bernheim-Jeune have courteously made available copies of the full texts of their contracts which covered transactions with Matisse between 1909 and 1926. Since these have considerable historical interest the first, translated into English, is given here in full, together with significant excerpts from the subsequent agreements.

In these contracts paintings are priced according to size, and size is indicated by number in the format or proportions of canvases conventionally used for figure paintings. Thus "*Format 50 Fig.*" means a canvas 116 x 89 cm or about 41¾ x 35″ in size; 40 Fig. = 100 x 81 cm (39⅜ x 31⅞″); 30 Fig. = 92 x 73 cm (36¼ x 28¾″); 20 Fig. = 73 x 60 cm (28¾ x 23⅝″); 10 Fig. = 55 x 46 cm (21⅝ x 18⅛″); 5 Fig. = 35 x 27 cm (13¼ x 10⅝″). "*Paysage*" numbers are the same length as "*figure*" but narrower; "*marines*" are still narrower.

Félix Fénéon, the business manager of Bernheim-Jeune, initiated the first contract, dated September 18, 1909:

FIRST CONTRACT 1909-1912

AGREEMENT MATISSE—BERNHEIM

Between Mr. Henri-Matisse (42, route de Clamart at Issy-les-Moulineaux, Seine) and Messrs. Bernheim-Jeune (15 rue Richepanse, Paris) the following has been agreed:

ART. I—All pictures of the below-mentioned sizes and intermediate sizes which Mr. Henri-Matisse executes before the fifteenth of September 1912 he agrees to sell to Messrs. Bernheim-Jeune, and they agree to buy them from him, regardless of what the subject is, at the following prices:

Format 50 Fig.—1,875 frs.
40 Fig.—1,650 "
30 Fig.—1,500 "
25 Fig.—1,275 "
20 Fig.—1,125 "
15 Fig.— 900 "
12 Fig.— 750 "
10 Fig.— 600 "
8 Fig.— 525 "
6 Fig.— 450 "

The prices of the pictures of intermediate sizes (formats "*paysage*" and "*marine*" and irregular formats) shall be in proportion to their surface and the above prices.

ART. II—In addition Mr. Henri-Matisse shall receive twenty-five percent of the profit obtained on the sale of the pictures.

ART. III—In the event that Mr. Henri-Matisse sells a certain picture while it is being painted, the difference between the above-mentioned prices and the sales price shall be shared fifty-fifty by him and Messrs. Bernheim-Jeune.

ART. IV—If Messrs. Bernheim-Jeune leave in storage with Mr. Henri-Matisse a finished painting and he sells this picture directly, the profit shall also be shared fifty-fifty.

ART. V—The sales price of pictures sold by Mr. Henri-Matisse under the conditions outlined in Articles III and IV shall be no less than about double the prices indicated in Article I.

ART. VI—Paintings which Mr. Henri-Matisse himself considers sketches shall not be covered by Article I or the following Articles. Those sketches which he intends to bring into circulation shall, however, be submitted to Messrs. Bernheim-Jeune and a separate arrangement can be made for each one of them. In case no friendly understanding can be worked out, Messrs. Bernheim-Jeune shall have the right but not the obligation to acquire the sketch as outright owners at the rates set forth in Article I.

ART. VII—As soon as Mr. Henri-Matisse has finished a picture he notifies Messrs. Bernheim-Jeune. When delivering a painting he gives them information regarding any negotiations he might have had about the picture.

ART. VIII—Neither Article I nor any of the following Articles is retroactive with respect to pictures which have been commissioned before this agreement, namely: his *Self Portrait*, two canvases of 50, a landscape of 20, two canvases of about 40.

ART. IX—Mr. Henri-Matisse is free to accept, without any compensation being due to Messrs. Bernheim-Jeune, firm orders for portraits or decorations which he receives directly. Decorations will be construed only as paintings of irregular size, the dimensions of which are strictly determined by the architecture of the place where they are to be installed.

ART. X—Messrs. Bernheim-Jeune will receive twenty-five percent on the orders for decorations and portraits which Mr. Henri-Matisse accepts through them as intermediaries.

ART. XI—Upon payment of a forfeiture of 30,000 francs and a simple statement in writing addressed to the other party, each one of the contracting parties has the right at any time to cancel this agreement for the remainder of the time it is to be in force.

ART. XII—In the event that Messrs. Bernheim-Jeune pay to Mr. Matisse the forfeiture of 30,000 francs as set forth in the previous Article, Mr. Henri-Matisse shall lose all claim to the profit ultimately to be derived by Messrs. Bernheim-Jeune from the sale of the pictures which they may have in storage at the time of the above-mentioned payment.

ART. XIII—This agreement has not been registered. If under any circumstances one of the contracting parties finds it advisable to have it registered, this party will assume the costs of registration.

Done in Paris, in two copies, the eighteenth of September 1909.

/s/ Henri-Matisse

SECOND CONTRACT 1912-1915

The second contract, September 18, 1912 to September 15, 1915, is virtually the same as the first except for Article V:

ART. V—The sales price of pictures sold by Mr. Henri-Matisse under the conditions outlined in Articles III and IV, shall be no less than about double the prices indicated in Article I. This clause is not reciprocal with regard to Messrs. Bernheim-Jeune, who of course try to sell the pictures of Mr. Henri-Matisse in the best interest of both parties. In exceptional cases they will be free to sell at prices considerably below twice the purchase price pictures which they have offered in vain for a considerable time to collectors; or if the purchaser is another art dealer, or if a reduction in prices might attract new customers to the art of Mr. Henri-Matisse.

THIRD CONTRACT 1917-1920

The third contract was in the form of a letter from Matisse to Bernheim-Jeune, dated Paris, October 19, 1917 (two years and more after the expiration of the second contract). The principal paragraphs follow:

I. During the three years beginning September 19, 1917, I agree to sell to you and you agree to buy from me one-half of my production of pictures between the formats 80 to 4 inclusive and at the prices mentioned below:

FORMATS	PRICE	FORMATS	PRICE
80	6,000 frs.	15	2,500 frs.
60	5,000 "	12	2,000 "
50	4,500 "	10	1,800 "
40	4,000 "	8	1,500 "
30	3,500 "	6	1,200 "
25	3,000 "	5	1,000 "
20	2,800 "	4	800 "

II. I agree not to sell to any third party, dealers or collectors, any picture which is in the process of being painted.

III. The division mentioned in Article I shall be handled as follows: I shall advise you each time a pair of canvases of equal or similar size is ready, and each time we shall draw lots for first choice.

IV. As far as my half of the pictures is concerned I agree not to sell any of them to any other dealers at less than the above prices marked up by thirty percent. If, however, the whole lot is sold the mark-up may be reduced to twenty percent. You, however, agree not to sell to any other dealer any of the paintings in your half at a price which is not at least forty percent above your purchase price.

V. Whether I received these commissions [for decorations, portraits, easel paintings] directly or through your intervention, they will count toward my half if they fall within the sizes defined in Article I.

FOURTH CONTRACT 1920-1923

After signing the fourth contract, for the three years beginning September 19, 1920, Matisse wrote Fénéon on October 29, 1920, from Nice, Hotel Méditerranée, that because of the rise in the cost of living he felt fully justified in having increased the prices of his pictures. He had also refused to sign for five years instead of the usual three. The contract itself followed the lines of the third contract, the letter of October 19, 1917, except for two additional articles:

ART. VI—Mr. Henri-Matisse has the right to keep four canvases for himself out of the pictures which are covered by this agreement.

ART. VII—Mr. Henri-Matisse engages himself not to sell the canvases covered by Article VI for the duration of this agreement.

The prices listed in Article I were as follows:

FORMATS	PRICE	FORMATS	PRICE
80	9,000 frs.	15	4,000 frs.
60	8,000 "	12	3,500 "
50	7,000 "	10	3,000 "
40	6,500 "	8	2,500 "
30	5,500 "	6	2,000 "
25	4,800 "	5	1,800 "
20	4,500 "	4	1,500 "

This contract was signed August 23, 1920.

FIFTH CONTRACT 1923-1926

The fifth contract to run from September 19, 1923, for three years was very similar to those of 1917 and 1920 except for the elimination of Article IV, a further increase in prices, and the elimination of the two largest and three smallest formats. The new price schedule, given in Article I, was as follows:

FORMATS	PRICE	FORMATS	PRICE
50	11,000 frs.	15	6,000 frs.
40	10,000 "	12	5,250 "
30	8,250 "	10	4,500 "
25	7,250 "	8	4,000 "
20	6,750 "		

APPENDIX D: TWO LETTERS FROM SHCHUKIN TO MATISSE, 1909, 1912

Because of their historic importance two letters from Sergei Shchukin in Moscow to Matisse are transcribed here in their original French (and orthography) from photographs in the possession of Pierre Matisse. A third letter, of October 10, 1913, is given in English on page 147.

The first letter is discussed, partially translated and its first page reproduced on page 133.

Moscou, 31 Mars 1909

Cher Monsieur,

Je trouve votre panneau[1] "la danse" d'une telle noblesse, que je pris la resolution de braver notre opinion bourgeoise et de mettre sur mon escalier un suject avec LE NU. En meme temps il me faudra un deuxieme panneau, dont le sujet serait tres bien la musique.

J'étais tres content d'avoir votre reponse: accepte commande ferme panneau la danse[2] quinze milles et panneau la musique[3] douze milles prix confidential. Je vous remerci beaucoup et j'espére d'avoir bientôt une esquisse du deuxième panneau.

Il fait maintenant à Moscou un temps bien mauvais, tres froid et toujours de la pluie. Ma santé est très bonne

J'espere que vous êtes bien portant et que le travail marche bien.

N'oubliez pas le pendant pour mes poisons.

Mes compliments à Mme Matisse.

Recevez l'assurance de mon entier devouément.

Serge Stschoukine

The second letter is discussed and translated in part on pages 134-135.

Moscou, 22 aout 1912

Cher Monsieur!

J'ai reçu hier votre lettre du 17 aout et je consens et même avec plaisir que vous exposez au Salon d'Automne le tableau des "Capucines à la danse."[4] Mais je vous prie d'envoyer les deux autres tableaux (le maroquain[5] et les poissons d'or[6]) à Moscou grande vitesse. Je pense beaucoup à votre tableaux bleu[7] (avec 2 personnes), je le trouve comme une émaille byzantine, tellement riche et profond de couleur. C'est un des plus beaux tableaux, qui reste maintenant dans ma mémoire.

Dans ma maison on fait beaucoup de la musique. Chaque hiver il y a une 10 de concerts classique (Bach, Bethoven, Mozart). Le paneau la musique[8] doit un peu indiquer le caractere de la maison. J'ai pleine confiance en vous et je suis sur que la musique sera aussi reussie comme la danse.[9]

Je vous prie de me donner des nouvelles de vos traveaux.

Toutes mes reserves dans les deux lettres precedentes sont annulées par mon télégram la derniere dimanche. Maintenant vous avez ma commande definitif pour les deux panneaux. Mes compliments à Mme Matisse.

En attendant vos nouvelles je reste

votre très dévoué

Serge Stschoukine.

1 *Dance*, p. 360.
2 *Dance*, p. 362.
3 *Music*, p. 364.
4 *Nasturtiums and the "Dance," I*, p. 382.
5 *Amido*, p. 378.

6 *Goldfish*, p. 376.
7 *Conversation*, p. 347.
8 *Music*, p. 364.
9 *Dance*, p. 362.

APPENDIX E: MATHER ON MATISSE'S DRAWING, 1910

Frank Jewett Mather, Jr.'s review of the 1910 exhibition of Matisse's drawings at the "291" Gallery, New York, appeared in the *New York Evening Post* during March 1910 and was reprinted *in toto* in *Camera Work*, 1910, Volume XXX, pages 50-51. Excerpts only are published here. The right-hand drawing reproduced on page 323 was surely in the 1910 exhibition, the left-hand one may have been, as may also have been the one reproduced on page 50. The exhibition is discussed on page 115.

MATISSE DRAWINGS

BY FRANK JEWETT MATHER

... It would be well if the visitor could forget that Matisse is the object of a cult, the reputed possessor of strange secrets and philosophies, the regenerator of the torpid art of the age. It would be well to ignore all this and suppose that these are anonymous sketches which the post has brought to Mr. Stieglitz, and which have so warmed his heart that he has asked his friends in to see them. Looked at in this way, the dread Matisses would lose all their portentousness. We should see merely a handful of peculiarly serious and drastic studies from the nude model. They are no more odd than working drawings usually are. Matisse's concern is in the tension, weight, and equipoise of the figure as a whole. He merely spots in the features, as negligible quantities, though now and then a skeletonized face has extraordinary character. If he had merely omitted the features, as draftsmen of the figure often do, seven-eighths of the repellent oddity of this work would disappear. As it is, the visitor must not bother about the faces, but keep his eye on the whole design until its energy and rhythm strike home.

Matisse conceives the body as a powerful machine working within certain limits of balance. The minute form of the tackles and levers does not signify for him, what counts is the energy expended and the eloquent pauses which reveal the throb of the mechanism. The important thing is that muscles should draw over the bone pulleys, that the thrust of a foreshortened limb should be keenly felt, that all the gestures should fuse in a dynamic pattern. So much for the vision. It differs in no essential respect from that of great draftsmen of all ages. A Matisse drawing, looked at without prejudice, is no more bizarre than a study of action by Hokusai or Michelangelo. It belongs in the great tradition of all art that has envisaged the human form in terms of energy and counterpoise. . . . Such drawing is odd only because it is so fine that much of it there cannot be. The nearest analogies to these sketches are those remarkable *tempera* studies by Tintoretto which have recently been discovered and published in part in the *Burlington Magazine*. In fact, Matisse is akin to all the artists who approach the figure with what Vasari calls *furia*. The Frenchman is a kind of modern Pollaiuolo. . . .

Yet, there is one question which a plain man might very properly ask, namely: "Is this all there is of it, or is it a preparation for something else?" To us, these drawings have a painful, we trust a misleading, air of finality. The few compositions represented in chalks or photography are merely extensions of the single figure or quite commonplace calligraphies. It is possible that Matisse will always be making these magnificent studies. The present exhibition gives small hint of constructive imagination. If so, he will merely take his place with other geniuses who have sacrificed themselves in the passionate invention of processes. Pollaiuolo and Hokusai, to a considerable extent, represent this inability to organize a complicated whole. Meanwhile one is grateful for so much. It is no small gift to have one's vision toned up to this strenuously controlled enthusiasm for the human mechanism. The effect of this work upon modern art can only be beneficial. Matisse as painter is almost unknown to the present writer, who suspects that there individual and arbitrary caprice may be masking as genial invention. As for these drawings, there is no manner of doubt. They are in the high tradition of fine draftsmanship of the figure. If, on sufficient acquaintance, they still seem merely eccentric to anyone, let him rest assured that the lack of centrality is not with them, but with himself.

APPENDIX F: WORKS BY MATISSE IN THE PUBLIC MUSEUMS OF ENGLISH-SPEAKING COUNTRIES

The following lists of works by Matisse in the collections of public museums in English-speaking countries are intended to encourage the readers of this book to study and enjoy original painting and sculpture, whenever available, rather than reproductions published here and elsewhere. Though public collections in other countries are not included in the list, attention should be called to the important groups of Matisse's paintings in the Statens Museum for Kunst, Copenhagen, the Grenoble Musée de Peinture et de Sculpture and, in Paris, the Musée National d'Art Moderne and the Musée de la Ville de Paris. However, the greatest collection of paintings by Matisse, that belonging to the Museum of Modern Western Art in Moscow, and the second greatest, that of the Barnes Foundation, Merion, Pennsylvania, are not, it appears, open to the public.

Paintings and sculptures only are listed; the number of drawings is given but prints are not included. The author has taken the liberty of adding, or in some cases correcting, the dates of works listed. The lists have been assembled and prepared by Olive Bragazzi and Letitia Howe.

A. H. B., JR.

CANADA

MONTREAL, QUEBEC. MONTREAL MUSEUM OF FINE ARTS
Femme à la fenêtre. 1922. Oil, 23⅞ x 36¼"

TORONTO, ONTARIO. ART GALLERY OF TORONTO
Jeannette, V. 1911-12. Bronze, 23″ high

GREAT BRITAIN

GLASGOW. GLASGOW ART GALLERY
La nappe rose. 1925. Oil, 24 x 32″. Gift of William McInnes
Tête de jeune fille. Oil, 16 x 12″. Gift of William McInnes

LONDON. TATE GALLERY
Nude. c.1895. Oil, 28⅞ x 21½″. Bequeathed by C. Frank Stoop
Notre Dame. 1900. Oil, 18⅛ x 15″
Arbre près l'étang de Trivaux. 1916 or '17. Oil, 36⅜ x 29″. Bequeathed by C. Frank Stoop
Woman Reading. 1921. Oil, 20 x 24½″. Gift of Contemporary Arts Society
La liseuse distraite. Oil, 29 x 36⅜″. Gift of Contemporary Arts Society

UNITED STATES

BALTIMORE, MARYLAND. BALTIMORE MUSEUM OF ART
CONE COLLECTION
Still Life with Peaches. 1895. Oil, 18⅛ x 13⅜″
Dam at Pont Neuf. 1896. Oil, 11 x 14½″
Compote and Glass Pitcher. 1899. Oil, 18½ x 22″
The Invalid. 1899. Oil, 18⅛ x 15″
The Slave. 1900-02. Bronze, 36⅜″ high
Madeleine (I). 1901. Bronze, 22¼″ high
Figure Resting on Hands. 1905. Bronze, 5″ high
Portrait of Pierre Matisse. 1905. Bronze, 6⅛″ high
Harbor of Collioure. 1905. Watercolor, 5⅛ x 8¼″
Yellow Pottery from Provence. 1906. Oil, 21¼ x 17¾″
Head of a Young Girl. 1906. Bronze, 6½″ high
Blue Nude (Souvenir of Biskra). 1907. Oil, 36¼ x 55⅛″
Small Head. 1907. Bronze, 3¾″ high
Head with Necklace. 1907. Bronze, 6⅛″ high
Reclining Figure (Reclining Nude, I). 1907. Bronze, 13½″ high
Two Sisters. 1908. Bronze, 17¾″ high
Seated Figure. 1908. Bronze, 13¾″ high
Crouching Figure. 1908. Bronze, 5⅛″ high
The Pewter Jug. 1916 or '17. Oil, 36¼ x 25⅝″
The White Turban. 1916. Oil, 31⅞ x 25⅝″
Eucalyptus at Montalban. 1917. Oil, 13½ x 16″
Aqueduct of Maintenon. 1918. Oil, 13 x 16⅛″
Figure on Cushion. 1918. Bronze 5⅛″ high
Seated Venus. 1918. Bronze, 9¼″ high
Venus. 1919. Bronze, 11⅜″ high
The Olive Grove. 1919? Oil, 23⅝ x 28⅜″
Large Cliff at Etretat. 1920. Oil, 36½ x 29″
Cliffs. 1920 or '21. Oil, 14¼ x 17⅜″
Cliff, Etretat. 1920 or '21. Oil, 15 x 18⅛″
Girl in Green Dress. 1921. Oil, 24 x 19⅝″
Interior with Spanish Woman. 1921. Oil, 29½ x 23½″
Flower Festival at Nice. 1922. Oil, 25⅝ x 36¼″
Woman with Violin. 1922. Oil, 28¾ x 23⅝″
The Music Lesson. 1922. Oil, 21¼ x 25⅝″
Divertissement. 1922. Oil, 19⅝ x 25⅝″
Rest in the Country. 1922. Oil, 15 x 18⅛″
Girl in Brown Taffeta Dress. 1922. Oil, 18⅛ x 15″

Girl at the Window; Sunset. 1922. Oil, 19⅝ x 24″
Anemones and Chinese Vase. 1922. Oil, 23⅝ x 36¼″
Girl Reading. 1922. Oil, 15 x 18⅛″
Odalisque with Tambourine. 1922. Oil, 21⅝ x 15″
Still Life with Dahlias. 1923. Oil, 19⅝ x 24″
Odalisque Reflected in a Mirror. 1923. Oil, 31⅞ x 21⅝″
Odalisque in Green Pantaloons. 1924? Oil, 25½ x 18½″
Interior: Flowers and Parrots. 1924. Oil, 46 x 29½″
Seated Nude. 1925. Bronze, 29½″
Reclining Odalisque with Green Sash. 1926. Oil, 19¼ x 25″
Ballet Dancer. 1927. Oil, 32 x 24″
Odalisque. 1928. Oil, 21⅝ x 15″
Reclining Nude (II). 1929? Bronze, 7⅜″ high
Girl in a Yellow Dress. 1929-31. Oil, 39⅝ x 32″
Tiari with Necklace. 1930. Bronze, 8⅛″ high
Venus Seated on Shell. 1930? Bronze, 13″ high
The Magnolia Branch. 1934. Oil, 60¾ x 65¾″
Pink Nude. 1935. Oil, 26 x 36½″
Blue Eyes. 1935. Oil, 15 x 18″
Portrait of a Girl Seated in Red Armchair. 1936. Oil, 13⅜ x 9¼″
Purple Robe. 1937. Oil, 28½ x 24″
Interior: Woman Seated under Plants. 1938. Oil, 21 x 25½″
Striped Blouse and Anemones. 1940. Oil, 18 x 14⅝″
Two Girls with Red and Green Background. 1947. Oil
Also, 113 drawings of which 78 are studies, or part of the *maquette*, for the *Poésies de Stéphane Mallarmé*

La Serpentine. 1909. Bronze, 22¼″ high. Gift of Friends of the Museum
Also a drawing, Adler Collection

BOSTON, MASSACHUSETTS. MUSEUM OF FINE ARTS
Carmelina. 1903. Oil, 32 x 23½″
The Vase of Flowers. 1924? Oil, 23½ x 29″

BOSTON, MASSACHUSETTS. ISABELLA STEWART GARDNER MUSEUM
Terrace at St. Tropez. 1904. Oil, 28¼ x 22¾″
Also, 3 drawings (before 1914)

BUFFALO, NEW YORK. ALBRIGHT ART GALLERY
A Glimpse of Notre Dame in Late Afternoon. 1902. Oil, 28½ x 21½″. Seymour H. Knox Fund
Reclining Nude (I). 1907. Bronze, 13½″ high. Room of Contemporary Art
La musique. 1939. Oil, 45¼ x 45¼″. Room of Contemporary Art
Also, 2 drawings

CAMBRIDGE, MASSACHUSETTS. FOGG MUSEUM OF ART, HARVARD UNIVERSITY
Geraniums. 1915. Oil, 23 x 18½″. Maurice Wertheim Collection
Still Life with Apples. 1916. Oil, 6 x 12″. Maurice Wertheim Collection
Also, 6 drawings

CHICAGO, ILLINOIS. ART INSTITUTE OF CHICAGO
The Slave. 1900-02. Bronze, 36⅜″ high. Edward E. Ayer Collection

Still Life—Geranium Plant, Fruit. 1906. Oil, 38½ x 31½". Gift of Joseph Winterbotham

Bowl of Apples. 1916. Oil, 46 x 35". Gift of Mr. and Mrs. Samuel A. Marx

By the Window. 1918. Oil, 28 x 23". Gift of Joseph Winterbotham

The Green Sash. c.1919. Oil, 18⅜ x 16½". Worcester Collection

Woman on Rose Divan. c.1921. Oil, 14⅞ x 18". Helen Birch Bartlett Memorial

Woman before an Aquarium. 1921. Oil, 31½ x 39". Helen Birch Bartlett Memorial

Figure. Bronze, 9¼" high. Gift of Mrs. Emily Crane Chadbourne

Also, 13 drawings

EXTENDED LOAN FROM THE CHESTER DALE COLLECTION

The Plumed Hat. 1919. Oil, 19 x 15"

Les Gorges du Loup. c.1920. Oil, 19½ x 24"

Odalisque with Raised Arms. 1923. Oil, 25½ x 19¾"

Still Life: Apples on Pink Tablecloth. 1924? Oil, 23¾ x 28¾"

Woman with Exotic Plant. 1925. Pastel, 25⅞ x 20"

CHICAGO, ILLINOIS. ARTS CLUB
One drawing

CLEVELAND, OHIO. CLEVELAND MUSEUM OF ART
Fête des Fleurs, Nice. 1922. Oil, 26½ x 37½". The Mr. and Mrs. William H. Marlatt Fund
Also, 1 drawing

COLUMBUS, OHIO. COLUMBUS GALLERY OF FINE ARTS
FERDINAND HOWALD COLLECTION
The Red Jacket. 1917? Oil, 18¼ x 14¼"
Eucalyptus at Montalban. 1918? Oil, 12 x 15¾"
Etretat. 1920. Oil, 35¾ x 28½"
Waiting. c.1922. Oil, 21¾ x 18⅛"
Roses. c.1924. Oil, 23¾ x 28¾"

DENVER, COLORADO. DENVER ART MUSEUM
The Two Sisters. 1916. Oil, 24 x 29". Helen Dill Collection

DETROIT, MICHIGAN. DETROIT INSTITUTE OF ARTS
The Window. 1916. Oil, 57½ x 45¾"
Also, 1 drawing

HARTFORD, CONNECTICUT. WADSWORTH ATHENEUM
One drawing

HONOLULU, HAWAII. HONOLULU ACADEMY OF ARTS
Girl Reading (Annélies, tulipes blanches, et anémones). 1944. Oil, 24 x 28¾"

LOS ANGELES, CALIFORNIA. LOS ANGELES COUNTY MUSEUM
(Woman in chair, music stand, open window.) Oil, 17⅞ x 20⅜"
Reclining Woman with Anemones. Oil, 19½ x 25½"
Also, 1 drawing

MINNEAPOLIS, MINNESOTA. MINNEAPOLIS INSTITUTE OF ARTS
White Plumes. 1919. Oil, 29 x 24". Dunwoody Fund

NEW HAVEN, CONNECTICUT. YALE ART GALLERY
Still Life with Torso. 1906. Oil, 21¼ x 17¾"

NEW YORK, NEW YORK. THE METROPOLITAN MUSEUM OF ART
Three drawings. Gift of Mrs. George Blumenthal, 1910
Also two watercolors, a bronze and five drawings, Alfred Stieglitz Collection, on extended loan to Museum of Modern Art, q.v.

NEW YORK, NEW YORK. MUSEUM OF MODERN ART
Still Life. 1899? Oil, 18⅛ x 15". Gift of General A. Conger Goodyear
Bouquet on a Bamboo Table. 1902. Oil, 21½ x 18⅛". Gift of Mrs. Wendell T. Bush
Reclining Woman, I. 1907. Bronze, 13½" high. Acquired through the Lillie P. Bliss Bequest
Bather. 1909. Oil, 36½ x 29⅛". Given anonymously
Standing Woman (La Serpentine). 1909. Bronze, 22¼" high. Given anonymously
The Red Studio. 1911. Oil, 71¼ x 86¼". Mrs. Simon Guggenheim Fund
The Blue Window. 1911. Oil, 51½ x 35⅝". Mrs. John D. Rockefeller, Jr. Purchase Fund
Piano Lesson. 1916. Oil, 96½ x 83¾". Mrs. Simon Guggenheim Fund
Gourds. 1916. Oil, 25⅝ x 31⅞". Given anonymously
Interior with a Violin Case. 1919? Oil, 28¾ x 24". Lillie P. Bliss Collection
Also, 4 drawings

EXTENDED LOAN FROM THE METROPOLITAN MUSEUM OF ART, ALFRED STIEGLITZ COLLECTION
Woman by the Seashore. Watercolor and pencil, 10⅝ x 8¼"
Nude. Watercolor, 5¾ x 9⅝"
Torso with Head. 1906. Bronze, 9⅜" high
Also, 5 drawings

PHILADELPHIA, PENNSYLVANIA. PHILADELPHIA MUSEUM OF ART
Mlle Yvonne Landsberg. 1914. Oil, 57¼ x 42". The Louise and Walter Arensberg Collection
Interior—Nice. 1917 or '18. Oil, 29 x 24". A. E. Gallatin Collection
Interior at Nice. c.1919. Oil, 18⅛ x 25¾". Gift of Mr. and Mrs. R. Sturgis Ingersoll
The Moorish Screen. 1921. Oil, 36¼ x 29". Lisa Norris Elkins Collection

EXTENDED LOAN FROM WALTER P. CHRYSLER, JR.
La danse. 1909. Oil, 108 x 144"

EXTENDED LOAN FROM THE CHESTER DALE COLLECTION
La coiffure. 1901. Oil, 36⅝ x 27½"
Pot of Geraniums. 1912. Oil, 16 x 13"
Moorish Woman. 1922. Oil, 13¾ x 9⅜"

PROVIDENCE, RHODE ISLAND. MUSEUM OF ART, RHODE ISLAND SCHOOL OF DESIGN
Still Life with Bowl and Book (Still Life with Lemons, etc., cf. page 397). 1914-15. Oil, 27¼ x 21¼"
Also, 1 drawing

RICHMOND, VIRGINIA. VIRGINIA MUSEUM OF FINE ARTS
Head of a Woman. Oil, 13¾ x 10½". T. Catesby Jones Collection
Head of a Girl. Oil, 13¾ x 10½". T. Catesby Jones Collection
Also, 3 drawings

ROCHESTER, NEW YORK. ROCHESTER MEMORIAL ART GALLERY
Girl with a Tricorne. c.1922. Oil, 24 x 20"

ST. LOUIS, MISSOURI. CITY ART MUSEUM
Nice, Interior. c.1919. Oil, 25⅞ x 21½"

SAN DIEGO, CALIFORNIA. FINE ARTS SOCIETY OF SAN DIEGO
Bouquet. 1916. Oil, 55 x 40½"
Also, 1 drawing

SAN FRANCISCO, CALIFORNIA. SAN FRANCISCO MUSEUM OF ART
Vase of Anemones. 1918. Oil, 24 x 18½". Gift of W. W. Crocker

HARRIET LANE LEVY BEQUEST
Corsican Landscape. 1898. Oil, 15 x 18"
The Serf. 1900-02. Bronze, 36⅜" high
Still Life. 1902? Oil, 9½ x 13½"
Madeleine (I). 1901. Bronze, 23½" high
Flowers. 1906? Oil, 13 x 9"
Girl with Green Eyes. 1909. Oil, 26 x 20"

Head (Grosse Tête). 1927. Bronze, 12½" high
The Table at the Café. Early. Oil, 16 x 12¾"
Fruit Dish. Early. Oil, 10½ x 13½"
Also, 5 drawings

TOLEDO, OHIO. TOLEDO MUSEUM OF ART
Dancer Resting. 1940. Oil, 25½ x 32"

WASHINGTON, D. C. NATIONAL GALLERY OF ART
ROSENWALD COLLECTION
Three drawings

WASHINGTON, D.C. PHILLIPS COLLECTION
The Studio, Quai St. Michel. 1916. Oil, 57½ x 45¾"
Interior with Egyptian Curtain. 1948. Oil, 45⅝ x 35"

WEST PALM BEACH, FLORIDA. NORTON GALLERY AND SCHOOL OF ART
Lorette. 1916. Oil, 13¾ x 10½"
Two Rays. 1920. Oil, 36½ x 29"

WORCESTER, MASSACHUSETTS. WORCESTER ART MUSEUM
The Promenade. c.1919. Oil, 22⅛ x 18⅞"

ANONYMOUS EXTENDED LOAN
La danse aux capucines. 1912. Oil, 74⅞ x 45"
Dans la campagne de Nice. c.1920. Oil, 12⅝ x 15⁹⁄₁₆" (sight)
La promenade. c.1920. Oil, 12⅝ x 15¾" (sight)
Goldfish. c.1922. Oil, 20¹⁵⁄₁₆ x 25¼" (sight)

APPENDIX G: ILLUSTRATIONS BY MATISSE

The following bibliography is divided into three sections each arranged chronologically: first, books illustrated by Matisse and for the most part produced under his supervision; second, books written by the artist's friends to whom he has presented a print or drawings; third, covers designed for magazines, books and exhibition catalogs.

Matisse's first illustrated book, the *Poésies de Stéphane Mallarmé* (1932), was commissioned by the Swiss publisher Albert Skira for whom the artist, at his own suggestion, later did the *Florilège des Amours de Ronsard* begun during the occupation and printed in 1948. His second volume, the American Limited Editions Club printing of Joyce's *Ulysses*, contains six soft-ground etchings, each accompanied by reproductions of preliminary drawings. With the exception of the Mallarmé and the Joyce, Matisse's other books have been designed during the past decade under the direction of the artist himself.

For E. Tériade, French editor of the magazine *Verve*, Matisse has illustrated *Les lettres portugaises* (Letters of a Portuguese Nun), his own book *Jazz*, and the *Poèmes de Charles d'Orléans*. The last two volumes reproduce in facsimile the artist's manuscript rendering of the text.

The *Pasiphaé* of Montherlant, illustrated with linoleum cuts, was published in 1944 by Martin Fabiani who a year previously had issued *Dessins: Thèmes et variations*, several series of drawings gathered together in a de luxe edition. The Reverdy *Visages* and the Rouveyre *Repli* combine full-page lithographs with smaller linoleum cut initials and ornaments.

The Baudelaire *Fleurs du mal* had been conceived with original lithographs as illustrations, but dry weather ruined the transfer paper on which Matisse had drawn and the printer was unable to pull adequate proofs. Fortunately photographs had been made of Matisse's drawings and these were reproduced for the book.

Matisse has often obliged friends and associates with drawings and prints for their books. Most interesting of these are the lithograph after Cézanne done for a Cézanne memorial published by Matisse's one-time dealer, Bernheim-Jeune, and the drawings contributed to Pierre Reverdy's and Tristan Tzara's volumes of poems.

Matisse's first magazine cover was designed in 1936 for *Minotaure.* Since then he has done four covers for *Verve, Transition,* and for the new revue *Roman.* A gala organized by the Paris newspaper *Ce Soir* occasioned the *Sainte Catherine* program. Matisse has also furnished covers for a booklet describing Skira's activity as a publisher, for his son-in-law Georges Duthuit's book on the fauve painters, and for catalogs of recent exhibitions of his work in Paris, Switzerland and Japan.

Most of Matisse's illustrations have been printed in Paris by Roger Lacourière for the etchings, the brothers Mourlot for the lithographs. The artist himself has briefly discussed his work as an illustrator, see pages 244-45, Appendix J and bibliography 46. Matisse's book illustrations are reproduced on pages 155, 180, 240, 245, 265, 268, 466-67, 494-501.

WILLIAM S. LIEBERMAN

Illustrations and further discussion of the more important books in the following list are included in this volume and may be found by consulting the index.

BOOKS ILLUSTRATED BY MATISSE

Poésies de Stéphane Mallarmé. Lausanne, Albert Skira et Cie., 1932. 29 etchings. Limited to 145 copies.

JAMES JOYCE, *Ulysses.* New York, The Limited Editions Club, 1935. Volume designed by George Macy. 6 etchings, each accompanied by 2-5 reproductions of preliminary drawings. Limited to 1500 copies.

HENRY DE MONTHERLANT, *Pasiphaé; Chant de Minos (Les Crétois).* Paris, Martin Fabiani, 1944. 18 full page linoleum cuts; also cover, linoleum cut ornaments and initials. Limited to 250 copies.

PIERRE REVERDY, *Visages.* Paris, Editions du Chêne, 1946. 14 full page lithographs; also cover, linoleum cut ornaments and initials. Limited to 250 copies.

ANDRÉ ROUVEYRE, *Repli.* Paris, Editions du Bélier, 1947. Volume designed by Matisse. 12 full page lithographs; also cover, linoleum cut ornaments and initials. Limited to 370 copies.

MARIANNA ALCAFORADO, *Les lettres portugaises.* Paris, Tériade, 1946. Volume designed by Matisse. 19 full page lithographs; also cover, lithograph ornaments and initials. Limited to 270 copies.

CHARLES BAUDELAIRE, *Les fleurs du mal.* Paris, La Bibliothèque Française, 1947. Volume designed by Matisse. 1 etching, 33 photo-lithographs, 69 wood engravings reproducing drawings; also cover, ornaments and initials. Limited to 320 copies.

HENRI MATISSE, *Jazz.* Paris, Tériade, 1947. Volume designed by Matisse. 152 pages of text and color stencils. Full and double page color stencil illustrations; text reproduces in facsimile the artist's handwriting; also cover. Limited to 270 copies. Also album of the 20 color stencils without text, limited to 100 copies.

Florilège des Amours de Ronsard. Paris, Albert Skira, 1948. Volume designed by Matisse. 126 lithographs consisting of full page illustrations and ornaments; also cover. Limited to 320 copies.

Poèmes de Charles d'Orléans. Paris, Tériade, 1950. Volume designed by Matisse. 100 pages of text and lithographs. Full page lithograph illustrations, lithograph ornaments for each page of text which reproduces in facsimile the artist's transcript of the poems; also cover. Limited to 1230 copies.

CONTRIBUTIONS OF PRINTS AND DRAWINGS

LOUIS THOMAS, *André Rouveyre.* Paris, Dorbon-aîné, 1912. Reproduces 1 drawing, portrait of Rouveyre, as frontispiece. Limited to 500 copies.

BERNHEIM-JEUNE ed., *Cézanne.* Paris, Bernheim-Jeune, 1914. Among prints by various artists, 1 lithograph by Matisse after a painting by Cézanne. Limited to 600 copies.

PIERRE REVERDY, *Les jockeys camouflés et période hors-texte.* Paris, printed by Paul Birault, 1918. Reproduces 5 drawings.

Limited to 105 copies. Also, another edition, published the same year, Paris, A la Belle Edition, limited to 343 copies.

FRANCIS CARCO, etc., *Tableaux de Paris.* Paris, Emile-Paul Frères, 1927. Among prints by various artists, 1 by Matisse. Limited to 225 copies.

TRISTAN TZARA, *Midis gagnés: Poèmes.* Paris, Editions Denoël, 1939. Reproduces 6 drawings. Limited to 1178 copies of which 28 contain in addition 1 drypoint. Also second edition, 1948, reproduces 8 drawings. Limited to 1000 copies of which 15 contain in addition 1 lithograph.

ELSA TRIOLET, *Le mythe de la Baronne Mélanie.* Neuchâtel and Paris, Ides et Calendes, 1945. Reproduces 2 drawings, 1 as cover. Limited to 5182 copies.

ANDRÉ MAURIAC, etc., *Alternance, textes inédits.* Paris, Le Gerbier, 1946. Among prints by various artists, 1 etching by Matisse. Limited to 340 copies.

TRISTAN TZARA, *Le signe de vie.* Paris, Bordas, 1946. Reproduces 6 drawings; also 1 lithograph as frontispiece. Limited to 540 copies.

ILIAZD (ILYA ZDANEVITCH) ed., *Poésies de mots inconnus.* Paris, the editor, 1949. Among prints by various artists, 1 linoleum cut by Matisse. Limited to 157 copies.

MAGAZINE, BOOK AND CATALOG COVERS

Minotaure (Paris, Albert Skira ed.), vol. 2, no. 9, October 1936

Verve (Paris, Tériade ed.), vol. 1, no. 1, December 1937

Verve, vol. 2, no. 8, September-November 1940

Verve, vol. 4, no. 13, 1945. Issued as *De la couleur: Henri Matisse;* also frontispiece and title page

Sainte Catherine 1946. Program organized by *Ce Soir*, Paris, November 25, 1946. 200 copies contain in addition 1 lithograph

JACQUES KOBER ed., *Les miroirs profonds: Henri Matisse.* Paris, Pierre à Feu, 1947. Also frontispiece; 999 copies contain in addition 1 linoleum cut and 1 lithograph

Verve, vol. 6, nos. 21-22, 1948. Issued as *Vence 1944-1948;* also frontispiece and page ornaments

Transition (Paris, Georges Duthuit ed.), no. 5, 1949

Albert Skira: Vingt ans d'activité. Paris and Geneva, Albert Skira, 1949. Also frontispiece portrait of the editor

GEORGES DUTHUIT, *Les fauves.* Geneva, Editions des Trois Collines, S. A. 1949.

Paris, Musée National d'Art Moderne, *Henri Matisse, Oeuvres récentes 1947-1948.* 1949 (exhibition catalog)

Lucerne, Musée des Beaux Arts, *Henri Matisse,* 1949 (exhibition catalog)

Paris, Maison de la Pensée Française, *Henri Matisse,* 1950 (exhibition catalog)

Roman, no. 1, January 1951. Saint Paul and Marseille. Pierre de Lescure and Célia Bertin, ed.

Tokyo, National Museum, *Henri Matisse,* 1951. Tokyo, Osaka, 1951. (Text in Japanese, exhibition catalog)

New York, Museum of Modern Art, *Henri Matisse,* 1951 (exhibition catalog)

APPENDIX H: HENRI MATISSE, "EXACTITUDE IS NOT TRUTH"

In October 1939 Matisse made a series of crayon drawings of his own face, four of which are reproduced on page 484. Eight years later in Vence Matisse picked out these four drawings for inclusion in his exhibition at the Philadelphia Museum of Art in 1948. Then, for the Philadelphia catalog, bibl. 152, he wrote a short homily on drawing and portraiture in which there is so much exactitude *and* truth that it is reprinted here in full, with the kind permission of the Museum.

The translation is by Esther Rowland Clifford.

EXACTITUDE IS NOT TRUTH

Among these drawings, which I have chosen with the greatest of care for this exhibition, there are four—portraits perhaps—done from my face as seen in a mirror. I should particularly like to call them to the visitors' attention.

These drawings seem to me to sum up observations that I have been making for many years on the characteristics of a drawing, characteristics that do not depend on the exact copying of natural forms, nor on the patient assembling of exact details, but on the profound feeling of the artist before the objects which he has chosen, on which his attention is focused, and the spirit of which he has penetrated.

My convictions on these matters crystallized after I had verified the fact that, for example, in the leaves of a tree—of a fig tree particularly—the great difference of form that exists among them does not keep them from being united by a common quality. Fig leaves, whatever fantastic shapes they assume, are always unmistakably fig leaves. I have made the same observation about other growing things: fruit, vegetables, etc.

Thus there is an inherent truth which must be disengaged from the outward appearance of the object to be represented. This is the only truth that matters.

The four drawings in question are of the same subject, yet the calligraphy of each one of them shows a seeming liberty of line, of contour, and of the volume expressed.

Indeed, no one of these drawings can be superimposed on another, for all have completely different outlines.

In these drawings the upper part of the face is the same, but the lower is completely different. In no. 158, it is square and massive; in no. 159, it is elongated in comparison with the upper portion; in no. 160, it terminates in a point; and in no. 161, it bears no resemblance to any of the others.

Nevertheless the different elements which go to make up these four drawings give in the same measure the organic makeup of the subject. These elements, if they are not always indicated in the same way, are still always wedded in each drawing with the same feeling—the way in which the nose is rooted in the face—the ear screwed into the skull—the lower jaw hung—the way in which the glasses are placed on the nose and ears—the tension of the gaze and its uniform density in all the drawings,—even though the shade of expression varies in each one.

It is quite clear that this sum total of elements describes the same man, as to his character and his personality, his way of looking at things and his reaction to life, and as to the reserve with which he faces it and which keeps him from an uncontrolled surrender to it. It is indeed the same man, one who always remains an attentive spectator of life and of himself.

It is thus evident that the anatomical, organic inexactitude in these drawings, has not harmed the expression of the intimate character and inherent truth of the personality, but on the contrary has helped to clarify it.

Are these drawings portraits or not?

What is a portrait?

Is it not an interpretation of the human sensibility of the person represented?

The only saying of Rembrandt's that we know is this: "I have never painted anything but portraits."

Is the portrait in the Louvre, painted by Raphael and showing Joan of Aragon in a red velvet dress, really what is meant by a portrait?

These drawings are so little the result of chance, that in each one it can be seen how, as the truth of the character is expressed, the same light bathes them all, and that the plastic quality of their different parts—face, background, transparent quality of the spectacles, as well as the feeling of material weight—all impossible to put into words, but easy to do by dividing a piece of paper into spaces by a simple line of almost even breadth—all these things remain the same.

Each of these drawings, as I see it, has its own individual invention which comes from the artist's penetration of his subject, going so far that he identifies himself with it, so that its essential truth makes the drawing. It is not changed by the different conditions under which the drawing is made; on the contrary, the expression of this truth by the elasticity of its line and by its freedom lends itself to the demands of the composition; it takes on light and shade and even life, by the turn of spirit of the artist whose expression it is.

L'exactitude n'est pas la vérité.

HENRI MATISSE
Vence, May, 1947.

APPENDIX I: MATISSE'S RADIO INTERVIEWS, 1942

Early in 1942 Matisse, while living in Nice, gave two interviews which were broadcast over the "Vichy" radio. The circumstances are discussed on page 258. Matisse sent transcripts of both broadcasts to Pierre Matisse in New York in a letter dated Nice, March 13, 1942. The broadcasts were given during the preceding two months. Excerpts are given below, translated by Marianne Hartog.

FIRST BROADCAST

Matisse began with some remarks about the influence of painters on popular vision and taste, then he answered the interlocutor's questions:

. . . Each human generation has seen through the eyes of the artists of the preceding generation. . . .

We have seen—after the rediscovery by modern artists of the emotional and decorative properties of lines and colors—how our department stores were invaded by materials decorated in endless medleys of color without any meaning. . . .

Finally all the eccentricities of commercial art were accepted (an extraordinary thing) because the public was very compliant and the salesman overawed them by saying when showing the goods: "This is modern."

Today the exaggerations have been quieted down. . . .

Why do you paint, M. Matisse?

To translate my emotions, my feelings and the reactions of my sensibility into color and design, something that neither the most perfect camera, even in colors, nor the cinema can do.

From the point of view of entertainment and distraction the movie has a great advantage over painted pictures. . . .

As for the portrait painters they are being outdone by the good photographers. . . .

After all this, what becomes of the artists? Of what use are they?

They are useful because they can augment color and design through the richness of their imagination intensified by their emotion and their reflection of the beauties of nature just as poets or musicians do.

Consequently we need only those painters who have the gift to translate their intimate feelings into color and design.

I have told my young students: "You want to paint? First of all you must cut off your tongue because your decision takes away from you the right to express yourself with anything but your brush."

To express yourself, how do you go about it?

A thorough study permits my mind to absorb the subject of my contemplation and to identify myself with it when ultimately I come to paint the canvas. This is done with the most elementary means: colors which have to be unmixed . . . so that their purity and brilliance will not be destroyed. I express myself only through their relationship. As for design I follow closely my inner feeling. Thus the intellectual part of my work is secondary and very little evident.

When do you consider a work finished?

When it reflects in a very exact way my emotion and I feel that there is nothing more to be added. . . .

Do you forget your works?

Never, although working every day for fifty years I have painted quite a few. . . .

Do you worry about the future of your works?

Since I am convinced that an artist has no greater enemies than his bad paintings, I do not release a painting or a drawing before I have made every possible effort; after that. . . . I have peace of mind. . . .

Remember that the advantage that painting has over the theatre is that future generations might repair the injustice of the generation in which the painting appeared, but in the theatre, if the play does not have an immediate success it may be buried for a very long time. As Debussy said, the theatre cannot afford glorious failures.

What memories do you have of your professors?

A single one among them counts for me: Gustave Moreau who turned out, among numerous students, some real artists. . . .

How do you explain the charm of your paintings of open windows?

Probably from the fact that for me the space from the horizon to the inside of the room is continuous and that the boat which passes lives in the same space as the familiar objects around me: the wall around the window does not create two worlds. . . .

Why does Nice hold you?

Because in order to paint my pictures I need to stay for a number of days under the same impressions and I cannot do that in any atmosphere but that of the Côte d'Azur.

The northern countries, Paris in particular, once they have developed the mind of the artist through the intense activity of their collective life and the richness of their museums, offer, I feel, an atmosphere too unstable for work.

SECOND BROADCAST

In speaking about "the prime position still held in the world by French independent artists," the interlocutor asked Matisse about the influence of the Prix de Rome, the rich scholarship for which students in the official Ecole des Beaux-Arts had competed annually since the end of the 17th century. Matisse answered:

Why do you mention the Prix de Rome? Let it die a beautiful death. The painters Manet, Degas, Claude Monet, Renoir, Cézanne have demonstrated its uselessness. Which artist's name among the Prix de Rome winners of the last fifty years can you put next to theirs? Albert Besnard? But he is a conventional painter who is hiding behind the palette of the Impressionists. The terrible Degas said: Besnard? Mais c'est un pompier qui prend feu.

There is not a foreign museum director or amateur who even knows of the existence of the Prix de Rome. There is not a student who has come to Paris to study painting who would think of going to the Beaux-Arts. Even picture postcards neglect its prize winners.

The interviewer led Matisse on: In your opinion, then, what are the reasons for this deficiency?

Undoubtedly the instruction given at the Beaux-Arts, the climax of which is the Rome competition, is deadly for the young artists. . . .

Because it forces them into the same cliché: believe it or not they are being taught to do a head, a bust, hands and feet in a limited amount of time, a "monstrous" procedure for the study of art. . . .

Because, manual dexterity alone counts.

Because, deprived of their instinct, their curiosity, the poor artists are turned into chronic invalids at a period of their lives, between 15 and 25 years, which determines their future. On the whole the milieu of the Beaux-Arts Prix de Rome is a mutual-aid society out of which nothing lasting has ever come. I have seen painters return from Rome quite desperate because they suddenly realized that they could not express themselves sincerely.

I repeat that the Rome competition must disappear because it is thoroughly sterile and even harmful. . . .

Has the management of the Beaux-Arts never held out a hand to the independent artists?

The management of the Beaux-Arts has never been interested in the independent painters. . . . It was the Prix de Rome alumni, members of the Institute, at the head of whom was Gérome, who refused half of the Caillebotte Bequest which contained the most beautiful pictures by Manet, Cézanne, Renoir and Pissarro. . . .

But now, M. Matisse, how can the State effectively take an interest in the young artists?

By starting free studios in which the young artists could receive criticism by masters of their choosing. Or, on the other hand, instead of all the privileges of the Prix de Rome and the support which the State gives the winners in the Salons, couldn't one give "traveling scholarships" to artists, who combine talent with strength of character, so that they could go in freedom to study abroad, or in our Colonies or even in France, anywhere they feel that there is a possibility to develop and enrich themselves? This, which seems obvious to me, isn't it going to come about some day?

APPENDIX J: HENRI MATISSE, "HOW I MADE MY BOOKS," 1946

In 1946 Matisse wrote some notes on his principles of design and illustration under the title *"Comment j'ai fait mes livres"* published by Skira in *Anthologie du livre illustré par les peintres et sculpteurs de l'école de Paris.* In referring to his books with lithographic illustrations such as the Ronsard, the *Lettres portugaises,* the Baudelaire *Les fleurs du mal,* and the Reverdy *Visages,* he wrote:

Though they differ in appearance they have all been done according to the same principles which are:

1 Rapport with the literary character of the work.

2 Composition conditioned by the elements employed according to their decorative values: black, white, color, style of engraving, typography. These elements are determined by the demands of harmony which arise during the actual progress of the work. They are never decided upon before the work is undertaken, but develop as inspiration indicates. . . .

I do not distinguish between the construction of a book and that of a painting, and I always work from the simple to the complex, yet always ready at any moment to reconceive in simplicity. Composing at first with two elements, I add a third insofar as it is needed to unite the first two in an enriched accord—I almost wrote "musical" accord.

I reveal my method of work without pretending that it is the only one; but mine develops naturally, progressively. . . .

I have forgotten a valuable precept: put your work back on the anvil twenty times over and then, in the present case, begin over again until you're satisfied.

BIBLIOGRAPHY

In his text and notes, the author makes frequent allusion to the items listed below referring to them by number. This compilation has thus been developed largely as a research bibliography, reflecting actual use and established by specific reference and quotation.

The several bibliographies on Matisse, noted in nos. 1-7, eliminate the necessity of a longer inventory here. Scheiwiller (no. 4c) is most detailed. Additional references, especially periodicals, are contained in the *Bibliographie der Kunst-wissenschaft* (Berlin, 1902-1920), in the *Répertoire d'Art et d'Archéologie* (1910-1941) and in *The Art Index* (1929-current). However, to increase the general usefulness of the bibliography, texts commonly available in American libraries have been introduced.

In addition to listing extant works, it seems important on the occasion of this publication to draw attention to major studies (bibl. 32b, 107, 209b) which may eventually be accessible to students of Matisse. Since the bibliography is classified rather than alphabetical, an index is provided for quick location of material assigned to different categories. Citations have been grouped as follows: *Bibliographies* (nos. 1-7), *General References* (nos. 8-39), *Writing by Matisse* (nos. 40-52), *Matisse Statements, Quotations, Letters & Interviews* (nos. 53-77), *Monographs* (nos. 78-93), *Reproductions and Folios* (nos. 94-107), *Catalogs: Collections, Exhibitions, Museums* (nos. 108-155), *Special Numbers* (nos. 156-164), *Articles and Miscellaneous References* (nos. 165-218). For illustrated books, drawings contributed to volumes, magazine and catalog covers, see Appendix G, p. 559.

BERNARD KARPEL
Librarian, The Museum of Modern Art

INDEX TO BIBLIOGRAPHY

Age Nouveau 204
Apollinaire 53, 166-166c
Aragon 102, 103, 146, 152
Armory Show 126, 187a, 191a
Art News 157, 157a
Art Présent 156
Art Sacré 157b
Asano 154
Ascher 166d
Asplund 158
Association of American Painters and Sculptors 126, 187a

Ballet Russe 166e
Baltimore Museum 109
Barnes 8, 78
Barr 3, 131, 131a, 167, 167a
Barry 72
Basel Kunsthalle 110
Basler 79, 167b
Bazin 5, 22
Becker 168
Bell 168a
Berenson 171
Bernier 168b
Bernheim de Villers 74a
Bernheim-Jeune Gallery 137
Bertin 169
Bertram 80
Besson 54, 81, 161
Bing Gallery 170
Block 172
Bolliger 21
Breeskin 172a-b
Brighton Gallery 112
Brummer 127, 127a
Brun 173

Brussels Palais 113
Buchanan 76
Buchholz Gallery 126a, 166d
Burgess 173a

Cahiers d'Art 158-158b, 174
Camera Work 159, 175
Carco 69
Carré Gallery 100a, 138
Cary 132, 132a
Cassarini 135
Cassou 22, 47, 100, 104, 104a, 156
Chamberlain 132-132b
Chroniques du Jour 159a
Chrysler 152a
Clark 192b
Clifford 49a, 152
Cogniat 140, 161
Cone 108, 109
Cooper 45
Copenhagen Glyptothek 114
Copenhagen Statens Museum for Kunst 115
Coquiot 9, 10
Courthion 60, 82, 82a
Couturier 157b
Craven 10a

DeKay 132, 132b
Dell 112
De Mazia 78
Denis 11
Desvallières 175a
Dorival 12
Druet Gallery 139
Du Bois 175
Dudley 176
Duthuit 13, 13a, 107, 177-179

Eddy 14
Einstein 15
Escholier 66, 83
Estienne 55

Faure 84
Fels 16, 84a
Fierens 158, 180
Flint 61
Francastel 17
Frank 165a
Frankfurter 157
Fry 85, 85a, 117, 158, 181-182
Furst 183

Galerie des Ponchettes 135
Gauss 18
Gazette des Beaux-Arts 140
George 96, 184-186
Gide 186a
Glaser 158
Goldwater 19
Grafton Gallery 116, 117
Greenberg 187
Gregg 187a
Grohmann 2, 158
Grünewald 86
Guéguen 158, 188
Guenne 57, 57a
Guillaume 185

Harriman Gallery 128, 128a
Hausen 188a
Hess, T. R. 157
Hess, W. 20
Hommage 160
Hoppe 21a, 56a

Howe 73
Huneker 132-132b
Huyghe 22, 23, 188b

Italiaander 189

Jedlicka 61a, 85

Kahnweiler 189a
Katzenbach & Warren 190
Kawashima 98a
Kimball 157, 191
Kober 87
Kuhn 191a
Kunstchronik 192
Kunstnernes Hus, Oslo 136

Lacaze-Carone 192a
Laprade 157b
Leicester Gallery 117a
Lejard 101, 105
Lipman 192b
Lucerne Museum 119

MacCarthy 116
MacChesney 56
Maeght Galerie 70a, 87
Maison de la Pensée Française 146
Malinque 106
Marchand 71
Marquet 202a
Martin 48a
Marx (Roger) 151
Mather 132a, 194
Matisse Gallery 129
McBride 88, 158, 193
Meier-Graefe 24, 195
Mercereau 196
Milan Comune 120
Montherlant 67, 67a
Montross Gallery 130
Mornand 25
Morse 197
Musée National d'Art Moderne 142-144
Museum of Modern Art 131-131b
Museum of Modern Western Art 121-124, 165

Neugass 198
Nice-Matin 173
Nicolson 199

Olivier 25a
Ozenfant 200

Pach 26, 201
Palme 201a
Palmer 97
Pertsov 202
Petit Gallery 145
Petit Palais, Paris 147
Philadelphia Museum 152
Photo-Secession Gallery 132-132b
Le Point 161, 202a
Poulain 156, 203
Puy 27, 28, 161
Purrmann 111, 188a, 204a-205

Quinn 133

Raynal 21
Rayssiguier 157b
Read 29
Régamey 157b
Rémond 157b
Rewald 29a-b, 205a
Roger-Marx 99, 206
Romains 84
Romm 89, 89a, 207
Rosenberg Gallery 148
Rump 115

Salles 158, 209
Salmon 22, 31
Salon d'Automne 150
Salon des Indépendants 149
San Lazzaro 30
Schacht 90
Schapiro 208
Scheiwiller 90a, 158
Schnerb 209a
Schniewind 209b
Scolari 40
Sembat 1, 91, 210
Sicre 74
Signac 31a

Skira 21, 32-32a, 211
Soby 190, 211a
Steegmuller 211b
Stein, G. 33, 64, 212
Stein, L. 34, 35
Stein, S. 53a
Sterling 5
Steuben Glass 212a
Svrček 98b
Swane 6, 92, 114, 136, 212b

Tériade 58, 63, 65, 77
Ternovetz 122
Tetzen-Lund 114a, 212b
Thannhauser Gallery 111
Thieme-Becker 2
Thomé 25
Time Magazine 213
Toison d'Or 125, 162
Tokyo National Museum 154
Transition 64
Tugendhold 121
"291" (Gallery) 132-132b
Tzara 98

Valentine Gallery 134
Vallotton 213a
Vaux 71a
Vauxcelles 140, 214, 215
Vence Chapel 72, 75, 106a, 157b, 168b, 169, 173, 189, 192a, 211b
Venice Biennale 155
Verve 163, 164
Victoria & Albert Museum 118
Vildrac 84, 94-95
Virginia Museum 152a
Vollard 151, 215a

Watson 216
Weill 35a
Werth 84
Westheim 55
Wheeler 36
Wilenski 37
Wright 38

Zervos 39, 93, 98, 158, 217, 218
Zolotoye Runo 125, 162

BIBLIOGRAPHIES

1 SEMBAT, MARCEL. Matisse et son oeuvre. 1920. *See bibl. 91*

2 GROHMANN, WILL. Henri Matisse. In Thieme, U. & Becker, F. Allgemeines Lexikon der bildenden Künstler. 24:248-9 Leipzig, Seeman, 1930

3 BARR, ALFRED H., JR. Henri Matisse. p40-42 New York, Museum of Modern Art, 1931. *A brief record of the most important books and articles in English, French and German*

4 SCHEIWILLER, GIOVANNI. Henri Matisse. p14-24 1933. *An extensive "nota bibliografica," successively enlarged in the following editions*

4a SCHEIWILLER, GIOVANNI. Henri Matisse. p14-26 1939

4b VALSECCHI, MARCO. Disegni di Henri Matisse. p13-30 1944

4c SCHEIWILLER, GIOVANNI. Henri Matisse. 5. ed. p14-32 Milano, Hoepli, 1947. *Arte moderna straniera, n. 3*

5 STERLING, CHARLES & BAZIN, GERMAIN. Matisse [notice biographique et bibliographique] L'Amour de l'Art 14 no.5: 110-12 May 1933. *Also in bibl. 22*

6 SWANE, LEO. Henri Matisse. p155-64 Stockholm, Nordstedt, 1944. *See bibl. 92*

7 KARPEL, BERNARD. Bibliography on the fauvist painters. In DUTHUIT, GEORGES. The fauvist painters. p102-115 New York, Wittenborn, Schultz, 1950. *Includes section on exhibitions (p115-122); partly published in bibl. 13a, 21*

GENERAL REFERENCES

8 BARNES, ALBERT C. The art in painting. p312-16, 498-502 et passim ill New York, Harcourt Brace, 1925

9 COQUIOT, GUSTAVE. Cubistes, futuristes, passéistes. p102-11 ill Paris, Ollendorf [1914]. *Modified edition, 1923*

10 COQUIOT, GUSTAVE. Les Indépendants, 1884-1920. ill Paris, Ollendorf [1920]

10a CRAVEN, THOMAS. Modern art. p160-76 New York, Simon and Schuster, 1934

11 DENIS, MAURICE. Théories 1890-1910. 4. ed. Paris, Rouart et Watelin, 1920. *First edition, 1912. Essays previously published including: Liberté, épuisante et stérile. La Grande Revue Apr. 10, 1908; La réaction nationaliste. L'Ermitage May 15, 1905, etc. Partly quoted here, p.63-64*

12 DORIVAL, BERNARD. Le fauvisme et le cubisme (1905-1911), vol. 2. Paris, Gallimard, 1944. *Bibliography*

13 DUTHUIT, GEORGES. The fauvist painters. ill (col pl) New York, Wittenborn, Schultz, 1950. *Documents of modern art, 11. Bibliographical details noted in bibl. 7*

13a DUTHUIT, GEORGES. Les fauves. ill (col pl) Genève, Trois Collines, 1949. *Revision of bibl. 177, issued in folio edition; translated in bibl. 13; bibliography, p237-45*

14 EDDY, ARTHUR JEROME. Cubists and post-impressionism. p33-49 ill Chicago, McClurg, 1914. *Second edition, 1919; bibliography*

15 EINSTEIN, CARL. Die Kunst des 20. Jahrhunderts. 2. Aufl. p24-33, 191-206, 557 Berlin, Propyläen, 1923. *Other editions, 1926, 1931*

16 FELS, FLORENT. L'Art vivant de 1900 à nos jours. p151-218 ill Genève, Cailler, 1950

17 FRANCASTEL, PIERRE. Nouveau dessin, nouvelle peinture: l'école de Paris. p120-34 ill Paris, Librairie de Médicis, 1946. *Bibliography*

18 GAUSS, CHARLES EDWARD. Tne aesthetic theories of French artists, 1855 to the present. Baltimore, Johns Hopkins, 1949. *Bibliography*

19 GOLDWATER, ROBERT. Primitivism in modern painting. p74-85 New York & London, Harper, 1938. *Bibliography*

20 HESS, WALTER. Die Farbe in der modernen Malerei. Selbtszeugnisse französischer und deutscher Maler zum Problem der Farbe seit Cézanne, p.88-89 München, Universität München, 1950. *Mimeographed edition; bibliography.*

21 HISTORY OF MODERN PAINTING. [Vol. 2]: Matisse, Munch, Rouault; fauvism, expressionism. Text and documentation by M. Raynal, A. Rüdlinger, H. Bolliger, J. Lassaigne. p17-31, 44-59, 139-41, 148 col pl Geneva, Skira, 1950. *German edition with enlarged bibliography by Hans Bolliger*

21a HOPPE, RAGNAR. Städter och konstnarer: resebrev och essaer om konst. p193-225 ill Stockholm, Bonnier, 1931

22 HUYGHE, RENÉ, ed. Histoire de l'art contemporain: la peinture. . . . Documentation réunie par Germain Bazin. p97-276 ill Paris, Alcan, 1934. *Previously published in L'Amour de l'Art (v. 14, 1933) with articles by R. Huyghe, A. Salmon, J. Cassou*

23 HUYGHE, RENÉ. La peinture française: les contemporains. Notices biographiques par Germain Bazin. nouv. ed. ill (col pl) Paris, Tisné, 1949. *Bibliography. First edition issued 1939 in English and French*

24 MEIER-GRAEFE, JULIUS. Entwicklungsgeschichte der modernen Kunst. v. 3, p621-6 Monaco, 1927

25 MORNAND, PIERRE & THOMÉ, J.-R. Vingt artistes du livre. p205-20 ill Paris, Le Courrier Graphique, 1950. *Bibliography*

25a OLIVIER, FERNANDE. Picasso et ses amis. p107-9 Paris, Stock, 1933

26 PACH, WALTER. Queer thing, painting. New York, Harper, 1938

27 PUY, MICHEL. Le dernier état de la peinture. 2. ed. p33-46 Paris, Le Feu, Union française d'édition [1911]

28 PUY, MICHEL. L'effort des peintres modernes. p61-78 Paris, Messein, 1933

29 READ, HERBERT. Art now. rev. ed. p67-72 London, Faber and Faber, 1948. *First edition, 1933 (London), 1934 (New York)*

29a REWALD, JOHN. The history of impressionism. ill New York, Museum of Modern Art, 1946. *Bibliography p446-63; translation published by Sansoni (Firenze, 1949)*

29b REWALD, JOHN. The history of post-impressionism. ill New York, Museum of Modern Art, distributed by Simon and Schuster [in progress]. *Scheduled for publication late 1952*

30 SAN LAZZARO, GUALTIERI DI. Painting in France, 1895-1949. ill New York, Philosophical Library; London, Harvell Press, 1949. *Revision of Cinquant' anni di pittura moderna in Francia (Roma, Danesi, 1945)*

31 SALMON, ANDRÉ. La jeune peinture française. p9-40 Paris, Messein, 1912

31a SIGNAC, PAUL. d'Eugène Delacroix au néo-impressionisme. nouv. ed. Paris, Floury, 1911. *Published serially in La Revue Blanche*

32 SKIRA, ALBERT, ED. Anthologie du livre illustré par les peintres et sculpteurs de l'école de Paris. p. xxi-xxiii, 74-76 ill Genève, Skira, 1946. *Includes bibl. 46*

32a SKIRA, ALBERT (PUBLISHER). History of modern painting. *See bibl. 21*

32b SKIRA, ALBERT (PUBLISHER). Matisse. Genève, Skira [in progress?] *Initially announced as monograph by Aragon with numerous color plates*

33 STEIN, GERTRUDE. The autobiography of Alice B. Toklas. ill New York, Harcourt, Brace, 1933

34 STEIN, LEO. Appreciation: painting, poetry, and prose. New York, Crown, 1947

35 STEIN, LEO. Journey into the self. Edited by Edmund Fuller. New York, Crown, 1950

35a WEILL, BERTHE. Pan! dans l'oeil! ill Paris, Lipschutz, 1933

36 WHEELER, MONROE, ED. Modern painters and sculptors as illustrators. 3. ed. rev. New York, Museum of Modern Art, 1946. *Bibliography; first edition, 1936*

37 WILENSKI, REGINALD H. Modern French painters. ill New York, Reynal & Hitchcock [1940]. *Other editions: 1944 (color plates), 1949 (revised)*

38 WRIGHT, WILLARD H. Modern painting, its tendency and meaning. p222-36 ill New York & London, John Lane, 1915

39 ZERVOS, CHRISTIAN. Histoire de l'art contemporain. p113-84 ill Paris, Cahiers d'Art, 1938

WRITINGS BY MATISSE

40 Notes d'un peintre. La Grande Revue 52no.24: 731-45 Dec 25 1908. *Complete English translation by Margaret Scolari in Museum of Modern Art 1931 catalog (bibl. 131) as well as here, p.119-23. Separately published under French title by Scheiwiller (Milano, All'Insegna del Pesce d'Oro, 1942) Russian translation in bibl. 162; German translation in Kunst und Künstler 7:335-47 1909. Frequently reprinted in whole or part (bibl. 4c, 7).*

40a [Autobiographical note] Formes no. 1:11 Jan. 1930

41 Dva pisma [Two letters on the Barnes murals]. Iskusstvo no.4:199-203 1934

41a On modernism and tradition. The Studio 9 no.50: 236-9 May 1935. *"Henri Matisse on modernism and tradition," simultaneously published in London Studio 109 no. 506*

42 Divagations. Verve 1no.1: 81,84 Dec. 1937. *Illustrations, p. 80-84.*

43 Notes d'un peintre sur son dessin. Le Point no.21: 104-10 July 1939. *Also published in bibl. 100a*

44 [Statement]. Verve 4no.13:9-10 Dec. 1945. *Untitled article on painting and painters translated in bibl. 45*

45 Observations on painting. Horizon 13no.75:185-7 Mar. 1946. *Translation by Douglas Cooper, bibl. 44*

46 Comment j'ai fait mes livres. In Anthologie du livre illustré par les peintres et sculpteurs de l'école de Paris. p.xxi-xxiii 1946 (bibl. 32). *Partly quoted here, p.244-5, 271, 563*

47 Le Chemin de la couleur. ill Art Présent no.2: 23 1947. *Accompanied by Jean Cassou essay, p30-34: La pensée de Matisse*

48 Jazz. Paris, Editions Verve, 1947. *"Cet album contient la suite des vingt planches au livre manuscrit Jazz de Henri Matisse." Texts also published in bibl. 48a, 142*

48a Jazz.[8]p 2 col. inserts Stuttgart, Gerd Hatje [194?]. *Reprint of text from bibl. 48; list of illustrated books; note by K. Martin*

49 Exactitude is not truth. In Philadelphia Museum of Art. Henri Matisse. p33-34 1948 (bibl 152). *Dated Vence, May 1947; reprinted here, p.561*

49a Letter from Matisse (to Henry Clifford). In Philadelphia Museum of Art. Henri Matisse. p15-16 1948 (bibl. 152). *Also in bibl. 142*

50 Henri Matisse vous parle. Traits no.8: [5] Mar 1950. *"Un article inédit."*

51 La Chapelle du Rosaire. In Chapelle du Rosaire des Dominicaines de Vence. [4]p 1951 (bibl. 106a). *Also in bibl. 173; translated here, p.288*

52 Le Texte[Preface to catalog]. In Tokyo. National Museum. Henri Matisse. p[1] 1951. *See bibl. 154*

52a [Letter]. In L'Art Sacré no.11-12: [2-3] 1951 (bibl. 157b). *Message to Bishop of Nice; reprinted in bibl. 173; quoted here p.287*

MATISSE STATEMENTS, QUOTATIONS, LETTERS & INTERVIEWS

53 APOLLINAIRE, GUILLAUME. Henri Matisse. La Phalange 2no.18 Dec. 1907. *Frequently republished (bibl. 166); translated here, p.101-2*

53a STEIN, SARAH. A great artist speaks to his students. Recorded in 1908. [Typescript, 1908] *Notes from the "Académie Matisse"; reprinted here, p.550-2*

54 MATISSE, HENRI. Matisse [statement on photography]. Camera Work no.24:22 Oct 1908. *G. Besson conducts interviews on pictorial photography*

55 ESTIENNE [CHARLES?] Gespräch mit Henri Matisse. In WESTHEIM, PAUL. Künstlerbekenntnisse. p140-3 Berlin, Propyläen [1925]. *Translated from a series published in Les Nouvelles, 1909*

56 MacCHESNEY, CLARA T. A talk with Matisse, leader of post-impressionists. New York Times Mar 9 1913. *Interview on the occasion of the Armory show; partly reprinted in bibl. 14; quoted in part here, p.146*

56a HOPPE, RAGNAR. På visit hos Matisse (1920). In his Städter och konstnarer. p193-9 1931. *See bibl. 21a*

57 GUENNE, JACQUES. Entretien avec Henri Matisse. ill L'Art Vivant no.18:1-6 Sept 15 1925. *Also published in bibl. 57a*

57a GUENNE, JACQUES. Portraits d'artistes. p123-7 Paris, Seheur, 1925. *Interview (bibl. 57)*

58 TÉRIADE, E. Entretien avec E. Tériade. L'Intransigeant Jan 14, 22, 1929. *Also bibl. 163*

59 MATISSE, HENRI. Confrontations. Formes 1 no.1:11 Jan 1930. *Extracts from statements, 1908-1929*

60 COURTHION, PIERRE. Rencontre avec Matisse. Les Nouvelles Littéraires June 27 1931

61 FLINT, RALPH. Matisse gives an interview on eve of sailing. Art News 29:3 Jan 3 1931

61a JEDLICKA, GOTTHARD. Begegnungen mit Henri Matisse. In his Begegnungen: Künstlernovellen. p102-26 port Basel, Benno Schwabe, 1933. *Also second edition: Erlenbach-Zürich, Rentsch [1945]*

62 Matisse speaks (editorial). Art News 31 no.36:8 June 3 1933

63 TÉRIADE, E. [Propos de Henri Matisse]. Minotaure 1no.3-4:10 1933. *A summary included in article "Emancipation de la peinture"; also reprinted in bibl. 163*

64 Testimony against Gertrude Stein. 15p The Hague, Servire press, 1935. *A supplement, pamphlet no. 1, to Transition no.23 1934-5*

65 TÉRIADE, E. [Propos de Henri Matisse à Tériade]. Minotaure 2no.9:3 Oct 15 1936. *Quotations in article "Constance du fauvisme"; reprinted partly in bibl. 163*

66 ESCHOLIER, RAYMOND. Henri Matisse. p30-1, 77-8, 88, 91-2, 97, 138, 141, 168 Paris, Floury, 1937. *Quotations based on notes written by Matisse, 1936-37*

67 MATISSE, HENRI. Montherlant vu par Matisse. Beaux-Arts 75 n. s. 243:1-2 Aug 27 1937. *Text supplied by J. C. Huppert*

67a MONTHERLANT, HENRY DE. En écoutant Matisse. L'Art et les Artistes 33no.189: 336-9 July 1938

68 MATISSE, HENRI. In the mail. In FIRST PAPERS ON SURREALISM. p[25-6] New York, Coordinating council of French relief societies, 1942. *Extracts from letters to Pierre Matisse, dated Sept 18 1940, June 7 1942*

68a MATISSE, HENRI. [Two radio interviews]. 1942. *Broadcasts over Radio "Vichy" France; first in early 1942, second winter 1942; partly quoted here, p.562*

69 CARCO, FRANCIS. Souvenir d'atelier: conversation avec Matisse. Die Kunst-Zeitung (Zürich) no.8 Aug 1943. *Swane (bibl. 6) also refers to another "Conversation" in L'Ami des Peintres (Genève, 1944) which may be identical*

70 MATISSE, HENRI. Océanie: tenture murale. Labyrinthe 2no.22-3:3 Dec 1946. *"Fragment d'une lettre"*

70a Témoignages de peintres. Derrière Le Miroir (Paris) p[2,6,7] Dec 1946. *"A propos de notre exposition: Le noir est une couleur," Galerie Maeght*

71 MARCHAND, ANDRÉ. L'Oeil [a visit with Matisse]. In KOBER, JACQUES, ed. Henri Matisse. p51-3 1947. *See bibl. 87*

71a MATISSE, HENRI. [Letter to Marc Vaux, July 5 1948]. Carrefour des Arts no.3:3 Summer 1948. *On "la nuit de Montparnasse"*

72 BARRY, JOSEPH A. Matisse turns to religious art. ill (port) New York Times Magazine p8, 24 Dec 26 1948

73 HOWE, R. W. Half-an-hour with Matisse. Apollo 49:29 Feb. 1949

73a MATISSE, HENRI. [Statement]. Transition Forty-Nine no.5:117-20 1949. *Questionnaire by Les Lettres Françaises on "art and the public" (1946)*

74 SICRE, JOSÉ GÓMEZ. [Unpublished interview]. Summer 1949. *Conversation recorded by an associate, corrected by Matisse*

74a [MATISSE, HENRI]. [Memoir]. In BERNHEIM DE VILLERS, GASTON. Little tales of great artists. p64-5 Paris, Quatre Chemins; New York, E. Weyhe, 1949. *French edition, Bernheim-Jeune, 1940*

75 [MATISSE, HENRI]. What I want to say; work on the Dominican chapel at Vence. Time 54:70 Oct 24 1949

76 BUCHANAN, D. W. Interview in Montparnasse. ill Canadian Art 8no.2:61-5 1950

77 TÉRIADE, E. Matisse speaks. ill Art News 50no.8:40-71 Nov 1951. *Art News Annual no. 21*

MONOGRAPHS

77a ARAGON, LOUIS. Henri Matisse dessins: thèmes et variations. 1943. *See bibl. 102*

78 BARNES, ALBERT C. & DE MAZIA, VIOLETTE. The art of Henri-Matisse. 464p incl 151 ill New York, Scribner, 1933

79 BASLER, ADOLPHE. Henri Matisse. 16p plus 52 ill (col front) Leipzig, Klinkhardt & Biermann, 1924. *Also published in Jahrbuch der Jungen Kunst 2:16-20 1921, Der Cicerone no.21:1001-5 Nov 1921*

80 BERTRAM, ANTHONY. The world's masters: Henri Matisse. 8p plus 24 ill London, Studio; New York, W. E. Rudge, 1930

81 BESSON, GEORGE. Matisse. [12]p plus 60 ill Paris, Braun, 1945. *Brief text (French, English, German); works selected by the artist, other editions (1943 etc.)*

82 COURTHION, PIERRE. Henri-Matisse. 58p ill Paris, Rieder, 1934

82a COURTHION, PIERRE. Le visage de Matisse. [135]p ill (col pl) Lausanne, Marguerat, 1942. *Originally issued as "Henri Matisse 1942" Formes et Couleurs no.2:3-26 1942*

83 ESCHOLIER, RAYMOND. Henri Matisse. 180p 68 ill (col pl) Paris, Floury, 1937. *Notes by Matisse (bibl. 66)*

84 FAURE, ELIE. Henri Matisse par Elie Faure—Jules Romains—Charles Vildrac—Léon Werth. 53p plus 70 pl. Paris, Cahiers d'Aujourd'hui, Chez Crès et Cie. [1920]. *New revised edition, 1923*

84a FELS, FLORENT. Henri-Matisse. [50]p ill pl Paris, Chroniques du Jour, 1929

85 FRY, ROGER. Henri Matisse. [50]p ill pl Paris, Chroniques du Jour; New York, E. Weyhe [1930]. *Same plates issued for similar editions, French by Florent Fels (bibl. 84a), German by Gotthard Jedlicka (1930), English by Roger Fry (1930); 38 ill, 40 pl, 4 color pl*

85a FRY, ROGER. Henri Matisse. 25p ill pl London, Zwemmer; New York, E. Weyhe, 1935. *Same text as 1930 edition, with substantial changes in ill; 60 plates, 7 drawings, 2 mounted color plates, folding color plate*

86 GRÜNEWALD, ISAAC. Matisse och expressionismen. 200p ill. Stockholm, Wahlström & Widstrand, 1944

87 KOBER, JACQUES, ED. Henri Matisse. [88]p ill Paris, Pierre à Feu, 1947. *Miniature edition of "Les miroirs profonds" (Galerie Maeght). Contributions include essay by Aragon: "Matisse où les semblances fixées."*

88 McBRIDE, HENRY. Matisse. 29p plates (col front) New York, Knopf, 1930. *Includes "addenda" from The New York Sun: Oct. 1927, Jan. 7, 1928*

89 ROMM, ALEXANDRE. Henri Matisse. Translated by Chen I-Wan. 74p ill Leningrad, Ogiz-Izogiz, 1937. *Russian text published in Moscow (1935), preceded by bibl. 207; bibliography; translated 1947 (bibl. 89a)*

89a ROMM, ALEXANDRE. Matisse, a social critique. Translated by Jack Chen. 96p ill (col pl) New York, Lear, 1947. *"To this edition 20 new drawings have been added"*

90 SCHACHT, ROLAND. Henri Matisse. 80p ill Dresden, Kaemmerer, 1922

90a SCHEIWILLER, GIOVANNI. Henri Matisse. 5.ed 32p ill Milano, Hoepli, 1947. *Bibliography; other editions noted in bibl. 4-4c*

91 SEMBAT, MARCEL. Matisse et son oeuvre. 63p ill Paris, Nouvelle Revue Française, 1920. *Peintres français nouveaux, 1; bibliography*

92 SWANE, LEO. Henri Matisse. 165p ill Stockholm, Nordstedt, 1944. *Contributions by T. Bjurström, H. Sörensen, S. Ullman; classified bibliography, p155-64*

93 ZERVOS, CHRISTIAN, ED. Henri Matisse. 96p ill Paris, Cahiers d'Art; New York, E. Weyhe, 1931. *English version, with different pagination, additional illustrations and plates in collotype. Contributions by P. Fierens, P. Guéguen, G. Salles, R. Fry, H. McBride, W. Grohmann, K. Asplund, G. Scheiwiller, G. Apollinaire, and the editor*

REPRODUCTIONS AND PORTFOLIOS

94 MATISSE, HENRI. Cinquante dessins par Henri-Matisse. 8p 50 plates Paris, Bernheim-Jeune, 1920. *"Album édité par les soins de l'artiste." Limited edition with original etching. Preface by Charles Vildrac*

95 VILDRAC, CHARLES. Nice 1921, seize reproductions d'après les tableaux de Henri-Matisse. [3]p plus 16 plates Paris, Bernheim-Jeune, 1922

96 GEORGE, WALDEMAR. Dessins de Henri Matisse. 18p plus 64 plates Paris, Quatre Chemins [1925]

97 PALMER, MILDRED. Henri Matisse. 1p plus 12 plates New York, Arts Publishing Corp. [1927?]. *Edited by Forbes Watson for Arts Portfolio series*

98 ZERVOS, CHRISTIAN, ED. Dessins de Matisse, 1936. [8]p plus 36plates Paris, Cahiers d'Art, 1936. *Special number of Cahiers d'Art, 11no.3-5: 69-148; includes essay by Zervos "Automatisme et espace illusoire" and poem "A Henri Matisse" by T. Tzara*

98a KAWASHIMA, R. Matisse. [14]p plus 36 plates (6 col) Tokyo, Atelier-Sha, 1936

98b SVRČEK, J. B. Henri Matisse. 30p incl ill (1 col) Prague, Melantrich, 1937

99 ROGER-MARX, CLAUDE. Les dessins de Henri Matisse. [6]p plus 30 plates Paris, Braun [1939] *Galerie d'estampes, 5*

100 CASSOU, JEAN. Matisse. 14p plus 24 col plates Paris, Braun, 1939 *Couleurs des maîtres, 1; English edition, New York, Tudor, 1939; also bibl. 104*

100a MATISSE, HENRI. [Dessins. 30 plates] Paris, Galerie Louis Carré, 1941. *De luxe album, reproductions of exhibited works (bibl. 138), Matisse notes on drawing (bibl. 43)*

101 LEJARD, ANDRÉ. Matisse: seize peintures, 1939-1943. 7p plus 16 col plates (in folio) Paris, Editions du Chêne, 1943. *Also issued as "Peintures, 1939-1946" (Paris, 1946) and with introduction by Denys Sutton (London, L. Drummond, 1946)*

102 ARAGON, LOUIS. Henri Matisse dessins: thèmes et variations; précédés de "Matisse-en-France" par Aragon. 39p plus 159 plates [Paris], M. Fabiani, 1934. *Limited edition, 950 copies in portfolio; 170 drawings*

103 ARAGON, LOUIS. Apologie du luxe. 8p plus 16 col plates Genève, A. Skira, 1946

104 CASSOU, JEAN. Paintings and drawings of Matisse. 12p plus 24 col plates Paris, Braun; New York, Tudor, 1948

104a CASSOU, JEAN. Matisse. 24p incl col plates London, Faber & Faber [1948]. *Issued in New York as "The Pitman Gallery"*

105 LEJARD, ANDRÉ. Matisse. 15p plus 20 col plates New York, Continental Book Center [1948?]. *Also French edition: Bibliothèque Aldine des Arts, no.4 (Paris, F. Hazan, 1948)*

106 MALINQUE, MAURICE. Matisse dessins. 16p plus 96 ill Paris, Editions des Deux Mondes, 1949. *Works selected by the artist*

106a MATISSE, HENRI. Chapelle du Rosaire des Dominicaines de Vence. [46]p incl ill Vence [La Chapelle du Rosaire] 1951. *Picture book preceded by statement, bibl. 51*

107 DUTHUIT, GEORGES & DUTHUIT-MATISSE, MARGUERITE. Le catalogue de l'oeuvre complète d'Henri Matisse. [in progress] *Announced in bibl. 119 as "en préparation"*

CATALOGS: COLLECTIONS, EXHIBITIONS, MUSEUMS

A selected list of exhibitions is noted by Swane (bibl. 6), whereas Scheiwiller (bibl. 4c) gives an extensive record of catalogs. Representative fauve exhibitions have been analyzed in Duthuit (bibl. 7); lists of Matisse exhibitions are published in Chroniques du Jour (bibl. 159a) and Sterling-Bazin (bibl. 5). Recorded below are *public collections* (bibl. 105, 109, 115, 121-124, 131a, 143); *private collections* (bibl. 108, 114a, 115, 133, 136, 141, 152a); *general exhibitions* (bibl. 112, 116, 117, 125, 126, 126a, 128, 137a, 140, 144, 147, 149, 150, 155); and *one-man exhibitions* (bibl. 110, 111, 113, 114, 115a, 117a, 118, 119, 120, 127, 127a, 128a, 129, 130, 131, 131b, 132, 132a-b, 134, 135, 137, 138, 139, 142, 144, 145, 146, 148, 151-154).

108 BALTIMORE. CONE COLLECTION. The Cone collection of Baltimore, Maryland. Catalogue of paintings—drawings—sculpture of the nineteenth and twentieth centuries. plates 71-123 Baltimore, Etta Cone, 1934

109 BALTIMORE. MUSEUM OF ART. Cone bequest number. . . . Catalogue. 32p ill 1949. *Special number Baltimore Museum of Art News, 13 no. 1:1-32 Oct. 1949. Texts by D'Arcy Paul, G. Boas, A. D. Breeskin. Matisse works: no 26-66, 109-126, also drawings*

110 BASLE. KUNSTHALLE. Henri-Matisse, 9 August—15 September. 23p plus ill 1931. *127 works, includes extracts from "Notes de l'artiste (1908 et 1929)"*

111 BERLIN. THANNHAUSER GALLERY. Henri Matisse, mit Geleitwort von Hans Purrmann und 64 Abbildungen. 80p ill Berlin, Luzern, 1930. *Exhibit held Feb. 15-Mar. 19, listing 265 works*

112 BRIGHTON. PUBLIC ART GALLERIES. Catalogue of an exhibition of the work of modern French artists, June 16 to August 31st. 36p 1910. *Matisse, nos. 133, 138; preface by Robert Dell*

113 BRUSSELS. PALAIS DES BEAUX-ARTS. 24 oeuvres de Henri Matisse. [32]p ill port. Bruxelles, Editions de la Connaissance, 1946. *Exhibited May; preface by Jean Cassou*

114 COPENHAGEN. NY CARLSBERG GLYPTOTHEK. Henri Matisse. 26p ill 1924. *89 works in September exhibition; introduction by L. Swane*

114a COPENHAGEN. TETZEN-LUND COLLECTION. Katalog over Chr. Tetzen-Lund samling af moderne fransk malerkunst. [71]p ill København, 1934. *Foreword by O. Thomsen; limited edition (100 copies)*

115 COPENHAGEN. STATENS MUSEUM FOR KUNST. Katalog over J. Rumps samling af moderne fransk kunst. Anden udgave 146p ill København, 1948. *First edition, 1929*

115a HAMBURG. SERVICE DES RELATIONS ARTISTIQUES DER FRANZÖSISCHEN HOHEN KOMMISSION. [Ausstellung Matisse.] Spring?1951. *No catalog available; described in Kunstwerk 5nr.1:53 1951; planned for circulation in Düsseldorf (Apr. 14-May 6) and other German cities*

116 LONDON. GRAFTON GALLERIES. Manet and the post-impressionists, Nov. 8th to Jan. 15th 1910-11 (under revision). 38p London, Ballantyne [1910]. *Matisse represented by paintings, drawings, sculptures. "The post-impressionists," p7-13, is unsigned preface written by Desmond MacCarthy from notes by Roger Fry. Partly quoted here, p.111*

117 LONDON. GRAFTON GALLERIES. Second post-impressionist exhibition, Oct. 5-Dec. 31, 1912. 53p plus ill London, Ballantyne, 1912. *Preface by Roger Fry: "The French group," color frontispiece by Matisse; exhibited works included paintings, sculptures, graphics.*

117a LONDON. LEICESTER GALLERIES. [Matisse exhibitions] 1919, 1928, 1936. *"Pictures by Henri-Matisse," Nov-Dec 1919, 51 works, including prints, preface by G. Apollinaire (bibl. 166c).—"Drawings, etchings and lithographs by Henri-Matisse," Jan 1928, 100 works.—Drawings, Feb? 1936 (reviewed bibl. 179)*

118 LONDON. VICTORIA & ALBERT MUSEUM. Exhibition of paintings by Picasso and Matisse. Dec 1945. *Lists 30 Matisse works; foreword by C. Zervos; sponsored by the British Council and the Association Française*

119 LUCERNE. MUSÉE DES BEAUX-ARTS. Henri Matisse, 9 juillet-2 octobre. 51p ill 1949. *308 works (1890-1946); texts by Jean Cassou and H. L. Landolt*

120 MILAN. COMUNE DI MILANO. Mostra di Matisse. [4]p col cover 1950. *Exhibit held Nov 1-21; 34 paintings, 6 drawings, 8 lithographs; preface by R. Cogniat*

121 MOSCOW. MUSEUM OF MODERN WESTERN ART. First museum of modern western art. Text by F. Tugendhold. p65-76 ill (col pl) Moscow, 1923. *Text in Russian; illustrations superior to 1928 catalog*

122 MOSCOW. MUSEUM OF MODERN WESTERN ART. Catalogue illustré. 123p ill 1928. *Matisse: plate 13; nos. 306-58. Russian text with French title page, preface and captions. Comments on amalgamation of S. I. Stchoukine, I. A. Morosov and M. I. Morosov collections by M. B. Ternovetz, director*

122a ———— Liste des oeuvres de Matisse existantes au Musée d'art occidental à Moscou. Bulletin de la Société de l'Histoire de l'Art Français p278-80 1928. *See also bibl. 165*

123 MOSCOW. MUSEUM OF MODERN WESTERN ART. Thirty-five selected masterpieces from the Museum of western art in Moscow. New York, Graphic Society [1935?]. *First album, possibly printed by Ogiz-Izogiz (Moscow). Note by R. Rolland dated "Moscow, June 29, 1935." Nos. xxiii-xxv by Matisse. Reproductions in color accompanied by Russian text; captions in English and French*

124 MOSCOW. MUSEUM OF MODERN WESTERN ART. Musée de l'art occidental moderne à Moscou. Moscou, Editions d'état ART, 1938. *Second album, probably printed by Ogiz-Izogiz (Moscow). Introduction and list of 32 color plates. Nos. xxviii-xxx by Matisse. Each plate accompanied by letterpress*

125 MOSCOW. TOISON D'OR (ZOLOTOYE RUNO). Salon de la Toison d'Or. 1908. *Special no. 7-9, 1908: Revue du "Salon de la Toison d'Or." Text in Russian, contents and captions in French. Includes 94 reproductions of French paintings (3 Matisse), 10 installation views of the French section, article by C. Morice "Nouvelles tendances de l'art français." Additional Matisse references in no. 2-3 1909 ("Exposition de tableaux 'La Toison d'Or'") and no. 6 1909 (bibl. 162)*

126 NEW YORK. ASSOCIATION OF AMERICAN PAINTERS AND SCULPTORS, INC. Catalogue of international exhibition of modern art . . . at the Armory. 105p [New York, 1913]. *Exhibited Feb-Mar; variant catalogs for Boston and Chicago showings*

126a NEW YORK. BUCHHOLZ GALLERY. Bronzes by Degas, Matisse, Renoir, Oct 19-Nov 13. [8]p 1943. *12 works by Matisse; preface by Jacques Lipchitz*

127 NEW YORK. BRUMMER GALLERY. Henri Matisse. Feb 24-Mar 22, 1924. *14 paintings, 6 drawings, 3 etchings, 13 lithographs; preface by Joseph Brummer*

127a NEW YORK. BRUMMER GALLERY. Sculpture by Henri Matisse, January 5th–February 7th. 1931. *Undated list of 46 works; Arts Club of Chicago exhibited 25 of these Mar 13-28*

128 NEW YORK. HARRIMAN, MARIE, GALLERY. Les fauves, October 20-November 22. 1941. *Matisse, no. 1-6; preface by Robert Lebel*

128a NEW YORK. HARRIMAN, MARIE, GALLERY. Poésies de Stéphane Mallarmé, eaux-fortes originales de Henri-Matisse. ill Dec. 3-30 1932. *20 works listed; colophon*

129 NEW YORK. MATISSE, PIERRE, GALLERY. [Henri Matisse exhibitions]. 1934-1949. *Jan 23-Feb 24, 1934 (Paintings)—Oct 27-Nov 21, 1936 ("La Danse," study for the Shchukin decoration)—Nov 15-Dec 10, 1938 (Paintings and drawings)—Feb 9-27, 1943 (Paintings, 1898-1939)—Nov 17, 1945 (Drawings)—Feb 1949 (Paintings, drawings, papiers découpés, 1946-1948)*

130 NEW YORK. MONTROSS GALLERY. Henri Matisse exhibition, January 20th to February 27th. [38]p plates (port, col front) 1915. *Lists 74 works in all media*

131 NEW YORK. MUSEUM OF MODERN ART. Henri-Matisse, retrospective exhibition, November 3-December 6. 61p ill [New York, W. W. Norton, 1931]. *Introduction by Alfred H. Barr, Jr. Includes "Notes of a painter" (bibl. 40); bibliography and chronology*

131a NEW YORK. MUSEUM OF MODERN ART. Painting and sculpture in the Museum of Modern Art. Edited by Alfred H. Barr, Jr. 327p ill 1948. *Supplemented by acquisitions noted in Museum Bulletin, 17 no.2-3 1950, 18 no.2 1950-51*

131b NEW YORK. MUSEUM OF MODERN ART. Henri Matisse [catalog of the exhibition]. 32p ill 1951. *Issued for Nov-Dec exhibition, to be shown also at the Cleveland Museum of Art, Chicago Art Institute, San Francisco Museum of Art. Includes checklist, chronology, list of 145 works (paintings, sculptures, prints, illustrated books, découpages)*

132 NEW YORK. PHOTO-SECESSION GALLERY. An exhibition of drawings, lithographs, watercolors, and etchings by M. Henri Matisse. . . . April 6-25. 1908. *Announcement of show at the Little Galleries of "291." Reviewed in Camera Work no. 23 (bibl. 175) by J. E. Chamberlain, C. DeKay, J. Huneker, E. L. Cary, and "The Scrip"*

132a NEW YORK. PHOTO-SECESSION GALLERY. An exhibition of drawings and photographs of paintings by Henri Matisse . . . February 23-March 8. 1910. *Announcement; actually Feb. 27-Mar. 20. Reviewed in Camera Work no. 30 (bibl. 175) as "Matisse drawings" by J. Huneker, B. P. Stephenson, F. J. Mather, J. E. Chamberlain, Harrington, A. Hoeber, Townsend, E. L. Cary*

132b NEW YORK. PHOTO-SECESSION GALLERY. An exhibition of sculpture—the first in America—and recent drawings by Henri Matisse . . . Mar 14-Apr. 6. 1912. *Announcement and checklist of 24 works (2p): Bronzes (1-6), plasters (7-11), terra cotta (12), drawings (13-24). Reviewed in Camera Work no. 38 (bibl. 175) by A. Hoeber, J. Huneker, D. Lloyd, J. E. Chamberlain, Harrington, DeKay*

133 NEW YORK. QUINN COLLECTION. John Quinn collection of paintings, watercolors, drawings and sculpture. 200p plates Huntington, N. Y., Pidgeon Hill press; distributors: Joseph L. Brummer, E. Weyhe, New York [1926]. *Substantial catalog issued by American Art Association for New York sale, Feb. 9-12 1927*

134 NEW YORK. VALENTINE GALLERY. Henri Matisse. 1927-29. "1890-1926," Jan. 3-31, 1927, F. Valentine Dudensing (announcement).—"Matisse, 1923-29," Dec. 9, 1928-Jan. 4, 1929 (checklist of 17 works)

135 NICE. GALERIE DES PONCHETTES. Henri Matisse. Janvier-Mars 1950. Exposition organisée par l'U.M.A.M. [38]p ill (port) Nice, 1950. *66 works, including textiles; texts by G. Salles, J. Cassarini*

136 OSLO. KUNSTNERNES HUS. Matisse, Picasso, Braque, Laurens, p8-13 ill [Oslo, J. G. Tanum, 1938]. *Exhibit arranged by W. Halvorsen for exhibition at Kunstnernes Hus, Oslo; Statens Museum for Kunst, Copenhagen; and Liljevach Konsthall, Stockholm. Text on Matisse by L. Swane; list of 31 works; photograph by Roger-André*

137 PARIS. BERNHEIM-JEUNE GALLERY. [Matisse exhibitions]. 1910-29. *Exhibitions include 1910, 1913, 1919, 1920, 1922, 1923, 1924, 1927, 1929. Details on dates and catalogs noted in Chroniques du Jour (bibl. 159a, p16) and elsewhere (bibl. 5)*

137a PARIS. BING GALLERY. 1927. *See bibl. 170*

138 PARIS. CARRÉ, LOUIS, GALLERY. Henri-Matisse: dessins à l'encre de Chine, fusains (oeuvres récentes). [8]p 4 ill Nov. 10-30 1941. *Unsigned essay; no list of works; supplemented by bibl. 100a*

139 PARIS. DRUET, E., GALLERY. [Matisse]. Mar. 19-Apr. 7, 1906. *55 paintings, 3 sculptures, graphics*

140 PARIS. GAZETTE DES BEAUX ARTS. Les fauves: l'atelier Gustave Moreau. [32]p ill 1934. *Exhibit held Nov.-Dec; catalog by R. Cogniat; preface by L. Vauxcelles; biographical notes; reviewed in bibl. 215*

141 PARIS. GUILLAUME COLLECTION. *See bibl. 185*

142 PARIS. MUSÉE NATIONAL D'ART MODERNE. Henri Matisse, oeuvres récentes, 1947-1948, juin-septembre 1949. 37p ill Paris, Editions des Musées Nationaux, 1949. *Introduction by J. Cassou. Extracts from "Jazz" (bibl. 48), "Une lettre de Matisse à Henry Clifford" (bibl. 49a), and "L'Anthologie du livre illustré" (bibl. 32)*

143 PARIS. MUSÉE NATIONAL D'ART MODERNE. Catalogue-guide. p88-90, supplément p[3] Paris, Editions des Musées Nationaux, 1950. *22 works*

144 PARIS. MUSÉE NATIONAL D'ART MODERNE. Le Fauvisme. 44p ill 1951. *Matisse, no. 90-104; exhibit held June-Sept; preface by J. Cassou*

145 PARIS. GEORGES-PETIT GALLERY. Henri-Matisse, 10 juin-25 juillet. 51p ill 1931. *142 works, plus graphics*

146 PARIS. MAISON DE LA PENSÉE FRANÇAISE. Henri-Matisse: chapelle, peintures, dessins, sculptures. [26]p ill 1950. *115 works shown July 5-Sept 24. Cover by Matisse; preface by Aragon, p7-15: "Au Jardin de Matisse"*

147 PARIS. PETIT PALAIS. Les maîtres de l'art indépendant 1895-1937, juin-octobre. 118p Paris, Arts et Métiers Graphiques, 1937. *61 paintings by Matisse; texts by R. Escholier and A. Sarraut*

148 PARIS. ROSENBERG, PAUL, GALLERY. Oeuvres récentes de Henri Matisse. 1936-37. *Paintings and drawings, exhibits held May 2-30 1936, June 1-29 1937*

149 PARIS. SOCIÉTÉ DES ARTISTES INDÉPENDANTS. [Catalogue de l'exposition]. 1901-date

150 PARIS. SOCIÉTÉ DU SALON D'AUTOMNE. [Catalogue de l'exposition]. 1903-date. *The 1945 show (Sept 28-Oct 29) records 37 Matisse works (p.45)*

151 PARIS. VOLLARD, AMBROISE, GALLERY. Matisse. 1904. *Exhibit of 46 works held June 1-18; preface by Roger Marx, quoted in part here, p.45*

152 PHILADELPHIA. MUSEUM OF ART. Henri Matisse: retrospective exhibition of paintings, drawings and sculpture organized in collaboration with the artist. 50p ill 1948. *Exhibit held Apr 3-May 9. Foreword by Henry Clifford. Essay by Aragon, p17-31, also published in Arts de France no. 23-24: 12-23 1949. Includes Matisse texts, bibl. 49, 49a. Drawings from show subsequently sent on tour by American Federation of Arts, 1948-49*

152a RICHMOND, VA. VIRGINIA MUSEUM OF FINE ARTS. The Collection of Walter P. Chrysler, Jr. p69-77 ill Virginia Museum of Fine Arts [and] the Philadelphia Museum of Art, 1941

153 SAN FRANCISCO. MUSEUM OF ART. Henri Matisse, Jan 11-Feb 24. 1936. *Included items from Stein and other American collections*

154 TOKYO. NATIONAL MUSEUM. Henri Matisse: church, oil paintings, drawings, collections, Mar 3-June 6, 1951, Tokyo, Osaka. Organiser: National Museum-Yomiuri Shimbun [newspaper]. 59p incl ill col pl [Tokyo, 1951]. *List of 114 works. Cover by Matisse. Preface by Matisse in French and Japanese (bibl. 52). Texts by Asano, and others in Japanese*

155 VENICE. XXV BIENNALE D'ARTE. Catalogo. p47-8, 287-9. Venice, Alfieri, 1950. *Matisse in fauve salon (no. 38-49) and French section (no. 23-62); preface by R. Cogniat*

SPECIAL NUMBERS

156 Art Présent. no. 2 1947. *Includes "Le chemin de la couleur" by Matisse; "La pensée de Matisse" by J. Cassou; "L'influence de Matisse au-delà des frontières" by G. Poulain, E. Pignon; English summaries*

157 Art News. v. 47, no. 2 Apr 1948. *Issued on the occasion of the Philadelphia retrospective. Illustrations include color plates and cover. Text, p16-30, 56-58, by T. B. Hess, A. M. Frankfurter, and F. Kimball (bibl. 191)*

157a Art News. 1952 Annual, no 21 Nov 1951. *Matisse texts and plates, p34-81. Includes two essays by Salles (bibl. 209) and Tériade (bibl. 77)*

157b L'Art Sacré. no. 11-12 July-Aug 1951. *Vence number, ed. by M. A. Couturier and P. R. Régamey, 32p incl ill. Contents: Letter by Matisse p [2-3]; address by Mgr. Rémond; two texts by M. A. Couturier; essay by J. de Laprade; "Le plan de la chapelle" by L. B. Rayssiguier, p20-23. Matisse note reprinted here, p.287*

157c Baltimore Museum of Art News. v. 13, no. 1 Oct 1949. *See bibl. 109*

158 Cahiers d'Art. no. 5-6 1931. "L'Oeuvre de Henri Matisse," 6 no.5-6: 229-316 1931. *Articles by C. Zervos, P. Fierens, P. Guéguen, C. Glaser, W. Grohmann, G. Salles, R. Fry, H. McBride, K. Asplund, G. Scheiwiller. Major article by Christian Zervos: "Notes sur la formation et le développement de l'oeuvre de Henri-Matisse" (p9-32). Also issued separately (bibl. 93)*

158a Cahiers d'Art. Henri-Matisse. 1931. *See bibl. 93*

158b Cahiers d'Art. Dessins de Matisse. 1936. *See bibl. 98*

159 Camera Work. Special number. Aug 1912. *See bibl. 175, 212*

159a Chroniques du Jour, no. 9 Apr 1931. *"Pour ou contre Henri-Matisse," II. ann., nouv. sér., no. 9. Includes "critiques" and "documents"; essays by Rey, George, etc.; extracts from "Notes d'un peintre"*

160 Hommage. no. 2 June 1944. *"Dessins de Matisse," photo by Brassaï, essay by A. Rouveyre*

161 Le Point. no. 21 July 1939. *Vol. 4, p99-142; "Notes d'un peintre," p8-14: texts by Besson, Cogniat, Huyghe, Puy, Romains*

162 Toison d'Or (Zolotoye Runo). no. 6 1909. *Cover-title, contents and captions in French; texts in Russian. Includes (I): "16 reproductions des oeuvres de Henri Matisse."—(II): A. Mercereau "Henri Matisse et la peinture contemporaine."—(III): Henri Matisse "Notes d'un peintre"*

163 Verve. no. 13 1945. *Vol. 4, no. 13, designed by the artist; titled "De la couleur"; essay by A. Rouveyre; statements by Matisse p13 (bibl 65), p20 (bibl. 63), p56 (bibl. 58)*

164 Verve. no. 21-22 1948. *Vol. 6, no. 21-22, designed by the artist; titled "Les tableaux peints par Henri Matisse à Vence, de 1944 à 1948"; facsimile of mss p [5]*

ARTICLES & MISCELLANEOUS REFERENCES

165 A ..., C ... L'art moderne français dans les collections des musées étrangers: Musée d'art occidental à Moscou. Cahiers d'Art 25 pt.2: 335-48 1950. *List of works, p337-48, from 1928 catalog (bibl. 122a)*

165a America & Alfred Stieglitz. A collective portrait edited by Waldo Frank, et al. ill Garden City, N. Y., Doubleday, Doran, 1934

166 APOLLINAIRE, GUILLAUME. Matisse. La Phalange. 2 no.18 Dec 15 1907. *Also published in bibl. 93, 153, 166a; translated here p101-2*

166a APOLLINAIRE, GUILLAUME. Il y a. p127-33, 179-80 Paris, Messein, 1925. *Matisse and the Salon d'Automne, 1913, also published in "Soirées de Paris," G. De Torre "Apollinaire" (Buenos Aires, Poseidon, 1946) and elsewhere*

166b APOLLINAIRE, GUILLAUME. Médaillon: un fauve. 1909. *Unpublished article by "Pascal Hédégat" from the Gertrude Stein collection at Yale; translated here p. 553*

166c APOLLINAIRE, GUILLAUME. [Matisse]. L'Intransigeant Apr 28 1913. *On the occasion of the Bernheim-Jeune exhibition; translated in bibl. 117a*

166d ASCHER, ZIKA. Ascher panels designed by Henri Matisse, Henry Moore. [8]p ill New York, Buchholz Gallery, Curt Valentin, [1949] *Limited edition of signed textiles; texts by Leigh Ashton and Zika Ascher*

166e BALLET RUSSE. Programme officiel des Ballets russes; théâtre de l'opéra, mai-juin 1920. ill (port) [Paris, 1920]

167 BARR, ALFRED H., JR. Matisse, Picasso and the crisis of 1907. ill Magazine of Art 44:163-70 May 1951. *Advance publication of two chapters, condensed from this book*

167a BARR, ALFRED H., JR. Picasso: Fifty years of his art. ill New York, Museum of Modern Art, 1946

167b BASLER, ADOLPHE. Henri Matisse. Jahrbuch der Jungen Kunst [5]: 339-49 1924. *Also Cicerone 216, 1924*

168 BECKER, JOHN. The museum of western painting in Moscow [part II]. ill Creative Art 10:278-83 Apr 1932

168a BELL, CLIVE. How England met modern art. ill Art News 49 no.6:24-27, 61 Oct 1950. *Also note bibl. 199*

168b BERNIER, ROSAMUND. Matisse designs a new church. Vogue p76, 131-2 Feb. 15 1949. *Includes Matisse statements; briefly quoted here, p. 260*

169 BERTIN, CELIA. A Vence Henri Matisse décore une chapelle. ill Les Arts Plastiques no.5-6:209-14 May-June 1949

170 BING, GALLERY. Les Fauves, 1904 à 1908. Paris, 1927. *Catalog for exhibition held Apr 15-30; preface by W. George also published in bibl. 186*

171 BERENSON, BERNARD. De Gustibus [letter to the editor]. Nation 87no.2263:461 Nov 12 1908. *Reprinted here, p114*

172 BLOCK, MAXINE, ED. Henri Matisse, port Current Biography 4:506-10 1943. *Bibliography*

172a BREESKIN, ADELYN D. Matisse and Picasso as book illustrators. ill Baltimore Museum News 14:1-3 May 1951

172b BREESKIN, ADELYN D. Swans by Matisse. ill (port) American Magazine of Art 28:622-9 Oct 1935. *Comments by Matisse*

173 BRUN, MARIO. . . . Mgr. Rémond a consacré hier à Vence la Chapelle du Rosaire, chef d'oeuvre de Matisse. ill Nice-Matin p4 June 26 1951. *Includes Matisse statement (bibl. 52a), address by Mayor Hugues, data on the chapel*

173a BURGESS, GELETT. The wildmen of Paris. ill Architectural Record 27: 401-14 May 1910

174 Cahiers d'Art. [Selected list of references]. 1926-1951. *Excluding items already noted in bibl. 93, 98, 158, 165, 177, 217, 218, as well as brief notices and illustrations recorded in the general indexes, the following refer to articles of interest:* 1no.1:7-9; 1no.7:153-61; 1no.9:239-40 *1926;* 2no.7-8:257-74 *1927;* 3no.2:159-63 *1928;* 5no.3:113-20 *1930;* 4no.7:285-98 *1929;* 10no.1:1-74 *1935;* 14no.1-4: 1-24 *1939;* 14no.5-10:165-71 *1939;* 15no.3-4:68-9 *1940;* 20-21:162-96 *1946*

175 CAMERA WORK (PERIODICAL). Henri Matisse at the Little Galleries. no.23:10-13 July 1908. *Selected reviews of April exhibition "at the Little Galleries of the Photo-Secession." Additional texts: no.30:47-53 Apr 1910 (Drawings); no.31:46-7 July 1910 (Du Bois review); no.38:45-6 Apr 1912 (Sculptures); special Aug 1912 number (Stein, bibl. 212). Exhibitions noted in bibl. 132-132b*

175a DESVALLIÈRES, GEORGES. [Review of salon]. La Grande Revue 42:145 Apr-May 1907

176 DUDLEY, DOROTHY. The Matisse fresco in Merion, Pennsylvania. ill Hound & Horn 7no.2:298-303 Jan-Mar 1934. *Partly quoted here, p. 241, 244*

177 DUTHUIT, GEORGES. Le fauvisme. ill Cahiers d'Art no.5,6,10 1929; no.3 1930; no.2 1931. *Published in 5 parts: 4no.5:177-92, 4no.6: 258-68, 4no.10:429-34, 5no.3: 129-35, 6no.2:78-82. Revised in bibl. 13a, translated bibl. 13*

178 DUTHUIT, GEORGES. Matisse and Byzantine space. Transition Forty-Nine no.5:20-37 1949

179 DUTHUIT, GEORGES. The vitality of Henri Matisse. ill The Listener 15no.371:342-4 Feb 19 1936

180 FIERENS, PAUL. Matisse e il fauvisme. ill Emporium 88:195-208 Oct 1938

181 FRY, ROGER. Henri-Matisse. Creative Art 9:458-62 Dec 1931. *Also in bibl. 93, 158*

182 FRY, ROGER. On some modern drawings. In his Transformations. p197-212 New York, Brentano's [1926]

183 FURST, HERBERT E. Henri-Matisse as a draughtsman. ill Artwork 7no.27:194-8 1931

184 GEORGE, WALDEMAR. The dual aspect of Matisse. Formes no.16:94-5 June 1931. *Supplemented by 12 plates (1 col)*

185 GEORGE, WALDEMAR. La grand peinture contemporaine à la collection Paul Guillaume. ill Paris, Arts à Paris, n.d.[1929?]

186 GEORGE, WALDEMAR. Le mouvement fauve. L'Art Vivant 3 no.54:206-8 Mar 15 1927. *Also published in bibl. 170. Translated as "The fauves exhibition" Drawing and Design 2 no.12:180-1 June 1927*

186a GIDE, ANDRÉ. Promenade au salon d'automne. Gazette des Beaux-Arts 34:476-85 Dec 1905. *Partly quoted here, p. 63*

187 GREENBERG, CLEMENT. [Exhibition at Pierre Matisse gallery: a review]. Nation 168 no.10:284-5 Mar 5 1949 *Partly quoted here, p. 266*

187a GREGG, FREDERICK J., ED. For and against, views on the international exhibition held in New York and Chicago. New York, Association of American Painters and Sculptors, inc., 1913. *Includes F. J. Mather, p.56-64: "Old art and new"*

188 GUÉGUEN, PIERRE. Sculpture of a great painter: Henri Matisse. XXᵉ Siècle no.4:3-13 Dec 1938. *Also French edition*

188a HAUSEN, EDMUND. Der maler Hans Purrmann. Berlin, K. Lemmer, 1950.

188b HUYGHE, RENÉ. Matisse and colour. ill(1 col) Formes 1 no.1:5-10, 31-2 Jan 1930. *"With palette, [auto]biographical note, signature"; for page 11 see bibl. 59*

189 ITALIAANDER, ROLF. Henri Matisse baut eine Kirche. ill Kunstwerk 5 nr.1:52-3 1951

189a KAHNWEILER, HENRY. Juan Gris. Paris, Gallimard, 1946. *Also English edition: New York, Curt Valentin, 1947*

190 KATZENBACH & WARREN, INC. Mural scrolls, no.1: Calder, Matisse, Matta, Miro. [8]p col pl New York, 1949. *Folio of silk-screen designs issued in limited editions; introduction by James T. Soby, statements by the artists*

191 KIMBALL, FISKE. Matisse: recognition, patronage, collecting. ill Philadelphia Museum Bulletin 43no.217:33-47 Mar 1948. *Also in bibl. 157*

191a KUHN, WALT. The story of the armory show. 28p New York, Walt Kuhn, 1938

192 KUNSTCHRONIK. [Matisse Ausstellung]. 20:238-9 (suppl) Feb 5 1909. *Cassirer exhibition (Jan); signed M. O. (Max Osborn?); additional text 25:153-4 1913-14*

192a LACAZE, ANDRÉ & CARONE, WALTER. Matisse . . .sacrifie 800 millions pour soeur Jacques dominicaine. ill(pt col) Match no.59:15-18 May 6 1950

192b LIPMAN, JEAN. Matisse paintings in the Stephen C. Clark collection, ill Art in America 22: 134-44 Oct. 1934

193 McBRIDE, HENRY. Matisse in America. Creative Art 9-463-6 Dec 1931. *Also Art News 29:6 Aug 15 1931, and bibl. 158*

194 MATHER, FRANK J. [Matisse as draughtsman]. New York Evening Post Apr 1910. *Reprinted here in part, p. 556*

195. MEIER-GRAEFE, JULIUS. Matisse, des Ende des Impressionismus. Faust nr.6:1-5 1923-1924

196 MERCEREAU, HENRI. Henri Matisse et la peinture contemporaine. Toison d'Or (Zolotoye Runo) no.6:I-III 1909. *Russian text (bibl. 162)*

197 MORSE, C. R. Matisse's palette. Art Digest 7:26 Feb 15 1933. *Excerpts from article in Symposium (Concord, N. H.) 4:56-69. Winter 1933*

198 NEUGASS, FRITZ. Henri Matisse. ill Deutsche Kunst und Dekoration 32 nr.6:372-80 Mar 1929. *Additional articles:Kunst 61 nr.1:13-20 Oct 1929, Art et les Artistes 20 no.106:235-40 Apr 1930, etc.*

199 NICOLSON, BENEDICT. Post-impressionism and Roger Fry. ill Burlington Magazine 93 no.574:11-15 Jan 1951. *Supplemented by bibl. 168a*

200 [OZENFANT, AMÉDÉE]. Les fauves, 1900-1907. ill L'Esprit Nouveau 2:1871-2 [1922?]. *Published under pseudonym, "Vauvrecy"*

201 PACH, WALTER. Why Matisse? ill Century Magazine 89:633-6 Feb 1915. *Partly quoted here, p. 179*

201a PALME, CARL. Konstens karyatider. Stockholm, Raben & Sjogren, 1950

202 PERTSOV, P. Matisse. *In* The Shchukin collection of French painting. p86-92 Moscow, 1922

202a LE POINT (PERIODICAL). Marquet:dessins. 48p ill Lanzac, 1943. *Special issue, 5e année, no.27, Dec 1943*

203 POULAIN, GASTON. Sculptures by Henri Matisse. Formes no.9:9-10 ill Nov 1930

204 Présence de Matisse. ill L'Age Nouveau no.39 July 1949. *16 unnumbered pages between p16-17; texts by B. Dorival, J. Bouret, D. Chevalier, R. Vrinat, Gischia*

204a PURRMANN, HANS. Aus der Werkstatt Henri Matisses. ill Kunst und Künstler 20 nr.5:167-76 Feb 1922

205 PURRMANN, HANS. Über Henri Matisse. ill Werk 33 nr.6:185-92 June 1946

205a REWALD, JOHN. Pierre Bonnard, New York. Museum of Modern Art, 1948

206 ROGER-MARX, CLAUDE. The engraved work of Henri Matisse. ill Print Collector's Quarterly 20 no.2:138-57 Apr 1933. *Also in Arts et Métiers Graphiques no.34 1933*

207 ROMM, ALEXANDRE. Henri Matisse. Iskusstvo no.3 1934. *Probably included in bibl. 89*

208 SCHAPIRO, MEYER. Matisse and impressionism. Androcles 1 no.1:21-36 Feb 1932. *Review of bibl. 131*

209 SALLES, GEORGES. A visit with Matisse. Art News 50 no. 8:37-39, 79-81 Nov 1951. *Annual no.21 (1952)*

209a SCHNERB, J. F. Exposition Henri Matisse à la Galerie Bernheim. La Chronique des Arts p.59 1910

209b SCHNIEWIND, CARL O. [Catalogue of prints by Matisse. Chicago, Art Institute of Chicago, in progress]. *Includes reference to notes by Henri Petiet*

210 SEMBAT, MARCEL. Henri Matisse. ill Les Cahiers d'Aujourd'hui no.4:185-94 Apr 1913. *Translated in part here, 145-6, 160*

211 SKIRA, ALBERT. Histoire d'un livre. In his Vingt ans d'activité. p10-14 ill Genève-Paris, Skira [1948]. *On the Ronsard edition; additional Matisse data:p8-9, 15-17, 81*

211a SOBY, JAMES T. Contemporary painters. ill New York, Museum of Modern Art, 1948

211b STEEGMULLER, FRANCES. Chapels on the Riviera. The Cornhill no.985:22-7 Winter 1950-51

212 STEIN, GERTRUDE. Henri Matisse. ill Camera Work Special Number:23-5 Aug 1912. *Reprinted in Twice a Year no.14-15:229-32 Fall-Winter 1946-47*

212a STEUBEN GLASS, INC. The collection of designs in glass by twenty-seven contemporary artists. p[7], no.21[2p] ill New York, 1940. *Catalog issued for Jan exhibition; text by F. J. Mather and J. M. Gates*

212b SWANE, LEO. Matisse i Tetzen Lunds samling. Tilskueren 2:206-16 Sept 1922

213 TIME (MAGAZINE). Beauty and the beast. ill (col pl) p52-7 Apr 5 1948. *Plates from "Jazz"; quotations by the artist*

213a VALLOTTON, FÉLIX. [Review of Salon d'Automne]. La Grande Revue p920 Oct 25 1907. *Partly quoted here, p9*

214 VAUXCELLES, LOUIS. Matisse. Gil Blas no.? 1907. *Quoted in bibl. 5*

215 VAUXCELLES, LOUIS. Les Fauves, à propos de l'exposition de la Gazette des Beaux-Arts. ill Gazette des Beaux-Arts 76no.86:273-82 Dec 1934

215a VOLLARD, AMBROISE. Recollections of a picture dealer. ill Boston, Little, Brown, 1936. *French edition, 1948*

216 WATSON, FORBES. Henri Matisse. ill The Arts 11:29-40 Jan 1927. *Also issued bibl. 97*

217 ZERVOS, CHRISTIAN. Notes sur la formation et le développement de l'oeuvre de Henri Matisse. ill Cahiers d'Art 6no.5-6:229-316 1931. *Also in bibl. 93, 158*

218 ZERVOS, CHRISTIAN. A propos de l'exposition au Musée d'art moderne de Paris. ill Cahiers d'Art 24no.1:159-70 1949

INDEX

Works by Matisse are indexed by title; works by other artists are listed under their names. Page numbers printed in italics refer to illustrations.

Text, captions to illustrations, notes and appendices are indexed here with two exceptions:

Appendix F, Works by Matisse in the Public Museums of English-speaking Countries: Museums are indexed but not works of art.

Appendix G, Illustrations by Matisse: only items previously mentioned in text are indexed.

Acknowledgments and Preface are not indexed.

The index has been prepared by Helen M. Franc.

Académie, see *Figure Study; Male Model*
"Académie Carrière," 38, 40, 42, 48, 49, 54, 86, 117, 303
Académie Julian, 14f, 36, 38
"Académie Matisse," 22, 88, 98, 103f, 105, 107, 109, 110, 116-118, 134, 259, 550-552
African art, see Congo "velvets"; Negro sculpture; North Africa
Agha Reza, *Prince and His Tutor*, 160
Ajaccio, see Corsica
Alcaforado, Marianna, *Lettres portugaises*, see *Letters of a Portuguese Nun*
Algerian Woman, 105, 130
Algiers, 82, 102, 154, 328
Amber Necklace, 251 n.1
Amido, the Moor, 134 n.1, 144, 155, 246, *378*, 555
Anemones with Black Mirror, 205, 207
Anemones and Women, 251 n.1
Angrand, Charles, 82, 82 n.7
Annélies, tulipes, anémones, see *Girl Reading*
Anrep, Boris, 149
Antoinette, 206, 206 n.8, *427-429*
Antoinette, 206, 246, *427*
Antonello da Messina, 285
Apollinaire, Guillaume, 83, 83 n.9, 101f, 145, 146f, 148, 177, 178, 183, 269; "*Médaillon: un fauve*," 553
Apollinaire, Guillaume, portrait of, 269
Apples (1897), 46, *299*
Apples (Chrysler Coll., 1916?), 190
Apples (Marx Coll., 1916), 180, 181, 189f, 194, 263, *406*, n.page 529

Apples (monotype), 177, 187, *399*
Apples on Pink Tablecloth, 212
Après le bain, see *Meditation*
Aquatints, 276
Aqueduct at Maintenon, 205
Arab Café, see *Moorish Café*
Aragon, Louis, 115, 259, 261, 262, 268, 270, 273, 274, 281; "*Apologie du Luxe*," 262, 264, 270
Arbre en fleur, see "*Mural Scroll*"
Arcachon, 181
Arcueil, 42, 302
Arensberg, Walter, 180
Arezzo, 83, 139
"Armory Show," 95, 95 n.6, 116 n.7 & 5, 145, 149-151, 163, 179, 180, 185
Arp, Jean, 191, 263, 265, 267
Art nouveau, 36, 92
L'Art retrouvé, see *Art Survives the Times*
Art Survives the Times, 260
Artist and His Model, 205f, *424*
Arum, Iris and Mimosa, 159, 206, 215, *389*
"Ascher Panels," 261, 279, *510*
Asia, 260, 275, *503*, n.page 529
Askew, Mr. and Mrs. R. Kirk, Jr., 325
Assy, Nôtre-Dame de Toute-Grâce, 279; *St. Dominic*, 261, 280, *511*
Asters, 215
Attention, jeune fille assise, 148
Aubusson tapestries, 250
Audra, Paul, 195
Ault, Mr. and Mrs. Lee, see *Lemons on Pewter Plate*
Autumn Landscape, 104, 178

Bacchanals, 88, 88 n.2, 135
Back, I, 52, 52 n.4, 100, 142, 142 n.9, 149, 150, 152 n.5, 200, 218, 218 n.1, 262, *313*, n. page 529; see also *Painter's Studio*
Back, II, 142, 200, 217, 218 n.1, 262, *458*
Back, III, 142, 200, 217, 218, 218 n.1, 262, *459*
Bakst, Leon, 207
BaKuba "velvets," 286
Bakwin, Dr. and Mrs. Harry, see *Artist and His Model; Decorative Figure* (bronze); *Jeannette, I; Two Negresses*
Balanchine, Georges, 91, 208, 216
Baldung Grien, Hans, 204
Ballet Dancer, 214f, 216, *447*; see also *Dix Danseuses*

Ballet Russe de Monte Carlo, 224, 252f, 253f, *483*; see also "*Rouge et Noir*"
Ballets Russes (Diaghilev), 197, 207f, 216; see also "*Chant du rossignol*"
Baltimore, Museum of Art, 557; see *Serpentine*. Cone Collection: see *Aqueduct at Maintenon; Ballet Dancer; Blue Eyes; Blue Nude; Carnival at Nice; Dam at Pont Neuf; Fruit Dish and Glass Pitcher, I; Girl in Red Chair; Girl in Yellow Dress; Harbor of Collioure; Interior with Flowers and Parrots; Invalid; Magnolia Branch; Odalisque in Green Pantaloons; Olive Grove; Pewter Jug; Pink Nude; Pink Nude—Study for; Seated Odalisque; Still Life with Peaches; Striped Blouse and Anemones; White Turban; Yellow Jug*; Cone Collection, drawings: see Cone, Claribel, portrait of; *Plumed Hat*; Swans for Stéphane Mallarmé, *Poésies; White Jabot*. Cone Collection, bronze sculpture: see *Figure with Cushion; Little Head; Madeleine, I; Reclining Nude, I; Reclining Nude, II; Seated Nude; Slave; Tiari; Two Negresses; Venus in Shell; Woman Leaning on Her Hands*
Barnes, Dr. Albert C., 180f, 192f, 199, 201, 208, 220, 222, 224, 241-244, 261, 262; see also Merion (Pa.), Barnes Foundation
Barnes Murals, see *Dance, I* and *II*
Barry, Joseph A, 279 n.9, 280f
Bartlett, Helen Birch, Collection, see Chicago Art Institute
Barye, A. L., 51 f; *Jaguar Devouring Hare*, 40, 52, 142, 303
Basle, Kunsthalle, see *Still Life with Oysters; Still Life with Shell*
—, Matisse exhibition (1931), 222
Bather, 78, 131 n.3, 134, 136, *161*
Bathers by River, 98 n.7, 181, 183, 190, 218 n.1, *408*
Bathers with Turtle, 78, 97, 105, 109, 123, 132, 133, 135, 136, 190, 224, 263, *357*
Baudelaire, Charles, *Les Fleurs du mal*, illustrations, 89, 261, 270, 273, *498*, 559, 560, 563; *L'Invitation au voyage*, 60
Baudelaire, Charles, portrait of, *240*, 246
Bauhaus, 109

Bayonne, Musée Bonnat, see Puvis de Chavannes, *Happy Land*

Bazaine, Jean, 264

Bazille, Frédéric, 33

Baziotes, William, 264

le Beau, Alcide, 19

Beauvais tapestries, 250f, 261, 278

Becker, John, 136

Belgrade, Museum of Art and Archeology, see *Trees near Melun*

du Bélier, 274, 560

Bell, Clive, 110f, 110 n.9, 126 n.7, 149

Bellini, Giovanni, *Feast of the Gods*, 88

Benois, Alexandre, 207

Bentinck, Lord Henry, 110

Berdeau, Mr. and Mrs. LeRay W., see *Flowers and Ceramic Plate*

Berenson, Bernard, 57, 98, 105, 111, 112, 114, 116, 308

Bergson, Henri, 185

Berlin, Autumn Salon (1913), 107

—, Cassirer Gallery, Matisse Exhibition (1908-09), 103, 107, 108, 113, 113 n.8, 148, 177

—, Gurlitt Gallery, Matisse Exhibition (1914), 77, 107, 177f, 178 n.4, 179

—, Thannhauser Gallery, Matisse Exhibition (1930), 221, 222

Berliner Sezession (1908), 108; (1913), 145, 177

Bernard, Emile, 40, 87, 119

Bernheim-Jeune, Josse and Gaston, 201, 221; see also Paris, Bernheim-Jeune

Bernheim de Villers, Gaston, see *Bouquet for 14th July; Manila Shawl*

Bernier, Rosamond, 260

Besnard, Albert, 34, 62, 563

Besson, George, 26, 195, 195 n.5, 196, 197; portraits by Matisse, 196 n.2

Bettera, 93

Bevilaqua, 48, 48 n.1, 52; see also *Male Model*

Biette, Jean, 38, 43, 48, 51, 83, 116 n.6, 117, 117 n.1, 158

Bignou, Etienne, 29, 221

Biskra, 82, 92, 94, 102

Black Door, 259, 267, *489*

Black Fern, 277

Black Scarf, see *Lorette VII*

Black Table, 197, 206, 207, 208, 209, 210, *430* and n. page 529

Blanche, Jacques-Emile, 34, 44, 57, 108, 119

Blasted Oak, 51

Blinding of Polyphemus, see Joyce, *Ulysses* illustrations

Bliss, Lille P., 201, 224; Bequest, see New York, Museum of Modern Art

Block, Leigh B., 263; see also *Black Fern; Interior with Spanish Vase; Plaster Torso*

Blue Dress in Ochre Armchair, 251 n.1

Blue Eyes, 223, 247, 247 n.1, 251, *471*

Blue Interior with Two Girls, 238, 276, *504*

Blue Nude (Souvenir of Biskra), 49, 58, 83, 83 n.5, 84, 94f, 94 n.3 & 4, 95 n.6, 96, 99, 100, 131 n.3, 150, 180, 199, 201, 218, 262, *336*

Blue Still Life, 58, 84, 86, 93, 93 n.2, 123f, 125, 126, 130 n.8, 147, 153, 178, 199, 199 n.5, 212, 215, *331*

Blue Window, 143, 147, 154, 156, 157, 166, *167*, 174, 186, 224, 229, 238; etching, 186

Blumenthal, Mrs. George, 115, 323

Boccioni, Umberto, 185

Bohain-en-Vermandois, 13, 15, 39, 41, 42, 44, 50, 51, 84, 158 n.3, 293, 307

Bois de Boulogne, see Paris, Bois de Boulogne; *Path in Bois de Boulogne*

Bois de Meudon, 194

du Bois, Guy Pène, 87, 116

Boldini, Giovanni, 34, 62

Bonheur de vivre, see *Joy of Life*

Bonnard, Pierre, 16, 36f, 40, 44, 57, 63, 100, 102, 107, 136, 158, 195, 200, 205 n.5, 244, 256, 257, 258, 260, 264, 265, 280; *Daphnis and Chloë* lithographs, 88f

Bonnat, L. J. F., 15, 34

Bony, Paul, 283

Book illustration and design, 89, *155*, 180, 196, 217, 219, 220, 223, *240*, *245*, 244-246, 248f, 253, 257, 259, 261, 262, 269, 270-275, *466-467*, *474*, *494-501*, *513*, 559-560, 563

Books and Candle, 13, 33, 197, *293*

Boston, Isabella Stewart Gardner Museum: 557; see also *Terrace, St. Tropez; Three Studies of Zorah* (drawing)

— Museum of Fine Arts: 105, 105 n.10, 557; see also *Carmelina*

Boucher, François, 33

Bouguereau, Adolphe William, 14, 15, 34, 36, 38, 222; *Wasp's Nest*, 14, *17*

Bouquet on Bamboo Table, 41, 43, 50, *307*

Bouquet for 14th July, 194, 197, 206f, 208, 209, *431*

Bourdelle, Antoine, 52, 135, 142

Bourdillon, 283

Bourgeat, 186

Boy with Butterfly Net, 94, 105

Brangwyn, Frank, 221

Braque, Georges, 83, 86f, 87, 87 n.10, 102, 142, 147, 150, 157, 158, 188, 223, 250f, 258, 260, 265f, 280

Braun, Heinz, 105; see also *Guitarist; Nude in Chair*

Breeskin, Adelyn, 245

Breton Serving Girl, 46, *298*

Bridge, 34, 35, *297*

Brighton, Public Art Galleries, Modern French Artists Exhibition (1910), 110, 148

Brittany, 35, 45f, 297, 298

Broadcasts, 258, 562f

Bronzes, see Sculpture

Brook with Aloes, 92, 105, 154, *328*

Bruce, Patrick Henry, 22, 59, 116, 116 n.5

Brummer, Joseph, 116f, 116 n.1 & 4, 118, 198; see also New York, Brummer Galleries

Brussels, Palais des Beaux-Arts, Matisse Exhibition (1946), 260

Bubnovy Valet, see "Jack of Diamonds"

Buffalo, Albright Art Gallery, 201, 557; see *Music* (1939); *Notre Dame in Late Afternoon; Reclining Nude, I*

Burden, Mr. and Mrs. William A. M., see *Pont St. Michel*

Burgess, Gelett, 56, 56 n.10, 74

Burroughs, Bryson, 139

Bush, Mrs. Wendell T., 307

Bussy, Simon, 256

By the Sea, 59f, *316*

Byzantine art, 91, 131, 132, 143 n.4, 184

Cabanel, Alexandre, 34, 553

Cabaret sketches, 38, 42, 98

Café arabe, Café maure, see *Moorish Café*

Café Volpini Show (1889), 64

Cafés Concerts, see Cabaret sketches

Cagnes, 196

Cahiers d'Art, 222, 251

Caillebotte Bequest, 16, 16 n.4, 35f, 563

"*Caloges*" *at Etretat*, 209, 229, *432*

Cambridge (Mass.), Fogg Museum of Art; 557; see Moreau, Gustave, *Apparition;* Picasso, *Seated Man* (drawing)

Camera Work, 98, 113 n.8, 115, 115 n.7, 1 & 2, 116 n.5 & 7, 144, 556

Camoin, Charles, 16, 38, 43, 44, 54, 145

Campaux, François, 260

Campbell, Arthur Bradley, see *Blue Interior with Two Girls*

Candlesticks, see Vence Chapel: altar candlesticks

Capa, Robert, 30, 31

Capucines à "La Danse," see *Nasturtiums and "Dance"*

Caracci, Annibale, 33, 60

Carco, Francis, 186

Carles, Arthur, 116

Carmelina, 45, 51, 96, 149, 201, *311*

Carnegie International Exhibitions, Pittsburgh: (1921), 198, 200; (1924), 198, 200; (1925), 200; (1926), 200; (1927), 200f, 212, 219; (1930), 219

Carnival at Nice, 210

Carolus-Duran, C.A.E., 34, 53

Carpenter, Mrs. John Alden, 199

Carré, Louis, 257; see also Paris, Carré Gallery

Carrière, Eugène, 34, 38, 42, 44, 53, 63, 106, 135; see also "Académie Carrière"

Carter, Morris, 145 n.7

Cartier-Bresson, Henri, 31, 32, 285, 287, 516, 523

Cary, Elizabeth Luther, 113, 115

Casein, 95, 341

Cassarini, J., 195, 262

Cassirer, Paul, 108, 159; see also Berlin, Cassirer Gallery

Cassou, Jean, 260

Le Cateau-Cambrésis, 13, 178

Catalog covers, *513*, 559-560

Cavalière, 104, 117, 130, 134, 161, 359

Ceramics, 100, 163, 337; ee also Tiles

Céret, 54, 178

Cézanne, Paul, 14, 16, 16 n.4, 19, 35, 37, 38f, 40, 46, 48, 49f, 53, 57, 58, 59f, .62, 63, 74, 81, 86f, 88, 92, 93, 94, 102, 106, 106 n.6, 109, 110, 111, 116, 118, 121f, 123, 127, 128, 132, 142, 146, 149, 158, 181, 199, 200, 203, 204, 215, 218, 229, 552, 559-560, 563; *Bacchanale*, 88; *Card Players*, 241; *Overture to Tannhäuser*, *18*, 106, 211; *Three Bathers*, *18*, 38f, 40, 44, 60, 86, 132, 146, 223

Chabaud, Félix, 38

Chamberlain, J. Edgar, 113, 115

Chambre rouge, see *Harmony in Red*

Champagne, Philippe de, *Dead Christ*, 33, 293

Chant de Minos, see de Montherlant, Henry, *Pasiphaé—Chant de Minos*

"*Chant du rossignol*," 89, 197, 208, 216, 244, *432*

Chapel of the Rosary of the Dominican Nuns, see Vence Chapel

Chapman, Mrs. Gilbert W., see *Interior at Nice*

Chardin, J.-B.S., 15, 33f, 46, 48, 122, 127; *Ray* (copy), 48

Charles d'Orléans, *Poèmes*, illustrations, 89, 271, 272f, *494*, *495*, 559-560

Chassériau, Théodore, 15

Chasuble designs, see Vence Chapel

Chatou, 42f, 54, 83

Chavasse, Jules, 67

Checker Game and Piano Music, 210f, *439*; see also *Interior with Boys Reading*

Chézières Road, 51, *309*

Chicago, Art Institute, 95 n.6, 150, 201, 557f; see also *Apples* (1916, Marx); *Apples on Pink Tablecloth*; *Odalisque with Raised Arms*; *Still Life with Potted Plant*; *Woman Before Aquarium*; drawings: *Nude in Chair*; *Woman Nursing Knee . . .* sculpture: *Slave*

—, Art Institute, Matisse Exhibition (1952), 263

Chicago, Arts Club, 558

Chinese art, 276; see also Oriental art

Chinese Box, 210

de Cholet, Guy, 105, 130 n.2

Christ après Philippe de Champagne, see *Copy of Dead Christ . . .*

Christ before Pilate, see Vence Chapel: *Stations of Cross*

Chrysler, Walter P., Jr., 263; see also *Apples* (1916?); *Dance—Study*; *Nude* (1917-18); *Lorette, VII*

Ciboure, 255

Citrons et anémones, see *Pink Tablecloth*

Clamart, 104; see also Issy-les-Moulineaux

Clark, Stephen C., 201, 224, 263; see also van Gogh, *Night Café*

Cleveland Museum of Art, 558; Matisse Exhibition (1952), 263; see also *Festival of Flowers, Nice*

Clifford, Henry, 261

Cliffs at Belle-Ile, 46, *297*

"Cloisonnisme," 82, 82 n.7

Coffee, 192, *415*

Coffee Pot, Carafe and Fruit Dish, *25*, 106, 126, 127, 129, 207, 214, *346*

Coiffure (1901), 49f, 51, 110, *306*

Coiffure (1907), see *Hairdresser*

Colarossi's, 42, 113, 116 n.4

Colin, Ralph F., see *Girl in Green* (1921); *Guitarist*; Vuillard, *Vuillard Family at Lunch*

Collages, see Cut-and-pasted paper

Collioure, 54f, 54 n.2, 61, 62, 71, 72, 77, 78, 81, 82, 83, 84, 88, 93f, 95, 97, 98, 99, 113, 142 n.10, 143, 151 n.4, 152, 178, 318, 328, 329, 333-338, 340, 374

Collioure, 132 n.5

Cologne, Sonderbund Exhibition (1912), 145, 149, 177

Columbus (O.), Gallery of Fine Arts, Ferdinand Howald Collection, 558; see also *Roses*

"*Comment j'ai fait mes livres*," see "*How I Made My Books*"

Communist Party, 262, 280, 281

Composition (1914), 187; (1938), see *Conservatory*

Cone, Claribel, 57, 95, 105, 143 n.2, 199, 201, 220, 224, 262; portrait of, 220, 247, *470*

Cone Collection, see Baltimore Museum of Art

Cone, Etta, 57, 83, 105, 198 n.1, 199, 201, 220, 223, 224, 262; portrait of, 247, 247 n.1

Conger Eel, 209

Congo "velvets," 286

Conservatory, 252, 275, *478*; early state, 252 n.2

Contracts with dealers, see Paris, Bernheim-Jeune, Contracts with Matisse; Paris, Rosenberg, Paul, Gallery: Contract with Matisse

Conversation (1909), 104, 106, 123, 126, 149, 152, *347*, 555

Conversation (1941), 259, 267, *487*

Copenhagen, Ny Carlsberg Glyptothek, Matisse Exhibition (1924), 198f, 221

Copenhagen, Statens Museum for Kunst, see *Zulma*; J. Rump Collection, 201, see also *Goldfish* (1909-1911); *Interior with Violin*; *Landscape at Collioure*; *Luxe, II*; Matisse, Mme, portrait of (1905); *Nude with White Scarf*; *Pink Onions*; *Place des Lices, St. Tropez*; *Self Portrait* (1906); *Still Life with Nutcracker*; *Street in Algiers*; *Street in Arcueil*

Copies after old masters, 33, 49, 60, 118, 132; see also Champagne, Philippe de, *Dead Christ*; Chardin, *Ray*; de Heem, *Dessert*; Pollaiuolo, *Hercules and Antaeus*

Copies and studies from casts, 13, 14, 15, 195, *293*, 550

Copy of Dead Chist by Philippe de Champagne, 33, *293*

Coq d'or, settings by Gontcharova, 207

Cordova, 143

Corinth, Lovis, 108, 129

Cormon, Fernand, 37f, 40, 48

Corner of Studio (c. 1900), *306*; (1912), *24*, 157

Corot, Camille, 34, 46, 88, 114, 204, 212

Corsica (Ajaccio), 37, 46f, 300

Corsican Landscape, 163

Cortissoz, Royal, 200, 222

Cortot, Alfred, portrait of, 216

Cottet, Charles, 34, 45f, 57, 108

Courbet, Gustave, 16, 34, 51, 123, 197, 204, 209; *Mademoiselle au bord de la Seine,* 146

Courthion, Pierre, *Visage de Matisse,* 257, 259

Couturier, Father M. A., 31, 279f, 284, 287, 511, 516

Couturier, Paul Louis, 14

Cowboy, 275, *501;* see also *Jazz*

Cowles, John, see *Girl in White Gown*

Cox, Kenyon, 150

Cranach, Lucas, 204

Craven, Thomas, 223

Croisé, Prof., 13

Cross, Henri-Edmond, 36f, 43, 47, 53f, 54 n.1, 59f, 62, 71, 81, 82 n.7, 97, 104, 132

Cubism and Cubists, 54, 56, 57, 84, 85-87, 87 n.10, 102, 106, 131, 142, 146f, 148, 150, 157, 158, 168, 171, 174, 179, 185, 187f, 190, 191, 201, 204, 211, 218, 258, 265f, 274, 280

Cushing, Howard, 148

Cut-and-pasted paper, 252f, 253 n.5, 254, 261, 262, 264, 270, 274, 275, 278, 279 n.8, 280, 284, *482, 500-501, 512-513, 525*

Cuttoli, Mme Paul, 223, 250f; see also *Window at Tahiti*

Cyclamen, 180

Czóbel, Belá, 83, 117

Dada, 204, 274

Dagnan-Bouveret, 45

Dahlias and Pomegranates, 276, 291, *508*

Daisies, 224, 253, 266, *485*

Dale, Mr. and Mrs. Chester, Collection, 36, 201, 558; see also *Apples on Pink Tablecloth; Odalisque with Raised Arms; Tulips*

Dali, Salvador, 263

Dam at Pont Neuf, 34

Dance (1910, Moscow), *28,* 78, 97, 104, 106, 123, 132-138, 143, 144, 148, 151, 160, 161, 189, 190, 203, 242f 244, 249, 254, *362, 363,* 555

Dance—Study (Chrysler), *23,* 107, 110, 127, 133, 135f, 138, 145, 149, 152 n.5, 224, *360,* 555, see also *Nasturtiums and "Dance"; Still Life with "Dance"*

Dance—Study (drawing), 135f, *361*

Dance (watercolor), 134, *363*

Dance, I (Mural, 1931-1932), 190, 220, 224, 241, 242f, 249, 253, 253 n.5, 254, 274, *462-463*

Dance, II (Mural, 1932-1933), 190, 220, 222, 223, 243f, 246, 249, 254, 263, 274, *464-465*

Dancer (cut-and-pasted paper, 1938), 274, *482;* (cut-and-pasted paper, 1950), 278; (sculpture), 100

Dancer and Armchair, Black Background, 29, 257, 259, 267, *488*

Danseuse assise dans un fauteuil, 267 n.1

Daumier, Honoré, 16, 21, 142

Davies, Arthur B., 149f, 179, 180; see *Serpentine; Standing Model*

Decorative Figure (bronze), 100, 152 n.5, 163, 174, *327*

Decorative Figure on Ornamental Background, 200, 203, 213f, 215, 224, 260, 269, *449; Study* (drawing), 213, *448*

Degas, H.G.E., 36f, 49, 57, 102, 110, 156, 563

Delacroix, Eugène, 15, 38, 38 n.2, 63, 64, 122, 149, 154; *Bark of Dante,* 27

Delaunay, Robert, 116 n.5, 147, 158, 204

Delectorskaya, Lydia, 223, 251, 255, 257; see also *Blue Eyes; Lady in Blue; Lydia; White Jabot*

Dell, Robert, 110

Demoiselles d'Avignon, see Picasso, *Demoiselles d'Avignon*

Denis, Maurice, 36f, 40, 44, 52 n.1, 54, 57, 60f, 63f, 81, 83, 86, 87, 88f, 91, 95, 96, 100, 106, 110, 111, 119, 135, 158, 200, 244; *Baigneuses,* 60 n.4; *Cupid and Psyche* series, 107; *Grande Plage,* 60 n.4; *Hommage à Cézanne,* 86, 87; "Definition of Neo-Traditionism," 64

Denver (Colo.), Art Museum: 558; see also *Two Sisters*

Derain, André, 38, 42f, 45, 49, 54, 55f, 83, 86f, 94 n.3, 106, 110, 111, 150, 158, 178, 181, 197, 201, 204, 244, 258; *L'Age d'or,* 88; *Drying the Sails,* 19, 55f; *Window on the Park,* 158 n.4, 203f

Derain, Mme André, portrait of, 186

Desserte, see *Dinner Table;* see also *Harmony in Blue; Harmony in Red*

"*Dessins: Thèmes et variations,*" 259, 265, 268, 270, 559

Desvallières, Georges, 35, 44, 62, 63, 99, 114, 119

Detroit Institute of Arts, 201, 558; see also *Window*

Deutsch, Mr. and Mrs. Richard, see *Still Life with Lemon*

Devémy, Canon, 279f, 511

Diaghilev, Serge, 197, 207f, 216, 224, 244

Dill, Helen, 417

Dinner Table, 35, 36 n.2, 45, 45 n.4, 46, 49, 53, 53 n.8, 67, 109, 124, *299;* see also *Harmony in Red*

Divisionism and Divisionists, see Neo-Impressionism and Neo-Impressionists

Dix Danseuses, portfolio, 216

Dodds, John W., 26, 118, 153, 550

Dominican Order, 279; see also Vence Chapel

van Dongen, Kees, 43, 83, 100, 106

Doors, see Enchorrena painted doors; Vence Chapel: confessional door

Doucet, Jacques, see *Goldfish* (1915)

Dove, Arthur, 116

Drawings, 13, *24, 39, 44, 47, 50, 54, 55,* 83, 89, 97f, 106, 111, 115, *130, 137, 141,* 142, *144,* 145, 148, 150, *155,* 178, 179, *180,* 184, 189, 196, 197, 198, 200, *202,* 206, 207 n.5, 211, 213, 217, 219, *221,* 223, 224, *225,* 247f, *249f, 250,* 251, *253,* 257, 259, 261, 262, *265, 268,* 269, 270, 271, 272, 273, 276, 277, 280, *283,* 284, *293, 295, 321-323, 361,* 379, *394, 401,* 405, *428, 429, 432, 439, 448, 456, 466,* 470, *473, 474, 478, 482, 484, 488, 508, 509, 521, 522,* 556, 559-560, *561*

Dream, 223, 247, *471*

Druet, 82, 124 n.3, 125, 156 n.3; see also Paris, Druet Gallery

Drypoints, 98f, 177, 186, 213, 216f, *312, 398*

Duccio, 83, 102

Duchamp, Marcel, 146, 150, 179, 185, 185 n.8; *Nude Descending Staircase,* 150, 185

Duchamp-Villon, Raymond, 146, 179; *Horse,* 179

Dudley, Dorothy, 241, 244

Dufy, Raoul, 40, 43, 54, 61, 83, 86, 201, 223, 244, 251

Duncan, Isadora, 135

Düsseldorf, Matisse Exhibition (1951), 262

Duthuit, Georges, 42, 56, 82, 105, 135, 198, 249 n.4, 255, 264, 559-560

Duthuit, Mme Georges, see Matisse, Marguerite

Ecole des Beaux-Arts, 13 n.4, 14-16, 37, 40, 255, 256, 258, 288, 553, 563

Ecole de la Ville de Paris, 52

Edström, David, 116 n.8

Eggplants, 153f; see also *Interior with Eggplants*

Egyptian Curtain, 238-239, 260, 262, 266, 276f

Egyptian sculpture, 120, 173

"The Eight," 112, 149

Einstein, Carl, 203

Elena, 251, *476*

Elissen, Robert, 201; see also *Idol* (1906); *Oranges* (1916)

Emergency Rescue Committee, 256, 257

Enchorrena painted doors, 259, 269f, *493*

England, visit of Matisse to, 37

Ensor, James, 91

Entrance to Kasbah, 25, 145, 156, 159, *386*

Epstein, Walther, 110

Ernst, Max, 263

Escholier, Raymond, 40, 223, 224, 242

Espagnole, see *Manila Shawl*

Essen, Folkwang Museum, see *Bathers with Turtle; Blue Window; Still Life with Asphodels*

Etchings, 45, 98f, 177, 178, 179, 184, 184 n.1, 185, 186f, *187*, 200, 203, 213, *214*, 216f, 220, 223, 224, *240*, 244, *245*, 246, 249f, 270, 271, *312*, *394*, *398*, *466-467*, *470*, *474*, 559-560

"*Etrange farandole*," see "*Rouge et Noir*"

Etretat, 197, 198, 209, 228, 231, *432*, 433

Europa, 89, 213 n.3

Eve, 281

"*Exactitude is Not Truth*," 128, 253, 561

Expressionism and Expressionists, 141, 142, 192, 193, 280

Fabiani, Martin, 257, 259, 268, 270, 271, 494, 559-560

Falaises d'Aval, see "*Caloges*" *at Etretat*

Falguière, J. A. J., 52

Fall of Icarus, 274, 275; see also *Icarus* (*Jazz*)

Fatma, the Mulatto, 145, 147, *378*

Faure, Elie, 197

Fauves and Fauvism, *16*, 38, 42f, 44, 47, 48, 49, 53, 54, 55f, 56 n.10, 59, 60, 62, 64, 71, 72, 77, 78, 81, 82, 83, 86f, 92f, 94, 96, 97f, 99, 100, 105, 107, 110, 113, 123, 125, 127, 128, 129, 130, 159, 171, 188, 193, 199, 200, 201, 204, 276, 288, 553

Fels, Florent, 217

Femme au chapeau (1905), see *Woman with Hat*; (1914), 186; see also *Marguerite in Veiled Hat*

Femme au corsage vert, see Merson, Olga, portrait of

Femme au tabouret, see *Woman on High Stool*

Fénéon, Félix, 61, 105, 185, 201, 553, 554; Collection, 54 n.1; see also *Tulips*; see also Paris, Bernheim-Jeune

Fenouillet, 37, 37 n.4, 47

Ferrier, Gabriel, 14

Festival of Flowers, Nice, 198, 210, *438*

Fiesole, 83

Figure with Cushion, 205, *424*

Figure Studies, 180

Figure Study, 97, *295*

Films on Matisse, see *Art Survives the Times; A Visit with Matisse*

Fish, 200

Fisherman, 54, 55, 98

Flaherty, Robert, 219

Flandrin, Jules, 16, 43, 123

Fleurs du Mal, see Baudelaire, Charles, *Les Fleurs du Mal*

Florence, 83

Florilège des Amours de Ronsard, see Ronsard, *Florilège des amours*

Flowers, 150; (1906), 83; (1909), 24

Flowers and Ceramic Plate, 100, 143, 154, 181, 224, *377*

Flowers in Silver Vase, see *Bouquet on Bamboo Table*

Fragonard, J. H., 33

France, La, 241, 253, 259, *485*

Frankfort-on-Main, Städtisches Museum, see *Flowers and Ceramic Plate*

Fremiet, Emmanuel, 123

French Window at Nice, 205, 232, *425*

Freudenberg, 45 n.4

Friedmann, Curt, 109; see also *Dinner Table*

Friesz, Othon, 43, 54, 55, 83, 86f, 100, 106, 201

Frost, A. B. Jr., 117

Fruit and Bronze, 28, 127, 128, 138 n.5

Fruit Dish and Glass Pitcher, I, 48, 48 n.4, 67; *II*, 48, 48 n.5, 67

Fruit and Flowers, 200, 212, *441*

Fry, Roger, 105, 110f, 126, 139f, 149, 158, 203, 206, 222

Fry, Varian, 30, 256, 257, 278

Fukushima, Baron, Collection, see *Yellow Dress*

Futurism and Futurists, 147, 150, 158, 185, 185 n.8, 204

Gaffé, René, 288

Galanis, 178

Galanis, Mme, portrait of, 186

Galitzin, Princess Elena, 251; see also *Elena*

Game of Bowls, 25, 106, 132, 134, 135, *356*

Ganymede, see *Study of Cast of Capitoline "Niobid"*

Gardner, Isabella Stewart, 105; see also Boston, Isabella Stewart Gardner Museum

Gates, John M., 251

Gauguin, 16, 24, 36, 37, 38, 40, 44, 45f, 47, 49, 57, 59, 64, 64 n.4, 69, 72, 74, 81, 82 n.7, 86, 87, 88f, 99, 106, 109, 110, 111, 149, 158, 229; *Head of Boy*, 39f

Gaul, August, 108

Geffroy, Gustave, 63

Germany, visits of Matisse to, 107-109, 134, 151

Gérome, Jean Léon, 15f, 34

Gide, André, 53 n.7, 63, 244, 256, 257

Giorgione, 88

Giotto, 83, 102, 122, 204, 220, 222

Girl with Black Cat, 131, 150, 189, *354*

Girl with Goldfish, 217

Girl in Green (1909), 106, 130; (1921) 210

Girl with Green Eyes, 105, 111, 128, 130, 152 n.5, 263, *352*

Girl with Ivy in her Hair—Study for *Joy of Life*, 89, 98, *321*

Girl in Persian Costume, 246, *468*

Girl Reading, 269, *492*

Girl in Red Chair, 223, 251, *476*

Girl with Tulips, 24, 106, 131, 140, *353*

Girl in Turban, 192, *414*

Girl in White Gown, 275

Girl in Yellow Dress, 216, 224, 246, *455*

Gischia, Léon, 264

Gitane (1906), 98 n.2; (1911), 143; see also *Gypsy*

Glackens, William, 112, 181

Gladioli, 206, 215, *452*

Glaser, Curt, 105, 177, 179

Glasgow, Art Gallery, 557; see also *Nappe Rose*

Glass design, 224, 251, *482*; see also Vence Chapel: window designs

Gleizes, Albert, 146, 178

Gleyre, M. C. G., 33

Gobelins tapestries, 261, 278

van Gogh, Mme Theo, 111

van Gogh, Vincent, 16, 35, 36, 37, 38, 39 n.5, 43, 47, 48, 54, 57, 59, 62, 63, 72, 74, 81, 86, 102, 109, 111, 149, 158, 229; *L'Arlésienne*, 38, 86; *Night Café*, 110

Goldfish (1909-10, Copenhagen), 100, 127f, 164, 190, 199, *348*

Goldfish (1911, Moscow), 28, 134 n.2, 144, 154, 164, *376*, 555

Goldfish (1912, Barnes), 100, 144, 149, 157, 164, 185, 188, 190, 203, *385*

Goldfish (1915, Marx), 157, 164, 168-169, 171, 174, 181, 188, 190, 191

Goldfish, see also *Girl with Goldfish, Goldfish and Sculpture; Interior with Goldfish; Moorish Café; Woman before Aquarium*

Goldfish and Sculpture (1911, Whitney), 100, 154, 157, 164-*165*, 168, 174, 187, 188, 278

Gómez-Sicré, José, 30

Gontcharova, settings for *Coq d'or*, 207

Goodyear, Gen. A. Conger, 199; see also *Music (Sketch); Still Life* (1899?)

Gorky, Arshile, 264

Gosol, 84

Göteborg, Museum, see *White Plumes*

Gouaches, 274, 278, 500-501, 512-513, 525

Gourds, 173, 190f, 197, 207, *412*

Gourgaud, Baroness, see *Interior with Goldfish*

Goya, F., 15, 36

Grande Chaumière, 42, 52, 116 n.4

Grande Revue, 96, 103, 119, 125

Graphic art, see Aquatints; Drypoints; Etchings; Linoleum cuts; Linoleum engravings; Lithographs; Monotypes; Wood engravings; see also Book illustration and design

Great Cliff at Etretat, 209

El Greco, 59, 85, 87, 143, 222; *View of Toledo*, 36

Greek sculpture, 100, 121, 123, 126, 127, 130, 139, 142, 550

Greek vase painting, 135, 243

"Green Line," see Matisse, Mme, portrait of, (1905)

Green Robe, 191, *412*

Greenberg, Clement, 264, 265f

Grenoble, Musée de Peinture et de Sculpture, see *Interior with Eggplants; Marguerite Reading; Oriental Rugs; Tangerian Girl; View of Tangier*

Grey Nude, 215f, *454*

Gris, Juan, 147, 168, 178, 187f, 204

Gris, Mme Juan (Josette), 178, 186

Grosse tête, see *Stout Head*

Grosz, George, 249

Grünewald, Isaac, 117, 259

Grünewald, Matthias, 109, 204, 285

Guenne, Jacques, 41

Guérin, Charles, 16, 19, 44, 63, 87 n.10, 107, 119

Guggenheim, Mrs. Simon, 163, 174

Guillaume, Paul, 192, 201; see also *Bathers by River; Piano Lesson*

Guitarist, 41, 44, 45, 51, 53, *310*

Gurlitt, 178; see also Berlin, Gurlitt Gallery

Gustave Moreau's Studio, 15, 34, *295*

Gypsy, 20, 94

Haas, Mr. and Mrs. Walter A., see *Joy of Life—Study; Woman with the Hat*

Hagen (Westphalia), Folkwang Museum (Osthaus collection), see Essen, Folkwang Museum

Hahnloser Collection, see *Black Table*

Hairdresser, 84, 95, 110, 149, 150, 199, *339*

Half-Length Nude, Eyes Cast Down, 99, *324*

Halvorsen, Walther, 105, 117, 189

Hamburg, Matisse Exhibition (1951), 262

Hamilton, George Heard, see *Jeannette IV*

Hanna, Leonard C., Jr., see *Bridge*

Haptic sculpture, 140f, 142

Harbor at Collioure (litho.), *61*, 98, 99

Harbor of Collioure, 62, *318*

Harmony in Blue, 106, 124f, 126, 129, 132, 133, 194, 215, *344*

Harmony in Green, 124

Harmony in Red, 24, 28, 46, 106, 123, 124-126, 133, 153, 207, 214, 215, *345*

Harmony in Yellow, 215, *451*

d'Harnoncourt, René, 219

Harriman, Marie, 246

Hartford, Wadsworth Atheneum, see "*Chant du rossignol*"

Hartley, Marsden, 115f, 204

Hartung, Hans, 264

Hat with Roses, 179, 180, 186

Head of Baudelaire, 240, 246

Head and Coffee Cup, 191, 192, *414*

Head of Italian, 142

Head of Marguerite (bronze), 213, 217, *401*

Head of Recumbent Figure, 324

"*Head with Tiara*," see *Tiari*

Head, White and Rose, 181, 188, 194, *402*

Heavenly Jerusalem, see Vence Chapel: window designs

Heda, W., 93

"Hédégat, Pascal," see Apollinaire, Guillaume

de Heem, Jan Davidsz, *Dessert* (copy), 33, 93, *171*; see also *Variation on Still Life by de Heem*

Heiberg, 22, 118

Helm, Mrs. George, see *Plumed Hat* (drawing)

Hendy, Philip, 201

Henri, Robert, 112

Henry, Charles, 47

Hercules and Antaeus, 249, *474*

Hermann, Curt, 108

van der Heyden, Jan, 33

Highet, Gilbert, 88 n.2

Hind, C. Lewis, 111

Hindu Pose, 211, *441*

"*Histoires juives*," 212

Hoeber, Arthur, 115, 149

Hokusai, 209, 556

Holbein, *Christina of Denmark*, 155

Holmes, Charles, 110

Homer, *Odyssey*, see Joyce, James, *Ulysses*, illustrations

Honolulu Academy of Arts, see *Girl Reading*

Hood, Raymond, 220f, 221 n.9

Horowitz, Vladimir, see *Nude by Window*

Horter, Earl, see *Italian Woman*

"*How I Made My Books*," 563

Howald, Ferdinand W., Collection, see Columbus Gallery of Fine Arts

Huneker, James Gibbons, 114, 115, 149, 222

Huysmans, J. K., 15, 44

Icarus, 274, 275, *500*; see also *Fall of Icarus; Jazz*

Idéistes, 36

Idol (1906), 94

Idol (1942), 267, 269, 279, *490*

L'Illustration, 19, 55f, 63, 72

Illustrations, see Book illustration

Impressionists and Impressionism, 16, 16 n.4, 35, 37, 38, 45f, 51, 63, 69, 72, 74, 88, 92f, 97, 98, 106, 108, 110, 111, 120, 125, 141, 142, 193, 194, 196, 199, 205, 206, 210, 237, 265, 288, 563

Ingersoll, R. Sturgis, 201

Ingres, J. A. D., 15, 85, 91, 102, 116 n.4, 149, 204, 551; *Bain turc*, 63, 91; *Odalisque*, 91

Interior with Blue Portfolio, 270

Interior with Boys Reading, 211, *439* and n. page 529

Interior with Eggplants, 100, 143, 151, 152-154, 157, 198, 201, 269, *374*

Interior with Flower and Parrots, 212

Interior with Goldfish, 164, 168, 177, 179, 185, 188, 190, 191, 203, *396*

Interior with Harmonium, 49, *302*

Interior—Nice (1917-1918), 196 n.5

Interior at Nice (1921), 209, 209 n.8, 210, *435*

Interior with Spanish Shawls, 24, 134 n.7, 143, 151, *372*

Interior with Spanish Vase, 266

Interior with Top Hat, 34, *296*

Interior with Violin, 196, 201, 204f, *421*

Interior with Violin Case, 205, *423*

Interior in Yellow and Blue, 260, 262 n.4, 275, 276, *502* and n.page 529

Invalid, 47, 49, *301*

Islamic art, see Near Eastern art; Persian art

Issy-les-Moulineaux, 23, 104, 127 n.4, 134, 139 n.7, 144, 146, 156-157, 163-164, 166f, 170f, 172f, 174f, 177, 178, 181, 183, 189f, 192, 193, 193 n.6, 195, 197, 206f, 346, 349, 353, 363, 364, 367-371, 373, 375-377, 381-385, 392, 406-409, 411, 412, 415, 419, 430-431, n. page 529
Italian Woman, 181, 188, 189, 199, *403*
Italienne, see *Italian Woman; Woman with Branch of Ivy*
Italy, visits of Matisse to, 83, 83 n.6, 102, 198, 200, 219, 220
Iturrino, 186
Ivy, Flowers and Fruit, 268

"Jack of Diamonds," 110
Jacques, Sister, 257, 269, 279, 279 n.1, 281
Jaguar Devouring Hare—After Barye, 52, *303*
Japanese Prints and Paintings, 36, 49, 90, 98, 102, 124, 127, 129, 156, 187, 192f, 209, 210
Japonaise, 51
Jazz: 185 n.3, 219, 253, 261, 264, 270, 271, 274f, 278, 287, *500-501*, 559-560
Jeannette, I, II, III, IV, and *V,* 104, 131, 140-142, 148f, 163, 179, 180, 213, 218 n.1, 262, *368-371*, 557; see also *Red Studio; Still Life with Bust*
Jeune femme, 252 n.2
Jeune femme à la pelisse, 269 n.2
Jeune fille debout, 148
Jewell, E. A., 222
Joaquina, 150
Jockeys camouflés, see Reverdy, Pierre, *Les jockeys camouflés*
Johnson, Mary E., see *Rumanian Blouse* (1937)
Joie de vivre, see *Joy of Life*
Jolas, Mme Eugène, 255
Jones, T. Catesby, 191, 201, 559
Joueurs de dames, see *Checker Game and Piano Music*
Jourdain, Frantz, 44, 56, 553
Joy of Life, 54, 58, 71, 81f, 83, 84, 85f, 88-92, 88 n.2 & 3, 93f, 96f, 98, 99 n.7, 103, 132, 133, 135, 136, 157, 193, 199, 218, 246, 251, *320*; detail, *361*; studies, *70*, 71, 89, 98, *321*
Joyce, James, *Ulysses*, illustrations, 89, 223, 249f, 270, *474*, 559-560; *Blinding of Polyphemus*, studies, 249, *474*

Kahnweiler, D. H., 83 n.5, 147, 178; see also Paris, Kahnweiler Gallery
Kandinsky, Wassily, 86, 264

Kann, Alphonse, 105, 110, 181, 184, 201; see also *Brook with Aloes; Gladioli; Rose Marble Table*
Katzenbach and Warren, Inc., see "Mural scroll"
Keck, Mr. and Mrs. Sheldon, 61
Kelekian, Dikran, 181
Kemenov, Vladimir, 262
Kessler, Count, 106, 111
de Kooning, Willem, 264
Krohg, Per, 117, 259
Kunstchronik (Leipzig), 108f
Kupka, Frank, 147
Kurashiki (Japan), Ohara Museum, see *"Caloges" at Etretat*

Lacourière, Roger, 246, 559-560
Lady in Blue, 234-*235*, 251, 252, 253, 263
Lady in White Gown, 260
La Forge, Mme, 186
La Fresnaye, Roger de, 178
Lagoon, 219, 264, 275, *500*; see also *Jazz*
Lamotte, Angèle, 274
Landsberg, Albert Clinton, 184, 184 n.2, 4 & 6, 185 n.2, 187 n.7
Landsberg, Mme, 184
Landsberg, Mlle Yvonne, 184f; portrait of, 131, 177, 179, 180, 184f, 187f, 189, *395;* drawing, 184, *394;* etching, 184, 185, 186, *394*
Landscape at Collioure, 55, 62, *70*, 71, 89
Laprade, 38
Large Interior in Red, 260, 262, 266, 277f, *507*
Large Nude, 163; see also 151 n.4, "*Grand nu à la colle*"
Lasker, Mr. and Mrs. Albert D., see *Idol* (1942); *Ivy, Flowers and Fruit; Meditation; Pineapple and Anemones; Plum Blossoms, Green Background; Still Life in Studio; Tabac Royal*
Lasker, Loula, see *Lemons against Fleur-de-lis Background*
Laurette sur fond noir, see *Green Robe*
Leda and Swan, 269f, *493*, and n. page 529
Lee, Arthur, 148
Le Fauconnier, 83
"Le Havre School," 83
Le Lavandou, 53, 104
Léger, Fernand, 191, 223, 251, 263, 280, 281
Lemons against Fleur-de-lis Background, 268, 269, 273, *489*
Lemons on Pewter Plate, 215, *450*
Leonardo da Vinci, 122, 123, 204
Letters of a Portuguese Nun (*Lettres Portugaises*), illustrations, 261, 271, 273, 279 n.1, *499*, 559-560, 563

Leveille, André, 260
Levy, Dr. and Mrs. David M., see *Shrimps*
Levy, Harriet Lane, 57, 105, 111, 199, 305, 352; see also San Francisco Museum of Art, Harriet Lane Levy Bequest
Levy, Rudolf, 105, 116
Lewisohn, Adolph, 201
Lewisohn, Sam A., 201
Lewisohn, Mrs. Sam A., 201; see also *Lorette in White Blouse; Pink Tablecloth*
Lhote, André, 258
Lieberman, Bertha Slattery, note p. 529
Liebermann, Max, 108
Lille, 15, 33
Linoleum cuts, 82, 98, 99, 177, 271 n.4, *325*
Linoleum engravings, 249, 271, 271 n. 4 & 5, 273, 274, *322, 494*, 559-560
Lipchitz, Jacques, 280
Liseuse, see *Marguerite Reading; Woman Reading*
Lithographs, *61*, 82, 98, 99, 99 n.6 & 2, 113, 177, 179, 186, 198, 200, 211, 212f, 216, 217, 272, 273f, 291, *324, 400, 445, 460, 494-499*, 559-560, 563
Little Head, 100, *326*
Living Art (*Dial*), portfolio, 199
Lloyd, David, 149
Loewenfeld, Victor, 141
London, Gargoyle Club, see *Red Studio*
—, Grafton Galleries, Manet and Post-Impressionists Exhibition (1910-1911), 110f, 148, 149; Second Post-Impressionist Exhibition (1912), 126, 140, 144f, 149, 163, 203, 218
—, Leicester Galleries, Matisse Exhibition (1919), 197
—, New Gallery, International Society of Painters, Sculptors and Engravers Exhibition (1908), 110
—, Tate Gallery, 37, 224, 557; see also *Tree near Trivaux Pond*
—, Victoria and Albert Museum, Matisse Exhibition (1945), 259f
Lorette, 181, 188, 188 n.3, 191f, 226; see also *Coffee; Girl in Turban; Green Robe; Head and Coffee Cup; Italian Woman; Lorette VII (Black Scarf); Lorette in White Blouse; Painter and His Model; Sleeping Nude; Studio, Quai St. Michel; Three Sisters, Triptych*
Lorette, VII, 191
Lorette in White Blouse, 188, 192, 226-227
Lorrain Chair, 194, 215, 277, *409*
Los Angeles County Museum, 558
Loti, Pierre, *Au Maroc*, 154
Loulou, 186

Loulou in Flowered Hat, 187

Lucerne, Musée des Beaux-Arts, Matisse Exhibition (1949), 194 n.4, 218, 262, 263, 560

Luks, George, 112

Lurçat, Jean, 223, 251, 280

Lute, 269, 278, 491

Le Luxe, I, 54, 78, 83, 95f, 132, 194, 260, 340

Le Luxe, II, 54, 87, 95f, 123, 125, 132, 135, 136, 149, 150, 152 n.5, 157, 163, 194, 201, 341

Luxe, calme et volupté, 53f, 54 n.9, 59, 60-61, 63, 64, 81, 82, 88, 89, 94, 95f, 126, 132, 218, 262, 317; Study, 54 n.9, 60, 316

Lydia, 276, 277

MacCarthy, Desmond, 111

MacChesney, Clara T., 146, 151

McBride, Henry, 139, 200f, 222, 224; "Matisse," 203

McBride, Mrs. Malcolm L. see Windshield

McIlhenny, Henry P., see Still Life on Table

McKim, Mr. and Mrs. William L., see Little Head

McMillan, Putnam D., see Three Bathers

Macy, George, 223, 249f, 474, 560

Madeleine, I, 48, 52, 305

Madeleine, II, 52

Magazine covers, 253, 270, 271, 275, 559-560

Magnelli, 264

Magnolia Branch, 223, 224, 247, 469

Maillol, Aristide, 37, 63, 88, 100, 217, 244, 257, 258; Désire, 142, 142 n.10; Seated Woman (La Méditerranée), 64

Maitland, Mrs. Ruth McC., see Italian Woman

Male Model, 48f, 92, 304; drawing, 44

Male Model—Sketch, 48f, 304

Malevich, Casimir, 86

Mallarmé, Stéphane, L'Après-midi d'un faune, 88; Poésies: illustrations, 89, 217, 219, 220, 223, 224, 240, 244, 245, 246, 249, 270, 271, 273, 466, 467, 559-560

Manet, Edouard, 16, 21, 34, 35, 36, 37, 50, 51, 57, 58, 59, 63, 74, 81, 108, 110, 111f, 123, 142, 193, 193 n.6, 206, 209, 229, 231, 563; Déjeuner sur l'herbe, 60; Musicians, 36; Olympia, 91, 111 n.6

Manguin, Henri, 16, 38, 43, 44, 48, 54, 57, 58, 83, 106, 158; Siesta, 19

Manila Shawl, 41, 123, 128, 131, 143, 148, 151, 183, 355

Manolo, 178

Mantegna, 135

Marble Top Table, 267

Marchand, André, 264

Margot, see Marguerite in Veiled Hat

Marguerite, 85, 94, 128f, 332; see also Head of Marguerite (bronze)

Marguerite in Fur Hat, 42, 194, 418

Marguerite Matisse, see Girl with Black Cat

Marguerite Reading, 83, 105, 128, 201, 332

Marguerite in Veiled Hat, 94, 94 n.6

Marin, John, 116

Marocain, see Amido, the Moor; Riffian, Half-Length

Marocaine, see Tangerian Girl; Zorah Standing

Marocains, see Moroccans

Marque, Albert, 56, 56 n.8

Marquet, Albert, 16, 37f, 40, 42, 43f 48, 49, 51, 54, 55, 83, 87 n.10, 98, 106, 109, 110, 145, 158, 178, 196, 198, 201

Marquet, Mme Albert, see Tree

Marseille, 196

Martin, Henri, 57

Martins, Mme Carlos, see Standing Model

Marx, Roger, 33, 43, 44f

Marx, Samuel A., 263, 406, n. page 529

Marx, Mr. and Mrs. Samuel A., see Apples; Goldfish (1915); Moroccan Garden; Variation on Still Life by de Heem

Massia, Joan, 186

Massine, Léonide, 197, 207, 207 n.5, 224, 252, 253f, 412, 482, 483; portrait of, 207

Masson, André, 254

Mather, Frank Jewett, Jr., 98, 115, 116, 150, 222, 556

"Matissare," 109

Matisse, Alexina, 23, 153; see also Dancer and Armchair, Black Background; Eggplants; Montalban

Matisse, Anna Héloïse Gérard, 13

Matisse, Auguste, 13 n.2, 111 n.4, 219

Matisse, Emile Hippolyte Henri, 13f, 34, 41

Matisse, Henri: Collection of the artist, 554; see also Back, I, II, and III; Breton Serving Girl; Books and Candle; Cliffs at Belle-Ile; Copy of Dead Christ by Philippe de Champagne; Decorative Figure—Study; Dream; Girl with Black Cat; Green Robe; Grey Nude; Head of Marguerite; Head, White and Rose; Interior with Harmonium; Interior with Top Hat; Interior in Yellow and Blue; Jaguar Devouring Hare—After Barye;

Jeannette, II and III; Landsberg, Yvonne, portrait of (drawing); Male Model; Moroccans; Mudocci, Eva, portrait of; Negro Boxer; Nude, c. 1909; Prozor, Greta, portrait of; Olive Trees, Collioure; Path in Woods of Clamart; Portrait in Moorish Chair; Rocking Chair; Rocks and Sea; Room in Ajaccio; Seated Figure, Right Hand on Ground; Self Portrait (1918); Self Portraits (1939, crayon); Shchukin, portrait of; Sleeping Woman; Still Life Against Light; Study of cast of Capitoline "Niobid"; Thousand and One Nights; Torso—Back View; Vence Chapel St. Dominic (preliminary drawing); Woman on High Stool

Matisse, Henri: Exhibitions, see Basle, Kunsthalle (1931); Berlin, Cassirer Gallery (1908-1909); Berlin, Gurlitt Gallery (1914); Berlin, Thannhauser Gallery (1930); Brussels, Palais des Beaux-Arts (1946); Chicago, Art Institute (1952); Cleveland, Museum of Art (1952); Copenhagen, Ny Carlsberg Glyptothek (1924); Düsseldorf and Hamburg (1951); London, Leicester Galleries, (1919); London, Victoria and Albert Museum (1945); Lucerne Musée des Beaux-Arts (1949); New York, Brummer Galleries (1924); New York, Montross Gallery (1915); New York, Museum of Modern Art (1931, 1951); New York, Pierre Matisse Gallery (1949); New York, "291" Gallery (1908, 1910 and 1912); New York, Valentine Gallery (1927); Nice, Union Méditerranéenne pour l'Art Moderne (1946, 1950); Paris, Bernheim-Jeune (1910, 1913, 1919, 1920, 1922, 1923, 1924); Paris, Carré Gallery (1941); Paris, Druet Gallery (1906); Paris, Georges Petit Gallery (1931); Paris, Maison de la Pensée Française (1950); Paris, Musée National d'Art Moderne (1949); Paris, Paul Rosenberg Gallery (1936, 1937, 1938); Paris, Vollard Gallery (1904); Philadelphia, Museum of Art (1948); Salon d'Automne (1945); San Francisco, Museum of Art (1952); Tokyo, National Museum (1951)

Matisse, Henri, photographs of, 22, 23, 26-32, 104, 109, 117, 118, 127, 189, 195, 196, 216 n.6, 217 n.8, 219, 219 n.5, 242, 245, 257, 267, 278, 284, 285, 462, 466, 483, 496, 497, 514, 519, 524

Matisse, Henri, self portraits, see *Self Portrait* (1906); *Self Portrait* (1918); *Self Portrait* (etching); *Self Portraits* (drawings); see also *Artist and His Model; Carmelina; Conversation; Nude in Studio; Painter and His Model; Still Life in Studio; "Exactitude is Not Truth"*

Matisse, Henri, as teacher, see "Académie Matisse"

Matisse, Mme Henri (Amélie Payrayre), 27, 37, 37 n.5, 41f, 47, 51, 53, 54, 54 n.2, 55, 62, 83 n.6, 104, 126, 128, 131, 142, 143, 147, 151, 152, 166, 177, 178, 183, 186, 189, 193, 198, 211, 218, 255, 258f, 529 n.

Matisse, Mme Henri, portraits of, *Mme Matisse* (1905—"*Green Line*"), 20, 41, 58, 62, 74-75, 93, 125, 128, 199 n.5; *Mme Matisse* (1913), 41, 147, 177, 180, 183, 184, 185, 189, *392*; see also *Conversation* (1909); *Guitarist; Manila Shawl; Music Lesson; Painter's Family; Red Madras Headdress; Woman with Hat; Woman in Kimono*

Matisse, Mme Henri, Tapestry after Derain, 54

Matisse, Jacqueline, 31

Matisse, Jean, 40f, 42 n.6, 152, 193, 196, 211; see also *Music Lesson; Painter's Family*

Matisse, Marguerite, 14 n.6, 41f, 42 n.6, 83 n.6, 85, 90 n.5, 94, 122, 131, 152, 181, 186, 186 n.6, 188, 193, 194, 196, 197, 198, 206, 210, 211, 216 n.3, 217, 255, 256, 258f, 529 n. (Questionnaire III); see also *Girl with Black Cat; Head of Marguerite; Head, White and Rose; Marguerite; Marguerite in Fur Hat; Marguerite Reading; Marguerite in Veiled Hat; Moorish Screen; Music Lesson; Painter's Family; Striped Jacket; Tea; Woman before Aquarium*

Matisse, Pierre, 31, 33 n.7, 35 n.9, 38, 41, 42, 50 n.7, 52, 135, 144 n.5, 152, 174, 178, 179 n.8, 183, 184, 188 n.3, 190 n.8, 193, 194, 195 n.5, 196, 200, 205, 208, 211, 245, 252 n.3 & 4, 255 n.5, 6 & 7, 256, 257, 257 n.5, 258 n.7, 259 n.8, 262 n.1, 268, 268 n.5, 269, 269 n.4, 5 & 6, 270 n.7, 286f, 466, 529 n. (Questionnaires IV and VII), 555; see also Matisse, Pierre, portrait of; *Music Lesson; Painter's Family; Piano Lesson*

Matisse, Pierre, portrait of, 130, *354*

Matisse, Pierre, Gallery, see New York, Pierre Matisse Gallery

Mauclair, Camille, 44, 56, 60, 62, 257

Maugham, W. Somerset, see *Woman in Yellow Armchair*

Maurer, Alfred, 62, 83, 116

May, Mr. and Mrs. Tom, see *Asia*

de Mazia, Violette, 192f, 222

"*Médaillon; un fauve,*" see Apollinaire, Guillaume, "*Médaillon: un fauve*"

Meditation, 208, 209, 247, *434*

Meier-Graefe, Julius, 108

Meissonier, 34

Melun, 42, 51, 308

Menard, René, 34, 57

de Menil, Mr. and Mrs. John, see *Brook with Aloes*

Mercereau, Henri, 110

Merion (Pa.), Barnes Foundation, 263; see also *Blue Still Life; Dance, I and II; French Window at Nice; Goldfish* (1912); *Joy of Life; Joy of Life—Study; Landscape* (1906); *Music Lesson; Red Madras Headdress; Riffian; Still Life with Bust; Three Sisters, Triptych;* Cézanne, *Card Players;* Picasso, *Composition* (1906); Seurat, *Poseuses;* see also Barnes, Dr. Albert C.

Merson, Olga, portrait of, 130f, *353*

Metalwork, 218, 285, 286, *516, 517, 524, 527* and n. page 529

Metthey, André, 100

Metzinger, Jean, 83, 146, 187f

Michaela, 259, 269, *491*

Michelangelo, 556; *Creation of Adam,* 136; drawing, 27; *Slave,* 211

Millet, Jean François, 114

Mimosa (rug), 261, 275, 279, *510*

Minneapolis Institute of Arts, see *White Plumes*

Minotaure, 271, 559-560

Mirbeau, Octave, 111

Miro, Joan, 86, 263, 288

Les Miroirs profonds, 261, 270, 273 n.8, 560

Model, 48, 92, *303*

Modigliani, Amedeo, 204

Moll, Greta, or Margarete (Frau Oskar Moll), 105, 107, 108, 116, 116 n.1, 2 & 6, 129, 133; portrait of, 105, 128, 129f, *351*

Moll, Oskar, 105, 107, 108, 116, 116 n.6, 199

Moll, Oskar and Greta Collection, see Moll, Greta, portrait of; *Nasturtiums and "Dance," II; Palm Leaf, Tangier; Pont St. Michel; Rose; Three Bathers*

"*Mon premier tableau,*" see *Still Life with Old Books*

Mondrian, Piet, 86, 263, 264

Monk in Meditation, 44

Monet, Claude, 16, 33, 35, 37, 46, 120, 197, 206, 209, 210, 552, 563

Monotypes, 177, 184 n.4, 186, 187, *399*

Montalban, 183, 205, *420*

Monte Carlo, 197, 207, 224, 254, *483*; see also Ballet Russe de Monte Carlo

de Montherlant, Henry, *Pasiphaé: Chant de Minos (Les Crétois),* illustrations, 89, 257, 259, 270, 271, *494,* 559-560

de Montherlant, Henry, portrait drawing of, 247, 247 n.6, 271

Montreal Museum of Fine Arts, 556

Moorish Café, 145, 147, 155, 160, 164, 209, *388*

Moorish Screen, 198, 200, 210, 211, 252, 263, 269, *437*

Moreau, Gustave, 15f, 16 n.4, 34, 35f, 37f, 43, 44, 45, 46, 48, 54, 63, 88, 110, 118, 195, 562; see also *Gustave Moreau's Studio*

Moreau, Gustave, *Apparition (Dance of Salome),* 15, *17*

Morice, Charles, 63, 87

Moroccan Garden, 145, 154 n.2, *380,* n. page 529

Moroccan Landscape with Horseman, 144

Moroccans, 172, 173, 191, 192, 200, 222

Morocco, see Tangier

Morosov, Ivan A., 105, 106f, 110, 144, 145, 147, 159, 198, 211; see also *Entrance to Kasbah; Fruit and Bronze; Seated Woman; Still Life with "Dance"; Window at Tangier; Zorah on Terrace;* Cézanne, *Overture to Tannhaüser;* van Gogh, *Night Café*

Morrell, Lady Ottoline, 110

Morrice, James W., 145

Morris, George L. K., 265f

Moscow, Museum of Modern Western Art, 154 n.4, 198, 261, 262; see also *Amido, the Moor; Arum, Iris and Mimosa; Coffee Pot, Carafe and Fruit Dish; Conversation; Dance* (1910); *Entrance to Kasbah; Fruit and Bronze; Game of Bowls; Girl with Tulips; Goldfish* (1911); *Harmony in Red; Interior with Spanish Shawls;* Matisse, Mme, portrait of, (1913); *Moorish Café; Music; Nasturtiums and "Dance," I; Nymph and Satyr; Painter's Family; Painter's Studio; Path in Bois de Boulogne; Red Commode; Riffian—Half-Length; Spanish Dancer; Still Life with "Dance"; Still Life in Venetian Red; Venice—Lady on Terrace; View of Collioure; Window at Tangier; Zorah Standing; Zorah on Terrace; Fisherman* (drawing); Cézanne, *Overture to Tannhaüser*

Moscow, Toison d'Or Salon (1908), 110, 148; (1909), 110

Moscow, visit of Matisse to, 134, 143, 152

Moslem art, see Near Eastern art; Persian art; see also Munich, Islamic Exhibition (1910); Paris, Louvre, Pavillon Marsan, Exhibition of Moslem Art (1903)

Mosse, Dr. Eric P., 140 n.1, 141

Motherwell, Robert, 264, 266

Mourlot Frères, 272, 273, 496, 559-560

Mudocci, Mme Eva, portrait of, 178, *401*

Müller, Joseph, see *Fatma, the Mulatto; Nude with Bracelet; Nude with Necklace*

Munch, Edvard, 99, 178; *Violin Concert,* 178 n.7

Munich, Islamic Exhibition (1910), 90 n.5, 109, 151, 152

Munich, Neue Staatsgalerie, see *Still Life with Geraniums*

"Mural Scroll": *Arbre en fleur,* 279, 279 n.8

Murals, 132-138, 216, 220f, 222, 223, 241-244, 246, 261, 263, 274, 276, 280f, 283-285, *362, 364, 462-464*

Murnau, F. W., 28-29, 219

Music (Sketch, 1907), 78, 79, 84, 96, 97, 132, 133, 135, 138, 180, 199

Music (1910), 78, 97, 104, 106, 123, 132-135, 138, 143, 144, 148, 151, 160, 161, 189, 190, 190 n.8, 203, *364*, 555; early state, 138, *365*; unfinished state, 138, 165

Music (1939), 224, 252, 267, 275, *481*; progress photographs, 252, *480*

Music Lesson, 42, 183, 189, 193f, 199, 203, 205, *419*

Mythe de la Baronne Mélanie, see Triolet, Elsa

"Nabis," 16, 36f, 40, 44, 47, 49, 57, 60, 63, 64, 72, 81, 82, 82 n.7, 86, 88, 96, 99, 100, 106, 110, 158

Nappe rose (Glasgow), 212, 557; see also *Pink Tablecloth* (Lewisohn)

Nasturtiums and "Dance," I, 127, 134 n.1, 144, 144 n.5, 148, 156f, 174, 194, *382*, 555

Nasturtiums and "Dance," II, 127, 144, 144 n.5, 149, 150, 156f, 174, 194, 199, 201, *383*

The Nation, 111f, 114, 150, 266

Nature morte aux roses de Noël et aux saxifrages, 269 n.2

Near Eastern art and influences, 90f, 90 n.5, 92, 94, 102, 109, 129, 151, 152, 286; see also Persian art

Negro Boxer, 278, *513*

Negro sculpture, 85, 100, 102, 139, 141, 141 n.4, 192, 193 n.6, 553

Neo-classicism, 204

Neo-Impressionism and Neo-Impressionists, 16, 36f, 47f, 53f, 53 n.7, 59, 62, 67, 71, 72, 81, 82, 82 n.7, 88, 92, 95, 96, 97, 110, 125, 288, 552

Neo-Romantics, 264

Neo-Traditionism and Neo-Traditionists, 36, 64, 81

Neue Sachlichkeit, 204

New Haven, Yale University Art Gallery, see *Still Life with Plaster Figure*

New York, Armory Show (1913), see Armory Show

New York, Brummer Galleries, Matisse Exhibition (1924), 198

—, Buchholz Gallery, see *Nu couché à la chemise; Reclining Nude, III; Standing Nude; Tiari*

—, Curt Valentin Gallery, see New York, Buchholz Gallery

—, Macbeth Gallery, "The Eight" Exhibition (1908), 112

—, Metropolitan Museum of Art, 115, 116, 558; see also *Nude Seated on Floor, Leaning on One Hand; Seated Model, Hands Clasping Knee; Seated Nude Leaning on Her Arm; Torso with Head;* El Greco, *View of Toledo;* Picasso, *Gertrude Stein*

—, Montross Gallery, Matisse Exhibition (1915), 116, 139, 140, 179, 180, 186, 198

—, Museum of Modern Art, 558; see also *Bather; Blue Window; Bouquet on Bamboo Table; Gourds; Interior with Violin Case; Piano Lesson; Red Studio; Still Life* (1899?). Drawings: *Dahlias and Pomegranates; Nude Seated on Floor, Leaning on One Hand; Odalisque with Moorish Chair; Plumed Hat; Seated Nude Leaning on her Arm.* Monotype: *Torso, Arms Folded.* Sculpture: *Reclining Nude, I; Serpentine; Torso with Head.* Derain, *Window on the Park;* Picasso, *Demoiselles d'Avignon; Woman's Head;* Signac, watercolor, *Arles*

—, Museum of Modern Art, Matisse Exhibition (1931), 116, 116 n.8, 222; (1951), 157 n.1, 263, 560

—, Pierre Matisse Gallery, see *Interior with Boys Reading;* Matisse, Pierre, portrait of; *Old Mill, Ajaccio; Pineapple*

—, Pierre Matisse Gallery, Matisse Exhibition (1949), 261, 263, 264, 266

—, Rockefeller Center, RCA Building, 220

—, A. P. Rosenberg & Co., see *Gladioli*

—, Thannhauser Gallery, see *Male Model* (drawing)

—, "291" Gallery, Matisse Exhibition (1908), 103, 113f, 148; Matisse Exhibition (1910), 115f, 148, 556; Matisse Exhibition (1912), 140, 144, 148f; "American disciples" (1910), 115f; Rodin Exhibition (1908), 113

—, Valentine (Dudensing) Gallery, Matisse Exhibition (1927, 1929), 200

—, E. Weyhe, see *Apples* (monotype)

"New York School," 264f

Newberry, John S., see *Plumed Hat* (pencil drawing)

Newton, Mrs. Maurice, see *Michaela*

Nice, 26, 27, 29-32, 183, 193f, 193 n.6, 195-198, 195 n.5, 196 n.2, 202, 204-206, 206 n.8, 208, 209f, 213f, 220, 254, 255-258, 261, 266f, 268, 420-423, 432, 434-443, 447-448, 451-457, 460, 462, 469, 478-483, 485-491, 494-496, 512, 513, 561

—, Ecole des Arts Décoratifs, 195, 205

—, Union Méditerranéenne pour l'Art Moderne, Matisse Exhibition (1946), 260; Matisse Exhibition, Galeries des Ponchettes (1950), 262, 263

Nightmare of White Elephant, 275, *501*; see also *Jazz*

Niobide, see *Study of Cast of Capitoline "Niobid"*

Norman, Dorothy, 115, 148, 148 n.4

North Africa, 82, 84, 102, 154; see also Algiers; Biskra; Tangier

"Notes of a Painter," 88, 98, 103, 108, 110, 119-123, 125, 160

Notre Dame (1904), 61

Notre Dame in Late Afternoon, 51, 69, *309*

Nu couché à la chemise (1905), 94 n.1, 217 n.8

Nude (c. 1909), 163

Nude (1917-18), 205 n.4

Nude in Armchair, (L 54, L 55), 212; (L 63), 211, 212, 213, *445*

Nude, Black and Gold, 106, 134

Nude with Bracelet, 177, 184; etching, 184 n.1

Nude in Chair, 98, 98 n.2, *322*

Nude, Face Partly Showing, 186, 212, *400*

Nude with Necklace, 158 n.2

Nude with Parrots, 217

Nude with Pipes—Study for "Joy of Life," 87, 98, *321*

Nude by Sea, 132, 134, 136, 149, *359*

Nude Seated on Floor, Leaning on One Hand, 50, 97, 556

Nude in Studio, 250, 251

Nude Study (before 1905), *48*

Nude in White Robe, 247, *468*

Nude with White Scarf, 132, 152 n.5

Nude by Window (1918?), 205, *422*
Nude by Window (1929), 215, *452*
Nude Woman Standing, see *Serpentine*
Nude in Wood, 83, 89, 150, *319*
Nymph and Faun (c.1909), 163, 269
Nymph and Faun (tapestry cartoon), 30, 257, 269, 278
Nymph and Faun, see also *Enchorrena painted doors*
Nymph and Satyr, 25, 89, 106, 132, 134, *358*

Oceania, 28, 217, 218, 219, 223, 279; see also Tahiti
Océanie—le ciel, 279
Océanie—la mer, 279, *510*
Ochre Head, 251, *477*
Odalisque compositions, 211f; see also *Decorative Figure on Ornamental Background; Hindu Pose; Reclining Odalisque; Seated Odalisque; Veiled Odalisque;* and following:
Odalisque in Green Pantaloons, 211
Odalisque with Magnolias, 211f, *440*
Odalisque with Moorish Chair, 202, 216, 217
Odalisque with Raised Arms, 198, 211, 213, 213 n.1, 232, *440*
Odalisque in Red Trousers, 107, 198, 260
Odalisque with Straight Back, see *Decorative Figure on Ornamental Background*
Odalisque in Striped Pantaloons, 212
Odalisque with Tambourine, 213, 232-233
Odalisque in Tulle Skirt, 216, 217, *460*
Of, George F., 82, 112; see also *Nude in Wood*
O'Keeffe, Georgia, 113 n.8, 204
Old Mill, Ajaccio, 46f, *300*
Olivarès, 186
Olive Grove, 210, *438*
Olive Trees, Collioure, 62, *318*
Olivier, Fernande, 34f, 87, 106; "*Picasso et ses amis*," 84f
Open Door, 46, *298*
Open Window (1905), *19*, 55f, 58, 62, 72, 73, 74, 125, 238
Open Window (1917), 195, 196, 204f, *420*
Optic sculpture, 140f
Orange Still Life, see *Still Life against the Light*
Oranges (1912), 145, 154 n.3, 155, 159, 211, 259, *389*
Oranges (1916), 181, 189f, 194, *406*
Oriental art and influences, 90f, 94, 99, 102, 129, 149, 192, 203, 209, 276; see also Byzantine art; Chinese art; Japanese prints and paintings; Near Eastern art; Persian art

Oriental Rugs, 82, 83, 92f, 105, 123, *329*
Orlik, Emil, 105
Orphism and Orphists, 116 n.5, 147, 204
Osborn, Max, 108 n.1
Oslo, National Gallery, see *Sculpture and Persian Vase*
Osthaus, Karl, 105, 106, 109, 132, 133, 143, 147, 149, 166; see also *Bathers with Turtle; Blue Window; Still Life with Asphodels*
Ostier, André, 29, 257, 267
"Outamaro," 187
Overmantel Decoration, 224, 252, *479;* charcoal studies, 252, 252 n.4, *478*

Pach, Walter, 83, 83 n.6, 116, 150, 179, 179 n.1, 183, 186, 217, 445; portrait of (etching), 179, 186, *398*
Padua, 83, 122, 220
Paine, Robert Treat, II, 201
Painted doors, see Enchorrena painted doors
Painter and His Model, 177, 191, 204, 205, 214, 260, *413*
Painter's Family, 29, 42, 143, 151, 152, 153, 157, 193, 208, 211, 269, *373*
Painter's Studio, 100, 142, 143, 144, 148, 151f, 152 n.5, 153, *375* and n. page 529
Paley, Mr. and Mrs. William S., see *Odalisque with Tambourine; Woman with Veil*
Palm Leaf, Tangier, 145, 154 n.2, 155f, 157, *381*
Palme, Carl, 116f, 116 n.1, 2, 6 & 8
Panneau décoratif pour salle à manger, see *Harmony in Red*
Panneau rouge, see *Red Studio*
Papiers collés; papiers découpés, see Cut-and-pasted paper
Paquemont, Charles, see *Chinese Box*
Pardee, William Scranton, 180
Paris, Bernheim-Jeune, 131, 134, 143, 200, 559-560
—, —, Cézanne Exhibition (1907), 87
—, —, Contracts with Matisse, 105, 107, 144, 183, 198, 199, 553-555
—, —, Futurist Exhibition (1912), 147, 185
—, —, Matisse Exhibition (1910), 107, 222
—, —, Matisse Exhibition (1913), 25, 140, 145, 148, 160, 196f
—, —, Matisse Exhibition (1919), 184 n.1, 187 n.8, 194 n.4, 196f
—, —, Matisse Exhibition (1920), 14, 197, 206 n.8
—, —, Matisse Exhibition (1922), 199, 210 n.2

—, —, Matisse Exhibition (1923), (1924), 199
—, —, van Gogh Exhibition (1901), 42, 86
—, Berthe Weill Gallery, 16, 41, 43f, 84
—, Bing Gallery, Fauves Exhibition (1927), 201
—, Bois de Boulogne, 42, 308, 466; see also *Path in Bois de Boulogne*
—, Carré Gallery, Matisse Exhibition (1941), 257
—, Couvent des Oiseaux studio, 81, 95, 103, 116-118
—, Couvent du Sacré Coeur, 22, 103, 117, 118, 134
—, Druet Gallery, 53, 99; Matisse Exhibition (1906), 82, 82 n.2, 98 n.2, 99 n.7 & 2
—, Durand-Ruel Gallery, 36, 37, 40; Gauguin Exhibition (1893), 16; Impressionist Exhibitions, 16 n.4
—, Exposition universelle (1900), 40f, 133
—, Georges Petit Gallery, Matisse Exhibition (1931), 16, 187 n.2, 197, 209 n.8, 210 n.3, 211 n.5, 221
—, Grand Palais, 40f, 52, 53, 84, 133
—, Kahnweiler Gallery, 87 n.10, 147
—, Katia Granoff Gallery, see *Model*
—, La Boëtie Gallery, Futurist Sculpture Exhibition (1913), 185
—, Le Barc de Bouteville Gallery, 36, 44
—, Louvre, 15, 33, 49, 60, 111 n.6, 118, 129
—, Louvre, Pavillon Marsan, Moslem Art Exhibition (1903), 90
—, Luxembourg Gardens, 42
—, Luxembourg Museum, 111 n.6, 260; see also *Decorative Figure on Ornamental Background; Odalisque in Red Trousers; Sideboard*
—, Luxembourg Museum, Caillebotte Bequest, see Caillebotte Bequest
—, Maeght Gallery, 270; see also *Gustave Moreau's Studio*
—, Maison de la Pensée Française, Matisse Exhibition (1950), 54 n.9, 94 n.1, 218, 261, 262, 278, 281, 515, 559-560
—, Musée de l'Art Moderne de la Ville de Paris (Palais de Chaillot), see *Dance, I* (Mural)
—, Musée des Arts Décoratifs, Exhibition of Persian Miniatures (1912), 160
—, Musée National d'Art Moderne, see *Algerian Woman; Decorative Figure on Ornamental Background; Large In-*

terior in Red; Luxe, I; Marble Top Table; Odalisque in Red Trousers; Painter and His Model; Reading Girl against Black Background; Red Still Life with Magnolia; Rumanian Blouse (1940); Sideboard; Two Friends

—, Musée National d'Art Moderne, Fauve Exhibition (1951), 54 n.9

—, —, Matisse Exhibition (1949), 261f, 264, 278, 513, 560

—, Musée de la Ville de Paris (Petit Palais), see Cézanne, Three Bathers

—, Palais de l'Industrie, Exposition d'Art Musulman (1893), 90

—, Père Tanguy Gallery, 44

—, Petit Casino, see Cabaret sketches (Cafés concerts)

—, Petit Palais, see Musée de la Ville de Paris; Salon d'Automne (1903)

—, Quai St. Michel apartment and studio, 37, 40f, 69, 103, 177, 181, 185, 191, 193 n.6; see also Interior with Goldfish; Painter and His Model; Studio, Quai St. Michel

—, Rosenberg, Paul, Gallery: Contract with Matisse, 223; Matisse Exhibitions (1936, 1937, 1938), 223

—, street sketches (c. 1896), 38, 98

—, Théâtre de l'Oeuvre, van Gogh Exhibition (1895), 36

—, views of Seine, 34, 38, 51, 68, 69, 186, 309

—, Vollard Gallery, 36, 38f, 52, 57, 106 n.6; 211; see also Vollard, Ambroise

—, —, Cézanne Exhibition (1895), 16, 36, 86; (1899), 86

—, —, Impressionist Exhibitions, 16 n.4

—, —, Matisse Exhibition (1904), 44f, 82

—, —, Picasso Exhibition (1901), 84

Park in Tangier, 144, 145, 154, 155, 380

Pasiphaé: Chant de Minos (Les Crétois), see de Montherlant, Henry

Pastels, 198

Pastoral, 89, 319

Pastoral compositions, 88f, 88 n.2 & 3

Path in Bois de Boulogne, 25, 44, 51, 106, 308

Path in Woods of Clamart, 144, 144 n.5, 157, 183, 194, 381

Payrayre, Amélie, see Matisse, Mme Henri

Pearlman, Henry, see Bathers by River

Peau de l'ours lottery sale, 67

Peladan, 123

Pellerin, Auguste, 111; portrait of, 181, 188 n.3, 189, 405; see also Three Sisters

Perret, Auguste, 279

Persian art, 102, 152, 160, 275

Persian Robe, 246, 246 n.4, 468

Persian Robe and Still Life, 266

Persiennes, see French Window at Nice

Petiet, Henri, 99 n.7, 186 n.6, 216 n.3

Pewter Jug, 194, 409; study, 194 n.4

Philadelphia, Museum of Art, 558; see also Coiffure (1901); Dance—Study; Interior—Nice (1917-1918); Landsberg, Yvonne, portrait of; Moorish Screen

Philadelphia, Museum of Art, Matisse Exhibition (1948), 253, 261, 266, 561

Phillips, Duncan, 201, 262; see also Washington, Phillips Gallery

Philpot, Glyn, 219

Photo-Secession, see New York, "291" Gallery; see also Camera Work; Steichen; Stieglitz

Piano Lesson (1916-1917), 42, 100, 174-175, 183, 189, 193f, 205, 222, 224, 263

Piano Lesson (pastel, 1923), 211 n.4

Picasso, Pablo, 43, 45, 57, 58, 62, 83-86, 102, 106, 107, 111, 142, 145, 146, 147, 149, 150, 157, 158, 159, 168, 186, 188, 197, 200, 204, 207, 211, 219, 220f, 222, 223, 251, 255, 255 n.2, 256, 257f, 259, 262, 263, 265, 266, 274, 281, 285 n.7, 286 n.8, 288

Picasso, Pablo, Charnel House, 263f; Composition (with two peasants—1906), 241, 465; Demoiselles d'Avignon, 22, 84, 85f, 87, 106, 142 n.6; Dr. Claribel Cone (drawing), 247; Dora Maar, 257 n.5; Friendship, 139 n.6; Gertrude Stein, 21, 84; Guernica, 257, 263; Plaster Heads (1932), 142; Portrait of Mme Picasso, 219; Portrait of Ambroise Vollard (drawing), 204; Seated Man (drawing, 1914), 204; Still Life, 30; Still Life with Plaster Bust, 142 n.8; Three Dancers, 200; Two Nudes (1906), 139 n.6

Picasso, Pablo, book illustrations: Aristophanes, Lysistrata, 249; Balzac, Chef d'oeuvre inconnu, 184 n.5, 244; Ovid, Métamosphoses, 244

Picasso, Pablo, collection, see Marguerite; Oranges (1912)

Piero della Francesca, 83, 102, 139

Pignon, Edouard, 264

Pineapple, 277, 506; see also Large Interior in Red

Pineapple and Anemones, 236, 237, 255, 266

Pink Nude, 224, 247-249, 253 n.5, 274, 472, 473; studies, 247f, 473

Pink Onions, 76, 77, 82, 93, 94, 123, 125, 127, 199 n.5, 229, 237

Pink Tablecloth, 212, 237, 443

Piot, René, 16, 63

Pissarro, Camille, 16, 33, 35, 37, 38f, 46, 47, 86, 210, 563

Pittsburgh, Carnegie International Exhibitions, see Carnegie International Exhibitions

Place des Lices, St. Tropez, 59, 86, 314

Plaster Torso, 207

Plum Blossoms, Green Background, 260, 277, 505

Plum Blossoms, Ochre Background, 277

Plumed Hat, drawings, 206, 225, 428, 429; see also Antoinette, White Plumes

Poèmes de Charles d'Orléans, see Charles d'Orléans, Poèmes

Poésies de Stéphane Mallarmé, see Mallarmé, Stéphane, Poésies

Pointillism and Pointillists, see Neo-Impressionism and Neo-Impressionists

Poiret, Paul, 166

Poland, Reginald, 198

Pollaiuolo, Antonio, 556; Adam (drawing), 139; Arcetri frescoes, 243; Battle of Nudes (engraving), 243; Hercules and Antaeus (Matisse drawing after), 249, 474

Pollock, Jackson, 264

Polynesia: Sea; Polynesia: Sky, 278f

Pons, Lily, see Ochre Head

Pont St. Michel, 67, 68-69; photograph, 69

Poppies, 207

Portrait in Moorish Chair, 216, 453

Portrait on Red Background, 198

Portraits, see Apollinaire, Guillaume; Baudelaire, Charles; Besson, George; Cone, Claribel; Cone, Etta; Cortot, Alfred; Derain, Mme André; Galanis; Galitzin, Princess Elena; Landsberg, Yvonne; Matisse, Henri, Self Portraits; Matisse, Marguerite; Matisse, Pierre; Massine, Léonide; Merson, Olga; Moll, Greta; de Montherlant, Henry; Mudocci, Eva; Pach, Walter; Pellerin, Auguste; Prichard, Matthew Stewart; Prozor, Greta; Rouveyre, André; Shchukin, Sergei I.; Stein, Michael; Stein, Sarah; Vaderin, Jeanne; Whittemore, Thomas

Pose de nu, see Carmelina

Post-Impressionism and Post-Impressionists, 46, 74, 110

Poussin, Nicolas, 33, 60, 64, 88, 132, 135, 158

Praxiteles, 139

Présages, Les (ballet), 253f

Prichard, Matthew Stewart, 105, 110, 145, 177, 184, 185, 186; portrait of, 177, 186, *398*

Primitive art and primitivism, 111, 149, 158, 203, 286; see also Congo "velvets"; Negro sculpture

Prints, see Aquatints; Drypoints; Etchings; Linoleum cuts; Linoleum engravings; Lithographs; Monotypes; see also Book illustration and design

Prix de Rome, 563; see also Ecole des Beaux-Arts

Propert, W. A., 208

Providence, Rhode Island School of Design, Museum of Art, 558; see also *Still Life with Lemons Which Correspond . . .*

Prozor, Mme Greta, portrait of, 181, 189, *405*

Pulitzer, Mr. and Mrs. Joseph, Jr., 263; see also *Bathers with Turtle; Conservatory*

Purists, 191

Purple Cyclamen, 152 n.5, 163

Purrmann, Hans, *22*, 48 n.1, 56, 58f, 77, 83, 84, 88, 94 n.3; 103, 105, 107f, 109 n.2, 113 n.8, 116, 116 n.1, 4, 5 & 6, 117 n.1, 134 n.7, 136, 143, 146, 151 n.4, 166, 177f, 179, 181f, 189 n.4, 190, 196, 196 n.5, 287; see also *Goldfish and Sculpture*

Puvis de Chavannes, 34, 37, 38, 59, 60, 64, 88f, 106, 132, 134, 134 n.6, 241f; *Happy Land*, 17, 60; Pantheon murals, 242

Puy, Jean, 38, 40, 42, 43, 44, 48, 51, 54, 55f, 77, 83, 86, 91, 96, 100, 106, 110, 148, 152, 158; *L'Après-midi d'un faune*, 88; *Resting under Pines*, *19*, 56

Questionnaires, n. page 529

Quinn, John, 150, 180, 198, 199; collection, 199, 201; see also *Apples* (1916), *Artist and His Model; Blue Nude; Cyclamen; Hat with Roses; Italian Woman; Music (Sketch); Still Life with Fruit; Variation on Still Life by de Heem*

Radio interviews, see Broadcasts

Rambosson, Yvanhoé, 44

Rambouillet, Château, see *Woman Reading*

Ranson, 82, 82 n.7

Raphael, 95, 123, 561

Raynal, Germaine, 184

Raynal, Maurice, 155, 184 n.8

Rayssiguier, Brother L. B., 279, 281

Reading Girl against Black Background, 253

Reclining Nude, I (sculpture), 94, 94 n.1, 100, 140, 179, 205, 217f, *337*; see also *Goldfish* (1909-10); *Goldfish and Sculpture; Music Lesson; Sculpture and Persian Vase*

Reclining Nude, II (sculpture), 94 n.1, 217f, *457* and n. page 529

Reclining Nude, III (sculpture), 94 n.1, 217f, *457* and n. page 529

Reclining Nude, II, with Stove (lithograph), 216, *460*

Reclining Nude (ceramic tile), 100, *337*

Reclining Nude (drawing), 217, 218, *456*

Reclining Nude, Head Down (etching), *214*, 217

Reclining Odalisque, 198, 216

Recumbent Woman, see *Reclining Nude*

Red Commode, 24, 106, 127, 128

Red Interior with Blue Table, 276

Red Madras Headdress, 41, 84, 104, 108 n.1, 123, 128f, 130, 150, 178, 199, 199 n.5, *350*

Red Still Life with Magnolia, 267f, 268, *487*

Red Studio, 100, 140, 143, 149, 150, 151, 154, 157, *162-163*, 164, 263, 278

Redon, Odilon, 36, 40, 44, 59, 63, 81, 91, 106, 109, 110, 124 n.2, 149

Régamey, Father, 287

Reis, Mrs. Bernard, see Merson, Olga, portrait of

Rembrandt, 16, 102, 561

Rémond, Mgr. Bishop of Nice, 286-288, 287 n.3

Renoir, Auguste, 21, 33, 35, 36f, 47, 57, 58, 63, 106, 123, 132, 146, 181, 183, 195, 196, 203, 205, 210, 241, 266, 563; *Judgment of Paris*, 88, 132; *Venus*, 196

Repli, see Rouveyre, André, *Repli*

Reverdy, Pierre, *Les jockeys camouflés*, illustrations, *155*, *180*, 196, 244, 270, 273, 559-560; *Visages*, illustrations, 261, 271, 273f, 559-560, 563

Revue Blanche, 47, 59, 67

Revue Hébdomadaire, 123

Rewald, John, 39, 82 n.7, 277; Questionnaires V and VI, see 13 n.4, page 529

Riabuchinsky, Nicolas, 110

Richmond, Virginia Museum of Fine Arts, 559

Riefstahl, Rudolf Meyer, 110

Riffain assis, see *Riffian*

Riffain debout, see *Riffian, Half-Length*

Riffian, 145, 155, 159, 199, 241, *391*, 465

Riffian, Half-Length, 145, 155, 159, *390*

Rignault, J., see *Street in Arcueil*

Rivera, Diego, 182, 220f

Robe jaune, see *Yellow Dress; Zorah in Yellow*

Robinson, Edward G., see *Dinner Table*

Rocaille Chair, 267, 275, *504*

Roché, Pierre, 84

Rochester (N. Y.), Memorial Art Gallery, 559

Rockefeller, David, see *Still Life with Fruit*

Rockefeller, Mrs. John D., Jr., 166, 220

Rockefeller, Nelson A., 220, 224, 250, 252; see also *Nude in Studio; Overmantel Decoration*

Rockefeller Center, New York, 220

Rocking Chair, 219, *221*

Rocks and Sea, 46, *297*

Rodin, Auguste, 34, 51f, 52, 52 n.1, 63, 100, 103, 113, 122, 123, 135, 142, 149, 217; *Balzac*, 52; *Henri Rochefort*, 39f, 41, 52; *Walking Man*, 52

Roger, Derik, 110 n.9

Roger-Marx, Claude, 98 n.5, 217; see also Marx, Roger

Romains, Jules, 195, 197

Roman, magazine cover, 559-560

Roman mosaics, 94

Roman sculpture, 13, 15, 293, 550

Romm, Alexandre, 222f, 262

Ronsard, Pierre, *Florilège des amours*, illustrations, 89, 257, 261, 270f, 271f, *496*, *497*, 559-560, 563

Room in Ajaccio, 47, *300*

Rose, 93, 105, *330* and n. page 529

Rose-Croix, 36

Rose Marble Table, 192, 193 n.6, 194, 277, *407*; see also *Three Sisters, Triptych*

Rosenberg, Paul, 241 n.6, 255, 255 n.1, 3, 4 and 6; see also *Window at Etretat*; see also Paris, Paul Rosenberg Gallery; New York, A. P. Rosenberg Gallery

Roses, 212

Rosicrucians, see *Rose-Croix*

Rouault, Georges, 13, 16, 16 n.4, *19*, 37f, 44, 48, 54, 55, 83, 94, 100, 106, 110, 142, 223, 244, 250, 251, 256f, 258, 260, 263, 264, 279f; *Cirque Forain, Make-up*, and *Portrait of Lebasque*, 142 n.6

"*Rouge et Noir,*" ballet design, 197, 208, 224, 241, 252f, 253f, 253 n.5, 263, *483*

Rousseau, le Douanier, Henri, *19*, 61, 63, 77, 106, 149

Rousseau, Théodore, 114

Roussel, Ker-Xavier, 36, 88f, 100, 106

Rouveyre, André, 195, 257; portrait of, 269 n.1; *Repli*, 261, 271, 274, 559-560
Rubens, P. P., 88
Rug designs, 261, 275, 279, *510*
Rumanian Blouse (1937), 251 n.1
Rumanian Blouse (1940), 260, 267
Rump, Johannes, 77, 95, 109, 181, 199, 201, 259; see also Copenhagen, Statens Museum for Kunst, J. Rump Collection
Russell, J. P., 35
Russian collectors, 105-107, 110, 143, 152, see also Morosov, Ivan A.; Shchukin, Sergei I
Russian Ballet, see *Ballet Russe de Monte Carlo; Ballets Russes*
Russian Revolution, 180
Ruysdael, Jacob, 33
van Rysselberghe, Théo, 53, 82 n.7

Sagen, Trygve, 178, 178 n.6, 199; see also *Hairdresser; Young Sailor, I*
Sagot, Clovis, 84
St. Dominic, see Assy, Nôtre-Dame de Toute-Grace; Vence Chapel
Saint-Gaudens, Homer, 219
St. Louis, City Art Museum, 559
St. Quentin, 13, 14
—, Ecole Quentin de La Tour, 13, 13 n.4
St. Tropez, 45, 48, 53f, 59f, 62, 71, 88, 89, 95, 104, 314, 315, 316
Salles, Georges, 260
Salon des Artistes Français, 43, 82 n.7
Salon d'Automne (1903), 43f, 86; (1904), 13 n.2, 52 n.3, 53, 57, 87; (1905), *19*, 55f, 56 n.8, 57, 58, 62-64, 71, 72, 74, 82f, 84, 87, 88, 91, 92, 98, 112, 199; (1906), 56, 83, 87; (1907), 78, 83, 87, 95, 96; (1908), 52, 87, 111, 114, 124 n.2, 125, 133, 138 n.1, 148; (1910), 104, 134, 148; (1911), 143, 148; (1912), 144, 148, 148 n.3, 152, 555; (1913), 177, 180, 183; (1919), 197; (1944, 1945), 259
Salon du Champ-de-Mars, see Salon de la Nationale
"Salon des Fauves," see Salon d'Automne (1905)
Salon des Indépendants (1891), 36; (1898), 47, 49; (1901), 40, 41, 42, 49, 86; (1902), 41, 43, 50f; (1903), 43, 51; (1904), 44, 51, 53, 61; (1905) 43, 53f, 57, 60f, 62, 63, 64, 86, 88, 95; (1906), 54, 56, 56 n.8, 71, 81f, 85, 86, 88, 99 n.6; (1907), 83, 83 n.5, 95, 99; (1908), 87; (1910), 131, 140; (1911), 143, 148, 148 n.3

Salon de la Nationale, 43, 53, 57; (1896), 34, 45, 49, 67; (1897), 35, 46, 46 n.1, 49, 67, 124; (1898), 38, 52; (1899), 40, 42, 49; (1904), 53
Salz, Sam, 181 n.5, 182
San Diego (Calif.), Fine Arts Society, 559
San Francisco, Museum of Art, 559; see also *Corsican Landscape; Girl with Green Eyes; Madeleine, I; Slave; Stout Head*
San Francisco, Museum of Art, Matisse Exhibition (1952), 263
Sargent, John Singer, 34, 62, 200
Sauerlandt, Max, 147
Schapiro, Meyer, 222
Schempp, Theodore, see *Fruit Dish and Glass Pitcher, II*
"Scheherezade," ballet, 207
Schmidt-Rottluff, Karl, 142 n.6
Schnerb, J. F., 58 n.2, 107, 146
Schniewind, Carl O., 99 n.7, 186 n.6, 216 n.3
Scissors-and-paste, see Cut-and-pasted paper
Scolari, Margaret, 35 n.1, 94 n.2, 116 n.1, 118 n.1, 5 & 7, 119, 160 n.1, 187 n.2, 204 n.3, 206, 220 n.7, 242, 242 n.3, 243 n.4
Sculpture, *23*, *27*, 40, 48, 51f, 82, 94, 99f, 104, 111, 117, 138-142, 144, 145, 148f, 179, 181, 185, 195, 200, 205, 213, 217f, 221, 224, 232, 262, 285, *303*, *305*, *313*, *326-327*, *337*, *366-371*, *401*, *424*, *444*, *456-459*, *461*, *517*, *524*, 551; see also Woodcarving
Sculpture and Persian Vase, 100, 123f, 127, *342*
Seated Figure, Right Hand on Ground, 138, *366*
Seated Model, Hands Clasping Knee, 98, *323*
Seated Nude (bronze, c. 1908), 138
Seated Nude (bronze, 1925), *27*, 200, 213, 217, 221, 232, *444*
Seated Nude (drawing, 1923), 213, 213 n.1
Seated Nude (linoleum cut), 276, *325*
Seated Nude, Back Turned (lithograph), 186, *400*
Seated Nude, Head on Arms, (drawing), 247; (drawing, 5th state), 247, *470*; (etching), 247, 249, *470*
Seated Nude Leaning on Her Arm, 98, *323*
Seated Odalisque, 215, *448*
Seated Woman (1908), 107; (study for linoleum cut, c. 1906), 98, 98 n.2, *322*
Section d'Or group, 146, 204
de Segonzac, Dunoyer, 135, 178

Self Portrait (1906), 58, 82, 86, 94, 96, 128, 130, 178, 199 n.5, *333*, 554
Self Portrait (1918), *26*, 195, 196, 205, *422*
Self Portrait (etching), 45, 98f, *312*
Self Portraits (drawings), 39, 97, 223, 241, 253, *484*, 561
Self portraits, see also *"Exactitude is Not Truth"*; see also *Artist and His Model; Carmelina; Conversation; Nude in Studio; Painter and His Model; Still Life in Studio*
Seligmann, Hans, see *Young Sailor, II*
Sembat, Marcel, 56, 82, 84, 105, 106, 145f, 148, 155, 156, 159, 160, 177f, 197, 201; see also *Marguerite Reading; Oriental Rugs; Tangerian Girl*
Sembat, Mme Marcel, see *Dance* (watercolor)
Serf, see *Male Model; Slave*
Serpentine, *23*, 104, 138, 139f, 141, 148f, 179, 180, *367*
Sert, José Maria, 221
Sérusier, Paul, 36f, 40, 44, 63
Seurat, Georges, 16, 36, 47, 53, 67, 111, 149; *Poseuses*, 241
Severini, Gino, 158, 185
Seville, 134 n.5, 143, 151, *372*
Seville Still Life, see *Interior with Spanish Shawls*
Sharaku, 192
Shaw, Quincy, 114
Shchukin, Sergei I., 57, 85, 88, 98, 104, 105f, 107, 110, 123, 124f, 124 n.2, 126, 131, 132-135, 143, 144, 147, 149, 152, 154, 155, 156, 157, 160, 166, 177, 179, 180, 183, 189, 207, 555; portrait of, *24*, 106, 247
Shchukin, Sergei I., collection, *24*, 25, 105f, 126, 143, 151, 198; see also *Amido, the Moor; Arum, Iris and Mimosa; Coffee Pot, Carafe and Fruit Dish; Conversation; Corner of Studio (1912); Dance (1910); Fisherman (drawing); Flowers (1909); Game of Bowls; Girl in Green; Girl with Tulips; Goldfish (1911); Harmony in Blue, Harmony in Red; Interior with Spanish Shawls; Lady on Terrace; Matisse, Mme, portrait of (1913); Moorish Café; Music (1910); Nasturtiums and "Dance," I; Nude, Black and Gold; Nymph and Satyr; Painter's Family; Painter's Studio; Path in Bois de Boulogne; Red Commode; Riffian, Half-Length; Spanish Dancer; Still Life (1900); Still Life (1901?); Still Life (c. 1907); Still Life in Venetian Red; View of Collioure (1906); Woman on High Stool; Woman on Terrace; Zorah*

Standing; Picasso, *Friendship*; Picasso, *Two Nudes* (1908)

Sheeler, Charles, 204

Shoenberg, Sydney M., see *Fruit Dish and Glass Pitcher*

Shostakovich, First Symphony, see "*Rouge et Noir*"

Shrimps, 201, 203, 209, 228-229, 231

Sideboard, 215, 260, *450*

Sideboard and Table, 48, 48 n.4, 49, 59, 66-67, 71

Siena and Sienese primitives, 83, 83 n.9, 102, 192

Signac, Paul, 16, 36f, 40, 43, 44, 45, 47f, 53f, 53 n.6, 59f, 62, 67, 71, 81, 82, 82 n.7, 92, 95, 96, 97, 104, 119, 122, 132, 158; *Bay of St. Tropez*, *18*; "*De Delacroix au Néo-Impressionisme*," 47, 47 n.3, 59, 67; see also *Luxe, calme et volupté*

Signe de la vie, see Tzara, Tristan, *Le signe de la vie*

"*Le Silence habité des maisons*," 276

Silk screen, 279, *510*

Simon, Lucien, 34, 45, 57, 108

Sisley, A., 33, 38, 120

Skira, Albert, 220, 241, 244, 246, 257, 261, 271f, 466-467, 496-497, 559-560, 563

Slave, 25, 48, 48 n.1, 52, 118, 142, 148, 179, *305*

Sleeping Girl, 267

Sleeping Nude, 191, *414*

Sleeping Woman, 259, 267, *486*

Sloan, John, 112

Smith, Alexander and Sons, see *Mimosa* (rug)

Smith, Jeffery, 58

Smith, Matthew, 94, 110, 117

Soby, J. T., 38 n.2, 288 n.7

Social Realism and Social Realists, 262, 264, 280

Société Anonyme, 116 n.5

Société Nationale des Beaux-Arts, see Salon de la Nationale

"*Song of the Nightingale*," see "*Chant du rossignol*"

Souvenir de Biskra, see *Blue Nude*

Spain, visit of Matisse to, 104, 134, 143, 151, 195

Spanish Dancer, *24*, 106, 130, 134 n.6, *352*

Speicher, Eugene, 200

Standing Model, 49, 86, 95, *338*

Standing Nude (1901) 48 n.8

Standing Nude (1906, Sculpture), 100, *327*

Stations of the Cross, see Vence Chapel: *Stations of the Cross*

Steer, Wilson, 57

Steichen, Edward, 23, 103, 104, 112f, 115f, 135, 136, 139 n.7, 144, 145, 148

Stein, Allen, 94, 105

Stein, Gertrude, 21, 37, 37 n.5, 41 n.4, 53 n.8, 56-58, 83 n.5, 84f, 95, 95 n.6, 104, 105 n.9, 106, 107, 116, 134 n.5, 143, 144, 145, 146, 178, 180, 199; see also Stein, Leo D., collection

Stein, Leo D., 21, 48, 48 n.1, 56f, 58, 61, 81, 82f, 84f, 92, 94, 94 n.4, 95, 104, 106, 107, 111, 112, 116, 116 n.6 & 8, 133, 135, 138, 139, 143, 147, 180, 181, 199, 222, 553

Stein, Leo D., collection, see *Blue Nude*; *Invalid*; *Joy of Life*; *Marguerite in Veiled Hat*; *Music (sketch)*; *Woman with the Hat*; *Yellow Jug*; Picasso, *Gertrude Stein*

Stein, Michael, 56-58, 74, 82f, 84, 104, 107, 111, 112, 116, 143, 152, 153, 177f, 181, 189, 198, 199, 201, 206; portrait of, *26*, 188 n.3, 189, 192

Stein, Mrs. Michael, see Stein, Sarah; Stein, Sarah, portrait of; see also *Open Door*

Stein, Michael and Sarah, collection, *20*, 58, 104, 178 n.4; see also *Autumn Landscape*; *Blue Still Life*; *Gypsy*; *Hairdresser*; *Joy of Life—Study*; *Landscape at Collioure*; Matisse, Mme, portrait of (1905); *Pink Onions*; *Red Madras Headdress*; *Self Portrait* (1906); *Sideboard and Table*; *Still Life with Bronze*; *Tea*; *Woman with Branch of Ivy*; *Young Sailor, I*

Stein, Nina, 61

Stein, Sarah, *22*, 56-58, 74, 82f, 84, 88, 98, 103f, 107, 116f, 143, 177f, 181, 189, 198, 199, 206, 208, 220 n.6, 247, 263; portrait of, 181, 188 n.3, 189, 192, *404*; study for portrait, 189, *405*

Stein, Sarah, Notes on Matisse's class ("*A Great Artist Speaks to his Students*"), 98, 117, 118, 127, 220 n.6, 550-552

Stencil, 261, 270, 274f, *500*, *501*, 560; see also Silk screen

Stendahl, Earl L., see *Tea*

Sterne, Maurice, 59, 82, 116, 116 n.1, 118

Sternheim, Thea, 159; see also *Oranges* (1912)

Steuben glass vase, 224, 251, *482*

Stieglitz, Alfred, 103, 112f, 115f, 144, 148, 150, 556; see also *Camera Work*; New York, "291"; see also *Nude Seated on Floor*; *Seated Nude Leaning on Arm*; *Torso with Head*

Still Life (1899?), 47, *301*; *Still Life* (1900), 25; *Still Life* (1901?), 25;

Still Life (c. 1907?), 25; *Still Life* (drawing—*Thème G, variation 5*), *265*, 268

Still Life with Asphodels, 93, 109, 127, *330*

Still Life with Black Knife, 34, 46, *296*

Still Life with Bowl and Book, see *Still Life with Lemons Which Correspond . . .*

Still Life with Bronze, 104

Still Life with Bust, 140, 142, 142 n.8, 144, 157f, *384*

Still Life with "Dance," 23, 104, 107, 127f, 156, *346*

Still Life with Fruit, 181, 189, *397*

Still Life with Geraniums, 107, 109, 123, 128, 224, *349*

Still Life with Greek Torso, 123, *342*

Still Life with Ivy, 100

Still Life with Lemon (1921), 209, 229, 230-231

Still Life with Lemons Which Correspond in their Forms to Drawing of Black Vase upon Wall, 181, 187f, 189, 190, 231, *397*

Still Life against Light, 48, *302*

Still Life with Melon, 181

Still Life with Nutcracker, 190

Still Life with Old Books, 13f, 33, 197

Still Life with Oysters, 257, 267

Still Life with Peaches, 34, 222, *294*

Still Life with Plaster Figure, 83, 93, 100, *329*

Still Life with Potted Plant, 92, 110

Still Life with Purro, I, 59, 86, *314*

Still Life with Purro, II, 59, *315*

Still Life with Red Commode, see *Red Commode*

Still Life—Seville, see *Interior with Spanish Shawls*

Still Life with Shell, 257, 267

Still Life in Studio, 212, *442*

Still Life on Table, 212

Still Life in Venetian Red, 24, 28-29, 106, 124, 125, 126, 129, *343*

Stockholm, Hallin's Gallery, "*Matissare*" Exhibition (1909), 109

Stockholm, National Museum, see *Park in Tangier*

Stoop, Frank, 224; see also London, Tate Gallery

Stout Head, 217, *456*

Stralem, Mr. and Mrs. Donald S., see *Hindu Pose*

Stravinsky, Igor, *Le Rossignol*, see "*Chant du rossignol*"

Street in Algiers, 82, 92, *328*

Street in Arcueil, 49, *302*

Striped Blouse and Anemones, 266

Striped Jacket, 186, *402*

Stuck, Franz, 108

Studio under Eaves, 50, 179, *307*

Studio Interior, see *Gustave Moreau's Studio*

Studio, Quai St. Michel, 171, 177, 181, 191, 262, *410*

Study of Cast of Capitoline "Niobid" or "Ganymede", 13, 13 n'.4, 15 n.2, *293*

Study for Decorative Figure, see *Decorative Figure on Ornamental Background— Study*

Study of Legs, II (lithograph), *445*

Study of Model's Back, *141*, 142

Sur la terrace, see *Zorah on Terrace*

Surrealism and Surrealists, 218, 251, 263, 264

Swane, Leo, 116 n.1, 178 n.6, 198, 199 n.4, 259

Swans, see Mallarmé, Stéphane, *Poésies*, illustrations

Swarzenski, Georg, 154, 181, 377; see also *Flowers and Ceramic Plate*

Symbolism and Symbolists, 36f, 45, 64, 72, **81**, 86, 87, 88, 110, 158

Synthetists, see Symbolism and Symbolists

Tabac Royal, 269

Tahiti, *28*, 217, 218, 219, 221, 223, 246, 251, 275, 278f

Tal-Coat, Pierre, 264

Tangerian Girl, 154 n.3, 155, 159, *387*

Tangier, 92, 144, 145, 154, 157, 159f, 173, 177, 192, 195, *378-381, 386-391*

Tapestry designs, *30*, 99, 219, 223, 246, 250f, 257, 261, 262, 269, 278f, *475*

Taubes, Frederic, 166

Tea, 42, 197, 199, 203, 206, 208, *426* and n. page 529

Tempera, 374

Tériade, E., 32, 106 n.6, 154 n.1, 216, 261, 270, 271, 273, 274, 494, 499, 500, 559-560

Terrace, St. Tropez, 53f, 59, 60, 105, 110, *315*

Tête de satyre (terra cotta), 148

Tetzen Lund, Christian, 77, 109, 178, 178 n.6, 181, 199-201, 259; see also *Blue Still Life; Coffee; Goldfish* (1909-10); *Joy of Life*; Matisse, Mme, portrait of (1905); *Pink Onions; Red Madras Headdress; Riffian; Sculpture and Persian Vase; Self Portrait* (1906); *Street in Algiers; Three Sisters with Negro Sculpture* (see *Three Sisters, Triptych*)

Textile designs, see "Ascher panels"; "Mural scroll"; Vence Chapel: chasuble designs; see also Rug designs; Tapestry designs

Thannhauser, Justin K., see Berlin Thannhauser Gallery; New York Thannhauser Gallery

Thayer, Scofield, 199, 201

Thèmes et variations, see *Dessins: Thèmes et variations*

Thénard collection (Paris), see *Still Life with Black Knife*

Thiis, Jens, 109, 147

Thorn Extractor, 99f

Thousand and One Nights, 261, 278, *512*

Three Bathers, 96, 97, 105, 132, *338*

Three Sisters (ex-Pellerin), 192

Three Sisters, Triptych, 181, 183, 192f, 193 n.6, *416*; left panel, *Three Sisters with Negro Sculpture*, 199

Three Standing Nudes, 187, *398*

Three Studies of Zorah, 155, *379*

Tiari, (or *Tiaré*) 185, 217, 218, *461*

Tigre, see *Jaguar Devouring Hare* . . .

Tiles, painted and glazed, 280, 282f, 283-286, *511, 514-515, 517-522*

Titian, 88, 123, 222, 266

Todd, John R., 220f

Toison d'Or, see Moscow, *Toison d'Or* Salon; see also *Zolotoye Runo*

Toklas, Alice B., 82

Tokyo, National Museum, Matisse Exhibition (1951), 262, 560

Toledo (O.), Museum of Art, 559

Toledo (Spain), 143

Toronto, Art Gallery, 557; see also *Jeannette, V*

Torso, Arms Folded, 187, *399*

Torso—Back View, 261, 276, *509*

Torso with Head, 100, *326*

Toulouse, 37, 47, 48, 48 n.4, 67, 301

Toulouse Landscape, 47

Toulouse-Lautrec, H. de, 16, 36, 63, 110

Toyokuni, *Woman and Attendants Watching Girls*, 192

Transition, 42, 58, 559-560

Tree, 47, *300*

Tree of Life, see Vence Chapel: window designs

Tree near Trivaux Pond, 194, *407*

Trees near Melun, 51, 105, *308*

Triolet, Elsa, *Le Mythe de la Baronne Mélancie*, 271, 560

von Tschudi, Hugo, 106, 109; see also *Still Life with Geraniums*

Tulips, 61

Tulips and Oysters, 268

Turitz, Dir. H. G., see *Girl in Persian Costume*

Turner, J. M. W., 37

Two Friends, 267

Two Negresses, 138f, 138 n.1, 140, 141, 179, *366*; see also *Fruit and Bronze*

Two Nudes, Two Heads of Children— Studies, 99, *312*

Two Rays, 209, 210, 232, *433*

Two Sisters, 192, 203, 263, *417*

Two Women in Street Costumes, 45, 98, *312*

Typography, 271, 272, *499*; see also Book illustration and design

Tzara, Tristan, 139 n.8, 251; *Midis gagnés*, 270, 559-560; *Le Signe de la vie*, 261, 559-560

Ucello, Paolo, 204

Ulysses, see Joyce, James, *Ulysses*, illustrations

Utamaro, 187, 192; see also *"Outamaro"*

Vaderin, Jeanne, see *Girl with Tulips; Jeannette*

Valentiner, W. R., 198

Vallors-sur-Ollon, 41, 51, 309

Vallotton, Félix, 37, 44, 51, 57, 59, 63, 83, 96, 99, 100, 158

Valtat, Louis, *19*, 55, 100, 107

Variation on Still Life by de Heem, 170-171, 180, 199

Vaughan, Malcolm, 222

Vauxcelles, Louis, 56, 56 n.8, 62, 63, 87 n.10

Veiled Odalisque, 213

Veiled Woman, 268 n.6; (drawing), *268*

van de Velde, Henry, 109

Vence, 30-31, 195, 238, 258, 261, 269, 270, 279f, 492, 498, 500, 502-509, 514-527

Vence, Chapel, 59, 238, 257, 261, 278, 279-288, *514-527*; altar, 281f, 284, 285, *517*; altar candlesticks, 285, *516*; altar cloth, 285, *516*; altar crucifix, 218, 285, *517, 524*, n. page 529; chasuble designs, 285f, *525*; confessional door, 286, *526*, n. page 529; exterior, 281, 283, *527*; interior, 281f, *516-517*; models, 261, 262, 280f, 282f, *514-515*; plan, 281, *282*; St. Dominic, 280, 282, 284f, *514, 515, 517, 522, 523* and n. page 529; St. Dominic, preliminary drawing, *31, 522*; St. Dominic, study (hand with book), *283*; Stations of the Cross, *30*, 276, 282, 284, 285, 288, *515, 516, 520, 521* and n. page 529; *Virgin and Child* (tiles, interior wall), 276, 284, 280 n.1, 282, *514, 515, 518, 519* and n. page 529; *Virgin and Child* (tondo, apse façade), *285-286; Virgin and Child and St. Dominic* (tile panel for sacristy door, study), *284*, 285; window designs, 253, 275, 279, 280, 281, 283, *514, 517*

"Vence 1944-1948," see Verve
Venice, 83
Venice, Lady on Terrace, 24, 83, 106 n.5
Venus in Shell, 217, 218, 461
Veronese, P., 129
Verve, 559-560; cover designs, 271; No. 1 (1937), 253, 253 n.5, 274; "Vence 1944-1948," 261, 270, 276, 277; No. 13, "De la couleur" (1945), 270, 274
View of Collioure, 25, 92
View of Tangier, 154 n.3
Vignier, Irène, 186
Vignier, Mme, 186
Villacoublay, 418
Villon, Jacques, 146, 179, 264
Virgin and Child, see Vence Chapel: Virgin and Child
Visages, see Reverdy, Pierre
Visit with Matisse, film, 260
Vlaminck, Maurice, 42f, 54, 55, 59, 72, 81, 83, 86f, 100, 106, 110, 111, 150, 158, 178, 201, 257, 258
Vollard, Ambroise, 18, 39, 42, 44f, 53, 54, 56, 84, 86, 88, 100, 109, 196, 204, 220, 244, 271, 494; see also Paris, Vollard Gallery
Vrinat, Robert, 264
Vuillard, Edouard, 16, 19, 36f, 36 n.2, 40, 44, 45, 47, 49, 50, 57, 63, 106; Vuillard Family at Lunch, 36 n.2

Warburg, Edward M. M., see Woman Leaning on Her Hands
Washington, Embassy of French Republic, see Interior in Yellow and Blue
—, National Gallery, see Bellini, Giovanni, Feast of the Gods; Manet, Musicians; Rosenwald Collection, 559
—, Phillips Gallery, 559; see also Anemones with Black Mirror; Egyptian Curtain; Studio, Quai St. Michel
Watercolors, 134, 363; see also Gouaches
Watson, Forbes, 200, 222
Watteau, Antoine, 33
Weber, Max, 87, 116f, 116 n.1, 2, 4, 5 & 6, 118, 124 n.2, 204; Figure Study, 22, 118; see also Reclining Nude (ceramic tile)
Weeks, Mabel, 112

Weill, Berthe, see Paris, Berthe Weill Gallery
Weimar Academy of Arts and Crafts, 109
Weisgerber, Albert, 22, 109
Weiss, E. R., 77, 105; see also Pink Onions
Wéry, Emile, 35, 45, 297
West Palm Beach, Norton Gallery, 559; see also Two Rays
Wheeler, Monroe, see n. page 529 (Questionnaire II)
Whistler, James McN., 102
White, Samuel S., 201; see also "Histoires juives"
White Jabot, 251, 253
White Plumes (Göteborg), 206; White Plumes (Minneapolis), 200, 206, 208, 427; see also Antoinette; Plumed Hat
White Turban, 192, 417
Whitney, Gertrude Vanderbilt, 148
Whitney, Mr. and Mrs. John Hay, see Goldfish and Sculpture; Luxe, calme et volupté—Study; Still Life with Purro, II
Whittemore, Thomas, 105; portrait drawing, 247, 315
Window, 171, 181, 182, 190, 191, 198, 411
Window designs, see Vence Chapel: window designs
Window at Etretat, 209
Window at Tahiti, 251 n.5, 278, 475
Window at Tangier, 25, 145, 154, 156, 157, 159, 386; Study for, 155
Windshield, 183, 194, 418
Winterbotham, Joseph, 201
Wintersteen, Mr. and Mrs. John, see Lady in Blue
Woman before Aquarium, 164, 209f, 436
Woman with Branch of Ivy, 20
Woman with Closed Eyes, 130
Woman with the Hat, 19, 21, 41, 55-59, 62, 72, 74, 81, 84, 86, 88, 93, 94 n.6, 112, 128, 183, 199, 263 and frontispiece
Woman on High Stool, 42, 177, 179, 180, 183, 184, 186, 190, 193, 393; see also Music Lesson; Piano Lesson
Woman in Kimono, 186, 187, 398

Woman Leaning on Her Hands, 100, 148, 326
Woman with Lute, 278
Woman Nursing Knee; Foot, 137, 138
Woman Reading, 34, 294
Woman on Terrace, 106
Woman with Veil, 215, 446
Woman in Yellow Armchair, 125 n.5, 255, 266, 486
Women at Spring, see Bathers by River
Woodcarving, 286, 526
"Woodcuts," see Linoleum cuts
Wood engravings, 273, 498, 560; see also Linoleum cuts
Worcester (Mass.), Art Museum, 559; see also Nasturtiums and "Dance," II
World War I, 178, 180, 181f, 197, 204, 205
World War II, 241, 253, 255-259, 272
Wrought iron, 283, 286, 515, 527 and n. page 529

Yale University Library: Alfred Stieglitz Collection, 112, 113 n.8, 144 n.6, 148 n.4; Gertrude Stein Collection, 107, 553
Yellow Curtain, 187f
Yellow Dress, 201, 201 n.4
Yellow Hat, 216 n.7
Yellow Jug, 83, 83 n.4
Yomiuri Shimbun, see Tokyo, National Museum, Matisse Exhibition (1951)
Young Sailor, I, 58, 82, 93, 96f, 179, 194, 199, 334
Young Sailor, II, 82, 93f, 97, 128f, 149, 150, 157, 163, 179, 194, 246, 335

Zervos, Christian, 136, 251
Zigrosser, Mr. and Mrs. Carl, 45, 312
Zolotoye Runo (Toison d'or), 98, 110, 115, 179
Zorah Standing, 145, 154f, 157, 159, 246, 378
Zorah on Terrace, 25, 145, 154, 159, 203, 387
Zorah in Yellow, 154 n.2, 159, 379; see also Three Studies of Zorah
Zulma, 263, 278, 281, 513
Zuloaga, 134
Zurich, Kunsthaus, see Marguerite in Veiled Hat